TV
BY DESIGN

MODERN ART AND THE RISE OF
NETWORK TELEVISION

THE UNIVERSITY OF CHICAGO PRESS

CHICAGO and LONDON

TV

BY DESIGN

MODERN ART AND THE RISE OF
NETWORK TELEVISION

● ● ●

LYNN SPIGEL

LYNN SPIGEL is the Frances E. Willard Professor of Screen Cultures and the director of the Center for Screen Cultures at the School of Communication at Northwestern University. She is the author of *Welcome to the Dreamhouse: Popular Media and Postwar Suburbs* and *Make Room for TV: Television and the Family Ideal in Postwar America*, also published by the University of Chicago Press.

The University of Chicago Press, Chicago 60637
The University of Chicago Press, Ltd., London
© 2008 by The University of Chicago
All rights reserved. Published 2008
Printed in the United States of America

15 14 13 12 11 10 09 08 07 06 1 2 3 4 5
ISBN-13: 978-0-226-76968-4 (cloth)
ISBN-10: 0-226-76968-2 (cloth)

Library of Congress Cataloging-in-Publication Data

Spigel, Lynn.
 TV by design : modern art and the rise of network television / Lynn Spigel.
 p. cm.
 Includes bibliographical references and index.
 ISBN-13: 978-0-226-76968-4 (cloth : alk. paper)
 ISBN-10: 0-226-76968-2 (cloth : alk. paper) 1. Television and art. 2. Modernism
(Art)—United States. 3. Art and popular culture—United States—History—20th century.
I. Spigel, Lynn. II. Title.
 N72 .T47S65 2008
 791.45—dc22 2008026887

♾ The paper used in this publication meets the minimum requirements of the American National Standard for Information Sciences—Permanence of Paper for Printed Library Materials, ANSI Z39.48-1992.

With love to my father, Herman Spigel, 1916–2004

CONTENTS

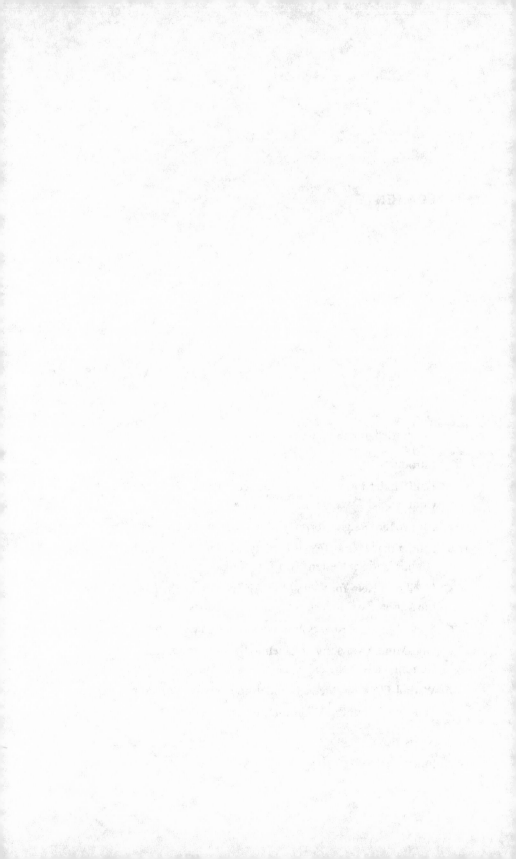

••• ACKNOWLEDGMENTS

I'm deeply grateful to friends and colleagues who helped with this book. I especially want to thank Dana Polan, Charlotte Brunsdon, and Jan Olsson for their support and enthusiasm for the project in its various incarnations. Many thanks, too, to Margie Solovay, Marita Sturken, Marcia Untracht, Michael Curtin, Kathleen McHugh, Chon Noriega, Tania Modleksi, David Morley, Nick Browne, Horace Newcomb, Mary Beth Haralovich, John Caldwell, William Boddy, Christopher Anderson, Steven Classen, Criswell, Victoria Johnson, Alison Trope, Ethan Thompson, J. J. Murphy, David James, Michael Renov, Marsha Kinder, Vibeke Pederson, Dilip Gaonkar, Karal-Ann Marling, William Germano, Marjorie Garber, Kathleen Rowe Karlyn, Marcia Brennan, Ken Wissoker, Mimi White, Lawrence Lichty, Chuck Kleinhans, Jacqueline Stewart, David Tolchinsky, John Haas, Debra Tolchinsky, Lane Relyea, Scott Curtis, Rick Morris, and Roberta Stack. I also want to extend my deep appreciation to Northwestern University president Henry Bienen, former provost Lawrence Dumas, and Dean Barbara O'Keefe for their generous support of my research.

This book would not have been possible without the patience, enthusiasm, and expertise of Douglas Mitchell, senior editor at the University of Chicago Press. I'm also very grateful to archivists who lent their support

and knowledge, especially Mark Quigley at the UCLA Film and Television Archive; Kari Horowitz at the Rochester Institute of Technology Wallace Library; Michelle Elligott, Charles Silver, and Anne Morra at the Museum of Modern Art; David Lombard at the CBS Photo Archive; and Greg Pierce at The Andy Warhol Museum. My research assistants, Andrew Douglas, Kirsten Pike, Linda Robinson, Elizabeth Nathanson, and Max Dawson, provided invaluable support.

And thanks to Jeffrey Sconce for everything.

INTRODUCTION

To promote its Bravia "next generation" TV, in October of 2006 the Sony Corporation launched a website featuring an equally "next generation" commercial. The second in its award-winning "Color Like No Other" campaign, the commercial looks more like a work of performance art than an ad for a household appliance. In fact, even while promoting a TV set, the commercial never shows one. Instead, massive bursts of blue, red, orange, purple, green, and yellow paint explode onto abandoned buildings in an urban landscape while curious onlookers stand by watching the event. The accompanying website displays a slideshow gallery that allows people to look at individual frames of the commercial, and it also includes a "making of documentary" that describes the enormous amount of time and effort—10 days, 7,000 liters of paint, 250 people—it took to make the ad.[1] Blurring the lines between site and website specific art, and confusing the terms of aesthetic contemplation and online shopping, Sony hopes to persuade its digital publics that the Bravia flat screen TV is not just high-tech but also high art.

With artistic and economic investments like this, it is easy to see why today's wired publics are captivated with the ideal of progress that new media promise. No matter what we actually watch on the set (the news, *American Idol*, Godard films, or reruns of *Matlock*), Sony and other electronics companies

imbue the technological platforms of new media with the aura of art, and they package their high-tech products with related ideals of "good taste" and class privilege.[2] Aimed at modern and postmodern art lovers everywhere, the Bravia commercial assumes that the people most eager and able to purchase these high-end gadgets are also most likely the people who conceive of themselves as an avant-garde art public. Yet, despite the industry's attempts to assure us that new technologies are always more culturally progressive than those of the past, the association between television, art, and cultural uplift is really not so new. In fact, since TV's inception, the television industry and the art world have depended on each other for promotion, sustenance, and their mutual appeal to publics.

This book explores the relationship between network television and the broader sphere of visual arts, especially modern movements in painting, graphic design, and architecture in cold war America. Focusing primarily on the late 1940s (when commercial television began in earnest) through the early 1970s (when the Public Broadcasting Service [PBS] and video art began to assert their own institutionalized protocols and artistic canons), I examine the deep cultural connections between the rise of network TV and the simultaneous "arts explosion" in postwar America. By looking at the social and labor relationships among fine artists, designers, advertisers, network executives, and program producers, I show that new movements in painting and modern design were integral to the business success of network TV (and by extension the success of the many corporations that advertised products on the new medium). In addition, by exploring a large range of television programs and commercials, I show how television developed a new aesthetics of "everyday modernism" that flickered across the living room screens in millions of American homes.[3] Like today's digital media, in the postwar period television was a new medium that provided unique opportunities for fine artists, commercial artists, and educators alike. Just as we now speak about television and digital "convergence," the history of television is also a history of convergence between old and new media.

The rise of network television took place at a time when modern painting and design became centrally important both to cold war political culture and to the new "consumer republic" in postwar America.[4] Sentiments of cultural nationalism, which had already surfaced in the 1910s and 1920s, grew stronger during the Depression and World War II when government-sponsored campaigns and museum exhibitions connected the love of art to the love of nation. By midcentury, after economic, political, and aesthetic transitions of previous decades, New York City had displaced Paris as the

world center for the visual arts, and New York School abstract expressionism rose to prominence as the centerpiece of the new "American" avant-garde. Abstract Expressionist painting played a central role in cold war campaigns to convince the world of America's cultural clout and its ethos of free expression. This was also an era of great popular enthusiasm for the visual arts. In the 1950s and 1960s, gallery and museum attendance in major urban centers grew to unprecedented heights. While viewed with a good degree of skepticism, the new movements in the arts—from abstract expressionism to pop to European art cinema, all became leading trends of their time, discussed and debated not only by art critics, but also in the popular culture at large. Finally, the rise of television occurred simultaneously with America's growing influence as an international center for modern graphic and architectural design, both of which influenced virtually all aspects of commodity culture. Indeed, this postwar "arts explosion" and the rise of television were not a mere historical coincidence; instead, art and television were deeply intertwined and dependent on one another for their mutual ascendance in U.S. cultural life.

Even before television became a household fixture, art museums and broadcast networks came together with mutual interests in the new medium. As early as 1941, the Metropolitan Museum of Art partnered with CBS to create experimental television broadcasts, lending its collection and expertise to a series of museum programs broadcast over New York City's experimental station WCBW. In July of 1941, on the occasion of the first of these television broadcasts, museum president Francis Henry Taylor enthused:

> We are living in a visual age where the complexities of modern civilization have demanded a minimum of words and a maximum of images. Television will be the instrument which will create as complete a revolution in the education of the future as the discovery of movable type and the invention of the printing press 400 years ago. We hope the day might not be far off when we can telecast our great treasures into every home and classroom of the nation. When that day is reached the visual senses of the American people will rival the 'musical ear,' which radio has done so much to develop.[5]

Taylor's dreams of art by TV were just the tip of the iceberg.

In the late 1940s, when the TV networks began to broadcast daily program schedules, there was a virtual revolving door among fine artists, graphic designers, modern architects, set designers, museum curators, network executives, and advertisers. For their part, network executives saw the visual arts as an invaluable resource because, above all, they needed to persuade the

public there was something visually interesting to watch on TV. Moreover, by showcasing programs on the arts the networks bolstered their reputations as public servants. Cultural programs helped networks and broadcasters to convince sponsors, audiences, and government regulators at the Federal Communications Commission (FCC) that their companies were not just economically sound, but also socially valuable. Documentaries and public-affairs programs like *Omnibus* (CBS) featured lessons on the arts and pro-vided an overall atmosphere of cultural uplift and edification. Meanwhile a dazzling number of entertainment genres—variety shows, sitcoms, and dramas—revolved around plots about modern art. Over the years, a slew of television characters took up the brush and the chisel. Lucy Ricardo took lessons from a French sculptor (*I Love Lucy,* CBS); Gracie Allen painted ab-stract portraits of her husband, George (*The George Burns and Gracie Allen Show,* CBS); Rob and Laurie Petrie went to art school in Greenwich Village (*The Dick Van Dyke Show,* CBS); Morticia and Grandmama Addams took lessons from Sam Picasso (*The Addams Family,* ABC); and Granny and Ellie May Clampett tried their luck in an art contest (*The Beverly Hillbillies,* CBS). Even television's nonhuman characters dabbled in the arts. TV's talking horse donned a beret and dipped his tail onto a palette (*Mr. Ed,* CBS) while a publicity photograph for *Lost In Space* (CBS) showed the robot dipping his mechanical arm onto a palette and painting an abstract work of art.[6] In these and other programs modern art was a special subject of narrative and vi-sual pleasure, sometimes played for mockery and laughter, but at other times mined for dramatic exploration.

Not only did the networks produce programs about the visual arts, they also developed in-house art departments that became centers of modern de-sign. Commercial television opened onto new experiments in scenic design, graphic design, and even architectural modernism as creative talent, adver-tisers, and network executives sought to make TV a source of visual attrac-tion. As NBC president Sylvester "Pat" Weaver said in 1952:

> Today, in the television industry, hundreds of artists . . . art directors, scenic designers, draftsman and visualizers express their individual talents before audiences so vast that an average Broadway theater would need to present the same attraction—eight performances a week—for nearly a quarter-of-a-century to reach an equal number of home viewers watching a single program. Because of the primarily visual nature of television broadcasting, a new field with strong and far-reaching potential has emerged for the graphic artist and craftsman.[7]

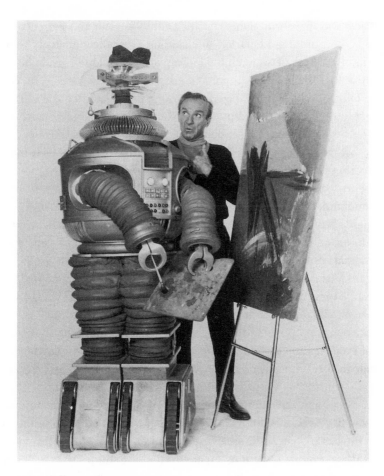

Robot (Bob May) and Dr. Smith (Jonathan Harris) dabble in the arts in
Lost in Space (CBS, ca. 1966).

A consummate advertising man, Weaver knew that visual design was espe-
cially important to advertisers who, in the booming postwar consumer soci-
ety, used modern graphic design in both print ads and television commercials
to imbue mass-produced products with a sense of individual "high" style.

CBS chairman William S. Paley and president Dr. Frank Stanton were even
more aggressive in their search for a modern graphic style. Themselves avid art
collectors, they built their quality reputation as the "Tiffany Network" largely
upon the talents of their in-house advertising and art department, headed by
influential art director William Golden, who designed everything from the
famous CBS "eye" logo to company cufflinks. CBS also employed acclaimed

architects and interior designers such as Eero Saarinen and Florence Knoll to design corporate headquarters and studios. Over the course of the 1950s and 1960s, all three networks hired leading artists, designers, and photographers like Ben Shahn, Feliks Topolski, Leo Lionni, René Bouché, John Groth, Georg Olden, Andy Warhol, Paul Strand, Saul Bass, Paul Rand, and Richard Avedon to design on-air and publicity art. So, too, in the 1950s advertising agencies began to establish art departments dedicated to television. By the late 1950s, critics began to talk about television commercials as a modern art medium in their own right. Advertisers drew on the latest innovations in modern graphic design and some deliberately emulated the style of new wave and underground cinema. In this regard, both television programs and commercials provided unique opportunities for nationwide audiences to see modern art and design. Television and modern art became so intertwined that market researchers and art critics began to wonder if television would change traditional modes of visual perception and aesthetic contemplation.

Despite these deep connections, the convergence between television and modern art is almost entirely neglected in media and cultural histories. Broadcast historians and critics typically regard early television as an admixture of previous popular entertainment forms such as circus, vaudeville, legitimate theater, movies, and radio. When they do look to the arts, historians generally consider television's relationship to the performing arts of opera, dance, symphony, and theater.[8] Yet, oddly enough, broadcast historians do not include painting, sculpture, architecture, or graphic design in the mix.[9] Given the fact that television is a visual medium, this lack of attention to the visual arts is especially curious. Apart from a few studies of art documentaries or educational programs, as well as several essays on pop's influence on shows like *Batman*, there is no sustained historical study of broadcast television's relationship to the broader context of postwar visual arts.[10] But television did not exist in a vacuum apart from other visual arts; instead, it came to prominence within an already existing, yet constantly changing, field of art and culture. Nor was television just a vehicle for transmitting other arts via art documentaries and instructional shows. Instead, television had a dynamic relation within the field of visual culture and it also helped to shape directions and attitudes within the professions of graphic design, museum display, architecture, and painting.

Given the enormous amount of modern art and design on television, we need to revise our understanding of what TV actually looked like during this period. Early television audiences saw variety shows, soap operas, sitcoms, dramas, news, and commercials packaged within a distinctly modern

graphic look designed by some of the nation's leading graphic artists and scenic designers. Modern graphic design, as well modern stage and set design, accompanied a good portion of the daily schedule. Modern design was indeed crucial to the visual culture of television. TV was not just a remediation of old entertainment forms; instead, television offered an eclectic mixture of old and new, transmitting a unique brand of everyday modernism to television viewers across the nation.

I began this book on a hunch, admittedly counterintuitive. What could television, that most lowly of low objects, have to do with art? Wasn't television just a "vast wasteland" as FCC chair Newton Minow declared in 1961?[11] At best, wouldn't television simply be a middlebrow affair, bringing corporately sanctioned but watered down lessons on Verdi, Shakespeare, and Picasso to the "masses"? Television is certainly one of the most hotly charged gadgets of the twentieth and twenty-first centuries, subject then and now to grave cultural disputes. In the cold war period, when respected sociologists, anthropologists, and critics like Lewis Mumford, Jules Henry, and Herbert Marcuse were lashing out at the conformist and mind-numbing effects of mass culture, television seemed to be the worst of the lot. Extending his "culture industry" thesis, in 1961 Frankfurt School émigré Theodor Adorno sharply attacked television for its evacuation of the "serious arts" in favor of formula and standardization. Insisting on the difference between authored art and television's mass produced consumer forms, he claimed, "To study television shows in terms of the psychology of the authors would be tantamount to studying Ford cars in terms of the psychoanalysis of the late Mr. Ford."[12]

Similar sentiments could be found in various venues of postwar culture. As Cecilia Tichi has argued, in the postwar period, literary critics, journalists, and sociologists variously depicted television as the enemy of books and the literary culture of reading, and she also shows how a number of postwar novels (most notably Ray Bradbury's 1953 science fiction classic *Fahrenheit 451*) depicted TV with themes of fascism and mind control.[13] Beat poets also used television as a symbol for widespread social catastrophe. In his 1961 poem, "Television Was a Baby Crawling toward that Deathchamber," Allen Ginsberg created a rhythmic chant out of the noise, not just of television, but also the entire technological, mass-mediated, and death-driven society of an apocalyptic age.[14] Even the more ebullient Marshall McLuhan, who famously called TV a "cool" participatory medium and praised its potential to create a "global village," derided TV for "hypnotizing the viewer" and claimed that because of its "tactical depth" and encouragement of viewer involvement "TV can transform the Presidency into a monarchic dynasty."[15] Although critics

like Gilbert Seldes and Jack Gould initially embraced television as a "popular art," by the early 1950s there was already widespread despair over TV's cultural worth, and by the end of the decade the only major "art value" imparted onto television came with critical reappraisals of its "golden age." But even this was a discourse of nostalgia filled with longing for a paradise lost. In this context, I admit, it seems unlikely that television would have much to do with art. Indeed, most television historians and critics don't start using the word "art" until they get to video art or music videos on MTV.

Insofar as possible, I hope to step back from this highly charged taste war by focusing instead on the material relationships between television and the broader sphere of postwar visual arts. This book, then, isn't a critical polemic about television's cultural worth (or for that matter, art's cultural worth). Instead, I explore the social networks and labor relations among painters, graphic designers, architects, educators, museums curators, television producers, network executives, broadcasters, and advertisers who worked together in mutual relations of support. I also consider the significant number of conflicts (over taste, aesthetics, and the general struggle between commercial values and art values) that often ensued. Finally, I explore how television aesthetics developed in relation to various postwar movements in the arts, from abstract expressionism to popism to art cinema to video art to mid-century modern architecture. Most broadly, throughout this book, I demonstrate how important television was in merging the popular arts of commercial entertainment with the elite venues of modern painting and design.

Given that contemporary critics often see television as being integral to the foundations of the postmodern conflation of "high" and "low" culture, it is especially curious that art historical work and museum exhibits on the fate of modernism and the avant-garde after World War II have been relatively silent on the role that television played in collapsing this great divide. While debates about the postwar status of a distinctly "American" modern art and its relationship to popular culture have circulated within art historical circles, art historians have primarily investigated the art world as the privileged term, giving little perspective on how popular media—especially television—served as a vehicle for the wide-scale dissemination of modern visual forms. In studies of television's postmodern aesthetics, proclamations about the collapse of high and low culture usually proceed with an analysis of *style*, but say little about the *social* agents and material processes through which the mergers between high and low took place.[16]

When historians and critics do consider television in relation to the visual arts, they typically begin with 1960s video art and/or multimedia perfor-

mances. In the 1970s and 1980s critics began to trace the aesthetic formations of video art as a response against commercial television. For example, in his groundbreaking essay of 1975, "Video: The Distinctive Features of the Medium," David Antin detailed the way early video artists developed their work in opposition to, or as a parody of, commercial TV. David Ross went even further, claiming that unlike the early cinema avant-gardes, "Television grammar . . . developed with no significant artists' participation."[17] But such statements ignore the numerous cross-media exchanges between fine artists, commercial artists, museum curators, and TV producers in the early broadcast era. This view of video as television's "other" has continued in much of the literature about video so that by now we inherit the distinction TV vs. video (and digital) as a commonsense historical procedure. This well-worn historical narrative—in which a younger generation of politically motivated artists challenges the stale formats and commercial logic of the older generation broadcast TV—has resulted in an unfortunate and misconceived division between television and video that still limits our understanding of the two media.

Since the 1980s, several museum exhibits and critics have attempted to revise this historical narrative by considering commercial television and video alongside one another.[18] Most recently, in his innovative book *Feedback* (2007), David Joselit rethinks the video art vs. broadcast TV divide by arguing that, at the level of network architecture, television is an open circuit with indeterminate possibilities for social use and alternative visual imaginaries.[19] Yet, despite his insightful theorizations, like previous critics Joselit's historical narrative focuses on video artists and media rebels of the 1960s, but says little about the ways in which the commercial networks developed in relation to the world of art and design. Instead, Joselit's brief account of 1950s commercial television follows the standard broadcast/video histories by demonstrating how the commercial networks closed off television's open circuits by constructing audiences as consumers of predetermined messages.

While it is true that one of the networks' primarily goals was to promote consumerism, their success in this regard depended largely on their liaisons with the visual arts and modern design (in both commercial and museum contexts). Moreover, the relationship between network television and art is not one of simple hegemonic incorporation in which artists simply "sold out" for their own commercial profit. Instead, artists, set designers, art directors, and museum curators who worked in early network television often expressed utopian aspirations for television's potential as a cultural form and means of visual expression (even if they nevertheless saw mass media corporations

as a means of facilitating this). There was, in fact, a high degree of visual experimentation on early network television—especially in the production of graphic art and commercials—which drew heavily on (and even inspired) directions in modern art and filmmaking. Therefore, rather than starting in the 1960s and focusing solely on counter-television, video art, multimedia happenings, and other such youth or counterculture uses of TV, I start in the era before video art came to prominence as "Art" with a capital "A." In fact, before museums and granting foundations anointed video as an art, many people in the arts were eagerly experimenting with commercial television.

Television's various representations of art and its own artistic practices have changed with the larger social and cultural shifts after World War II. Chief among these were: (1) the growth of a middleclass market for art; (2) the professionalization of modern graphic design and its growing importance to global corporations; (3) political and social battles over the canon of fine art itself; and (4) the nation's almost obsessive interest in defining a modern "American" vernacular, a form of American modernism that no longer depended on Europe, but was instead geographically rooted in the home base of New York.

Although the history and meaning of American modernism is a subject of debate beyond the scope of my project, a few observations will, I hope, situate readers with regard to the status of modern art at midcentury, and in particular to its role in the U.S. at the time. Over the course of the twentieth century, the U.S. public experienced the influx of international modernisms via theater, cinema, gallery exhibitions, picture magazines, literature, furniture, fashion, and architecture. So too, over the course of the century, American "homegrown" modern art movements from Ashcan School painting to the art of the Harlem Renaissance to regionalist painting to experiments with abstraction and collage had taken hold. Patrons of the arts—most notably Peggy Guggenheim—imported European modern art to New York, and her 1940s "Art of This Century" show (which she mounted with architect Fredrick Keisler) showcased American examples—most famously Jackson Pollock.[20]

Like previous forms of modernism, at midcentury modern art was not one thing, but a series of conflicting styles, theories, and practices. Among art critics, there was a theoretical focus—at least since Clement Greenburg's 1939 essay "Avant-Garde and Kitsch"—on: (1) the question of what constituted authentic art in a commodity culture; (2) the problem of figuration vs. abstraction (and the idea that art should empty itself of content to become pure form); and (3) a related debate over the place of politics in art.[21] As Erika Doss demonstrates in her study of Thomas Hart Benton and Jackson Pollock,

Depression Era regionalists and American scene painters conceptualized modern art in humanistic terms as part of a larger utopian sociopolitical struggle. But in the wake of Nazi and Fascist-inspired art, American modern artists (especially abstract expressionists and their enthusiasts) became wary of political/state agendas, seeing art instead in formalist terms as ideally divorced from directly ideological and political goals.[22] Nevertheless, as I noted early on, American modernism (especially abstract expressionism) came to have a central place on the world stage and played a central role in cold war era campaigns to spread American culture abroad.[23]

As a specific term "midcentury modernism" is typically associated with furniture design, architecture (both commercial and residential), textiles, and other industrial arts. Yet the period's visual art movements such as abstract expressionism and pop were also associated with interior décor (via collectors and corporate art), graphic design, advertising art, and/or architecture. Indeed, one of the defining features of midcentury modernism is the continuum between modern (fine) art and everyday objects (often designed in mass-produced knock-offs for middleclass consumers). Even if the general public did not go in for abstract expressionist paintings, the quotidian objects of everyday life—from Kleenex boxes to wallpaper patterns to women's boomerang dress prints—acquainted consumers with the latest trends in modern art and design, and the relationship between the fine arts and modern design became evermore consolidated and intertwined.

So palpable was the arts and design explosion that critics began to speak of a visual revolution that had inundated virtually every aspect of everyday life and had fundamentally changed the way people looked at the world. This midcentury concern with visual perception was a continuation of—rather than a break with—earlier forms of modernism. Historically, modernist movements in the arts explored new "ways of seeing" (for example, cubism broke up the picture plane while Dada explored absurdist or chance acts). So, too, philosophers had previously theorized the sensorial changes that accompanied modern industrial culture. In his widely influential essay, "The Work of Art in the Age of Mechanical Reproduction" (1936), Walter Benjamin spoke of new modes of visual perception and "distraction" (particularly with regard to cinema) and he considered how mechanical reproduction contributed to the break down of art's ritual function and "aura."[24] At midcentury, art critics returned to similar questions, but observed that transformative developments in science, art, technology, and consumer/media culture required new theorizations of visual experience in the postwar world. Books like György Kepes's *The Language of Vision* (1944), Moholy-Nagy's *Vision*

in Motion (1947), and Rudolph Arnheim's *Art and Visual Perception* (1954) variously engaged issues of visual experience as a central matter for theories of art and design.[25] Noting these and other examples in his 1955 essay, "Our New Ways of Seeing," William Sener Rusk argued that in the context of scientific, philosophical, and psychological discoveries, as well as social changes, postwar publics were no longer shocked by the modernist movements of earlier decades. "Our New Ways of Seeing," he claimed, "involve a more vital change in our reactions to contemporary art and architecture than even the forms themselves, whether functional, abstract, or non-objective."[26]

Meanwhile, critics in the popular media urged the public to think about fine art and vernacular forms (from buildings to mixing bowls to package design) within a general theory of visual perception in the postwar world. In the 1950s, MoMA produced television programs devoted to the perceived transformations in visual practices with titles like *Point of View* and *The Revolution of the Eye*. In the early 1970s, the BBC television series *Ways of Seeing* with John Berger (as well as Berger's book based on it) capped off this midcentury focus on visual experience in the modern western world. Considering the integration of art into the everyday world of consumer culture, *Ways of Seeing* suggested that art was part of a more general "language of images" in which makeup ads and Rubans's nudes exist side by side.[27] As part of this language of images, television was integral to modern ways of seeing the world, and it showcased (via graphics, advertising art, set design, and other audio-visual attractions) modern art and design on a regular basis.

Certainly, the postwar period was not the first to witness these mergers between art and commercial culture. Nor were the television networks the first corporations to promote their goods and services through appeals to fine art and high design. Instead, many of the historical trends I describe in this book were already underway in the late nineteenth and early twentieth centuries when art and commerce began to merge in significant ways. Cultural and art historians such as Neil Harris, Roland Marchand, T. J. Jackson Lears, Andreas Huyssen, Thomas Crow, Robert Jenson, Cecile Whiting, Erika Doss, and Michelle Bogart have demonstrated how the arts and commercial culture have been increasingly intertwined since industrialization.[28] Following this work, I show that culture, industry, art, and education are never exclusively formulated or separately constituted in modern media institutions. Indeed, during the 1950s and 1960s, media corporations became central supporters of fine art, using the arts as tax shelters and employing fine artists and graphic designers to build their images and brands. Corporate sponsorship flourished in the context of the Kennedy and Johnson administrations'

unprecedented support for the arts. In 1962 President Kennedy became the first president to appoint a Special Consultant on the Arts (August Heckscher) and by 1965 President Johnson institutionalized the National Endowment for the Arts (NEA) as a government organization that orchestrated funding opportunities for artists and cultural centers. Network chiefs were among those who shared the view that art was good for business, and they often presented themselves as patrons of the arts. Speaking to the Ohio Arts Council in 1967, CBS's Frank Stanton proclaimed, "Commerce, industry and the arts are, I think, on the eve of a new alliance everywhere in our country. . . . To keep or earn the respect of the investment world, of other businesses and of other institutions . . . a business must now show evidence of a regard for the standards of excellence, good taste, and distinction that both inspire and are stimulated by the arts."[29]

As numerous historians have shown, gender and domesticity have historically played key roles in the mergers between art and commerce. Even while artists and/or critics often rejected the "feminine" domestic arts as "kitsch," the art world has historically depended on women as consumers, and by the early twentieth century the space of domesticity became central to the sale of calendar art and other reproductions of "masterworks." In the 1930s and through the postwar period, everything from French impressionism to surrealism to abstract expressionism to pop to op art were intimately tied to venues of women's commercial culture, from shop windows to advertising art to fashion.[30] Similarly, television was centrally aimed at women, and although postwar critics often dismissed TV's "feminine" genres (especially the soap opera) as the "lowest of the low," television often appealed to women by displaying modern art and graphic design. As I show with the case of MoMA, even modern art museums used television as a way to court female publics.

In part, then, this book interrogates and reconsiders the reigning perceptions of television as "kitsch" and its historical denigration as a domestic medium. While there is often good reason to criticize television, assaults on the medium are often based on myths and misconceptions about the television audience—its tastes, its "public interests," and its cultural practices. For example, during television's first two decades, business elites and people in the arts typically considered big cities like New York to be the arbiter of good taste and many a network executive made the erroneous assumption that Southerners or Midwesterners had pedestrian "rube" palettes. Meanwhile, throughout the period, educators and network public-affairs producers made programs on the arts that seemed endlessly to flop with TV audiences.

In their exasperation the producers often blamed the tastes of the "lowbrow" TV crowd rather than the funding structures, distribution channels, and limited visions that resulted in often boring and pedantic programs that nobody of any class or educational background wanted to watch.[31]

Janice Radway and Joan Shelly Rubin have both demonstrated how a "middlebrow" taste culture was formed in the 1930s through the establishment of, for example, the book-of-the-month club and radio lectures on great books and poems.[32] While some critics saw this dissemination of taste as a progressive form of edification for the "masses," others found middlebrow culture even more scandalous than the "lowly" arts. In his 1960 article "Masscult and Midcult," Dwight MacDonald lashed out at middlebrow culture, claiming that it watered down high art to serve mass tastes, an issue that museum curators also hotly debated during the period.[33] But in the postwar era concerns about taste were not confined to the rarified debates of critics like MacDonald; instead the discourse on taste itself became a popular pastime. First published in *Harper's* in 1949 and reprinted in *Life* a few months later, Russell Lynes's article "Highbrow, Lowbrow, Middlebrow" set off a widely publicized discussion of the brow levels. Paperback advice books followed, offering people multiple choice "taste tests" that (as one book put it) allowed readers to "find out precisely in what directions you need to move to improve your 'culture quotient.'"[34] In other words, in the postwar period the cultivation of taste was a means of social mobility for the aspiring classes.

Television became crucial to these discussions of taste because it acquainted large numbers of Americans with modern art and design on a daily basis, and in the context of their everyday lives at home. All the new art movements became subjects for contemplation on television, and they also offered aesthetic models for TV programs and commercials. So, too, as it evolved over the course of the 1950s, television became a key means of signifying cultural distinction. For some groups, hating TV quickly became a way of establishing oneself as "cultured" (as early as 1954, critics spoke of "TV snobs" who expressed their hate for TV in letters to the editor or mail to networks).[35] For others, the ability to distinguish "quality" TV from "waste" was a means of exhibiting one's distinctive palette. For still others, loving "bad" TV became a way of establishing one's belonging to a sophisticated in-crowd that watched TV with a "campy" wink. Indeed, television was a magnet for a grave cultural dispute about taste and the related politics of class, gender, race, and—especially with camp—sexual orientation, and as the era's taste standards shifted, the question of good vs. bad TV took on new meanings.

In our contemporary period, we often look back on the first generation of

TV audiences as if they were soppy sponges willing to absorb all that television had to offer. Yet, television audiences were never so naive. Instead, they began to form "taste publics" almost from the start. As I show in the case of television comedian Ernie Kovacs, early television fans often expressed their discerning palettes by the programs and performers they chose to watch. So, too, jazz programs, for example, appealed to audiences who imagined themselves as different from the rest of the TV crowd, and artists like Duke Ellington and Dizzy Gillespie made use of television as a medium through which to convey forms of Black modernism (both visual and audio) to viewers with specialized tastes. By looking at the actual historical dialogues about television, we find a much less stereotyped picture of taste. In fact, I suspect that TV audiences of the 1950s were just as taste-driven as our contemporary "niche" cable audiences, even if they had less of a menu from which to choose. Throughout the period, a number of television programs and commercials catered to so-called sophisticated tastes in hopes of reaching "class" rather than "mass" markets.

Although television is typically seen as the ultimate example of "enlightenment as mass entertainment," and certainly the crown and glory of cold war consensus, this book focuses just as much on the power struggles and eccentricities in the network system as on the hegemonic forces at work. I show how various people working in television struggled with commercial imperatives and/or used commercialism for their own creative pursuits. From this perspective, for example, I explore Kovacs, whose eccentric vision on 1950s television has since earned him the title "father of video art," but who at the time actually shared a particularly happy relation with his sponsor, Dutch Masters Cigars. I also consider the barely known television career of Andy Warhol, who epitomizes the mergers of art and commerce during the three-network era. Warhol's experiments with television since the 1960s and into his cable shows of the 1980s provided a space for queer visibility and an alternate view of everyday life from the one network TV typically offered. In focusing on people like Kovacs and Warhol my goal is not to address them as exceptions to a rule (or the shining beacons in a degraded wasteland) but rather to rethink the processes by which people "make do" within the context of corporate media production. People like Kovacs and Warhol were resourceful, and even when their work fell flat, their endeavors demonstrate how it was possible to innovate within the system of commercial TV.

Taken as a whole, then, this book is part of an ongoing effort among historians and sociologists to better understand the social dynamics of art, commerce, and taste in U.S. culture. At many times while researching this

book, I was surprised to find so many connections between the art world and the television industry, and I was also intrigued by the fact that so many programs seemed obsessed with the subject of modern art, or else used concepts of modern design for sets, title art, commercials, and publicity. Yet how to explore the connections between art and television was not initially obvious. Over the course of this research I sometimes felt that I was simply on a wild goose chase. In the end, this book reconstructs the historical convergences of art and media by bringing different archival collections and trade sources into new dialogues with one another.

Insofar as NBC is the only network that deposited its extensive collection of corporate papers to an archive, television histories often rely on the NBC Records to understand business and programming strategies. While I do draw upon the NBC Records, CBS was the network that was most interested in modern art and design. I was lucky to find the largely uncatalogued collection of CBS's art director, William Golden, held at the Rochester Institute of Technology. I was also lucky to find an extensive collection of papers at the MoMA Library that details the museum's early efforts to produce broadcast television programs. Similar collections—such as the Ernie Kovacs Papers at the University of California, Los Angeles (UCLA), television-related collections at the Metropolitan Museum of Art, the Duke Ellington Collection at the Smithsonian National Museum of American History, and a number of television-related collections at the New York Public Library were invaluable. This book is also based on extensive research of programs and commercials deposited at a number of archives, most notably the Paley Center for Media, the UCLA Film and Television Archive, the Wisconsin Center for Film and Television Research, the Andy Warhol Video Collection at the Andy Warhol Museum, and the Celeste Bartos Film Study Center at MoMA.

Much of this book focuses on New York City, where network business offices, leading national advertising agencies, and movements in U.S. postwar art (from New York School abstract expressionism to Andy Warhol's Factory) flourished. In the early 1950s, New York was both the primary location for television production and a world center for the visual arts. New York–based museums, fine artists, and graphic designers were fascinated with the possibilities that TV had to offer, and while other areas of the country showed similar interest, New York was the major hub where television and modern art converged. Although television production increasingly moved to Hollywood in the mid-1950s, the business offices of the networks and advertisers remained centrally located in New York and their liaisons with the art world

continued through the decades. This book maps this geography of culture as much as it traces developments across time.

The period I have chosen for consideration represents a specific moment in U.S. history when the arts played a crucial ideological role in cold war sensibilities about national progress and citizenship. The Eisenhower, Kennedy, and Johnson administrations placed enormous emphasis on the arts as both a means of enlightenment and a tool for international expansion, and network television, National Educational Television (NET), and PBS were themselves key to these endeavors. However, by the end of the 1970s, many of these ideals were already shifting. The rise in the early 1980s of cable networks such as MTV, as well as public-access channels, created different exhibition contexts and meanings for the arts on television. New developments in graphic design, corporate branding, and computer-generated graphics created a new look for television in the 1980s—a look John Caldwell calls "televisuality"—which had important differences from the design ideals in 1950s and 1960s network television programs and commercials. According to Caldwell, who begins his book with a synopsis of the stylistic flourishes and "art discourses" on television since the 1950s, the cable era witnessed an unprecedented investment in stylistic excess in programs ranging from syndicated magazine formats like *Entertainment Tonight* to auteur series like David Lynch's *Twin Peaks* (ABC).[36] In addition to changes within commercial network program production and aesthetic forms, the period I examine also witnessed the rise of new kinds of television produced outside the network regime. The availability in 1965 of Sony Portabacks on the consumer market allowed for the growth of video activism and art movements, while the proliferation of video cassette recorders starting in the 1970s provided alternative modes of distribution. Finally, the politics and values in the art world themselves changed dramatically in the 1960s, as artists, civil rights groups, and feminists often rebelled against the white European male-centric canon, and against the museum itself.

In this sense, the period under consideration represents a distinct constellation of forces in the art world, in the television industry, and in society more generally, forces that developed and changed to create different opportunities and publics for media art. In the context of these changes, commercial network television began to leave the arts to other venues (cable, PBS, video art, and now, of course, digital arts) and to shore up their business practices around entertainment genres (and even their news divisions began to dwindle). Arts programming became more of a "niche" affair. Ironically

in this respect, while television is often seen as the postmodern medium par excellence, after the mid-1970s, high and low—at least on broadcast television—became increasingly bifurcated so that networks narrowed their business goals, leaving arts programming largely to cable, museum videos, PBS, and other "narrowcast" venues. This book, then, tells the story of a particular historical conjuncture when the visual arts and commercial television merged in unique and profound ways.

1

••• HAIL! MODERN ART

Postwar "American" Painting and the
Rise of Commercial TV

On March 4, 1949, NBC presented an episode of the *Admiral Broadway Revue*, one of the first variety shows on television, and one of the first to engage the subject of modern art. Starring comics Sid Caesar and Imogene Coca, the program opens with a production number about bohemian lifestyles that sets off a series of routines focused on such varied fads as coffeehouse folk music, psychoanalysis, and modern dance. Sandwiched in between the au currant lineup is the most elaborately designed "set piece" of all—a song-and-dance extravaganza about abstract painting, aptly titled "Hail! Modern Art."

The routine begins as the curtain opens onto a huge modern painting that serves as a backdrop for singers and dancers, some dressed as museum goers out for a day of art appreciation, others as artists complete with smocks and berets. Looking curiously at the painting, they break into song:

> Modern Works of Art
> Take first place in our heart
> And this is the museum
> Where we all come to see 'em
> Chorus: Hail! Modern Art
> It's cubistic, surrealistic
> Non-objective and reflective

There are some who think it's cracked
But that's because it's abstract
Chorus: Hail! Modern Art

After several more stanzas with similar lyrics, a female contortionist (Hin Lowe) emerges from the frame of the huge painting. Dancing to Oriental themes and dressed in Chinese pajamas, she winds her legs several times around her head. The audience appreciatively applauds.

To be sure, "Hail! Modern Art" was not alone in its depiction of modern art as "cracked," exotic, distorted, and altogether foreign from American cultural norms. Such beliefs about modern art could also be found in films, pulp novels, newspapers, vaudeville, legitimate theater, and on radio, and they appeared well before the TV age. When modern European art (such as Marcel Duchamp's famous urinal) was first exhibited at the 1913 Armory Show in New York, newspaper critics mocked the wild, crazy, and decidedly foreign moderns.[1] Hollywood movies took up these themes in films such as the B-thriller *Crack Up* (1946), which dramatizes the exploits of a mad museum curator, and Alfred Hitchcock's *Spellbound* (1945), which features a dream sequence by Salvador Dali to depict the nightmares of a tortured soul.[2] In these and numerous other examples, modern art took on a decidedly suspect nature, whether played for laughter or high dramatic suspense.

Nevertheless, over the course of the 1930s and through the 1950s, modern art had become something of a popular craze. Beginning in 1934, Associated American Artists (AAA) began marketing affordable prints of famous artworks (especially the then modern art of regionalist painters) to middle-class consumers who could order them through direct mail or buy them in department stores across the country.[3] After the war, middleclass department stores like Macy's and Gimbles sold paintings (via credit financing) to the public. Museum-going became a popular trend. The number of art galleries in New York grew from 40 at the beginning of the war to 150 by 1946, and both public and private gallery sales skyrocketed during the war.[4] By 1962, the Stanford Research Institute estimated that "120 million people attend art-oriented events" and that "attendance at art galleries and museums almost doubled during the 1950s."[5] According to the Stanford report, the new "cultured American" was in part the result of technology that made possible "first class reproductions" at a "cost many can afford."[6] Twentieth-century European modernism was particularly in vogue. In 1958, the *New York Times* reported that there was a growing demand for reproductions of "modern masterworks" among young couples that were buying good quality repro-

Chapter 1

ductions of European artists such as Braque, Picasso, Feinger, Roualt, and Mondrian.[7] For those who'd rather "do it themselves," paint-by-number kits became a national mania in the 1953 Christmas season. One of the first in the Craft Master paint-by-number series was a still life rendered in a faux Matisse style and titled (presumably after Jackson Pollock) *Abstract No. One*.[8]

What role did television play in this context? Although broadcast historians have explored television's reliance on theater, vaudeville, radio, circus, and cinema, television's relationship to the postwar enthusiasm for modern painting remains virtually unexplored. Yet, as in my opening example, television often appealed to its first audiences with "free" shows of modern art. Moreover, as the "Hail! Modern Art" routine suggests, television did not just rekindle popular skepticisms about modernism; it also welcomed modern art and developed its own means for looking at it within the context of commercial entertainment. Remarking on the situation in 1957, James Thrall Soby (art critic and curator at MoMA) said:

> One of the many indications of art's enormous popularity in this country is the frequency with which it is mentioned on TV or furnishes the central theme of TV programs. . . . It's getting so a fantastic number of TV performers mention art in one connection or another, and unlikely people turn out to be aspiring painters or dedicated connoisseurs. A short time ago on Edward R. Murrow's *Person to Person*, for example, Xavier Cugat confessed that he wanted 'most of all to paint' . . . The next thing we know Jack Benny will abandon his violin for an easel.[9]

More generally, a wide variety of television genres—from cultural-affairs programs to melodramas to variety shows to sitcoms to quiz shows—showcased modern art on a regular basis. Even *TV Guide*, the major national magazine for television, used modern art to woo subscribers. Mixing modern art with traditions of variety entertainment, the front cover of a 1957 issue shows popular variety host Ed Sullivan and star Judy Taylor while the back cover offers a lesson on non-objective art (which then dovetails into a promotional ad for the magazine).[10]

To be sure, when presenting modern art, television did not exactly follow the orthodoxies of the art world's definitions of the postwar American avant-garde. Rather than simply mimicking art-world canons for cutting-edge artists of the day (e.g., the Pollocks, Willem de Koonings, Robert Motherwells, or Mark Rothkos), television presented modern art as a grab bag of historical styles. On television everything from surrealism to cubism to abstract expressionism (and, by the 1960s, pop and op) was part of the "shock of the

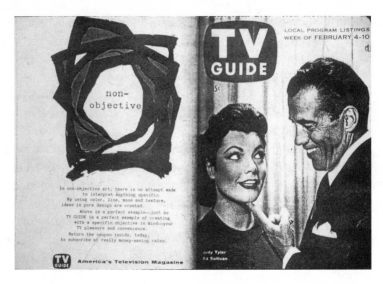

TV's Ed Sullivan and nonobjective art share the bill on this front and back cover of *TV Guide* (February 4–10, 1957).

new." So, too, given its performative nature, television's version of postwar modernism was embroiled in acts of self-presentation. On television (as in other venues of popular culture), the very act of engaging in artistic interests was itself a way to display one's progressive, au currant, tastes. In this sense, no matter in what style they were actually painting, celebrities of the Xaviar Cugat kind exhibited their status as postwar "moderns" by presenting their love of art as a distinctly contemporary lifestyle.

Moreover, the new medium was the perfect vehicle for rendering modern art as an everyday lifestyle for progressive publics. As a living room fixture, television offered audiences a way to feel "at home" with modernism and to experience art as a form of home entertainment. Watching television from their domestic interiors, viewers experienced modern art and design in the context of an assortment of art and period styles with which they decorated their homes (everything from American scene paintings to "moderne" chairs to the then popular rage for Colonial furniture). In other words, what I have called "everyday modernism" was a hybrid of historical styles that viewers could "poach" and recombine in ways that would surely have offended the tastes of orthodox modernists.[11] Meanwhile, the stories that television told about art and the forms through which TV displayed it created a new visual environment—a virtual gallery—for painting in the postwar period.

This chapter explores how television showcased the visual arts—primarily painting—in the 1950s through the early 1960s, during the height of the cold war. The taste for modern art on the new medium was a constant source of debate, and as such was bound up with larger cultural struggles over the meaning and value of culture, and American painting in particular, in the new U.S. postwar society. Television's depictions of and discourses on the visual arts took place at a time when art was not only a subject of popular interest but also of grave political concern to the nation. Television's rise as a new medium dovetailed with cold war efforts to disabuse the world of the widespread perception that, while an economic and political superpower, the U.S. was still a *cultural* colony of Europe. America might have been famous for Hollywood movies, big bands, and comic books, but when it came to culture with a capital "C," Europe (and especially Paris) was still considered the arbiter of taste. In this context the elevation of American culture, and the distinctive character of American art, became central topics of concern among art critics, museum curators, market researchers, educators, advertisers, and popular critics alike.

Television programs of the 1950s often presented the arts as a national, even patriotic concern. On television the display of art was typically tied to the more widespread search among art critics, museum curators, business leaders, and even government officials for a uniquely "American" form of modern art, an American vernacular distinct from European art and capable of representing the U.S. as the leading center of the free world. However, given television's foundations in sponsorship, network and advertising executives sought out a commercially viable means of communicating ideas about art and culture in ways that might appeal to broad national audiences. Television offered a *quotidian* form of postwar modernism, showing the public how to enjoy new trends in the visual arts as an everyday national pastime. In the process, television contributed to a redefinition of the American vernacular that was ultimately based on the idea that American modern art was commercial art, with no apologies and no excuses. In fact, the TV commercial turned out to be one of the primary vehicles for the creation of this truly homegrown form of modern art.

PAINTING IN COLD WAR CULTURE

The popular embrace of art was connected to larger national agendas. In the 1930s, the federally sponsored Works Progress Administration (WPA) helped create a national audience for art by funding 103 community art centers in various regions of the country.[12] Government-sponsored campaigns

such as "Buy American Art Week" (1940) established connections between consumerism, aesthetic contemplation, and good citizenship.[13] During the war, the U.S. government promoted art appreciation as a form of patriotism linked to the defense of American civilization against Nazi barbarism. In the early 1940s, museums such as MoMA and the Metropolitan Museum of Art gained respect by linking their institutions to the war effort. MoMA's "Road to Victory" show (1942), which featured photographs by Edward Steichen (then a lieutenant in the navy), won critical acclaim as "a declaration of power and our will to win the war."[14] In the 1950s Winston Churchill and President Eisenhower both served as role model "weekend painters" for the American public, endorsing amateur painting not just as pleasant relaxation but also as an ideal pastime for progressive citizens.[15]

Not only was art a national trend, by mid-decade the national taste for art was connected to the perceived triumphs of the American avant-garde over European masters. Summarizing the historical trend, Erika Doss observes:

> If European strains of modern art, especially those of French avant-garde art-
> ists such as Picasso and Matisse, had previously commanded the attention of
> collectors and curators, the post–World War II era saw a surge of interest in an
> American avant-garde, and American culture in general. By mid-century, New
> York had clearly replaced Paris as the world capital of modern art—the culmi-
> nation of aesthetic, social, and economic trends decades in the making—and
> modern art had become widely understood as 'American' art.[16]

In this geographical, economic, and ideological context, modern art also came to be a central component of cold war strategy. As Serge Guilbaut has argued, debates about the relationship between European modernism (especially its roots in Paris) and a uniquely American form of modern art engaged intellectuals during the Depression, and increasingly during and after World War II "every section of the political world in the United States agreed that art would have an important role to play in the new America."[17] Since the establishment of the Department of Cultural Affairs in the late 1930s, the federal government had officially recognized the importance of culture in securing international good will. Despite many humanist intentions, the major strategic focus of these cultural exchanges was the government's desire to counteract the prevailing image of Americans as militaristic vulgar brutes (or what one book later called "the ugly American"), an image that dominated the European and Latin American imaginations.[18] A major mission of the Department of Cultural Affairs—and later, during World War II, the Office

Chapter 1

of War Information—was to counteract this notion of the ugly American and spread a more genteel, peace-loving image of Americans abroad.

After the war, these forays into cultural imperialism were enacted under the Marshall Plan as American media industries and government offices applied policies of "containment" and searched for new markets for the free world around the globe. Guilbaut argues that the attempts to construct an American art scene, distinct from Paris and situated instead in New York, coincided ideologically with the new ethos of corporate liberalism that saw Communism as a threat and sought to contain it globally. Modern art and the American avant-garde were nourished, he claims, by a climate of thought that divorced art from the politics of the thirties and favored the freedom of individual expression that abstract expressionism, with its sense of eccentric psychology, especially provided.[19] Moreover, as Eva Cockcroft argues, the United States Information Agency (USIA) and the Central Intelligence Agency (CIA), in conjunction with MoMA and the Whitney Museum of American Art, promoted American art in the name of freedom, using abstract expressionism in particular as a "weapon of the cold war."[20] Organizing shows and international exchanges, these institutions used the new American painting to spread the image of a cultured America abroad.

Although the CIA, museum world, and the more general climate of corporate liberalism often nourished the new American painters, more conservative government leaders thought abstract expressionism was inconsistent with American values and even subversive, and they tried to stop its exhibition overseas. In 1946, when the State Department put together an international exhibit called "Advancing American Art," the contemporary paintings chosen for exhibition became the site of public and Congressional controversy as various government officials attacked the work of painters who had been connected to the Communist party in the 1930s (before this was considered a "cardinal sin"). Among the most outspoken, Representative George A. Dondero of Michigan regularly denounced abstract art as "communist" calling it the work of "brainwashed artists in the uniform of the Red art brigade."[21] A devout anti-modernist, President Harry S. Truman mocked the "modern day daubers and frustrated ham and eggs men" whose art paled in comparison to the great masters. In his diaries he observed that comparing the likes of Rembrandt to the "lazy nutty moderns" was like "comparing Christ with Lenin."[22] Because abstract art emptied itself of recognizable content, people assumed it could easily contain covert meanings completely eccentric to the proverbial "vital center" of U.S. consensus politics. At its paranoid extreme, rumors

circulated that American abstract artists were working as foreign agents by inserting military maps into their paintings.[23]

Meanwhile, art critics debated the relative political value of abstract expressionism. Influential critics such as Clement Greenberg, Harold Rosenberg, and Meyer Schapiro championed New York School abstract expressionism, seeing it as the expression of a uniquely American avant-garde, divorced from the Marxist politics of the 1930s yet also an antidote to the homogenizing effects of mass culture. Even before the postwar period, Greenberg famously formulated this view of painting in his 1939 essay "Avant-Garde and Kitsch."[24] By the 1950s, Schapiro argued that abstract expressionism counteracted the alienating labor conditions of advanced capitalism by reinstating the artist's individual expression and handicraft.[25] However, as the movement became a dominant and self-perpetuating trend, prominent critics (including Greenberg and Schapiro) became annoyed by some of the painters' predictable "trademark" style. As Jennifer Way demonstrates, in the 1950s critics complained that painterly abstract paintings were themselves falling sway to the logic of mass culture because too much art was generated and "too many paintings looked the same." Art critics bemoaned what they perceived to be abstract paintings' standardized techniques and styles that could easily be mistaken for advertising designs.[26]

Critics in the popular press were equally ambivalent. On the one hand, abstract expressionism was the talk of the town. Analyzing the philosophy at Time-Life, Doss concludes that publisher Henry Luce embraced abstract art as an emblem of individuality and the American way of life. Starting in 1948 *Life* magazine published roundtables on modern art, and in 1949 the magazine featured a story on Jackson Pollock. On the other hand, as Doss also notes, the popular press often mocked modern art and the "highbrows" who liked it (for example, the Pollock story was itself both celebratory and mocking in its portrait of the painter).[27] Moreover, American art was not always received well on foreign soil, especially in the capital of modernism, Paris. Although abstract expressionism often fared well with European art critics, the European public typically saw American art as a cheap imitation of the real thing.[28] Ironically, then, despite their status as "vulgar" and despite the fact that Europeans sometimes deemed them as such, those products categorized as American popular arts (comic books, movies, hit-parade music) typically did better with European audiences than did American high culture, and for this reason the popular arts were often regarded as more viable vehicles for the solicitation of international goodwill. In both the domestic and global context, the ambivalent and at times outright hostile attitudes to-

ward modern painting resulted in a series of struggles over what exactly was meant by the terms American "culture" and American "art."

In this matrix, television played a key role in distinguishing American from European modern art. As art critic Katherine Kuh of the *Saturday Review* asked, "How many of us would like to know how American is 'American Art'? Simple questions like these are effective grist for television."[29] The issue of national identity was crucial as television sought ways to negotiate the "high" (and, typically assumed, communist) world of European modernism with the more all-American popular arts in the States. A range of program genres took up these issues and in the process audiences learned ways to look at the visual arts through the lens of a new, and decidedly commercial, medium.

THE SEARCH FOR AN "AMERICAN ORIGINAL"

In the 1950s, the subject of American painting was continually posed on "prestige" public-affairs programs such as *Camera 3, Omnibus, Wisdom,* and *See It Now.* For the networks such programs served a strategic purpose in persuading the nation that television was a form of respectable culture. NBC president Sylvester "Pat" Weaver is notorious for his programming efforts in this regard. In the early 1950s Weaver devised a programming plan he called "Operation Frontal Lobes" designed to disseminate the arts and sciences via network TV. So costly was his plan that apart from a few primetime network shows, most "frontal lobes" broadcasts operated in the red, as sustaining programs without advertiser support. Nevertheless, as Vance Kepley argues, rather than being simply philanthropic, Weaver deployed "Operation Frontal Lobes" in the context of his larger concerns for the corporate welfare of his network.[30] In the late 1940s and early 1950s, cultural programming played a key role in the networks' ability to secure affiliate contracts with broadcast stations across the nation. Local broadcast stations obtained licenses from the FCC on the basis of their promise to serve the "public interest," and for this reason, public-affairs programs on the arts helped broadcasters demonstrate their commitment to community values and cultural uplift. In this context, network public-affairs programs served as an incentive for broadcast stations to become network affiliates. These programs offered an attractive and *free* alternative for broadcasters needing to fulfill public interest obligations.

In addition, public-affairs programs helped broadcasters build a prestige image that was attractive to sponsors. Sponsors thought these programs helped stations attract a "class" rather than "mass" audience. Although the term "class audience" did not necessarily correspond to a viewer's economic

standing per se, sponsors considered "class" audiences to have more discriminating tastes than average consumers and to be willing to spend discretionary income on those tastes. In addition, advertisers assumed women associated cultural programs with refinement and family values, and because sponsors also knew that women were responsible for the lion's share of household purchases, they wanted to invest in stations that projected an aura of good taste. In fact, even if sponsors did not actually buy time in public-affairs programs, many corporations hoped to associate their products with broadcast stations that aired them. Not surprisingly in this regard, the pages of *Sponsor* (the primary trade journal for broadcast advertisers) were full of promotional ads from television stations around the country that boasted of their public-affairs shows on the arts.[31]

Meanwhile, network executives knew that many of their business clients (especially major advertisers) fancied themselves as part of the sophisticate professional class and therefore would respond to network programs offering cultural enlightenment. Weaver's primary competitors, CBS chairman William S. Paley and president Dr. Frank Stanton, were themselves part of this art-conscious business elite, and like Weaver they knew that cultural-affairs programs were a boon to their network's reputation. Even the fledgling ABC network, which began radio operations in 1943 and which is generally considered to have been the most "lowbrow" of the networks, used cultural programming as a way to attract sponsors. In its 1948 annual report (directed at affiliates and sponsors), ABC bragged about its "Page One event: the televising of the season's opening of the Metropolitan Opera under the sponsorship of the Texas Company" as well as its broadcasts from Carnegie Hall sponsored by the American Oil Company.[32]

In the context of these programming strategies, the visual arts were especially important to the new television culture. Although paintings had been discussed on educational radio programs, and while the picture magazines like *Life* had previously featured artists and artworks, television brought a new and dynamic audio-visual display of art into the home. However, rather than interviewing the more controversial American abstract expressionist artists, 1950s network public-affairs programs more typically championed the already canonized European masters (from Michelangelo to Picasso to Van Gogh) or else showcased American Depression Era and wartime artists, thereby linking the patriotic past to the art of the present.[33] In their coverage of U.S. artists, public-affairs programs presented artists not only as quintessentially "American" but also as family types, and they often used a "visit to the artist's home" format.

For example, in a 1959 episode of *Person to Person* (CBS) Edward R. Murrow interviews the premier poster boy of World War II, Norman Rockwell, showing his perfect American family and little dog Lolita at home. Addressing Mrs. Rockwell, Murrow says, "You must have quite a decorating problem. Do you keep many of Norman's original paintings on your wall?" Painting is thereby depicted as a domesticated and familial form, much in line with the Office of War Information's use of Rockwell during World War II to symbolize Roosevelt's "Four Freedoms," which all revolved around the right to private life apart from government intervention. In fact, when Murrow tours Rockwell's studio (also in his home), he points to two of the paintings most notable for this logic—*Freedom of Speech* and *Freedom of Worship*.

Making the patriotic message even clearer is the fact that Murrow, in a previous segment, interviews Fidel Castro (who at the time had just assumed power as premier of Cuba and was eagerly embracing U.S. press attention to bolster his image).[34] Although Castro presents himself as a family man (he is with his son and dog, and he even shows Murrow his baby pictures), the unkempt beard, the fact that he appears to be wearing pajamas, his missing wife, and the fact that he is in a hotel room rather than his home, marks him as decidedly outside the American iconography of family life that Rockwell made famous during the war. This juxtaposition of Rockwell with the Cuban revolutionary leader speaks, not too implicitly, to the debates about America and foreign threats that circulated at the time. Still, Rockwell's folksy stance made him less than a viable leader in the quest for the American modern. Television, therefore, explored other possibilities, and in the process American painting was often ambivalently presented. On the one hand, as with the Rockwell-Castro program, American painting was often disassociated from foreign and elitist connotations. On the other hand, just as in the culture at large, on television the value of American painting was rooted in its ability to spread an image of American progress and "freedom" abroad. In other words, in its attempt to define "American" art, television balanced residual ideals of isolationism with postwar ideals of internationalism.

A 1955 episode of CBS's *See It Now* even more explicitly illustrates this point. Significantly titled "Two American Originals," the program was divided into two segments, one which featured artist Grandma Moses, the other jazz great Louis Armstrong. Grandma Moses, who had come to national prominence in the early 1940s, was famous for her so-called primitive art that rendered, in a craft tradition, realistic subjects such as houses, pets, and other domestic scenes. For some, she represented the quintessential American vernacular, the term "primitive" assuming a positive connotation

here as the art world placed "high" value not only on Moses but also on other untraditional artists (for example, children's art was also being validated at the time). Murrow's interview took place in Moses's humble home studio where her practical arts-and-crafts aesthetic was most notable through the folksy decor. Murrow asks Grandma, "Have you decided what picture you're going to paint next, Grandma Moses?" Moses replies, "I'm going to try to get into something different . . . well more, more modern. I've been inclined to paint old scenes, I suppose since I'm old." To which Murrow retorts, "Or old enough to go modern."

This curious exchange between the grandmother of American art and television's premier newsman suggests the ambivalent attitudes toward the old and the new, tradition and modernization, which surrounded the definition of the American modern vernacular for the postwar world. The figure of Grandma Moses offers a resolution for this ambivalence as she is literally rendered a "modern primitive." As such, she negotiates the contradictory values of the more traditional American representational art (by which I mean the rendering of recognizable subject matter) and the newer forms of abstraction that often worked to negate subject matter (as, for example, with Pollock's "drippings" or with Larry Rivers's *Washington Crossing the Delaware* [1953] that abstracted portions of this historical scene). Moreover, as opposed to what President Truman called the "lazy, nutty moderns," he and other government leaders liked Grandma Moses, so much so that her work was officially recognized when President Eisenhower's cabinet presented him with a specially commissioned Grandma Moses landscape depicting the Eisenhower farm.[35] In the *See It Now* episode, her nationalism is underscored when Murrow asks her, "Do you ever look at the paintings of a foreign artist?" and she replies, "Some. I never have seen so much. You know I've never been away from home much. Most that I've seen is in pictures." The exchange clarifies that Grandma Moses is truly an American original, untouched by foreign influence. The meaning of modern is thus construed simply as something contemporary, but it remains quintessentially American.

However, as *See It Now* also makes clear, being American meant nothing if American did not translate as such abroad. In other words, American art for the modern world was art recognized as such in Europe. One of the reasons Grandma Moses was famous enough to be on *See It Now* in the first place was because she was one of the few American painters that the European public embraced after World War II. The segment with Louis Armstrong further suggests the international value of American art. Murrow follows Armstrong

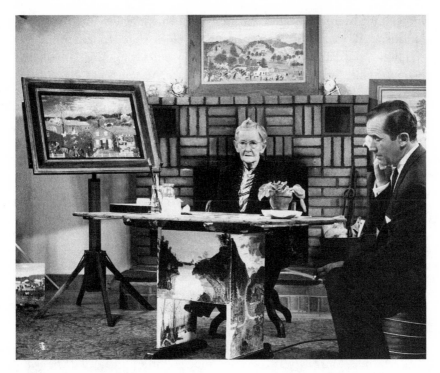

Grandma Moses and Edward R. Murrow (June 29, 1955). Photograph by Otto Kallir. Copyright 1973 (renewed 2001). Grandma Moses Properties Co., New York.

as he plays to adoring audiences in Paris, and he concludes by announcing, "Satchmo is one of our most valuable items for export."

Satchmo's exportability was symptomatic of the significant popularity American jazz artists enjoyed in Western Europe, and by the late 1950s, in post-colonial nations. Jazz musicians had historically played to adoring audiences in Europe and had migrated there, especially to Paris, since World War I. So, too, rather than being associated with white militaristic "ugly American" masculinity, the black jazz musician had traditionally been treated by Parisians as an artist compatriot.[36] In the 1950s, just like modern painting, jazz became a "cultural weapon of the cold war" as the State Department featured artists like Armstrong, Dizzy Gillespie, and Duke Ellington in international tours.[37] In her study of the State Department tours, Penny Von Eschen shows how jazz artists became cultural ambassadors who spread an image of a freedom-loving America overseas, an image that was especially important

for winning over the loyalties of nations then emerging from decades of colonialism. Above all, the State Department allowed the U.S. government to counteract the daily news of U.S. race riots by portraying America as a land of opportunity for all citizens, regardless of race. Although not all jazz musicians necessarily agreed with State Department objectives, and while some also experienced racism on the tours, Van Eschen argues that for many jazz artists the tours "represented a critical victory in civil rights" by opening up opportunities for African Americans on the world stage, while also serving as a powerful venue for a counterculture of black modernism."[38]

Television jazz shows similarly provided a venue for black artists while at the same time fulfilling the national agenda to spread images of American freedom abroad. In 1963, in a direct attempt to tie jazz to free-world propaganda, the CBS public-affairs show *International Hour* featured *Voice of America*'s emcee Will Conover as host, and presented itself as the utmost in modern progressive-style jazz by showcasing such artists as John Coltrane, Stan Getz, and Count Basie.[39] Some of these programs did well on the export market, playing in a range of nations from France to Germany to Singapore to Kenya.[40] Edward R. Murrow was himself an advocate for the internationalization of jazz. In 1955, at the time he produced the "Two American Originals" episode, Murrow was collecting footage for a film titled *The Saga of Satchmo*, and as part of that project he funded Armstrong's trip to Europe. Some of the Paris footage made its way to the "Two American Originals" episode, and even while Murrow was not working explicitly for the State Department tours, the image of the jazz artist as a cultural ambassador was central to the program.

It is not just that television aired cultural programs with nationalist messages; rather, as the newest media marvel, television was itself a symbol of American progress. Having been used for wartime surveillance and reconnaissance, television was first and foremost an instrument of public safety and national security. Television network executives regularly boasted of the medium's broader national purpose in spreading goodwill and good culture abroad. As part of his cultural edification vision, Weaver claimed that NBC television would serve a global purpose by "making the entire world into a small town, instantly available, with leading actors on the world stage known on sight or by voice to all within it." But Weaver and others like him typically conceived of television's internationalism in relation to American supremacy worldwide, and they thought more about spreading a consensus view of America abroad (Weaver spoke of spreading a view of "American Agreement") than of using television for dialogues among diverse peoples.[41]

These nationalist aspirations materialized in programming efforts, most notably in NBC's *Wide Wide World*. Broadcast between 1955–58, *Wide Wide World* was a gala public-affairs program that reflected NBC's commitment to public service on an international scale. Largely shot on location and via live remote feeds, the program promised to "take viewers around the world," or at least to areas where remote feeds could travel (mostly Canada, Mexico, and Cuba), and in the spirit of localism it also presented slice-of-life scenes from small towns across the U.S. Moreover, the program had an edifying mission; episodes variously showed dancer Martha Graham, Broadway director Marshall Jameson, and "masterpieces in oil" by Vincent Van Gogh, Henri Matisse, Paul Gaughin, Edward Hopper, Robert Motherwell, and Pablo Picasso on display at the Metropolitan Museum of Art. As Lisa Parks argues, by promoting itself as an omniscient and mobile force for worldviews, *Wide Wide World* functioned as a "liberal pluralist flipside to red scare paranoia," and also worked to "naturalize network television's cultural presence and economic expansion in the U.S. and abroad."[42]

Although Parks focuses on the expansionist hubris of *Wide Wide World*, the program was also symptomatic of a contradictory underlying sense of America's inferiority complex when it came to culture—especially in comparison with Europe. European culture had for many years served as the comparative index against which the U.S. measured its brow levels, and despite the postwar search for an "American original," Americans still widely looked to Europe for their ideas about good taste. Moreover, market researchers noted that the lust for European art and fashion was no longer a class phenomenon as it had been in previous decades but rather was becoming part of mass culture as more and more Americans purchased Italian sports cars, Danish modern furniture, and a host of other Euro-style fashions. In 1958, Ernest Dichter (president of the Institute for Motivational Research) observed, "There is very little isolationism left in American taste. There are more foreign books in translation, more foreign art shown and reproduced, and more foreign wine consumed than ever before."[43] The popular fervor for European art was registered in lavish Technicolor films like John Huston's *Moulin Rouge* (1952) and Vincente Minnelli's *Lust for Life* (1956), which took audiences on imaginary trips to Europe, following the lives of Toulouse-Lautrec and Vincent Van Gogh. Television specials on these and other artists were also in vogue. As early as 1950 *Philco TV Playhouse* (NBC) aired an hour-long teleplay titled "The Life of Vincent Van Gogh" while Picasso and Goya were the subjects of 1950s network specials. So, too, even while they mostly featured wartime and Depression Era American artists, public-affairs

programs often appealed to "Frenchness" and "Britishness" when attempting to convince audiences of their cultural clout.

Produced by the Ford Foundation in conjunction with CBS, *Omnibus* is the perfect example of the contradictory attitudes in play. On the one hand, host Alistair Cooke's "Britishness" lent *Omnibus* an air of European sophistication, and the program showcased Renaissance paintings, abridged versions of Shakespeare, and Russian and French ballet.[44] On the other hand, *Omnibus* mixed the European masters with more "folksy" American subjects. For example, Cooke interviewed small-town newspaper owners and schoolteachers. In this regard, *Omnibus* encapsulated the central taste paradox at the heart of public-affairs programs—they had to exude localism (as per the FCC "public interest" mandate) while at the same time appealing to the "class" audience associated with urbane cosmopolitan tastes. Considering how his program achieved this balance, Cooke described *Omnibus* as "a vaudeville show embracing many centuries and with something for everybody."[45]

This melting-pot appeal is the basis for a 1953 *Omnibus* episode that revolves around a visit to the home of the premier Depression Era social realist and regionalist painter, Thomas Hart Benton. Benton's career was itself born of a mix of European modernism (with which he experimented in art school in Paris) and American mass culture (he painted movie sets for Fox and Pathé in the 1910s). His art was an admixture of realistic subject matter and aspects of modern style that emerged in regionalist murals depicting slice-of-life scenes, often critical of social inequities such as labor exploitation. Despite his social criticism, big corporations such as American Tobacco and Standard Oil commissioned Benton to make artwork for advertisements. In 1941, Benton painted *Outside the Curing Barn* as an ad for Lucky Strike cigarettes. But by the postwar period, Benton realized that big business was not interested in art that contained social criticism, and he felt that his liaisons with big business had been a failure.[46] By the time of the *Omnibus* episode, Benton had likewise rejected his connections both to the New Deal inspired WPA-funded art and to the modern artists that emerged from the Depression (especially his former student, Jackson Pollock). Holding onto his regionalist aesthetic, he moved to the Midwest, a place that he thought spoke to the folksy values of the real America in way that the New York City art world could not.

Given his rejection of big city modernism and his status as America's premier Depression Era painter, Benton would seem to be the perfect representative of the American vernacular. However, in the *Omnibus* episode "American" art was itself less easily defined. Although the program presents

Benton and his family in their humble Midwestern home, it includes two British stage actors, Alistair Cooke and Claude Rains (a family friend), who, by way of their "Britishness," give the program a highbrow feel. At the beginning, Cooke invites viewers into the Bentons' home for a "typical" night of family life among the art set. Rains exhibits some of Benton's work and reads the poetry of Carl Sandburg. Then, after Rains shows Benton's famous Huck Finn lithograph, Benton reads a passage from a Mark Twain novel. Folksinger Susan Reed plays the harp and sings a ballad, and Benton's thirteen-year-old daughter reads from the French novella, *The Little Prince*. American art may be "homegrown" (as Twain, Sandburg, and folksongs suggest), but it still depends on Europe to achieve its cultural clout.

This ambivalent relationship between American and European art came to a dramatic pitch during the early days of the Kennedy administration. The "Camelot" presidency drew shamelessly on European art to legitimate its own cultural standing as leader of the free world. One of President Kennedy's greatest triumphs was to secure (in cooperation with French minister of culture, Andrew Malraux) the first U.S. traveling exhibit of the *Mona Lisa*, which he acquired on loan from the Louvre. In a television press conference on the subject, the connections between art and international diplomacy are made explicit as Kennedy positions the acquisition of the *Mona Lisa* as "a reminder of the friendship that exists between France and the United States."[47] The fascination with European art spilled over into the details of the president's everyday life. In 1961, when Jacqueline Bouvier Kennedy launched her historic campaign to redecorate the White House, she hired a favorite French society decorator, Stephane Boudin, to help oversee the job.[48]

Mrs. Kennedy's "Frenchness" (her Chanel outfits, her fluent command of the language) was already well known to the American public when she appeared in her 1962 CBS special, *A Tour of the White House with Mrs. John F. Kennedy*.[49] Under attack in the press for spending national tax dollars on the frivolous goal of redecoration and for hiring a Frenchman to mastermind the plan, the Kennedys saw the television program as a way to win the consent of the American public. The live-on-tape program used Jackie's female narration to teach the nation about the importance of visual design not just for private pleasure but also for public service. Both on air and in the press, Jackie always referred to the project as a restoration of national heritage, and she boasted of her diligent search for original American furnishings and decorative antiques. At the end of the program, President Kennedy even told the audience that the purpose of redecorating was to teach young people to "become better Americans."

Jacqueline Kennedy exhibits her modern feminine style as she stands before the father of the nation in the newly decorated White House (1962).

Ironically, however, while Jackie insisted on the need to imbue the White House with a sense of American heritage, she nevertheless spoke mostly of European design, comparing the east room to the palace at Versailles, talking of Shakespeare and ancient Greece, and even boasting that the wallpaper, with its scenes of America, was made in France. Moreover, Jackie's Europhilia emerged in irrepressible ways. In one segment she laments the fact that presidential portraits had so often been painted by "inferior artists," and she then goes on to praise President Monroe for having imported an excellent set of candelabras from France. When asked whether she thinks if "there is a relationship between the government and art," or if it is "because you and your husband just feel this way?" she replies:

> That's so complicated. I don't know. I just think that everything in the White House should be the best. The entertainment that's given here. And if it's an American company that you can help, I like to do that. If it's not, just as long as it's the best.

Although critics at the time applauded Jackie's knowledge of the arts, her brand of snooty Europhilia was, throughout the period, just as easily the cause for popular mistrust (especially when exuded by less pretty and demure presenters).[50] In fact, television dramas and spy programs often associated art (especially European and American modern art) with the communist threat and the equally threatening image of the modern woman.

ART PLOTS, COMMUNIST PLOTS, AND MODERN WOMEN

When remarking on television's obsession with painting, MoMA's James Thrall Soby claimed, "I don't know how many times during the past two years I've watched mystery stories in which the theft or forgery of a painting has been the subject of a complicated exercise in skullduggery and sleuthing."[51] Not only did television dramas deal with suspicious art collectors and forgery, they often connected art crimes to "un-American" lifestyles. Whereas public-affairs shows like *See It Now* and *Omnibus* depicted Depression Era and wartime artists as good citizens and family types, television dramas about modern painters did just the opposite. Dramatic programs typically represented modern artists as a threat to American family values, and they also often associated modern art with unsavory European influences.

A 1957 episode of CBS's anthology drama *Playhouse 90* titled "One Coat of White" illustrates the pervasive conflation of modern art, Europe, and the

threat to American family life. In this drama, actress Claudette Colbert plays Betsy Gregg, an American tourist in France who falls in love with the "greatest living French artist," Lautisse (a name that *Saturday Review* called "a provocative amalgam of the names Lautrec and Matisse"). Lautisse, who hasn't painted in years, refuses to let anyone know his true identity, falls in love with Betsy and follows her back to her home in Seattle where her grown-up children are "horrified by what they consider to be their widowed mother's middle-aged escapade." Betsy is torn between her love for her children and her unsuitable European modernist suitor. The conflict is resolved when the children in Seattle undergo a financial crisis and decide to put the home up for sale. As the *Saturday Review* explains:

> The children propose to help its salability by giving its fence a coat of white paint. But Lautisse gets there first and begins to cover the fence's surface with abstract forms which he quite rightly describes as 'rather like Miro.' His skill gives the game away naturally, his identity becomes known to the children and the public, and within hours curators of some of the leading American art museums have arrived on the scene and are bidding against each other for sections of the fence at fabulous prices per running foot.[52]

Although "One Coat of White" has a happy ending, the odd couple of the American housewife and the French modern artist provide the terms of dramatic conflict, asking viewers to decide whether an American woman ought to be engaged with modern art. As a mother transgressing her children's wishes and social mores, Betsy represents a new breed of postwar modern womanhood that scandalizes accepted codes of female sexuality. This program presents its female heroine and her out-of-control desires for French men as a threat to the isolationist and family values of the previous two decades. However, it resolves the dilemma of the American family's place in an increasingly international postwar world by having the French modern artist literally save the American family home.

More generally, in popular culture "modern" women were decidedly suspect. In fact, the threat of the modern woman even achieved the status of a popular theory encapsulated by the term "momism." First coined by Philip Wylie in his 1941 book *Generation of Vipers,* the term was widely used throughout the 1950s. Wylie argued that women were in a conspiracy with industry to rob men of their power and create a culture of sissies.[53] Wylie connected his fears of women to an equally paranoid vision of the broadcast media. In the 1941 edition, and the sixteen more that followed, Wylie claimed that women had somehow teamed up with the broadcast industry by

using radio, and later television, as tools for dominating men. The constant "goo and sentimentality" emitted through the wires would turn men into "desexed, de-cerebated, de-souled" homebodies. Not only did such emasculation threaten individual men, it foreshadowed "national death."[54] To this end, Wylie even compared what he called the "matriarchal" use of broadcasting in the U.S. with Goebbels's "mass-stamping" of the public psyche in Nazi Germany.[55] Wylie's hyperbolic ravings testify to Andreas Huyssen's claim that femininity has historically been aligned with mass culture (and its threatening, degraded status), while high art is seen as the prerogative of male elites.[56] But importantly, in mass-culture venues such as television, the threat of femininity could just as easily be associated with the foreign (which typically meant communist) threat of European and American modern art.

In this sense, even while the American public embraced Jacqueline Kennedy's stylish knowledge about art, television dramas often presented the underside to this form of cultured femininity. Time and again, television dramas attracted audiences by staging scenarios about the explosive and threatening aspects of women associated with the arts, especially European and American modernism.[57] Like Jackie, these women were "to-be-looked-at" objects of attraction, but rather than donning classically tailored Chanel suits, they were the "bad girl" molls of an underground avant-garde populated by swindlers, communists, and vixens. Television dramas and spy shows presented evil women who eschewed traditional gender roles to engage in the underworld of European art. Meanwhile, male characters that dabbled in the arts were typically depicted as effete European dandies, the perverse flipside to the upstanding American family man.

For example, "A Man of Taste," a 1955 episode of the CBS anthology drama *Climax!* tells the story of Mr. Charles Westling, a vain British dandy who runs a Parisian gallery and has a nasty habit of murdering artists in order to make their paintings go up in price. Told in flashback from his prison cell, the episode follows Westling's dubious career with his even more treacherous French fiancé, Florizelle (played by the then exotic glamour girl Zsa Zsa Gabor). The pair set out to kill a young American painter, Matt Sloan, who is studying in Paris on his GI Bill scholarship after being holed up in a Korean prison camp. Although a patriot, Sloan is represented as a bad-boy abstract expressionist artist (a la Jackson Pollock) and looks very much the part in his rumpled clothes. Claiming that his paintings are "violent and say what has to be said," Sloan rejects Westling's attempts to market his art to bourgeois clients and insists his paintings are "not pictures to be hung in people's living rooms with television sets and Persian rugs."

In his anti-domestic pose, Sloan perfectly encapsulates the image of the "macho" abstract expressionist artist in the 1950s. Following the reigning gender stereotypes, the portrayal of male artists was complicated by long-held cultural suspicions that men who went in for art were somehow not "real" men. In the 1950s, the public persona of the male artist was constructed in part through a defense against femininity and homosexuality and erupted in hyperbolic images of super-manly abstract expressionists who declared their masculinity by (supposedly) detaching themselves from commercialism and all things feminine and domestic.[58] Just as Pollock was notorious for his cowboy, action painter (even drinking man) image, Sloan is the spitting image of the abstract expressionist defense against femininity and all things domestic.

However, on the family medium of television, this hyperbolic form of raw masculinity was itself a problem that had to be contained within the civilizing contours of moral melodrama where good and evil are clearly drawn and where family values ultimately triumph. In this case, the story turns into a murder plot focusing on Florizelle's diabolical scheme to kill Sloan with a poison mushroom omelet. In other words, the murder weapon is something any mom might cook up, so that Florizelle's devious plan highlights her perversion of the housewife role. Posing as a sweet older couple in a farmhouse, Florizelle and Westling serve up the omelet, but Sloan is onto them and the evil couple wind up in prison. Meanwhile, a reformed Sloan marries an American girl and fathers a child. The art plot once again dramatizes a conflict between American and European art by punishing evil foreigners and women. In the process, the threat of the bad-boy abstract expressionist is resolved through his newfound status as American family man (the exact kind of person who might own a television set and Persian rug).

Other programs dealt with female artists gone astray. Most striking is a 1957 episode of *I Led Three Lives*, a syndicated program that revolved around the life of Herbert A. Philbrick, a counterspy for the FBI who posed as a pipe-smoking advertising executive. This episode told the tale of Margaret, a young female art student engaged to Paul, her art-school teacher, who supplements his meager earnings as a painter through his day job as an ad man. At the beginning of the story, when Paul visits Herbert to talk over an advertising campaign, he tells Herbert he suspects Margaret is a communist. Margaret, it turns out, is not only a communist spy; she is a modern artist who plants microfilm in her collages. In one scene, when Herbert visits the art school, Margaret asks, "Did you ever see a collage painting before, Herb? Collage is old fashioned but we moderns go in for it when we want to puzzle people."

"Bad girl" Margaret hides secret codes in her communist collage on *I Led Three Lives*, "The Fiancé" (ZIV Television, syndicated, 1956).

Then, in more sinister tones, she says, "We take little pieces like these . . . well, they should be pieces of your heart. Who are you, Herb? . . . Oh, the man who corrupts commercial artists with money. Do you know what you've done to Paul? You've made him unable to understand my genius." As opposed to Margaret's interest in modernist collage, Paul and Herbert both express their preference for representational art that has recognizable subject matter (and Herb specifically calls modern art "strange"). In the end, in the true terms of momism, it turns out that Margaret has turned communist because she hates her mother.[59] When mother and daughter finally reconcile, Margaret is purged of her communist sins, turns in her modernist collage for a wedding ring, and she and Paul live happily ever after. In this way, the program not only conflates the threat of modernism with the threat of women, it also presents the commercial artist as an American hero, a counterspy for the FBI who staves off the communist threat. In this sense, *I Led Three Lives* doesn't simply celebrate traditional family values; it also celebrates the role of commercial art in the burgeoning postwar consumer culture.

Similar stories about suspicious forgers, foreigners, smugglers, and wayward women were staple plots in anthology dramas. Vincent Price and Peter Lorre's pilot episode for *Collector's Item*, an anthology drama about "fraud, forgery, and smuggling in the field of art" features Zsa Zsa's sister Eva Gabor as evil Countess Gia Ferrano whose Texan fiancé suspects she is a smuggler. On CBS's *The Perry Mason Show*, "The Case of the Purple Woman" (1958) features a woman suspected of murdering her art-forger husband while "The Case of the Posthumous Painter" (1961) deals with a wife accused of murdering her artist husband (who has faked his death in order to raise the price of his paintings). Horror and science-fiction anthologies such as *Thriller* (NBC), *The Twilight Zone* (CBS), and *One Step Beyond* (syndicated) presented gothic

and/or paranormal tales of modern artists caught in a web of danger or driven insane by aberrant visions.[60] Other dramas focused on "bad girl" models that broke up marriages and ruined lives. Hosted by Boris Karloff, *Thriller's* "The Devil's Ticket" (1961) tells a story of a mediocre modern painter who sells his soul to the devil and to the equally devilish beatnik seductress bent on destroying his marriage. Also about domestic terror, *Thriller's* "Portrait without a Face" (1961) deals with a murdered abstract painter who seems to be painting from the grave in order to avenge his killer. As it turns out, the killer is a female model who posed for him in the nude. Similarly, "Hand Painted Murder," a 1954 episode of the NBC mystery series *Mr. and Mrs. North,* investigates the murder of Sylvia, a sexy artist's model who vamps just about every man in town. (In a not too subtle reference to Picasso, the artist is named Bucasso and seems perversely thrilled by his model's murder, which he takes to be the symbolic death of his "Sylvia period.")

As in the above example, the artist's model was often a suspect figure and/or treacherous vamp in these shows.[61] *Armstrong Circle Theater's* "The Secret of Emily Duvane" (NBC, 1953); *Goodyear Television Playhouse's* "Suitable For Framing" (NBC, 1954); and *Errol Flynn Theater's* "The Model" (syndicated, 1957) revolved around men who suspected their wives or daughters of posing in the nude. Even sitcom housewives were scandalized by their engagements with art. ABC's *Father Knows Best,* one of the most wholesome family comedies of its day, presented a 1957 episode ("Brief Holiday") in which mother Margaret decides she has had enough of housework and goes downtown where, among other pleasures, she visits a local artist to have her portrait done. When her husband Jim finds out she's involved with an artist, he's sure there is something else going on. On CBS, *The Dick Van Dyke Show* presented a 1964 episode in which Rob Petrie discovers that his wife Laura has posed in the nude ("October Eve"), and the final scene shows the bohemian artist (who paints with water guns) unveiling an abstract portrait of Laura. In 1965 the same series ran an episode in which a sexy Greenwich Village artist tries to seduce Rob in her garret behind Laura's back ("Draw Me a Pear"). The scandalized housewife plot was so long-lasting that in 1985, when Andy Warhol appeared on the 200th anniversary episode of ABC's *The Love Boat,* the story revolved around his encounter with a seemingly typical Midwestern housewife (played by *Happy Days* mother Marion Ross) who is actually hiding the fact that she used to be outrageous superstar "Marina Del Rey" in Warhol's 1960s Factory entourage. Granted, by 1985 *The Love Boat* episode is already a pop parody of the cold war era bad girl art plot; nevertheless it speaks to the pervasive cultural associations between the scandal of modern

Laura and Rob Petrie (Mary Tyler Moore and Dick Van Dyke) convene with bohemian artist (Carl Reiner) in *The Dick Van Dyke Show*, "October Eve" (CBS, 1964).

art and the scandal of modern women (and, in Warhol's case, the scandal of queer masculinity). Indeed, with remarkable consistency, in family dramas and sitcoms, art turned out to be a sign of gender trouble that precipitates melodramatic conflicts and threatens American family values.

In addition to being a source of dramatic conflict, abstract paintings often visually disrupted television's aesthetic conventions of realism by introducing visual forms that conflicted with the naturalistic sets and continuity editing styles that made television seem true to life. In his essay "Narrative Space," Stephen Heath shows how Hollywood cinema used continuity editing and framing practices to create a realistic story world and a sense of unified perspectival space. By counterexample, he examines a pivotal scene in Hitchcock's detective thriller *Suspicion*, which features a scene with a post-cubist abstract painting that hangs on the murder suspect's wall. Heath argues that Hitchcock derails the spatial coherence of the storyworld (and the point-of-view editing style that produces it) by having a detective gaze for a prolonged period of time at the abstract painting. Positioned on a wall outside the central space of action in the scene, the painting seems superfluous to the plot, and because of its abstraction and its duration as an image, the shot reveals an alternative way of organizing time and space that interrupts the seamless continuity of film frames, exposing the artifice of classical Hollywood realism itself.[62] Although most television programs were made with less intentional directorial panache, and while they were often shot with multiple cameras (and so less reliant on Hollywood cinema's shot-reverse-shot editing style), modern paintings similarly disrupted television's continuities of time and space and its photographic realism.

For example, in *I Led Three Lives*, when the detective looks at Margaret's abstract collage, the camera cuts to the reverse shot of the artwork. The collage

fills up the entire television screen and, as in Hitchcock's *Suspicion*, the abstract art offers another "scene," an alternative way of organizing images. The collage insert provokes the TV viewer precisely because it looks so different from the realistic visual style of the rest of the program. Similarly, because abstract paintings often occupied a central place in the set design, they became the visual focus for TV spectators. For example, in *Thriller's* "Portrait without a Face," the naturalist mise en scene of the family home (furnished in traditional décor and old-fashioned flowery wallpaper) is set off-balance by numerous abstract paintings, including a large canvas (rendered in the style of Franz Kline) that hangs over the family mantle and dominates the frame.[63]

More generally, in TV art plots, modern paintings destabilized television's realistic mise en scene, suggesting that there were in fact other ways to perceive reality from those most typically deployed by TV cameras. Moreover, even if the stories associated modern art with evil communists and scandalous women, in the end the modern paintings were often the center of both visual and dramatic excitement for viewers. The sheer perpetuation of these art plots suggest that modern painting was a subject of popular fascination with inherent entertainment value for TV networks.

VAUDEO MODERNISM:
ART AS "BOFFO" ENTERTAINMENT

Quite paradoxically, it was television's oldest and most populist form—vaudeville—that turned out to be the ideal showcase for modern art. Like the *Admiral Broadway Review*, variety shows such as *The Dinah Shore Show* (NBC), *The Buick-Berle Hour* (NBC), *Your Show of Shows* (NBC), *The Jack Benny Show* (CBS), *The Eddie Fisher Show* (NBC), and *The Colgate Comedy Hour* (NBC) provided a stage for the popular presentation of modern art movements, from abstract expressionism to Beat poetry to modern dance. So cliché was the art "shtick" that on a 1953 episode of NBC's *Buick-Berle Hour*, guest star Paul Douglas advises host Milton Berle, "Don't start any of those corny art gallery routines. I know them all . . . the jokes you get out of the file." Nevertheless Berle and Douglas perform an art gallery routine featuring a slew of corny jokes about wacky modern paintings.

Unlike the more "class" orientated public-affairs programs with their specialized publics, variety shows were aimed at a mass audience and drew heavily upon the traditions of popular vaudeville theater—so heavily that the trade journal *Variety* referred to variety shows as "vaudeo."[64] These programs presented modern painting within the context of traditional American

vaudeville formats, thereby diffusing the highbrow and foreign/communist connotations of modernism within the broad humor, pratfalls, song-and-dance romps, and stock plots of the vaudeville stage. Moreover, as *Omnibus*'s Alistair Cooke realized, vaudeville's "something-for-everyone" olio format broadly appealed to the diverse tastes of television's national public.

A 1958 episode of *The Red Skelton Show* (CBS) is a prefect example of the way in which modern art became both a source of visual pleasure and "boffo" entertainment for a wide national audience. The program featured a stock vaudeville routine revolving around a "city slicker vs. country bumpkin" story that features Skelton's recurring rube character, the dimwit Clem Kadiddlehopper. In what was by then a cliché gag, the no-talent naive rube (or sometimes a chimp, a child, or a daft housewife) paints an abstract mishmash that pretentious city folk mistake for brilliant art. In this case Clem paints a picture of a cow so badly that a New York City philistine mistakes it for the latest thing in abstract art and pays $10,000 for it. Hoping to cash in on "the rave of the New York art world," a New York City art agent whisks Clem off to a Greenwich Village garret complete with abstract paintings hanging on the walls and beatnik women in slinky clothes. Finally, a matron of the arts commissions Clem to make a mural for her new museum. When he unveils his masterpiece, everyone is aghast to find that Clem has painted a picture of a barnyard animal on the wall of the museum lobby. When they ask him if he calls this a mural, he responds, "I thought you said to paint a mule." (One wonders if Warhol's famous cow-head wallpaper at the Castelli Gallery in 1966 was inspired by Clem or similar rube plots of this period!)[65]

Although the Clem skit mocks modern artists and their highbrow patrons, the program is not a simple rejection of the modern style. Instead, the show's presentational form indulges modern art. Like the "Hail! Modern Art" routine, this program begins with a lively production number featuring singers and dancers dressed in smocks and berets and prancing around the stage while holding abstract paintings. The variety show's emphasis on kinetic presentations therefore enlivens art, making painting appear more immediate, direct, spontaneous, and present in the viewers' lives. In other words, Skelton and his variety-show contemporaries presented modern art within the context of television's reigning aesthetic of "liveness." In the late 1940s and through the 1950s, leading east coast television critics like Jack Gould, Robert Louis Shayon, and Gilbert Seldes claimed that television was best when it gave the audience an impression of being on the scene of a live spontaneous event, watching things happen in real time.[66] Similarly, in industry trade journals and production manuals the aesthetics of liveness (and

Dancers swing to modern art in this credit sequence for *The Red Skelton Show* (CBS, 1958).

Red Skelton as dimwit Clem Kadiddlehopper accidentally paints a modern masterpiece in *The Red Skelton Show* (CBS, 1958).

related ideals of immediacy, presence, spontaneity, and kinesis) were oft-cited virtues of the TV form. What is, however, most striking is that at least when it came to abstract expressionism (also often called "action painting"), this sense of liveness permeated much of the critical discourse on American painting itself.

Indeed, even while abstract expressionist painting seems the direct opposite of the variety show's populist "boffo" appeal, leading art critics valued precisely the same formal qualities in painting that the leading television critics valued in variety shows: liveness, kinesis, spontaneity, and presence. In 1953 influential art critic Clement Greenburg spoke of the "new spontaneity and directness" of American abstract expressionism, saying that these paintings offered the public "a plentitude of presence." Moreover, these comments came in a symposium titled "Is the French Avant-garde Over-Rated?" in which Greenberg championed the sense of spontaneity, immediacy, and presence as a uniquely American quality while claiming that French abstract expressionism lacked a "fresher, more open, more immediate" sensibility.[67] As Marcia Brennan argues, Greenberg dismissed the French paintings

as being "tailored, buttery, suave, sumptuous, pat, and virtually embalmed under hermetically sealed surfaces" while "their American counterparts were characterized as being open, blunt, spontaneous, direct, immediate, and virtually alive."[68] Similarly, artists like Pollock and Motherwell as well as leading critics such as Schapiro, Harold Rosenberg, and Thomas B. Hess praised New York School abstract expressionism for its "spontaneity," "physical vitality," "metaphysical presence," and "improvisations."[69] Although art critics typically deplored mass culture, such emphasis on liveness and spontaneity erected similar aesthetic criteria for both painting and television.

In addition to their aura of liveness, variety shows presented modern art through modern set design. Some scenic designers for variety shows took a direct cue from modern painters. For example, in 1952 and 1953 *The Dinah Shore Show* (NBC) broadcast numerous episodes featuring set designs modeled after famous European and American artists. Scenic designer Eugene Berman fashioned sets in the style of Georgia O'Keefe, Alexander Calder, Raoul Dufy, Grant Wood, and Pablo Picasso. Reporting on the phenomenon, *Look* magazine showed one set that featured Dinah's song-and-dance troupe swinging on mobiles that were styled after Calder, and another that showed Dinah decked out in an evening gown and standing next to a "composite of surrealistic art styles." As *Look* observed, "Painting and sculpture, usually confined to galleries or private collections, have been receiving attention on coast-to-coast television. . . . Since Miss Shore's show goes into thousands of homes, art of this sort is being brought to a much wider audience. Art lovers, teachers, and others have written hundreds of letters to let Dinah know they are aware of this." According to *Look*, "One hepcat scrawled, 'Man, I dig this modern kick the most. It's real cool in the bitter.'"[70]

Beyond modern paintings per se, from the late 1940s and through the 1960s many art and stage directors featured modern set design as a source of visual pleasure.[71] In his 1952 book *Designing for TV*, NBC art director Robert J. Wade noted that variety shows, musical revues, ballets, and extravaganzas often had "abstract or stylized" stage sets. Designers, he observed, especially used "skeletal" sets associated with Russian constructivism (these were also used in American musical revues and films). Composed of uncovered scenic frames fashioned into a meaningful design and often set against a curved backdrop (referred to as a cyclorama), the constructivist skeletal sets had a clean, minimalist look (an element especially important on early television because of the limitations of lighting and stage space, and the need to keep the small screen from looking too busy). According to Wade, skeletal constructivist sets were "in essence . . . the outgrowth of one of the dogmas

of modern stylization which insists that form be defined in space mainly by plane or linear means, such as certain types of architecture and of metal sculpture." Yet, he continued, "In practice skeletal settings are used in television revues and variety shows because they are clean lined, understandably impressionist without being arty, very economical and capable of being extended or reduced for subsequent usage . . . [and] they are light, easily handled and shifted and require only a minimum of painting."[72]

Although Wade claimed skeletal sets were not "arty," he nevertheless likened the work of the scenic artist to that of Picasso and Dali. In this respect it is not surprising that skeletal sets often exuded a modern-art feel.[73] Designed by renowned Broadway and TV stage director Max Leibman, the modern dance routine in the *Admiral Broadway Revue* episode discussed at the beginning of this chapter used skeletal sets composed of curved spirals, while the "Off the Beam" routine (about bohemian hipsters) in the same show used a surreal-looking skeletal set with letters spelling out "No Don't" hanging from a stylized rendering of tree branches. After producing the *Admiral Broadway Revue* Leibman and his scenic designer Frederick Fox went on to use constructivist skeletal sets in the hit NBC variety program, *Your Show of Shows*. Similarly, in the early 1950s ABC art director James H. McNaughton and CBS scenic designer William Cecil used skeleton sets for variety shows on their network. The trend continued. *The Frank Sinatra Timex Show*, which had a modern "swinger" aura, often employed skeletal sets. In a 1959 episode Frank and his guest stars Dean Martin and Bing Crosby literally "hang out" on a simple geometric set that looks like monkey bars (but also has a grid-like Mondrian feel) while guest star Mitzy Gaynor does a modern dance routine titled "Hurricane" in which she moves across a stage decorated with tiny twirling wind machines and small abstract shapes that hang from bars. The set resembles something between the art of Ray Eames, Joan Miró, and Alexander Calder.

Scenic designers considered how average television audiences might react to modern stylized designs. In 1949, for one of the earliest network productions of *Shakespeare*, producer/stage director Worthington Minor (best known for his anthology drama *Studio One*) followed a cutting edge trend in theater by using modern costume and scenic design to mount a television adaptation of Shakespeare's *Julius Caesar*. Discussing the program, critic Harriet Van Horne recalled, "Old hands for soap opera and gangbuster shows said the public wouldn't know what the hell it was all about. And anyway, who ever heard of a Roman senator in a tweed suit?" Nevertheless, she enthused, "Television's first *Julius Caesar* was one of the most exciting events

There is a definite economy of space and money in the use of skeletal type scenery. Above, a city street scene for a dance number in a theater-studio revue. Below, an abstract design for a sound stage musical number backed by a neutral cyclorama.

In *Designing for TV* (1953), Robert J. Wade discusses skeletal set design at NBC.

in show business that winter. As for the idiot public, it liked the show so well that Minor had to repeat it."[74] Similarly, in *Designing for TV*, Wade argued that "most producers" thought that the "ordinary viewer" was fully capable of sensing "double meanings," and could easily appreciate the use of symbolism in a "mass entertainment medium."[75]

Abstract stylized sets were frequently used in the big budget colorcasts of the late 1950s. In these programs, modern design, lighting, and color worked

together to create a sense of abstract design and at times even sculptural space. For example, NBC's 1958 special *An Evening with Fred Astaire* (which won nine Emmy Awards, including one for scenic design) was a visual feast not just of tap, ballroom, and modern dance but also of RCA's color system.[76] The sets are notability minimalist, often just a cyclorama backdrop with vertical panels and a few props (such as a table or a bench). Despite the minimalism, vibrant abstract designs are created through the use of a bold color palette and lighting. In the opening and closing segments the stage floor is adorned with large yellow, blue, green, fuchsia, and red circles that are offset by a simple backdrop composed of blue, green, and red vertical panels (and, for variation, the colors of the backdrop change occasionally with lighting switches). Dressed in a formal black tux and white shirt, Astaire is a singular presence while his red scarf flies through the air when he dances across the circular color fields on the stage floor. In the finale, jazz musician Jonah Jonas, dancer Barry Chase, and the Hermes Pan Dancers join Astaire on stage where they all perform a blues, jazz, and modern dance medley against a skeletal set that looks like a stairway to heaven as it shoots up toward clouds painted in a highly stylized manner. A wall composed of vertical shapes and bold colors frames the right side of the stage, while a bench is placed in the middle of an otherwise empty stage. Chase wears chic black Capri pants to augment the fashionable feel. Here as elsewhere, the use of abstract stylized sets (in conjunction with costume design) created a distinctly modern look for television, even in shows that harked back to vaudeville and musical revues.

JAZZ SETS

As in the Astaire show, jazz and blues often provided the musical inspiration for visually modern set and costume design. Broadcast historians have typically explored minstrel and mammy stereotypes on early network television (especially in the CBS black-cast sitcoms *Amos 'n' Andy* and *Beulah*). Although they also focus on minstrels and mammies, J. Fred MacDonald and Donald Bogle both attest to the important breakthroughs made by black jazz artists during the period in presenting themselves as artists and part of modern society.[77] As is well known to jazz historians, musicians such as Dizzy Gillespie and Duke Ellington specifically tried to represent themselves outside the demeaning imagery of the minstrel performer and within the lexicon of black modernism. Although television historians have largely ignored the genre, television jazz programs typically exuded a modern feel, and in this context modern set design was especially important. While TV

jazz shows certainly carried with them the legacy of television's racist protocols (for example, they abided by TV censor prohibitions against mixed race dancers or any physical contact between races), these shows presented an alternative to the residual nineteenth-century minstrel form by framing black artists in the visual aura of postwar modern design. And while the programs mostly had white hosts, black jazz artists often strategically used these shows as occasions to promote their latest albums and/or explore television's creative possibilities for the modern African American performance arts.

Hosted by popular critic Gilbert Seldes and co-produced by NBC and NET, *The Subject is Jazz* had an abstract modern look. A 1958 episode featuring Julian Cannonball Adderley shows Seldes lecturing the audience on bebop and cool jazz, with Adderley performing Charlie Parker's "Confirmation" and Dizzy Gillespie's "A Night in Tunisia" against a modern skeletal set designed by the award-winning Jan Scott (one of the rare female art directors in early network television). Even more extravagant in its scenic backdrops, a 1959 episode of the *Timex All Star Jazz Show* (CBS), hosted by sitcom and variety star Jackie Gleason, features Dizzy Gillespie, Duke Ellington, and Louis Armstrong playing modern jazz against a painted mural depicting ghetto apartments in a semi-abstract style. Camera distance and angle variation provide unusual slanted perspectives that foreground the abstract, geometric look and also highlight the spontaneity and improvisational aspects of jazz for live TV. Gleason tells the home audience, "Don't be surprised if now and then you see a camera that sneaks up and looks like it's playing in the band because you see Timex wanted this program to be ad lib and sort of off-the-cuff." To which Armstrong adds, "I see . . . They want to show the world what jazz is like." Similarly, in a 1957 episode of CBS's *The Lively Arts* ("The Sound of Jazz") host John Crosby enthuses, "Jazz and live television have one big thing in common. The quality known as immediacy. You gotta catch both of them at the moment they happen." The program created what Crosby referred to as an aura of "authenticity" by showing players wearing sweatshirts, smoking, walking around, and improvising on a bare studio set.[78] For fear of her looking contrived, the producers even instructed Billie Holiday to take off her evening gown and perform in slacks and a ponytail.[79] Cameras were positioned at extreme angles to create a sense of distorted abstract space, and the program proceeded in a self-reflexive mode with Crosby sitting at the control switches as he introduced the acts. More generally, music critics of the period deplored the vaudevillization of jazz on TV, and they sought visual designs that spoke to the values of authenticity, improvisation, self-reflexivity, and formal experimentation that Crosby's show addressed.[80]

Among African American jazz artists, Duke Ellington took a special interest in television as a new venue for audio-visual expression. A painter since his youth, Ellington was especially interested in using visual and theatrical interpretation to compliment his musical compositions, which by the 1950s were increasingly conceived as experiments with form (for example, in 1956 he created "Such Sweet Thunder," an orchestral suite based on Shakespeare's *A Midsummer Night's Dream*). Although many of Ellington's variety show appearances featured his Depression Era and wartime popular hits like "Take the A Train," "Sophisticated Lady," and "Satin Doll," a number of his TV performances spoke to his painterly talents. For example, his 1962 special, "The Art of Ellington!" is entirely organized around the relationship between jazz and painting. The shooting script instructs the cameraman to follow host Raymond Burr as he walks toward reproductions of Picasso, Gauguin, and Cézanne, commenting, "You know . . . I've always compared jazz music to contemporary art. Great artists, Picasso, Gauguin, Cézanne, were always exploring in the same manner that a great jazz artist seeks new musical ways to express today's feelings and frustrations." Continuing the comparison, Burr later adds, "Actually, a recording is a painting. Each groove is a brush stroke of the artist. . . . And tonight , we go on record with an exhibit of Duke Ellington's greatest paintings . . . on records! Duke . . . you're on!" The stage directions call for a medley of Ellington's hits accompanied by close-ups of contemporary paintings. In a later performance, Burr talks about Ellington's motion picture score for Otto Preminger's *Anatomy of a Murder* while Saul Bass's award-winning film poster (which quickly became a hallmark of modern design) hangs in the background.[81]

Apart from his variety show appearances, Ellington stands out because he was the first African American artist to create an episode of a primetime network drama that was entirely devoted to the audio-visual experimentation of jazz.[82] Broadcast live on May 8, 1957, Ellington's "A Drum Is a Woman" was the first colorcast episode of CBS's *United States Steel Hour*. Ellington originally conceived "Drum" in the 1940s for a film to be directed by Orson Welles, but the idea finally materialized in 1956 as an album that Ellington created (along with his partner Billy Strayhorn) for Columbia Records, a subsidiary of CBS. Seeing the television program as a way to cross-promote the record, color television, and United States Steel products, the network and sponsor gave the show a major publicity campaign in newspapers and on broadcast stations around the country.[83] The network, United States Steel, and its advertising agency, Batten, Barton, Durstine, and Osborn (BBDO) also gave Ellington comparatively free reign as lyricist, composer, and narrator of the show.[84]

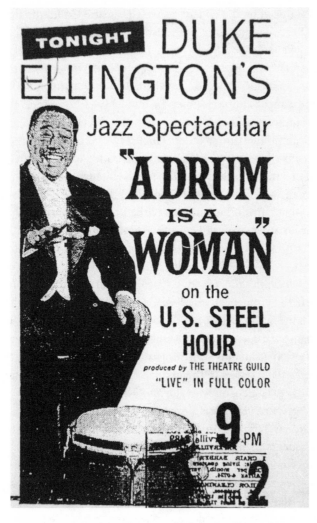

Advertisement for Duke Ellington's "A Drum Is a Woman" on
The United States Steel Hour (CBS, 1957).

Aimed both at the mass audience and at the more rarified class audience,
"Drum" balanced the dual (and often shifting) connotations of jazz at mid-
century as both a popular American vernacular form and authentic art of
"longhair" appeal.[85] Ellington said he targeted the program at "a real adult
intelligent audience," and even while he explicitly resisted the "educational"
label, he aimed to attract a class audience of viewers with what he called
a "jazz fantasy" that told the history of jazz in an entertaining allegorical

format.[86] Produced by the widely respected Theatre Guild, the program had an all-black cast composed of such distinguished talents as Margaret Tynes (who belonged to the New York City Center Opera Company and sang on the album version of "Drum"), Joya Sherrill (who had previously been a vocalist in Ellington's band); Carman de Lavallade (a ballerina for the Metropolitan Opera); and dancer/choreographer Talley Beatty (who trained at Katherine Dunham's studio).[87] Willard Levitas (who had previously designed sets for the prestige anthology drama *Studio One*) served as set designer. Alvin Ailey, soon to become the renowned dance troupe leader, was an extra.[88]

The story features Caribee Joe, who is enchanted by his drum, which turns into a woman, Madame Zajj. The narrative follows Zajj as she magically transports herself from the jungle to Barbados, New Orleans, Chicago, New York, and even outer space. Like the standard anthology drama, "Drum" had a three-act structure, but unlike most teleplays (which typically had a classically constructed beginning, middle, and end, and usually followed the logic of realist melodrama or comedy), "Drum" interpreted the history of jazz through African-influenced modern dance, Ellington's musical score, and bebop-style narration delivered by Ellington himself. Although shot with standard camera direction (fairly static shots with dancers moving towards and away from the cameras), the program aimed at audio-visual experimentation. The first act begins in the jungle, where Caribee Joe appears with his drum while the dance troupe performs "The Love Dance" to a bongo beat. The shooting script calls for an expressionist, stylized tone, noting that the dance should be "lyrical in quality, exotic and sensuous."[89] Act III's "Ballet of the Flying Saucers" is similarly stylized. The shooting script calls for a set that is "Abstract, fanciful to the extreme" with "dancers costumed, lit, and staged to suggest science-fiction 'beings' rather than people."[90] Although the actual broadcast is often less visually ambitious than the script, the dance and music work together with stage direction and lighting to give the program a rhythmic feel, despite the relatively static cameras. The stage is often crowded with performers, at times dancing with their backs to the camera (not a typical choice for television stage and camera directors, who typically aimed for visual legibility and clarity). As one of the first teleplays to be colorcast, "Drum" looked novel merely by virtue of the hues (one reviewer called it a "collage of . . . swirling globs of indigos and vermilions").[91] For its time, the program was also daring in its depiction of black sexuality on screen, with many scenes highlighting the beautiful bodies of Zajj and Jo (who appeared in a loincloth and naked from the torso up). As narrator, Ellington draws attention to Zajj's

promiscuity as she travels from city to city and fling to fling, while the dance sequences stage her erotic encounters.[92]

Although Ellington supported the cold-war-inspired promotion of jazz as an emblem of American freedom (he headlined a State Department jazz tour in 1962 and was generally sympathetic with cold war initiatives to spread jazz abroad[93]), "Drum" was no simple celebration of jazz as a homegrown "American original." Instead, both in theme and style, "Drum" exhibits the kind of hybrid modernism that Paul Gilroy traces across the "Black Atlantic" cultural routes of Africa, the Caribbean, Europe, and North America.[94] The program creates fantasy-scapes that conjure up the hybridity of experience (especially the merging of the jungle with the industrial city) in the black diaspora. For example, for Act III, the script, states, "Out of the JUNGLE SCENE. . . . There is an arching semi-circle of people who represent that part of the city which is Bop atmosphere. . . . JOE receives from the line of people the beret, the glasses, the bopster's beard, the piece of skin, the jacket, which take from him his primitive look, and give him instead the accoutrement of Bop Civilization."[95] The juxtapositions of the jungle with the city suggest the merging of cultures across the continents that comprise modern jazz.

In the end, "Drum" received mixed reviews with critics calling it everything from "too high in the musical stratosphere," "too sophisticated," a "thumping bore," "an interesting but meaningless collage," "exotic," "real wild, man," and "the most unusual dramatic hour in recent TV history."[96] Even the *Chicago Defender*, which reported that civil rights leaders praised the program for "displaying Negro talent in a manner allowing for dignity," panned "Drum" for being "disjointed" and "leaving viewers confused."[97] Several critics objected to the entire premise of "A Drum Is a Woman" on the grounds that it suggested wife beating, a charge that may well have belied white discomfort with the program's erotic display of black sexuality on screen.[98] Whether due to the critics' uneven responses or to his own agenda, Ellington did not continue to adapt musical compositions for episodic television.[99] But the mixture of jazz, visual modernisms, and eroticism that "Drum" presented did find its way to television in more whitewashed versions of "hipster" culture.

Most prominently here, starting in the late 1950s, Hugh Hefner's late night syndicated program *Playboy's Penthouse* mixed modern design and jazz to appeal to a TV "in-crowd."[100] Filmed in Chicago, the show featured Hugh's penthouse apartment appointed with "moderne" furniture and abstract expressionist paintings. Although essentially a variety show with olio lineups, the program exuded a hip aura with a bevy of bunnies, lots of mixed drinks,

and also lots of mixed races. For example, in a 1960 episode Dizzy Gillespie plays horn as white bunnies hover around him adoringly. Considering the history of taboos around mixed raced performances on television, the show must have appeared radical for its time. Still, the racial and sexual dynamics were entirely symptomatic of the moment. On television, Heff's swinger persona was constructed not just via his bachelor pad bunny patch and abstract expressionist paintings, but also through his self-representation as "simpatico" with the "cool" styles of African American jazz artists. Heff was in this sense the shining example of the "White Negro," a phrase Norman Mailer coined in 1957 that associated the idea of "cool" with what Mailer perceived to be the more authentic and spontaneous aura of black masculinity.[101]

While *Playboy's Penthouse* was strictly a late night syndicated affair, the networks provided tamer, more nationally viable versions of the hip vaudeo format. Known for his intellectual demeanor (including his jazz piano playing, black frame glasses, and "hipster" banter), comedian Steve Allen was network television's premier "hep cat" vaudevillian, a modern sophisticate aesthete with enough of the wisecracking clown in him to appeal to both a class and a mass audience.[102] A 1959 episode of *The Steve Allen Plymouth Show* (NBC) is a perfect case in point. The episode offers a lineup including comedian Don Knotts, popular singer Frankie Lane, sitcom star William Bendix, and premier Beat Generation poet Jack Kerouac. On the heels of the success of his 1957 book *On the Road*, Kerouac was at the time experiencing (and also courting) a wave of media attention, and the "beatnik" had become a popular subject of interest.[103] In fact, on the night of broadcast, the *Chicago Tribune* ran a story titled "TV Goes All Out on Beatniks," noting the many TV shows from noir-style cop shows like *Peter Gunn* (NBC, CBS) to family sitcoms like *The Danny Thomas Show* (ABC, CBS) that featured beatnik plots.[104]

When Allen introduces Kerouac, the sequence appears as just another "act" in the night's entertainment lineup. Sitting at a piano, Kerouac chats with Allen while Allen plays a jazz riff. The set is decorated with garden-variety abstract expressionist artwork from the period. Given the fact that Kerouac was himself a painter and close friend to artists Kline, Rivers, and de Kooning, it is fitting that the stage setting should reflect these interests. However, despite these "high" pretensions, the talk show and variety elements create a popular and familiar context for Kerouac's performance, which, as might be imagined, is in no way like the performances of Frankie Lane, Don Knotts, or William Bendix. Rather than cracking jokes or belting out torch songs, Kerouac reads a passage from *On the Road*. The performance is staged as if in a jazz club, and it is shot in close-up and medium close-up with the

camera dollying in to create a sense of movement and intense focus on Kerouac's somber face. Yet, unlike the typical TV personality, Kerouac refuses to look into the camera. Instead, he averts his eyes as he reads from the page. Absorbed in his rhythmic prose, he is decidedly alienated from the television audience. The abstract paintings, the free-style jazz, and Kerouac's aloof demeanor add up to a rather strange departure from the other acts.

Summarizing the Beat aesthetic, Daniel Belgrad argues, "Beat poetry and bebop jazz shared a common cultural project: to oppose the culture of corporate liberalism with spontaneous prosody embodying the tenets of intersubjectivity and body-mind holism."[105] Nevertheless, in the corporate liberal world of 1950s television, Kerouac's spontaneous prosody and Allen's jazz riff, as well as the colorful abstract paintings on the set, all served the purposes of the sponsor.[106] Right after Kerouac's poetic reading, the scene shifts to Don Knotts, who plays a bumbling traveling salesman hawking new Plymouth sedans. Although the relationship between Kerouac's road story and the car commercial have obvious thematic connections, the transition from Kerouac's intense prose about the heroic male drop-out who searches for life's meaning on the road to Knotts's send-up portrayal of a Willy Loman–type traveling salesman precipitates an abrupt change in mood.[107] The transition asks audiences to swap aesthetic contemplation for consumer pleasure. The colorcast spectacle of abstract artworks that are used as the backdrop for Kerouac's performance are in this sense just a "teaser" for the true color spectacle—the Plymouth cars themselves, which are also displayed on stage. In this regard, the program equivocates between the visual pleasure to be found in paintings and the visual spectacle of products offered in the new postwar consumer society. Looking at art on television is therefore always also implicated in the shopper's gaze.

COMMERCIALS:
THE TRUE "AMERICAN ORIGINAL"?

Even while television presented modern art as being threatening, elitist, or downright nonsensical, art served as a vehicle for attracting audiences and selling products. On television, art and commercialism were strange but faithful bedfellows, and sponsors recognized the intrinsic value of art—and modern art in particular—for American business.

Just as companies like the Container Corporation of America and American Tobacco had used fine art in advertising before the war to keep their products in view and associate industry with patriotism, cultural respectability, progress, and public service, after the war these and other companies

continued the trend. Charles T. Coiner, vice president and art director for N. W. Ayer and Sons, said he engaged the "services of such top-notch artists as Picasso and Raoul Dufy" to lend an air of "prestige" to products.[108] Although the business wing of advertising agencies of the 1950s often valued market research over creativity, art was in no way displaced by business science. Instead, advertising journals hotly debated the "design vs. research" issue.[109] In 1947, leading graphic designer and advertising artist Paul Rand published *Thoughts on Design*, which had an enormous impact on the use of modern art in advertising, particularly the use of collage, photograms, and abstract paintings by the likes of Joan Miró, Jean Arp, and Paul Klee.[110] One year later, *Advertising and Selling* considered the influence of cubism, Dadaism, surrealism, and abstract expressionism on corporate ads and modern illustration, and many other advertising trade journals continued to consider the use of art throughout the 1950s.[111]

Even if ads did not directly imitate any particular "ism," an emphasis on modern graphic design was widespread. Advertising artists of the 1950s especially embraced the "big picture" ad (both photographs and illustrations) for its clean modern look. *Art Direction* (the major trade journal for advertising art directors) observed that between 1937 and 1957 ads had become less cluttered with copy so that "the big picture has replaced the big word."[112] More generally, the terms "visual communication" and "symbolic communication" began to replace "copywriting" as the adman's essential concern. The move to big picture ads had to do with the advertiser's desire to overcome two related marketing obstacles: (1) the huge amount of advertisements displayed in the postwar consumer society; and (2) consumers' mistrust of advertising claims. Not only would big picture ads catch the attention of consumers inundated by advertising come-ons, people would be more apt to believe pictures than the "tired words about technological advantages which the consumer's common sense tells him aren't true."[113] Moreover, advertisers knew that mass-produced products had become so standardized that people could no longer tell the difference between, say, one brand of canned peas and another. In this context, the trade journal *Advertising Age* noted, "Style rather than utility has become the primary function of goods in our economy."[114] Accordingly, advertisers thought that big picture ads with a unique visual flair would make a brand stand out among others.

Assuming that women were more "art-wise" than men, advertisers considered the big picture ad as the ideal way to reach female consumers. In 1956, the Leo Burnett agency conducted a taste survey that asked ninety-four "average housewives" to express their reactions to forty ads. The survey

concluded, "Housewives want lots of art, and little copy. To fully suit their composite taste, the ratio of art to copy probably should approach zero. They want the picture to tell the whole story."[115] In her 1958 advertising handbook, *What Makes Women Buy*, Janet Wolff promoted the big picture ad as a labor saving device for women, saying:

> The picture ad has come about in part because of the great number of sales messages today. Women are dividing their time between more and more selling appeals—so each one has to be made as quickly and directly as possible. The simplest and quickest way to communicate an idea is found to be through pictures, and women accept this timesaving and entertaining method. The work of prominent artists and photographers is utilized to a far greater extent in selling forms than formerly.[116]

In his 1961 book, *Visual Persuasion*, advertising executive Stephen Baker likewise noted that women liked big picture ads with modern "gay and colorful" paintings, and he also observed that sophisticated modern illustration made women "feel they are being 'talked up' to; this makes them feel that they are smart and knowing and possess good taste."[117] Even if, as Penny Sparke has argued, the penchant for clean modern design expressed a highly rationalized vision that divorced itself from the traditionally feminine decorative arts, advertisers directed this modern new look especially at female consumers.[118]

All sorts of household goods came wrapped in the modern style. As *Art Direction* declared, "Brandmarkers frequently like abstract art," and the trade journal went on to compare a cookie box to paintings by Mondrian, Klee, Delaunay, and Kandinksy. With more practical goals in mind, many advertisers embraced modern design as a simple way to make compelling art. *Printers' Ink* observed, "Mondrian Layouts are Easy!" while another article in the same journal noted "Mondrian Layouts Multiply." [119] Nevertheless, other advertisers opposed the modern style. *Advertising Age* railed against the "Be-Bop school of advertising" with its "fancy-boy art directors" and "frustrated bohemians."[120] Summing up the arguments, in 1950 *Advertising and Selling* reported:

> The Great Battle of Advertising Art is now raging in and out of the agencies. It seems as if you say a kind word for Abstract Art, you label yourself an outspoken enemy of Conventional art and visa-versa. . . . A common argument against abstract art is that it is not easily understood by many readers. Perhaps not. But an abstract illustration may have great effect in attracting the reader's

attention and leaving with him a strong impression of the product and company name.[121]

As a new medium of visual communication, television came to play a major role in this battle between modern and conventional copy. Advertisers wondered whether a mass audience would go in for the "sophisticated" tastes of modern design or whether they would prefer commercials that used more realistic forms. In his annual report for the 1949 Art Directors Club of New York Exhibit (the leading professional award show for advertising artists), President Lester Rondell, observed: "The advent of television presents a challenge to art directors and advertisers that further spotlights the battle between good taste and buckeye."[122] In this context, television became an experimental testing ground for advertisers who wanted to figure out how best to represent products to appeal to national tastes. Although many TV sponsors produced straightforward demonstrational commercials of the "buckeye" kind, others considered artistic experimentation to be a valuable asset. According to *Art Direction*, television advertisers especially used modern art in commercials aimed at "sophisticated audiences" who had prior experiences with modern painting and visual forms.[123]

Insofar as advertisers thought sophisticated shoppers—especially women—were attracted to anything "new," they often used modern design on TV.[124] Car companies (which increasingly aimed their cars at women drivers) were especially aggressive in this regard. Just as Plymouth used the Steve Allen/Kerouac episode to showcase its 1959 fall automobiles, Chrysler (Plymouth's parent company) used *An Evening with Fred Astaire* as a visual backdrop for its "Forward Look" tailfin cars (a slogan that Chrysler introduced in 1955). The cars appeared on stage in numerous colors against a cyclorama with an orange-and-blue abstract design painted on it. The opening title credits for the program were composed of the "boomerang" design Chrysler then used as its trademark. (The trademark resonated with similar boomerang designs used on modern textiles and for "moderne" furniture such as Charles Eames's famous boomerang coffee table.)

The Timex Company made similar associations between modern products and the modern look of the television programs it sponsored. The *Timex All Star Jazz Review* featured product spokesman John Cameron Swazy telling the home audience, "Television is modern" and that Timex watches are also "modern in every way." Even more emphatically, a commercial in the *Frank Sinatra Timex Show* directly compared the Timex watch to modern art. Set against a backdrop of modern paintings and holding a piece of sculp-

ture, Swazy claims, "You know, ladies and gentleman, there's much more to art than just paintings and, uh, sculpture. For instance, here is a beautiful example of the fine art of watch making. The Timex ladies' waterproof. So smart, rich, and simple it can be worn with any costume." Using art to attract women consumers, the commercial promised that Timex offered a "high fashion sculpted look," but the ad also related high art and haute couture to more down-to-earth homemaking crafts. In one of the then famous Timex "torture tests" in which the watch "takes a licking and keeps on ticking," a woman spokesperson submerges a watch into a baking bowl, adds eggs and flour, and then subjects the batter to an electric mixer, all to prove that "Timex can take a beating." In this sense, the commercial connects the modern artistry of Timex to the everyday art of women's cooking. In fact, as the spokeswoman beats her batter and extols the virtues of the Timex watch, she also gives recipe tips to homemakers. Quite paradoxically in this regard, whereas television melodramas and sitcoms associated modern art with scandalous femininity, commercials made special appeals to homemakers by acknowledging their taste for modern design.[125]

Even Duke Ellington's "A Drum Is a Woman" served the purposes of selling products to the modern and decidedly white suburban housewife. The program featured two commercials for "Today's Kitchens" that showcased modern kitchens designed with metal cabinets from U.S. Steel. The housewife stood inside an Eden of modern appliances set against decorative drapes sporting the then modern textile patterns composed of abstract shapes. Hoping to hook housewives on the modern style, United States Steel offered a mail-in "kitchen planning book" whose cover was similarly rendered with modern abstract design. The jarring juxtaposition between the white suburban housewife in her sleek steel kitchen and the program's bebop narration and black modern "primitive" style was indeed hard to miss; yet apparently United States Steel assumed this was precisely the kind of program environment with which to attract modern women with progressive tastes.

The sponsors for public-affairs series also thought carefully about how to associate their products with programs that had a modern feel. *Omnibus* sponsor American Machine and Foundry (AMF) selected *Omnibus* because company president Morehead Patterson "felt that *Omnibus*, being experimental, was like AMF, an experimental company" and, therefore, he thought the show "could be used to define the company to the public." Hoping to imbue AMF with a cutting edge look, Patterson "told his agency to produce commercials to fit this experimental show, and he insisted that he wanted no drums, bugles, fanfares, or the usual trappings of ordinary promotion."

Instead, AMF coined a new slogan for its commercials on *Omnibus*: "AMF products are better . . . by design," and it changed its trademark's typeface to create a more modern look for the corporation. Although AMF executives did worry that viewers might find commercials a jarring intrusion into art appreciation, market research showed that *Omnibus* audiences felt "no significant negative attitude towards the commercials" and that "viewers appear to be well conditioned to commercials generally."[126] Indeed, as television searched for a homegrown "American" form of modern art, it also accustomed audiences to the economic imperatives of its own culture industry.

The *See It Now* "Two American Originals" episode featuring Grandma Moses and Satchmo makes an even more explicit appeal to modern art-wise consumers. In the first segment, the narrator says, "Out of the modern Shulton plant come these two brand new men's products. Old Spice Electric Shave Lotion and Old Spice Body Talcum." Like Grandma Moses herself, Old Spice mediates the old with the new. The integrated commercial in this program underscores the "art" value attached to the product as the narrator boasts that Old Spice is a "real American original" and shows viewers the "magnificent murals that decorate the lobby" of the Old Spice factory. The camera pans across the mural and displays Old Spice bottles in a kind of gallery setting— as if these products are art objects. A second filmed commercial uses abstract whimsical animation to send the same message implicitly through the use of modern graphic design.

More generally, advertising agencies and film companies that specialized in commercials used modern graphic design in animated ads. Some of the animated commercials look like experimental Dadaist and surrealist cinema of the 1920s that featured abstract, non-narrative arrangements of human forms and vernacular objects (i.e., Ferdinand Léger's *Ballet Mécanique* [1923] or Man Ray's *Emak Bakia* [1928]). Indeed some of the directors of animated commercials at leading independent commercial film studios worked as painters, independent filmmakers, or photographers using the commercials as a way to fund their art. Kraft Foods and the pharmaceutical company Abbott Laboratories both hired photographer Jim Brown (who studied at the Chicago Art Institute) to make short animated ads that featured safety pins and Q-tips dancing in rhythmic patterns.[127] Similarly, a Young & Rubicam (Y&R) commercial for Band-Aids ("Strip, Patch, Spot," 1960) is a mélange of hazardous objects (pins, needles, nails, hammers, razors, cats, scissors, knives, matches, and bows and arrows) all edited in a fast-paced montage. As the animated objects appear successively on screen, a female voice yells, "Watch out! You could get stuck and spiked and banged and hit and torn

and bit and nicked and pinched and scratched and scissored and sliced and burned and scalped. You should get Band-Aids!" Many animated commercials were rendered in this semi-abstract style, and many were executed with simple geometric shapes. Some were figural, presenting whimsically drawn men, women, or animals rendered in simple black-and-white line drawings and/or abstract shapes. Others combined whimsical line drawings and abstract shapes with bold non-naturalistic color palettes to present a fantasy look.

Independent animation companies such as Storyboard, United Productions of America (UPA), Playhouse Pictures, and Ray Patin Productions specialized in these abstract and semi-abstract (and usually whimsical) animated commercials.[128] Most famous at the time for its cartoon characters Mr. Magoo and Gerald McBoing Boing, UPA was a leader in the commercial field, winning numerous awards for its animated ads rendered in the modern graphic style. Many UPA staffers were painters and illustrators who showed their work at galleries in Los Angeles and New York. UPA's supervising director, Gene Deitch, had two of his animated films shown at the 1957 Brussels International Exposition Experimental Film Festival. In a review of the company, *Art Direction* noted, "The influence of the modern painters and contemporary graphics artists is reflected in their work."[129] Praising UPA's "sophisticated" and "intellectual" themes and contrasting its "imagistic" drawing style to the more "literal" work at Disney, a 1952 feature story in the *New York Times* declared, "UPA is imposing what amounts to the spirit and style of modern art upon . . . the movie cartoon." One year later, in 1953, *New York Times* art critic Aline B. Louchheim likened UPA's work with line drawings to "such fine artists as Matisse, Picasso, Steinberg and, above all, Mogdigliani," and she called UPA's commercials "visual delights" that "are among the best 'art' programs so far to be seen on TV."[130] Deitch became famous for his modern looking Piel's Beer commercials featuring the whimsically animated characters Bert and Harry. UPA also produced stylized "moderne" commercials such as an ad for CBS-Hytron television and radio tubes ("Demonstration," 1955) that featured a female figure split and stretched into distorted designs with abstract shapes that popped on and off the screen.[131]

In addition to their modern graphic design, animated commercials often used what *Printers' Ink* called "abstract sound."[132] A space-age looking abstract ad for Esso Gasoline (no title, 1957) used a "nervous musical background that reflects the frenetic nature of our times and evokes a mental picture of highway traffic," while UPA's commercial for CBS-Hytron used a composite of electronic noises.[133] UPA was, in fact, a leader in abstract sound.

Gerald McBoing Boing, which premiered on CBS in 1953, was based on a Dr. Seuss story about a boy who becomes a big success as a sound-effects genius on radio, and in 1952 UPA made a fifteen-minute industrial film for CBS titled "More than Meets the Eye" that used semi-abstract symbols to show the impact of sound on human perception (CBS used the film to woo prospective sponsors). Advertisers often also designed jazz soundtracks for animated spots. In 1955 Storyboard and the advertising firm W. B. Doner and Company used jazz to score a number of abstract animated commercials including an ad for Speedway 79 gasoline ("Boogie Woogie," ca. 1955); an animated commercial for King Collum pork sausage (no title, 1955) that used a Mondrian-style layout; and a commercial for E-Z Pop popcorn ("Bop Corn," 1954) with animation composed of whimsically drawn faces (rendered as squiggly shapes) that sing scat as they pop against a backdrop of flashing abstract designs. In hipster lingo the announcer says, "E-Z Pop Man, that's real bop corn."[134]

By the end of the 1950s, commercials of the "moderne" kind were a staple on early television. Trade journals singled them out not only as good ad art but also as effective sellers, and these ads won awards from professional organizations and even from the art world itself.[135] As early as 1955, MoMA held a special exhibition devoted to UPA (both its feature films and its commercials). In that same year the Simon R. Guggenheim Museum commissioned Storyboard's founder, John Hubley (also a onetime UPA artist), to make *The Adventures of* *, an abstract animated film about modes of visual perception that was the first animated film to be produced and financed by an art museum.[136]

Given their recognition in the world of modern art, the abstract animated commercials might even be the missing link between abstract expressionism and its successor, pop art. In other words, while communicating the postwar obsession with abstraction, these commercials nevertheless returned subject matter (in the form of products) to art. Insofar as Andy Warhol, Roy Lichtenstein, and Claes Oldenberg were variously obsessed with comic book heroes, package art, and the industrial mode of production (and given Warhol's own career as a commercial artist in the 1950s) it seems likely they would have had ample opportunities to notice that the art world had, by the mid-1950s, already exalted the commercial to the status of the painterly arts. Meanwhile, for the general public, the abstract animated commercial came to be an everyday form of modernism, a way of looking at ordinary things through visual and audio engagements with cutting-edge graphic and sound design. Commercials habituated people to the act of looking at abstract imagery, and they

This UPA commercial for CBS-Hytron television and radio tubes was exhibited at the 1955 UPA show at MoMA ("Demonstration," 1955).

Moderne animation graces the screen in this commercial for Esso gasoline (1957).

Abstract shapes "bop" to jazz in this Storyboard commercial for E-Z Pop ("Bop Corn," 1954).

made the high seriousness of abstract art (at least the seriousness of abstract expressionism) into a fun, whimsical pursuit. In her *New York Times* review of MoMA's 1952 "Cubism and Futurism" show, Louchheim speculated that people were no longer shocked by the visual abstractions of the early twentieth-century modernists. In fact, she argued, "Boccioni's sculpture 'Development of a Bottle in Space' seems much less mysterious than the stop-motion TV commercial where a package of cigarettes unwinds its own cellophane strip and cigarettes burst through its top."[137]

Despite television's stories of communists, female spies, scandalous housewives, snooty highbrows, crooked dandies, and city slickers, commercial television became a showcase for visual experimentation with all things modern. Not only did network programs hail modern art with spectacular stagecraft and colorcast spectacles, the visual environment of television advertising relied on modern art and graphic design in order to sell products to consumers. More than just peddling savory pork sausages or buttery "Bop" corn, television used modern art and graphic design to sell the public—and especially women—an image of themselves as progressive-minded citizen-consumers. In the new television culture, being an American meant being a taste-conscious, visually literate consumer who appreciated the latest trends in graphic design. As market researcher Pierre Martineau put it, "As a nation we have suddenly developed a taste for taste. This is true even of the mass market."[138] Even if the average housewife didn't know the difference between a de Kooning and a Kline, she could easily exercise her superior discretion when choosing among an array of artfully packaged and advertised products.

In this respect, television played a crucial role in forming what Lizabeth Cohen calls the emergence of a "Consumer Republic," a postwar national ideology promoted by federal economic policies in which buying products to keep industry alive was tantamount to being a good citizen.[139] Moreover, Cohen argues, the newly defined "consumer-citizen" was encouraged to think of herself as part of a classless progressive society where better products were available to all (even while a sizable minority of Americans still lived below the poverty line). Although Cohen focuses on economic policy and the business side of marketing, this same ethos was commonly found among design experts and advertising art directors who thought of themselves not only as tastemakers empowered to stimulate consumer desire but also as civic leaders of a national campaign to democratize taste.

Some advertisers and market researchers even thought that the mass media had raised national taste standards and improved U.S. culture. In 1958

the editors of *Art Direction* published a forum on the issue of taste, asking industry leaders, researchers, and designers to consider the American postwar palette. Lester Rossin of Lester Rossin Associates said the "use of 'visual language' in advertising and sales promotion is playing a major role in the development of the American taste-level by stimulating consumer's visual awareness," while Dichter claimed that mass media created "esthetic values among consumers." Addressing television's influence, Virgil Exner, designer of Chrysler's "Forward Look" cars, claimed, "The widespread use of television and radio" had contributed to a "cultural explosion" that is "expressive of our true national life." Similarly, industrial designers Walter P. Margulies and J. Gorden Lippincott argued, "No matter what might be said of the influence of television on the mass mind, it has at the very least brought certain aesthetic concepts, a sense of style and design to areas which never before were introduced to such things." Praising NBC's daytime show *Home* (which had a rotating stage the producers called a "machine for selling"), Margulies and Lippincott said that television "has served to introduce contemporary art and decoration to widely spread and isolated parts of the country, which had hitherto looked upon such concepts as rarefied, peculiar, and certainly not for the average person." Due to the commercial edification of average citizens, they predicted, "The stage is set for a revival, or rather an emergence of a new mass American taste."[140] In other words, mass media was turning the ugly American into a design-conscious aesthete.

In this elevated atmosphere, leaders in the network television industry embraced modern art in their attempts to create a modern *commercial* visual culture capable of achieving their goals—amassing affiliates, building audiences, and, above all, providing a virtual showroom for sponsors. The burgeoning field of modern graphic design was central to these efforts. In fact, the CBS network staked its future on modern design, employing fine artists, photographers, graphic designers, and architects to create a new progressive look for a broadcast network that had been around since 1928. Largely through its use of modern design, CBS became the leading television network in the field, outdoing the others in sales and ratings for much of the 1950s and 1960s. In the next chapter I explore CBS's leadership and considerable investments in the field of modern graphic design and advertising art in the 1950s, activities that demonstrate just how important modern art was to the business success of network TV.

2

••• AN EYE FOR DESIGN

Corporate Modernism at CBS

> A corporation should be like a good painting; everything visible should contribute to the correct total statement; nothing visible should detract. —ELIOT NOYES, 1962

In 1948, CBS commissioned photographer Paul Strand to illustrate a trade advertisement aimed at prospective sponsors. Accompanied by the caption "It Is Now Tomorrow," Strand's photograph depicts television antennas looming over the New York City skyline. The antennas dominate the composition while skyscrapers located at the very bottom of the frame appear dwarfed, as if in miniature, and sinking out of sight. By making television the central attraction in a vanishing city, Strand's photograph gets to the heart of the CBS sales message: in the postwar marketplace, the new electronic landscape of television will be more important to commerce than offices, shops, or any other physical place in the urban environment. The accompanying ad copy underscores the point by promising sponsors that companies that advertise on CBS television will "make sharp and lasting impressions" on audiences "today and tomorrow."[1]

Hiring Strand to design this ad was a wise choice on the part of CBS. Strand's sharp-focus photographic style rhymed with the theme of "sharp and lasting impressions" that CBS wished to communicate to sponsors. Moreover, by hiring Strand CBS hoped to impart an aura of high art and respectability to its television operations. By 1948 Strand was well known as a photographer and documentary filmmaker in New York City art circles

Paul Strand, "It Is Now Tomorrow" (1948). Reprinted with permission of CBS.

(MoMA held a major retrospective of his work in 1945) so that the elite class of Madison Avenue business clients that CBS wished to attract would have understood his stature as an artist.[2] The subjects that Strand photographed—ranging from urban and rural landscapes to ordinary people and everyday objects—spoke of American vernacular culture but also, as the MoMA retrospective suggested, to a particularly modern aesthete sensibility, a sensibility that was shared by many advertisers and business leaders of the time.

As we saw in chapter 1, the use of fine art and art photography in advertising was in itself nothing new, and CBS was certainly not the first corporation to dabble in the arts. As Roland Marchand demonstrates in his history of public relations, over the course of the 1920s and through the 1940s, U.S. corporations often employed fine artists and sponsored museum and fair exhibitions in order to associate their companies with good taste and democratic ideals of enlightenment.[3] For a regulated industry like broadcasting, the use of art in advertising was particularly important for convincing the FCC of the medium's higher purpose. So too, according to Marchand, art's ability to give a company a respectable reputation helped alleviate the problems of "scale" for national corporations; in other words, national companies could appeal to local populations by promising to support local cultural institutions and to provide national standards of excellence for people in

small towns and big cities alike. This issue of scale was especially important to broadcasting networks whose business depended on providing national programming to local affiliates and markets. Indeed, despite its urbane sensibility, the design ethos at CBS was rooted in the need to create a nationwide standard of excellence that would nevertheless appeal to the indigenous and specific tastes of affiliate station managers and their local audiences (a goal which, as we shall see, was often fraught with tension). Finally, by associating itself with the arts, a corporation could build a forward-looking workforce. In the 1940s, the Container Corporation of America used fine art in corporate ads designed to "attract to their organization young and modern-minded employees and to show that Container Corporation is ahead of its times."[4] With similar aspirations, CBS and NBC both commissioned artists in the 1940s to promote their radio networks. In the 1930s, CBS's design ethos was already wedded to its image as an arbiter of progress. Paley's right-hand "concept man" Paul Kesten (who came to the radio network from a career in advertising) was described by one associate as "vice-president in charge of the future."[5]

Corporate advertising especially flourished during the 1950s when it merged with the growing field of modern design (both graphic design and architecture). Corporate identity programs were important to the development of multinational corporations that sought to communicate with a universal visual language (trademarks, trade dress) across cultures and through time. In his book, *The Corporate Personality*, design consultant Wally Olins notes that designers produced identity programs that made their clients appear "modern" and "cool" but also "ordered," "homogeneous," and "controlled."[6] As a modern mass medium bent on selling an image of itself as both a rationalized business and cutting-edge technological marvel, television was particularly suited to this double vision. As television grew in influence, the medium became a central workplace for artists (photographers, typographers, graphic artists, fine artists) who found employment in art departments at networks, broadcast stations, and advertising agencies. These artists gave networks a public face just as much as any single TV program did. Corporate trademarks like the CBS eye and NBC peacock gave the abstract business of networking a tangible visual look that was instantly recognizable to business clients and audiences alike.

This chapter explores how television networks—especially CBS—created a new visual environment for their business operations by turning to the world of modern graphic design. My argument is simple: the rise of television as both a business and cultural form can't be understood simply through

the standard accounts of sales statistics, network-affiliate contracts, ratings, program planning, business deals, and policy decisions. Instead, the rise of the television industry must also be considered—as it was by the business culture of the time—from the point of view of visual design. Television executives were in the business of visual communication; as visual communicators, they had to convince their business clients and the general public that they understood how to make good images. To be sure, as visual communicators themselves, advertisers were intensely interested in how well their products would be displayed on TV. In order to present their best public face (and so attract advertisers and audiences alike), network executives devoted considerable resources to trademarks, corporate advertising, newspaper ads, and on-air graphics. In the field of modern design, CBS served as an example for the other networks and broadcasters, and even more extensively, CBS influenced the larger field of corporate advertising and graphic design. In addition, these forays into modern design helped shape the general public's perceptions of television as a new and modern media form. When people watched TV or read newspaper promotions for TV programs they inevitably also encountered modern design. Modern design was a crucial part of the television image and the cultural experience of watching TV.

The lack of attention to modern design among broadcast historians has resulted in a number of untested truisms about what the TV experience was for viewers. Most historians assume the TV experience was programs and stars. From this perspective, broadcast historians usually reach back to a "golden age" of vaudevillian variety shows, Broadway-influenced anthology dramas, radio-influenced news and public-affairs shows, and a sprinkling of programs featuring famous personalities, most of whom came from film, vaudeville, radio, and/or newspapers (e.g., Arthur Godfrey, Lucille Ball, Ed Sullivan). Although broadcast historians aren't wrong—indeed, television programs did evolve from previous entertainment and information forms— the singular focus on programs blinds us to the variety of visual experiences that early TV actually offered. Insofar as television was not just programs but also trademarks, advertisements, credit sequences, and station graphics, the people who watched television (or saw publicity for TV shows), were also witnessing cutting-edge developments in the art of modern graphic design. In this sense, rather than just transporting viewers back to older entertainment forms (like vaudeville or Broadway or radio), television also taught viewers how to see these older forms within a modern visual context. Just as modern stage design revitalized the variety show's "vaudeo" style, modern graphic design reconfigured the old media for the new.

My aim in this chapter is, then, twofold. First, I consider how television executives of the 1950s used modern design to build their businesses. Second, I examine how corporate advertising created a modern visual look for television as a new media form, different from the forms of the past. As the leader in the field, CBS was a center for all this activity, but, as we shall see, it was not alone.

THE TIFFANY NETWORK AND
THE DESIGN CONTEXT

After WWII, when television began to be a commercial reality, the CBS network made a concerted effort to distinguish itself as the "Tiffany Network," a prestige organization with quality appeal. As many broadcast historians have noted, it did this in part by hiring star talent away from NBC, by creating a topflight news division, and (as we have already seen) by producing public-affairs programs. But even while CBS was known for its news division and quality showmanship, the bulk of programming on CBS did not really look all that different from that offered on its major competitor, NBC. NBC's Sylvester "Pat" Weaver also espoused ideals of quality programming and, as his "Operation Frontal Lobes" initiative suggests, he was heavily invested in promoting cultural fare. Rather than opting for high or low per se, both major networks (and to a lesser degree even the more fledging ABC network) offered an eclectic mix of cultural programming and public-affairs shows along with more popular genres like soap operas, sitcoms, and police shows. Moreover, even while CBS continued to promote itself as a prestige organization, over the course of the 1950s the network actually became the bane of TV critics after canceling many of its public-affairs programs (like *See It Now*) in favor of churning out higher rated but more formulaic westerns, sitcoms, and quiz shows (the latter of which resulted in the famous quiz show scandals).

In this regard, CBS's reputation as the Tiffany Network was less a function of its programs per se than it was of the way the programs were promoted and packaged. Graphic design and publicity art were especially crucial to CBS's ability to distinguish itself from other networks and convince elite business clients on Madison Avenue of its quality appeal. In the 1950s CBS television created a unique corporate brand by using modern graphic design and fine art to promote its products and services. So successful was CBS in creating a prestige image and in attracting audiences and sponsors that by 1953 it became the number one network in program ratings and advertising sales, a position it occupied throughout the decade and into the early 1960s.[7]

Moreover, by 1954 CBS was not just the leading U.S. television network; it was also the largest advertising medium in the world.[8]

The network's focus on modern design was in part inspired by the tastes of its leadership. Not only was chairman William S. Paley an art collector with an impressive array of French impressionist and post-impressionist paintings, he also sat on the board of MoMA, and even (dubiously) claimed to be a personal friend of Henri Matisse.[9] His office at CBS was adorned with the works of great European masters, which shared the space with his television set and many broadcast awards.[10] Second in command, CBS president Dr. Frank Stanton was even more knowledgeable about art, and he was also passionately interested in architecture and furniture design. Stanton's office was notorious for its minimalist modern design complete with Mies Van de Rohe chairs, a marble table (in place of a desk), and modern artworks including a wood relief by Jean Arp, sculptures by Alberto Giacometti and Marino Marini, and an abstract oil painting by Pierre Soulages. Reporters consistently described both Paley and Stanton as sophisticated, urbane men whose tastes in clothing, cars, and even women exhibited their progressive outlook.[11] In 1950, when *Time* magazine featured a cover story on Stanton, the reporter commented not only on his business expertise but on his five bedroom New York apartment that "glitter[ed] with glass, polished woods, and geometric abstractions" and looked "a little like a wing of the Museum of Modern Art."[12]

Although Paley and Stanton had a direct impact on the CBS "look," the network's investment in modern design wasn't based solely on the personal tastes of its directors. Instead, like Weaver at NBC, Paley and Stanton were primarily concerned with building their network's reputation and revenues. In forging a business strategy for television, they used modern art and design as tools for that greater purpose. Paley and Stanton thought that the best way to promote the quality of their products and services was to associate the network with artistic excellence. Modern design especially suited the demands of a television network that needed to exude an aura of technological progress. As Stanton claimed:

> I think there are few needs greater for the modern, large-scale corporation than the need for a broad public awareness of its personality—its sense of values. . . . Everything we produce at the Columbia Broadcasting System, including our own printed advertising, reports, documents, and promotion, is carefully considered from the viewpoint of the image we have of ourselves as a vigorous, public-spirited, profitable, modern enterprise. We give the most

careful attention to all aspects of design. We believe that we should not only be progressive but look progressive. We aim at excellence in all the arts, including the art of self-expression.[13]

Given that CBS was advertising to advertisers, the need for artistic excellence was even more critical. As Stanton recalled in 1962, "Distinction in advertising was a quality essential to the growth of CBS. As media ourselves, we could not afford to place in other advertising media less than first-rate art and copy."[14]

Stanton's observations were especially germane to the context in which he worked. In 1954, *Sponsor* conducted a survey of how executives at advertising agencies felt about ads for television stations. According to the findings, most agency executives believed "station advertising lacked imagination and some thought it was downright dull." *Sponsor* reported that station advertising often presented factual information (such as ratings) that didn't necessarily convince sophisticated advertisers to buy advertising time on the channel. In other words, station advertising often took the market research approach over the design orientation. The case of CBS is particularly interesting in this regard because Stanton was not just an art lover; he also had a Ph.D. in psychology, specializing in the subject of audience retention of media messages. In the late 1930s, before coming to CBS, Stanton worked with audience research pioneer Paul Lazarsfeld to create the "Program Analyzer," one of the first audience research measurement devices. Given his pedigree, Stanton took market research extremely seriously, yet he believed that research alone would not address the challenges faced by a media corporation that needed to persuade other media executives to buy its services. As Stanton knew, the sponsors to whom CBS aimed its corporate ads had their own market research departments, so they could easily see through network advertisements with trumped up claims about program ratings. For this reason, Stanton and his colleagues at CBS thought that advertisers needed to be motivated by something else besides market research data, and that something else was modern design.

At a time when advertisers were hotly debating the modern art vs. buckeye approach, Stanton clearly sided with the former, steering his network away not only from data-heavy advertising, but also from the lowbrow artwork of most station advertising at the time. According to the 1954 *Sponsor* study, a particularly popular advertising genre in the period was "the cheesecake ad" in which stations used pretty girls to attract agents and sponsors. Of these, one account executive said, "You bet I stop and look at an ad with a classy

looking dame in it. To tell you the truth, though, I usually don't remember the name of the station which ran the ad."[15] In fact, the pages of *Sponsor* were filled with cheesecake ads throughout the 1950s, and many local stations ran beauty contests, printing pictures of the winners in the trades. In response to these standard exploitation tricks, Stanton distinguished his network by using clean, often abstract, modern design with "class" sensibilities.

In the late 1940s Stanton created a brand for CBS by making all visual representation of the network an in-house operation. Rather than the typical practice of hiring an advertising agency to promote the business, CBS created its own advertising and promotions department that fully controlled CBS's corporate image. In 1951, Stanton appointed William Golden to be creative director of advertising and sales promotion for the CBS Television Network. The title signaled that Golden was more than an advertising art director (the position he already occupied at CBS), but rather in charge of all visual materials—from program advertisements to trademarks to advertising rate cards for the sales department to annual reports for the research department to corporate stationery to aspects of building and studio design. Golden not only controlled all facets of CBS's visual look, his designs were actually produced in-house by the CBS production department. The only task that CBS farmed out was the placement of ads in print media (in the 1950s this was done by the McCann-Ericsson agency). As CBS's major competitor, NBC also hired prominent graphic artists (many working in the modern style), but no single art director at NBC controlled the network's image in the way Golden did at CBS. As a result, NBC's image was never so visually coordinated. Comparing the two leading networks in 1953, *Fortune* observed that whereas NBC (under its parent company RCA) had more success securing control over the hardware (for example, RCA had just won the patent for its color system in a bitter war with CBS), CBS was the leader in "showmanship" and "the graphic arts."[16]

In addition to advertising to business clients, Golden and his staff designed program promotion (including newspaper ads as well as on-air slides and trailers) and sent these promotional materials in readymade publicity kits to CBS's owned and operated (flagship) stations and to affiliate stations across the country. Flagship and affiliate stations in turn used Golden's art to promote themselves (and CBS programs) in newspaper ads and on TV itself.[17] This meant that even while Golden's primary relationships were with business clients, his artwork was widely seen by the general public. Anyone who watched CBS TV or read the TV section of their local paper would have seen at least some of the designs produced by Golden and his staff. As

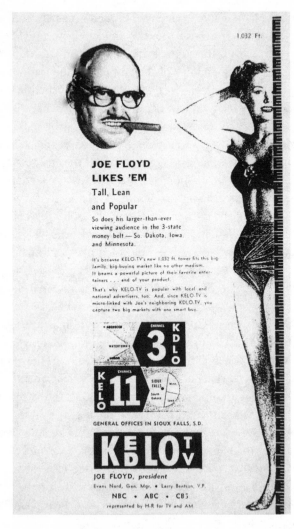

"Cheesecake" advertisements like this used women to woo sponsors (*Sponsor*, 1955).

Stanton claimed in 1953, in addition to advertising to advertisers, the art director is also "advertising to the public to persuade them to listen to and view these programs."[18]

Golden was well seasoned for this complex job. Golden began his career as an advertising artist at the *Los Angeles Examiner* in 1929, and by 1936 Dr. M. F. Agha, the widely revered art director at Condé Nast publications, in-

vited Golden to join the staff at *House & Garden*. One year later, Golden left the magazine to take a job at CBS, and in 1940 he was appointed art director of the radio network. Requesting a temporary leave of absence from CBS in 1942, Golden worked in the Office of War Information and served as art director of army training manuals. After the war, in 1946, Golden resumed his work at CBS, and from 1951 until his death in 1959 he and his staff created a distinct visual look for the network. Having worked at *House & Garden*, Golden had a particular knack for designs that would attract a "mass" audience, and especially the all-important female consumer, but at the same time his clean, modern designs spoke to a "class" sensibility that associated the network with dignified tastes.[19] His ability to speak to a broad public in a visual language that nevertheless articulated class aspirations was essential to the CBS Tiffany brand. By the end of his short life (he died at the age of forty-eight), Golden had received numerous awards from professional organizations and, as the inventor of the CBS eye, was generally recognized as one of the leaders in the field of modern design. As Stanton claimed, "Bill Golden was our relentless master in the pursuit of the first-rate."[20]

Golden's rise to prominence at CBS was in part a function of the larger changes taking place in the world of advertising and graphic design. Although many of the leading advertising firms of the 1950s grew profoundly dependent on market research, as we saw in chapter 1, by the mid-1950s modern graphic design was not only routinely used in corporate advertising, it was also becoming centrally important to consumer advertising.[21] In fact, while business historians have often characterized the 1950s as the "dark age" of creativity in advertising, not all advertisers wanted to be the proverbial "man in the gray flannel suit," as the title of Sloan Wilson's 1955 bestselling novel about uncreative money-grubbing ad agents suggested.[22] Rather than discounting creativity, trade journals such as *Printers' Ink, Art Direction, Print*, and *Sponsor* ran feature stories on art directors and graphic designers, elevating their status in the field. Most aggressively, professional organizations promoted the field of modern design. Established in 1914 and 1920 respectively, the American Institute of Graphic Arts (AIGA) and the Art Director's Club (ADC) grew in prominence after World War II, and they often collaborated with fine-art venues.

In 1941, when Golden was employed at CBS radio, the Metropolitan Museum of Art in New York opened its galleries to advertising artists for the first time by hosting the twenty-first annual exhibition of the New York ADC. Golden's advertisement won an ADC medal in the category of black-and-white photographs. The event itself marked the growing relationship between

the fine and commercial arts, as well as their publics. Museum president William Church Osborne presided over the opening ceremonies for the exhibition, praising the high quality of the advertising art on display. According to the *New York Times*, he regarded the exhibit to be an important event for the museum and he even "attributed to advertising much of the country's increased interest in art."[23]

The Museum of Modern Art also contributed to the prominence of graphic design and commercial art, both in its own museum publications (that were designed by such prominent graphic artists as Will Burtin) and in exhibitions it held for the ADC.[24] For the 1949 ADC exhibit, MoMA displayed the advertising art in tight patterns within gray-framed plaques (mounting the ads as authentic art), and the entire exhibit was televised under the auspices of architect Philip Johnson.[25] In her review of the exhibit, *New York Times* art critic Aline B. Louchheim singled out a CBS radio advertisement illustrated by renowned Depression Era artist Ben Shahn and executed under Golden's direction. Titled "No Voice Is Heard Now . . ." the advertisement was a black-and-white line drawing of empty chairs for the CBS orchestra, evoking radio's musical presence through the absence of human form. While figural and whimsical, the ad nevertheless had a modern abstract feel; its allusion to the CBS orchestra via the idea of absence was a highly conceptual way to invoke radio's imaginary presence in the home. Describing this ad, Louchheim compared it to the work of a modern master. "In the line drawings of William Golden . . . and by Ben Shahn—I see the influence of Paul Klee tempering the conventional cartoon. To this reviewer, the black and white work of this kind was outstanding in the exhibition." Noting how other ads in the exhibit echoed Miró, Arp, and Mondrian, Louchheim spoke of the "class" vs. "mass" audience attracted to this kind of abstract and conceptual copy.[26]

More generally, during the 1950s, universities and art exhibitions encouraged contacts between graphic design and fine art. In July of 1950, Yale University announced its creation of a new Department of Design with painter/designer Josef Albers as chairman.[27] By 1958, *Print* reported that there were "approximately 100 schools of art and design in the United States" and that "design schools in America today are attaining and offering a new thinking, a new standard" geared more to "technological advances" and "art theory" than the old courses in decorative arts.[28] Meanwhile, commercial artists often exhibited their work in New York City art galleries after it appeared in print, and these exhibitions were "quite a lively success."[29] The AIGA mounted small shows that featured, for example, Saul Bass's film posters and record covers, Paul Rand's ads and package designs, Boris Artzybasheff's covers for *Time*

magazine, and Shahn's posters and advertising illustrations. A member of the AIGA, Golden was chairman of its "Design and Printing for Commerce" exhibition, and in 1954 he inaugurated the "50 Advertisements of the Year Show" that promoted modern design.[30]

The establishment of the International Design Conference in Aspen (IDCA) was especially important to America's stature as a world leader in design. Held in 1951, the inaugural conference was a landmark occasion. Walter Paepke of Container Corporation of America initiated and sponsored the conference along with his company's art director, Egbert Jacobson. Frank Stanton of CBS was among the numerous prominent business leaders who attended. Other participants included prominent architects such as Eero Saarinen (who went on to build CBS's Black Rock), graphic artists and typographers such as Herbert Bayer (chairman of design for Container Corporation of America), and art directors and illustrators like Leo Lionni (who took over Will Burtin's reign as art director at *Fortune* in 1949 and often worked for CBS). Over the course of the 1950s and 1960s, the IDCA focused on a variety of themes pertinent to the relationship between modern design and business. Speakers came from diverse fields such as fine arts, behavioral science, education, engineering, theater, motion pictures, sociology, economics, history, philosophy, semantics, business, psychology, and architecture.[31]

Through all of these venues, the growing field of modern design created a context for television's own visual repertoire that had important ramifications for the medium's rise and the public's ways of looking at it. Even while many television programs harked back to older entertainment forms, CBS used modern graphic design to promote television's status as the arbiter of a new progressive and sophisticated postwar culture. Nevertheless, tensions between modern art and mass sensibilities ensued.

AVANT-GARDE VS. KITSCH VS. CRAFT

Although he was responsible for many abstract and conceptual designs, and while he often employed fine artists and illustrators that had modern sensibilities, Golden was skeptical about avant-gardism. At the 1959 Typography USA Conference in New York he said, "If there is such a thing as 'New American Typography' surely it speaks in a foreign accent. And it probably talks too much. Much of what it says is obvious nonsense."[32] In particular, Golden worried about the influence that European design theory was having on young designers in the U.S., and he made an example of one young adman in his department whom he fired. "He had all the latest and obscure publications from here and abroad. . . . He would argue endlessly on

theory. . . . and he was just paralyzed with fright at the sight of a blank layout page."[33] Although Golden noted his debt to the graphic design of a previous generation of émigrés, including designers from the Bauhaus School, he felt that the newer generation of Europhile artists was misguided.

Golden had even more contempt when it came to the influence of American abstract expressionism. He argued that abstract expressionist painters were successful in part because of the "absence of content" in their work, and he criticized their "intolerance of any other school."[34] At the 1959 Aspen Conference he observed:

> There is one inviting avenue of escape that seems to give comfort to an increasing number of designers, and certainly to almost all the younger ones. It is that wonderful panacea that came to full flower in a disturbed postwar world: the abstract expressionist school of painting. . . . Business can accept it because it is successful, and oddly 'safe' since it says absolutely nothing. The cynical advertising designer can embrace it because it can help him demonstrate his independence of content. The young designer finds it a wonderful shortcut—a do-it-yourself—Art.[35]

Once again, Golden was especially annoyed with the way avant-gardism had influenced a young generation of graphic designers to think of themselves with hubris as being "Renaissance Man" artists rather than employees in a corporation.[36] To Golden the job of an art designer was clear: to make illustrations that expressed the message that the client wanted to communicate. Golden advised that the young designers should stop "confusing Art with design for business" and stop "making demands on business that it has neither the time nor the obligation to fulfill."[37]

Despite his allegiance to business, Golden was himself a liberal who donated his time and talents to political causes, including Adali Stevenson's presidential campaign. He was a humanist who thought art should have content and meaning, and as his above observations suggest, he disliked abstract expressionism because he felt that its lack of content made it "noncommittal" to any particular ideal. Not surprisingly in this respect, he was close friends with artists Ben Shahn and Feliks Topolski, both of whom he met when working for the Office of War Information during World War II, and with whom he shared a strong political affinity against fascism and an equally strong conviction that art had a social and political obligation to promote democratic culture. Golden hired Shahn and Topolski for numerous CBS projects. In fact, during the years that Shahn worked for CBS he was under investigation by the House Un-American Activities Committee (HUAC) for

his alleged communist sympathies. But despite the fact that CBS required rigid loyalty oaths from all employees, Golden, Stanton, and Paley refused to blacklist Shahn from the network. Golden was not alone in his ability to be a liberal and a corporate player at the same time. Instead, his corporate liberalism was a general mentality of the era, and many business executives like him (including Paley and Stanton) put faith in the idea that corporate growth would create not just a stronger economy but also a better world.

Nevertheless, Golden was certainly aware of the tradeoffs involved. "The dilemma of the literate advertising designer," he said, "is that emotionally he is part small businessman and part artist. He isn't strong enough to cut himself from the world of business to make the personal statement of the artist. He isn't a pure enough businessman to turn his attention completely away from the arts. He somehow wants the best of both worlds."[38] Golden responded to this dilemma pragmatically by conceptualizing his job not as Art (with a capital "A") but as a craft. "The printed page," he said, "is not primarily a medium for self-expression. Design for print is not Art. At best it is a highly skilled craft. A sensitive, inventive, interpretive craft, if you will, but in no way related to paintings."[39] For Golden, craftsmanship was not at all a compensation for something better. Instead, he argued, "Craftsmanship is something people have to nourish and hang on to. It's disappearing from our society. I don't care whether you're a shoemaker or a shirt maker or a typesetter or a printer. Craftsmanship is valuable. I see nothing more rewarding than trying to do something as well as you can."[40] In fact, despite his dedication to CBS, Golden remained entirely suspicious of mass production and he saw craft production as a holdout against it. "In the brave new world of Strontium 90—a world in which craftsmanship is an intolerable deterrent to mass production—it is a good thing to be able to practice a useful craft . . . that can so far do something that neither the Management Executive nor the electronic computer can do."[41]

Rather than as an artist, Golden represented himself as the consummate corporate craftsman. In an oft-circulated publicity photo, Golden stands in the lobby of CBS Television City, dangling a cigarette in his hand and wearing a fashionable black business suit, white shirt, and black tie.[42] The photo depicts Golden neither as a virtuoso "bohemian" artist nor as a "grey flannel suit adman," but as a stylish designer standing before his famous CBS eye trademark that is reproduced—seemingly a million times over—as a decorative pattern on Television City's expansive lobby wall. The idea that art would be reproduced as décor was anathema to leading art critics of his time who would have seen this as a reigning example of the kitsch effects of mass culture.

From this point of view, Golden's pose before his wall of eyes was more than a promotional statement for CBS. Whether intentionally or not, his pose was also a blatant rejection of art critics' devaluation of the decorative arts.

Most paradoxically, even while art critics disputed the corporatization of art and condemned its decorative uses as kitsch, the line between art and craft during the 1950s was itself less than clear. In fact, despite Golden's antipathy for the abstract expressionist's avant-garde pretensions, his craft model was in many ways simpatico with de Kooning and Pollock who, as David Craven argues, valued artisanship as a counterpractice in a mass-produced world. As Pollock said, "Craftsmanship is essential to the artist" as a response to "the aims of the age we are living in."[43] So, too, even if art critics deplored this, artists of the 1950s were themselves not necessarily against having their art being used as décor. In 1951, *Vogue* reproduced Pollock's paintings as backdrops for fashion layouts, and the 1949 Pollock cover story for *Life* features him in a pose that looks strikingly similar to Golden's CBS publicity photo.[44] In the *Life* photo, Pollock leans, with hands crossed and cigarette dangling from his mouth, before his *Number 9* (1948) "drip" painting that runs horizontally across the wall behind him. In fact, despite Pollock's more bohemian look, this photo might even be seen as the model for Golden's pose before his wall of eyes. Yet whatever the family resemblances, there were distinct differences between Golden and Pollock's sense of craft. Even if Golden and the abstract expressionists placed a common value on artisan labor, Golden viewed himself as a corporate craftsman working directly for his client (CBS), while the painters saw themselves as artists (in the Romantic sense) who dealt with the market primarily through agents, patrons, and galleries.

True to his vision, Golden established a tightly run craft shop that was housed within the CBS Madison Avenue office compound. CBS's craft shop model of production was different from the notoriously conformist-oriented "organization man" work worlds in most advertising agencies of the 1950s.[45] Rather than stifling creativity, CBS encouraged innovation, albeit within the confines of Golden's control. Compared to Walt Disney's plant (the prototype for mass-produced art), Golden's staff was small (a handful of staff artists and roughly thirty-nine employees). And unlike Disney animators who often conceived of themselves as "weekend artists" that just happened to work on Disney's production line for sustenance, Golden's small staff was composed of top specialists who had a guild mentality and variously expressed their pride in product.[46] The craft shop model also allowed Golden to attract major talent for commissioned artwork because it gave artists a good degree of autonomy within the overall CBS plan.

William Golden poses before his wall of eyes in the lobby of Television City. Photograph by Ezra Stoller (ca. 1953). Reprinted with permission of CBS.

Again, in contrast to the top-down Disney studios, Golden thought of CBS more as his customer than as his boss. He constantly struggled to maintain autonomy over design, and while the struggle did get harder over the years, he attributed his degree of success to the fact that he was able to avert interference from above. The ads, Golden said, "were for the most part kept clean and powerful because they were made with a consistent policy, by one department with the approval of one agency of management. They were never shown to anyone in advance of publication."[47] Corroborating this, vice president of CBS Television John Cowden said, "Bill flatly refused to submit art for approval to anyone."[48] In fact, Golden orchestrated each facet of production, selecting his own paper stock, typefaces, and, where possible, printing methods. Golden's art department even controlled the packing and shipping of promotional materials, ensuring that envelopes were well designed by, for example, doctoring inks in the CBS metering machine to make sure the color of "handle with care" harmonized with the package design. *Print* magazine referred to this remarkable orchestration of design elements as Golden's

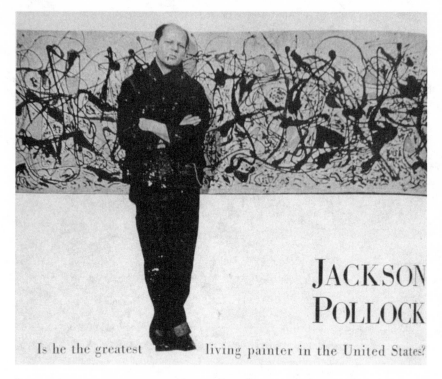

JACKSON
POLLOCK

Is he the greatest living painter in the United States?

"Jackson Pollock: Is He the Greatest Living Painter in the United States?" (*Life*, August 8, 1949). Copyright 1949 Life Inc. Text reprinted with permission. All rights reserved. Arnold Newman photograph of Pollack reprinted with permission of Getty Images.

"ensemble plan," a plan that *Print* said was predicated on an "almost fanatical concern for detail."[49]

Although weary of artistic modishness, Golden often commissioned artists who were identified with modern illustration and modern movements in the fine arts. His own designs often had surprise elements such as unusual spatial layouts or full-color inserts in business publications. While known for his originality, it is also clear that Golden developed techniques that his former boss M. F. Agha had innovated and that other top designers such as Paul Rand were using at the time (these included Agha's innovation of the double-page layout in *Vogue*, and general developments in graphic design such as the "big picture" layout, minimal advertising copy, the integration of typography into design elements, and the use of "white" empty space). Golden said his ads "were perhaps most successful for what they left out than for what they contained."[50] In this respect, Golden's aesthetic ideals were very much part

of what design critics such as Sparke and Maud Lavin have called modern design's "clean," "ordered" vision, an aesthetic that developed in prewar European design movements (especially the Bauhaus) and which Sparke, Lavin, and others have seen to be ideologically compatible with the corporate, technocratic, and paternalistic ideals of postwar Western mass societies.[51] Many designers at the time spoke of this "clean" and "ordered" design vision as being especially good for global expansion into international markets because of its direct visual impact and minimal use of words.

As the man behind the CBS eye, Golden was one of the chief architects of international branding. Although he created the eye as a national symbol, it has since become a global sign for CBS. Explaining its evolution in an essay titled "My Eye," Golden said that he modeled the trademark on a hex sign he saw while driving in the Pennsylvania Dutch country. The eye made its first appearance as an on-air station identification in October of 1951. Not coincidentally, this was also the year when CBS split its radio and television operations into two separate units. Paley and Stanton urged everyone at CBS to do everything they could to create two separate identities for radio and television.[52] The eye design was Golden's response to the mandate. Its function as a symbol, Golden explained, was "not only to differentiate us from the other television networks, but from our own radio station."[53] From this point of view, the CBS eye directly communicated the visual impact of the new medium. Moreover, it had the quintessential Tiffany touch: it communicated the idea of television with the utmost simplicity and clarity of form. To guard against monotony, Golden created a number of versions, including one that showed the eye superimposed over moving clouds, an image which looked very much like René Magritte's 1928 painting *Le Faux Miroir* (but which Golden never acknowledged as a source).[54] By 1960, *Television Age* called the eye "one of the most familiar trademarks in American Life."[55]

Not only was the eye a promotional tool for audiences and business clients, it helped create an identity for a CBS corporate culture in which camera operators, set designers, advertisers, secretaries, and virtually all workers were brought together under a single brand. The eye, in other words, encouraged the kind of guild loyalty CBS sought out more generally. By 1959, Golden's eye appeared on marquees, trucks, mobile units, cameras, theater curtains, and the exterior and interior of CBS studios. It was stenciled on the back of scenery flats and lighting equipment, and it also appeared on corporate paraphernalia including ashtrays, matchboxes, neckties, and cuff links of inlaid marble that executives often wore. It was featured in trade and consumer advertisements. It appeared on business reports, stationery, rate

cards, press releases, and booklets. Golden said, "Hardly a month goes by without someone suggesting a new use for it."[56] Doodles and photographs saved in Golden's papers suggest that Golden found his trademark a source of personal pride and even office fun. One photograph, apparently taken on his birthday, shows Golden sitting at his desk upon which are all sorts of eye paraphernalia, including a birthday cake decorated with a huge CBS eye.[57]

Even while the network television business had little in common with the early industrial culture of artisanship and guilds, the eye was still essential to the "imagined community" of CBS affiliates across the country. In an industry based on virtual connectivity between a centralized network business office and affiliate stations in far-off places, the CBS eye served as a major visual reminder of one's loyalty to the CBS brand. CBS sent promotional kits to affiliate stations filled with corporate art, including pre-prepared eye mock-ups promoting CBS shows so that station managers could easily use the trademark for their own local newspaper ads. The eye was in this sense a visual aid that CBS used to solidify its affiliate base at a time when securing contracts with affiliates was a primary goal for network success. By supplying affiliates with promotional kits filled with eye trademarks and other advertising and onscreen art, CBS hoped that its stations around the country would reflect the Tiffany vision.[58]

Nevertheless, CBS's attempt to bring good design to the locals was often fraught with battles over taste. Golden's urbane sophisticated designs didn't always appeal to local station managers and business clients around the country who were accustomed to using "cheesecake" art or the factual (ratings-heavy) styles for print advertising. Speaking of the CBS eye, Golden admitted that while he tried to keep affiliates from misusing and overusing the trademark, it was a "losing battle."[59] To overcome resistance to modern design and to combat the misuse of his artwork, Golden held meetings with affiliates in which the network art and sales departments tutored local station artists on the proper use of the materials in Golden's promotional kits. In this way, CBS tried to redirect the advertising vernacular of local stations toward its more sophisticated New York City tastes.

Despite his obvious knack for national branding and his willingness to carry out corporate mandates, Golden was loath to think himself as a mass media man. In fact, he expressed extreme dissatisfaction with the parts of his job that involved consumer advertising, which for him always brought up the problem of "buckeye" tastes. Golden viewed these aspects of the job as a nuisance imposed on him by the sales and program departments. In a report titled "The Background of Consumer Advertising," Golden lashed

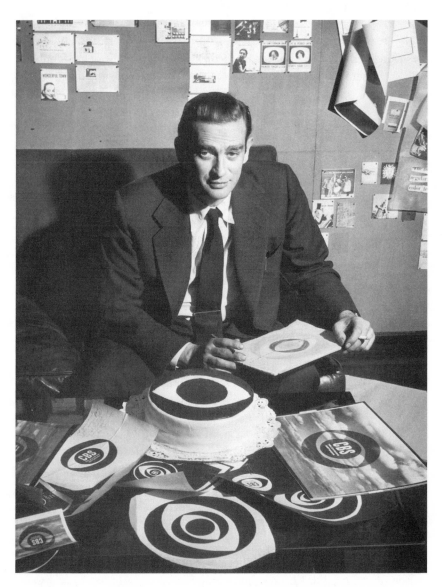

William Golden in his CBS office (ca. 1956). Reprinted with permission of CBS and photograph courtesy of the Wallace Library, Special Collections, Rochester Institute of Technology.

out at CBS's mass advertising for national publics, and he worried about the negative effects this had on the art department's quest for good design.[60] Nevertheless, by 1957 he admitted, "Consumer advertising absorbs an increasingly greater proportion of the television network's advertising effort," and he acknowledged that his job had become geared toward the mass public.[61] In fact, he said, "A truly effective nationwide advertising campaign in newspapers can easily cost more than the program itself."[62] Ironically, despite his antipathy toward consumer ads and mass tastes, Golden's modern designs had become their own form of mass entertainment.

MODERN ARTISTS FOR A
MODERN NETWORK

In 1951, the same year he launched the eye trademark, Golden created a print gallery of television art by commissioning well-known artists and illustrators to sketch CBS artwork for program advertising and promotional materials. This was a major departure from the dominant advertising strategy used by networks and local stations at the time. In the early 1950s, newspaper ads for television programs aimed at the general public were often either publicity photos of stars or else typeface print ads that looked like theater lobby cards or vaudeville bills. This strategy was fast and inexpensive, and it also complemented the more general theatrical analogies that surrounded television in the early period. At a time when young couples in urban areas were moving to mass-produced suburbs, many of the popular nighttime television programs provided audiences with an illusion of being at a downtown theater. Variety shows like Milton Berle's *Texaco Star Theater* (NBC) modeled themselves on vaudeville, complete with studio audiences and curtain calls, while the Broadway-influenced anthology dramas like *Goodyear Playhouse* (NBC) created an illusion of a night on the town by adapting Broadway material and showcasing stage actors. So, too, ads for television sets often used this "home theater" strategy, with slogans like "Private Theater TV," "Chairside Theater," and pictures of couples watching TV while dressed for a night on the town.[63]

Given this emphasis on live theater, many newspaper ads for television variety shows used the theater-bill format. For example, in February 1954 the *Chicago Tribune*'s TV page ran an ad for the *Colgate Comedy Hour* broadcast on WNBQ (NBC's flagship station in Chicago). The ad was literally a vaudeville bill hung on a brick wall (which appears to be the façade of a theater) with a janitor's bucket and broom leaning on it. ABC, NBC, and DuMont also created visual analogies to theater for their more prestigious anthology

dramas, by, for example, showing theater lobby cards with the title of the play and the actor credits. And in the early 1950s station ads for the evening line-ups often used the vaudeville theater-bill aesthetic of alternating type fonts to indicate the separate acts.

Although CBS featured many variety shows and anthology dramas that simulated theatrical experiences, its advertisements for these genres visually suggested something else entirely. As Golden claimed:

> Faced with the new fact of consumer advertising, we tried to consider it very carefully. . . . We tried to consider it as a new entity. We didn't think we should imitate the advertising of motion pictures or the theatre, because it was neither of these things. We knew very well that theatrical advertising was burdened with its own baggage and its obsolete traditions. We considered it an opportunity to make a new kind of advertising for a new medium.[64]

In distinction to the theater-bill advertising used by their competitors, CBS associated its programs with the world of fine art, haute couture, and gallery culture by hiring modern painters and fashion-magazine illustrators, some who (like Ben Shahn) were internationally renowned. By commissioning important artists and illustrators, Golden created a brand identity that instantly associated CBS with superior visual artistry. In 1951 Golden commissioned the successful French painter and portraitist René Robert (R. R.) Bouché, who was by then well known for his fashion illustrations that appeared in *Vogue*.[65] Starting with newscaster Edward R. Murrow in 1951 and continuing across the decade, Bouché sketched the network's top stars including Jack Benny, Burns and Allen, Red Skelton, Bing Crosby, Eve Arden, Mary Martin, Lucille Ball, Raymond Burr, and many more. Bouché's signature appeared on every sketch, and because all the sketches were done in the same style, they appeared to be an artist's series.

By the 1950s, the practice of using an artist's signature in advertising copy was a tried-and-true, if often debated, technique among art directors and their clients. Advertisers discussed the use of signatures in the trade press as early as 1917, when J. Walter Thompson president Stanley Resor decided not to include artist signatures on the grounds that they might detract from the ideas of the sales message and also elevate the status of the artist (and hence his price for the ad). So too, advertising executives feared that the more other advertisers used the same artists, the less originality and impact an illustration would have. In contrast, other advertisers and their clients felt that an artist's signature "lent prestige to the images, and less directly, to the product, especially when the signature was that of a leading illustrator."[66] By the

These ads for NBC and CBS appeared side by side in the *Chicago Tribune* (February 28, 1954). Next to NBC's "vaudeville" style ad, René Bouché's sketch strikes a more artful pose. Bouché sketch reprinted with permission of CBS.

1920s, clients like Texaco, Lux, and R. J. Reynolds all used advertisements with signed illustrations. According to Michelle Bogart, the signature debate during that period was part of a more general tension between a romantic view of art and a pragmatic business view of sales.[67] In the 1950s this debate persisted as advertisers battled over the hard sell vs. artistic approach.

Under Golden's direction the ads at CBS were based on a careful balance of the tensions involved. Bouché's lineage in both the fine art of French portraiture and the world of upscale women's fashion illustration made him the perfect balancing act between the romantic and business view of art. Insofar as advertisers knew that women either directly made or else influenced most of the household purchases, Golden's use of Bouché helped to target female

EDWARD R. MURROW, broadcasting's most respected reporter, brings a new dimension to television reporting today. In his new half-hour program "SEE IT NOW" you will see the exciting potential of television as a news gatherer. You will watch a scrupulously edited report of the week's significant events, some of it on film, some of it happening before your eyes. You will meet, face to face, kings and commoners, soldiers and scientists, politicos and plain people who are the masters—or the victims—of events that affect us all. From your own armchair, you will witness the world.
—today at 3:30 on the CBS Television Network WCBS-TV Channel 2

René Bouché, advertising portrait of Edward R. Murrow (1951). Reprinted with permission of CBS.

readers with class aspirations and to convince them that television would elevate their family's cultural pedigree. And because Bouché's ads were often aimed directly at advertisers themselves (for example, they were placed in trade papers like *Variety*), Golden's use of Bouché might well have spoken more to what advertisers thought would appeal to women than what women actually wanted. Whatever the case, the Bouché sketches turned popular TV stars into class acts.

Although many of the Bouché sketches advertised variety show stars that originated in vaudeville, in form and style the sketches had a modern, contemporary, fine-art sensibility. In line with Golden's view that ads should leave out more than they contained, Bouché's ads were simple line drawings

with elliptical sketch strokes that sometimes abstracted whole portions of the figure and often used the empty space of the layout to evoke form. Most importantly for CBS, the sketches captured not just the likeness of the star, but also the experience that a viewer might have while watching that star on TV. In this regard, unlike the standard publicity still, the sketches evoked television's ability to capture movement. Although not cartoons or caricatures, Bouché's sketches had an animated quality. He often drew stars engaged in a characteristic gesture (from smoking a cigar to performing a deadpan grin). In addition, Bouché's hurried-looking drawings and elliptical use of line made the sketches appear as if they were not quite finished, thus offering audiences the chance to participate by filling in the blanks. This quality fit well with advertising philosophies during the period, which stressed the importance of viewer identification and active involvement with the sales pitch.

The portrait of Jack Benny, first drawn in 1952, is a perfect example. Benny appears (torso and up) with his classic deadpan look while gazing sideways off frame. The sketch uses elliptical lines to outline the contours of the human form. The entire right side of the torso and parts of the face are indicated by the thinness or else entire absence of line. The greatest visual interest is directed—through the bolder, thicker strokes—toward Benny's folded hands at his waist (a classic Benny posture) as well as to his eyes, which are boldly drawn to capture his famous impish gleam. In other words, Bouché directed the reader's eye toward those body parts that Benny used to elicit laughter in a visual medium. Given the fact that Benny had for years been a radio performer, Bouché's choice to concentrate on the visual aspects of Benny's comedy was apt. The ad showed viewers what television would let them see that radio could not; it gave audiences a clear understanding of the experience they would have if they watched rather than listened to *The Jack Benny Show*.[68]

Over the years, Golden used a range of artists, assigning them to projects that complimented their talents and the genres/styles in which they worked. Known for his modern designs for jazz album covers, David Stone Martin illustrated ads for musical specials, and he also designed ads for comedies, westerns, and cop shows (these ads were detailed figural pen-and-ink drawings of scenes or stars, but Martin used modern techniques of distortion, exaggeration, and blotted lines).[69] Jan Ballet, a children's book illustrator who worked in the modern graphic style, illustrated ads for family-oriented fare like *Cinderella*, and both he and Leo Lionni made lighthearted trade ads. For photographic ads, Golden chose art photographers such as Strand, and his staff produced publicity photographs with unusual layouts that integrated

typeface into the design. For news programs, special events, and cultural programs, as well as for corporate brochures and reports, Golden especially drew on his wartime friends Shahn and Topolski.

Shahn developed a reputation as both a prominent painter and commercial artist in the 1930s and 1940s, and by 1947 *Look* named him one of America's "ten best artists." Moreover, as Britain's major graphic arts journal, *The Penrose Annual*, observed in 1959:

> Ben Shahn, perhaps, has had the strongest influence on the younger generation of graphic designers. The temptation to imitate his deceptively simple ragged line is irresistible. He is the best example of the modern universal artist. He does not lose prestige by lending his work to industry. He . . . has triumphantly bridged the gap between fine and applied art, not dissimilar to the universal artist-craftsman of the Renaissance.[70]

Even while he was one of the few painters of his day to admit to working for corporations, Shahn's work dealt with political subjects. In 1931–33 he painted a series of images titled *The Passion of Sacco and Vanzetti*, about the Italian anarchists who many believed had been framed for murder. During the New Deal, he worked with Diego Rivero and documented Depression Era poverty in photographs and paintings commissioned by the government. In a tribute to Golden, Shahn said he and Golden shared the "deepest agreement politically" and recalled that at CBS they worked together in "complete understanding and remarkable co-coordination." Moreover, Shahn shared Golden's antipathy toward abstract expressionism, particularly with regard to its abandonment of content. For Shahn, whose postwar work continued to focus on political and social issues, the human values of art were essential. Yet, despite his defense of content and figuration, Shahn embraced modern techniques of visual abstraction and, like Golden, he valued graphics that had clean design and immediate impact.

The corporate art Shahn made for CBS business clients tended to be the most abstract. His double-page trade ad "Harvest" (which was also used as cover art for a CBS business folder) juxtaposed nature and technology in a graphic metaphor that promoted the idea of CBS as a "bounty for profit-seeking advertisers." A black-and-white line illustration, one side of the layout presents a harvest of wheat stalks with crisscrossing stems bundled like wires and gently waving in the air. The other side shows a metaphorical harvest of television antennas and wires, also bundled together and crisscrossed through the airwaves. The copy reads, "Each year America's rooftops yield a new harvest—a vast aluminum garden spreading increasingly over the face

Each year America's rooftops yield a new harvest—a vast aluminum garden spreading increasingly over the face of the nation.

The past season produced a bumper crop on all counts: 3½ million new antennas bringing the total number of television homes to 34,567,000.

The average television family spent more time watching its screen than ever—5 hours and 20 minutes a day.

Day and night CBS Television broadcast the majority of the most popular programs and during the past season extended its popularity by enlarging the network to 209 stations—a 75% increase in a year.

Today CBS Television delivers more homes for less money than any other network, and in comparison with its closest competitor, offers an even better buy than it did a year ago.

CBS Television advertisers invested $165,268,000 over the past 12 months —a 20% greater investment than was made on any other network.

By demonstrating television's ability to move our expanding national product into the American home *most efficiently*, CBS Television has become the world's largest single advertising medium.

Harvest

THE CBS TELEVISION NETWORK

Ben Shahn, second page of double-page layout for "Harvest" (1955). Reprinted with permission of CBS.

of the nation. The past season produced a bumper crop on all counts: 3 1/2 million new antennas."

Shahn also illustrated advertisements for programs aimed at minority audiences—the class rather than mass audience that CBS often singled out for documentary, educational, and cultural programs. While figural, these illustrations were semi-abstract in design. A 1958 newspaper ad for "Fallout," a special episode of CBS's highly respected news program *See It Now*, is a good example. At the time that he made the ad, Shahn was interested in images of nuclear disaster. (His series "The Saga of the Lucky Dragon," named after the Japanese fishing boat dusted by lethal fallout after the 1954 U.S. H-bomb test in Bikini, would be mounted at the Downtown Gallery in 1961.) Placed in the Sunday TV listings in the New York, Chicago, and Los Angeles markets, the "Fallout" ad was an ink line drawing, rendered in Shahn's signature "ragged line" style. The sketch depicts two disembodied heads with eyes looking fearfully upwards, presumably at the sky (which is represented only by empty white space). Shahn draws attention to the frightened eyes and furrowed brows, which are much more thickly drawn than the other features. By emphasizing the upward gaze of the frightened eyes, Shahn also moves the

SEE IT NOW with Edward R. Murrow reports on the question troubling people all over the world—

FALLOUT

In Part II of "Atomic Timetable" a group of world famous scientists present their conclusions on the effects of atomic radiation caused by nuclear explosions today and for future generations. Don't fail to tune to the CBS Television Network today from 5 to 6:25 ⓧ CHANNEL 2

Ben Shahn, "Fallout" (1958). Reprinted with permission of CBS.

reader's eye up the page toward the empty sky. The visual terror of the people in the ad is thus transformed into visual terror for the reader. By directing the reader's gaze toward the empty sky (rather than, for example, showing what was by then the stereotypical image of a mushroom cloud), Shahn indirectly suggests that there are aspects of nuclear disaster that remain invisible, and so even more terrifying than audiences may imagine. The ad poses a visual question that can only be answered by watching *See It Now*. To find out what's up there, you must tune in. In this respect Shahn's sketch does double duty. It associates the program with a renowned artist, but it is also a perfect advertising vehicle because it promotes the act of TV spectatorship itself.

In addition to public affairs and news programs, Shahn illustrated promotional materials for quality dramas. The cover to a promotional booklet for CBS's 1959 production of *Hamlet* is composed of Shahn's ragged-line rendering of Hamlet's contemplative gesture (his head resting in the palm of his hand) that uses modern illustration techniques of distortion (an elongated

nose) to create a highly interpretive semi-abstract sketch. In that same year he designed a promotional kit and ad for a *Playhouse 90* adaptation of *For Whom the Bell Tolls* that featured screen and stage actors Jason Robards, Maureen Stapleton, and Eli Wallach. But rather than promote the stars in the tradition of theater and movie advertising, Shahn designed a portrait of Ernest Hemingway—a choice that suggests a concept of the reader/viewer as an intellectual (in other words, the person that the advertisement targets is someone who values authorship over celebrities). While figural and capturing Hemingway's likeness, Shahn's portrait is abstract in concept and execution. Unlike the *Hamlet* sketch, this portrait is highly "worked over," conveying Hemingway's tortured soul through thick brush strokes going in opposite directions. Whole portions of the face are nearly obliterated by blackness. Meanwhile, a thin line drawing of the ears creates a whimsical, if entirely counterintuitive, contrast to the dark mass of black strokes covering the face.[71] Although designed for corporate publicity, as with much of these materials, CBS also used the *Hamlet* and Hemingway sketches for consumer newspaper ads so that these drawings formed a "horizon of expectations" for audiences. In other words, Shahn's abstract sketches encouraged audiences to experience CBS quality dramas as a form of modern art.

Not only did Golden choose artists that fit with the program genre, he sought out artwork that complemented CBS's programming and sales strategies. This was particularly true when it came to promoting the network's greatest asset: live origination. As numerous broadcast historians have noted, access to the live feed was the networks' greatest source of power in the early period.[72] Unlike an individual broadcaster or a telefilm syndicator, a network could transmit programs simultaneously over long lines to multiple stations, and by 1951 the coaxial cable made it possible to transmit live programming nationally. This is one of the chief reasons that local broadcast stations found it useful to sign affiliate contracts with the networks. Networks provided their station affiliates with high-production-value live programs and they attracted advertisers to the stations because of their national reach. Meanwhile, to stave off competition from telefilm syndicators and program packagers, the networks constantly promoted their live TV shows as being better than filmed programming. But from a print advertiser's perspective, promoting "liveness" presented special challenges.

Capturing the live sensibility in a still sketch or photograph was a difficult task for an artist. Sketch art and photography typically have an aura of "pastness" about them insofar as they arrest and record a scene or person at a specific point in time. As with the case of Bouché, artists for television could

counteract these tendencies through techniques of illustration that high-lighted a performer's movements and engaged the reader in the ad through, for example, Bouché's use of elliptical unfinished lines that asked readers to actively fill in the absence (and therefore to imagine TV itself as a live and participatory event). While Bouché typically handled popular singers and comics, the genres of news and special events posed more extreme challenges because they were in essence about the "here and now." For these genres, Golden commissioned artists who were known for their unique ability to convey spontaneous action and kinetic motion.

For example, in 1953 Golden commissioned Topolski to render sketches for the broadcast of Queen Elizabeth's coronation.[73] The coronation was ex-tremely important to all three networks, not only because the public was interested in British royalty but also because of the way the event was trans-mitted. The event was filmed as it happened on a weekday morning and the footage was flown via jet to the U.S. and Canada for broadcast that evening. In other words, even while the networks did not have the technical where-withal to present the coronation live per se, they approximated liveness through rapid transport.[74] In fact, CBS and NBC raced to be the first to have the films on air, and each network set up a studio at the Boston airport so as not to waste a minute of time. For Golden, the question was how to promote a filmed event to capture the sense of liveness and the feeling of "immediacy," "simultaneity," and "being there" that the network hoped to convey through its race against time.

Topolski fulfilled a number of demands for the job. Not only was he living in Britain and a British subject at this time, in 1951 the British government commissioned him to paint the *Cavalcade of Commonwealth* (a 60 foot by 20 foot mural) for the Festival of Britain. Topolski's status as a renowned artist and his association with the Festival of Britain lent distinction to the CBS broadcast, while his London location made him an eyewitness corre-spondent, someone present at the scene with immediate live access to the event. Most importantly, Topolksi's draftsmanship style helped to promote a sense of liveness and "being there." Critics often commented on the vi-brancy and movement in Topolski's drawings.[75] His pen-ink-pencil wash sketches for CBS created this sense of vibrant motion through swirling forms of the queen in her horse-drawn carriage accompanied by British bobbies on horseback, all drawn to depict a sweeping vista of the event as it happened.[76] Paradoxically, in this sense, sketch art conveyed something a photograph of the Queen could not. Drawings served as a "convergence" medium that re-placed the past-tenseness of photography with a new sense of immediacy

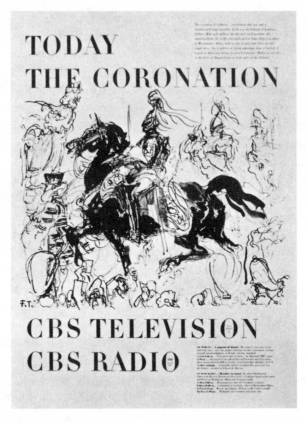

Feliks Topolski, "Today the Coronation" (1953). Reprinted with permission of CBS.

captured through the speed of live transmission—even when live TV was time-delayed. In this respect, Golden's art department allowed CBS to navigate the complex temporal and geographical problems inherent in international broadcast transmission and endemic to the modes of recording technology that the network chose to invest in at any one time.[77]

ON-SCREEN ART

As is obvious from these campaigns, even while Golden hired people like Bouché, Shahn, and Topolski primarily to appeal to business clients, over the years the corporate art was also disseminated widely to the broader American public. Increasingly, as Golden realized, he had "blundered into consumer advertising."[78] In addition to the newspaper ads, the promotional kits Golden

disseminated to affiliates across the country gave the public many occasions to see CBS art on screen. In 1957, Golden noted that in that year alone the art department supplied "33,600 copies of 168 promotion kits" containing "66,000 prints of 475 trailers" and "75,000 copies of 500 slides" to affiliates.[79] The CBS eye always popped up before and after programs, while promotional slides and trailers were broadcast on a regular basis. In addition, title cards, credits, and station-break art designed by the graphics art department (a separate unit from Golden's) imbued the CBS program schedule with modern sensibilities.

On-air title and promotional art is largely ignored by broadcast historians (in part because interstitial graphic materials were typically not preserved and original title sequences are often cut out of syndication packages). Yet by ignoring the fact that television programs were aired alongside modern graphic design, we also misunderstand what audiences of the 1950s and 1960s actually saw on their TV sets. Modern graphic design was a major part of the daily entertainment, and as such it helped establish aesthetic protocols for how audiences actually experienced the medium.

For example, the Bouché sketches often appeared at the beginning and/or end of promotional trailers for programs like *The Ed Sullivan Show*, *The Kate Smith Show*, *The Red Skelton Show*, and *The Jack Benny Show*. These sketches augmented the aura of "vaudeo-modernism" on the CBS evening lineup. Even if these programs were primarily revivals of vaudeville "schtick," circus, and/or radio transplants (featuring an olio lineup of acrobats, ventriloquists, torch singers, opera divas, pianists, vaudeville skits, and slapstick routines), the aura of modern graphic design revitalized the older entertainment forms with a sense of the new. For example, *The Jack Benny Show* typically began with the Bouché sketch, after which Benny did a humorous monologue that was followed by a series of skits, Benny playing his violin (badly), and commercials for JELL-O or Lucky Strike cigarettes. Although the monologue, skits, violin massacres, and advertising jingles were all throwbacks to his vaudeville persona and radio show, the new element of graphic design framed the program within a modern look. So, too, because Benny often delivered the monologue while standing in front of a curtain imprinted with multiple images of the CBS eye, home audiences had occasion to witness the trademark presented as an element of stage décor. In this sense, a program's radio/vaudevillian content was only one feature of what media theorist Nick Browne calls the "television supertext," a text composed not just of discrete programs, but of an entire flow of broadcast materials—promotions, ads, and other interstitial materials.[80] Conceived as such, the "supertext" of early

television was certainly not a simple throwback to old entertainment forms; rather, television provided a distinctly modern visual experience that repackaged old forms within the contours of modern design. In this way historical entertainment genres were given a modern sensibility with title art, trailers, and other promotional materials that accompanied the programs and greeted audiences on a daily basis.

Even daytime soap operas—one of the oldest broadcast genres—were presented through the rhetoric of modern graphic design. A CBS trailer for *The Edge of Night* shows a scene from the soap opera followed by title art that is an abstract rendering of a sunset composed of two large intersecting circles—one black, one white, and the intersecting area is gray. Similarly, the title art for the CBS soap opera *Search for Tomorrow* is an abstract collage design that features a maze (suggesting the "search" idea), while the title art for *The Secret Storm* has a large abstract key shape (evoking the secrets to be unlocked) and inside the key there is an image of a lightning storm (evoking the stormy romances on the show). In all of these cases, even while the programs themselves were radio transplants of one of the oldest broadcast forms, in keeping with CBS's design policy, the title art framed the soaps within the context of modern graphic design.

As the person in charge of on-air art, CBS graphic art director Georg Olden headed up a relatively small staff and commissioned talent, much as Golden did for the advertising and promotional art. Like many of his colleagues at CBS, Olden had worked as a graphic artist during World War II—in his case for the Office of Strategic Services (OSS) where he met other graphic artists, architects, and designers, including art director Will Burtin, architect Eero Saarinen, and Broadway set designer Jo Mielziner. In 1945, at the age of twenty-four, Olden joined the art department at CBS's New York station, WCBW.[81] During his fifteen years at the network, Olden made a significant impact on the field of graphic design, winning some twenty-five awards for his title and promotional art. Olden was also one of the first African Americans to hold an executive position at a television network. African American publications singled him out as a symbol of the new opportunities that television might hold for the race. Meanwhile, in his private life, Olden was a painter. A photograph of Olden reproduced in the African American magazine *Opportunity* shows him standing in his Bronx, New York, home, next to his television set and his painting of an African American face rendered in a semi-abstract style (and the caption points out that his paintings are "abstract").[82] For his commercial art at CBS, Olden adopted a whimsically abstract and minimalist style, very much in line with the Tiffany brand and the

Georg Olden poses in his Bronx, New York, home with his TV set and one of his own paintings (*Opportunity*, Summer 1947).

field of modern graphic art generally. In this sense, although African American leaders and journalists embraced Olden's inclusion at CBS, unlike his painting, his artwork for the network did not engage any particular African American subject matter or expressive style associated with African American modern art per se. (One rumor even had it that when he dropped the "e" in George, he did so to make his clients assume he was Scandinavian rather than African American.) To be sure, like his fellow artists at CBS, Olden was a corporate craftsman whose art spoke to the network's identity rather than his own.[83]

On a daily basis, Olden and his staff prepared title cards and station-break art for on-air use before and after programs and during station breaks. Titles were created in three formats: (1) "flips" (titles or credits presented on cards that were turned by hand off-camera); (2) "telops"(title or credit cards reduced in size and fed into a TV camera from a separate projection room); and (3) "crawl"(titling material that was done on a scroll and filmed to appear

in movement on the TV screen). Titling was produced much in the same way as film strips or slide art: a design was rendered on an illustration board, lettering was done on a separate cel overlaid on the image, and then the two were photographed as a unit. While styles of presentation varied for different programs, the graphic artists at NBC and ABC also designed on-air art and sent these materials to their affiliate stations.

Like Golden, Olden valued simple, clear, direct designs, and he said that a TV artist must show "impeccable taste."[84] Yet taste was difficult to achieve in the medium, especially in the early 1950s. As Olden noted in 1953, program producers and local station managers didn't always understand the value that top graphic artists brought to television. Consequently, in the early 1950s, producers and local stations were often unwilling to pay for expensive title art, preferring instead to run makeshift "supers" over live shots.[85] Not only did graphic designers have to battle this "get it on the cheap" mentality, they also had to deal with the limits of the medium itself. These included the compromised aspects of gray scale and color tones as well as problems with picture sharpness. Moreover, unlike print advertising, which could vary in size and shape, television graphic art was basically "static," demanding a 3:4 space ratio. Working with these limitations, Olden used "uncluttered" designs and "any modern type face," which he claimed were generally legible on screen. In other words, these technical limitations encouraged the use of abstract, clean design.[86]

In the 1950s, Olden was a leader in the "titling" field and designed much of the CBS on-screen art himself. Like Golden, he was interested in the relationship between image and type. He made clever use of typography in his title art for the western *Gunsmoke*, which was composed only of the program's title running diagonally across the layout. The *o* in "Gunsmoke" had a gunshot hole in it.[87] His design for *The Web* (a suspense/thriller) was a geometrically rendered spider's web with an abstract image of a man running through it (as if running through a maze) with the show's title integrated into the design. His title art for the sitcom *Private Secretary* cleverly mimics a typewriter, spelling out (in lowercase type) "private secretary" and "cbs television." But the words have numerous *x* marks on them to suggest typos. This visual gag also evokes the humor in store for audiences who watch the show.

According to CBS designer William Bunce, title art had to have "a good strong idea, which captures the essential feeling of the show" and "be pleasing or arresting to the eye of the viewer."[88] Explaining his method, Bunce took as his example the half-hour family drama, *Mama*, a nostalgic program (originally on radio) about a warm and intelligent Norwegian woman and

Georg Olden, title art for the CBS mystery series *The Web*
(1950). Reprinted with permission of CBS.

her family who live in turn-of-the-century New York. According to Bunce,
he captured the program's feminine "homey" feel by using hairpins as the
central "prop" to spell out the name of the show. Bunce arranged the hairpins
in a "quiet" and "sedate" manner to evoke the lead character's personality,
and he added a lace doily as a background to "soften" the design and "pin-
point the era for the TV audience."[89] Although Bunce didn't say so, his de-
sign resembled needlepoint, even while it was characteristic of CBS's modern
look. In fact, Bunce managed to evoke the homespun look of women's crafts
while at the same time effectively creating the clean, orderly, anti-decorative,
and manmade look of modern design. Even while the show evoked nostalgic
memories of turn-of-the-century America, as well as radio characters of the
past, the title art offered distinctly modern forms of visual pleasure.[90]

When viewed from a design perspective, modern graphics were especially
important to the aura of consumerism that television conveyed. Not only
did the title art rhyme with the abstract-style animation used by companies
like UPA, television on-screen art featured techniques in modern graphic
design that were also being used on product packages during the period. TV
shows came "wrapped" in a visual language that accompanied a whole array
of household product packages (many of which were being redesigned in the

1950s and 1960s). In fact, package designers spoke often of creating package art specifically for readability on the TV screen. In 1956, NBC graphic artist Edward Bennett claimed, "When manufacturers see their package on the TV set, in a living room atmosphere," they are often in "shock." *Art Direction* observed, "TV may cause many packages to be redesigned . . . not because of reproduction requirements, but because the manufacturer suddenly becomes aware of the esthetic weakness of the package. . . . As Leo Lionni might say, ugly packages are an invasion of one's esthetic privacy."[91] By 1964, the Package Designer's Council held a seminar devoted to the subject of television's effect on package design. Just as Golden, Olden, and other TV art directors valued the clean modern look, package designers and TV advertisers thought packages "should be simple, uncluttered, so as to be memorable. A package is an ad, but it's more like a billboard than a full-page in *Life*. Few words and striking design are needed."[92] Analyzing the overly detailed package art for Minute Maid orange juice, William Duffy, senior art director in charge of TV at McCann-Ericsson, said that busy packages were "not especially good for the shelf and certainly not the screen." Similarly he thought that the Silver Dust package was "loaded with advertising messages" so that "none of it reads with any impact" on TV. In contrast, Duffy praised packages that had been redesigned for television's 3:4 ratio. Borax was revised to have a "cleaner look"; Wheat Chex eliminated its "gook"; Golden Ladle spaghetti sauce "was cleaned up"; and Top Brass men's hairdressing, Lipton's tea, Pepsodent toothpaste, and Nabisco cookies all simplified their labels and adjusted their colors for impact on the small screen.[93]

The fact that all of these were everyday products aimed at and purchased primarily by housewives was not lost on the designers who carefully studied women's perception of package and product design. As Mary Beth Haralovich demonstrates, market researchers of the 1950s subjected housewives to all kinds of motivational, survey, and "depth" research to calculate, for example, how effectively a label on a shortening can might trigger a housewife's emotions or how well a detergent's "social image" might appeal to a housewife's class aspirations.[94] Researchers also considered the relationship between seeing a product on TV and then recognizing it at the store. The Perception Research Lab at the University of Chicago ran experiments testing visual perception of brands and retention of package art on TV. John Lanigan, vice president in charge of the commercial film company Video Tape Productions, Ltd., spoke about the need for packages to be simple not only so they registered clearly on TV, but also so that housewives could recall seeing the package when at the point of sale. "Women pushing shopping carts down

supermarket aisles are not unlike highway drivers—they must read, see, identify, recall in a matter of seconds." Consequently, "Few words and striking design are needed."[95]

In this respect, the clean modern designs used for television advertising and on-screen art had immediate ties to the visual experience of shopping for everyday things. Film theorist Anne Friedberg has argued that the conjuncture of early cinema and window shopping provided women with a mobile "flaneur's" gaze predicated on their increased access to the previously male-dominated public spaces of urban leisure and consumption, and to the cinema's depiction of far-off places previously inaccessible to the Victorian woman.[96] In a similar way, the conjuncture of early television and modern graphic design provided female spectators with a new form of *simulated flaneurie*, condensed down to the "telesecond" of TV product recognition and available, not through walking in the city, but rather through the conjoined experiences of watching TV and driving to (or through) the supermarket.[97] Whatever one's gender, the stylistic continuity between on-air title art and the modern designs used for package art created a continuous perceptual loop that made the act of watching TV and the act of buying products extremely compatible visual experiences. Certainly, this is what every advertiser hoped. Sponsors repeatedly spoke of television as a "visual environment" for their products and they continually debated the quality of the environment that TV provided. On-screen graphic design became central to this visual environment.

In this respect it is not surprising that NBC was just as aggressive as CBS in the art of title design and other on-air promotional materials. A 1954 report on the graphic art studios at NBC explained the painstaking printing processes and technical inventiveness needed to transmit printed materials electronically on a daily basis.[98] In the mid-1950s, when John J. Graham became NBC's art director for advertising and promotion, he developed design concepts that used animated images.[99] A cubist painter, Picasso devotee, and friend to Andy Warhol, Graham embraced simple abstract designs and also had an eye for color (his famous "in living color" Peacock logo is a prime example). Like his competitors at CBS, Graham thought that the ten-second title art used at station breaks had to have "clarity and simplicity." Assuming that audiences often moved around during breaks, Graham reckoned that moving images rather than still art would "stop them for a moment." In addition to the animated peacock, he and his staff produced compelling graphic film sequences composed of simple, often abstract, designs to capture attention. For example, for *The Dean Martin and Jerry Lewis Show*, NBC associate

art director Al Sherman created a sequence composed of three shots of the performers. But rather than clips of Dean and Jerry doing shtick, Sherman designed an abstract collage in which images of the stars were cut and pasted together so that the performers looked as if they were flying into and out of the frame in every direction. In this way, NBC depicted the variety show not as vaudeville but rather as a cutting edge experiment in film montage. Using similar techniques, Graham and other NBC artists created two or three shot montage sequences that had a modern, abstract look.[100]

Like print advertising, on-air television art at all three networks won professional awards. The professional recognition of television title art was part of the growing respect for the art of television commercials, which the ADC began to nominate for awards in 1948. In addition, during this same period the ADC presented awards for movie titles, record album covers, and poster art, a category especially advanced by Saul Bass whose compelling modern designs for Otto Preminger's films *Man with the Golden Arm* (1955) and *Anatomy of a Murder* (1959) as well as Alfred Hitchcock's *Vertigo* (1958) and *Psycho* (1960) were soon hanging in MoMA.[101] Within this arena of graphic design, television titling art had become a subfield of its own.[102] Encouraged by professional recognition as well as the jobs to be found, graphic designers defined the on-screen "brand" look of television networks and stations in years to come. Golden's successor at CBS, Lou Dorfsman (who had previously been the art director in the radio division), told the *New York Times* in 1964 that there was a conscious effort to bring good design to the screen. Echoing Golden, he claimed, "Simplicity and cleanliness are generic to good design. . . . On TV 30 seconds is a lot."[103] Even ABC, which had been the least involved in design in the 1950s, became design conscious. In 1964, ABC hired the renowned graphic designer Paul Rand to make its new trademark.[104] In fact, by the 1960s graphic art had become so important to the networks that *Print* claimed the quality of TV promotional kits and on-screen materials "often outshine the shows being promoted!"[105]

THE GOLDEN AGE OF WILLIAM GOLDEN

The centrality of modern design to early television demonstrates just how important TV was to the creation of a new visual culture born of the corporate ethos of postwar consumer society. From its inception, television was a medium through which design, fine art, commerce, and popular entertainment all converged. Although the Tiffany network was the leader in the field, elements of modern design could be seen on all three networks. By the 1960s there was nothing short of a design explosion around TV. Nevertheless,

the television industry of the 1960s was different from the one Golden first encountered when he first took his post as director of creative design and promotions for CBS Television in 1951. Golden's sudden death in 1959 coincided with transitions in program production, network-advertiser relations, and commercial design that made the Golden years at CBS both strongly influential of things to come yet at the same time a unique moment onto itself.

By the mid-1950s, major Hollywood movie studios operated television subsidiaries, while independent telefilm companies like Lucille Ball and Desi Arnaz's Desilu were also flourishing in Los Angeles. Many East Coast critics denounced the move to Hollywood as the end of a golden age of New York–produced live dramas and news shows like *See It Now*. They feared the onslaught of cheaply filmed genre shows (sitcoms, westerns, cop shows, etc.) that in their view were examples of television's ultimate bow to crass commercialism. This transition to Hollywood film production also marked the end of Golden's golden age at CBS, and he himself noted it with acrimony.

In his report, "The Background of Consumer Advertising," Golden attacked the Hollywood studios for initiating new contract systems with talent that in turn put new demands on the art department. These studio contracts gave increasing power to stars and their agents, who wanted celebrities' names plastered all over publicity materials. Golden thought these contractual agreements would invariably lead him down the path he had successfully avoided—theater advertising. To Golden, a star's name was superfluous detail cluttering up his clean, modern designs. As he wrote in 1956:

The beginning of bad consumer advertising [started] about two years ago [when] an advance ad for a proof was inadvertently shown to a producer's agent. He found to his dismay that our ad did not live up to the producer's private contractual commitments to the cast, which specified the size and position of each picture and name. On an appeal to the 20th floor we were overruled in the interest of talent relations, and the ad was run to satisfy his contract (not ours). The advertisement satisfied only a contractual commitment. It benefited neither the program, the stars, nor the interests of CBS Television. This was just the beginning of the steady deterioration of our advertising. This corruption came into full flower when 'Ford Star Jubilee' and other Hollywood originated shows began to make billing demands, and when for the first time in broadcasting, contracts for talent contained billing commitments. Presently there began to appear in our offices a standard form prepared by Business Affairs containing all billing requirements.[106]

Resenting interference from Hollywood producers and agents, Golden concluded, "We have inherited all the obstacles to advertising that plagued the advertising of Broadway and Hollywood. . . . I suggest that it is time to cut through this nonsense by returning complete responsibility for advertising to the advertising department."[107]

Clearly, Golden wanted to protect his craft shop model of production in which artists had more immediate control over their products. Nevertheless, the forces of mass media and "by committee" production were taking hold.[108] While CBS Television continued to have its own art department in the 1960s, and while it was still known as the Tiffany Network, the emergence of Hollywood television did have an impact on the way art was made at CBS. For example, in a telling departure from Golden's anti-theatrical stance, for the 1962–63 season CBS art director Dorfsman hired renowned Broadway and movie sketch artist/publicist Al Hirschfield to make an ad campaign for the fall season featuring caricatures of the CBS star-studded lineup.[109] Although Dorfsman dedicated himself to the good design imperatives consistent with Golden, the corporate atmosphere in which he worked had changed. In 1964, CBS restructured its approach to advertising by having one central art department oversee the art departments in each of its corporate divisions.[110] This meant that the art director in the Television Division had to answer to a higher power, something Golden would have detested. Olden left the network in 1960 to become TV group art supervisor at BBDO (where he would "dream up ideas for commercials"), but he admitted that while he never had to seek approval for designs at CBS, at the advertising firm his ads had to be authorized by clients.[111]

Technological changes, such as the transition to videotape, the use of color film, and "Chromo Key" special effects changed the look of on-air art, while the increasing use of photography over sketch art in advertising had an impact on the visual look of all three networks (in the 1960s, newspaper ads for CBS tended to be big-picture photographs of stars or scenes from programs). Finally, changing modes of sponsorship (from single sponsors to participation purchases of sixty-minute or even shorter spots) created different power dynamics among the programming, sales, and art departments. Because sponsors no longer typically produced single shows (such as the *Texaco Star Theater* or *Goodyear Playhouse*), they worried that audiences would not recognize their brand names. In an attempt to combat this problem (and to achieve the kind of brand identification it had enjoyed in the 1950s with *I Love Lucy*), in 1964 the Philip Morris Company hired portrait artist Alfred C. Chadbourn (an instructor at the Famous Artists School, which was known

for its "You Can Draw Binky" mail-order courses) to paint publicity portraits of such CBS headliners as Red Skelton, Raymond Burr (of *Perry Mason*), and the entire cast of *Gilligan's Island*. *Sponsor* claimed the campaign was "part of a legitimate fine arts project," noting Chadbourn had "worked with the greats, like Henri Matisse, Antoni Clave and Georges Braque." Whatever its merits, the idea of farming out art to a sponsor (and no less one that employed the disreputable Famous Artists School) would have been anathema to Golden.[112]

Despite all these corporate and technological changes, the field of television graphic design that Golden, Olden, and the commissioned artists at CBS spearheaded grew to be a major part of television program and commercial production in the 1960s. As I discuss in chapter 6, the 1960s "creative revolution" at advertising agencies emphasized the importance of the art director and modern graphic design both in commercials and in television promotional materials. By the 1960s, local television stations also placed increased focus on the corporate image and visual design. As *Print* observed in 1965, television stations around the country were recognizing the value of "clean" graphic design for station promotions and on-air art—a lesson that, as *Print* acknowledged, CBS had taught them all.[113]

The CBS art department of the 1950s demonstrated that modern design would lend prestige to a mass medium and to corporations more generally. It also proved the simple fact that television was itself a modern visual medium, not just a record of stage plays, vaudeville, and radio. The design ethos at CBS Television took shape at a historical moment when the fine arts, advertising, and design were repositioning themselves and finding new ways to merge and prosper. As Paul Strand's 1948 photograph implied, the new electronic landscape of television was a key site for these mergers. Yet, as the case of CBS suggests, the artisan culture of graphic designers did not entirely conform to the mass culture imperatives of the new consumer society. Despite Golden's contribution to the corporatization of culture, the process by which this took place was rife with contradiction and even resistance to mass art. Meanwhile, in their contribution to the creation of a new media form, graphic artists packaged television in a distinctly modern look. It was here that audiences saw not just familiar forms of the past, but also visual innovations in modern graphic art. Even if art served the purpose of the market, CBS promised its first publics that they too could have an eye for design if only they watched TV.

3

••• SETTING THE STAGE AT TELEVISION CITY

Modern Architecture, TV Studios,
and Set Design

> Facilities like Television City will help immeasurably I'm sure in making this
> medium one of the greatest mass communication tools we have ever known.
> I believe that CBS television is to be congratulated for its vision and its courage.
> —EARL WARREN, GOVERNOR OF THE STATE OF CALIFORNIA, 1952

Located on a twenty-five-acre lot in the Fairfax district of Los Angeles, CBS
Television City looks rather unremarkable by today's standards. The sprawl-
ing studio complex, which was completed by 1953, contains none of the retro
glamour of Paramount Studios just blocks away, nor does it project the ro-
mantic dishevelment of Hollywood and Vine. In fact, despite its enormous
size, Television City is easy to miss.

But if contemporary eyes stare blankly at the huge black-and-white el-
ephant on the corner of Beverly and Fairfax, in the early 1950s this was not
the case. Designed to be a state-of-the-art facility for television production,
Television City was the material embodiment of CBS's stunning future, and
both governor Earl Warren and Los Angeles mayor Fletcher Bowran wel-
comed the complex with futuristic fervor. In 1954, the American Institute of
Architects (AIA) awarded the firm of William Pereira and Charles Luckman
a merit award in the category of "cultural" buildings for their achievement.[1]
Even if Television City did not pan out exactly how CBS and its early enthu-
siasts expected, this "made-for-TV" city reveals just how important modern
architecture was to network executives at the time.

In *Making the Modern*, Terry Smith argues that the success of Ford Mo-
tors in the 1920s and 1930s was achieved not only through its assembly line

production process and surveillance over workers, but also through the use of modern architectural design to create a cutting-edge, progressive look for the factory and corporation more generally.[2] This insight is just as applicable to the architectural designs used by media networks. In fact, like the car company, both NBC and CBS invested in modern architecture as a means to bolster their corporate image.[3] In 1938, NBC followed up its Radio City building (1933) in New York's Rockefeller Center with a Hollywood Radio City designed in the modern International Style with a streamlined look. NBC publicity called the building "A Modern Plant for a Modern Institution" and especially boasted of the studio's "highly functional" and "progressive" character.[4] A few years earlier, in 1935, CBS commissioned industrial designer Norman Bel Geddes, who drafted plans for huge CBS entertainment centers (embedding radio studios in performing and visual arts facilities, athletic fields, restaurants, and gardens).[5] Although Bel Geddes's dream never materialized, CBS hired the Swiss émigré architect William Lescaze (who was by then one of the leading practitioners of modern architecture and design in the U.S.) to build its Hollywood Columbia Square location.[6] Completed a few months prior to the NBC studio, it too was designed in the modern International Style with streamline motifs, ribbon windows, and a large glass façade. When Columbia Square opened on April 30, 1938, CBS presented a star-studded broadcast "A Salute to Columbia Square" featuring Bob Hope, Al Jolson, and Cecil B. DeMille.[7] On that program, Jolson joked that Columbia Square "looks like Flash Gordon's bathroom." CBS Television City was the culmination of these earlier plans for studios modeled on modern design. Built at a time when the U.S. was becoming a world center for architectural innovation and experimentation (if not necessarily avant-gardism per se), Television City expressed the goals of progress and prosperity through corporate modernism—a perfect parallel to CBS's vision for graphic design.

Indeed, Television City was more than a practical solution to the business of producing television programs. Its design and conception gave CBS a distinctly modern look that added to the network's Tiffany status. This modern look not only defined the building itself; it also translated into high-tech stages and technical excellence for programs that were viewed by the national audience. In other words, Television City was intended to give CBS programs a unique look and feel much in the way that Hollywood movie studios prided themselves on their studio styles. In this respect, modern architectural design was a business strategy, a tool for building corporate success via product differentiation.

CBS was not alone in its efforts to build a state-of-the-art television studio. Instead, in the late 1940s and through the 1950s, "television city" was a generic term used by a number of television outlets that wanted to build cutting-edge production facilities. As the longtime competitor to CBS, NBC also invested considerable sums of money and technical know-how to erect its own production facilities in Burbank, California. However, just as with graphic design, CBS was the frontrunner in the race. As the *New York Times* reported in late 1952, CBS was not only the first to open "the video temples of Hollywood," Television City was the most "spectacular" in scope, making it the model for the "new homes of revolutionary design."[8] With Television City, CBS transformed the business of network television from an abstract conglomeration of signals and wires into a physical place of high-tech stages and star-studded glamour that sponsors and audiences recognized as a distinctly new media site.

"WORKING IN A CLOSET"

At the most practical level, Television City was a solution to the widespread problem of studio space. In fact, space was a number one concern for everyone involved in early television, and the lack of it affected the number and quality of programs any one company could produce. Reviewing the space shortage and its disastrous effects on programs, *New York Times* critic Jack Gould declared that New York City television producers were "working in a closet."[9]

Even before television took off as a commercially viable medium, studio space posed a major dilemma for radio networks experimenting with television production. Members of the American Television Society (ATS), a professional organization composed of entertainment industry executives and creative talent, spoke at their monthly New York City meetings about the challenges of television production, including studio space and stage design. In March of 1946, when ATS hosted a special luncheon on the subject of television scenic design, CBS artist James McNaughon (who did the stagecraft for one of the first acclaimed experimental dramas, *Susan and God*) told ATS members that a television art director "must be ingenious enough to achieve results comparable to the stage and motion pictures in very limited areas and at only a fraction of the cost."[10] By 1948, when network primetime schedules began in earnest, studio space was a must for the major networks, which produced many of their own nighttime programs.[11] To solve the space shortage, ABC, CBS, NBC, DuMont, and independent television outlets began to acquire (via outright ownership or lease arrangements) theaters, concert

CBS Television City. Photograph by Ezra Stoller (1953). Reprinted by permission of Esto.

halls, hotel ballrooms, music arenas, skating rinks, and even a Coca-Cola bottling plant.[12] But studio size was not just a practical need; it was also a sign of prestige. In 1948 Stanton bragged about CBS's plans to erect two huge studios in the Grand Central Terminal Building, and in 1950, when CBS leased and remodeled New York's Town Theater and Peace House auditorium, network executives boasted that CBS now had larger television operating stages than any other network.[13] According to CBS director of research Oscar Katz, studio space and good programming went hand in hand so that a network had to consider "building in two directions"—both the literal architecture of studio construction and "the architecture in building high audience appeal" through "program construction."[14]

Insofar as television took off at speeds the industry did not predict, the need to create modern studios with quality facilities grew ever more profound. In his 1952 book *Designing for TV*, NBC's Robert J. Wade confessed, "Today most sound stages used in live television are inadequate."[15] Describing the typical studio production, Wade said that television sound stages normally had "flat-floor areas 1,500 to 10,000 square feet" and used three or four cameras. Explaining the compromises art and stage directors had to make on these small stages, he observed, "Scenes are played out at any point in the studio accessible to cameras, and settings are usually arranged around the outer periphery as close to walls as possible in order to provide sufficient room in the central areas for camera and microphone boom movement."[16] The standard use of "three folds" (a series of three scenery flats attached to each other) added to the space crunch because they were "cumbersome and rigid" and

A typical set design for dramatic programming at NBC (ca. 1954).

"cluttered up the stage."[17] The sponsor's pitch—often done live—also took up precious space.[18]

Moreover, shooting in sequence for live production further restricted the freedom that art and stage directors had in the already cramped studio spaces. And, because network executives and talent (especially comedians) thought that the presence of a studio audience created a sense of spontaneity and immediacy, they often demanded that the cramped studio spaces include room for auditorium seating. Scenic designer David Ffolkes observed that the presence of studio audiences meant that designers "had to work with the knowledge that all of the stage is in the studio audience's view. Instead of being able to put all of one's small settings on the stage at the same time in order of their sequence, switching the camera quickly and efficiently from one to another when the scene changes are required, one is forced to employ a complicated system of travelers" for transitions.[19] In essence, the cramped sound stages for early television production contributed to the static proscenium feel that many art directors found disappointing.

Faced with such challenges, art and stage directors developed a multitude of visual tricks (many already used in cinema) to achieve depth of field and an illusion of spaciousness. A room could be made to look deeper or objects closer by using forced perspective (for example, a camera operator could exaggerate camera distance or use a short lens).[20] NBC staff designer Otis Riggs

recommended that an impression of spaciousness could be made by scaling scenery down in size or "carefully diminishing the room's over-all proportions."[21] To deal with cramped stages, scenic designers also fashioned trompe l'oeil and convertible sets. For example, William Molyneux, the scenic designer for NBC's *Voice of Firestone* (which was shot on one of the largest stages of its time) noted "Even the Center Theatre stage in New York can be crowded at times. . . . We had a boudoir scene so large that there was no room for a separate scene for a Travel Bureau that was to follow later. So, we painted the Travel Bureau on the back of the flats for the boudoir, merely reversing them when the song in the boudoir was finished."[22] Set designers also created an illusion of space by using "gobos" (20 inch by 30 inch cards) that served as masks with the center cut out so that a camera could shoot though them. For instance, a gobo might represent an arch behind which was the interior of a church. By having the camera dolly through the gobo/arch, realism and depth of field was attained. Curved cycloramas as well as wallpaper, photo enlargements, "mural-drops," and rear-screen projection were also popular.

In addition to using visual tricks to create a sense of spaciousness, early television producers tried to combat the static, cramped proscenium feel of reconverted theaters through camera mobility. In fact, camera mobility was the reigning aesthetic choice of the time. As early as 1946, a report on the CBS experimental television station noted, "The artistic quality of the television picture is dependent on the skill of the dolly technician to move his camera and cameraman in and of the action."[23] *Studio One*'s production of *Julius Caesar* (CBS, 1949) was especially groundbreaking in this regard. The teleplay broke away from the static proscenium arch to feature mobile cameras and fluidly choreographed scenes with parading soldiers and swarming mobs. Jack Gould of the *New York Times* praised the "fluid direction" and "vitality that lifted television to the status of a glorious art."[24] After the success of *Julius Caesar*, many top-flight stage designers and directors began to internalize the need for mobility as a commonsense working assumption. Noting, "Space in television is always at a premium," *Voice of Firestone*'s William Molyneux said, "Fundamental to all set-planning is the consideration of the camera's freedom to move into the action. Otherwise the effect is static. In TV the camera moves as though it were another character."[25] Similarly, award-winning set designer Jan Scott observed, "One of the most important characteristics of the art of television is movement—mobility of cameras in and around, even through, objects. . . . It is this quality of camera movement that makes designing for TV so very different from being in the theatre [where] . . . you see everything from one fixed angle."[26]

Nevertheless, achieving mobility was a tricky affair because the lack of wide spaces and the screen size placed limits on motion. This meant that techniques different from those used in theater needed to be applied. Speaking of the "economy of space" in television staging, *Theater Arts* critic Charles Adams recommended that because actors' movements across the small stages were limited, to achieve "fluidity of motion" the director had to move actors on a "depth basis"—"toward and away from the camera" and should also strive for "continual movement of the camera itself—dollying in and out, booming up and down."[27] ABC cameraman Myron Freedman boasted of his network's Houston camera crane that allowed for sixty-foot dolly cameras and other extensive camera movements in musical shows. *Art News* praised James McNaughton (who was now art director at ABC) for "creating a new art of décor" by moving away from a single-plane conception of set design borrowed from "easel painters" toward sets rigged up on dollies that "can be wheeled around" for "fluid" action on the small television stages.[28]

Solutions to achieving the twin aesthetic ideals of spaciousness and mobility varied. Taking the most economical approach to the space problem, NBC television director Norman McCleery introduced "Television in the Round," which used arena style seating and no (or minimal) backgrounds. His first NBC arena production of *Romeo and Juliet* (1949) made extensive use of extreme close-ups and included none of the conventional scenery.[29] "We must break away from the tyranny of the proscenium arch," he insisted. "It's idiotic for directors to think in terms of little boxes." In addition to his aesthetic minimalism and anti-realist stance, McCleery admitted that television in the round was also a cost-saving concept, requiring no "high priced [scenic] designers" and bypassing the theater monopoly of "the Shubert's and the real estate interests who own the legitimate houses in New York."[30] While McCleery represented the limit case of cost-saving minimalism, many stage directors and scenic designers agreed that small casts and uncluttered sets were ideal for television. Throughout the 1950s award-winning television plays such as *Philco TV Playhouse*'s "Marty" (NBC, 1953) used "slice of life" stories that played "tight" rather than "wide." Yet, even when choosing to go "small," television directors and designers still often tried to achieve the ideals of spaciousness and movement so valued at the time. Anthology dramas often required rapid transitions, camera mobility, intricate blocking, and numerous sets. Extant scenic designs and technical charts in the NBC Records show that by the mid-1950s the prestige anthology dramas like *Armstrong Circle Theatre* and *Kraft Television Theatre* routinely used 5–10 sets, with additional space needed for dollies, Houston camera cranes, and rear-

screen projection—all of which ideally enhanced the sense of mobility and spaciousness.[31]

Some producers even attempted elaborate spectacles. For example, in 1951 NBC's Fred Coe produced "The Great Escape" (an episode of the *Philco TV Playhouse*), which "involved as much preparation, scenery-wise, as a Broadway play." Set designer Otis Riggs built a barracks room ten feet above the studio floor and NBC supplied 1,000 cubit feet of supporting platforms for the sets, props, and cast.[32] Remarking on this and other such programs, TV station consultant Bert Gold asked, "How lavish will TV studio production get?"[33] Apparently, Gold had spotted a trend. By 1952, NBC's Sylvester "Pat" Weaver began to plan his television "spectaculars" (star-studded live plays aired "in living color" with RCA's new color system). CBS responded with "extravaganzas" of equal scope. These productions demanded large stage areas, increased variation in camera set-ups, more mobility of action, rapid set changes, and color-keyed lighting, all of which required additional studio space.[34]

More generally, as television matured, the preference for spaciousness and mobility, coupled with technical innovations (such as color), required expansive studios that could accommodate the unique demands of producing for the small screen. In the early 1950s, these studios were about to materialize. As Wade noted in *Designing for TV*, "Vast, efficiently articulated, spacious television cities for New York, Hollywood and possibly other production centers are no longer mere dreams of the future—architects and engineers are beginning to sharpen their pencils in earnest."[35]

CBS TELEVISION CITY . . . IN HOLLYWOOD

In 1948 the *New York Times* observed that TV production was going west. "The Hollywood prophets insist, when coast to coast networks are in operation, there is little doubt that this area will be furnishing a major portion of the programs." The availability of stars and equipment, the warm climate for the live broadcasting of outdoor events, and "more space for building television studios" all made Los Angeles a big draw.[36] Moreover, the Supreme Court's "Paramount Decree" of 1948, which divested the major movie studios of their theater chains, effectively ended vertical integration in the movie business and so drastically changed the economy of motion-picture production. To achieve economies of scale, the once-grand studios downsized by shedding themselves of studio lots and other motion-picture assets (such as star contracts). The timing could not be better for broadcast executives who needed talent, technicians, and land.

In fact, at the same time that many of the major film studios were beginning to rent out, scale down, or sell off lots, the television networks envisioned building huge television studios. At the March 1948 ATS meeting Stanton announced CBS's plans to build "the largest television studio plant in the United States" and he added, "I guess that means the world." One year later NBC president Niles Trammel boasted of his network's scheme to build a television center in Chicago, and at the same time, NBC also began to speculate for land in Hollywood.[37] It was, however, the fledging ABC network which took the first leap when, in 1948, it purchased the 20-acre Vitagraph property in Hollywood from Warner Brothers (which included two sound stages and which ABC claimed would be the "most modern [TV studio] on the west coast" after renovations).[38] At this time, ABC trailed the other networks in audience size and advertising revenue, and when compared to NBC and CBS it had very few affiliate stations around the country, making live transmission impossible in most locations.[39] Given that they could not compete in the area of "live from Broadway" production, ABC executives saw the purchase of the Vitagraph lot as a way to cultivate relations with the motion-picture industry and star talent.[40] The "ABC Television Center" opened for business in 1949. Two years later, in 1951 when United Paramount Theatres announced plans to acquire ABC, the Hollywood location made even more sense from a business perspective. Yet, despite the corporate logic, ABC Television Center was essentially two converted movie stages, and its operating capacity at the time did not amount to the revolutionary goals of a "television city" designed ground-up specifically with TV in mind.[41]

In contrast, CBS's Television City was a vast undertaking, both in terms of expenditure and in terms of conceptual design. In 1950, CBS acquired fifteen acres of land occupied by Gillman Stadium, a sports field in the Fairfax district of Los Angeles located next to the Farmers Market, one of the city's major tourist sites. The network subsequently bought additional parcels of adjacent land, giving it room to expand on a twenty-five-acre lot. As was typically the case with CBS design ventures, Paley and Stanton justified the expense not simply on the basis of practical needs for television production, but even more so because they thought the studio would serve as a marketing tool that would further promote CBS's status as a quality operation and an arbiter of progress. In a press release CBS claimed Television City would "Take advantage of all foreseeable future trends in designs and techniques."[42] To design their "city," Paley and Stanton hired the newly formed architecture firm of Pereira and Luckman Associates.

William C. Pereira and Charles Luckman were the ideal men for the job.

Graduates of the University of Illinois School of Architecture, each had backgrounds complementary to the goals of a media corporation. Pereira designed the Armour and Company exhibit building at the 1931 Chicago World's Fair, after which he opened his own firm and designed theaters for the Paramount-controlled movie-theater chain Balaban and Katz. Hired by Paramount Studios in 1938 to design a studio, Pereira so impressed his bosses that Paramount made him chief art director. In 1942 he received an Oscar for special effects for Cecille B. DeMille's *Reap the Wild Wind*.[43] In 1948, when Pereira was teaching at the University of Southern California's School of Architecture, CBS hired him to survey existing movie studios and to determine whether one could be converted for television production.[44] But Pereira found that television required different working protocols than did movies, particularly because of the amount of programs needed and the speed at which they had to be made. Rather than converting a movie lot, Pereira instructed CBS that the best way to proceed was to build from the ground up.

Luckman was an advertising man and business mogul. After earning his degree in architecture in 1931, he took a job as a draftsman in the advertising department of the Colgate-Palmolive-Peet Company. By 1943 he had become president of the Pepsodent Company (maker of toothpaste). One year later, the British-controlled soap and margarine empire, Unilever Ltd. (known in the states as Lever Brothers), acquired Pepsodent, and Luckman became Lever's president in 1946. By this point Luckman was so revered in business circles that *Time* magazine ran a cover story on him, dubbing him the "jet-propelled boy wonder of U.S. sales promotion."[45] Not only was he a business maverick, during his tenure at Pepsodent and Lever Brothers Luckman became fully versed in the protocols of broadcast advertising. In fact, both companies were major radio advertisers with hit CBS shows like *Amos 'n' Andy* and *My Friend Irma*. It was in this context that Luckman first met Paley, with whom he claimed to have "negotiated and squabbled many times" over sponsorship time slots on the network.[46]

While president at Lever Brothers, Luckman also rekindled his original interest in architecture, and significantly in relation to his work for CBS, he especially promoted the construction of a uniquely modern American style. In the late 1940s, he commissioned and worked extensively with the architects who designed the Lever House building, one of the first glass skyscrapers to be built in Manhattan, and often noted as a hallmark of modern design. In his memoirs, Luckman recalls that he told the architects to make the building look completely different from London's classically designed Unilever

House (a massive granite convex structure, complete with Ionic columns and a statue of Queen Victoria, symbol of the Empire, out in front). "Let's design a building with materials that emphasize the most modern American technology," Luckman told the architects. "Lever House should be unmistakably *American*."[47] In 1949, after a battle with Lever Brothers' London management, Luckman resigned his post as president of Lever Brothers, and in 1950 he started a practice with Pereira in Los Angeles. His penchant for a new vernacular form of American modern design would be fully expressed in the firm's many projects, especially Television City.

During their partnership (which lasted until 1958), Pereira and Luckman designed an extraordinary wide range of commercial, business, entertainment, transportation, educational, cultural, civic, and military structures, including Robinson's department store in Beverly Hills (1951); the Hilton Hotel headquarters in Beverly Hills (1952); the Camp Pendleton master plan (1954); Bullock's Fashion Square Mall in Santa Ana (1958); the Los Angeles International Airport master plan (1958), the Disneyland Hotel (1958); and the IBM headquarters in Los Angeles (1958). When they parted ways, they each went on to design major projects. Luckman's projects included the NASA Manned Spacecraft Center (aka the Lyndon B. Johnson Space Center, 1961); the U.S. pavilion at the 1964–65 New York World's Fair; the renovated Madison Square Garden (1968); the original Los Angeles Convention Center (1972); and Hawaii's Aloha Stadium (1975). Pereira's designs "dominated the look of Los Angeles for 30 years," spanning such projects as the Los Angeles County Zoo (1959); the Lockheed Aircraft Corporation master plan (1959); the University of Southern California master plan (1960); the Orange County Airport (1960); the master plan for Irvine Ranch (1961); the theme building for the Los Angeles County Airport (1961); the Los Angeles County Museum of Art (1964); and the Los Angeles International Airport master plan (1967).[48] In short, Pereira and Luckman were central to the look of modern office buildings, military bases, transportation centers, college campuses, shopping centers, fairs, theme parks, stadiums, hotels, factories, and communication and entertainment complexes in the first two decades following World War II. Television City expressed different aspects of all these venues. In particular, it combined the regimented efficiency of postwar American modern design with a form that not only expressed its function but also promoted the CBS brand. Given their respective backgrounds in the film and soap/advertising industries, and given their previous connections with Paley, Pereira and Luckman were especially tuned into the needs of a major television network.[49]

Although Television City had something in common with the old Hollywood movie studios, Pereira and Luckman did not primarily model it on the movie lot concept.[50] Certainly, a television network required a different capacity for production than a film studio because it had to fill the airwaves with programming on a daily basis. CBS estimated that Television City was capable of turning out about twenty-eight hours of live programming a week.[51] According to one reporter, this meant that CBS could make about twenty-two times as much entertainment product in a year as any of the largest Hollywood movie lots, and about twenty-three times as much annually as all New York's legitimate theaters.[52] In this respect, it is not surprising that CBS executives referred to Television City as a "plant," "assembly line," and "factory" rather than a studio, and observers saw it in a similar light. *Variety* called Television City the "Ultimate in Push-Button Entertainment" and likened it to a warehouse in need of good products.[53] Similarly, the *New York Times* noted that "the new techniques" used to build Television City "get their inspiration from the auto plants in Detroit" and promised that the studio would have the "marvels of assembly-line production and push button operation—the ultimate in conveyor-belt entertainment that can be threatened only by a general strike of company vice presidents."[54] In 1952, when "men in the automobile industry in Detroit" saw the plans for Television City they "found it a staggering demonstration of the practical thinking and promise that CBS Television was investing in its future."[55]

Nevertheless, in keeping with their Tiffany vision, Paley and Stanton wanted to create a factory capable of fostering artistic creativity, and they therefore charged the architects with communicating the twin goals of art and industry. With his profound affection for modern design, Stanton spearheaded the project, and communicated goals to the architects. Describing the design objectives, Pereira and Luckman said:

> Our aim was to develop a facility in which the creative elements in television—
> the actors, musicians, writers and directors—were provided with the best en-
> vironment for working and for projecting their talent; and at the same time
> design a plant in which entertainment could be mass-produced with enough
> economy and efficiency to meet the requirements of the management group
> in reducing operating costs. Since these objectives are common to the entire
> television industry, we felt that, in a sense, we had an opportunity to do a trail-
> blazing job for an uncharted industry.[56]

The trailblazing aspects of Television City fit well with Pereira's more general interest in taking on projects for which there was no preexisting blue-

print. As James Steele explains in his book on Pereira, Television City was one of the first among a long list of Pereira's "visionary" projects. His penchant was "to design plans to satisfy the future." In fact, Steele's lavishly designed book covering Pereira's many projects is an explicit plea to assign Pereira recognition as one the great modernist architects of the twentieth century. Pereira's relative obscurity, Steele claims, is not due to his lack of projects, style, or innovations, but rather due to his penchant for delegation. Rather than embracing the status of the modernist genius, Pereira liked to seek out and assign talented workers to projects, and he was modest about his own contributions. According to Steele, Pereira "was a strictly principled minimalist modernist, even if he repressed *The Fountainhead* Roarkian ego that went with it."[57] In this respect, Pereira was the perfect CBS employee. Much like William Golden, he offered up a central vision and maintained control of those who worked under him, yet (likely because of his motion picture background) he was able to work with a crew in a crafts context.[58] Meanwhile, as the "boy wonder of industry," Luckman had all the big business factory expertise, making him the mass-production end of the project. In fact, Luckman even claimed to have initiated the practice of conducting market research for architectural firms, a practice which would have been especially appealing to the consummate market researcher, Dr. Frank Stanton.[59]

Pile driving for the first unit of Television City began on December 29, 1950.[60] The original plant had eight and a half acres of floor space and was designed around a core of four studios (each measuring 12,100 square feet, the largest television studios ever built at the time).[61] According to Steele, "The structural system of steel frame and reinforced concrete allowed the studios to 'float' in a 5-inch acoustically cushioned air-space."[62] Like midcentury modern office buildings more generally, Television City was composed of industrial materials and had clean simple lines, a minimum of decoration, a modular and flexible design, and it made ample use of glass, steel, and concrete for its construction. In form and function, as *Architectural Forum* noted at the time, the building was a "tool for TV Production."[63] Dressing rooms, craft shops for sets and costumes, and storage areas were located outside the main structure, under a broad concrete belt girding the building, which allowed for a free flow of circulation, intended to keep costs low. Rehearsal halls were located one level above the studios while the building's lower level contained the central technical/master control area. The ground level incorporated screening and conference rooms as well as areas for film storage. Administrative and production offices were in the service building, and the lobby was located at the north elevation (facing the Hollywood Hills). A canopied pedestrian

ramp with a marquee that said "Television City" led into the building. While CBS spent approximately $15,000,000 on the initial building, the estimated cost for the completed plant was a then whopping $35,000,000.[64] In other words, despite the lack of marble surfaces and ornamental flourish in favor of the midcentury modern penchant for industrial materials and clean lines, Television City was a significant investment for CBS.

The most striking innovation from the point of view of structure was what *Architectural Forum* called the building's feeling of "impermanence."[65] Television City was "to an unprecedented degree composed structurally and visually of large, plain, moveable surfaces" and "easily demountable walls" that were designed to anticipate expansion from the original four studios to an eventual twenty-four studios. This sense of impermanence meshed with the rootless Los Angeles culture, and it fit with the "planned obsolescence" of modern industry more generally. The impermanent design also ideally suited the needs of network television, which in 1952 was still spreading its reach over the nation. As Pereira and Luckman explained:

> The premise underlying our design approach to the new CBS television facility was the requirement for complete flexibility. Two factors imposed this need for flexibility. First, in terms of size alone, it was necessary that the facility could be expanded as the growth of television called for enlarged quarters; second, the very newness of the medium required flexibility to accommodate technological changes.[66]

Pereira and Luckman created "immense interior flexibility" in studio space by using suspended sets, movable lighting, and wiring grids" so that "any portion of the studio can be used for production."[67] The goals of flexibility and impermanence made CBS Television City an altogether different kind of workplace from Ford's factory.

Indeed, despite Stanton and Paley's desire to mimic the efficiency aspects of the factory model, their business was organized around different goals from, say, an automobile or soap manufacturer. Whereas Ford's factory system aimed to produce efficient workers for industry, mass communication corporations like CBS hoped to produce eager consumers for advertisers. From this point of view, Television City not only had to be a well designed factory; its studios also had to look good on television where they were ultimately seen by national audiences. This was particularly important to CBS because the network conceived of the plant as a place for live broadcasting (often with studio audiences), which meant that home audiences would see the studios and stages as they were shot at the time of transmission. In fact,

whereas broadcast historians typically equate the move to Hollywood with the transition to filmed programming, at the time when CBS built Television City, Paley and Stanton conceived of the studio as a cutting-edge technical advance for *live* television productions. As *Variety* reported in 1952, although CBS saw a need to have a stake in the then growing industry of telefilm production (its own hit sitcom *I Love Lucy* was shot on film), "TV City is strictly a 'live' baby."[68] This was true not only of the live variety shows like *The Jack Benny Show* or anthology dramas like *Studio One*, but even of half-hour family sitcoms like *Life with Father*.

Given this emphasis on live studio set-ups, the architects paid considerable attention to the spatial arrangements of the studio audience. Pereira and Luckman explained, "The size and layout of studios in which audiences will be accommodated were problems requiring intensive research, since a great diversity of opinion has been registered about how large an audience should be permitted on a television show, and where that audience should be placed in relation to performers." While they initially considered handling the studio buildings in circular, octagonal, or pentagonal forms, they ultimately adopted the "sandwich-loaf" principle, with four large rectangular studios divided by service doors. Two of these studios accommodated audiences, and for these they settled on an audience size of 350 seats "with the audience placed between the center camera range and the stage floor" and the audience section beginning at a lower level than the stage and rising halfway back in the auditorium to the stage level. The seating arrangement allowed for the maximum number of seats without disturbing the production on stage, and it also permitted the much-desired use of mobile cameras. This design was entirely in line with the industry's overall investment in liveness during the period and the wish among producers to convey an aura of immediacy and intimacy that made viewers feel as if they were there on scene and participating with the events. Accordingly, Pereira and Luckman observed, "With the camera platforms in the midst and on the sides of the audience, the spectators will feel that they are actually a part of the production that is taking place."[69] As a mode of television production, Television City was therefore also a tool for promoting a particular form of spectatorship. With Television City, CBS tried to create a complete simulacrum (literally, an architectural model) of participatory spectatorship in which home viewers felt magically transported to the place of presentation.

In addition to designing a spatial simulacrum that modeled itself on live theater, the architects had to pay attention to the temporal demands of television, which were again different from those of a traditional factory. While

Chapter 3

Fordism relied on regimented time clocks for workers, mass media corporations had different needs. Rather than the rigid time clock, networks had to insinuate themselves into the more flexible and flowing patterns of people's work and leisure time. In this regard, while Television City might have functioned as an efficient factory for the people who worked there, its architectural form had to address televisual (rather than just architectural) time. Accordingly, the architects designed Television City to suit the nearly round-the-clock time schedules and rapid-fire timing of mass media. Pereira and Luckman concentrated on traffic flows by creating huge hallways and outside runways that allowed massive units (such as scenery flats) to be transported through the building without obstructing the steady flow of talent, executives, technicians, and visitors who rushed through the building according to the scheduling demands of television production. "This emphasis on split-second timing," said the architects, "has not been a major consideration in architectural planning for any other medium [but] becomes mandatory in television, where the volume of production surpasses anything achieved, and where production costs can become uneconomic unless the most optimum conditions for efficient operations are provided."[70] *Architectural Forum* concurred, saying, "Speed and directness are the key words in the design. Nothing bulky is in the way of the swift movement necessary to get a show on and off stage."[71]

In this sense, the building was a material manifestation of what Paul Virilio calls telecommunication's collapse of time and space into "speed." According to Virilio, telecommunication's instantaneous and simultaneous delivery of messages erases the distance between places, and our sense of time becomes less bound up with the time it takes to travel through physical space.[72] Although Virilio speaks mostly of the virtual places of satellites, telerobotics, and digital media, the case of Television City suggests that this "speed up" effect was, at the dawn of television, already inscribed in the physical spaces of studio transmission. CBS promoted Television City by claiming that it accommodated the "driving demand" for "speed," a demand that made television "different from any other show business."[73] Along these lines, the building accommodated television's need for simultaneous broadcasts through the multiplication of studio units: the four studios could produce programs at the same time. Meanwhile, the state-of-the-art technologies delivered technical cues in rapid time. For lighting, Television City had an Izenour board, which the *New York Times* referred to as "TV's lighting wonder" and which required only two human operators.[74] Originally designed for theatrical use by Yale drama professor George C. Izenour, the board was essentially an electronic brain that "memoriz[ed] lighting cues of inhuman complexity and

deliver[ed] them on time."[75] In all these ways, architectural time and space adjusted to television time and space, creating a new kind of "media architecture" that would become central to communications corporations.

In her work on modern architecture, Beatriz Colomina argues, " Modern architecture is a form of media." What makes modern architecture modern is not just the use of glass, steel, and reinforced concrete, but also its engagement with the media (both in the sense of its representation in the media and in its own status as a form of media, publicity, and representation). "Modern architecture is all about the mass media image."[76] Television City expressed its status as media architecture through its formal appearance, especially its demountable "curtain wall" (its expansive glass-and-steel frame) that adorns the face of the four-story service building. Associated with iconic midcentury skyscrapers such as Mies van der Rohe's Seagram building and Gordon Bunshaft's Lever House (which Luckman helped develop), the curtain wall made the building, as Steele suggests, "an appropriate symbol of Los Angeles' leadership in the media industry."[77] Moreover, as a design element the curtain wall invoked the television screen itself. In his analysis of the Seagram building, as well as the multitude of mass-produced copies made in the 1960s by corporate firms, Reinhold Martin likens the curtain wall to mass media, and to television in particular. Like television, the curtain wall collapses near and far and inside and outside onto its shimmering glass/mirror-like surface, behind which the flux of the city and the workplace are contained in a single organized complex.[78] And, like television, the curtain wall's reflective glass surface paradoxically "makes visible and conceals (i.e., screens) at the same time" the event "to which it bears silent witness."[79] If, as Martin suggests, the curtain wall is like a TV screen, then Television City takes the analogy one step further by making the curtain wall literally function as an advertising device. Composed of more than 12,000 glass sheets (one of the largest glass installations of its time), the service building's façade worked like a television screen to broadcast the company image. Through the huge panes of glass, one could see the vast tiled wall of CBS eyes (3,600 individual eye tiles in all) located inside the lobby. Ezra Stoller, the leading architectural photographer and a major influence on the visual promotion of modern design, shot numerous publicity photos of the wall, some through the glass façade to highlight the "see-through" screen effect.

The CBS logo and signage used on the building served, in a more direct sense, to advertise the corporate message. The eye trademark was subtly placed on upper corners of the building exterior, recalling its similar corner placement in newspaper advertisements and on-air title art. In this sense,

Television City's curtain-wall façade, architectural model. Reprinted by permission of Esto.

CBS Television City was emblematic of the growing relationship between modern graphic and architectural design, a relationship nourished by venues such as the Aspen conferences where architects and graphic artists met on a yearly basis. Not surprisingly, in this regard, CBS consulted with Golden on signage and interior décor. The words "CBS Television" appeared on all visible building elevations, but this too was done with subtlety, using one of Golden's preferred typefaces—Didot Bodoni—to augment the building's modern, clean look. The name "Television City, " also in Bodoni, appeared on a marquee-like structure in the front of the central arcade ramp leading to the entranceway. As with all CBS art, Television City was an advertisement that was perfectly coordinated with Golden's "ensemble plan"; every image contributed to the distinctive look of the Tiffany brand.

With fair, shopping mall, and theme park architecture in their life-work repertoire, Pereira and Luckman certainly had a talent for corporate branding. In this sense, although the urbane CBS executives might have been loathe to consider it as such, Television City adhered to principles of 1950s

Los Angeles theme architecture (the giant doughnut on the roof of Randy's Doughnuts or the hotdog design on Tail o' the Pup) in which the building becomes an advertisement that communicates its function through the indexical sign of its product form. But unlike the doughnut and hotdog that have since become icons of LA "kitsch," the CBS building was aimed at more sophisticated tastes. Rather than literally hanging a hot dog or doughnut on top of the roof, CBS Television City used the indirect conceptual approach of modern design. The building was not a TV set; rather it evoked "televisioness" as an abstract idea. Television City communicates the experience of television as a design concept.

Not only is the façade a giant glass screen, like a 1950s television program, Television City's exterior is black and white. The name "Television City" appears black-on-white on one edifice and white-on-black on another, and the two edifices meet at a sharp corner so that the overall effect is high contrast and sharp focus (which perhaps not coincidently were also two of the most often promoted and desirable qualities in TV reception). This sense of high contrast and sharp focus is further suggested across the exterior, which is composed of a vast expanse of white concrete that is strikingly offset by black metal paneled walls (the only color on the original building was red trim used for railings on the studio-level platform and the pedestrian ramp). So too, like television itself, the building was designed with daytime and primetime "day parts" in mind. To this end, Stoller's publicity stills showcased the different ways that Television City looked under daytime and nighttime conditions.[80] Daytime photos highlighted the studio's status as an efficient production plant with clean, simple, orderly lines. Nighttime photos presented Television City as if it were electricity itself, with light beaming through the plate-glass façade that was silhouetted against a jet-black sky. Yet, despite all the lights, Television City had had none of the circus atmosphere of Times Square nor did it look like electrified Hollywood movie palaces. Instead, the building used natural and artificial light to augment its clean stark modern design. According to Steele, Television City was one of Pereira's "most strikingly 'modern' buildings" and as such "is almost visually severe."[81]

Set against the backdrop of the Fairfax district's ecru and pastel Spanish-style homes (that have an Old World feel), Television City's black and white walls, enormous glass-curtain-wall façade, electrification, and austere modern style must have seemed at the time eccentric, certainly more technological than natural.[82] And while the Fairfax area has colorful gardens and tree-lined streets, Television City was landscaped with a vast parking lot that wraps around the building creating a kind of car-moat that separates it (and

Television City by night. Photograph by Ezra Stoller (1953). Reprinted by permission of Esto.

secures it) from the street. In its list of Television City's amazing "vital statistics," *Variety* reported that the parking lot and roadways were made of 26,000 yards of asphalt ("enough to build a 24-foot highway two miles long") and noted that the lot had room for 710 cars, which all parked for free.[83] Similarly, CBS publicity photos showcased the parking lot as if the huge expanse of cars was somehow more impressive than the building itself. The only hint of nature in these photos was a glimpse of cropped lawn and a few stray trees (usually shot on the margins of the frame), as well as low green shrubs and small potted trees in perfectly ordered cement planters, all lined up in pristine geometrical symmetry around the building. CBS Television City was in this sense an arbiter of Los Angeles's postwar status as an "autotopia" where the commuter and his/her car connoted a landscape of progress, mobility, and quotidian privacy so that parking lots (or residential carports) came to have an aesthetic value of their own.

Parked on their sofas in their private homes, yet offered the chance to travel "live" to TV Land, the home audience was in a fundamental way also part of this new autotopic landscape. As Margaret Morse has argued, the parallel construction of television, freeways, and shopping malls in postwar America created a new architecture of experience where traditionally public activities had been reproduced as "models" of publicness that offered new forms of

simulated social life.[84] Television City in many ways was a monument to this new form of sociality. As a design concept, the studios of Television City made home audiences feel as if they were out for a night on the town, watching a play or musical revue in a big-city theater—not home alone, but in the company of others. CBS's promotion of Television City spoke specifically to its status as a "model," holding out the promise of the simulated theatrical/social experience on offer.

PROMOTION AND COMPETITION

Television City functioned not just as a state-of-the-art studio for program production but also as a tool for network promotion. To this end in May of 1952, CBS displayed an elaborate architectural model of Television City to its affiliates at a meeting in the Starlight Room in New York's Waldorf-Astoria Hotel. Taking "two months of work through day and night by twelve men," the model was itself hailed as a major achievement of modern architectural design.[85] Not only was it interactive, allowing people to push buttons to control the studio's array of technical gizmos, the model included landscaping, parking lots, and automobiles as well as 200 miniature human figures molded in attitudes of their working duties at the studio. In line with Pereira and Luckman's interest in architectural time, the interactive model even permitted onlookers to see what the studio looked like under daytime versus nighttime conditions. David J. Jacobson, director of public relations at CBS, referred to the model as a "monster," recalling that when it was shipped to New York from Los Angeles it took "three trucks to haul the whole thing into the Waldorf Astoria."[86]

Nevertheless, the monster was apparently worth its weight in gold. According to Jacobson, big department stores across the country wrote to CBS asking for the rights to show the model to their customers. "What they had heard and read about Television City made them think that the model was a wonderful gimmick for increasing store traffic. In their enthusiasm every store promised that they would do at least one full page of advertising in their local papers and support the whole model promotion in their city with store windows as well."[87] In the summer of 1952 the model was displayed in department stores in major urban markets across the country, beginning with Macy's department store in New York's Herald Square. Promoting the event, an advertisement in the *New York Times* told prospective female shoppers, "You can watch electric controls lift the roof, move the walls, turn a revolving stage. . . . See the stars' dressing rooms, the master control room, the workshops." Making the occasion even more spectacular, a bevy of CBS

Television City's parking lot rhymes with the new autotopia in Los Angeles. Photograph by Ezra Stoller (1953). Reprinted by permission of Esto.

morning and daytime stars were on hand to promote the display.[88] According to Jacobson, "Over 150,000 people flocked around the Television City model at Macy's," and as it toured around the country from Boston to Philadelphia to Pittsburgh to Detroit to Minneapolis, it played to "SRO" crowds. By the time it returned to Los Angeles, where it went on display at Bullock's department store and the Farmers Market, "It had played to an audience of around 5,000,000 persons."[89]

As a business strategy, CBS executives used the model not only to entice viewers, but also to stave off competition from their longtime opponent, NBC. In September of 1951 NBC purchased thirty acres from Warner Brothers Studios and nineteen acres of adjacent land from the city of Burbank to build its own radio-television plant.[90] Unlike CBS, NBC purchased the studio lot with hopes of retaining sound stages and other facilities. Also unlike CBS, the NBC plant did not attempt a grand modern design, but rather was built largely with practical concerns for interior technical facilities and expediency in mind. In October of 1952 when CBS Television City was near completion, NBC held a preview showing of its television studios that occupied one and a half acres on the lot. Although NBC's studios were nearly one-third the price and smaller than those in the CBS plant, John K. West, vice president of NBC's Western Division, bragged that the studios "have the most modern

facilities for changing scenes and presenting telecasts, as well as dressing rooms, rehearsal studios—and even a steam bath and massage parlor."[91] The NBC studios were especially constructed for RCA's color system, and the studio was not officially dedicated until 1955, at which point NBC referred to it as "Color City." However, given the fact that NBC's Hollywood and Vine studios had been named "Radio City" since 1938, the network was not about to lose out to CBS.

The competition stiffened when, on October 1, 1952, NBC announced plans for a premiere telecast at the Burbank studio of an "all star" variety show with Jimmy Durante, Dinah Shore, Phil Harris, Harpo Marx, Red Skelton, and George Jessel. CBS executives, who had been planning their own "all star" telecast, were frantic. Television City was still in construction.[92] Rather than allow NBC to steal the show, CBS decided to use one of its nearly completed sound stages to broadcast an episode of its live half-hour sitcom, *My Friend Irma*. On October 4, CBS's *My Friend Irma* and NBC's *All-Star Revue* ran back-to-back, coast-to-coast telecasts, each network attempting to win the Hollywood race.[93] One month later, even though Television City was not complete, CBS decided to launch its official opening ceremonies. Proclaiming November 15, 1952, "Television City Day," Los Angeles mayor Fletcher Bowran enthused, "Just as the first motion-picture camera grinding away in a vacant lot in what is today Hollywood marked the beginnings of newer and greater things for the Southland, so will CBS Television City mean prosperity, more employment, a more beautiful city and increased tourist trade for the benefit of all."[94] On November 12, *Variety* ran a special issue devoted to the opening of Television City calling it "another historic milestone" and noting, "Its horizons for revitalizing Hollywood are limitless."[95] To inaugurate the event, the city and CBS orchestrated a parade down Wilshire Boulevard's "Miracle Mile" that was to march up to Television City where Mayor Bowran planned to cut the white silk ribbon, officially opening the studio before an enthralled public. CBS orchestrated a coast-to-coast airplane junket of sixty newspaper journalists in hopes of promoting the occasion.[96]

Unfortunately for CBS and the mayor, the parade was a washout. Heavy rains filled the notoriously sun-drenched California sky. In lieu of the parade, CBS held the ribbon cutting in the lobby of the new plant—hardly the fanfare fitting for its multi-million dollar venture. CBS executives and Mayor Bowran stood inside Television City "with rain beating against the huge plate glass windows." Televised on the local CBS station, the opening ceremonies included stars Art Linkletter (who acted as master of ceremonies) and the then popular "glamour girl" Zsa Zsa Gabor. CBS president in charge of tele-

vision, J. L. Van Volkenberg, echoed the mayor's remarks about the impor-
tance of Television City for Los Angeles, and religious leaders were also on
hand to anoint the event. Rabbi Edgar F. Magnin noted "the role the TV
Center will play as a source of cultural, dramatic, and spiritual endeavor in
the nation," and clergyman Dr. Forest Weir offered thanks for the "imagina-
tion of minds and the craftsmanship of hands that made possible this marvel
of communication." The network's top brass, Paley and Stanton, who were
scheduled to arrive from New York via plane, missed the ceremony due to
the bad weather.[97]

Despite the local calamity, at a national level the opening of Television
City did achieve its full luster. On the evening of "Television City Day," CBS
went coast-to-coast with its star-studded dedication program aptly titled
Stars in the Eye. The real star, however, was the building itself.

STARS IN THE EYE

An hour-long variety special, CBS's *Stars in the Eye* opened with explosive
fireworks indicating the excitement to come. The first act featured the cast
of *Amos 'n' Andy* (billed as "Andy" Spencer Williams, "Kingfish" Tim Moore,
and "Amos" Alvin Childress) as they flew in an airplane (actually a stage
set) from New York to LA. The fictional pretense established the actual geo-
graphic journey made by CBS as it moved to its Hollywood locale. Standing
in for awed viewers everywhere, the three actors (all in their fictional charac-
ters) engaged in comic banter about the move:

AMOS: I'm sure anxious to get to Los Angeles and see that CBS Televi-
 sion City. You know, I understand they got some really great
 new things there.
KINGFISH: Oh, yeah.
ANDY: Yeah, sure must be interesting all right. You know I'm anxious
 to find out how all that television stuff works.

After a typical *Amos 'n' Andy* skit in which Andy plays the naive fool to King-
fish's shady hustler (he ties to sell Andy a phony insurance policy), Amos
looks out the airplane window and enthuses, "Hey, look fellas, there's Los
Angeles down there!" Kingfish replies, "Yeah, and I think I can see CBS Tele-
vision City from here. Boys we headin' right for it." At this point the camera
cuts to a sweeping aerial view of Television City, showing the plant in all its
sprawling glory.

The use of *Amos 'n' Andy* as the opening act is both predicable and curi-
ous. On the one hand, *Amos 'n' Andy* (which had been on radio since 1929),

was a television ratings success, and from this point of view the cast was a logical choice with which to inaugurate the future success of the new CBS plant. On the other hand, in 1952, the program was the subject of great controversy as the National Association for the Advancement of Colored People (NAACP) protested its racist stereotypes.[98] In this respect, the presence of Amos, Andy, and Kingfish as the opening number creates a mixed message: the ultramodern architecture of Television City is embedded in the residual form of the nineteenth-century minstrel show and its regressive racial politics. Indeed, despite its claims to technological progress, Television City somehow depends upon the preservation of (and even nostalgia for) antiquated and, at the time, highly contested race spectacles. The airplane sequence also stages a curious inversion of the real "white flight" taking place in conjunction with the rise of television. Rather than white people fleeing to the suburbs, CBS shows African Americans migrating to an imaginary Television City that nevertheless exists primarily to entertain white middleclass consumers whom sponsors wanted to attract.

After the aerial view establishes the overall grandeur of the plant, the scene dissolves to a sound stage where a CBS floor manager presides over a rehearsal for a dance number. This dissolve initiates the "back-stage musical" plot premise around which the entire show is organized. The premise is further elaborated when the scene shifts to the CBS executive offices (actually a stage set that is decorated with a wall of Emmys, a TV console that has the CBS eye trademark on the screen, and four telephones on a desk). This skit introduces audiences to the real vice president of CBS Television programming, Harry Ackerman, who chats with a fictional TV producer played by CBS actor Gale Gordon. The two establish the humorous plot premise: CBS's infamously "cheap" and "vain" Jack Benny has put up all the money for the program, but as a consequence he is trying to run the show by interfering with every aspect of production. Ackerman and Gordon strategize on ways to keep Benny in line. When one of the four phones rings, Ackerman answers it to discover he has none other than William Paley "from New York!" on the line. Ackerman tries to assure Paley that everything is okay, but Benny continues to wreak havoc as the stars rehearse for the show.

Most instrumentally, the backstage musical plot serves as the perfect premise for displaying CBS Television City in all its glory. Throughout the program, viewers get a backstage studio tour of all the spectacular sets, dressing rooms, sound stages, and (as the above skit suggests) executive offices. We see Jack Benny's living room and his Maxwell car parked on the street in front of his home (which is rendered in a huge photo-mural backdrop). We

see *Life with Luigi*'s Italian pizzeria; *I Love Lucy*'s living room and Tropicana nightclub; the lobby area and dressing rooms in Television City; and dance and musical numbers that have elaborate stage sets. In short, the program establishes the CBS "studio style," which like the architecture itself is based on flexibility and expansiveness. At Television City, the deep roomy stages, multiple and moving cameras, perfectly-timed lighting system, and elaborately orchestrated in-house costume and scenery craft shops allow for the creation of a variety of genres from musical variety shows to intimate family sitcoms to talk shows to Broadway revues to live anthology dramas.

Most importantly, the studio style highlighted the then desired aesthetic qualities of mobility and spaciousness. In other words, Television City did not create an entirely unique studio style so much as it differentiated CBS products by showing how much better the Tiffany network could achieve these ideal aesthetic results. At least when compared to the static staginess of many of the programs that were shot in the old reconverted theaters, the programs at Television City looked large, fluid, and kinetic. The stages were so large even a car could drive across them. Sets at Television City could be easily moved and quickly realigned. Dollies, cranes, and multiple cameras allowed for variation of camera distance (including overhead shots) to break up the proscenium feel of the programs shot in smaller studios. The in-house and easily accessed craft shops, engineers, and film-storage area made the construction of cycloramas, gobos, rear-screen projection, and other elements of stagecraft simpler. The advanced sound technology gave actors increased ability to move across the stage. Similarly, the Izenour lighting board provided intense illumination for legibility at all points of the stage so that actors could easily move positions, while its electronic brain and "memory" gave instant cues for changes in mood and ambiance. In addition to increased mobility, Television City's aesthetics of liveness were promoted by the camera placement between the audience and the stage, and by the constant sound of studio applause (that was induced through electrical "promoters"). Finally, the CBS curtains (with eyes all over them) served as a backdrop on the stage to remind viewers of the Tiffany brand.

The dedication program's musical-dance numbers especially showcased the stagecraft at Television City. The most elaborate "set piece" featured Gizelle McKenzie and Bob Crosby (Bing's brother) in an intricately choreographed song-and-dance act. The act begins in a dressing room (again, actually a set) as McKenzie and Crosby rehearse their duet, "It Takes Two to Tango." The scene then shifts to the actual sound stage where they and other CBS dancers perform a revue/medley of dance styles across the ages,

including a tango, a French minuet, the Charleston, a waltz, and the jitterbug. This medley format allowed the producers to display the flexibility and rapid-fire timing of scenery and costume changes possible at the plant. Elaborately decorated sets glide in and out of view while makeup, hairstyles, and period costumes change instantly with each dance. The result is an exquisite promotional display that shows how Television City's architectural and technical achievements allowed CBS programs to achieve the stunning effects of a live Broadway show.

Stars in the Eye also included sketches designed specifically to feature the building itself as a modern marvel. But as with the *Amos 'n' Andy* opening act, modern design was paradoxically portrayed via old entertainment forms, within the lexicon of television's vaudeo-modernism. One sketch features Jack Benny playing a vaudeville stock character, the bumbling professor. The sketch begins as Benny enters the stage carrying a classroom pointer. Dressed in a tux and wearing thick black-rim glasses, Benny stands in front of the CBS eye curtain. He then proceeds to display the two-ton model of Television City that had been on view at department stores. Just as in the publicity photos, this televised view especially focuses on the huge parking lot that is filled with model cars. Even Benny's "lecture" refers back to LA car culture. He jokes:

> Now, ladies and gentlemen, for the benefit of our audience at home watching the show, I would like to explain how big CBS Television City really is. . . . Now these buildings cover an area of approximately 63 thousand square feet. . . . And there's enough concrete, ladies and gentlemen, in this building to build a highway, a two-lane highway 8 1/2 miles long. Of course, we had to borrow some of the materials so in case you happen to be on the freeway tomorrow you'll find a piece missing between Anaheim and Cucamonga.

Benny's performance not only conveys the enormous size and modern design of the studio, it also features another aspect of the Television City studio style—the constant "insider" references to Los Angeles (and its smog, cars, freeways, and stars). Despite the fact that the program is aired coast to coast, Benny addresses national audiences as if they were all Angelinos. At the time, this was a major shift from the New York, Yiddish-oriented variety show humor found in programs like *The Texaco Star Theater, Admiral Broadway Revue,* or *Your Show of Shows.* For this reason, as a studio style, the LA in-jokes marked the significant transition from East to West Coast production. Similar insider humor and modes of address were common to Television City variety shows like *The Jack Benny Show* and *The Red Skelton Show,* and

Jack Benny does a vaudeville-style lecture routine while pointing to the enormous model of Television City (*Stars in the Eye*, CBS, 1952).

this continued through to 1960s and 1970s programs like *The Jackie Gleason Show*, *The Smothers Brothers Comedy Hour*, *The Carol Burnett Show*, and *The Sonny and Cher Show*. In this respect, even while Television City is built for a national audience, its "spatial imaginary" is located in Hollywood. Not surprisingly in this regard, newspaper ads always announced that the programs were "Live from Television City, Hollywood."

Stars in the Eye showcased official recognition of Television City's importance for Los Angeles through the presence of Mayor Bowran and Governor Warren. Warren is featured in a skit in which he plays straight man to vaudeville-radio-movie-TV star Gracie Allen. Portraying the official ambassador to Television city, Gracie goes to the governor's office to invite him to be on the show. The scene opens with a few musical bars from "California, Here I Come," reminding viewers one more time of the switch from New York to LA locales. As the skit unfolds, Governor Warren reads Gracie a bit of his dedication speech in which he calls Television City one of the "milestones of recent history." (The epigraph with which I began this chapter is an excerpt from the speech.) The final curtain call unites the mayor and governor with the entire star cast. Presiding over this alliance between California government and Hollywood celebrity culture, CBS president in charge of television, Van Volkenberg, thanks viewers for joining him "in this dedicatory program from CBS Television City, a factory designed to bring even better CBS television programs from the world's most important talent center."

A few days after the program aired, *Variety* ran a front-page rave review, not only of the program but also of the building itself. Calling Television City "The most unique plant in modern show biz," *Variety* claimed, "The whole atmosphere of the dedication weekend suggested that the . . . signposts

point to Hollywood [which] . . . is charged today with a kind of electric excitement."[99] Building on the momentum, Paley extended his West Coast stay for ten days to launch what *Variety* called "Operations TV City," a major push to take advantage of the "pix slack" by convincing Hollywood's most creative movie directors, producers, writers, and other talent to "accept TV's big time stature" and work for CBS.[100] According to *Variety*, "TV's Westward Ho!" was in full swing. "Columbia's leadership and pioneering in pouring millions into a vacant space to further the advance of a new electronic art is concrete evidence of faith and permanence in Hollywood's place in the future of television. . . . So it's California, here we come and even if sung in off-key it sounds good. To us. To the east we say, sorry, fellers, but you may like it out here."[101] Not surprisingly, back in New York, not many people did. Suspicious of the move to Hollywood and angered at the waning of New York production, East Coast critics began their tirade (which lasted through the 1960s) on the mass-produced Hollywood series. Noting the irony of the modern facility being promoted through vaudevillian variety acts, in his review for the *New York Times* Jack Gould called the CBS dedication program "old hat." "All in all, it was only too typical of a great deal of the television that has been coming out of Hollywood."[102]

The New York bias against Television City was not just based on cultural tastes; it was also rooted in territorial and economic concerns on the part of New York City officials who saw Television City and the NBC Burbank studios as a clear threat to their control over the television economy, especially with regard to jobs and tourism. In 1956, Abe Stark, the president of the New York City Council, warned, "The same unsolved dilemmas which caused the motion picture industry to be lost to our city thirty years ago now threaten New York's leadership as the television capital of the world." Consequently, he advocated the construction of a twenty-two-acre "Television City" to stave off the migration. One year later, Mayor John J. Kane of Secaucus, New Jersey, announced his plans to build a huge $100,000,000 "television center" near the New Jersey Turnpike, but all three networks refused to participate in the scheme.[103] Instead, by 1960 most primetime series production took place in Hollywood. Although the networks did continue to build new facilities in New York and Chicago, this was mostly for daytime and news programs, and the studios were still scattered across converted theaters and public meeting halls.[104] In 1961 the *Wall Street Journal* reported, "This lack of centralized facilities has been partly blamed for the transfer of most TV production to the film studios in Hollywood as well as the dearth of live dramatic shows."[105] Although East Coast critics and city officials might have deplored the "Holly-

woodization" of television, by the early 1950s all the networks knew that TV was indeed going west.

In the end, the future that CBS imagined both did and did not happen. Program production increasingly did move to Hollywood. However, live production for nighttime series became less routine. ABC's early efforts in filmed series production set an example for the two major networks. As the networks realized that profits were to be earned in reruns of recorded programs, CBS and NBC also began to steer away from live productions and to invest more in film production and videotape. Seeing the profits to be earned in television, after 1952 the major movie studios (reorganized after the Paramount Decree) opened up television subsidiaries, and as the decade evolved they made co-production deals with the networks and often also leased studio space to independent telefilm producers.[106] As recorded programs became more common, Television City's sound stages, which were set up for live production, were less important to network production overall. Despite the fact that Pereira and Luckman had designed a flexible studio that could be converted to film production, CBS could just as easily film or tape television in its Burbank studio and it could also contract out with telefilm producers using studios around town.

In his 1962 book *The Hungry Eye*, Eugene Paul offered a detailed description of Television City ten years after its conception. Describing it as a "severely modern" building of "visual beauty," Paul nevertheless observed, "If function was a criterion, that was another matter." Paul lamented that despite the enormous production capability of the studios, the only things currently made "live" at Television City were "two soap operas and a quiz show."[107] The once live broadcasts of Jack Benny, Red Skelton, *Playhouse 90, Climax!,* and *Four Star Jubilee* were now all "gone or resting in film and tape." Although Paul underestimated the building's use (in fact a number of variety shows and specials were taped there), the point was that studios set up for live production were no longer the mainstay of television production. Noting that the ratings for live prestige dramas like *Playhouse 90* had plummeted, Paul pointed out the irony of Television City. Whereas people in the early 1950s saw CBS Television City as material proof of the "demise of the film industry," in 1962 the film industry was flourishing in the television business, and it was live TV that was dead. Speaking of Television City, one telefilm producer told Paul, "It's a shame to see it idle. I sure could use the space."[108]

Although both Television City and the NBC Burbank studios underwent some expansion and modification in the 1950s, television networks never developed a studio system in the way that movies had during Hollywood's

heyday. CBS increasingly used Television City as a market research tool, welcoming busloads of tourists with free tickets to shows on a year-round basis. These tourists served (and continue to serve) as a free test market for researchers eager to study audience responses to network shows. Dr. Frank Stanton's double life as audience researcher and modernist aesthete is therefore perfectly expressed in the outcome. Nevertheless, modern architectural design did affect the look of television stations and studios across the country. Even a few months before Television City was competed, CBS's Philadelphia affiliate WCAU opened a modern television station designed in the International Style that, while of much smaller scale, had many of the same design features that Television City had (including, for example, an all-glass façade and flexible structures).[109] While Television City was in progress, Paley hired Pereira and Luckman to remodel the Sheffield Farm property (a huge dairy) in Manhattan for live television production.[110] The architects also went on to design ABC's regional production centers in San Francisco, Los Angeles, and New York, as well as the KETY Television station in Santa Barbara, California (1954), and the KTTV Television station in Los Angeles (1954).[111] Moreover, their vision of media architecture inspired the local vernacular of television stations in the middle of the country, which also wanted modern, progressive designs. In 1954, the WSBT Radio-Television station in South Bend, Indiana (1954), hired Pereira and Luckman to build its new studio, and in 1953 Idaho's KBOI (a CBS affiliate) hired Pereira and Luckman to consult with their local firm of architects to build its new studio in Boise, which station vice president Willis Moffit claimed would "be of the most modern construction."[112]

FROM TINSEL TOWN TO BLACK ROCK

After Television City, CBS executives, especially Stanton, searched for more ways to augment the Tiffany brand through modern architectural design. In the mid-1950s, Stanton began pushing for a new office headquarters in New York. A onetime aspiring architect himself, Stanton commissioned his friend Eero Saarinen, the acclaimed modernist architect who had previously designed such futuristic structures as the Trans World Airline Terminal at Kennedy (then Idlewild) Airport and the curved IBM Research Center in Yorktown, New York. Although Saarinen died in 1961 before Black Rock was erected, his design served as the blueprint for the building. Saarinen said he wanted the building to be a "soaring thing," and he set about making his first and only skyscraper. In addition, he hoped to distinguish Black Rock from then popular glass office buildings (like the Lever House) by creating a flat

black granite surface with grey glass windows. As the architects' statement claimed, "From the beginning, this corporate headquarters was imagined as a dark building, for it would seem quieter and more dignified." Moreover, unlike the feeling of impermanence at Television City, the architects stated, "It was also decided that this structure should be permanent in its appearance."[113] In this sense, Black Rock was the antithesis of Television City's low, sprawling, glass, and sun-drenched California style. The two buildings perfectly express the competing ethos of East vs. West Coast architectural modernisms in the 1950s, yet, in their own ways both buildings share CBS's (and especially Stanton's) penchant for clean, modern, minimalist design.

Paley and Stanton fought bitterly over Black Rock. Less enamored of austere modernism than Stanton, Paley hated the original mock-ups, thinking the design too severe. Even the finish of the stone was a source of dispute.[114] Paley wanted a less austere-looking pink marble, but when pushed by Stanton he compromised by insisting on shiny black marble rather than the flat finish called for in the original design. Aline Saarinen, Eero's widow (and a well-known art critic), wrote a letter to Stanton in 1962 begging that the surface be as Eero wished: "I am told that you and Mr. Paley are making the final decision on the granite this Friday. . . . I feel compelled . . . to make my feelings known to you. . . . I am convinced Eero never envisioned this building as having in any way a polished or shiny look. . . . A highly polished surface tends to dissolve and distort form."[115] In the end, Black Rock conformed to Stanton and Saarinen's austere modernist—and anti-decorative—sensibilities. In 1965, under Stanton's meticulous guidance, Saarinen's plans for Black Rock materialized in a thirty-eight-story building rising 491 feet and clad in unpolished black granite.[116]

As with Television City, graphic design was important to the building's overall look, so much so that *Print* magazine ran a feature story on Black Rock stating, "Graphics form an integral part of the total design." Golden's successor Lou Dorfsman (who not only was a graphic artist but also had a background in architecture) demanded "good clean design," insisting on the use of refashioned Didot typeface (known as "CBS Didot") for exterior signage and the often-used "CBS Sans" for elevator numbers. Dorfsman even replaced the numbers on seventy-five Swiss clocks with CBS Didot numerals and he masked cafeteria vending machines with the CBS Didot lettering.[117] For the interiors, Stanton hired Florence Knoll, who had previously designed his office in the Madison Avenue building and was by the early 1960s widely recognized as the leader in the modern revolution in office design.[118] A committee composed of Stanton, Paley, Dorfsman, and several museum

directors chose the major artworks, which included abstract paintings by Vasarley, Soulanges, and Pollock—all reflections of Stanton's tastes. Keeping up with the times, pop and op art also enhanced the interior. Dorfsman even commissioned an original artwork titled "Gastrotypographicalassemblage" for the cafeteria; it was fashioned after a printer's job case (a case filled with wooden letterforms and copper engravings), but it also had the found-object look of assemblage art works being produced in the period by artists like Ed Keinholtz.[119] The artwork was a huge 38 by 8 1/2 foot mural composed of white painted wooden letters in 250 different typefaces that spelled out words and phrases all having to do with food, and it included 85 food-related objects. Black Rock therefore bridged the austere high modernism that had inspired CBS's Tiffany look in the 1950s with (at least gestures toward) the growing pop sensibility of the 1960s. The only departure from this cutting-edge visual palette was Paley's office, which had deep mahogany furnishings, dark green carpets, and impressionist paintings by Lautrec, Picasso, and Derain. Commenting on Paley's decorative choices, MoMA's John Hightower called the CBS chairman's office "overripe."[120]

The building itself was a source of widespread disagreement. For their part, architecture connoisseurs embraced it. The AIA awarded it first honor for its "superbly simple and disciplined" form that exuded "strength and elegance."[121] In his *Architectural Forum* essay of 1965, "Slaughter on 6th Avenue," Peter Blake singled out Black Rock as a triumph amidst the mass-produced curtain-wall office buildings that he called "the slaughter that is our cities today." Praising Black Rock as a departure from the "the unity of the glass and metal curtain wall, generally picked to satisfy budgets rather than art," he claimed the CBS headquarters was "really a BUILDING, not speculative cubage wrapped in exterior wallpaper."[122] With similar admiration, in the *New York Times*, Ada Louise Huxtable praised Black Rock for being a "building, in a true classic sense," not a "cigar lighter, a vending machine, a nutmeg grinder" or any of the "large-scale commercial structures" that were designed to be a "handy commercial package."[123] In other words, to use Greenberg's famous formulation, Black Rock was avant-garde, not kitsch. Indeed, unlike the LA theme architecture that signified what the building did, or even the more subtle media architecture of Television City, Black Rock was designed as a monument onto itself.

Nevertheless, in the CBS vision, the antagonisms between avant-garde and kitsch were always balanced by a more expansive view of modern design as "showmanship." As with Television City's department store model, the whole building was also conceived as a public relations ploy and source of entertain-

ment for the TV audience. During its construction, instead of the makeshift stanchions, plywood, and planking typically used for pedestrian walkways, Dorfsman created a huge sidewalk exhibition space composed of illustrated panels and recorded messages of historic news broadcasts, presidential campaigns, and previews of the CBS fall lineup. Still, Black Rock never really was a "hit" with the public. As Huxtable noted, the skyscraper failed at a popular level: "The dark dignity that appeals to architectural sophisticates puts off the public, which tends to reject it as funereal." Chiding the American public for wanting only "bright and shiny" things made of "tinsel and tinfoil," Huxtable clearly sided with the sophisticates even while she admitted that the building was not, as Saarinen had hoped, a "soaring thing."[124]

The avant-garde vs. kitsch controversy surrounding Black Rock neatly summed up CBS's business dilemma since the early 1950s. Should a television network aim to please sophisticated business clients on Madison Avenue, or should it appeal to the popular tastes of a national audience? Should it be a prestige cultural center, or should it emulate the Hollywood movies and Broadway/vaudeville revues? Should it present modernist versions of Shakespeare in the round, or should a network build factory-like stages for Jack Benny and Dinah Shore? If Television City provided a functional space for the production of popular TV programs, its architectural form, and certainly the form of Black Rock, retained a deep investment in the modernist style and an erudite taste culture immersed in the pleasure of pure form. Even Black Rock's location suggested CBS's aesthete outlook. Situated between 52nd and 53rd Streets on the Avenue of the Americas, Black Rock was just across the street from the Museum of Modern Art. In the next chapter I'll cross the block to explore MoMA's vision for television production in 1950s New York.

4

••• LIVE FROM NEW YORK—IT'S MoMA!

Television, the Housewife, and
the Museum of Modern Art

In January of 1954, NBC presented "Modern Art on Horseback," a public-affairs show devoted to the subject of abstract art. Scripted by students at New York's Cooper Union Art School, and showcasing their abstract renderings of horses, the program nevertheless depicted modern art with the typical popular skepticism. The opening skit shows a husband and wife preparing for a day of cross-purposed leisure. While the housewife sets off for some brow-lifting pleasure at the modern art museum, her art-wary husband wants to see movies at the Bijou. "Modern art! Not that! Not that!" he protests when he figures out her highfaluting scheme. Unrelentingly, she insists: "You're going to catch up with the modern world! You're going to go in there! And you're going to like those pictures . . . if they *kill* you!" An off-screen narrator sums up the scenario, observing, "Sooner or later it happens to every man in America. Some woman decides that it's high time for him to see modern art." Despite this nod to the anti-modern crowd, the show goes on to convince home audiences (men and women alike) that modern art is in fact as fun as a day at the Bijou. Complete with an all-star lineup including popular actors Burgess Meredith and Hans Conried, as well as special guest star Dr. Seuss (who eagerly proclaims "I know very little about modern art"), this educational program made abstract art into popular TV entertainment.[1]

The students at Cooper Union were by no means unique in their quest to make art education entertaining. Nor were they the first to assume that women were more "artwise" than men. In fact, this program was part of a much larger cultural initiative—waged by traditional institutions of the arts—to make art appealing to the growing ranks of television watchers, and especially to housewives. Just as network television programs engaged audiences with spectacular displays of "vaudeo modernism" and thrilling melodramas about murderous painters, museums turned to television to court new publics. In the late 1940s and early 1950s, museums in New York, San Francisco, Detroit, Dallas, Boston, Buffalo, St. Louis, Los Angeles, Toledo, and other cities tried to use television as a form of popular pedagogy, hoping to teach viewers about their collections and encourage museum patronage. In the face of suburban expansion, these urban institutions of the arts saw television as a key tool in reaching the suburban family audience. And like the students at Cooper Union, these institutions also tried to increase their "fem" appeal by using entertainment formats aimed especially at women as the guardians of the arts.

This chapter considers how the worlds of museum art and commercial television collided in the 1950s and through the early 1960s. I focus on New York's Museum of Modern Art, which had a sustained and developed interest in using television to communicate the visual experience of looking at gallery art. In 1939, the year MoMA opened its West 53rd Street building (a starkly modern structure that Alan Wallach calls a "utopian" engagement with the technological future[2]), MoMA officials began to consider television as a technological marvel that might extend the museum's reach past its newly built doors. Consequently, in this same year, MoMA became the first museum in the United States to present itself in a television program. The program (broadcast live from the NBC studios) featured Alfred H. Barr (who was then MoMA's director) and newly appointed MoMA president Nelson Rockefeller discussing Brancusi's *Bird in Flight*.[3] By the late 1940s, when television began to enter American homes, MoMA was among the most enthusiastic players in the field.

Most crucial in all its endeavors were the museum's assumptions about the new suburban television culture and the domestic environment of reception. In attempting to use television as a forum for painting, MoMA officials continually stressed the need to reach the typical TV viewer at home. And rather then using educational broadcasting as their inspiration, they sought liaisons with commercial networks. By presenting art in the language of entertainment—and especially through televisual conventions of liveness and women's

genres—the museum hoped to establish itself as a commercial success in its own right. While now a forgotten chapter in media history, MoMA's early interest in television and its struggles with the medium suggest something of the complex relationship between fine art and commercial media in the postwar period. Indeed, the case of MoMA asks us to rethink the binary logic that pits television against art, domesticity against publicness, and entertainment against education.

As the bastion of the urbane world of modern art, and as a central institution promoting the male-centered canon of European modernism, MoMA nevertheless courted television audiences—especially housewives—in order to maintain its dominance as the leading museum of modern art (not only in the United States, but increasingly abroad). However, while recognizing the need to woo home audiences with entertaining programs, MoMA officials also expressed a great deal of anxiety about the effects their use of television might have on the museum's reputation and prestige among its traditional art patrons.

Certainly, this conflict was not new. The case of MoMA's Television Project is part of a much longer set of historical relationships among modern art, women, domesticity, and consumerism. As Christopher Reed argues, since the nineteenth century, modernist movements have depended on women, domesticity, and consumer culture for their patronage and cultural hegemony. Department stores, haute couture, and calendar art were among the greatest popularizers of modern art. But, at the same time, modern art and architecture have tended to "assert their accomplishments through contrast with domesticity," and artists, curators, and the art works themselves have expressed a great deal of anxiety about consumer culture, domesticity, and all things feminine.[4]

So, too, even while reaching out to housewives, MoMA historically promoted the view that authentic artists were men of white European decent. Although MoMA had by midcentury championed a new American avant-garde, as Gibson suggests, MoMA was actually part of the establishment art world and as such contributed to the male-centered canon of New York School abstract expressionism. As Gibson also claims, MoMA virtually erased the numerous women and African American artists who were also working within the context of abstract expressionism but who were typically exhibiting their paintings and sculptures in smaller galleries in New York.[5] In this regard, despite its forays into women's consumer culture, MoMA's exhibitions generally ignored women's artistic production and affirmed establishment views

of the artist as a heroic male type who rebelled against a "femininized" mass culture. The simultaneous embrace and "othering" of femininity, domesticity, and commercial women's culture is at the heart of the cultural struggle waged by MoMA as the museum attempted to juggle the cultural fields of popular media and modern art.

FROM PROP HOUSE TO IN-HOUSE
While television historians have focused on the networks' interest in Broadway theater and performing arts as sources and inspirations for early programming, we know very little about the role other cultural institutions played in the development of television as an institutional and cultural form. We know even less about the way television might have influenced the broader field of visual culture and traditional modes of gallery exhibition and reception. Despite the fact that cultural theorists have generally hailed the postwar period for its postmodern blurring of high and low culture, and despite the fact that critics widely view television as the postmodern medium par excellence, the actual historical links between television and the traditional cultural institutions of modernity are barely understood.

When it came to art museums, at least, these links were strong. In the early 1950s, museums across the nation took an interest in using television as a kind of second gallery, hoping both to educate viewers and to advertise the museum itself. Just as MoMA had opened its doors to the ADC award shows, in 1944 through 1946 MoMA hosted monthly meetings of the American Television Society, welcoming network presidents like Dr. Frank Stanton and Allen B. DuMont as well as a host of advertising executives, educators, creative artists, and technicians.[6] For their part, the networks encouraged these ties. Between 1940 and 1946 CBS partnered with the Metropolitan Museum of Art to experiment on broadcast formats and color transmission.[7] During the late 1940s, Paley attended meetings of the Television Committee of the citywide Museum Council, where he expressed CBS's strong interest in collaborating with art museums.[8] Moreover, Paley sat on the board of directors at MoMA and was instrumental in forming various partnerships between that museum and his network. Meanwhile, CBS's competitor NBC was just as aggressive about museum partnerships. The NBC records are full of letters from museum directors, artists, and other groups in the visual arts, and the network actively sought to co-produce and/or air programs with art museums. In short, the worlds of museum art and television joined together in mutual relations of support. As the assistant curator at the San Francisco

Museum of Art claimed in 1952, "Television programs presented during an eight month period reached approximately 1,500,000 people, or ten times the annual attendance at the museum."[9]

In 1948, even before most Americans had a TV set, MoMA aired programs in conjunction with NBC, CBS, and local New York broadcasters.[10] By 1949, the museum had increased its activities, participating in a television production about every other week. An internal report stated, "At the present rate of requests from telestations we will have participation in twice as many shows, or one a week during 1950."[11] MoMA's early participation in television was facilitated by the fact that local broadcasters and national networks were hungry for anything that could catch the visual attention of the viewer. So, too, as a center for production and as one of the first areas of the country with multiple television stations, New York City was filled with production companies hoping to capitalize on the new medium. As MoMA's public relations director, Betty Chamberlain, claimed:

> The tele situation here in New York seems to be going in all directions at once. Practically everyone in television has simultaneously and suddenly decided that there is great disgust on the part of the public at seeing nothing on television except sports. So they are all at once trying to discover uses for culture— or Kultur. Some new tele outfit, usually starting in someone's apartment, is springing up at least every week, and all these budding hopefuls came around to talk to me about the possibilities of art on television. But none of them have any ideas.[12]

In Chamberlain's view, the problem was that commercial broadcasters approached the museum as a prop house, an attitude that was perhaps best summed up by Paley, who reportedly told a museum official, "Just give us the material . . . and we'll put it on the air."[13] In distinction, Chamberlain and her colleagues at MoMA wanted to play an active role in program production by developing techniques through which to convey the importance of art to the public (and hence the importance of the museum itself). To that effect, one in-house report stated in 1949, "Although television may not reach huge audiences at present, it seems worthwhile for the museum to familiarize itself with the medium and to come to know what makes a good tele art program. This should put the Museum in a position of a certain amount of authority in the field, which may be valuable particularly when reproduction on television is improved and when color is introduced."[14] As this report suggests, MoMA saw television not simply as a venue for publicity or education, but as central to the maintenance of its own cultural power.

MoMA's interest in television was part of its more long-term democratic mission—since the 1930s—to court the general public, especially women (a mission which had previously led to complaints by critics that the museum had "vulgarized" art).[15] In 1936, MoMA reported that since 1930 it had "arranged and prepared more than 100 [radio] broadcasts on modern art."[16] Between 1943–45, the Metropolitan Museum of Art conducted a "Masterpieces in the Subway" campaign in which mass transit became a gallery for reproductions of canonical artworks that commuters could purchase via mail order for a small (ten cent) price.[17] With its 1942 "Road to Victory" show MoMA also reached out to a broad public, positioning itself as a space of citizenship open to a common cause. After the war, in the context of the postwar "art craze" and the surge in gallery and museum attendance, MoMA's patronage soared to unprecedented heights. In 1962, the Stanford Research Institute estimated that tourism at MoMA was "only outnumbered by the Empire State Building."[18]

While museum officials welcomed and certainly promoted this surge in museum patronage, they nevertheless were nervous about the tastes and decorum of their new museum publics. Continuing with the historical ambivalence (or outright antagonism) between modern art movements and women that scholars such as Reed, Huyssen, and Griselda Pollack have detailed at length, this postwar boom in art museum patronage left some museum officials anxious about what they perceived to be the unruly practices of their new female patrons.[19] In 1961, an executive at New York's Metropolitan Museum of Art noted that the rise in museum attendance had resulted in groups of "young mothers who don't understand why they can't wheel their baby coaches through the galleries." Met director James J. Rorimer further complained that the upsurge in museum attendance, "presents us with very many problems," and he especially singled out women's spike heels as "my bête noire."[20] Even if women wore flats, they posed a serious challenge to the visual dynamics of museum display. Rumors circulated about servicemen who "were drawn [to MoMA] less by a collection of interesting paintings than by the collection of interesting girls."[21] MoMA officials thought this tourist class of patrons was "a curious cat to skin."[22] Consequently, the museum studied their tastes and motives, and curators prepared exhibits with their interests in mind.[23]

In attempting to attract these wider publics, MoMA directors knew that their specialization in modern art posed unique challenges. Museum officials were aware of the fact that modern painters (especially abstract expressionists) were often the subject of popular mockery and/or associated with

communism and un-American values. They were also keenly aware of the fact that some U.S. senators and congress people were trying to stop the promotion of American modernism abroad. Opposing these government tactics, during the cold war MoMA championed the cause of modern art. Under the auspices of museum president Nelson Rockefeller (whose mother founded MoMA and who dominated the museum's direction in the 1940s and 1950s), MoMA was centrally instrumental in the efforts to embrace modernism and to popularize American painting abroad. According to Russell Lynes, MoMA's numerous international programs were directly political, intended as an antidote against the idea (widely held overseas) that while an economic superpower, America was nevertheless a cultural wasteland.[24] Eva Cockroft has further detailed MoMA's efforts to spread American modern art abroad, showing how these efforts dovetailed with similar strategies by the USIA and CIA (which also wanted to promote American art in the name of freedom), and especially flourished with Rockefeller's financial and political support.[25] In addition to Rockefeller, other leaders at MoMA were also invested in cold war cultural initiatives. Tom Braden, who went on to become a CIA agent and formed its International Organizations Division (the nucleus of the cultural Cold War), was secretary at MoMA in the late 1940s and the chair of the TV Committee of the Museum Council.[26] In general, during the cold war, MoMA's international programs were designed to disseminate the view that the new American art movements symbolized the utmost in individual expression in a free world, thereby embracing the ethos of corporate liberalism through which, Guilbaut argues, modern art and the American avant-garde were nourished in this period.[27]

Outside of these directly political cold war initiatives, the idea that modern art and design represented freedom and individual expression permeated much of MoMA's promotion to ordinary citizens. In this regard, it is not surprising that the appetite for modern art was especially associated with youth and progressive lifestyles. In 1952 MoMA began to allow museum members to borrow paintings, prints, and sculptures for their homes. Most of the borrowers were young people eager to try out modern abstractions and nonobjective art.[28] So too, in the postwar years, MoMA and other museums and galleries promoted modern furniture design as the signature style for a progressive housewife. In 1949, a number of New York City art museums (including MoMA) collectively mounted a series of lectures called "Home Fashion Time" with speakers on everything from furniture to textiles, while the Detroit Institute of Arts mounted a show it called "For Modern Living."[29] This trend continued through the 1960s when art and big industry

Chapter 4

were increasingly wed. By 1966, the Fibers Division of the Allied Chemical Corporation sponsored a gallery exhibition billed as "color happenings" that exhibited psychedelic art for the home and showcased a housewife who—like a performance artist—used slide projectors to change her décor so that she might "change her home as often as she changes her dress."[30] In all of these ways, museums and galleries made bridges between the world of art, everyday life, and consumerism, and promoted modern art within a vernacular mode that spoke the language of "ordinary" people—particularly the housewife. For museum curators, television (as the ultimate bridge to both everyday life and acts of consumption) seemed an obvious tool for the development and promotion of the visual arts.

Within this context, MoMA pursued television with four related aims. First, it attempted to intervene in policy debates regarding the future of commercial and educational channels. Second, it tried to create its own programs for commercial distribution (albeit within the confines of its nonprofit status as a public museum). Third, it hoped to devise television production techniques that would maximize audience pleasure. And fourth, it attempted to establish a television archive consistent with its efforts in the Film Library. Funding for these ambitious aims came in 1952 when MoMA received a three-year grant from the Rockefeller Brothers Fund to study the museum's relationship to television. Conducted under the auspices of avant-garde filmmaker Sidney Peterson and Douglas Macagy (special consultant to the director of the museum) the "Television Project," as it was called, became especially active in the area of in-house productions.[31] Peterson spearheaded a series of what the museum called "experimental" telefilms and oversaw museum production of various series on the arts. At a time when television's future was unclear, Peterson imagined the medium as an egalitarian art form, and he wrote a lengthy dissertation on its prospects—even likening the television image to the mannerist movement in painting. In addition to—and often at odds with—Peterson's more aesthete, if populist, vision, other participants in the Television Project also took part in the museum's more general interests in using television for education and publicity, an interest that was taken up by the education, design, architecture, and painting departments. (In fact, the only people who openly opposed television were the people in the Film Library, who were reputed to "hate TV." But even they eventually were active in archival projects.)[32] In all of these efforts, MoMA explored TV's role in teaching the public how to appreciate, consume, and look at art in the age of television.

Given these institutional ties, it seems especially curious that broadcast

historians have generally ignored the connections between commercial TV and art museums. In part, the reason for this is that the first major U.S. broadcast histories were written in the 1960s, at a moment when the reigning national discourse on television imagined commercial TV as art's opposite. I am referring, of course, to the FCC and chair Newton Minow's "Vast Wasteland" speech, which he delivered to the National Association of Broadcasters in 1961. The speech carved out a fundamental schism between commercial TV and the arts, a schism that focused debates on the medium throughout the decade. In this discursive context, broadcast historians (most notably Eric Barnouw) presented romantic tropes in which educators, journalists, and people in the arts assume the part of disenfranchised heroes who fight against the crass commercial industrialists.[33]

Yet, when we look at the historical record, there is really no evidence that people in the arts a priori resisted commercialism nor did they necessarily refuse to associate with popular cultural forms and practices. And why should they? Museums had previously accepted commercial sponsorship, and they were well acquainted with techniques of theatrical showmanship and department store display.[34] MoMA, for example, had a long history in trafficking with New York City's commercial culture. In the 1930s, the museum built a patronage for European modernism through tie-ins with department stores.[35] From this point of view, television seemed more a logical extension of the shop window than the classroom.[36] MoMA was aptly suited to the medium because of its historical commitment to industrial design and the display of everyday objects. A report in the museum files boasts, "MoMA . . . can always put something on TV due to its policy of interpreting the field of art to include household things as well as paintings, etc."[37]

MoMA's early efforts in television also challenge our present-day taste hierarchies and implicit cultural assumptions about the relative value of educational/public TV versus commercial channels. In fact, rather than embracing educational TV and public funding, notes in MoMA's files indicate that, with varying degrees of enthusiasm, museum officials had a clear preference for commercial broadcasting over educational channels, and museum officials even organized against state control of television in this regard. Certainly, the museum saw an economic advantage to commercial broadcasting. While educational programs required considerable subsidies, commercial TV would "allow the museum to operate on a "self-supporting basis."[38] But just as important, MoMA's commercial orientation was rooted in Depression Era struggles over radio that had already soured many in the arts about the

potential for grassroots educational channels. In the first four years of network television, the FCC "freeze" on station allocation made the possibility of educational broadcast stations even more remote. But even when the FCC lifted the freeze and allocated 252 educational UHF channels, people in the arts were often more interested in commercial stations and network delivery than they were in the prospects of educational channels. This was certainly the case with MoMA. When the freeze ended in 1952, Chamberlain (who attended policy-related meetings) sent a memo to museum director René d'Harnoncourt advising him: "The lifting of the freeze will make news. My feeling is that we should not release our TV plans in conjunction with this, or tied up with it at any time, because we should not let it be thought that we are planning our programs just for the educational channels only."[39]

What MoMA resisted was not educational channels per se, but rather *state run* educational television.[40] Thus, although the museum did support educational television under the banner of a New York City station, it opposed the board of regents' plan to build and control stations. Chamberlain kept vigilant notes on the meetings of the New York State Board of Regents in which she spoke constantly of her antagonism toward their plans for educational stations—an antagonism that d'Harnoncourt apparently shared. In Chamberlain's view, state-run channels posed the threat of censorship or at best bureaucratic governance of art education. In particular, she focused on the inferior level and indoctrinating effects of art education in the school curriculum, noting that the state had not "always been progressive." Moreover, she noted that the board of regents did not further the goals of MoMA's education department and had not been "receptive to our school's teaching methods."[41] With their zeal to provide the public with their own brand of art education, MoMA officials also knew that educational channels would not provide the large audiences that commercial television promised.

Given all this, MoMA officials thought commercialism was the way to go. It was simply a matter of figuring out how to fund the museum's commercial endeavors and still maintain nonprofit status. As one internal report of 1953 noted, we need "to discover the value of the institution as a commodity in the commercial field. Either we have such a value or we don't."[42] A few months later, Macagy wrote a self-congratulatory memo to d'Harnoncourt in which he spoke of a meeting with CBS that he had attended. In that memo he proudly claimed that MoMA was "in the position to talk the language of the network boys."[43] Clearly, the museum conceived of its educational function completely within the logic of commercial public relations.

THE HOUSEWIFE AND
THE CONNOISSEUR

In seeking bridges with commercial broadcasters, the museum made assumptions about its audiences and their tastes. Although the MoMA archive for the Television Project contains almost no concrete information on ratings and demographics, internal memos and reports continually hypothesized about audiences and what they wanted.

In his 1955 report, *The Museum Looks in on TV* (a book length manuscript written for the Rockefeller Brothers Fund), Macagy saw the TV audience as a special challenge for the traditional museum. His first chapter, "The Connoisseur and the Viewer," detailed broad differences between the traditional aesthete of centuries past and the contemporary TV audience. While the art connoisseur was "contemplative," the television viewer is "distracted," "busy with housework in the morning, or tired after a day at the office." If the connoisseur submerged himself in the artwork, the television viewer is "inattentive to the visual quality of the image" and instead responds to "movement and the story." While the connoisseur was "elite" and part of a minority culture, the television viewer is more "catholic" in his tastes. While the connoisseur was a solitary "gentleman," the TV viewer is a family (he spoke of the "suburban" setting) where women play a key role.[44] Calling television viewers "restless hermits," he conceptualized the audience as homebodies who used television as a means of diversion from domestic boredom more than as a tool for engagement with culture.[45]

If Macagy imagined the traditional art connoisseur as male and described (in clearly loaded terms) art's fate in the new suburban family context, his colleague Sydney Peterson had an even more explicitly gendered—and contrived—theory. In 1953, in a report written for the Rockefeller Brothers Fund, Peterson drew a sketch of the TV audience that portrayed the average viewer as both feminine (if not biologically then at least in spirit) and divorced from city life. Borrowing sociologist David Reisman's famous characterization of suburbanites as "the lonely crowd," Peterson argued that the audience for TV art programs was the "lonelier crowd"—a group of atomized isolated viewers who lived in suburban exile.[46] In his psychological profile of the average member of this lonelier crowd, Peterson argued that programs on the arts misunderstand suburbanites because they assume the audience is the "monstrously simplified figure of . . . a housewife" who is "profoundly uninterested in learning." While he agreed that "Men are not a significant audience for art programming," he attempted to come up with a less condescending attitude toward the viewer.[47]

In so doing, Peterson theorized—in a somewhat inexplicable move—that the audience for art programs was a "hermaphroditic family group with or without a child."[48] In describing this "androgynous adult" viewer, Peterson claimed, "The relative proportion of feminine to masculine attributes in the figure of the adult would be roughly two to one." To illustrate his position, he drew a picture of the housewife's brain. Outlined in pink crayon, the head was apparently feminine. Various regions of the brain were designated by different TV genres. In what looked like a coloring book version of phrenology-style "brow" charts, Peterson put the masculine-defined genres of news and "public issues" at the top of the head while the female-oriented "domestic issues" were positioned at the low end of the neck. By and large, however, the housewife's brain was colonized by commercials that were scattered throughout.[49]

To be sure, Peterson and Macagy formulated their views about the family audience for art within the broader context of the era's fascination with "taste"—and in particular the association of taste with vernacular arts and domesticity. This fascination was famously instigated by Russell Lynes's article, "Highbrow, Lowbrow, Middlebrow." Originally published in *Harper's Magazine* in February 1949 and then popularized by *Life* (in summary form) in April of that year, the article argued that while tied to economic class and profession, taste had replaced class to become the new mode of social distinction in America. "The old structure of the upper class, the middle class, and the lower class is on the wane," he argued. "It isn't wealth of family that makes prestige these days. It's high thinking."[50]

When *Life* presented its summary of Lynes's views, it included a two-page picture chart outlining the various taste levels.[51] The chart depicted everyday, vernacular objects. For example, while the highbrow coveted Eames chairs, the middlebrow liked Chippendales; while the highbrow wanted industrial objects like ashtrays from chemical supply companies, the lower middlebrows wanted his and hers towels; while highbrows went in for Calder, the lower middlebrows bought lawn ornaments; while the upper middlebrows sported quiet tweed jackets, the lowbrows wore old army clothes. In this way, the chart associated taste with the domestic and traditionally gendered objects of fashion and home décor. In fact, for Lynes, the mark of a true highbrow was that he had completely aestheticized everyday life. As he wrote, "It is this association of culture with every aspect of daily life, from the design of his razor to the shape of the bottle that holds his sleeping pills, that distinguishes the highbrow from the middlebrow or lowbrow."[52]

The sexually charged aspect of this highbrow fascination with the everyday was nowhere better stated than in Lynes's quotation of Edgar Wallace

who, when asked by a journalist "What is a highbrow?" answered "A highbrow is a man who has found something more interesting than women."[53] Here as elsewhere, the gender of the highbrow was male, even while his tastes seemed to be in the traditionally feminine realm of domesticity. This contradiction went beyond the stereotypical association of taste for décor and fashion with dandyism or gay sensibilities and into a highly ambivalent set of cultural vexations around what exactly constituted masculine and feminine dispositions in relation to the modern vernacular arts of postwar culture.

This enigma of the gendered nature of taste—coupled with more traditional class-based concepts of brow sensibilities—haunted the directors of the TV Project as they searched for ways to appeal to broad publics while—nevertheless—maintaining their legitimacy among their own traditional highbrow "art" publics. On this, Peterson and Macagy took clearly different views. While Macagy spoke with what Lynes would have called a highbrow's disdain for both middlebrow museum patrons (Macagy called them "the weekend throngs") and TV's "restless hermits," Peterson hoped to use television for the cause of art, and in particular he sought ways to address housewives (or at least his hermaphrodite viewer with a female brain) living in suburbia U.S.A.

Although Peterson's views were quirky, his basic assumptions about the female nature of the television audience also informed MoMA's more general attempts to promote modern art. As early as 1948, a museum report stated that MoMA had "participated in many daytime programs aimed primarily at housewives."[54] By speaking directly to housewives about homemaking concerns, the museum hoped to "educate" women about art's relevance to their daily lives. Yet, at the same time, given their views on the nontraditional, distracted, and feminized TV art publics out in the suburban hinterlands, both Peterson and Macagy deliberated on the most effective ways in which television should speak to these viewers, and in this regard they considered the kinds of programming formats and modes of narration that might keep audiences tuned to art programs.

In Macagy's clearly pessimistic view, the fate of art on television was compromised by at least three obstacles: the audience, the technology, and the commercial imperatives of the medium. Macagy speculated that TV viewers were averse to artistic contemplation. TV viewers, he opined, did not typically grow up in a home that cultivated the arts, nor were they even as artistically minded as the "weekend throngs" who came to the museum. "Although museums are used to dealing with people who are inexperienced in art," he argued, "there is a great difference between the person who goes to the

trouble of visiting a museum and the one who may choose to go elsewhere without moving from his living room." "Television's restless hermits," he continued, are "not content to meditate with the mind's eye." Instead, he argued, they have a "practical outlook" toward art.[55]

Although couched in clear disdain for it, Macagy's notion of the "practical outlook" seems somewhat a precursor to Pierre Bourdieu's concept of the "popular disposition": the attitude toward art that expects it to have a useful function, an immediate application to everyday life.[56] Macagy believed the audience's practical orientation toward art was aggravated by the fact that the technological/reproductive quality of the TV image was so low that TV could never offer a true aesthetic experience. Contesting those people at the time who predicted that TV would do for art what radio had done for music, he quipped, "Looking at a television version of a painting . . . is like listening to a symphony orchestra over the international telephone on a bad day."[57]

Moreover, he argued, commercial broadcasters fostered a "practical outlook" because, above all else, they wanted to turn aesthetic experiences into acts of shopping. Macagy directly tied this practical outlook—and the commercialism of the medium—to the industry's promotion of the live aesthetic and its forms of intimate address that made the viewer feel "there" on the scene of presentation. The whole tendency," he speculated, "is in the direction of reducing . . . 'psychical distance.' It is a concerted effort to identify what appears on the screen with the phenomenal scene of the living room. The viewer must be made to believe that he is the object of personal address. . . . part of the studio group. And the studio group, it may be recalled, is a unit in the elaborate economic machinery of commercial production for mass consumption." If this "gives him a gratifying sense of belonging," he continued, "it is because he likes to be part of a society bearing the values represented to him by industry." "The fabricated pictures the viewer sees," he concluded, "are calculated to put him right where commerce wants him to belong. . . . 'Immediacy' is a trite television myth."[58] In this regard, for Macagy, the contemporary zeal for "liveness," "immediacy," and "presence" among television producers and network executives was anathema to the museum's effort to create a sense of distance between the viewer and the work of art so necessary, he thought, for true aesthetic contemplation.

Although he did not mention Walter Benjamin, it is clear that Macagy thought television's electronic reproductions of art destroyed the sense of "aura" imbued by the traditional museum.[59] Whereas Benjamin believed the destruction of aura via mechanical reproduction might help to democratize art by making art both more available and less intimidating to broad publics,

Macagy thought that the museum's democratic mission was to disseminate aura on a mass scale. In Macagy's view (and the view of many museum officials of the time), rather than demystifying the value of the original artwork, museums would ideally turn everyone into aesthetes who contemplated art with the proper sense of awe and wonder for the singular masterpiece on view *only* in the museum. For Macagy, then, television's illusion of liveness, its practical/commercial orientation, its inferior technical reproductions, and its distracted suburban audiences made this sort of aesthetic contemplation impossible.

In light of all this, Macagy thought that rather than using television as a substitute for firsthand aesthetic experience, the museum could use television to fulfill its democratic responsibility to educate the public and lead them toward the virtues of art appreciation.[60] Nevertheless, just as they dismissed state-run educational channels, both Macagy and Peterson were particularly weary about what Macagy called "kindergarten classes of the air."[61] Macagy argued that while art critics should avoid conforming to broadcasting modes of personality and performance that are "embarrassing" to them, they nevertheless must leave their "museum manners" behind and find an appropriate way to perform their roles as experts for their new TV publics.[62] Peterson was especially adamant on this topic. He argued that the use of experts lecturing an audience was a "dangerous game." The connoisseurship of the mass audience," he claimed, "has a very different basis from that of the expert."[63] Peterson felt the art program should organize itself around popular entertainment genres, showmanship, and participatory modes of address. As an example he noted, "The most successful cookbook of the day is the *Joy of Cooking* and probably the most popular approach to painting is one of joy through looking."[64]

To be sure, some of these communicative styles had already been played out on radio. As Paddy Scannell argues in his work on BCC radio, "The communicative task that broadcasters faced was to find forms of talk that spoke *to* listeners, modes of address which disclosed that listeners were taken into account in the form of the utterance itself." "What this came to down to," he suggests, "was that broadcasters discovered that existing forms of talk [the lecture, the sermon, the political speech] were inappropriate for the new medium of radio." Instead of rhetorical forms designed for publics constituted as crowds, the BBC devised more informal modes of address that spoke to "each listener as someone in particular" in a vernacular language and with subject matter to which this ordinary listener could relate.[65] In a similar way, in the 1950s MoMA had to find a new visual vernacular so that art might speak to

individual viewers watching TV in their homes. In the process, museum officials discovered that existing modes of art education—the classroom lecture, the gallery tour, the slide show—did not interest the audiences to whom they now spoke.

In their quest to find a popular television format for art education, MoMA officials had examples to emulate. Even before the advent of television, in the 1930s MoMA developed popularizing strategies in its radio series *What's Art to Me?* (sponsored by the museum) and the first nationally broadcast art series, *Art in America* (underwritten by the American Federation of the Arts [AFA] and the Carnegie Corporation). One museum report advised avoiding "aesthetic theory expressed in philosophical terms." Instead, the report suggested, radio programs should make art relevant by connecting it to discussions of everyday life, by offering prizes in call-in formats, and by including listeners in on-air discussions in which ordinary people's "accents and grammar" would "not be put through the mangle before being released."[66] The *Art in America* series replaced experts with actors, attempting to make art (both modern and traditional art) entertaining and dramatic, and the series enjoyed popular success (listeners reportedly threw listening parties where neighbors gathered to hear the programs and the museum received over 4,000 pieces of listener mail in the first five weeks of the broadcast).[67]

In the early 1940s, the Metropolitan Museum of Art and CBS began to experiment with television broadcasting and devised ways to address the TV audience. Jointly directed by museum staff and cultural critic Gilbert Seldes (who also directed all program planning for CBS at the time), the Metropolitan Museum programs began with *The Arts in the Americas* aired over CBS's WCBW in 1941 (which then reached a very small audience of "early adapter" viewers).[68] The programs used popular subjects, but presented them in a static lecture mode that neither Seldes nor museum staff liked.[69] When the museum and CBS resumed experiments after World War II, they made more visually adventurous programs, using moving cameras and film inserts that "brought in other dimensions of time and space."[70] These programs also dealt with topics that would make art "accessible, enjoyable, and useful to the largest possible number of people."[71] For example, the 1945–46 broadcasts included a fashion show program using the museum's costume collections and featuring professional models. A museum report observed, "Such a show is a 'natural' for television."[72]

After the war, a number of museums around the country were designing art programs of the popular sort. In 1951, Allon Schoener, assistant curator at the San Francisco Museum of Art, produced one of the first successful

museum series, *Art in Your Life,* which included episodes such as "Furniture for Modern Living" aimed to "make art understandable and to demonstrate its importance . . . entertainingly, with no deviation from the standards from which we stand."[73] *Art in Your Life* was so popular that NBC executive Davidson Taylor spoke with Schoener about the possibility of producing an art program for the network.[74] The Museum of Fine Arts, Boston (BFA), also aggressively pursued popular formats. In 1953, the curator for the Egyptian collections appeared on Polly Huse's *Domestic Diary* program on WBZ-TV and, like the people at MoMA, the director for the Division of Education noted, "We have found that the commercial stations are increasingly cooperative."[75] By 1960, the BFA boasted of the popular success of Brian O'Doherty's *Invitation to Art* series (which began in 1958 on WGBH and was picked by the NBC flagship station in New York in 1960). The BFA also bragged about the popular success of a "'Whodonit' art quiz game . . . telecast from the lecture hall" starring O'Doherty trying to stump other museum staff.[76]

In seeking entertainment formats, museum officials knew that they faced stiff competition from "hobby art" programs on commercial stations that featured "telegenic" art teachers with audience appeal. Among these was television's most popular artist, Jon Gnagy, a self-taught "doodler" from Pretty Prairie, Kansas. Having worked as an art director at an advertising agency, Gnagy first appeared on television in 1946 in *You Are an Artist* (sponsored by Gulf Oil and aired on NBC's New York City flagship station, WNBT). By 1952 (when MoMA began its Television Project) Gnagy had already gained a wide following for his fifteen-minute shoestring budget show *Draw with Me.* In an interview with the *New York Times,* Gnagy admitted, "Let's not call my program art. . . . It's a fence-straddling combination of entertainment and education." The program featured Gnagy showing viewers how to draw owls, flowers, and other such realistic subjects step by step. According to the *New York Times,* "The only things [about the show] that could be called arty are the plaid shirt and the Van Dyke beard. This, however, is considered to be part of the showmanship."[77]

On the face of it, Gnagy's program seemed to be exactly what the people at MoMA had in mind—entertaining showmanship that encouraged the viewer to learn via participation. But, in fact, the people at MoMA thought Gnagy a bane to art education. The Committee on Art Education, a national group of 1,200 educators chaired by MoMA's director of education Victor D'Amico, adopted a resolution condemning the show.[78] The resolution, which they mailed to WNBT, proclaimed: "Television programs of the John Gnagy type are destructive to the creative and mental growth of children and perpetuate

"Midwestern Doodler" Jon Gnagy (NBC, ca. 1946).

outmoded and authoritarian concepts of education."[79] In this regard, although MoMA officials sought to educate via entertainment, they nevertheless distanced themselves from the likes of this Midwestern doodler. Once again, the problem was that MoMA had to balance its assumed role as a democratic cultural institution that engaged a broad public while still appeasing the aesthete and urbane dispositions of patrons and museum officials who had a considerable degree of antagonism toward popular modes of expression.

In order to balance these competing aims and publics, MoMA devised strategies by which to represent intellectuals in nonthreatening ways. As early as 1947, MoMA produced a film (in conjunction with Princeton University) titled *What Is Modern Art?* that depicted an artist giving a lecture on modern art to a rather skeptical woman who served as a kind of relay with whom equally skeptical audiences might identify.[80] Similarly, in a 1939 radio broadcast MoMA presented museum president Nelson Rockefeller chatting with the popular radio announcer/newscaster Lowell Thomas, who said, "Good evening, everybody. Maybe I am the right one to give the news slant, because so much about art is news to me. I'm the perfect layman, asking, what's it all about."[81] Peterson embellished this tactic for television. In art programs, he argued, "The audience should be represented in the person of an innocent bystander able to ask questions which might embarrass the emcee, who has,

after all, his personality, his public persona . . . to protect."[82] In other words, Peterson assumed that audiences would enjoy knocking the experts off their museum pedestals.

A good example of the host-humiliation technique came on October 16, 1954, when MoMA televised its twenty-fifth anniversary show. Hosted by d'Harnoncourt and director of museum collections Alfred Barr, the anniversary show appeared as an episode of the CBS public-affairs program *Dimension*. It was broadcast live and used liveness in strategic ways. In the opening sequence, d'Harnoncourt presents a Leger painting and is joined on stage by a professor from NYU's art history department. When the professor decides to show Stuart Davis's abstract painting *The Flying Carpet,* he suddenly realizes the painting is not in the room. With a look of puzzled embarrassment, he asks the cameraman to move to another gallery space where the painting hangs. But, unfortunately for the professor, more mayhem is in store. When the camera moves to the next gallery, it reveals a rather disheveled-looking TV floor manager hanging out in front of the painting, smoking a cigarette, so close to the canvas in fact that it appears he is going to burn a hole in it. When the floor manager realizes he is on live TV, he runs out of the frame. The befuddled professor then tries to make the best out of a bad situation and calls the floor manager back, asking him whether he likes the painting. The floor manager replies, "Uh huh, it's nice, it's big," to which the professor remarks, "You can tell us what you really think. Because if you don't like it, you won't be the first person who didn't respond favorably to modern art."[83]

If you haven't already guessed, this entire broadcast—mistakes and all—was scripted from the start. The floor manager was an actor. The shot of the floor manager running from the frame was listed as an "accident shot." The stage directions read: "Camera is seemingly bumped and viewer now sees part of the 'Flying Carpet' and Floor Manager, well to the left, [is] perplexed . . ." After the "accident shot," the professor would "laugh" and call the floor manager back to scene, reminding him (and, of course, viewers) "this is a very casual program."[84] The script was based on the assumption that the viewing audience did not like to be lectured by intellectuals, and as one report stated, the show ideally would give viewers the sense that the "audience [was] eavesdropping" on the conversation.[85] The program also anticipated what MoMA officials more generally assumed about the television audience's disposition toward modern art, as well as toward professors. The floor manager character takes the role of the skeptic, airing the then widespread populist distrust of modern art. Meanwhile, the professor is knocked down a few pegs because he has made such a terrible mess of things on live TV. Thus, the seemingly

earnest dialogue between the professor and the floor manager was nothing other than a staged act, more like a vaudeville routine than a classroom lecture. (Perhaps not coincidentally, Peterson later recommended that the art program's emcee "be able to play straight man to the other straight men.")[86]

Insofar as Peterson and other officials at MoMA especially targeted the housewife, they used similar scenarios of staged spontaneity in art programs aimed specifically at women. Moreover, rather than simply simulate causal talk (as in Scannell's radio examples) MoMA officials tried to simulate "girl talk." In these programs the housewife trumped the expert, becoming a kind of everyday critic whose practical homemaking experience and feminine sensitivity gave her a kind of arty "horse" sense that the educated (mostly male) experts lacked.

The television publicity surrounding MoMA's Good Design exhibition is a perfect case in point. A 1953 museum proposal called for thirteen half-hour programs directed by Edgar Kaufmann Jr. (director of Good Design at MoMA). The budget submitted by the production company being contracted to make the telefilms stated, "The films are to stimulate, as far as possible, the intimacy and spontaneity of a 'live' TV show."[87] Kaufmann's treatment for the series sheds further light on the way this sense of intimacy and spontaneity was used to simulate casual conversation among the hosts and female audiences at home. According to the treatment, the introduction to the series would be filmed at MoMA and would present the selection committee (composed of artists, designers, and museum experts) "sitting on a lounge with six superb objects." Just after this, the "female influence [would be] brought in" by a character who was a "homey type."[88] This attempt to create a sense of dialogue between the expert and the housewife was key to the rhetoric of MoMA's TV efforts.

Although the films for the show never materialized, the Good Design exhibit was publicized in 1954 on a two-week series of live spots that appeared on Margaret Arlen's CBS morning show. The show was "addressed to [the] morning housewife audience."[89] Once again, the spots were scripted, even while they had the feel of spontaneous conversation. The proposal for the morning spots called for a "cast" that included a "bright housewife (amateur?)" character who would ask Kaufmann questions.[90] Like the floor manager in the twenty-fifth anniversary show, this character was probably intended as a stand-in for the naive viewer. But unlike the rather déclassé floor manager—and as the parenthetical "amateur?" phrasing indicates—she was probably designed to flatter the audience by being a little more art-wise than the average housewife. When they went to air, the Good Design spots used

a more pared down interview format with Kaufmann, Arlen, and a "guest" designer, but they retained their homey appeal. The script for the March 17, 1954, broadcast text called for a "living room type set" where Kaufmann appeared as Arlen's guest. It was probably no accident that the program (and others like it) included women designers. The Good Design spots further encouraged viewer identification and participation by informing the audience that the objects on display were, as Arlen pointed out, "available to everybody—at every price."[91]

In programs like this, MoMA's weekly ventures on morning and daytime TV were part of a more general set of cultural strategies that linked fine art with homemaking practices. These strategies complemented the museum's gallery exhibitions on modern design, and they resonated with magazines, books, and newspaper stories that advised homemakers how to hang paintings as an element of interior décor.[92] So too, MoMA's television programs used narrative strategies found in network cultural-affairs programs that associated art with the everyday life of the middle-class homemaker. The "visit to the artist's home" format (in, for example, the *Omnibus* episode featuring Benton or the *Person to Person* episode featuring Rockwell) provided viewers with a sense of "dropping in," not only on the artists and their families, but also on the artwork itself. Like the "eavesdropping" theme in the anniversary show, this was a non-didactic form of documentary; any lessons learned about art seemed more coincidental than planned.

By the early 1960s, the non-didactic imperative led to the presence of women hosts and art critics turned "fem-cees." NBC's Aline Saarinen was the first art critic to be hired for regular appearances on a network program. She appeared in short segments of the morning show *Today*, and she also hosted and scripted episodes of NBC's *Sunday* program (a public-affairs show) as well as numerous critically acclaimed art documentaries. By 1964 she became the third woman correspondent for NBC News.[93] Although she was an intellectual (she had been an arts editor and reporter at the *New York Times* and *Art News*, and had authored the bestselling book *The Proud Possessors* [1958]),[94] Sarrinen often commented on her dislike for educational TV. In 1953, when the Ford Foundation paid Saarinen to come up with ideas about how to portray art on educational channels, she (with the help of her architect husband, Eero, and friends Charles and Ray Eames) outlined a plan, but the Ford Foundation "said the ideas were too far ahead."[95] Like the people at MoMA, Saarinen understood that intellectuals did not go over well on television and she insisted she was an "entertainer" rather than a "stuffy" critic.[96] "It's fun to be talking in the vernacular," she said in an NBC press

release for the *Today* show. Portraying her audience as "men shaving in motels [and] women doing their housework," she insisted she never "tried to talk down to anybody."[97]

Despite her preference for casual talk, Saarinen exuded an aura of cosmopolitan sophistication to which other women could aspire. Even before her television appearances she wrote stories on architecture, art, and travel for magazines like *Vogue* and *Cosmopolitan*, which also spoke to modern women with class aspirations. Building on her sophisticated womanliness, on *Today* Saarinen combined discussions of artists and architects with the more everyday subjects of interior décor, fashion, and etiquette. NBC promoted Saarinen as the ultimate art show "fem-cee," and critics consistently focused on her womanly wiles, referring to her as "tall, trim and talkative," "brilliant, sexy, [and] fascinating," "a pretty little whippet under a puff of yellow hair," and "the sweetheart of public affairs."[98] Working in the context of the male-dominated News Division at NBC, Saarinen seems to have used her womanliness to her own advantage. In press interviews, she said that her girlhood goal was to be "intell-uptuous."[99] This carefully blended potion of sex and smarts made Saarinen appear as the ultimate "modern woman," and her flair for haute couture gave her a Jackie Kennedy appeal.[100] Time and again, her fashionable femininity caught the eye of critics just as much as (or maybe more than) the art she presented. She appeared "looking comely in a bright red Dior suit," wearing "shocking pink" while "strolling with grace" through the Israel Museum in Jerusalem, and "dressed to the teeth . . . in the Lobby of the new Culture Center in Los Angeles."[101] Maintaining her dignity through it all she told *Time*, "I'm a woman, but not a chick."[102]

Given her "fem appeal" and her penchant for showmanship, it is not surprising that MoMA asked Saarinen to host its 1964 television program inaugurating its newly opened east wing and renovated sculpture garden designed by Philip Johnson.[103] The shooting script includes opening introductions in which Saarinen expresses the views of the "doubting Thomas" crowd through an intimate conversation that paradoxically reasserts the "auratic," awe-inspiring function of the museum while instructing viewers to feel comfortable with modern art. When co-host Frank Blair asks her "What has the museum meant to you, Aline?" she responds, "So many things, Frank. The first modern art I ever saw was in this museum. I've had so many different feelings here . . . shock . . . surprise . . . irritation . . . puzzlement. And pleasure and awe and wonder too."

Saarinen and Blair proceed to minimize the shock and maximize the pleasure by taking viewers on a whirlwind tour to the home studios of Henry

Moore (in the English countryside), Marc Chagall (pictured at home with his wife in the south of France), Alberto Giacometti (in Paris), Alexander Calder (with his family in the green farmland country of Sache in Touraine), Joan Miró (with his wife on the island of Majorca), and Stuart Davis (in his Manhattan apartment, watching television with the sound off). In her interviews Saarinen focuses on homey, feminine things, by, for example, displaying Miró's mural of his grandchildren or talking with Louise Calder about her "hushed pink and rose" outfit and her hobby art passions for making crochet gloves and hooked rugs. Sandwiched in between this "visit to the artist's home" extravaganza, Saarinen and Blair manage subtly to squeeze in a lecture about all the great European modernist art one can see at MoMA; but rather than delivering this in a didactic sermon mode, they do this while chatting in a French café and showing sweeping panoramas of Picasso's house.[104] Although *Art in America* noted that the sight of the "chic slight blonde talking to you next to a huge Henry Moore" could be "a distraction" from the artworks, this and other reviews applauded the MoMA program as a visual feast of camera work and artistry.[105] More generally, Saarinen often took an active role in consulting on the shooting script, and critics often praised her keen eye for cinematographic translations of paintings, so much so that one critic even called her the "female Fellini."[106]

In addition to attracting audiences and winning critical acclaim, from the networks' point of view, museum programs of this spectacular nature were a boon to the sale of color television sets and to the acquisition of sponsors (who thought color television would be a better sales environment for products). As early as 1950, the networks used both MoMA and the Metropolitan Museum of Art to test their color systems over local stations. Broadcast in 1954, NBC's first nationwide color-compatible show was titled "A Visit to the Metropolitan Museum of Art."[107] Not only was the show a promotional tool for NBC's parent company RCA (which had recently won the government patents for the standard color system), it also served the museum's interest in courting a nationwide audience to visit its newly renovated galleries.[108] The following year MoMA jumped on the color bandwagon when Alfred Barr appeared on a special color segment of NBC's *Home*, an afternoon program aimed at housewives. Host Arlene Francis opens the segment, saying, "Our next feature will be televised in both color and black and white . . . using the RCA Compatible Color Television System. And owners of color sets are in for a real treat, because today's subject is modern art." Barr displayed the work of artists known for their use of color: Kandinksy (*Improvisation*), Chagall (*Birthday*), Dove (*Grandmother*), and de Chirico (*Anxious Voyage*).[109]

The use of paintings to promote color television grew even stronger in the mid-1960s when all three networks were making the transition to full-color schedules. In a 1965 speech before the Friends of the Whitney Museum, NBC chairman Robert Sarnoff stated the connection between his network's goals and the prospects for museums in no uncertain terms. "Color television is enjoying a fantastic boom," he boasted. "So is art. Both are interrelated."[110] Under the rubric of its "In Living Color" campaign, NBC aired documentaries on national art museums, including shows on the Louvre and the Kremlin as well as Saarinen's programs on the Whitney Museum of American Art ("The American Image," 1967) and the Metropolitan Museum of Art ("Marvelous! Magnificent!" 1970).[111] When promoting "Marvelous! Magnificent!" Saarinen told *Time*, "We're doing a variety show, with art as the 'acts.'" Elaborating on the program's pop sensibility in the *New York Post*, she claimed, "I wanted to try techniques we use in commercials and in *Laugh-In*."[112]

Saarinen was not the only woman to serve as a popularizer for these "blockbuster" TV museum shows. In the 1966–67 season, when all three networks switched to full-color primetime lineups, this popular commercial sensibility came to a dramatic pitch when the Philadelphia Museum of Art became the stage for the CBS special "Color Me Barbra" featuring superstar Barbra Streisand. Act I is set in the museum galleries where Barbra takes the role of a French chambermaid who cleans the museum at night. As she stops to contemplate the artwork, the paintings come to life, and Barbra (seemingly a victim of Stendahl Syndrome) projects herself into the canvas. For example, when she arrives in a gallery full of abstract art, Barbara sheds her black and white French maid outfit and reappears in a colorful halter gown that mimics the abstract patterns in the paintings. Dressed as a canvas, she then performs a modern dance routine. In another sequence, Barbara takes a more somber tone. After looking a little too long at a Modigliani painting, she becomes the girl in the picture, enters a set made to look like a Parisian café, drinks a glass of wine, and belts out the French lyrics to "Non C'est Rien." Obviously recalling the famous "painting come to life" sequence in Vincente Minnelli's *An American in Paris* (1951), the program served as a not-too-subtle ad for color TV. While set in the staid space of an art museum, the "art into life" conceit not only provided a stage for colorful performance, but also a reason for constant costume changes. As with Saarinen, only in a much more exaggerated way, the program doubled as a fashion show in which paintings and haute couture shared the stage.

Interestingly, as well, given MoMA and the networks' early attempts to use the popular vernacular to appeal to audiences, act II of "Color Me Barbra"

is set in a circus. In other words, just in case the museum's largely European collection was a turn-off for the non-art crowd, the producers provided a true form of Americana. In fact, the program is quite self-reflexive about this. In the opening part of the circus segment, Barbra greets the audience in French. English subtitles appear on the screen. However, her Frenchness turns out to be a vaudeville gag as she breaks out of the French language to return to her Jewish-American persona. Now, as she switches back to English, the subtitles turn to French. The circus act, then, neatly undoes all the pretensions of her previous visit with European art. As a whole, "Color Me Barbra" is a perfect example of both the museum's and network's aim to present art through vernacular genres, a sense of live performance, and a special appeal to the female viewer.

FROM PROP HOUSE TO FLOP HOUSE

By the time "Color Me Barbra" made its way into American living rooms, art (like everything else on TV) had become a network-controlled affair. MoMA, in fact, ended its entrepreneurial efforts in the mid-1950s, leaving behind barely a trace of its once grand designs for in-house productions. Indeed, despite MoMA's early interest in television, the new medium posed obstacles to the museum's traditional function as a bastion of modern art. While MoMA (and other museums) often complained of practical problems (such as television's inferior reproduction techniques or the fear that artworks would be damaged or even stolen by production crews), these were considered stumbling blocks that might be overcome. But the one problem that seemed insurmountable was, ironically, the very thing that the Television Project was designed to master: commercialism. Despite MoMA's rigorous efforts to establish links with the industry, the commercialism of the medium and the widely held prejudices about its audiences made people at the museum nervous.

As early as 1948, officials at MoMA spoke of the need to counteract a "tendency [in the industry] to relate the museum or the works of art . . . with the advertised product," and they also refused to appear in programs that "seemed totally undignified" or "ridiculed" art in some way.[113] A good example came in 1951, when d'Harnoncourt received a letter from CBS executive Fred Rickey asking him to lend Picasso's *Girl Before a Mirror* for a local afternoon program that would test the network's color TV system. The color broadcast would feature popular TV entertainers Arthur Godfrey, Ed Sullivan, and Faye Emerson as well as high-art fare. (The Metropolitan Museum of Art had already loaned Renoir's *By the Seashore* to CBS.)[114] Apparently,

Barbra Streisand's dress matches the paintings as she sings and dances in the Philadelphia Museum of Art (*Color Me Barbra*, CBS, 1966).

Barbra Streisand in act II of *Color Me Barbra* (CBS, 1966).

d'Harnoncourt found the request of great importance because he turned the letter over to Alfred Barr (who, then director of museum collections, typically was not involved in issues of TV publicity). Barr agreed to loan the painting with strict provisos. First, he stipulated that because Faye Emerson was "not herself well informed about pictures" the museum would require her to consult with a representative from MoMA. Second, he insisted that the artwork should "not appear in the same image with the advertising material, which I believe is a Pepsi-Cola bottle, and that there would be no direct connection made between the museum's loans and the advertising commercial."[115]

The tensions expressed in this incident permeated the entire atmosphere of MoMA's Television Project in the next three years. The most serious problems arose around the production of the in-house experimental programs. While MoMA's education department enjoyed both popular and critical success with its 1952 children's series *Through the Enchanted Gate* (which aired nationally as a public-affairs program on NBC), the series that Peterson produced with the Rockefeller monies led to heated disputes.[116] More

The Invisible Mustache of Raoul Dufy, TV program conceived by Sidney Peterson for MoMA with UPA and NBC.

hopeful than Macagy about television's possibilities for the museum, Peterson thought that television had much in common with painting (especially mannerism), and he hoped these commonalities might be used strategically to bridge the art world with consumer culture.[117]

His first venture was an animated children's series he called *They Became Artists*. Above all, it was an attempt to explore the marketability factor. To produce the series, Peterson orchestrated a four-way deal between the museum, NBC, the artist Marc Chagall, and the independent Hollywood animation company UPA, which produced the cartoons *Mr. MaGoo* and *Gerald McBoing Boing* as well as the innovative television commercials discussed in chapter 1. Legal complications with Marc Chagall and the difficulties of coordinating agreements among the numerous parties involved doomed this project to failure. Although a film about Raoul Dufy was completed, in the end, as one report put it, "The museum directors felt that it did not further the cause of modern art, and though Dufy transparencies were used they could not see that there was enough art in it to warrant giving it a museum label."[118] Consequently, the museum returned the film to UPA and stipulated

Chapter 4

that MoMA's name never be used in connection with it. Despite the fact that NBC offered to continue with the UPA series (as well as to collaborate on two other museum projects), MoMA declined the offer.[119]

The second project, a series of telefilms titled *Point of View*, was similarly disappointing. Conceived as a series of fifty-two or more programs, each fifteen minutes in length, the programs were to be "filmed for either network broadcast or syndication."[120] Although commercial in nature, the series experimented with the expressive aspects of the medium in ways Peterson thought would combine aesthete sensibilities with television's popular aesthetics and commercial logic. The basic goal of the *Point of View* series was to "present the city itself as a work of art" (and in this regard the series echoed previous documentary/avant-garde city films). In addition, it was designed "to cope with the problem of using TV, as in effect, an additional gallery. . . . with the programming requirements of the commercial medium."[121] In 1955, the project was further described as an attempt to use André Malraux's dream of a "'museum without walls' . . . in the interest of getting closer to a hypothetical TV audience."[122] As these descriptions suggest, Peterson seems to have assumed that because commercial television privileged a sense of liveness and focused on everyday subjects it was fundamentally hospitable to his (and his colleagues) wish to make the public see the "spirit of art" in the objects of everyday life. He thought he could create experimental documentaries that would run on commercial stations while also fulfilling the museum's aesthetic disposition. Trying to bridge the two domains, Peterson wound up pleasing no one.

The seven-minute pilot, "Architectural Millinery," was "a study of hats and roofs in New York and elsewhere."[123] The film made visual comparisons between skyscrapers and headgear, forcing the spectator to see the city from an aerial perspective. Museum staff and directors regarded it as a failure; nevertheless its basic goals were considered promising, and Peterson resumed production on the series. The second film, "Manhole Covers," took the opposite point of view, picturing New York City as seen from the underground perspective of sewers.[124] The film opens on a shot of MoMA's exterior after which it cuts to a camera that emerges out of a manhole. The narrator states, "And there is another museum, which is the city of New York itself."[125] In many ways, the film reads as an experiment with form, using exaggerated camera angles and montage to produce something of the "shifting planes of reality" that Peterson thought television had in common with mannerist painting. But, despite his interest in formal experimentation, Peterson was hoping to achieve popular appeal by taking a "light and witty approach to the props of

everyday life."[126] Attempting to "arrive at a kink of commentary somewhat less didactic than is the case with the usual documentary," he used the radio/ TV comic Henry Morgan as the narrator.[127] In addition, he intercut the film with silent footage from Charlie Chaplin shorts and the "Pumpkin Race."

Peterson's divided sensibility was immediately rejected by the museum. An internal museum report on the *Point of View* series states, "The series brings up for the nine millionth time the question of the audience. Whom are we trying to attract. . . . the great majority of people who come to the museum can be figured to have a reasonable amount of education. The audience cannot be supposed to have the same."[128] But it was not just that the museum thought the films were too "difficult" for the TV crowd. Instead, MoMA officials seem also to have feared for their own reputation. "The Museum . . . seemed to feel . . . that by affixing its signature to either of the films the Museum would be thought to be endorsing the architecture of the buildings or lowering its intellectual level by inducing people to look at manholes."[129] In March of 1955, MoMA sold the films to the Mavro Television Company with the proviso that the company "agrees to make no reference to, nor use the name of the Museum of Modern Art in the films themselves, nor in any advertising, selling, or promotion of these films nor in any other manner whatsoever."[130]

While it is obvious that Peterson seems to have been somewhat misguided, or at least out of touch with the tastes of MoMA's directors, the situation more generally highlights the complex tensions that existed between the museum's commercial goals and its desire to maintain cultural legitimacy. The case also suggests that while both commercial TV and the art world wanted to make art more relevant to life, art and commerce still distinguished themselves in important ways. TV liveness and the industry's focus on everyday domesticity was simply not the same as the art world's desire to make patrons understand the relevance of modern art in their lives. While at times the two institutions cooperated in mutual relations of support, at other times the goals of the art museum and those of the television industry were completely different in nature. At still other times, the two institutions feared that such collaborations would weaken their legitimacy within their respective cultural fields.[131] As Pierre Bourdieu has taught us, the journey from one cultural field to another can sometimes result in a loss of prestige and power for the person who dares to cross the line.[132]

ART LESSONS

MoMA's short-lived romance with television, and its fears about its own cultural devaluation, attest to the difficulties that traditional institutions of

culture had when attempting adjust to the demands of television. While the museum initially saw itself as part of a TV avant-garde, it eventually threw in the towel and adjusted itself to a more backstage role. Macagy's 1955 report declared that MoMA had shut down in-house production indefinitely. Notably embittered, in 1957 Magacy wrote an article for *Art in America* summarizing his report and sharpening his criticisms about television's crass commercialism and its negative reflection on museum values. Despite MoMA's numerous forays into women's programs, Macagy harshly attacked museums that "lent their names, members of their staffs, and works of art for appearance on the morning show called 'Home,'" which he said was "cunningly contrived to titillate the social aspirations of a large female audience" by showcasing commercial products with "rhapsodic glamour." "From the standpoint of the museum," he continued, NBC's *Home* "could hardly seem more than a dubious essay in public relations. The candle-power spent is worse than worthless as it places art in a false light."[133]

Despite Macagy's ire, MoMA did continue to use television as a publicity vehicle for the museum and for its own vision of modern art. A perfect example came in 1957 when MoMA hosted an episode of CBS's new cultural-affairs program *Odyssey*. Titled "The Revolution of the Eye," the program was essentially a more straightforward educational version of Peterson's *Point of View* series, focusing on the way modern art had revolutionized ways of seeing. Its entertainment "hook" was the presence of Hollywood actor and art collector Vincent Price, who had just soared to popular TV fame in front of an audience of some fifty million people on the *$64,000 Challenge* in a battle of the art wits with actor/art lover Edward G. Robinson. When speaking at a 1957 banquet held by the American Federation of the Arts (at which Marcel Duchamp and Meyer Schapiro also spoke), Price enthusiastically told his audience about the upcoming *Odyssey* episode. According to Price, upon learning that "The Revolution of the Eye" would be the episode's title, "I said, 'It's wonderful. It's terribly exciting. What the hell does it mean?'" This and other jocular jabs at the intelligentsia sent waves of laugher streaming through the audience (composed largely of art dealers and collectors).[134] Once again, the worlds of TV entertainment and New York museum culture may have collided, but their liaisons were fraught with tensions between popular and aesthete sensibilities. In this atmosphere MoMA accepted its subordinate role as "content provider" for network TV, relinquishing their own in-house productions and Peterson's neo-Dadaist attempts to mix art with everyday life.

To be sure, it was not just that MoMA shied away from television production. As network production moved from New York to Hollywood and

as the major Hollywood film studios solidified contracts with the networks, MoMA's chances to compete in the commercial arena were fading fast. Macagy's 1955 report admitted that most art shows were sustaining unsponsored programs that lost money for commercial broadcasters. The ratings were characteristically low.[135] Television remained an inferior means of reproduction, and, like Macagy, many felt that it did not promote an aesthete sensibility in the observer. In addition, as the museum fully realized the legal difficulties involving copyright and the privacy of artists (problems that Peterson specifically addressed in an appendix to Macagy's 1955 report), the prospects for the Television Project seemed dim.

But even while MoMA did not come out the victor, its early participation in television provides clues about the broader historical relationships between modern art and commercial media culture in postwar America. First, as the evidence here suggests, the "postmodern" blurring of high and low was not simply achieved through some general postwar condition of late capitalist production which is then expressed in cultural styles. Too often, discussions of postmodern visuality lose all sense of historical agency and events that might explain the circumstances under which high and low came into cultural contact. At least in this case, the evidence suggests that any mergers that took place were part of concrete historical struggles. The art world maintained its distinction from the world of commercial television, even as it sometimes merged with the industry in vested interests. In fact, the maintenance of this distinction in the face of a booming media culture was one of MoMA's central concerns.

Beyond this, however, this case also raises questions about the ways in which the visual arts and gallery exhibitions themselves changed in relationship to new forms of expression on television. TV's kinetic liveness and participatory modes of audience address dovetailed with movements in the art world including action painting, performance art, and happenings—all of which variously foregrounded liveness, intimacy, and participation. So too, TV's presentation of amateur art and its address to housewives as amateur designers dovetailed with the art world's increasing problematization of the relationship between amateurism and professionalism. Its presentation of domesticity and commercial imagery is consistent with pop and assemblage art's fascination with household products and industrial production (and, as several art historians and museum exhibits have shown, pop artists used television as subject matter in their work).[136] Finally, although in complex ways, its address to women dovetails with women's own increased participation in the art world. While I am certainly not suggesting a direct causal relationship

between television and postwar art movements, it does seem important to consider how television's ways of looking at art—especially its use of liveness, participatory modes of address, and vernacular women's genres—might be related to changes in the public perception of art, the artist's own perception of her/his craft, and the physical spaces of gallery display.[137]

After 1955, MoMA was less interested in using television as an electronic extension of the gallery than it was in collecting television as an art object in and of itself.[138] Although Richard Griffith, director of the Film Library, was initially hostile to television (stating in 1952 that he would tolerate MoMA's interests in television only "as long as it is not [in] the same department as the film library"), by mid-decade he recognized the economic value that television might have for the library, particularly with regard to potential rental requests for footage.[139] In addition, Griffith had to respond to the wishes of museum directors, board members, and most importantly the museum's founding family, the Rockefellers. As early as 1952, Nelson Rockefeller wrote to d'Harnoncourt suggesting that the museum put on an exhibit featuring "the best in TV (films or kinescopes)."[140] Upon hearing of Rockefeller's suggestion, Griffith acknowledged that the museum might consider using some television films or kinescopes in a film retrospective. But, in keeping with his fear of vulgarization, Griffith suggested that films and kinescopes should be "only the best, very short, and constituting the museum's explicit endorsement of the kinds of art film-making they represent, with an implicit denouncement of other kinds."[141] In other words, Griffith wanted to make sure that television would not pollute the Film Library's image as a "tastemaker," a reputation which, as Haidee Wasson has shown, was crucial to MoMA's Film Library since 1935.[142]

In 1962, one year after Minow's "Vast Wasteland" speech, MoMA's Film Library held a retrospective of "golden age" programs it called "Television U.S.A.: 13 Seasons." Given the museum's "live from New York" bias, it is perhaps no surprise that most of the programs chosen for the exhibit were New York–produced live anthology dramas, live variety shows, news and documentary series, fine art performances, and other programs on the arts. *Gunsmoke* was the only Hollywood series included in the show. The program book for "Television U.S.A." suggests some of the fundamental ambivalence MoMA officials had toward commercial television by this point. The book stated that television was divided in "two camps": the industry that is concerned with money and "artists and journalists whose standard of 'success' is the degree to which television realized its potentialities as an art form."[143] Given this statement, it is most paradoxical that "Television U.S.A." also

included commercials in the exhibit. In fact, the program book stated, "Almost everything has been tried to create original commercials. As a result, radical avant-garde experiments which would be frowned upon in other areas of television are encouraged in this field."[144] Consequently, "Television U.S.A." exhibited everything from Brewer's beer to Rival dog food ads as proof of television's potential avant-garde status.

Why did MoMA reject commercialism, but honor commercials? MoMA's embrace of commercials was based on its historical willingness to display industrial design and advertising art (as, for example, in its previous ADC award shows and its UPA exhibit). In fact, the cover art for the program book for "Television U.S.A." was Ben Shahn's CBS ad *Harvest* (his abstract drawing of crisscrossing TV antennae). Moreover, MoMA's view of commercials as avant-garde art coincides with its embrace in the early 1960s of pop and assemblage art. (In 1961 MoMA mounted William C. Seitz's "Art of Assemblage" and by 1962 MoMA held a symposium on pop.)[145] In this respect, although MoMA and the Film Library still operated on enlightenment ideals of cultural edification, the museum also responded to the shifting nature of art discourses and practices, particularly the leveling of "high" and "commercial" genres that was so important to pop aesthetics. "Television U.S.A." reflected the museum's ambivalent and competing claims to popism's aesthetic embrace of the commercial and the Wasteland Era's anti-commercial ideals.

Five years after the retrospective, in 1967, MoMA opened its Television Archive. By this time, however, MoMA had greatly narrowed its goals. Rather than saving TV programs as "art" and deliberating on television's aesthetic virtues, the Film Library primarily sought to become a clearinghouse for TV art documentaries, by far a much less controversial endeavor. By the end of the 1960s, the museum had effectively shut down all aspects of the Television Project's original impetus to explore TV's artistic potential. Instead, by the early 1970s, MoMA embraced the emerging world of video art, engaging a more narrowly defined "art" public and leaving behind its dream to reach large audiences with commercial TV.

This shift from TV to video was officially inaugurated in 1974 when MoMA invited artists, museum curators, and critics to "Open Circuits: An International Conference on the Future of Television." The conference would become a hallmark event in the elevation of video art to museum-art status, and despite the conference's subtitle, television seemed to have no future at all. At that conference video was established as Art (with a capital "A") largely through assertions of its difference not just from television's commercialism, but also from television's domestic, everyday, feminine status. Indeed,

MoMA's embrace of video art degraded television by aligning it with femininity and the home. In his essay for the book that came out of the conference (*The New Television*), Gregory Battcock spoke of early television as part of the "mother form" of architecture. Noting new developments in both portable cameras and video aesthetics, he stated: "By moving the television set away from the wall one moved it away from its mother." And this move away from the mother ushers in an "era of visual video communication of importance equal to that of the sculptural communication begun in ancient Greece."[146] Even more explicitly anti-feminine in its logic, the blurb on the back of the conference book declared, "*The New Television* reflects deep concern for TV's present condition and submits proposals for reviving a young and already *emasculated* medium."[147]

It is no small irony that this trivialization and feminization of television should take place at MoMA, a museum that had previously attempted with great rigor to further the cause of modern art by courting the commercial television audience, especially the housewife. Indeed, as the case of the Television Project shows, the great divide between television and art was in no way inevitable nor was it conceived as so from the start. If we now widely regard TV as art's opposite, this isn't a natural conclusion nor is it based solely on social distinctions of "taste." Instead, these commonsense taste distinctions are also the product of concrete historical struggles among institutions and industries that fought for power over visual culture and its publics. As television enabled more people to see painting in new ways, MoMA officials tried to form links with commercial broadcasters and networks. By pursuing this commercial path, they hoped to bypass the demands and biases of the state-run education system. They also attempted to appeal to families—and especially housewives—by presenting art in entertaining "women's" genres. Despite MoMA's failures, the Television Project demonstrates that there were significant links between the private sphere of suburban domesticity and the public/urbane world of art. To think of these worlds as binary opposites is in fact to misunderstand the cultural logic of late capitalism. Indeed, for cultural critics, this case suggests a need to reconceptualize the historical relations among entertainment and education, domesticity and public culture, femininity and modernism, and television and art.

5

••• SILENT TV

Ernie Kovacs and the Noise
of Mass Culture

In 1957 NBC hired the offbeat television comedian Ernie Kovacs to direct, write, and star in one of its first color specials, *The Saturday Night Color Carnival*. Although NBC aired the program in order to display the visual splendor of its new color system, Kovacs used the occasion to marvel at the decidedly displeasurable audio elements of television's ubiquitous "white noise." Often referred to as the "Silent Show," the program contained no dialogue apart from Kovacs's opening monologue. Smoking his signature cigar and speaking into the camera, he said, "There's a great deal of conversation that takes place on television. From way in the morning 6 AM . . . to all hours of the night. I thought perhaps . . . you might like to spend a half hour without hearing any dialogue at all."[1]

By way of demonstration, Kovacs offered what would become his famous "Eugene" skit featuring a bumbling working-class antihero whose noisy antics disrupt the relaxing quietude of an upper-crust gentleman's club. With no spoken words, Kovacs's Eugene character manages to create a soundscape of crashes, clangs, squishes, and gun blasts that accompany a virtuoso pantomime performance. An ardent fan of Buster Keaton, Kovacs evoked the physical mayhem of the silent clowns, yet he did so while experimenting with the aesthetic demands and peculiar constraints of television's audio-visual

form. This program, and many other Kovacs programs like it, are filled with sight gags and artfully rendered musical montages that incongruously edit together sound and image in ways that deviate from and often self-reflexively comment upon the typical TV conventions of sync-sound editing, televisual liveness, and the realist illusion of time and space. For Kovacs, television was not just a medium through which to transmit other arts or art education. Instead, like MoMA's Sidney Peterson, he wanted to make television an art form in its own right. But unlike Peterson who started as an avant-garde filmmaker and worked within the conflicted goals of the art museum, Kovacs began his career in radio and worked at the TV networks, where he had considerably more success.

During his lifetime critics hailed Kovacs as a TV genius and in the 1980s (two decades after his death), video artists and critics embraced him as the father of video art.[2] Certainly, Kovacs's many talents and his absurdist sense of humor did result in programs that looked different from the great majority of television shows, both then and now. Yet, as Bruce Fergusson has argued, by viewing Kovacs solely within the context of video art, critics have forgotten the fact that above all Kovacs was a commercial broadcaster.[3] Indeed, when viewed from the perspective of broadcast history, Kovacs's artistic experiments are less a function of his vision for a video-art future than they are a response to the economic, social, and discursive context in which he worked. In particular, as his "Silent Show" suggests, Kovacs's interest in artistic exploration was directed at wider social anxieties about the disruptive and distasteful noise of the new commercial television culture.

This chapter explores Kovacs within this broader set of cultural anxieties about TV noise. During the 1950s newspaper critics and television viewers began to express displeasure for the high-pitched sales pitches of overzealous admen and the endless babble of TV programs. The public distaste for television noise in turn fueled industry and even regulatory efforts to appeal to quieter, more refined tastes. In 1961, when Newton Minow delivered his "Vast Wasteland" speech to the National Association of Broadcasters, he attacked not only "the procession" of "mindless," "violent," and "boring" programs but also "commercials—many screaming, cajoling and offending."[4] His words summed up a much wider public debate, which started in the mid 1950s, about television's relentless chatter and offensive commercial din. In this discursive context, noise was a real material problem (i.e., people actually thought TV was too loud). But, as in Minow's "Vast Wasteland" speech, TV noise also came to stand for a more general disgust with television's tasteless entertainment and its lowbrow status. In other words, "noise" was a

metonym for all of television's failures—proof that the medium could never be art. Nevertheless, and quite paradoxically, this debate about TV noise actually helped to foster avenues of artistic experimentation with television's audio-visual possibilities.

In the context of the debates about TV noise, both program creators and television advertisers grew interested in creating new forms of silent television, and to do so they often turned to silent cinema for models. These alternative and often non-realist explorations in sound and silence are now largely forgotten in media history. While film sound theoreticians such as Michel Chion have argued that video art or music video hark back to silent cinema and avant-garde image-sound experiments, the point I wish to make is that these kind of experiments with sound happened way before the advent of video art or music video—and they happened within the practices of mainstream commercial TV.[5]

But why would silence and silent cinema become important to a medium that most theorists say is all about talk, or at least simulated talk? Television is fundamentally about models of discursivity—the talk show, the newscaster, and the endless babble of advertisers demanding, "Hey, you! Buy this product!"[6] Given the dialogue-centered nature of television, Chion argues that TV is "fundamentally a kind of radio 'illustrated' by images," and he claims, "Silent television is inconceivable."[7] However, as the Kovacs example demonstrates, there in fact was silent television—or perhaps more correctly there was television that experimented with silence. This chapter first explores the widespread debates about TV noise in the 1950s and 1960s; it then examines Kovacs's experiments with silence and sound; and finally it looks at other forms of silent television that followed in his wake. This history reveals surprising connections between the commercial imperatives of network television and artistic exploration—between the taste for popular TV entertainment and the taste for absurdist, even avant-garde forms.

FIDELITY, REALISM, AND LIVENESS
Like the transition from silent to sound cinema, the change from an audio to an audio-visual broadcast system was accompanied by a flurry of debates about the relation of sound to images and the kind of aesthetic and sensory experiences on offer. Even before television was a commercial reality, aestheticians and industry executives contemplated the advent of "radio with pictures." In his essay "In Praise of Blindness" art theorist Rudolf Arnheim took a decidedly negative view of radio programs that attempted to visualize the sound of music. In line with his more general theories of art, he claimed

that radio was best when it worked within its aesthetic limitations—in other words, when it presented itself as an aural medium unencumbered by the indexical references to its space of presentation. So, for example, in his view, radio broadcasts of orchestral performances that included the sounds of the theater—feet shuffling, murmurs, applause—destroyed the listening experience. In his 1935 essay speculating on the advent of television, Arnheim argued that because television always referred back to its space of transmission, it never could achieve the pure art of radio. Rather than an art, at its best TV was a document of live performance, and therefore, "like the motorcar and airplane. . . . a means of cultural transportation."[8]

By the late 1940s, when television was fast becoming a commercial reality, Arnheim's was clearly the minority view. In fact, rather than seeing the documentary aspects of television as an obstacle to art, most industry executives and television critics promoted television precisely for its ability to anchor radio's sounds in place—to reveal the space of the performance and to imaginatively transport the viewer to the scene of presentation. Even while many critics ridiculed television shows that were mere "radio with pictures" and demanded better visual presentations, they nevertheless embraced television's ability to create a sense of "being there," and rather than seeing this as mere "cultural transportation" they saw this as one of television's most desirable aesthetic features. From this point of view, even more than the cinema with its novelistic and theatrical traditions of realism, in television the illusion of realism was always tied to expectations of authenticity—that is, what you saw and heard was really there and it was happening as you watched it.

TV critics promoted television's spatial orientation and source fidelity as its greatest aesthetic virtue. As we have already seen, critics insisted that TV was best when it exploited its qualities of "liveness, immediacy, simultaneity, and presence," qualities that gave indexical proof to the source of transmission. These expectations for authenticity and live experience also pervaded the promotional discourse for television sets. As early as 1944, the Capehart Farnsworth Company advertised its television set with the slogan "Your Private Window on the World." Through the 1950s advertisers used this window metaphor, claiming that TV offered not just realism, but an aperture onto reality itself.[9] Early television production manuals made similar predictions. Thomas H. Hutchinson's book *Here Is Television: Your Window on the World* (1946) was, of course, an explicit reference to this logic.[10] In the early 1950s, when home electronics manufacturers began to promote new hi-fi sound systems, this promise of authentic experience was tied not only to picture quality but also to sound fidelity. In 1953, CBS-Columbia promoted

its first "full fidelity" TV sets with an image of an eye and ear, side by side on the layout. The ad promised consumers an immersive experience of reality through "picture depth and detail" and 'hemispheric' sound." Using upper case typeface to emphasize the volume, the ad told consumers, "SWITCH IT ON AND THE WHOLE ROOM PLAYS! Hear for yourself the room-filling reality of 360° Full Fidelity Sound."[11] Such claims to television's immersive re-alism—its potential to create not just an image of reality but rather an entire architecture of actuality ("a whole room that plays")—were central to the idea of high fidelity throughout the decade.

The idea of sound fidelity was not a new invention. As Jonathan Sterne ar-gues, the term fidelity was first applied to sound in 1878, and since then "every age has had its own perfect fidelity." Advertisers had previously promoted radio and the phonograph with promises of faithful sound reproduction, claiming, for example, that listeners would not be able to tell the difference between the real Caruso and his reproduced voice. "Sound fidelity," Sterne argues, "is much more about the faith in the social function and organization of machines than it is about the relation of sound to its source."[12] In the 1950s, sound fidelity was ultimately about the new public faith in television as a machine that would not, could not, lie. According to the promotional rheto-ric of the time, television's ability to transmit images and sounds live as they happened made it truer to life than either the recorded realism of cinema or the "blind" encounters with radio sound.

Although television critics and promotional materials touted TV's abil-ity to make audiences feel as if they were there on the scene of presentation, television's ability to do so has never really been based simply on the techni-cal transmission of a signal through a feed. Instead, television's realism and especially its aura of liveness and fidelity to its source are produced through the artful orchestration of sounds and images.[13] In this sense television's ontology rests on a fundamental contradiction between its status as docu-ment and its status as art. Television seduces its audience's faith in its realism through techniques of narration, camera work, continuity editing, sound de-sign, staging, and lighting that make viewers believe that they are watching a live performance unfold in real time.[14] This is generally true not only of live-originated programs, but of filmed and taped fare (for example, even while they are taped, soap operas, sitcoms, and game shows often feel live).

The cultural and industrial demand for TV to seem live (even when it is filmed or taped) is also why silence seems so impossible on television. As Mark Slouka argues, silence is associated in western culture with death—the end of time.[15] This is why a breakdown in TV sound (say on a live newscast)

also has an unnerving quality—as if the image were not enough to enliven the body of the person on screen. To secure the illusion of liveness over death, commercial television cultivated ways of filling silence with the sounds of life. For example, studio audiences and canned laughter have been important to the medium from the start. However, TV sound soon precipitated a problem of its own. This problem—"the noise problem"—was rooted in a larger concern about TV fraud.

SOUND FRAUD

Despite the promotional hype and utopian expectations that television would be a window on the world, over the course of the 1950s, television's authenticity was increasingly called into question, particularly because of its commercial nature. The critical attacks on television's commercialism escalated at the end of the 1950s with the quiz show scandals in which producers and advertisers were indicted for giving answers in advance to contestants on big-money quiz shows like *Twenty-One*. By the time of the scandals, attacks on television's over-commercialism and objections to false advertising had virtually destroyed faith in TV's status as a document. It is interesting to note in this context that the Revlon Corporation, one of the sponsors accused of rigging the programs, featured a "soundproof booth" on its show *The $64,000 Question*. But the booth was itself revealed to be a fraud. The producers allegedly pumped hot air into the soundproof booth so that contestants would perspire for added dramatic tension. More generally the scandals made people wonder if television's sounds and images were as real as they appeared to be. What if the seemingly spontaneous questions and answers between host and contestant were scripted dialogue rehearsed in advance? What if studio audiences had been prompted by producers to grimace, clap, and gasp? In the midst of this public-relations crisis and impending FCC investigations, network executives began to repackage their entire "golden age" discourse about TV's documentary status. Rather than a "window on the world," the presidents of CBS, NBC, and ABC all defended their networks by claiming that TV was show business offering dramatic entertainment and therefore TV should not be expected to be real.[16]

The quiz show scandals were just one element of a much larger critical assault on television's commercialism, which was typically coupled with condemnations of its failed authenticity and even outright fraud. By 1956 and through the 1960s, the Federal Trade Commission (FTC) cracked down on fraud in television commercials, citing ads that used camera tricks and mockups to make viewers believe that ordinary products had magical powers.[17]

Even more often, protests against TV fraud were directed at TV's audio elements. There were two specific complaints about TV sound's fraudulent nature: one was targeted at canned laughter, the other at the volume level of commercials.

The first of these has been addressed by Jacob Smith, who explores TV laugh tracks in the context of a more general history of recorded laughter. Smith's focus is on the mechanized and uncanny quality of recorded laughter.[18] For our purposes, it is also important that canned laughter precipitated panics around fraud. Critics began to complain that the sounds of canned laughter tricked audiences into believing that something was funny when it was not. The canned laughter controversy emerged in the context of a more general politics of taste in which TV critics were bashing TV comics like Milton Berle and Red Skelton for doctoring their stale routines by adding phony guffaws.[19] As the only network indicted in the scandals, CBS was particularly cautious. In fact, Stanton was so worried about his network's image that he went so far as to outlaw the use of laugh tracks in comedy shows—a short-lived rule that angered many CBS comics.[20]

The second controversy concerning TV sound was specifically directed at commercials. People feared that broadcasters and sponsors had colluded to raise the volume for commercial breaks in order to make viewers attend to the sales pitch. This fear resonated with the growing climate of criticism about advertising and its manipulation of people's minds. Novels like Frederic Wakeman's *The Hucksters* (1946), industry exposés like Vance Packard's *The Hidden Persuaders* (1957), and films like Frank Tashlin's *Will Success Spoil Rock Hunter?* (1957) portrayed advertisers and broadcast executives as greedy shysters, trained to dupe the unsuspecting masses.[21] A 1959 Gallup Poll survey suggested that the public had a dismal view of advertising: 67 percent of those polled thought "TV commercials use[d] untruthful arguments."[22] Corroborating this, a major longitudinal study of advertising by Social Science Research Inc. reported that even if people liked commercials, they thought they were "tricky" and "flashy." Moreover, the researchers concluded that this widespread mistrust was connected to the public's perception that ads were too loud. The study cited a "vehement, but not atypical mass market housewife" who said the typical commercial "Stinks. . . . Those guys who holler at you a mile a minute; they are very obnoxious."[23] Similarly, at a 1956 conference for the American Association of Advertising Agencies (AAAA) Jean Wade Rindlaub, vice president of BBDO, told fellow advertisers that housewives disliked "screaming, hammering, hard-pressure commercials and exaggerated claims and strident voices and general overbearing loudness."[24] In

this context the loud commercial was a constant concern for advertisers like Rindlaub who saw noise as an impediment to sales.

The volume controversy was officially recognized in April 1956 when the FCC monitored the sound levels of commercials in response to "complaints from the general public and members of Congress alleging that excessive volume [was] used by broadcast stations when making commercial announcements." Although the regulators found only one instance of "overmodulation," the volume controversy persisted.[25] In 1963 the *Wall Street Journal* reported, "The FCC has uncovered a problem of truly major significance. It's getting a lot of complaints from TV viewers that the sound level of commercials is irritatingly louder than the sound heard during the rest of the program."[26] Over the next two years, FCC chairman E. William Henry, a frequent critic of commercial noise, conducted a major study of sound levels used for commercials that resulted in a series of FCC recommendations to broadcasters about the appropriate levels of sound for commercial interruptions.[27]

For their part, the television networks repeatedly attempted to bypass government regulation and control the noise controversy through public relations and technological solutions. Once again, as the only network indicted during the quiz show scandals, CBS was especially concerned with charges of TV fraud and over-commercialism. In 1958, the network launched a series of goodwill newspaper ads that aimed to restore faith in the CBS brand by recounting examples of high-quality CBS documentaries, news, and cultural programs from symphony to Shakespeare. One of the ads in this series specifically responded to the noise issue. The ad began: "If you are disturbed by the fact that one part of a television program sometimes sounds louder than another, it doesn't necessarily mean it *is* louder. It may just be the way you react to sounds." The ad boasted that CBS engineers had created a new technological solution to noise, the "Automatic Gain Control Amplifier," that "has reduced the human factor to a minimum" by ensuring a balanced level of sound throughout the program." "This," CBS promised, "should make watching television even more delightful than it is now, if such a thing is possible."[28]

In this regard, CBS's concept of sound was less about fidelity to the point of transmission than it was about pleasing audiences by carefully controlling the listening experience. Indeed, sound fidelity would mean audiences would actually hear the traces of humans, and their irritating voices, in the studio. Instead, the Automatic Gain Control Amplifier promised to standardize listening experience for a national audience. Assuming that sound was a highly subjective sensation that varied with personal tastes, CBS sought to find a

middle ground—a perfect balance—of sound modulation that would appeal to the widest possible market. Embedded in this concept of balance was the assumption that sound should be mechanically reproduced as a commodity and marketed to what we might call "middle-ear" tastes. By 1966, CBS laboratories used the new science of psycho-acoustical research to perfect this middle-ear sensibility with a sound meter that automatically limited the excessive loudness on all radio and television broadcasts. According to the *Wall Street Journal* the device would also "protect television viewers from the jarring effect of excessively loud commercials."[29]

Beyond sound levels per se, concerns about TV noise belied a more general set of anxieties about the intrusion of mechanized sound into the private world of the family home. As Jacques Attali argues, sound is "deeply social," "a tool for the creation of community," but also "the demarcation of territory and power." The modern technologies of recording and transmitting sound," he writes, "are tools for social power."[30] Everywhere we look," Attali observes, "the monopolization of broadcast messages, the control of noise, and the institutionalization of the silence of others assure the durability of power."[31] In discussions of TV noise, commercials were often depicted as the domineering effects of an administered culture, an invasion by the market of someone's private territory and unconscious mind.

Concerns with TV noise were part of a more general discourse on noise control in the home, a discourse that can be traced back to the 1910s when military and big industry began to sponsor studies of the effects of noise on human behavior and soldier/worker efficiency.[32] In the postwar period, domestic engineers applied military/industrial principles of noise control to the domestic environment and home magazines advertised a slew of sound-proofing products that were originally designed for military and factory uses. In this respect, it is not surprising that discussions of domestic noise often used the language of military invasion. In a 1957 article titled "Suggestions on How to Cut Down Home Noise," the *New York Times* reported that since "World War II, a clanking army of television sets, grinding air conditioners, electric kitchen equipment and workshop tools has entered the American home."[33] More generally, military metaphors of being "blasted," "detonated," or "bombarded" by TV noise were common, and commercials were typically the biggest offender.

Meanwhile, advertisers and market researchers borrowed concepts from military training in their studies of the effects of noise on consumer behavior. Just as military leaders and industrialists sought to improve soldier/worker efficiency by minimizing noise from airplane engines, gunfire, or factory

whistles, postwar advertisers sought to improve consumer behavior (and to thereby ensure more efficient sales) by controlling noise levels of television commercials. At its most extreme, the application of military/industrial principles to consumers in their private homes took on the sinister tones of psychological warfare. Design consultant James Real offered a particularly chilling vision. In his presentation at the International Design Conference in Aspen in 1959, Real laid out, in explicitly military terms, his theory of noise and consumer persuasion. Calling advertisers "noisemakers," Real claimed that they were engaged in a "truly desperate economic war" against "obstinate consumers" whom he likened to unpredictable "people components in weapons systems." Just as the military needed to control for the "failure of the biochemical link" (i.e., the "human subsystem" that was susceptible to "emotional vagaries"), Real argued, "American business must deliver a more predictable consumer." He thought commercial noise was a major obstacle to this battle. "It is patently ridiculous," he argued, "to simply assault him [the consumer] with an increase in the volume of noise." Instead, "We must study him with a view to increasing the effectiveness of noise. We must get him, as the saying goes, where he lives."[34]

Broadcasters especially understood the importance of getting consumers where they lived. Employing military metaphors, Harold E. Fellows, president of the National Association of Broadcasters, warned, "It is not a principle of good selling that a man's ears must be detonated before his mind responds. . . . A broadcaster lives in the home; a member of the family should know better."[35] As Fellows understood, from the consumer's point of view, TV noise was not merely invasive; it was also tantamount to bad manners, a disruption of domestic decorum. TV viewers wrote to newspapers and networks complaining that loud commercials were causing family fights, waking up children, irritating neighbors, and disrupting dinnertime. Capitalizing on the problem, manufacturers offered sound muffling gizmos. In 1954 the Aer Vue Corporation of Brooklyn, New York, advertised a "TV Hush" that let "TV addicts . . . stay up nights without the late show annoying the neighbors," while also permitting "arm chair sitters" to "turn down the volume [on] commercials."[36] Still, the noise complaints continued. In 1965 one man even wrote to a top NBC executive complaining that the theme music for the NBC color peacock, as well as the jingles for Curad Strips and Jiffy Peanut Butter commercials, made his dog howl. The annoyed viewer moaned, "He's a nice dog, but he suffers from NBC." Expressing his concern to serve the many and not the few, the network executive responded: "We regret that your dog has reacted unfavorably to the theme music accompanying the NBC Peacock.

We can appreciate your concern, but we have also observed that what may be music to the ears of one dog can be a catcall to another. Thus, we might be able to modify the music to meet the approval of your dog but in doing so we might well incur the disapproval of many others."[37]

ERNIE KOVACS AND THE
TASTE FOR SILENCE

In the context of concerns about TV noise, people in the television industry began to experiment with silence as a logical response to audio displeasure. Such experiments harked back to previous forms such as pantomime and silent film and/or they revived experiments with sound that can be traced to avant-garde performances in the early decades of the twentieth century. Indeed, the public distaste for TV noise, and the related concerns about fraud and manipulation, had the curious effect of promoting experiments with sound and silence as a way to make TV its own form of art.

Even before the noise controversy per se, television producers considered the possibility of silent programs. As early as 1947, Lee-Wallace Tele-Shows in New York produced "World of Silence," a half-hour program of dramatic pantomime that depicted "highly dramatic happenings that occur without words."[38] From 1948 and through the 1950s, TV clowns such as Sid Caesar, Imogene Coca, and Red Skelton featured pantomime in their network variety shows.[39] So pronounced was the trend that as early as 1950 *Chicago Tribune* critic Lee Wolters noted that TV was "reviving the art of pantomime" and he praised TV comics who emulated silent cinema stars like Chaplin, Keaton, and Harold Lloyd. Conversely, the great radio comics—Jack Benny, Bob Hope, and Fred Allen—fell flat on TV because they lacked a visual dimension and were still "clinging to techniques that made them the top dogs on radio."[40] More generally, critics valued visual humor over mere "radio transplants."

Among people experimenting with visual style in television comedy, Ernie Kovacs was no doubt the most prolific. Kovacs produced an assortment of both local and network programs, usually insisting on absolute control of almost all program elements—writing, acting, hosting, producing, set design, sound, even title art—something no other primetime network performer imagined doing at the time.[41] Like other comics, Kovacs sometimes used pantomime to tell a story, but Kovacs's experiments with sound and silence were of a different order. Whereas most television pantomime created a realistic illusion and used music and sound effects to enhance realism, punctuate jokes, and make action legible for audiences, Kovacs specialized in absurd visual

tricks, elaborate set pieces, and anti-realist montage symphonies that juxtaposed rapidly edited and incongruous images against music ranging from the classical compositions of Tchaikovsky to modern composers like Bela Bartock to offbeat contemporary performers such as Yma Sumac and Juan Garcia Esquivel (musicians who have since been repackaged as "lounge" and "exotica" performers). Meanwhile, his numerous sight gags and visual tricks used sound counterintuitively and sometimes with no particular relation to the image at all. Although he was an ardent follower of silent-film comics and while critics often compared him to Chaplin, Kovacs did not primarily see himself either as a silent comic or a mime.[42] As he told the *New York Times* in 1961, rather than directly imitating the silent-film clowns or pantomime artists, "Eighty percent of what I do is sight gags. I work on the incongruity of sight against sound."[43]

Although Kovacs developed his experimental tool kit on local daytime and late-night TV in the early 1950s, the 1957 "Silent Show" special emerged as his tour de force. Signaling his preference for the absurd (rather than just storytelling pantomime), Kovacs frames the episode in a sound paradox. During his opening monologue he asks, "If a tree were to fall in a forest and there was nothing live to hear it, would there be sound?" To demonstrate the vexation, he puts cotton in the ears of a toy squirrel. The camera then cuts to a tree falling in a forest. When the camera cuts back to the squirrel there is no sound on the soundtrack. Moments later, Kovacs removes the cotton from the squirrel's ears and we hear a loud noise that sounds more like pots and pans clashing than a tree falling. The joke, of course, involves fidelity; the sound does not occur as it happens in nature, or for that matter in the studio at the time of transmission, but only later and from the unlikely point of view of a stuffed squirrel.[44]

The remainder of the show is devoted to two silent sketches. The Eugene pantomime skit was, as I stated early on, specifically concerned with noise and taste as the working-class Eugene wreaks havoc on the peaceful silence in the gentleman's club. No doubt due to the novelty of the color broadcast, Eugene is dressed in a brightly colored checkered jacket (the script makes special note of the purple, greens, and reds of the costume design). Ironically in this regard, while the special is silent, his clothing is "loud"—the sartorial equivalent of low taste.[45] Kovacs uses sound to elaborate this class dimension by associating Eugene with the "noise" of the working classes that offends the sensibility of highbrows.

Elaborating on this theme, the Eugene skit draws attention to the way mass media and modern technologies of communication have created a battlefield

of noise in which the aesthete ideal of quiet contemplation has become un-thinkable. Upon entering the club, Eugene surveys a number of items in the room, with Kovacs mining each for their comic potential as noise. Many of these items are mass-produced forms ranging from cheap reproductions of famous artworks to modern technologies of communication. When Eugene looks at a reproduction of the *Mona Lisa*, the painting laughs. When Eugene opens up a book titled "Digging the Panama Canal," we hear the crashing sounds of heavy machinery. Similarly, when he opens up *Camille*, the novel emits sounds of a coughing woman. When Eugene dials a telephone in the club, the soundtrack plays loud machine gun noises in lieu of normal dial tones. And, when Eugene decides to have a drink, his digestive track turns into a sound machine from which are transmitted mechanical rather than human sounds. In other words, Eugene's body itself becomes a medium for sound transmission. In fact, in a 1961 reprise of the same skit, Eugene literally becomes the sound source as he plugs a tiny record player (playing "Mack the Knife") into his stomach, which has an electrical socket on it.[46] As in comedy more generally (and certainly in the films of Chaplin, Keaton, and Lloyd), humor arises from the confusion between the human body and machine, but in this case the comedy is also a visual pun on sound fidelity. By turn-ing sight gags into sound gags and mismatching sound and image, Kovacs reveals the fact that television is not a "window on a world" but an art form replete with audio-visual tricks created through editing (as well as a battery of other techniques).

The skit's finale (which Kovacs referred to as the "tilted table bit") takes this self-reflexive strategy a step further. Kovacs sits at a table where he re-moves items from his lunchbox (olives, milk, etc.) that roll down a slanted table built on an eighteen-degree angle with the camera also positioned on an angle to compensate for the slant (in effect, the table looks perfectly hori-zontal, but the objects inexplicably roll across it). Once again, the soundtrack plays incongruous noises (for example, as they roll across the table the olives sound more like pin balls than food). After considerable noise and frustra-tion (both for him and for the gentlemen at the club), Eugene decides to straighten out the tilted table. But rather than having Eugene physically move the table, Kovacs repositions the camera itself so that it literally reframes the scene, straightening out the table but also tilting the rest of the image. In this way, Kovacs punctures any sense of realism in the skit, revealing the fact that television cameras do not simply "record" real space and action, but rather create spatial illusions and optical tricks.[47]

The show's second skit—a rendition of Kovacs's "Nairobi Trio"—humor-

Ernie Kovacs (as Eugene) pours milk on the tilted table (ABC, 1961 version of the original "Silent Show").

The Nairobi Trio (ca. 1957).

ously undermines sound-image syncopation in televised musical performances. The skit (which Kovacs had in various versions on other shows) features three apes (actually Kovacs, his wife Edie Adams, and Kovacs regular Barbara Loden, all dressed in ape masks, long coats, and derbies). Like wind-up toy monkeys that play instruments in perfect synchronization, the trio plays Robert Maxwell's "Solfeggio" (a catchy tune named after singing exercises). One ape sits at a xylophone, while the other two keep the beat by hitting blocks of wood (on a table) with a mallet and peg. But, as the song

progresses, the trio's perfectly syncopated movements get off track, and with increasing acrimony the apes begin to beat each other over the head with their mallets. The ensuing chaos disrupts and renders absurd the logic of being "on time" that mechanization—and TV schedules—presuppose. At the end of the skit, Kovacs (still in his gorilla suit and shot in a close-up) removes his mask and, addressing the camera, gestures with his lips as if to say "goodnight," but then, true to his "no talk" promise, falls silent.

Despite the lack of dialogue, the 1957 "Silent Show" was, of course, not silent. Not only did it have music, the script called for "a 23 piece orchestra with 6 violins, 1 viola, 1 cello, 1 bass, 5 saxes, 3 trumpets, 3 trombones, 1 drum, 1 harp, 1 piano, and a 'rinky-dink' honky-tonk piano too."[48] And because the program was taped before a live audience, many segments even had audience laughter, whistles, and applause.[49] Nevertheless, critics hailed the program for reducing TV noise. Comparing Kovacs to Jerry Lewis, who preceded him on the NBC schedule, the critic at the *San Francisco Examiner* said that Kovacs "Lit his cigar and told everybody to shut up" but Jerry Lewis made a "'frightening fool' of himself . . . ran noisily around the stage, twisted his big mouth . . . talked baby talk and screamed to music like a squealing pig." The review suggested that Lewis's comedy was a lower form of humor precisely because it relied on the noisy stock routines (baby talk, squealing, running around the stage) that might occur in a vaudeville theater or on a nightclub floor where a comic has to play to the wings; in distinction, the critic claimed Kovacs allowed the "TV medium to speak for itself," and so had become "TV's comic genius of 1957."[50] Many others agreed. Comparing Kovacs to Lewis, a column in *Time* stated, "Kovacs won the comparison test, hands down. . . . Producer-Writer Kovacs buttoned his lip tight and proved himself TV's most inventive master of pantomime, sight gags, and sound effects."[51] The NBC night telephone room reported "200 hundred complimentary calls" for the show on the night it aired and numerous people across the country wrote letters to Kovacs praising the show. Even the U.S. government endorsed the "Silent Show" by choosing it as the only TV program to be screened at the 1957 Brussels Worlds Fair.[52]

Kovacs further established his stance against laugh tracks, studio audiences, and commercial noise in a series of specials he made for ABC between April 1961 and his untimely death in January of 1962.[53] Scheduled to follow ABC/Warner's notoriously violent (and loud) shoot-out crime series *The Untouchables,* the first special features Kovacs walking onto a studio set on which mannequins are strewn like dead bodies.[54] There is no sound at all. Climbing over the mannequins, he makes his way into an empty studio auditorium and

sits down on one of the chairs. Directly addressing the camera, Kovacs says, "Sometimes they don't sweep up so good after *The Untouchables.*" But the sound track is not synchronized to his lip movements. This continues for a while with no explanation, and because Kovacs refers to himself in the third person, it becomes hard to tell whether he is intentionally speaking as an off-screen narrator or if there is actually a technical glitch in the broadcast. Meanwhile, the visual track contains its own trick effects in the form of a superimposed image of a miniaturized woman who appears to be sitting (like a little fairy) on Kovacs's shoulder. Finally explaining the bewildering situation, but still in non-sync sound, Kovacs says: "We don't have a studio audience for this show. There are no laughs on the soundtrack either. All in all it's kind of an intimate vacuum. Incidentally there's no little girl sitting on my shoulder. There's nothing wrong with your set." By purposefully confusing the source of television narration and acknowledging his audio-visual tricks, Kovacs denaturalizes the illusion of liveness, intimacy, and spontaneity that so many television shows tried to construct. Unlike the standard TV hosts who routinely tried to make audiences believe they were witnessing events in real time, Kovacs's out-of-sync dialogue reveals the fact that much of television was prerecorded and edited, even when it seemed live.

In addition to Kovacs's ruminations on silence, sound, and narration, the ABC specials featured his elaborate montage sequences that juxtaposed images incongruously against one another and alongside equally counterintuitive musical tracks. The first special offered a rapid-fire montage orchestrated contrapuntally against Tchaikovsky's *1812 Overture* (which, perhaps not coincidentally, was itself composed of musical fragments of hymns, folk songs, bells and cannons, and passages of Tchaikovsky's invention). The montage opens with an obese ballerina dancing (to the point of exhaustion) from the back of the stage and up toward the camera. It then cuts to a quick succession of incongruous objects shot in extreme close-up—toy mechanical monkeys playing drums; celery stalks being broken by human hands; a cow head with cow bells turning side to side as Tchaikovsky's bells peal; eggs breaking in a frying pan—all syncopated to the bombastic sounds of the *Overture*. Unlike the standard variety show crooner or slapstick skit, the montage did not exactly solicit either listening pleasure or laughter. Rather it provoked visual shock at the absurd combinations of eggs, ballerinas, cow heads, monkeys, and Tchaikovsky. Other ABC specials featured musical montages like the "Kitchen Symphony" and "Office Symphony," each of which juxtaposes images of everyday objects against classical and/or offbeat tunes.[55]

Taped in real time, such montages were incredibly hard to produce. Due

to the costs of and limits on rehearsal time, Kovacs had to plot out his visual tricks meticulously in advance. For the "Office Symphony" (which was scored to Juan Garcia Esquivel's jazzy tune "Jalousie" and is sometimes referred to by that name) Kovacs wrote a four-page (single-spaced) memo to his staff, stipulating the painstaking detail and labor required for the roughly three-minute segment. It is worth citing an extensive portion of this memo to give a sense of the enormous effort involved:

> In time to the music, this pen must drop gobs of ink out of the point. The phone, which will be located directly in back of the pen must have the dial work briefly, only one full turn will be needed in synchronization to the music in short movements, a kind of syncopated beat, the ear-piece and talking-piece of the phone must be made to rock back and forth in time to the music while remaining on the cradle it raises on one end, drops, raises on the other end, and drops . . . but also must be completely controlled manually. To the right of the phone is an old-fashioned pencil sharpener, with the hole facing us. I would like a little electric motor to turn the handle on this which will be at the back, but the handle should be big enough so that . . . we can still see the end of the handle going around in the back. Directly in back of this is the water carafe with a large thermos-type cork stuck on top. This must be made to raise and lower on a musical cue. I would suggest that the cork be about 4 inches long so that we can push it up as high as that much and lower it again. (Again facing the desk) to the right of this carafe are four water glasses. These must be able to [be] tapped from the bottom so that they will move, visibly. On the lower right end of the desk is a desk spindle which is possibly the most interesting device on the desk. This should have three sheets of paper approximately 5 by 7 with some scribbling on it attached at equal distance places on the spindle. I would like this to work in this manner that the spindle can be pulled into the desk, pushed up again and the pieces of paper will resume their original position. The spindle should be about 8 inches high but also capable of going another twelve inches up for effect. At limbo, I would like ten paper clips on what appears to be a tray.

The memo goes on for several more paragraphs. In closing Kovacs concedes to his staff, "I don't know how the hell you're going to get this done by Sunday—but 'rots of ruck.'" And the memo is signed, "Ernie (with love)."[56]

Kovacs's numerous experiments with sound and image, as well as his use of montage and collage, not only demanded different modes of production, they also spoke to different craft and aesthetic traditions. In particular, Kovacs's experiments recall Sergei Eisenstein, Vsevolod Pudovkin, and

Grigori Alexandrov's "A Statement on the Sound-Film" (1928) in which they asserted the value of montage and the use of sound not as canned theater (as in the Hollywood talkies) but as "contrapuntal" within and against montage sequences to create "orchestral counterpoint of visual and aural images."[57] Kovacs's interest in silence, music, and montage also echoes Dadaist, surrealist, and futurist performances in the 1920s (some of which used radio) and experiments with "musique concrète" that used a cut-up aesthetic by, for example, re-editing and splicing together audio and film soundtracks to produce absurd, anti-realist effects.[58] Moreover, his fascination with silence occurred parallel to contemporary American experimental composers, most obviously John Cage, whose performance piece *4'33"* (created in 1952) featured musicians playing nothing.[59]

Although Kovacs did not leave behind long treatises on any of these artists (or any theory of art for that matter), he was certainly knowledgeable about the history of film, radio, theater, and music (his record collection was composed of some 7,000 disks of numerous periods and genres). So, too, as readers may have already guessed, after his death critics compared Kovacs's programs to the theater of Bertold Brecht, and especially Brechtian strategies of self-reflexivity and the "breaking of the fourth wall" (the illusionary wall between the actor and the audience that bourgeois theater maintained).[60] As with his out-of-sync opening monologue, Kovacs often talked to audiences while sitting at the switches of the studio control room where he would, for example, dim the picture or play with the vertical and horizontal controls, thus demonstrating the techniques by which television technicians created illusions. And just as Brecht thought about theater through analogies to film montage (a term Brecht borrowed from Eisenstein) and juxtaposed incongruous fragments to shock his audiences into critical engagements with the play (and ideally larger political matters), Kovacs's many contrapuntal montage sequences had shock value (if not politically, at least aesthetically) when compared to the conventional illusion of liveness and theatrical realism on 1950s TV.

Although it is difficult to say how strongly Kovacs was influenced by Brecht, Kovacs was obviously aware of him. He directly borrowed from Brecht's biggest commercial success, *The Threepenny Opera* (1928), using Kurt Weill's "Mack the Knife" (with German lyrics) in many of his programs. Contemporary American audiences would have known the song because a sanitized version of *The Threepenny Opera* played on Broadway in the early 1950s. By 1958 singer Bobby Darrin popularized the tune with a hit single that dropped the more scandalous violent lyrics of the original (and numerous

vocalists from Louis Armstrong to Rosemary Clooney also sang covers). Kovacs, however, always played the German version of "Mack the Knife" (most often the extremely nasal 1958 Wolfgang Neuss version). And rather than performing it as a vocal act in variety-show fashion, in the ABC specials Kovacs used "Mack the Knife" as the sound track for bizarre "blackout" sight gags (a form Kovacs lifted from vaudeville and burlesque, but used for his own purposes).

For example, one blackout sight gag shows two women sitting in a baseball stadium while engaged in a conversation as they watch a player up at bat. The conversation itself makes no sense, and the punch line—as was typically the case in the blackouts—was self-consciously stale (Kovacs cuts back to the baseball field where the ball is stuck to the bat). Rather than using canned laughter to prompt the home audience to respond in kind, Kovacs cuts to a black screen with an oscilloscope pattern waving across it as "Mack the Knife" plays in the background, and then he cuts back to another sight gag. In this sense, rather than the classic vaudeville "pie in the face," the joke is rendered oblique, and is in fact not really funny at all. As in Brecht, the audience is distanced from the conventional response usually associated with the form. Kovacs left viewers to figure out how to react on their own. As a critic for the *Plain Dealer* in Cleveland, Ohio, noted, "While Kovacs' special shows have always a strong vein of humor they also are highly experimental in character, sometimes totally serious in content and hard to classify."[61]

KOVACS AND THE ANTI-TV TV WATCHER

Regardless of whether people at the time recognized his links to Brecht per se, Kovacs was the only popular entertainer on network television to be consistently likened to avant-garde artists. Commenting on the second ABC special, the influential syndicated columnist Harriet Van Horne called it a "raffish exercise in surrealism." Noting the "camera's jiggery-pokery," she explained, "We saw abstract patterns, forming and reforming, marvelous kaleidoscope effects, all synchronized with the most surprising music. Surprising because it was by Bela Bartock and Deems Taylor. These are composers you don't see in the closing credits on the Red Skelton Show."[62] Other critics agreed. Reviewing the first ABC special, the TV critic for the *Los Angeles Examiner* exclaimed, "Salvador Dali, Look Out!" The *New York Herald Tribune* called the ABC specials "abstract art"; the *San Francisco Examiner* declared that watching Kovacs was like taking "a tour through a museum of modern lunacy"; and *Newsweek* compared Kovacs to James Joyce.[63] Such responses were not just restricted to "big city" critics on the coasts. Whether or not they

Ernie Kovacs paints with sound waves (ABC, 1961).

liked Kovacs, critics around the country almost always referred to his unique artistic style. Writing about the first ABC special, a critic for the *Virginia Pilot* observed, "It was nothing for the habitual Untouchables or Ozzie and Harriet viewers. It was, however, an imaginative, unpretentious bit of avant-garde." A critic for the *Louisville Times* in Kentucky said, "There is something of Dali about Kovacs, and something of Louis Lumiere and George Melies, two of the first experimenters with film. . . . Kovacs' comedy is unique."[64]

To be sure, Kovacs was not the only source of creative experimentation on 1950s TV. TV host Dave Garaway (whom Kovacs admired) was noted for his visual tricks; *The George Burns and Gracie Allen Show* modeled itself on the play *Our Town*, featuring Burns in a double role as character/narrator who self-reflexively commented back on the sitcom plot; the anthology drama *Gulf Playhouse* [aka *First Person*] routinely presented its main character as an invisible off-screen voice who narrated via subjective camera (the series even featured an episode narrated from the point of view of a squirrel); Orson Welles's *Fountain of Youth* (his never-picked-up 1958 pilot for Desilu) featured Welles speaking directly to the camera and orating the night's story while the camera moved over a series of still images; and Rod Serling routinely super-imposed himself into the night's episode, welcoming an assortment of un-lucky characters into the *Twilight Zone*. Even more like Kovacs, on his vari-ous late night and variety shows, Steve Allen featured camera tricks, bizarre stunts, and blackout sight gags (in fact some of these sight gags were virtually the same gags that Kovacs used). So, too, much as Kovacs liked to "torture" the TV image through camera spins, wipes, zooms, and other visual tricks, as early as 1951 (way before the advent of video art) photographer Caroll Seghers

was already distorting the TV image to create what *Life* magazine called "a zany new form of modern art."[65] Yet, despite these contemporaries, Kovacs was the only performer on network TV whom critics consistently singled out as a descendent of the avant-garde and video genius in his own right. As early as 1956, Jack Gould of the *New York Times* referred to a "Kovacsian" style—a term that numerous critics used again and again, signaling an auteur status that no other TV comic of his time achieved.[66]

In publicity and interviews, Kovacs promoted his eccentricities, cultivating his image as a rare TV auteur. Kovacs often spoke of his rage at the company "suits" whose "efficiency" approach to production was antithetical to his method. His 1957 book, *Zoomar*, a thinly veiled hate letter to the networks, followed the exploits of an advertising agent turned broadcast executive who went insane.[67] Yet, despite his eccentric production habits and struggles with the network brass, Kovacs was actually a Hollywood insider. In 1957, he accepted a movie deal at Columbia, and after moving to Beverly Hills, his circle of friends included Billy Wilder, Jack Lemmon, Milton Berle, Edward G. Robinson, Frank Sinatra, Dean Martin, and Tony Curtis. To offset his expensive tastes (and rising debts), by the end of the 1950s at the height of the quiz show scandals he hosted the panel quiz show *Take a Good Look* (for which he reportedly had "one of the sweetest 'deals' in Hollywood").[68] He also did guest spots on variety shows. But even here he was billed in roles that enhanced his offbeat persona. On *The Eddie Fisher Show*, he appeared in a musical variety act about beatniks; on *The Dinah Shore Show*, he and wife Edie Adams sang a parody version of "My Funny Valentine" with mismatched sound and lyrics; on Perry Como's notoriously "relaxed" musical variety show, he shook things up with camera hijinks that made Como disappear and tilt on an angle.[69]

While billed as an oddball artiste, Kovacs was certainly not a highbrow. Rather than aligning himself with any of the "brow" levels, Kovacs scandalized the rigidly defined taste hierarchies of the 1950s by refusing to occupy any particular point on Lynes's infamous "highbrow, lowbrow, middlebrow" taste map. Kovacs was a classical music enthusiast, yet he used the masters as soundtracks for montages that featured cow heads and pencil sharpeners; he mocked TV westerns and cop shows, yet at the same time he made fun of Peabody Award–winning cultural shows like *Omnibus*; he was just as happy to spoof used car dealers as he was to poke fun at poets (his beloved character Percy Dovetonsils read trite, if adorable, poems while dressed in a satin smoking gown). His 1959 NBC special *Kovacs on Music* captured his catholic tastes by featuring his earnest love for classical music while also knocking the masters off their middlebrow pedestals.[70] With no dialogue (apart from

Chapter 5

an opening introduction) and no laugh track, the show opened with André Previn and a seventy-piece orchestra (dressed in tails) playing Kovacs's theme music, "The Oriental Blues." The set-piece finale was the *Swan Lake* ballet performed by dancers in gorilla suits.

In short, Kovacs was the poster boy for "counter-distinction," a term that Bourdieu uses to describe a "taste habitus" that defines itself against the normative standards of good taste in a culture.[71] Kovacs demonstrated his counter-distinction not only on his programs, but also by writing for or giving interviews to such disreputable publications as *Mad*, *Frenzy*, and *Zany*. In 1960 *TV Guide* ran a cover story about Kovacs and Adams in which the couple mocked cultural programs by offering up ideas for ridiculous TV shows like "'Now, Say Gorgonzola' featuring Irving Gaughin postimpressionist at work in his Montmartre (Iowa) studio." The cover pictured Adams posed as the *Mona Lisa*, and the reporter noted, "Ernie has a less stuffy attitude to the arts."[72]

Kovacs also exhibited his counter-distinction via his domestic décor, allowing interviewers to visit his homes on numerous occasions. For example, in 1958 a reporter for *Holiday* magazine visited Kovacs and Adams at their sixteen-room, seven-bathroom New York City penthouse, which nevertheless was, according to the reporter, located on the "unfashionable Upper West Side, a highly imprecise location to be inhabited by a celebrity." Despite its grandeur and enviable amenities ("four telephone lines, with countless extensions, four complete hi-fi systems, several centuries of antiques, a mounted armory of guns, two giant wooden black armoires"), the reporter noted, "All these posh vistas somehow avoid the protestation of success common in Kovacs' bracket." Instead, the article speaks of "Kovacsian dishevelment," of "half-dead cigars in ashtrays on marble tables, broken gold doorknobs, piles of TV scripts held down by poker chips, cards littered on [the] solarium and sopping wet lounge chairs on [the] deck." The same apartment is featured in a 1955 episode of Edward R. Murrow's *Person to Person* where Kovacs shows off his Louis XV commode. But rather than displaying the precious antique as if it were art (as, for example, Alistair Cooke might on *Omnibus*), Kovacs decides to show audiences how he uses his antique as a cabinet to store his new hi-fi; moreover he plays a new recording he has made that features sounds of explosions and people screaming, horrible sounds that emanate from the exquisite commode. Indeed, Kovacs incorporates his aesthetic of mismatched sound and image into his daily décor, and he displays this with counter-distinctive glee to the TV audience.[73]

People who watched Kovacs gravitated to his eccentric persona. Being

a Kovacs fan meant also being somehow different from the rest of the TV crowd. At a time when sociologists like Harry Henderson and William H. Whyte were critiquing suburban conformity and the deadening "organization man" work worlds at corporations, people who yearned for individual distinction may well have taken special pleasure in associating themselves with the offbeat star.[74] At the very least, liking Kovacs meant that you did not conform to conventional taste standards. Characterizing his fans, Kovacs said their typical attitude was "*We* dig you, Ernie, but nobody else will!"[75]

The fan mail preserved in the Kovacs Papers suggests that Kovacs fans saw themselves as a minority audience of what we might call "anti-TV TV watchers"—people who watched only certain shows that they felt were entirely different from the rest of TV. For example, Olga Beck of Cleveland, Ohio, wrote, "We have learned to turn the TV knob to 'OFF' but you are one performer who has stayed our hand." Mrs. Jacob Fox of Elmhurst, New York, wrote, "In the business of television, where mediocraty [sic] seems to be the common denominator, your honest striving for original entertainment is valuable."[76] In the 1950s, Kovacs and Steve Allen were the two major network TV performers who cultivated this anti-TV TV watcher taste culture (and, not surprisingly, given the specialized tastes to which they appealed, critics often compared the two).[77] For his part, Kovacs encouraged his fans to see him as an anti-TV TV star. Kovacs told reporters he almost never watched TV. "I've got eleven TV sets in my home but you'll never find one on. My wife (Edie Adams) and I just don't watch it. I don't even see my own shows."[78] Yet, from the number of TV spoofs on his programs, it seems obvious that Kovacs had a vast knowledge of what was on TV; at best it appears that he underestimated his own viewing habits.[79]

Kovacs said most of the fan mail came from "doctors, lawyers, writers, newsmen, actors, college and high school students, also housewives," but not from the "9 to 5 clerk who bowls every Thursday night."[80] In a classic case of Bourdieuian "distinction," Kovacs fans exhibited their sense of taste by commenting on the inferior intelligence of the people who didn't "dig him." Kovacs once said, "Everybody thinks the rest of the public is moronic," and his fans apparently agreed.[81] Mrs. Haladen H. Hungate of Indianapolis, Indiana, told Kovacs, "You are too smart for the average viewer. I am not average." Mrs. Edward Joseph Schmidt of Milwaukee, Wisconsin, wrote, "Your program Friday evening . . . was a real tribute to the intelligence of your viewing audience too in that you refrained from having audiences present at the studio to laugh and applaud for us." Miss Ann Davidson of Queens, New York, told Kovacs that his program "was the one late-night show that those slightly

above the moron level could enjoy."[82] Distinguishing themselves from the average fools, fans often alluded to their college-level educations and superior knowledge of the arts. Robert Marks of Flushing, New York, wrote:

> That ballet you did on your special show was the funniest presentation of *Swan Lake* I have ever seen. My wife had to literally pick me up off the floor—I rolled off my chair laughing. I would also like to compliment your wife on her performance of the Villa Lobos songs. I have a degree in music, and was completely astonished that a voice so well trained in the popular idiom could show an aptitude for the classical form.[83]

Recommending that Kovacs do a skit about modern art museums, Mrs. Ed Blackwell from Indianapolis, Indiana, asked:

> Have you ever walked through an art gallery filled with "wild" modern paintings and equally "wild" viewers staring in moody silence at the aforementioned paintings? You could make something wonderful of a situation like this! By the way, I spent 5 ½ years in an Art School and I suppose an equal amount of time roaming through all the Museums and Art galleries in this country. Believe me, I do not dislike "modern" art, but I do dislike things ugly and phony which masquerade as art. Many thanks for your excellent programs.[84]

As these letters suggest, at the same time that fans reported their artistic and educational credentials, they also demonstrated their counter-distinction by seeing through phonies or liking gorilla ballets. Like Kovacs himself, these fans seemed to have enjoyed their ability to move promiscuously among the rigidly defined taste hierarchies of the period. Although some viewers and critics did attack him for the license he took with the masters, Kovacs's adoring audience found his irreverent attitude toward art to be one of his most attractive features.

Moreover, Kovacs's experiments with sound and image inspired viewers to create their own experimental art. Numerous fans sent him unusual drawings, trick photographs, and descriptions of performances modeled on Kovacs's interest in sound-image experimentation. Although some of these seem to have been inspired by a viewer mail-in contest Kovacs conducted between 1954 and 1955, others appear to be spontaneous reactions. For example, Mr. Thomas Kullman of St. Charles, Missouri, sent Kovacs a drawing for a video trick he discovered involving vertical roll, telling Kovacs, "I decided to only let you in on it exclusively . . . because I have always enjoyed your satire." Mr. C. H. Trutner from Jersey City, New Jersey, sent Kovacs pictures of his Siamese cats, which he claimed were fans of the show. Rather than just cute

pet pictures, however, these were overexposed to create an artistic effect, and the accompanying letter includes precise explanations about the exposure time, lens types, lighting, camera distance, and angles used to produce the artistry. Mrs. Betty Gluckman from Newark, New Jersey, sent Kovacs a post-card on which she drew an eye. Using a photograph that she had taken of a pair of sneakers, she cut the photo into a round eyeball shape and glued it to the center of the eye. She titled it "The Ernie Kovacs Show at 12:14 1/4 A.M." And Marjorie L. Sheldon of Cleveland, Ohio, told Kovacs that she and six of her co-workers were doing a "take-off" of his Nairobi Trio for their annual Christmas party. They called themselves the "Zanzibar Zextet."[85]

The creative activity that Kovacs inspired challenges the historical truism that television's first audiences were passive viewers, willing to watch anything and everything on television, simply because TV was new. Instead, it is clear that even in the very first decade of commercial television, viewers began to establish critical hierarchies of taste, and at least in the case of Kovacs they were an interactive audience, making their own cultural forms in dialogue with what they saw on TV. Way before Internet bloggers or the Slash fiction fan artists that Henry Jenkins and others describe, the American public used the new technology of television as a form of "convergence culture" that allowed them to produce homemade art out of mass communications.[86] In their time, Kovacs's fans saw themselves as a new breed of anti-TV TV connoisseurs who could see and hear the difference between mere commercial noise and TV art. Like Kovacs himself, they expressed their distinction from the rest of the TV crowd not only through words, but also through homespun experiments with video, photography, and music.

As a historical figure Kovacs is interesting precisely for the ways he inspired audiences to think about TV, not simply as a showcase for other arts, but as a creative medium that needed to be evaluated and developed in its own right. Kovacs experimented with sound and image at a time when critics lashed out against the noise of mass culture, and his experiments engaged critics and audiences in a full exploration of television's audio and visual potentials as art. Yet, most paradoxically, even while his silent episodes and musical montages elevated him to the status of TV artist, silent TV also turned out to be his most commercially viable idea.

SILENCE SELLS

Although Kovacs was viewed as an artist in his own time, it would be hasty to see his work as a radical break with commercial television. Even if he despised the network suits, Kovacs was not anti-commercial.[87] Quite to the contrary,

Kovacs often spoke of how much he adored his sponsor Dutch Masters Cigars, which gave him artistic control over production as well as a stash of expensive cigars. In fact, in response to the "noise" criticism launched at advertisements, Kovacs innovated not just silent programs, but also silent commercials.[88] Indeed, the most curious part of the revival of silence in the TV age was that silence was rediscovered as an ingenious sales technique.

Kovacs's panel quiz show, *Take a Good Look* (ABC, 1959–61), was the first vehicle for his silent ads. Each week Kovacs wrote, performed, and scored a wordless commercial for Dutch Masters. In fact, while critics often panned Kovacs for stooping to do a quiz show, they nevertheless effusively praised the creative ingenuity of the ads.[89] The commercials depicted Kovacs doing pantomime and sight gags. The first episode contained an ad that showed Kovacs at the symphony listening to Haydn's String Quartet, op.3, no. 5 (the music used in most of these ads) while smoking a cigar. Nobody seems to notice. The camera swings up slowly to reveal the string orchestra, every member of which is also smoking a cigar. The camera pans down to show the cigar box over which is superimposed the sponsor's slogan: "Step up to finer smoking pleasure with Dutch Masters."[90] The 1961–62 specials also contained silent ads. One of these shows Kovacs in an old western shoot-out. As the Haydn quartet plays, Kovacs fires shots at the villain. But rather than dying, the villain puffs his cigar and smoke pours out of the bullet holes all over his body. The camera pans down to his boots, where a box of Dutch Masters lies on the ground.[91] Proud of his work and happy with his sponsor, Kovacs said, "I'd like to start a full-fledged campaign for noiseless commercials. I'm convinced that people have had more than enough talk on TV. . . . From the mail we receive, I know viewers appreciate a few moments of silence during the commercials. And I think the message comes over at least as effectively as some ex-circus broker shouting at his armchair audience."[92]

Judging from the fan letters in the Kovacs collection, Kovacs was right. Mr. Seymour Soloman from New York City wrote, "Since I am rather impressionable, it was easy for me to fall under the sway of . . . your commercials, and I've taken up cigar . . . smoking and chewing." Mr. Soloman was so inspired by Kovacs's silent ads that he wrote a script for his own silent commercial and asked Kovacs to use it on one of his upcoming shows. Even women vowed their loyalty to the product. Mrs. Mona Gibbs from Woodland Hills, California, told Kovacs, "I am going to switch to Dutch Masters! And my husband might not like it. . . . No fooling, your commercials are dillies." Mrs. Art Treadwell from Alameda, California, admitted, "I am too inhibited by the mores of modern society to smoke cigars," but "If I did smoke cigars . . .

Ernie Kovacs parodies a western showdown in this silent commercial for Dutch Masters cigars (1961).

I would rush to my nearest tobacconist and buy out his supply of Dutch Masters."[93]

Even if the female fans didn't personally use the sponsor's product, the folks at Dutch Masters must have been happy that Kovacs had a large female fan following. During this period, the Cigar Institute of America was grappling with ways to change women's image of the cigar smoker from a gruff unmannered slob to a sophisticated, polite man that housewives would allow on their sofas. With this objective in mind, in 1956 the Cigar Institute of America launched a major advertising campaign in *Life* magazine that tried to "win the respect and the confidence of women as far as the male cigar smokers are concerned." The ad campaign not only attempted to elevate the image of the cigar smoker in women's minds, it also tried to teach women how to teach men to have "good manners in smoking cigars" by, for example, encouraging "women to serve cigars after dinner by bracketing it with other items: cigars and brandy and cigars and fruit."[94] For its part the Dutch Masters brand had its own strategy for improving the image of the cigar smoker. In 1957, Dutch Master's advertising agency, Erwin, Wasey & Co., hired the well-known French artist André François to illustrate (and sign) a print advertisement that spoke from a woman's point of view. The top portion of the ad was a semi-abstract brushstroke illustration of a woman on a divan. Below her was a photograph of a handsomely dressed suitor carrying a gift for her and smoking a cigar.[95] Given its interest in winning over women, it seems likely that the cigar company regarded Kovacs's female fan base as an asset in convincing men to "step up to finer tastes."[96]

Regardless of gender, Kovacs's success in this period was also in keeping with sponsors' growing recognition that it might just be better to target a "class" audience by supporting innovative programs than to support programs in the "common denominator" mold. Commenting on the silent

ads, Jack Mogulescu (advertising vice president and marketing director of Consolidated Cigar) said that while Kovacs "didn't pull big ratings," both the cigar company and the ad agency were "convinced that what they lost in headcounts, they more than gained in effectiveness . . . if a program has some unusual values, even if it has a smaller audience, it has the basis for commercial success. I think the Kovacs show proved that."[97] Account executive Bob Davis agreed that while Kovacs didn't have huge ratings, the commercials "engendered good will in everyone."[98] Taking note of this popular enthusiasm, in 1960 the trade journal *Advertising Age* said that Kovacs was one of "the TV commercial's best public relations experts right now."[99] In fact, Kovacs's silent commercials were so popular and so effective for his sponsor that they were repeated by popular request, and shortly before his death in 1962 Colgate-Palmolive (which sold household products to mostly female consumers) began negotiating with Kovacs to make silent commercials (no programs) for their company.[100] Meanwhile, a critic for the *Atlanta Journal* wrote, "I wish Ernie could organize a full-fledged, industry-wide campaign for silent commercials."[101]

Kovacs's commercial viability shows that sponsors were not antagonistic to innovation and experimentation; instead, innovation was crucial to television's commercial logic. Although Wasteland Era critics sharply separated these two arenas, the case of Kovacs demonstrates that artistic experimentation and commercial imperatives were actually joined together and could in fact be mutually lucrative. Artistic experimentation was not only a reaction against commercial noise; it was also (for Kovacs and his successors) a way of gathering audiences around commercial TV and even making them more likely to buy consumer products. Viewers and critics liked Kovacs's silent commercials and even viewed them as art. In this regard the anti-TV TV watcher turned out to be a commercially viable taste culture, a "class" (rather than "mass") audience that Hollywood and Madison Avenue wanted to exploit, largely because they thought this audience was uniquely motivated to buy certain products and had the discretionary income to do so. Indeed, Kovacs was in the vanguard (if not the direct influence of) a new wave of aesthetic innovation that took place not in the trenches of the video-art underground, but rather on Madison Avenue, in Hollywood studios, and in the business offices of network executives.

In fact, Kovacs's experiments with sound and silence gave way to a rash of television programs that also experimented with silence and silent-film techniques. In 1958, CBS premiered *The Gamblers,* a half-hour series that used still photographs from picturesque locations around the world to tell adventure

stories with minimal dialogue. Although short-lived, *The Gamblers* attracted interest among advertisers who applauded the "quieter" approach to TV.[102] On ABC, Warner Brothers' cop show *77 Sunset Strip* ran a dialogue-free episode titled "The Silent Caper" that self-reflexively presented its hero kicking a TV set that had no sound. TV sitcoms such as *The Patty Duke Show* (ABC) and *Gilligan's Island* (CBS) also did parodies of silent movies.[103] On CBS, Rod Serling's *Twilight Zone* included two dialogue-free episodes, one featuring Agnes Morehead as an alien being invaded by earthmen, the other starring Buster Keaton as a man who travels back in time to the era of silent films.[104] Silent-film star Sessue Hayakawa also revived his silent-film shtick when he appeared as a guest on a 1959 episode of *The Steve Allen Show*. After introducing him to the home audience, Allen showed a clip from Hayakawa's 1914 silent film, *Typhoon*. Perhaps believing that TV audiences would not be able to deal with three minutes of silence, Allen wisecracked over it. Following this, Allen asked, "What would have happened if the television tube was invented about forty years ago? They didn't have the sound thing really swinging then, so you would have had silent television, right?" He then performed a silent TV interview with Hayakawa with inter-title cards and gestural acting (a la silent cinema) to enact a thoroughly mundane TV chat followed by Hayakawa doing a mock silent commercial.

This interest in silent cinema took place in the context of a more general cultural embrace of silent films that were screened both on early television and in the growing circuit of revival house theaters. As early as 1948 WJZ in New York featured silent films in a weekly series, and after that numerous stations followed suit.[105] By the 1960s, the networks showcased silent films in various formats including network specials like NBC's *Laughter USA* (1961), which featured Chaplin and Keaton.[106] Broadcast on ABC between 1960 and 1961, Kovacs's own show *Silents Please!* was one of the first silent-film retrospectives with Kovacs introducing a silent film each week from the den of his Beverly Hills home. Like his quiz show, this program featured silent commercials.[107]

Although they trafficked in silence, none of these programs employed the kind of audio-visual experimentation seen in the Kovacs specials. Unlike Kovacs's absurd sound-image aesthetic, most silent TV was motivated by plausible narrative conventions such as time travel, flashbacks, plays within plays, retrospective formats, dream sequences, and parody, and many of them (like the Steve Allen/Hayakawa bit) included studio audiences or laugh tracks.[108] In short, in the wake of Kovacs's success, the revival of silence in most TV series functioned within Hollywood's limited regimens of experimentation

in which network executives aimed to please not a narrow base of TV critics and anti-TV TV watchers, but rather a large national audience looking for more conventional forms of novelty within the system.

AND NOW . . . LESS WORDS
FROM OUR SPONSOR

In the context of the debates about commercial noise as well as the new trend for silent TV, art directors at advertising agencies grew interested in using silence as a sales technique. As advertising columnist Peter Bart of the *New York Times* noted in 1961, advertisers were beginning to "observe that men who create TV commercials have become involved in a shouting contest," and in response a new group of art directors were taking the silent approach.[109] Whatever critics (both then and now) say about Kovacs's status as an artist, genius, or offbeat weirdo, his experiments with silence were at the vanguard not just of video art but of TV commercials as well.

In 1958, one year after Kovacs's silent show, Chevrolet featured a wordless commercial that was a "simple story . . . told in naturalistic pantomime" of a boy who gets his father to buy him a Chevy so he can impress a girl.[110] Produced by the commercial film company Lawrence-Schnitzer Productions in conjunction with the ad firm Campbell-Ewald, the Chevy commercial had mood music, but no dialogue. Producer Jerry Schnitzer observed, "The use of too many words overwhelms the audience and paralyzes the identification and participation which we so strongly try to accomplish."[111] Rather than taking an "inspiration from radio," Schnitzer argued, commercials must "communicate non-verbally . . . they must pictorialize their themes and shrug off their dependency on inert sounds."[112] Other advertisers agreed. J. Walter Thompson, one of the major agencies for television commercials, dubbed a humorous sales pitch for 7-Up over old silent movies ("Old Movie Kitchen," 1959).[113] In that same year Jack Gould of the *New York Times* praised wordless ads for Pontiac Automobiles, Wrigley Gum, and Pepsi-Cola. A critic for the *Atlanta Journal* specifically traced these sorts of commercials back to Kovacs, saying that Kovacs had started a "small revolution in TV commercials."[114]

Whatever their derivation, by the early 1960s silent commercials were all the rage at the "creative shops" on Madison Avenue that specialized in arty ads. One of these creative shops, Doyle, Dane and Bernbach (DDB), made award-winning ads for Polaroid Cameras, American Airlines, Cracker Jacks, and Levy Bread that used minimal dialogue within an overall strategy of understatement.[115] The Levy Bread commercial ("Delicatessen," 1964) shows an Asian boy in a Jewish deli ordering a sandwich. The only words spoken are

at the end of the commercial when the announcer says, "You don't have to be Jewish to love Levy's real Jewish rye bread." Throughout the 1960s, commercials for such products as Goodyear tires, Life cereal, Dial soap, Tang instant drink, Calanese carpet, Adams sour gum, Viceroy cigarettes, and Bengay ointment developed the clever use of superimposed typography (referred to as "supers") in dialogue-free or minimal-dialogue commercials. Most self-reflexively, a commercial for Brazil coffee ("Why Not?" Handman & Sklar, 1967) begins (in lowercase type): "This is a silent commercial." The next shot uses larger type to ask "Why Not?" This is followed by a shot of the product, and then by a shot of a woman looking at her husband's hand reaching for a cup of coffee. The last shot is composed of lowercase type that says, "It's going to get very noisy again in one second." End of commercial, and presumably back to TV noise.

Explaining the move towards quieter commercials, Stephen Frankfurt, vice president and executive art director at Y&R observed, "In print advertising, advertisers have long used white space to heighten dramatic impact. Yet when it comes to TV advertising, everyone seems intent upon cramming the maximum amount of action and noise into the allotted time." Like Schnitzer, Frankfurt believed that by interjecting silent interludes into commercials advertisers could create more effective ads. In addition to silence, Frankfurt claimed, "The subtle use of music can build a commercial statement far more effectively than words."[116] Under Frankfurt's direction, Y&R produced a silent spot for Johnson & Johnson Band-Aids ("Field," 1963) that showed a little girl running along a beach and holding up her slightly scratched finger as she approaches her mother. Hoping to depart from the standard advertising jingle, Frankfurt hired Leonard Bernstein's arranger, Sidney Raymond, to score the ad. Similarly, Frankfurt experimented with wordless commercials in which the only sound was a selection from Mozart.[117] Kovacs's influence seems hard to ignore.

The resemblance to Kovacs is even more pronounced in an ad for Encyclopedia Britannica's "True Life" children's books. With art direction by the widely respected Georg Olden (who had previously been director of graphic arts at CBS), the commercial ("Library," McCann-Erickson, 1964) appears to be a direct homage to Kovacs's Eugene skit. It opens with three children (two boys and a girl) tiptoeing towards a library door and listening to hear whether anyone is inside. The leader of the group turns around to the other children, puts his finger to his lips, and makes a hushing sound. As they enter the library, the children stealthily tiptoe towards a wall of books. When the first boy opens up a book about Native American hunters, we hear buffalo

A clever use of typography makes
viewers attend to a wordless
soundtrack in this commercial
for Life cereal. The ad ends with
crunching sounds ("Crunch,"
DDB, 1966).

herds running and see footage of the scene. When the girl opens her book on elephant babies, we hear elephant calls and see the animals drinking from a waterhole. Finally, like Kovacs's trick paintings that often sprouted leaks, the book even splashes water on the girl.

As with Kovacs's commercials, advertisers thought that silent ads drew a more sophisticated class of viewers. A 1962 article in *Printers' Ink* singled out the silent ads for 7-Up, saying that they appealed to consumers who had "sophisticated" tastes and purchased products in a highly selective, discriminating way.[118] *Art Direction* spoke often of silent ads and remarked on the educated class of consumers to whom they appealed. In 1962 *Art Direction* columnist Ralph Porter announced, "We are entering the era of quiet reflective commercials which now seem to hold on to a more educated and willing audience. . . . Perhaps it took all this time to convince the client that he can sell as much if not more without shouting." Porter singled out a silent ad for Levy Bread as one of the best, saying it was "reminiscent of early Chaplin in its penetrating characterization."[119] Drawing on his knowledge of silent-film history, Porter declared that television advertisers were taking lessons from the montage techniques of Eisenstein and the Keystone Cops. He likened the work of advertising artists to Eisenstein's use of framing and composition, claiming, for example, that Jerry Schnitzer's TV commercial for Clairol Hair Color was a contemporary version of Eisenstein's techniques. (The commercial was essentially an analytic study of a woman's hairdo rendered with a montage-type photographic layout of a female head.)[120]

Porter went so far as to claim that television offered a new experimental medium for advertisers akin to the age of the early silent-film art. Echoing Eisenstein's disdain for the talkies, he wrote:

The early silent picture era forced movie makers to pictorialize themes in understandable emotional terms making words unnecessary. . . . With the advent of sound, the spoken replaced the written word and old movie techniques which had created a delightful art form were frozen into a state of verbal mesmerism. Present-day motion picture artists are aware of the importance to recapture those wonderful pictorial effects. But present-day movie makers are tied to the new medium of television, a medium that forces experimentation. If for no other reason than the survival of films, these experiments are vital to the creative flow of the visual entertainment industry. It is, therefore, a noteworthy event when the television producer comes up with techniques reminiscent of the prodigious silent era but re-designed to fit current cultural patterns.[121]

In direct contrast to the then reigning logic that television was a "vast wasteland" of stale plots, generic formulae, and above all commercial noise, Porter thought that television was an experimental medium on par with early cinema, and he saw commercials as the apex of TV art.

Porter's views on television commercials were expressed at a time when the advertising industry was engaged in what advertisers called a "creative revolution." Art directors had become more powerful at agencies, and when it came to television commercials, independent film and video production companies expanded and flourished. As cutting-edge agencies like DDB and Y&R invested in creative experimentation, and as independent commercial production companies explored new techniques of graphic production, the arty TV commercial was becoming a boom economy of its own. Silent ads were central to this creative revolution, and along with Porter, some of the most creative art directors were taking a lesson from the silent masters. For example, in 1959 Schnitzer ruminated on his debt to silent cinema, claiming that at its best the "Commercial can become Chaplin's 'formed film.'"[122] Several years later art director/producer Lee Savage concluded that commercials were returning to the "language of tricks" in the silent films that "charmed audiences in 1925."[123] "Today, just the way programs and commercials are mixed together," he claimed, "is preposterous enough to make Eisenstein wonder about a new definition of the word 'montage.'"[124] *Art Direction* columnist Dr. Irving Taylor even cited Rudolf Arnheim's *Film as Art* when considering the art of the TV commercial. According to Taylor, just as Arnheim believed "sound adulterated the pure art of silent film," in TV ads "silence is badly needed—if only to give some of the noise a chance to be heard." Claiming that "experimental research has shown that as time is filled with sound, less is heard," Taylor advised, "Admen . . . should observe the old Japanese Samurai

sword fight; Warrior assumes a silent posture and then in one swipe, his op-
ponent is neatly severed in half."[125]

Indeed, on television even the seemingly empty space of silence was
turned into a commodity form. As Slouka argues, in a technological society
inundated by noise, silence has become a rare commodity packaged and sold
to those who can afford luxury resorts and nature retreats far from the din
of everyday life.[126] Certainly, in the late 1950s TV advertisers realized that
the class audience would pay for products promoted via silence. Neverthe-
less, I do not think this history of TV silence can be explained merely as the
irony of commodification. We can't fully understand these experiments with
TV sound and image just by turning to models of hegemonic incorpora-
tion of art or advertiser manipulation. Instead, this history discloses a more
symbiotic relationship among commercial media, artistic experimentation,
and broader cultural practices of taste. Television's commercial imperatives
did not merely shut down people's ability to explore alternative models of
audio-visual aesthetics. Rather, commercialism—and the public outcries
against commercial noise—also led to experiments with sound and silence
that interrupted the dominant trends of fidelity and TV realism more gener-
ally. These experiments fostered a taste culture—a minority audience—that
viewed themselves as anti-TV-TV watchers. Silent TV was in many ways an
early example of narrowcasting to a niche audience fed up with the noise of
mass culture. Like the pay cable slogan, "It's Not TV: It's HBO," Kovacs prom-
ised his fans that their TV pleasures would not be mundane.

From this point of view it is also not surprising that these early experi-
ments with TV silence—both in programs and in commercials—were
quickly renamed "Art." Just as Kovacs was able to juggle the roles of offbeat
genius and cigar salesman, the makers of commercials were increasingly per-
ceived not just as advertising hucksters but also as filmmakers/directors. In
1963 a television critic for the *Los Angeles Times* reported that, as opposed to
the popular view of advertisers as untrustworthy men who "slunk around the
fringes of a polite society," the makers of commercials were full-fledged art-
ists who "won prizes at Cannes and Venice." He singled out none other than
Jerry Schnizter (the maker of the first wordless Chevy ad, the Clairol ads, and
numerous other wordless commercials), noting that Schnizter "has the cour-
age to say art and commercial in the same breadth."[127]

Meanwhile, in other spheres of cultural production, the 1960s witnessed a
profound interest in audio-visual experimentation that circulated back and
forth between commercial and avant-garde venues. By the mid-1960s a new
group of video and performance artists began to reclaim television as art,

not just by experimenting with video images, but also by experimenting with sound. Video artist Nam June Paik was trained as a musician and experimented (along with avant-garde cello player Charlotte Moorman and composer John Cage) with sound, music, and feedback in his early videos and video installations. So too, in the 1960s the public outcry against commercial noise ironically came full circle as electronic noise and audio-video feedback became a component of youth club culture and eventually "noise" bands. In 1968, when a critic for the *New York Times* reported on an electronic performance by Pro-Musica at Carnegie Hall, he claimed that the group (which played electronic sounds to filmed projections of fish) had been influenced not only by the Dadaists or John Cage, but also by television commercials.[128]

Despite the early public outcry against TV noise, the relationship between commercial noise and the audio-visual arts turned out to be more a feedback loop than a mere antithesis of terms. Silent TV had come full circle, orbiting around a number of fields of cultural production. From its roots in the European avant-gardes to the television work of Ernie Kovacs to Madison Avenue boardrooms to video and performance art and back again, silence and other experiments with sound-image relations resounded across different cultural domains. The extent to which the artists in any one domain crossed over to the other is often hard to pinpoint, yet it is clear that both television artists like Kovacs and advertisers searching for fresh ideas skirted the boundaries of popular television and the wider field of audio-visual arts, and it is also clear that critics and audiences at the time noticed and compared the points of contact. With that last insight, I will take a cue from the word-mincing samurai swordsman and end this chapter.

6

●●● ONE-MINUTE MOVIES

Art Cinema, Youth Culture, and
TV Commercials in the 1960s

The 1960s was a decade of high irony for television. While Newton Minow decried the medium as a "vast wasteland" and rallied for a new educational network, television saw its greatest artistic achievements not in programs per se, but rather in commercials. Resentful of the FCC and critical attacks on commercials, advertisers often promoted themselves as television's creative avant-garde, or as one article in *Art Direction* declared, commercials were "Dynamic Oases in a Desert of the TV Wasteland."[1] The "creative revolution" that nurtured the silent ads of the early 1960s also gave way to a virtual renaissance at advertising firms that resulted in a flurry of audio-visual experimentation. This artistic renaissance grew out of the 1950s rise of modern graphic design and the animated ads in that period. Yet, by the mid-1960s graphic designers and advertising art directors were more deeply involved with the youth culture of the era.

As Thomas Frank shows in *The Conquest of Cool*, the creative revolution at advertising agencies of the 1960s was not just an art-for-art's-sake endeavor; advertisers also engaged and even helped orchestrate the belief systems and values of the 1960s counterculture.[2] While most advertising firms of the 1950s were notoriously business minded and practical in orientation, the creative revolution fostered a new, unconventional, anti-authoritarian attitude among

advertisers that was expressed in less hierarchical workplaces; the embrace of young talent; and even the sartorial choices of advertising artists who traded in their gray flannel suits for dashikis, love beads, and jeans. So, too, these younger, hipper advertisers extolled the virtues of rock 'n' roll music, smoked marijuana, and some even recommended LSD as a tonic for visual discovery. Frank's analysis of advertising trade journals and exemplary campaigns from the decade shows how copyeditors and artists at cutting-edge "creative shops" identified with youth culture and used countercultural views to market products from Volkswagens to Alka-Seltzer. His book offers a keen historical glimpse at the work worlds of this "now" generation of advertising experts and the way in which they promoted new ways of seeing products—and capitalism more generally—in a society that had become highly suspicious of advertising and admen alike.

While Frank is mostly concerned with print advertising, his insights also apply to the work worlds of art directors and film producers who made TV commercials. The artists who made commercials were typically young and identified with youth culture. Not only did they adopt hippie styles, they also embraced the youth culture's love of the cinema. The rise of art-house cinemas in major U.S. cities after WWII, as well as a surge of film courses and festivals on college campuses, created a burgeoning youth audience for international art cinema, experimental and underground films, and revivals of silent films and classic Hollywood fare.[3] Just as advertisers modeled silent commercials on Eisenstein and Chaplin, they looked more broadly to cutting-edge developments in cinema for methods of visual communication. Television commercials of the 1960s were often extremely condensed versions of techniques and ideas that advertisers gleaned (or in fact invented) through their associations with film culture, especially European new-wave cinema and independent, experimental, and structural films of the 1960s.

The sponsors' immediate intention was, of course, to find new visual techniques that would make people watch commercials and desire products. Just like print advertisers, television sponsors of the 1960s sought out more youthful consumers. Moving away from aggregate ratings and family audiences, sponsors targeted the 18–49-year-old demographic, which they saw as the most lucrative market. The younger end of this younger demographic was also the target audience for the burgeoning film culture, and advertisers thought these desirable youth audiences would be more likely to enjoy commercials that used cutting-edge cinematic techniques. In this respect, advertisers' turn to art cinema was good business. But advertisers' engagement with cinema was not simply instrumental. People who made commercials

were often cinephiles, and as the 1960s progressed some advertising artists even saw themselves as part of a filmmaking avant-garde. More than just an appropriation of film art for commercialism's sake, advertisers' interest in cinema attests to the increasingly complex relations among segments of post-war bohemia, the 1960s countercultures, and the Madison Avenue "establishment." Meanwhile, by employing the latest cinematic techniques, sponsors helped turn TV audiences into art-film publics.

THE CREATIVE REVOLUTION AND
ART-FILM COMMERCIALS

By the late 1950s roughly 80 percent of television commercials were shot on film.[4] With the bulk of network primetime programs being produced at Hollywood film studios, live commercials were no longer a routine network practice. As an economic and industrial form the filmed commercial provided a number of practical benefits. Mistakes in performance or product failures (such as appliances that would not work) could be edited out; production could be scheduled to fit the availability of the talent; directors could shoot on location; and clients could save money by amortizing production costs over repeated uses of the same commercial. Yet, the move to filmed commercials was not just a practical solution. It was also an artistic choice. In fact, filmed ads could be extremely costly to produce. By 1959 nearly all commercials were shot on expensive 35 mm film, the same width used for Hollywood feature production, and the average shooting ratios were 7:1.[5] To complement the networks' transition to color primetime lineups, advertisers increasingly used color film, which cost up to one-third more than black and white.[6] This was a sizable investment, especially considering the fact that in the 1960s the lion's share of viewers was watching color commercials on black-and-white sets.[7] Yet, in the sponsor's mind such expenses seemed worth it.

As television matured, sponsors realized that they were in an extremely competitive playing field, vying to get the attention of audiences inundated by ads. In his advertising handbook of 1957, *The Television Commercial*, Harry Wayne McMahan noted, "The average family consumes 360 television commercials a week," and for this reason, he told advertisers, "You should not assume you have a completely captive audience in front of the television set. You still must gain their attention, then their interest."[8] In 1964 the AAAA conducted a national study on consumer judgment that found that the average individual reports he or she sees or hears about seventy-six advertisements per day. Of these, 16 percent were considered either annoying, offensive, enjoyable, or informative, while most ads—84 percent—did not provoke

any particular impression at all. One of the primary reasons that ads made a neutral impression was that people thought they looked like other ads or said the same things.[9] Commenting on this, the vice chairman of the AAAA's Board of Improving Advertisements said, "Boring people is expensive."[10]

Throughout the 1960s advertisers searched for ways to make commercials stand out in an advertising-saturated culture. Just as print advertisers of the 1950s thought that visually dynamic big-picture ads would create increased recognition and retention, throughout the 1960s advertisers experimented with new artistic methods by which to grab people's attention. Sponsors' concerns with audience attention rose to new heights in the late 1950s and 1960s when they found themselves buying thirty- or sixty-second spots in network programs they did not produce or even necessarily like.[11] Advertisers often worried that dull or tasteless programs would reflect poorly on sponsors' products, regardless of the ratings the programs received. In this context, they tried to leave favorable impressions in the viewer's mind at rapid speeds. There were a number of solutions to this goal. Some advertisers preferred straightforward realism and demonstrational live-action spots, which they thought promoted the idea of honesty in advertising at a time of intense FTC investigations and critical attacks on advertisers. But others experimented with the commercial form, hoping to grab viewers (especially the younger desirable demographics) with ads that spoke to distinctive and contemporary tastes. The art-cinema commercial was one of the era's primary methods by which television advertisers courted second-generation TV viewers who, in the advertisers' mind, had grown weary of the standard commercial pitch.

The commercial film business grew exponentially from the mid 1950s through the 1960s. By 1959 film production houses specializing in commercials "engaged approximately 20,000 people, mostly in New York, but also in Hollywood and points between."[12] By 1968, the *New York Times* estimated that there were roughly 400–500 commercial directors in New York alone, where an estimated $100 million was spent annually on producing TV spots.[13] During the 1960s, all the major advertising firms contracted out to commercial production houses, using about thirty to forty such houses on a regular basis. While the reigning producers of film commercials in the 1950s specialized in animation, by the mid-1960s independent production houses like VPI Productions (owned by Electrographics), MPO Videotronics, and Film Fair all specialized in live-action film (and later videotape), and major Hollywood studios like Warner Bros., Fox, and Columbia's Screen Gems had commercial film subsidiaries.[14] In addition to competing for consumers' hearts and minds, advertisers and commercial film companies also competed for a host

of new professional awards—not only the awards (available as early as the late 1940s) from the ADC and AIGA, but also new awards such as the Clio (established in 1959).

In this context, the art of the television commercial (or what the trades typically called the TVC) flourished. Advertising art directors and commercial film producers sought artistic status commensurate with the amount of capital invested in ads.[15] Rather than thinking of commercials as the television equivalent of print advertising, advertising firms increasingly set up separate art direction TV departments, and rather than seeing themselves as photographers or illustrators, advertising artists often saw themselves as film directors/producers. As Ralph Porter announced in *Art Direction*, "A new genre is emerging on the TV commercial scene, and still photographers become movie makers."[16] In contrast to the static, talky feel of 1950s demonstrational ads, the live-action filmed TVCs used montage sequences, moving camera, mood lighting, location sets, and/or color photography.

The ninth annual International Design Conference in Aspen, which took place in the summer of 1959, was a landmark occasion for this new focus. The IDCA devoted an entire day to a session on the "film image," and a range of filmmakers, psychologists, scientists, graphic artists, and commercial directors discussed various aspects of film form. Graphic designer Saul Bass, whose title sequence for *The Man with the Golden Arm* was screened at the conference, moderated the session. Also included were documentary/experimental filmmaker Norman McClaren (who had also just shot the television credit sequence for *The Jack Paar Show*); commercial producer Jerry Schnitzer (of silent commercial fame); and scientist/photographer/documentarian Roman Vishniac (who also made commercials).[17] Dialogues among artists, scientists, and commercial filmmakers were further encouraged by the range of films screened at the conference, which included everything from animated experimental shorts like McLaren's *Penpoint Percussion and Dots* (1951) to experimental filmmaker Maya Deren's *At Land* (1944) to Stanley Kubrick's feature *Paths of Glory* (1957) to French and British television commercials.

In addition to juxtaposing commercials with art cinema, the IDCA gathering initiated discussions about film language itself. Bass opened the session with a brief history of silent cinema in which he spoke of the need for moving, dynamic forms. Following Bass, Schnitzer argued that the commercial "can tell a story by applying the basic principles of cinematic art." He added, "The filmed commercial can, as it must, tell its story with dynamic movement. Emulating from still photography, it has often failed; witness those commercials whose only action takes place between the nose and the chin

of the announcer." Schnitzer pleaded with his fellow commercial filmmakers to stop being "hacks" and start being "artists." With obvious bitterness he remarked, "Even if theatrical film makers continue to look down their noses at it," the commercial film industry is "a thriving industry, rich in growth potential."[18]

Although the various speakers rallied for the TVC as a form of "art," the main issue at the session was film's perceived power as a form of visual persuasion. Arguing that human communication should be a subject of scientific study, Gilbert Cohen-Séat "gave an extraordinary demonstration of this vital interplay between film and audience by showing three filmed situations, each without sound or titles, and asking conference attendees to interpret the scenes just shown. The entire experiment was meant to show the wide variation of responses that a film might generate and to demonstrate how a director might manipulate audiences toward a preferred meaning."[19] Other speakers at the conference noted their debt to the history of film theory, which at least since Lev Kuleshov's experiments with montage in the late 1910s through the 1920s, had been engaged in psychological and aesthetic questions of film form and viewer response.

More generally, advertising art directors were enthralled with film art and its connection to the art of persuasion. As early as 1957, *Art Direction* discussed "films as they relate to the television industry and advertising," and by 1958, the trade journal struck a deal with major Hollywood motion-picture companies "to review all applicable films" in a regularly occurring film review column penned by Ralph Porter. Porter reviewed films that contained visual or audio techniques conducive to advertisers' goals of persuasive rhetoric. In his first reviews of 1958 releases he recommended such eclectic examples as the science-fiction thriller *The Fly* (for its special effects); *La Parisienne* starring Brigitte Bardot (Porter claimed it had sex appeal); Nicholas Ray's *Wind Across the Everglades* (which he called "a turbulent poetry of movement"); and the Cary Grant/Sophia Loren vehicle, *Houseboat* (which he claimed was "particularly noteworthy for its excellent use of authentic Washington, D.C., backgrounds").[20]

By the early 1960s, *Art Direction* had embraced European art cinema as the ideal mode for TVC production. Porter recommended that advertising artists take a cue from the "stream of consciousness" techniques used in Federico Fellini's *8 1/2* (1963), and he compared director François Truffaut's *Jules and Jim* (1962) to the commercial for 7UP that used silent film footage.[21] Porter also praised DDB for taking a "European feature film approach to commercials" by allowing content to follow form. He claimed that DDB ads for

A poetic montage for Zee napkins ("Softness," DDB, 1962).

Rainer beer and Zee tissues had an "Ingmar Bergmanesque aura of mountain paths and pastoral beauty." A Zee napkin commercial, he said, "Approaches a Fellini tongue-in-cheek concept of an assortment of 'La Dolce' characters breakfasting on a lush lawn."[22] Similarly, Porter recommended Tony Richardson's *Tom Jones* (1963) for its painterly color photography and "mobile camera work," and he observed that advertisements for cigarettes, soda, and deodorant used images of "peace" that were "born . . . out of the works of neo-realist film-makers."[23]

Other columnists for *Art Direction* also noted the connections between art films and TV commercials. Murray Duitz singled out Jean-Luc Godard's *Alphaville* (1965) as being of "special interest to the maker of commercials," for its "strong graphic scenes," "strong contrasts," "symbols," and "editing."[24] Upon its U.S. release in 1967, columnist Don Baron told readers to "Go See *Blow-Up!*" Analyzing Michelangelo Antonioni's new-wave film about a fashion photographer who solves a murder by enlarging photos of a crime scene, Baron claimed that *Blow-Up* presented the "film counterpart" to what he called the "exploded ad." "For better or worse," Baron wrote, "*Blow-Up* and

present day art directing are destroying, respectively, the art of storytelling and the art of advertising. At least that art or craft which says there is a birth, life, and death, or a beginning, a middle and an end." In other words, Baron not only embraced new-wave cinema, he also thought that advertisers were themselves riding the new wave of a visual revolution that left behind classical realism and embraced visual forms that portray life as "haphazard. . . . the opposite of the quid pro quo."[25]

More generally, *Art Direction* rejected Hollywood-style realism in favor of stylistic codes of art cinema including contemplative framing of people deep in thought, abstract long shots of landscape or cityscapes, unusual point-of-view shots, rapid montage, and graphic collage, as well as the hand-held techniques of cinema verité documentaries.[26] By 1967, the cinematic commercial had become so dominant that when *Art Direction* asked leading advertising executives to comment on the state of commercials, virtually all of them saw the application of art and experimental film techniques as the most important trend of the decade. Jack Roberts of Carson/Roberts claimed TVCs used "more experimental" photography and that "greater demands were placed on creative people . . . for executing the concept in 'one minute movies.'" Alvin Chereskin of ACR noted the predominance of rapid montage, saying TV commercials had "more staccato visuals that chop, chop, chop." Mike Elliot of EUE said, "To me, 1966 was the year of the 'look.' Visually it seemed as though all the TVCs were just one long lens, wide lens, sun flare, hand held, swish-pan, zoom in, whip out, discotheque sound, cut-to-the-beat piece of film."[27]

This new focus on art and experimental cinema was related to the lifeworlds of advertisers themselves. Advertisers' interest in film evolved in the late 1950s when New York City was becoming a major center for film societies and festivals. Art directors on Madison Avenue had many opportunities to interact with this burgeoning film culture. In fact, *Art Direction* was filled with reports about film festivals and societies such as Amos Vogel's Cinema 16. In 1961, Porter observed, "Of all the film societies in the country none has influenced the creative television artist more than Cinema 16. Their experimental, avant-garde and new art forms pop up with amazing regularity. . . . Agency Art Directors and film producers flock to view these private showings at Cinema 16 [and] much of what they see eventually finds its way into TV commercials."[28]

Film festivals further encouraged dialogues between advertisers and filmmakers because they screened commercials alongside art and underground films. While commercials were sometimes exhibited as pure camp, more

often they were taken seriously as art. Starting in 1957, the Cannes Film Festival screened both films and television commercials, and advertising executives from firms such as McCann Erickson and J. Walter Thompson served as judges for the television selections.[29] As noted in chapter 4, MoMA showcased TV commercials as an "avant-garde" art form in its Television U.S.A. retrospective, and by the mid-1960s, the MoMA Film Library began to circulate reels of award-winning commercials to universities. In this context, college campuses embraced the TV commercial as a new art form. A symposium held at Princeton University titled "What's Happening: The Arts 1966" brought together a panel of anti-establishment thinkers and artists including poet Allen Ginsberg, author and journalist Tom Wolfe, novelist Günter Grass, and *Realist* magazine editor Paul Krassner. In addition to these luminaries, the conference ran a mini-festival of TV commercials organized by Wally Ross, the president of the American Television Commercial Festival.[30] Meanwhile, even some art-house theaters embraced commercials as a new attraction. In 1965, the Bleeker Street Cinema in Greenwich Village (which typically showed European art films and revivals of Hollywood movies) prepared a festival devoted to TV commercials (even more oddly, these were on a bill with public-affairs shows).[31] Following this, the City Center in New York featured commercials in the International Tourné of Animation that also included numerous abstract films. In what had become a critical cliché, *New York Times* critic Vincent Canby said, "Some of the best films in the City Center program are actually TV commercials."[32]

The fourth New York Film Festival at Lincoln Center was a watershed occasion for the merger of commercials and cinema. The 1966 festival showcased TV commercials in a program titled "The One Minute Movie," which was one of twenty-seven programs organized under the umbrella term "independent cinema." TV commercials for beer, laundry detergent, and deodorant shared the screen with experimental flicker films by Tony Conrad and Victor Grauer, animated collages by Stan Vanderbeek, abstracts by Henry Smith, the Maysles Brothers 16 mm "direct cinema" documentary on Marlon Brando, and Robert Whitman's multi-media production "Two Holes in the Water, No. 2," composed of a giant vinyl inflating balloon, a soundtrack featuring rushing water, and a film portraying female nudes. Assembled by John Brockman, the twenty-five-year-old associate of underground cinema guru Jonas Mekas, this independent cinema strand of the festival was explicitly intended to be counter-Hollywood and was attended mostly by "youthful cinema buffs who daily packed the museum auditorium."[33] Amos Vogel, who directed the New York Film Festival, said the program was attempting to be a

"valid cross-section of what's going on in independent cinema today."[34] With irony the *New York Times* observed, "By Mr. Vogel's definition the independent cinema includes commercial films."[35] Apparently, despite the wasteland criticism launched against TV commercials, members of the New York underground felt comfortable placing commercials alongside some of the most extreme examples of experimental, countercultural, anti-Hollywood forms.

The cultural contacts between TVC directors, intellectuals, poets, novelists, graphic artists, musicians, and filmmakers provided a context in which advertising critics developed their own auteur system. In a 1963 column in *Art Direction*, Porter singled out Fred Mogubgub, a graphic artist who worked with montage and collage, and whom Porter predicted would become "our own 'new wave' filmmaker." Mogubgub had become something of a hot property on Madison Avenue, so hot that the advertising firm J. Walter Thompson gave him "free rein to develop [a] commercial" for its client, Ford. Interpreting Ford's main-selling themes ("America Loves a Ford" and "Ford is a carefree car"), Magubgub created a rapid montage of graphic symbols, typeface, and photographs that included images of hot dogs, banana splits, George Washington, and the Statue of Liberty, and he even did something that was "just not done" by including an image of another product (7UP) in the montage.[36] Although the ad seems entirely pop in conception, Porter compared it to the visual montage of Eisenstein. Whatever its derivation, creative innovation translated into enormous power and control for graphic artists like Mogubgub who increasingly became the bread and butter of the industry.

By the latter half of the 1960s, TVC directors were demanding high salaries. As production executives knew, the directors could make or break their company. As a standard practice, ad agencies procured bids from a variety of production houses, and the big firms regularly used a roster of thirty to forty such houses. Given the stiff competition, the presence of a specific director at a production house could outweigh the cost of a bid. In 1968 Milt Felson, assistant executive secretary of the Directors Guild of America, admitted, "Everybody has the same facilities to do the commercials, but the talent is the thing they sell."[37] This meant that individual directors were able to charge a high fee for their work, and since many of the most desired directors were young, transient, and often had sites on motion picture or television directing, the talent pool was scarce. Felson estimated that there were about 300–400 directors working in New York in the late 1960s, and the average pay for freelance work was then a whopping $170 a day. The most sought after directors could earn up to $3,000 a day. Many had Ivy League degrees,

were former advertising agency art directors, or came from Hollywood or industrial film production. To control fees and consolidate talent, commercial production houses like EUE/Screen Gems, MPO, and VPI Productions assembled a studio system of "auteur" directors by hiring freelancers as dedicated staff.

Some advertisers actually crossed the line into the world of feature-film success. The first notable example is Richard Lester, a highly prolific advertising artist who also directed, produced, and wrote British television programs and films in the 1950s and early 1960s, and went on to achieve major success when he directed the Beatles films *A Hard Day's Night* (1964) and *Help!* (1965). Although his life as an adman was not widely known to the Beatles youth audience, time and again advertisers, film critics, and filmmakers spoke of Lester's double life as adman and hip movie auteur. Writing for *Art Direction*, commercial film producer Lee Savage observed that Lester "is using the shorthand language that he has learned from communicating with the super-sophisticated audiences of the TV commercials. He is using this language in his real movies to express himself and that same audience loves him for it." Moreover, according to Savage, Lester was making the Hollywood "entertainment industry sit up in its wheelchair and take notice" by showing them how to reach the TV-literate youth audiences of the day.[38]

Commercials had indeed become a cinema of their own, and people noticed. Critic Joan Walker of the *New York Times* joked, "It is better to look at commercials without having them interrupted by programs." She also noted, "Commercial makers go to the movies a lot . . . and many of them saw 'Last Year at Marienbad,' 'Dr. Zhivago,' the James Bond series, and of course, 'Bonnie and Clyde.'"[39] Discussing their avant-garde look, Jones observed, "Some had titles like underground movies." *Television Quarterly*, the journal of the Television Academy of Arts and Sciences, published an article titled "Be Quiet, The Commercial's On" that endorsed advertisers' "willingness to experiment" and reminded readers that in critical circles commercials were in the same league as cutting-edge films.[40] Filmmakers also noted the trend. Stanley Kubrick said, "Actually I think some of the most imaginative filmmaking, stylistically, is to be found in TV commercials."[41]

Sometimes the new art-house commercials were purposely self-reflexive about quoting European art films. A commercial for Foster Grant sunglasses ("Sunglasses of the Stars," Geer, DuBois & Co, 1969) presents movie director "Señor Fellitini" taking a picture of (the real) actress Jill St. John in front of the Coliseum. In a somewhat more subtle homage, Xerox produced a TVC that rivaled a Godard film ("Ordinary Paper," Papert, Koenig, and Walsh,

1964). The commercial was part of Xerox's new marketing campaign aimed at young college-educated consumers, who the company believed would be its future customers.[42] Filmed in black and white, it opens on a Parisian street scene as a chic woman enters a very modern-looking office and hands a clerk a book. After copying a page, the clerk hands it back to the woman, and she responds "C'est très bien." (The only English spoken is the announcer's voice at the end of the ad.) Following this, another customer uses the Xerox machine to copy a pack of cigarettes, his watch, and keys. The final product looks like a Ferdinand Léger collage.

Although obviously spoofs, such ads assumed that ordinary TV viewers— or at least the kind of viewers that sponsors desired—would be knowledge- able enough about art cinema to get the joke. Indeed, from a business point of view the art-house TVC flourished because advertisers envisioned their target audiences as more worldly and media literate than first-generation TV viewers. Summarizing market research studies, McMahon's 1957 advertising manual recommended, "Do consider your viewer as more intelligent than ever before. Mass Communications—and especially television—have made him smarter about the world around him than any previous generation."[43] Charles Goldschmidt, chairman of the board at Daniel & Charles, said, "The young will not tolerate the kind of advertising their parents have been fed for so many years. To them, it is nonsense—'Mickey Mouse' they call it and they resent terribly being patronized in this way." "The more sophisticated agen- cies," he noted, "have . . . tried to develop a better understanding of how to talk to this younger generation. . . . Make no mistake about it, Grandmother advertising is not 'hip.'"[44] Speaking specifically about television commercials, Whit Hobbs, senior vice president at Benton & Bowles, observed, "In the beginning, TV commercials were childishly easy to do. And people who watched them were childishly easy to please." In contrast, in the 1960s, "Com- mercial television has done a remarkable job of growing up. And so have the people who watch it." This second-generation TV audience was bored with "routine" commercials and savvy about advertiser tricks. Accordingly, Hobbs advised fellow advertisers, "You have to grade up." "Most commercials," he said, "talk down . . . The really good ones aim high. . . . At best, they talk up to the consumer. At least, they talk to him on his level."[45]

Making fun of commercials had in fact become a popular pastime and ad- vertisers knew it. By the mid-1950s and especially in the 1960s *Mad* magazine often mocked commercials, with comic satires like "My Fair Adman." Paro- dies of commercials were often understood (or perhaps misunderstood) as

part of the new camp sensibility ("It's good *because* its awful") that Susan Sontag's "Notes on Camp" famously theorized in 1964. Although Sontag talked of camp in relation to the naiveté and innocence of mass culture—especially old Hollywood movies—camp quickly became a popular catchall phrase for any kind of mockery of pop culture, including TV commercials. A year after "Notes on Camp" was published, *The Camp Followers Guide!* (an Avon pulp paperback) listed everything from TV dinners to *The Lawrence Welk Show* to advertising slogans as sources to mine for camp pleasure. The book even printed sheet music and lyrics for old Colgate, Pepsi, Alka Selzer, Brylcream, Roto-Rooter, and Wheaties commercials.[46] To be sure, advertisers knew that audiences delighted in mocking the outworn look and feel of 1950s commercials, and while that wasn't in itself necessarily bad for business, it did mean that TVC producers needed to find ways to talk to a new generation of viewers who perceived themselves as advertising-savvy.

Considering the need to "flatter" this more intelligent media-literate TV viewer, *Printers' Ink* discussed the rise of the "Adult Commercial." According to the trade journal, "Today's screen-watcher is more experienced in movie techniques than his grandfather. . . . The 'adult commercial,' therefore is one that leans heavily on its audience's sophistication in terms of previous experience with advertising and communication techniques." Analyzing commercials that used unusual juxtapositions, rapid editing, visual puns, and artful compositions, *Printers' Ink* claimed, "An adult commercial depends on the viewer's ability to grasp visual metaphor."[47] Art director Lee Savage observed, "The audience has caught on so well to the absurdity of image juxtaposition [on television] that they are developing games of their own to sophisticate it still further." As an example, he said some "hip," "super-sophisticated" viewers had invented a "Do-It-Yourself montage" game by turning the TV set on its side, placing a cardboard cutout in front of the screen, turning off the sound, and turning on the radio. "This," Savage concluded, "is the kind of audience that Madison Avenue is communicating with. Madison Ave., better than Hollywood or Broadway, speaks their language."[48]

As sponsors pondered ways to reach media-literate consumers, the art-house TVC proved especially worthy. When advertisers referenced "Fellitini" or Godard, they did so assuming that a sizable segment of the audience would have some basic knowledge of art films. Most importantly, from a business point of view, advertisers thought the art-house TVC was just hip enough to flatter and engage the desirable younger demographic that was developing sophisticated "cinephile" tastes.

FROM ART HOUSE TO IN-HOUSE

The proliferation of art-house cinemas and revival houses in urban markets and college towns after World War II meant that more and more Americans had knowledge of the films upon which advertisers modeled their ads. According to Barbara Wilinsky, while industry insiders initially thought that the new art-cinema houses would be "sure seaters" that played to empty houses, the success of films like Roberto Rossellini's *Rome, Open City* (1945) and Fellini's *La Strada* (1954) proved that art houses would become a popular trend. Although initially appealing to an audience of mostly adult (over thirty) single men, by the 1960s art cinema had spread to more mainstream publics and even suburban drive-ins. So, too, as Hollywood officially abandoned its production code, its own films began to look more like the adult—and sexier—European art-film fare.[49] Given their scrupulous tracking of markets, it is not surprising that advertisers noticed. In a 1963 article about the exploding "culture market," *Printers' Ink* observed that while there were only about a dozen art houses in 1950, "In 1960 there were some 500 art movie houses" and "the art side of the [movie] industry is rosy."[50]

Indeed, by the 1960s the art cinema had become something of a national phenomenon. Even for people who didn't frequent art houses, newspapers and national magazines (such as *Time, Life,* and *Vogue*) regularly reviewed European art films and/or provided in-depth close-ups of directors (especially Fellini and Bergman) and they also reported on glamorous European stars like Marcello Mastroianni, Jean Seberg, and Hollywood transplants like Sophia Loren and Brigitte Bardot. Nationwide audiences could also see these directors and stars featured as Academy Award nominees for the "best foreign movie" category. By the end of the 1950s, knowledge about international cinema was a major form of cultural capital that "sophisticated" people could translate into social mobility by demonstrating it at cocktail parties, on college campuses, and just about anywhere that cultured people roamed. In his advice book *The Cultured Man* (1959), Dr. Ashley Montagu even included a pop quiz that tested readers on movie knowledge and informed them about the films one needed to see to "improve your culture quotient." Almost all the movies were classic European films being revived at art houses (e.g., Robert Wiene's *The Cabinet of Dr. Caligari* [1919]; Fritz Lang's *M* [1931]; F. W. Murnau's *The Last Laugh* [1924]; Jean Renoir's *Grand Illusion* [1937]).[51] Even popular TV series traded on people's knowledge of art cinema. In a famous episode of *I Love Lucy's* European season ("Lucy's Italian Movie," 1956), Italian movie producer "Vittorio Fellippi" offers Lucy a role in his new neo-realist film titled *Bitter Grapes*. In this regard, by the time advertisers drew upon

art-cinema techniques, television audiences already had many opportunities to become acquainted with European art films, and most people knew that art cinema signified highbrow taste. At the very least people understood that art films were hard to understand, and like abstract art of the 1950s, were "wacky," "exotic," and "way out."

Most importantly from the point of view the TV advertiser, television was itself a major venue for the new film-buff culture. In the early days of television local broadcast stations cultivated this buff audience by airing film "packages" that were popular with audiences. For example, in the late 1940s the four stations in Chicago ran sixty features a week and network flagship stations used movies to fill fringe-time hours. In 1951 New York's CBS flagship station WCBS became the first station to offer a regularly scheduled feature-film "Late Show."[52] While films on early television generally came from "Poverty Row" B-film companies or else foreign (primarily British) film outlets, by 1955 the major Hollywood studios began to release (mostly pre-1948) features to television stations.[53] In 1956 almost 3,000 features entered television distribution, two-thirds of the number released in all previous years.[54] With more films in circulation, Late Shows (and even Late Late Shows) presented everything from silent films to A-films of the Classical Hollywood era and, on some stations, European art cinema.

By the early 1960s, the *New York Times* reported that a growing number of "night owls" were "addicted" to midnight movies, with somewhere between 250,000 and 700,000 viewers tuning into each movie on the WCBS program.[55] Moreover, the most dedicated of these viewers established a distinctive taste culture. According to the *New York Times*, "Genuine cinema buffs prefer the antiques, first-runs they claim are for squares."[56] Although audience research showed that women tended to watch more movies on TV than men,[57] this article and others like it presented the film buff as a man, perhaps harking back to the 1940s "single man" audience for the original art-house craze. Throughout the 1960s, the typical image of the TV film buff was a male addict watching a Late Show, unable to sleep or shake the habit, but also (as in the above example) a self-identified hipster and night owl who promiscuously tuned in for TV pleasure while the rest of the family slept.

In 1961, hoping to capitalize on the recent availability of more contemporary Hollywood feature films, as well as the desirable younger demographics that tuned in for (and also went out to) movies, NBC led the networks in bringing feature films to a regularly scheduled primetime slot when it debuted *NBC Saturday Night at the Movies*.[58] Unlike the previous movie packages, NBC aired recently released films with big box office names. The strategy proved

to be a huge success. *NBC's Saturday Night at the Movies* lured audiences away from CBS's *Gunsmoke* and ABC's *Lawrence Welk Show* (both of which ranked high in the ratings, but appealed to older and demographically less desirable audiences). Judging from its sponsorship lineup (which included food products, makeup, painkillers, and pet foods) the series also strongly targeted female audiences.[59] Following NBC's success, CBS and ABC began scheduling similar primetime feature film series. By 1968, at least two hours of primetime were occupied with feature films every night of the week. As William Lafferty observes, "Network feature films became the programming phenomenon of the 1960s."[60]

So popular were movies on TV that critics attributed the growth of the new film-buff culture to television. Considering the proliferation of art-house and revival cinemas in New York City, a reporter for the *New York Times* said television was one of the major catalysts. Art houses and revival theaters benefited from "a growing interest of younger people in old pictures and the exposure of screen classics on video." "Although television," the *Times* continued, "might seem lethal to the theatrical life of old films, [it] has apparently been the most important in reviving interest in them." As evidence of television's influence, the *Times* observed that the most often televised movies—for example, Orson Welles's *Citizen Kane*, the Marx Brothers' *A Night at the Opera*, and Humphrey Bogart films (which were "exposed to death on TV")—did especially well in revival/art-house theaters like the New Yorker Theater on Broadway and the Bleeker Street Cinema in Greenwich Village. Also considering the wave of cinephilia, a reporter for the *Los Angeles Times* declared that TV had been more important to the rise of 1960s film culture than either art houses or MoMA's film screenings. "If America is saturated in cinema, it is because TV networks hold a permanent, round-the-clock festival of *movies* from the 30s and 40s."[61] By the end of the decade, in 1969, art critic Lawrence Alloway claimed, "Today TV shows old movies . . . continually and in so doing has created a new kind of Film Society audience of TV-trained movie-goers."[62]

In addition to Hollywood movies, the networks catered to distinctly art-house tastes.[63] In the wake of Minow's "Vast Wasteland" speech and the outpouring of critical attacks on television for its over-commercialism and banal programs, all three networks attempted to stave off public criticism and FCC investigations by initiating new documentary series, all shot on film and some using the cinéma vérité and direct cinema styles. Also to stave off criticism and improve public relations with affiliates and audiences, networks nurtured cultural series and specials on the visual and performing arts, some

of which included interviews with famous European directors and discussed European cinema. In 1964, Ingmar Bergman appeared as a guest star on ABC's "Inger Stevens Sweden Special" (Stevens, who was then a popular sit-com star, interviewed Bergman at the Swedish Royal Academy of the Arts). The following year, ABC's documentary series *Scope* presented an interview with Fellini. Underground and experimental U.S. filmmakers also appeared on TV. In 1965, CBS reporter Mike Wallace interviewed structural filmmaker Stan Brakhage, while a 1966 CBS special, *Shots from the Underground*, presented artist/filmmaker Bruce Connor.[64] In the raging youth-culture environment, *NBC Experiment in Television* (a public-affairs show broadcast in what critics called the "intellectual ghetto" of the Sunday afternoon timeslot) featured a 1967 episode titled "Movies: The Now Generation" that promoted student shorts made at leading film schools.[65]

One year later *NBC Experiment in Television* presented an even more exciting visual feast by featuring a special primetime episode devoted to Fellini and his autobiographical film, *A Director's Notebook*. Fellini used this television engagement to promote his new theatrical release, *Satyricon* (much of *A Director's Notebook* was a "making of" story that tried to capture the look and feel of the film). With voiceover narration from Fellini himself, *A Director's Notebook* signified its art status with slow tracking cameras, lush color photography, and fantasy scenarios in which "Italian truck drivers became Roman legionnaires, butchers were metamorphosed into gladiators . . . [and] a woman switched from modern bourgeois matron to sadistic Messalina." According to Fellini all of this was intended to create "an exalted picturesque, neurotic world," but apparently his sponsor did not appreciate that.[66] Although Burlington Industries had initially agreed to underwrite the program, the company dropped the option when executives saw a preview "complete with bacchic frenzies and the ghostly prowl of transvestites in the night-shrouded Coliseum."[67] Nevertheless, as *Time* magazine noted, even if Burlington Industries was queasy in this case, as a series *NBC Experiment in Television* had "developed an odd byproduct: many advertising agencies have asked for screenings of some of the shows. What they wanted to see was not their content, but their technique[s]—to decide if they were applicable to TV commercials."[68] Ironically, the public affairs "intellectual ghetto" was serving as the research-and-development wing for advertising firms eager to cash in on experimental visual forms.

In addition to the networks, local TV stations (especially in big city markets) encouraged cinephilic engagements with television. Starting in 1963, New York's educational station WNDT (channel 13) produced *The Art of*

Film, with episodes devoted to such directors as Bergman, Antonioni, Fellini, Kurosawa, DeSica, Godard, and Dreyer. According to producer Edith Zorrow, the program was not just for "film buffs." Instead, it was "more for a person who likes good food, literature, and art, and with the viewpoint that films are more than just entertainment."[69] Art films also played on local commercial stations. In 1960, WNTA in New York aired a television adaptation of *Rashomon*, Akira Kurosawa's critically acclaimed film of 1950, which followed different people's accounts of a rape and murder. Produced by David Susskind, directed by Sidney Lumet, and starring Ricardo Montalban as the Japanese villain, the TV version handled the film's multiple-point-of view structure by dividing the story into multipart episodes that were stripped across one week. With a similar focus on international art cinema, in 1964 New York's WOR aired *Two*, a fifteen-minute film directed by premiere Indian filmmaker Satyajit Ray as part of WOR's *Esso World Theater* series.[70] In addition to these "made-for-TV" art films, independent commercial stations ran festivals and late-night showings of art-film features. As part of a multipronged effort to bolster ratings by introducing quality fare, Los Angeles's independent station WKJZ-TV scheduled an Ingmar Bergman Festival in 1967, and it also added European art films to its movie play list.[71] In 1964, Chicago's independent station WGN began to feature international art films like *The 400 Blows* (1959), *The World of Apu* (1959), and *Hiroshima, Mon Amour* (1959) on its new late night program *Cinema 9* (titled after its dial number, but also likely a reference to Cinema 16). *Chicago Tribune* critic Francis Coughlin warned that *Cinema 9* was only for the "late night viewer capable of understanding serious themes" and for a "grown up viewer possessed of enlightened good judgment." Not only was the audience he had in mind sophisticated and mature, it was also the "men's only" club of late-night movie buffs. Coughlin said that women might find these films too racy, and suggested that if they didn't like art films they should "take up knitting."[72] Once again, even while women were just as likely or even more likely than men to watch movies on TV, the late-night zone (whether for Hollywood revivals or art films) was defined in specifically gendered terms.

Nevertheless, even the earlier hours of the evening schedule were beginning to look more cinematic as the TV industry tried to capitalize on the latest movie trends. In the context of critical malaise and slips in the ratings (especially for the 1950s variety shows, anthology dramas, and even some of the 1950s family sitcoms), networks attempted to reach the desirable 18–49 younger demographics with programs that seemed distinct from yesterday's TV. Independent production companies like Revue, Rod Serling Produc-

tions, and David Susskind's Talent Associates began to devise network series that had an artier, cinematic feel (and often a lot more violence as well).[73] In 1955, Alfred Hitchcock became the first major Hollywood film director to lend his name to a television series, *Alfred Hitchcock Presents* (CBS), which was produced by Revue. Hitchcock's carefully crafted persona emerged on television in the opening and closing segments, where he became famous for mocking his sponsor, Bristol Myers. (While Hitchcock said the sponsor initially disapproved, he won them over, and according to *Printers' Ink*, the commercials were the greatest draw for the fourteen million viewers who watched the show.)[74]

So, too, the period's embrace of jazz and the Beat sensibility translated into a new cycle of stylized detective series such as *Peter Gunn, 77 Sunset Strip*, and *Johnny Staccato*. The latter starred and was sometimes directed by the American independent film director John Cassavetes, whose critically acclaimed improvisational film *Shadows* first played in art houses in 1959. Aired on ABC and NBC between 1959 and 1960, *Johnny Staccato* had what critics would later call a distinctly *film noir* feel, with dark lighting, urban settings (some shot on location), and hardboiled cop voiceover narration. Its lead character was an alienated private eye who doubled as a jazz pianist at Waldos, a Greenwich Village bar (the bar setting was in the tradition of *noir*, but also included abstract art, Beat-looking glamour girls, and sometimes poetry readings). Bringing the independent film ethos to television, Cassavetes used performers from his own actor's studio, many of whom (like his wife, Gina Rowlands) had been in *Shadows*.[75] Although short-lived, *Johnny Staccato* garnered publicity for Cassavetes while at the same time acquainting TV viewers with the new American independent cinema.

Some television executives and artists were quite explicit about their desire to make art-cinema TV. Dan Melnick (who had of been head of ABC programming in the early 1960s) joined forces with David Susskind's Talent Associates to create *N.Y.P.D.*, a cop show that Melnick said he styled after Alain Resnais's *Hiroshima, Mon Amour* and *La Geurre est Finie* (1966). Aired on ABC between 1967 and 1969, the show won critical accolades not just from TV critics but also from film critics. In his column for the *New York Times*, film critic Rex Reed said that Melnick used "hand-held cameras, a la Godard or Agnes Varda, and [was] shooting each episode like a European art film."[76] While Reed wondered if audiences would like a "cops and robbers series a la Alain Resnais," Melnick enthused, "Audiences are more sophisticated than given credit in terms of what kind of story will interest them and what kind of film technique. They've all seen Antonioni and Fellini and Resnais movies.

They're not dumb. They don't need old-fashioned dissolves to tell them time has passed."[77] Given the close relations between advertisers and European art cinema, it is not surprising that *N.Y.P.D.*'s cinematographer, George Silano, had previously made television commercials.

Whether through its cinema-inspired TV series, its revivals of screen classics, or its presentation of international art films, television became a major vehicle for the formation of the new film culture. Despite the fact that most historians still view 1960s television as a "vast wasteland" of sitcoms, game shows, and westerns, the culture bug bit television just as hard as, and maybe even harder than, other venues of everyday life. In this context, advertisers developed their art-film commercials with full knowledge that a good number of TV viewers would "get it." By the 1960s, cinephilia had become good business, and not just for the entertainment business, but also for American industry at large. Most importantly, when it came to television advertising, art cinema was a lucrative strategy for wooing the all-important female consumer.

COMMERCIALS: A WOMAN'S CINEMA?

Although the stereotypical image of the film buff was a young, urbane, male hipster, women were a major audience for both televised movies and the more stylishly cinematic television shows. TVC producers knew that art cinema commercials not only engaged segments of the media-literate younger demographic; these ads were also attractive to women. However, rather than the typical art cinema focus on alienated male heroes who drifted aimlessly through meandering plots, many of the more arty TV commercials targeted housewives, focused on female heroines, and had a clear goal in mind: "Buy this product!" Just as advertisers had in previous decades believed that women took a special interest in ads that used fine-art imagery, directors of television commercials thought that art-house commercials were a draw for female consumers.

By the 1960s, advertisers believed that even when men were watching television, women made most of the program choices. Richard A. R. Pinkham, senior vice president of Ted Bates and Co. (one of the largest television advertisers of the period), observed, "Most nighttime program viewing decisions are made by women."[78] Accordingly, he and other advertisers searched for programs and ads that might fulfill female fantasies. Even the "shoot-'em-up" stylized cop shows and macabre thrillers included commercials targeted at women. (For example, *77 Sunset Strip* was sponsored by Alberto, which used the show mostly to advertise women's hair products. *Alfred Hitchcock*

Presents, which was sponsored by Bristol-Meyers, mostly advertised pain-killers and other low-ticket supermarket items, and the middle commercials were Clairol spots for women's hair dye.) As visual forms, the commercials themselves also appealed to women. While many TVCs of the 1960s were rather straightforward realistic demonstrational ads or else had fantasy figures like Mr. Clean, the award-winning commercials (and the ads that art directors liked to make most) often imported cutting-edge cinematic techniques to appeal to younger, hipper, more economically mobile women. Art-cinema commercials especially aired during nighttime hours when advertisers assumed women would be less distracted by housework, and therefore more able to attend to the complex visual track. Most of these commercials won Clio, ADC, AIGA, and other professional awards.

Over the course of the 1960s, many commercials for everyday household products and cosmetics used stylistic flourishes of art cinema including rapid montage, location shoots, moving camera, high-end film stock, color, elaborate musical scores, and a battery of visual effects. Some commercials created the feel of European art films by, for example, featuring moody, dark, and poetic scenes then associated with French new-wave films' homage to American *film noir,* such as Godard's *Alphaville* and Truffaut's *Shoot the Piano Player* (1960). A commercial for Breck shampoo ("Night Ride," Y&R, 1964) presents shots of a woman's face framed through a windshield and edited together with car headlights and stop signs to create a poetic montage. An ad for Cole of California's new "scandal" swimsuits with plunging v-necks and see-through mesh looks like a stylized European spy thriller. Police search lights illuminate a high-fashion model (dressed in a swimsuit) running on the beach at night to the tune of jazzy suspenseful music that adds to the art-cinema feel ("Beach" campaign, Klosterman Agency, 1965). Another ad in Cole's "Beach" campaign shows the same model on a brass bed at the seashore, an image that looks somewhere in between a page from *Vogue* and a Fellini film (with connotations of the more sexually "scandalous" European art cinema).

The moody look of the French new-wave crime film was especially popular among sponsors who wanted to connote a sense of danger and even fear. A commercial for Goodyear tires ("Foggy Road," Y& R, 1966) used the art-cinema look to create a moody suspense thriller in which a chic woman drives in a mist-filled night only to get a flat. With high-contrast lighting and blue as the dominant color, the commercial is composed of rapid editing between close-ups of the woman's face, close-ups of a tire as it drives through the night, darkly lit shots of tree trunks, and stylized shots of the woman

Cole of California uses poetic juxtapositions and symbolic sensuality worthy of art cinema ("Beach" campaign, Klosterman Agency, 1965).

getting out of her car in the shroud of darkness. In effect, the commercial has so much hip cinematic artistry that it is possible to miss the entirely predictable and old-fashioned "helpless woman" theme. Admitting his intentions, the agency producer said, "We wanted to involve our audience in the fear a woman can experience in being alone. The fog background was designed as a 'wall' around the woman. It shut her off from help, in addition to contributing to the mood. The dominant color of blue was chosen to heighten this lonely effect." Just in case audiences missed the point, a male voiceover says, "When there's no man around, Goodyear should be."[79]

These cinematic ads were expensive and labor intensive, and they required enormous precision with six- to seven-person principle crews as well as production assistants, talent, and the agency's in-house art department. Filmed by the commercial production house Film Fair, a commercial for Hunt's tomato paste ("Relatives," Y&R, 1966) went to painstaking lengths to recreate the aura of Italian neorealist cinema. This almost entirely silent spot depicts a Polish-American woman serving her husband's Italian family an authentic Italian dinner. Although the plot sounds simple, over 6,000 feet of film were

shot to capture the ninety feet used in the commercial. As this shooting ratio suggests, the producers went to great lengths to get the look they were after. Following the widespread use of nonprofessional actors in neorealist cinema, Film Fair hired ethnically correct unknown talent (Italian waiters, would-be actors, and a Polish secretary) to play the roles. The shot set-ups were self-consciously posed, with extensive use of extreme close-ups and moving camera. The producers designed the lighting to capture a "Sunday afternoon" look, and the set was painstakingly appointed with naturalistic details and furnishings. To achieve the authentic feel, the actors actually consumed two chickens and four bottles of wine during the two-day shoot.[80]

Given their big-ticket costs as well as their need to capture a sense of movement, car commercials especially used cinematic techniques. These commercials came in the wake of car manufacturers' new focus on the growing market of women drivers, and Chevrolet took the lead in this regard.[81] An award-winning Chevrolet commercial ("Pinnacle," Campbell-Ewald, 1964) uses aerial color photography that sweeps into an image of a red Chevy convertible on top of a mesa in Monument Valley as a woman in a white dress stands up in the car. The entire effect is something between a *Vogue* fashion layout and a John Ford western (just the right blend of romance and action to capture both the female and male viewers). The only dialogue heard is the male announcer's voice at the end of the commercial saying, "In a class of its own. Chevrolet for 1964. Stands alone."[82] Chevrolet placed this and other ads like it in NBC's *Bonanza*, which the company thought would provide a tasteful atmosphere for their sales message. Noting the striking quality of the cinematic ads, the producer for *Bonanza* admitted, "The Chevrolet commercials are the most beautiful ever made. I hope sometimes our show matches the quality of the commercials."[83]

In addition to their striking cinematography, the Chevy ads appealed to women by putting them in the driver's seat and using codes of art cinema (in particular, art cinema's proclivity to establish the impression of emotional states rather than to develop linear plotlines) to convey a woman's point of view. This is nowhere more apparent than in a Chevy commercial ("Lazy Afternoon," Cambell-Ewald, 1966) that presents a young woman driving through the countryside in her Caprice Custom Coupe. Scored to the hit song "Lazy Afternoon," which the advertiser called "provocative," the ad is shot in pastel colors and soft focus, giving it the dreamy look of an impressionist painting. Like many advertisers of the period, Campbell-Ewald proceeded on the logic that the best ads were those that allowed viewers to place themselves in the scene.[84] Describing the ad, the catalog for the American

With aerial photography and swooping camera movements Chevrolet evokes the sweeping vistas of a John Ford western ("Pinnacle," Campbell-Ewald, 1964).

Television Commercial Festival said it "emotionally involved the viewer by letting him use his imagination."[85] By shooting through the windshield, the director allowed the viewer to experience the pastoral scene from the female driver's vantage point. These point-of-view shots were combined with overhead tracking shots of nature (such as treetops and cows in a field), all of which were edited together with shots of the car taken at various angles and distances. At one point, the woman gets out of the car, lies in a pasture, and the camera looks from her point of view up at the sky. By using art-cinema strategies of poetic montage, contemplative framing, and subjective camera, the ad recreated the psychological state of the sublime freedom this women enjoyed by driving into nature in her sporty new Caprice. Meanwhile, because the woman was alone, viewers could easily project themselves into the scene either by desiring the car, the woman, and/or the experience she was having on her lazy afternoon.[86]

More generally, by conveying themes of liberation, mobility, and female pleasure (outside of the home), commercials like this were part of advertisers' growing recognition that women no longer identified with the housewife role. Even before Betty Freidan lashed out at the media's "occupation housewife" stereotypes in *The Feminine Mystique* (1963), advertisers knew that the housewife image was unappealing to many women. For example, in her 1957 book *What Makes Women Buy*, Wolff told advertisers, "The term 'housewife' no longer carries prestige," especially "in the upper- and middle-income groups." Citing Dichter's motivational research, Wolff claimed that housewives rejected brands that had a "housewifely association." Instead, "greater travel and mass communication have given women generally better tastes," and women had become more "cosmopolitan" and "sophisticated." Similarly, in *Visual Persuasion*, Baker noted that even while women liked childrearing,

cooking, and home decorating, "Few women are entirely satisfied with their lot in life. . . . Therefore, pictures that promise means of 'getting away from it all' usually score high in getting women's attention." These included high-fashion ads, ads invoking romance, and ads that provided a promise of either real or imaginary travel. "The romantic promise of seeing new lands," Baker said, "beckons women. They are keenly interested in meeting new people, becoming 'cultured' (keeping up with the Joneses on an intellectual level)."[87]

In this context, the art-cinema TVC offered women an invitation to roam (imaginatively) through the streets of European cities while gazing at the products displayed on the living room screen. A commercial for Cover Girl makeup ("On the Riviera," SSC&B, 1965) was set in Nice–Monte Carlo and used "a contemporary quick cut technique to capture the mood of young, on the move glamour girls." Not surprisingly, commercials for travel-related ser-vices and products (such as airlines, luggage, and hotels) appealed to women as adventurous consumers, and many of the ads used art-cinema techniques as well as staging borrowed from Hollywood extravaganzas.[88] Some of these "traveling housewife" commercials were extremely self-reflexive—even to the point of parody—about their art-cinema cosmopolitanism. A commer-cial for Stella D'Oro breadsticks ("Walking Girl," Firestone Agency, 1965) used "Cinéma Vérité backgrounds" and showed a woman walking through Rome with the direct intent of "spoofing the 'Italian Scene' . . . or at least the Italian Scene as it is known to those people who patronize the films." Al-though self-consciously parodic, the commercial nevertheless won awards at the American Television Commercial Festival for its "beautifully unified" music and photography which "give us an effect that is actually more 'Italian than Italian.'"[89] Answering the all-important question, "Does this sell bread-sticks better than a straightforward recital of the product's superiorities?" the agency producer said, "We think so because this is basically an 'impulse' item. If people think of it in exciting Continental terms, they are going to give it a try."[90]

BOND GIRLS, MOD MODELS, AND FEMALE POP STARS

Advertisers further promoted the cosmopolitan feel of art cinema in TVCs that combined cutting-edge cinematic techniques with references to London's mod-fashion explosion.[91] In the early 1960s, the James Bond films sparked a series of print advertisements and commercials with the Bond look, and by the mid-1960s spy television shows like *The Man from U.N.C.L.E.* (NBC) and the British import *The Avengers* (ABC) used space age and mod-style

fashions to capture the aura of swinging London and liberated sexuality.[92] One of the first television sponsors to do this was Goodyear tires, which produced a commercial ("Wide Boots," Y&R, 1965) that became the buzz of the trade press.[93] The commercial follows Bond-looking models standing on a racetrack in a desert landscape. The ad opens on the legs of three women in go-go boots walking across the frame. (Although their bodies are cut off just below the waist, the hemlines of their black and white op art patterned dresses are also visible in the shot.) Then the camera follows the women as they walk past another mod model (this one wearing an orange minidress, boots, and hip sunglasses) with her leg on a tire. As she kicks the tire, the camera zooms in, moves up the woman's leg, and then the tire rolls out of frame. Next, the scene cuts to a racetrack where a mod model signals women racecar drivers to begin a race. A fast-paced montage of mod models, tires, and racecars ensues. Throughout, the soundtrack plays a cover of Nancy Sinatra's hit single "Boots," except with new lyrics: "Wide boots are made for rolling / They hold the road for you / They roll and roll and roll / 'cause Goodyear built 'em to."[94]

In commercials such as these, it was not just the Carnaby Street clothing and pop songs, but also the use of mod-style graphics that projected a new look. The "Wide Boots" ad (like all the ads in Good Year's "Go-Go" campaign) superimposed the first two letters in Goodyear over the image, using mod (swirling) typeface to spell out "Go-Go," an obvious reference to go-go boots but also something everyone wants their car to do. Speaking of the new trend in graphics, a 1969 article in *Print* observed that the explosion in London of Mary Quant fashions and stores like Bazaar meant that these same fashion outlets had to "also employ visual and graphic methods of making themselves different from the old guard—and each other. In the swinging, frantic world of Carnaby and Kings, graphics play an important part." The article showed everything from shopping bags to store marquees as proof of the graphics explosion. In a similar way, advertising artists for television commercials focused on ways to differentiate products by employing mod moveable type as part of graphic collage. Together, the elements of mod graphics, fast-paced montage, fashion photography, Carnaby Street costumes, thin young models, and jazzy and/or rock music soundtracks, defined the mod style TVCs of the mid to late 1960s.[95]

The 1960s diet "soda wars" resulted in a number of these ads. A commercial for Tab diet soda ("Crazy," Marshalk, 1965) aimed at "the young 'with it' heavy user of carbonated drinks" was composed of a rapidly edited montage showing surprising combinations of mod models, a lion's head, images of

Fashionable flaneurs visit New York's Paraphernalia in this commercial for the International Coffee Organization ("Mod Shop," McCann-Erickson, 1967).

the soft drink bottle (with mod typeface), and similar mod typeface spelling out "One Crazy Calorie." As the producer explained, "By using nine different models in quick jump cuts that almost look like fashion stills [and] by showing striking black and white op art styles . . . and by adding a jazz tempo—'Crazy' achieves the timely look aimed for."[96] Using a similar style, a Diet Pepsi ad ("Girl Watchers," BBDO, 1967) featured a woman in a mod dress walking in an airport while being ogled by pilots and businessmen. Not to be left out of the diet drink lineup, the International Coffee Organization sponsored a TVC ("Mod Shop," McCann-Erickson, 1967) that presented slender young models dressed in mod fashions while going on a shopping spree at Paraphernalia, the fashionable New York boutique that sold Betsy Johnson clothing (and was New York City's answer to London's Mary Quant and Bazaar). So important was the connection between fashion and the cinematic ad that the fashion magazine *Harper's Bazaar* opened a film consultant division in 1968 to "bring a distinctive look to TVCs."[97]

The connection between mod fashion and cutting-edge cinematic trends was also important to television specials that sponsors specifically designed to

appeal to the "taste of the TV-wise audience" and to "enhance product identification."[98] A number of these were aimed specifically at fashion-conscious female consumers and had a specifically cinematic look. In 1967, ABC aired three specials dedicated to Twiggy, the rage of the "Swinging London" fashion scene. The first, *Twiggy in New York*, follows the seventeen-year-old model as she embarks on her American debut, bombarded by fans and frequenting department stores. Shot in the then trendy cinéma vérité style, the documentary captures Twiggy in intimate behind-the-scenes poses, for example watching cartoons on television, preparing for fashion shoots, and applying mascara to her famous lashes. To augment the New York independent-film sensibility of the program, Woody Allen (who had recently directed *What's Up, Tiger Lily?*) interviews Twiggy. Praising the "impressionistic technique of Cinéma Vérité," Jack Gould of the *New York Times* nevertheless complained that the whole thing was "bait for sponsors." In tune with the program itself, a commercial for Coty cosmetics shows a behind-the-scenes vérité-style fashion shoot with models dressed in mod clothes, edited together with women putting on "groovy eye makeup."

Sponsors also invested in female pop recording artists who appealed to the young demographics. Petula Clark and Nancy Sinatra each hosted specials that depicted the stars in mod fashions, artfully constructed cinematic sequences, and equally cinematic commercials. Sponsored by Plymouth, *Petula: The Beat Goes On* (NBC, 1968) shows Petula in miniskirts, day-glow gowns, and go-go boots. Unlike most variety shows, which were shot live on tape, the special begins with a contemplative cinematic cityscape of Los Angeles as the soundtrack plays Petula's hit single "Downtown." These cinematic portions of the program provide a context for Petula to promote her new film, *Finian's Rainbow* (directed by a young Francis Ford Coppola). The show goes on to interweave picturesque location shots of Los Angeles tourist attractions with live-on-tape performance numbers that Clark and her guest star Harry Belafonte perform in front of a live studio audience. In between all the artistry, Clark hawks Plymouth cars by singing a cover of the Sonny and Cher song "The Beat Goes On" while posing on a stage fashioned to look like a discotheque. The commercial is itself a cinematic extravaganza with rapid editing, quick zooms, and mod graphics that create a youth-generation, swinging-single brand identity for Plymouth cars.[99]

Nancy Sinatra's *Movin' with Nancy* (NBC, 1967) is a similar mix of cinematic style and mod fashion, this time directed by Broadway stage director Jack Haley, Jr., dotted with rat-pack guest stars, and sponsored by Royal Crown (RC) cola. Shot entirely on film, the special begins with rapidly edited

(and entirely fetishistic) shots of Nancy's red leather boots as she gets into her red convertible car. Wearing all the latest Carnaby Street trends (polka dot miniskirts, yellow minicoats, purple bobby caps, all colors of go-go boots, trendy pantsuits, leather driving gloves, and white trench coats with black stockings), she sings her way through a lavishly filmed color spectacle complete with aerial photography, highly stylized set pieces, contemplative framing, and landscape/cityscape montage sequences. Like the heroes of European art films, Nancy takes to the road and drifts, with no apparent purpose, from one scene to the next. In one sequence, Nancy appears in a myriad of mod outfits at various California sites including the Golden Gate Bridge and Century City Mall while singing a moody rendition of "This Town" ("is a lonely town"). To underscore the sense of alienation, the set is decorated with artfully posed mannequins that give the scene a self-conscious staginess found in modernist theatrical productions. Another, more upbeat, segment presents a rapid-fire fashion shoot starring Nancy in a bright yellow pantsuit and Sammy Davis, Jr., in a wildly patterned dashiki-style shirt and love beads. Set to the tune of Ray Charles's "What'd I Say," the sequence uses rapid editing and psychedelic effects (including bright colors, mosaic graphics, swirling patterns, and disco-like strobe lights) to show Nancy and Sammy shooting pictures of themselves while dancing to the bluesy and increasingly erotic beat. In keeping with the theme, three integrated commercials feature Nancy (as well as other pop stars) singing rocked-out versions of the RC jingle "It's a mad, mad, mad, mad cola!"

Communicating themes of liberated "swinger" femininity via the visual codes of art cinema and mod fashion, the Petula and Nancy specials nevertheless softened this new femininity with more traditional images that would play well with a national audience. The Petula special includes an elaborately staged sequence with Clark singing to children and it also features her aboard the *Queen Mary* (docked in Long Beach, California) and drinking high tea. *Movin' with Nancy* features Dean Martin (billed as her "fairy godfather") and culminates in a spectacularly Oedipal finale where Nancy sings a tribute to her real father, billed as "Daddy." Not only does the segment feature Frank, it shows Nancy caressing blown-up pictures of him as she introduces his act. Yet, despite these attempts to portray the stars as loving mothers, British royalty, and dutiful daughters, the sponsors' desire to project a "hip" aura and draw in younger consumers also led to places where TV did not traditionally go.

The Petula special contained explicit antiracism and antiwar messages. Not only did it feature Petula and Belafonte singing protest songs about racism

and Vietnam, it also included an elaborate modern dance sequence in which Petula sang the Beatles' song "We Can Work It Out" as black and white dancers engaged in a mock fistfight on a dance floor covered with a huge peace sign.[100] Perhaps even more daring than this explicit political commentary was the fact that both the Clark and Sinatra specials broke the broadcasters' traditional taboo against mixed-race dance couples by showing young white women dancing and singing with black men who were overtly sexual.[101] In fact, in the case of *Petula: The Beat Goes On*, the sponsor's representative objected to a duet in which Clark ever so slightly touches Belafonte's arm. Although the scene aired intact, the incident generated bad press for Plymouth when Belafonte wrote a scathing and very long article in the *New York Times* lashing out at networks and sponsors for their racism. Acknowledging the legacy of Hollywood films that featured "oversexed" black men, Belafonte observed the irony of the fact that on TV "The Negro is always presented as asexual. White heroes and heroines can make love all over the screen but the Negro is apparently above that or incapable." Reporting on the widespread use of stereotypes and the institutional racism at corporations, he condemned the "white superstructure," stating "The prejudice is so pervasive in the television industry that it invades every allied field. . . . For example, the advertising agencies that prepare commercials for TV employ 2,200 advertising executives, and 11 of them are Negro."[102]

The Belafonte incident suggests the paradox at the heart of the advertising industry during this period. Seeking to reach young, hip, media-literate consumers, advertisers employed young-generation art directors who developed cutting-edge visual styles and promoted youth-culture themes with liberation messages both in commercials and in the programs they supported. But the business-minded executives at networks and advertising firms nevertheless still worried that the mass audience (and local affiliate stations) might reject the "far out" styles and values. As many sponsors were discovering, it was difficult to attract a younger, hipper urban audience without alienating their base of affiliate stations around the country and provoking viewer complaints.

At the same time, however, the creative end of the advertising business grew interested in dealing with socially relevant issues. In her book *The Groove Tube*, Aniko Bodroghkozy (following Todd Gitlin) argues that 1960s/1970s programs like *The Mod Squad* (ABC) and *The Monkees* (NBC) packaged youth rebellion through processes of hegemonic incorporation that not only defused but also commodified countercultural resistance to mainstream values. But advertisers were not just the monolithic voice of big

industry eager to project "groovy" images of rebellion so long as this was good for capitalism. Although network executives and sponsors of the late 1960s did aggressively seek to package "relevant" programs, there was by no means an absolute, clear-cut opposition between the counterculture and the mainstream.[103] The people making TV ads and programs were much more heterogeneous and conflicted in their purpose than we often assume. While the networks did often censor out radical content (as with the Petula special or *The Smothers Brothers Comedy Hour* that CBS heavily policed for antiwar themes[104]), a number of commercial filmmakers began to identify more with media activists than with the network suits.

FROM CREATIVE REVOLUTION
TO CULTURAL REVOLUTION

Although commercial art directors spent much of the 1960s injecting deodorant commercials with cinematic flair, their interactions with the filmmaking underground provided a completely other trajectory and purpose for their endeavors. Indeed, one of the most stunning outcomes of the advertisers' interests in film culture was the advent of advertisers who disengaged from commercialism to become independent media makers and even members of the 1960s filmmaking underground.

By the end of the 1960s, people in the counterculture were themselves savvy about the value of publicity. As a number of cultural and media historians have shown, both documentary filmmakers and the newly formed video collectives of the late 1960s and early 1970s staged media events and/or provided alternative coverage of political events and issues not typically seen on the evening news.[105] Bodroghkozy demonstrates that despite their attacks on commercialism and network TV, youth-culture leaders Jerry Rubin and Abbie Hoffman recognized the value of the one-minute sound bite for their cause. Most dramatically, Hoffman referred to the yippie's televised protests of the 1968 Democratic convention as "advertising for the revolution," and he suggested that activists appropriate the formal properties of TV commercials to promote political and social change.[106] With irony, David Joselit observes that Hoffman's success as a media rebel actually wound up returning him to the center of mainstream media culture; he became a kind of radical chic cult personality who appeared on such programs as *The Dick Cavett Show* where he (like every other star) functioned as a lead-in for commercials. Following Todd Gitlin, Joselit argues, "Mainstream media always attempts to defuse the force of oppositional politics," and he sums up the situation saying, "The challenge of media activism is thus the nearly impossible task of producing

telegenic but oppositional content while resisting absorption within the institutional framework of TV."[107]

The situation, however, is even more complex because so-called mainstream TV was itself a conflicted terrain composed of people who did not necessarily think of themselves as corporate suits. In fact, like Hoffman, back on Madison Avenue a growing number of advertising artists also viewed themselves as "advertisers for the revolution." As Frank shows, despite their willingness to work for consumer capitalism, many young-generation advertisers actually perceived themselves as part of the counterculture and in some cases did help to orchestrate it. In this vein, in 1968 (at a time of unprecedented urban uprisings and race protests) *Print* published an article titled "Madison Avenue Gets Involved" that praised advertising art directors for their pro-bono work on inner-city causes such as the "Poor People's Campaign," "Rat Control," and the "Give a Damn" campaign. The trade journal applauded Madison Avenue for its "involvement in the burning (literally) social issues of the day" and for "coming out for the disadvantaged . . . and consequently against the views and attitude of a quite sizable (perhaps majority) portion of the population." "In short," the article concluded, "instead of catering to public opinion, Madison Avenue is trying to convert it."[108]

No doubt *Print* was engaging in a bit of self-congratulatory rhetoric, yet the article also demonstrates how advertisers of the period negotiated their dual commitments to Madison Avenue and their simultaneous sense of themselves as countercultural warriors out to challenge and convert the views of the infamous silent majority. In this case as elsewhere, advertisers had it both ways at once. By the late 1960s, the "mainstream" and the "underground" were not always as cleanly divided as is typically assumed. If, as scholars like Bodroghkozy and Joselit argue, the dominant culture contained and defused forces in the counterculture via the process of hegemonic incorporation, this was an extremely contingent process, rife with contradictions, conflict, and compromise. The mainstream and underground certainly battled, but they also mutually defined and depended on each other in dizzying ways. The process often took place from below, in the work-worlds and cultural spaces of lived experience where identities and identifications between high and low, bohemian and businessman, art and commerce, were not cleanly divided, but were instead messy and always in play.

Since the 1950s, experimental animators and "offbeat" companies like UPA supported themselves by making commercials. By the 1960s, the relations between filmmakers and TVC makers were even more fluid. Given the fact that advertisers participated in the film-festival circuit and also attended

cine-club events at venues like Cinema 16, it is not surprising that a number of commercial artists developed sympathies with experimental and underground filmmakers. In a review of the "New Cinema" symposium held at MoMA in 1967 (a show that included such notorious underground filmmakers as Jonas Mekus, Shirley Clarke, and Emile de Antonio), *Art Direction*'s Murray Duitz explained that New Cinema (which he alternatively called "underground cinema") was not art cinema but instead a cinema of opposition and revolt. In this context he praised the techniques of Ed Rocha, Peter Kubelka, and other filmmakers who were known for their experiments with cinematic form.[109] In 1968, when Duitz reviewed short "concept" films at the New York Film Festival, he similarly praised films that used non-sync sound, discontinuous time and space, free association, and other antirealist strategies in connection with counterculture themes, especially sexually explicit content and nudity.[110] Meanwhile, Porter and other advertising columnists enthused about the underground film techniques used by Andy Warhol (a subject to which I will return in the next chapter).

Like the dashiki-adorned advertisers Frank discusses, but aiming to please the film savvy crowd, some TVC directors projected an image of underground moviemaker. In 1968, the production company VPI launched a $100,000 publicity campaign that promoted its star TVC directors with the slogan, "Talk to a Head Who Thinks with His Film." The graphics for the ad, which showed illustrations of the heads of various VPI directors, had a decidedly "rock poster" look (the "head" was a not-so-subtle, tongue-in-cheek reference to drug culture). As Peck Prior, executive vice president of VPI, noted, these ads targeted advertising firms with "20- and 22-year-old art directors with their long hair [and] funny clothes."[111] According to Prior, these hippie-identified art directors were hard to keep on staff since most had loftier artistic goals.

Throughout the 1960s, and especially in the latter part of the decade, a number of commercial artists tried to break into filmmaking—not just into Hollywood (as with Richard Lester), but also into the experimental and underground scene. As *Print* described the situation, designers and art directors were "swept up in the move toward filmmaking . . . Often working with 16 mm equipment, and using their friends and family as crew and actors, these artists developed their own scripts and started shooting their own films."[112] For example, in 1967 art director/producer Martin Goldman convinced McCann-Erickson to allow him to use their facilities to shoot his twelve-minute film titled *7* (which he described as an "art house" short featuring a "simulated group therapy" session, executed with one BNC 35 mm

camera). Not only did Goldman use the McCann-Erickson office space, he also rounded up his crew from copywriters, editors, and announcers at the agency. Reporting on the film in *Art Direction*, Goldman depicted his use of corporate time and resources as a laudable and even desirable offshoot of his advertising career.[113]

Other advertising artists were at war with big business in the classic sixties "drop out" fashion. Fred Mogubgub (of Ford commercial fame) is a prime example. Rather than becoming the next new-wave director as Porter had predicted, Mogubgub became a member of the filmmaking underground. On the occasion of the New York Film Festival in 1968, Mogubgub burned his experimental seventy-two-minute film, *The Day I Met Zet*, on the steps of Lincoln Center. Described by the *New York Times* as "an artist-filmmaker known for zany and creative TV-commercial films," Mogubgub told the *Times* this was an act of "protest against the paucity of American works" at the festival. Advertiser gone media rebel, Mogubgub was entirely in line with the emerging ethos of guerilla media producers who staged media events to gain attention for their political and cultural causes. Moreover, as a savvy advertiser himself, Mogubgub made sure to film his film-burning protest so that he could further publicize his cause.

By 1969, the "anti-establishment advertiser turned filmmaker" took on new proportions with the release of Robert Downey's *Putney Swope*.[114] The film followed in the tradition of postwar novels like *The Hucksters* as well as exposés like Packard's *The Hidden Persuaders* and Hollywood films about sleazy admen. However, *Putney Swope* offered several twists on the genre. Unlike the serious exposés and novels, *Putney Swope* was a caustic spoof of the advertising industry. Also unlike earlier books and films, the film featured an African American antihero who ran Truth and Soul, an advertising agency specializing in offbeat ads. Shot mostly in black and while, the film had mock color commercials (produced by Truth and Soul) integrated throughout, leading one *New York Times* reviewer to say, "The movie has all the form of a feature-length collection of television commercials."[115]

Thirty-three-year-old writer/director Downey claimed that *Putney Swope* was inspired by his own stint as the director of the commercial-film production company Filmex. In an interview with the marketing journal *M/C* (formerly *Printers' Ink*), Downey was depicted (and also self-represented himself) as a guru of the underground. *M/C* observed, "He shows up anywhere in well-worn blue jeans, tee-shirt and leather cowboy jacket." True to this portrait, the accompanying photograph showed him donning a leopard-trimmed cowboy hat, muttonchops, and a rumpled shirt.[116] Moreover, Downey spoke of himself

as "a paranoid anarchist," and poked fun (as did his film) at the "Establishment" and people who "sell out." Calling commercials the "garment center of the film world," he mocked commercial filmmakers who "make sure the right light's on a beer bottle and then walk around like they are Fellini."[117] Downey also criticized the racial tokenism at advertising agencies and said this was an inspiration for the film.

Downey's decision to make his hero black was in keeping with the larger public attacks on industry racism (such as Belafonte's) as well as government reports and hearings about the relative absence of people of color both on screen and working at high-level (or even mid-level) jobs at advertising firms and broadcasting companies.[118] In the same year that *Putney Swope* was released, the pilot episode of the NET program *Black Journal* presented a spoof about white network executives and their one black colleague at the "Equality Network." (In a not-so-subtle reference to the Belafonte-Clark performance, the mock network officials worry about a black performer touching a white woman on screen.) Certainly, advertisers were themselves well aware of their industry's racism.[119] In 1966, *Print* published a mock script for a play that spoofed the racial tokenism and sexism of TV advertisers. Titled "An Absurd Black (and White) Comedy of American Family Life in Three Acts, a Prologue, and an Epilogue (Musical Accompaniment Optional), Written after Viewing 45,512 TV Commercials," the script begins by describing its "dramatis personae" in the following way: "A typical American fun family of four, consisting of Dad, Mom, Sis, and Sonny. Note: in the interests of chic, the cast performing these roles should be thoroughly integrated. The ratio might be one Negro to three whites, or preferably, two Negroes to two whites. Three Negroes is probably overdoing it."[120] Here as elsewhere, racism became a subject of social criticism—not just for leftist critics who disparaged mass media, but also for advertisers who thought of themselves as part of the counterculture.

Cut within this mold, Downey spoke of his failure in the advertising business as a mark of pride, bragging about how he had left Filmex to embark on a series of low-paying jobs, only to reemerge as an underground filmmaker. Meanwhile, *M/C* observed that *Putney Swope* was "breaking all house records at Cinema II on New York's Third Avenue." According to *M/C*, even while "*Swope* holds up a mirror in which ad men are petty, selfish, mean, out for the buck, and mercenary enough to filch their recently expired boss's gold cuff links," advertisers loved the film. "A random survey after a recent noontime showing" at Cinema II found that "Ad men are some of its most avid supporters. 'Great. Loved it. He didn't go far enough,' raved two account executives."[121]

Advertisers' effusive praise for the film suggests just how acceptable—even heroic—the "advertiser turned rebel filmmaker" had become.

FROM FILM BUFFS TO ARMCHAIR CRITICS

The "one-minute movie" is just one example of the paradoxes in play at a time when fine art and business were becoming increasingly intertwined. During the 1960s, the allegiances between art and business flourished in ways that William Golden and his staff at CBS would probably never have imagined (or even liked). Golden thought the task of the advertising artist was to communicate the message of the business for which he worked—and not to communicate a personal or social viewpoint. But by the late 1960s, more and more advertising artists had something to say. Insofar as Madison Avenue relied on the art directors' and film directors' talents to woo upwardly mobile, media-literate, younger consumers, the advertising industry could no longer so easily separate itself from the cultural and political changes afoot. In the process, art and advertising grew profoundly interdependent.

Speaking of the paradox of art and commodification, Thomas Crow argues, "The story of art within the new politics of the 1960s is one of considerable ambivalence, as artists attempted to reconcile their stance of opposition with increasing support for their activities in a new and aggressive global marketplace."[122] Television advertisers (many of whom thought of themselves as bohemian, even oppositional artists) often found big business to be a willing supporter, and as we have seen, some repositioned their allegiances entirely. Meanwhile, the TV commercial was exalted as a form of avant-garde art. Although it is hard to know if the formal techniques and/or counterculture themes in the cinematic ads changed people's ways of seeing the world, advertising agencies thought these ads persuaded people to buy products. Indeed, even if most consumers weren't counterculture identified or avant-garde enthusiasts per se, art films and underground cinema often turned out to be excellent sales techniques in a world where consumers had become media literate.

In fact, during the 1960s the networks began to realize that metareflexive commentary on advertising was itself good for ratings. Most strikingly, media critic Marshall McLuhan became the darling of the advertising agencies and a pop star in his own right. Trade journals like *Art Direction* and *Printers' Ink* cited McLuhan with reverence, and the networks featured him in public-affairs shows and specials. *NBC Experiment in Television* devoted an entire episode to him ("This Is Marshall McLuhan," 1967). Following the lead of

Chapter 6

the Madison Avenue advertising agents with whom he worked as a media consultant, McLuhan compared the "Wide Boots" Goodyear commercial to Fellini's *8 1/2*.[123] If McLuhan's comparison seemed a shocking revelation to the NBC audience, it was, as we have seen, an entirely routine insight in the advertising trades. In this sense rather than viewing McLuhan as a media prophet (as many in the counterculture did), it seems more likely that advertisers embraced McLuhan because he confirmed and articulated their beliefs and agenda for them.

In 1967, McLuhan (billed as a "media consultant") appeared in the ABC special *Twiggy: Why?* in which he instructed viewers how to "read" the meaning of the mod model. Fitting her into his already popularized theories about how electronic media were "retribalizing" the world into a "global village," McLuhan enthused "Twiggy is tribal." While he seemed blind to (or at least comfortable with) the sexual objectification of women inherent in his theories, he also fit Twiggy into his "cool media" concept, claiming that Twiggy "is a symbolic suggestion" that "encourages involvement." "Twiggy . . . means real turned-on." A few moments later, the soundtrack plays the Rolling Stones hit "Let's Spend the Night Together." Whatever the message, by packaging Twiggy with McLuhan's metacommentary on her, ABC "spoke up" to the female audience it aimed to attract. Even if you bought the Twiggy eyelashes that were promoted on the special, you could wear them with a knowing wink.

In short, in the 1960s Madison Avenue recognized that "interpretation" and "metareflection" were something that television audiences liked to do— that, in fact, media criticism was good for marketing. In this sense, the sophisticated art cinema commercial was not simply a means by which to compel viewers to purchase products through devious manipulation or (to use Vance Packard's term) "hidden persuasion." Instead, advertisers knew that their commercials circulated in a media environment in which the desirable 18–49-year-old audiences conceived of themselves as media savvy publics who couldn't be fooled by Madison Avenue hucksters. In this context, the cleverest advertisers revealed their rhetorical strategies willingly, and often in the ads themselves, which became increasingly self-reflexive about advertising come-ons.

At the end of their famous 1944 "Culture Industry" essay, Max Horkheimer and Theodor Adorno observed, "The triumph of advertising in the culture industry is that consumers feel compelled to buy and use its products even though they see through them."[124] By the 1960s, the advertising industry knew that people not only saw through ads, they *enjoyed* their skills of decipherment. The art-house commercial, with its symbolic density and aura

of artistic complexity, allowed media literate publics to experience the joy of being sophisticated "readers." These commercials talked up to the younger media literate publics by addressing them not as advertising's dupes but as erudite critics of complex texts who could imaginatively travel to the art house while watching TV at home.

7

••• WARHOL TV

From Media Scandals to
Everyday Boredom

In the last year of his life Andy Warhol was painting a history of American television. From the scant evidence he left behind, that history may well have been the first "tele-biography," a history not exactly of his life, but rather of the images that came across his television set. While he completed only one of the ten prints he planned to produce (the televised moon landing), his fascination with television began much earlier. Starting with his purchase of an RCA television set (which he recalled having done in 1955) and his acquisition in 1965 of a video camera, Warhol both watched and made a lot of TV. This included television appearances, commercials, the production of experimental TV soap operas, video diaries, and three cable television shows (the last on MTV). For Warhol, who famously referred to his tape recorder as his wife, his TV set, video camera, and VCR may well have been the "other women."

In fact, as Warhol wrote in 1975, "In the late 1950s I started an affair with my television which has continued to the present, when I play around in my bedroom with as many as four at a time."[1] His joke (if that is what it is) reveals something of Warhol's promiscuous relation to television at a time when most people in the arts would have denied even watching one TV. Warhol seems an apt figure with which to end this book because he was the only artist of the period who seriously explored the potential uses of ordinary commercial

TV. Rather than abandoning TV for video art, or dismissing it as "wasteland" pap, Warhol engaged with commercial television as a viewer, producer, and also as a layman critic and fan. Moreover, at least by the standards of his time, he apparently liked TV for all the wrong reasons. Rather than extol the potential virtues of television for education, uplift, or media revolution, his interests lay in TV's most ordinary everyday genres—soap operas, makeover shows, fashion shows, and gossip/talk.

Even before he had a video camera, in 1964–65 Warhol codirected an unfinished film titled *Soap Opera*, which uses television and bits of actual TV footage as a structuring theme. *Soap Opera* is one of the first (if not the first) theories of television aesthetics. The film rearticulates the relationship between commercials and narrative time on television. Whereas television soaps are notorious for their stagy dialogue and cliff-hanger effects, Warhol's soap scenes have no dialogue and pose no enigmas. The sequences alternate between silent scenes of Warhol superstar Baby Jane Holzer and other non-professional actors who seem to be improvising everyday scenes (fighting on the telephone, unpacking groceries, making out, reading the newspaper, masturbating, dancing, engaging in what appears to be a lesbian love tussle). These scenes are intercut with commercials for the Roto Broilette broiler, Glamerine rug cleaner, Seven Day Beauty Set shampoo, Secret deodorant, the Miracle Edge knife, Pillsbury cake mix, a Wondrascope microscope/compass, and a public service announcement by Jerry Lewis for the National Multiple Sclerosis Society. All were actual commercials made by Warhol's friend Lester Persky.[2]

In line with his penchant for serialization, Warhol repeats the Seven Day Beauty Set commercial twice in his mock TV lineup, thereby restaging yet also disordering television's everyday programming flow. The commercial itself runs for about five minutes and is an over-the-top performance of a "hair torture" test that a model undergoes in an effort to prove that Beauty Set shampoo will set your hair for seven days and won't wash out. The model is subjected to all kinds of hair tortures—starting with a simple windy car ride that tussles her tresses and ending with her spectacular submission to a hurricane-simulation machine that whips her around the studio. Next to the excitement of the ad, Warhol's soap scenes of explicit nudity, masturbation, and women engaged in an erotic brawl all appear very boring. Because the scenes are shot with a static camera, bad lighting, and no sound (and most segments have almost no editing), the soap opera portions of the film seem entirely banal when compared to the commercials. In this way, the film makes sex (whether it be heterosexual, homosexual, or masturbation) mundane.

Andy Warhol as himself with bartender Isaac Washington (Ted Lange) in the two hundredth episode of *The Love Boat* (ABC, 1985).

Now let me fast forward to the 1970s and 1980s when Warhol appeared as a high-paid model in numerous print ads and TV commercials and as a guest star on the popular TV show *The Love Boat*. Given this historical trajectory, one way to understand Warhol's relationship to television is through what has by now become a standard historical explanation—a "before and after" story arc that basically divides the "good" Warhol of the early 1960s (this includes the soup cans, Jackies, Marilyns, the disaster series, and his early films) from the later "bad" Warhol who became a self-proclaimed "business artist," owner of *Interview* magazine, and court jester portraitist for the rich and famous.[3] In this historical narrative, Warhol's film *Soap Opera* could easily be seen as indicative of the "good" Warhol who approaches the world of commerce—in this case TV—with a cool, dispassionate, and ironic detachment. As Cecile Whiting points out, pop's most enthusiastic critics of the 1960s endorsed pop for what they perceived to be its cool style and formalist detachment from its subject matter.[4] Nevertheless, this way of understanding Warhol winds up returning him to the modernist—and masculinist—embrace of irony and distance from all things kitsch—in effect erasing Warhol's queerness and denying or at least bypassing pop's more complicated and integral relations to domesticity, everydayness, femininity, and consumerism.

At least when it comes to his TV work, this before-and-after narrative is not a valuable way to understand Warhol's lifelong engagements with the medium. For one thing, in this historical narrative the TV productions, which are generally post-1968, are always already part of the "bad" Warhol. In this context, the TV shows and appearances have remained largely unanalyzed. Apart from John G. Hanhardt's pioneering exhibition at the Whitney in 1991, and a few follow-ups to that, we know almost nothing about Warhol's considerable investments in TV.[5] Proposing an alternate framework, David James argues that rather than explaining Warhol through a rise-and-fall scenario, or attempting to divide the "good," politically astute Warhol from the "bad" business artist, it would be more appropriate to consider the complexity of his lifelong engagements with at least four fields of cultural production: "Noncommercial culture (the early jeux d'esprit, decorated letters and booklets, or the films he 'made just to make them'; art (the orthodox serigraphs and paintings); industrial culture (the commercial portraits, 'movies that regular theaters would want to show'); and purely commercial culture (his late advertising)." Moreover, James argues, what makes the situation even more complex (and the various artifacts more difficult to categorize) is that Warhol did not distinguish among these. Instead, "Each flowed in and out of the others, with formal motifs or compositional strategies passing through the entire field."[6] James's more expansive view is particularly useful for understanding Warhol's relation to television because it lets us see Warhol's commercial aspirations not merely as tragic, but rather in connection to the broader aspects of his life and work. My point here will not be to reclaim Warhol TV as "art" or to equivocate between his videos and his paintings. Instead I am interested in how Warhol used ordinary television in ways that intervened in and at times reordered television's routine modes of representation.

Although it would be wrong to suggest that Warhol TV was overtly activist or politically motivated, it is nevertheless the case that Warhol offered alternatives to the reigning logics of television during the three-network period. As with his film *Soap Opera*, Warhol's appearances on and productions for television reveal a counterlogic to the networks' prevailing use of television as a medium organized around nuclear family consumer publics. Still, like everything Warhol did, his work in television was always rooted in his canny (and uncanny) sense of commerce.

COMMERCIAL ART AND POP TV

Warhol began his career as a graphic artist in the context of the postwar explosion of modern design. Living and working in New York as a commercial

artist gave him numerous opportunities to interact with people who moved between the fields of fine art, graphic arts, television production, and advertising.[7] As is well known, Warhol's greatest recognition as a commercial artist came with his drawings for I. Miller and Sons, an exclusive shoemaker in New York. In addition to shoes, he also made designs for a host of venues associated with women's culture. He created window displays in upscale stores like Bonwit Teller; he made illustrations for nearly every major fashion magazine (starting with his first commission for *Glamour* in 1949); he illustrated *Amy Vanderbilt's Complete Book of Etiquette* (1955) as well as his own self-published cookbook.[8] Like Ben Shahn (but unlike his contemporaries Jasper Johns and Robert Rauschenberg, who did commercial work under pseudonyms), Warhol was open about his commercial practice, even as he sought recognition on the museum and gallery circuits.

Although barely discussed by historians and critics, Warhol was actually a major player in the emerging field of television art. In the early 1950s Warhol befriended art designers at television networks, including NBC peacock designer John J. Graham and CBS set designer Charles Lisanby, who was one of Warhol's closest companions. Lisanby recalled having first met Warhol at a party given by an NBC set designer. According to Lisanby, at that first meeting Warhol "was interested in the fact that I was working in television and because other very fine artists like Ben Shahn worked in television occasionally—Andy wanted to do that."[9] As Warhol recalls in his diary, during the 1950s he designed weather drawings for CBS.[10] But his ambitions also led him to become a "signature" artist, making title art and ads for both NBC and CBS and, like Shahn, he won awards and large commissions.[11] By 1952 Warhol won his first ADC award for his advertising illustration of "The Nation's Nightmare," a CBS radio program about teenage drug addiction. An ink-and-tempera sketch of a boy shooting up, the illustration was executed in the modern graphic style of the time. For example, like Shahn, Warhol used foreshortening to create a sense of distortion and abstraction of the human form, and his "blotted line" technique resembled Shahn's ragged lines. In the early 1950s, contemporaries even saw Warhol as the "cheap" Ben Shahn.[12]

By 1953 Warhol had already made a splash on the TV title-art circuit. In that year, CBS director of graphic design Georg Olden listed him as one of the top twelve title artists in the "Who's Who in Art" for television. Olden singled out Warhol's title art for a 1953 episode of CBS's *Studio One*, "Letter of Love," which was commissioned by a producer of *Studio One* at Olden's suggestion. In 1954 *American Artist* reprinted the "Letter of Love" title art as an example of *Studio One*'s groundbreaking decision to commission "well known artists"

Andy Warhol, "Nation's Nightmare" for CBS radio (1952). Reprinted with permission of Corbis and © 2008 Andy Warhol Foundation for the Visual Arts/ARS, New York.

for the small screen.[13] Like the CBS illustration, the "Letter of Love" title art is a semi-abstract ink line and wash drawing of a young boy, although this image is somewhat more abstract. Only the top of the boy's head is visible as he pens a letter, and the drawing uses an abstract shape to indicate a torso, squiggles to indicate lines in the clothing, thin abstract intersecting lines to indicate the paper for the letter, and foreshortening to create a distorted sense of scale. The hand drafting the letter is exaggeratedly large while the other hand is visible only as an abstract geometrical design (which almost looks like a hook rather than a hand). In effect, the figure looks disfigured. As with other modern graphic artists, the networks typically commissioned Warhol for programs aimed at a "class" audience, which they assumed appreciated the conceptual aspects of modern illustration.

After Warhol exhibited his soup cans at the Ferus Gallery in Los Angeles in 1962, his makeover from commercial to pop artist was underway. During the early 1960s, pop displaced abstract expressionism as the reigning art movement of its time. Pop was a marketing success with collectors and often

Chapter 7

Andy Warhol, title art for *Studio One* "Letter of Love" (1953). © 2008 Andy Warhol Foundation for the Visual Arts/ARS, New York.

the talk of the popular press.[14] However, it also precipitated a fierce debate among art critics. In the early 1960s Greenberg, Schapiro, Max Kozloff, and other devotees of abstract expressionism saw Warhol (and many other artists working in the pop style) as the ultimate expression of a debased consumer culture, and they especially reviled pop's industrial techniques, its equivocation between painting and design, and its return to mundane subject matter—no less soup cans, comics, and TV.[15] Starting with British pop artist Richard Hamilton's *Just What Is It That Makes Today's Homes So Different, So Appealing?* (1956), numerous pop and assemblage artists of the time used television sets (and sometimes television screen images) in their work. These include, for example, Ed Keinholz's *The Big Eye* (1961), Tom Wesselmann's *Great American Nude* (1962), Robert Rauschenberg's *Dante's Inferno* (1964), and Warhol's *$199 Television* (1961).[16]

Not only was pop art about commercial media, it was easily appropriated by the media. According to Whiting, "Pop advertisements first appeared in abundance between 1964 and 1966 in home and service magazines for women

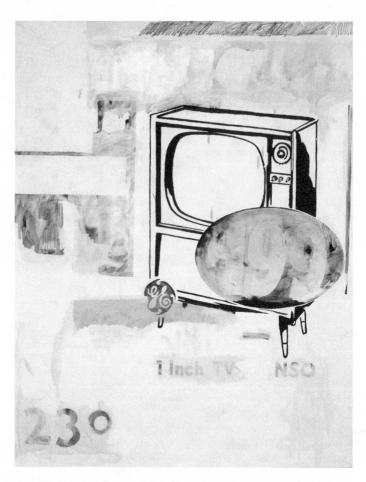

Andy Warhol, *$199 Television* (1961). Reprinted with permission of Corbis and © 2008 Andy Warhol Foundation for the Visual Arts/ARS, New York.

of the middle and upper-middle class," and "most such ads were inspired by Lichtenstein's [romance comic] paintings."[17] The case of television is, however, somewhat different. As opposed to its early adaptation in print ads, pop iconography did not appear often on television programs or commercials until the latter half of the 1960s.[18] Nor did advertising trades of the early 1960s typically discuss the use of pop sources for television commercials. It seems likely that this disinterest was largely due to the aesthetic expectations for and technical limitations of color TV.

During the late 1950s and early 1960s, people in television thought of color in relation to photographic naturalism, not pop's bold and synthetic color

Chapter 7

palette. Advertisers and TV producers searched for ways to make a rose look as a red as it looked in nature or for skin tones to appear like real flesh. In addition, many advertisers worried that color reproduction introduced distortion into package designs, especially with the early "additive" color systems in which color saturation and contrast made some hues appear muddy. As *Art Direction* reported, "Purple corn flakes, sea green face lotion or the total invisibility of the client's name on the package . . . these are some of the nightmares that haunt those who create color TVCs." Primary colors like "yellow and red darkened perceptibly on color film," perhaps a reason why Lichtenstein (who often used primary reds and yellows) was not easily translated to the small screen.[19]

Yet, despite these problems, advertisers believed that color enhanced the persuasive power of ads and they continued to experiment with it. Meanwhile, in an effort to capitalize on their color-system patents, RCA and NBC aggressively promoted color to both advertisers and viewers, spearheading an industry-wide transition that was capped off in the 1966–67 season when all three networks moved to all-color lineups for primetime shows.[20] In this context, pop art, and in particular its premier artist Warhol, became increasingly popular on television screens across the nation.

First broadcast in 1966, ABC's *Batman* was television's first all-out pop extravaganza. The program pictured a wild array of colorfully outfitted villains fighting with the caped crusader in scenes that were shot at extreme camera tilts and with comic-strip-style blurbs ("OW!" "POW!" "SPLAT!") inserted into the frame. A 1967 episode, "Pop Goes the Joker," most pointedly references Warhol when the Joker plays a dastardly con artist gone pop artist who is supported by poor little rich girl Baby Jane Towser (a not-too-subtle reference to Warhol's Baby Jane Holzer). Although the style evokes pop, the script follows the pattern of the 1950s art plot, only now pop displaces abstract expressionism as the threat to civilization when the Joker holds Gotham City's dowagers hostage in his pop art studio/hideout. The "teaser" cliff-hanger shows Batman and Robin about to be sliced into shreds by their cackling foe as they whirl around on a Calder-like mobile that is decorated with knives. Critics (including McLuhan) embraced *Batman* not just for its use of pop's visual iconography and pulp-fiction themes but also for its camp awareness of its own "badness."[21] Aware of the program's potential popularity with the TV-literate in-crowd, ABC's publicity department aggressively encouraged viewers like McLuhan to read *Batman* as pop and camp. For the premiere episode the network staged a posh "cocktail and frug" party that took place at the fashionable New York discotheque Harlow's. After cocktails, ABC held

a special screening of *Batman* at the York Theater, whose lobby was adorned with Batman drawings and stickers that sported slogans proclaiming their status as "authentic pop art." Guests at the York were reportedly unexcited about the show, but in true pop style, they cheered when a commercial for Kellogg's Corn Flakes (featuring the mock Grant Wood "Gothic" couple singing the Kellogg's jingle) came on the screen.[22] Turning the TV premiere into an art "happening," ABC's in-crowd guest list included such famous pop icons as Jacqueline Kennedy (who did not attend) and Warhol (who did).[23]

If TV's pop art explosion offered Warhol an opportunity to mingle with celebrities (something he enjoyed throughout his career), in this same period television advertisers began to rediscover Warhol's place in the world of commercial art. Notably, however, advertising artists did not initially embrace Warhol as a painter of pop images; instead, in line with their interests in cinema at the time, they celebrated Warhol as an underground filmmaker. In his May 1967 film column for *Art Direction*, Porter reviewed Warhol's first major underground hit, *Chelsea Girls* (1966). Warhol's aesthetic of minimal editing, duration (and self-proclaimed interest in boredom), and his use of unprofessional actors and unscripted (or minimally outlined) scenarios would appear to be anathema to advertisers' investment in montage, fast-paced movement, attention-grabbing content, detailed storyboarding, and professional acting—perhaps a reason why *Art Direction* never reviewed Warhol's earlier films such as *Sleep* (1963), a roughly five-and-a-half-hour film loop of a man sleeping, or *Empire* (1964), an eight-hour shot of the Empire State Building. Embracing Warhol for the first time, Porter wrote a rave review of *Chelsea Girls*, calling it "a tour de force," and especially praising its use of split screen to "set a visual rhythm for the film." One month after Porter's review, another column in *Art Direction* observed that advertisers were beginning to adapt Warhol's split-screen style to the art of TV commercials, and the trade journal particularly admired an ad for the athlete's foot spray NP-27 that was supposedly inspired by *Chelsea Girls'* split-screen/multiple-projection technique.[24]

Given his newfound popularity among TVC producers, it is not surprising that Warhol made his first foray into broadcast television with a TV commercial. In 1968, shortly after recovering from his near-fatal shooting, Warhol accepted a commission from the advertising agency F. William Free & Co., which represented Shrafft's restaurants in New York. In its efforts to change Shrafft's image from a "little old lady" sweets shop to a haunt for the young and hip, the agency hired Warhol to give the company a new look. In line with advertisers' interest in underground film at the time, the agency

Andy Warhol, "Underground Sundae" commercial for Shrafft's (1968).

originally wanted Warhol to make an ad that resembled his black-and-white underground movies. Yet, as the premier pop colorist, Warhol instead tapped into the advertising industry's interest in color experimentation, and the commercial's psychedelic look also must have appealed to the advertiser's interest in evoking hip counterculture themes.

Known as the "Underground Sundae," the one-minute commercial begins with a shiny red dot flashing on screen. The "red dot turns out to be a maraschino cherry, which turns out to be sitting on top of a chocolate sundae, which turns out to be the focal point for a "swirling phantasmagoria of color." Magenta, red, and chartreuse are dominant in the frame as the sundae materializes. Apart from photographic stills of individual frames, there is no existing copy of the ad, but period accounts of the soundtrack suggest Warhol's name is mentioned prominently.[25] The final frame of the ad shows his signature as a credit line running diagonally across the screen, proclaiming: "The chocolate sundae was photographed by Andy Warhol."[26] In other words, taking an author's credit, Warhol approached the TV commercial as an artist's medium, a point that Schrafft's president Frank G. Shattuck underscored when he told *Time*, "We haven't got just a commercial. We've acquired a work

of art."[27] Apparently, other advertisers agreed. According to the marketing journal *M/C*, after Warhol made the Schrafft's commercial, "There was an immediate wave of interest among other advertisers and agencies, and Warhol got together with a production house to produce an experimental tape."[28]

Meanwhile, for its part, the art world also gave Warhol's "Underground Sundae" rave reviews. In a 1969 issue of *Art in America* devoted to new experiments with video, John Margolies spoke at length about Warhol's commercial. The magazine printed a still from the "Underground Sundae" alongside stills from Nam June Paik's abstract videos *Participation TV* and *Tango Electronique* as well as examples of video and performance art works by Les Levine and Allan Kaprow. In other words, *Art in America* placed Warhol's ice cream commercial in a "discursive series" with video art. Stating this in no uncertain terms, Margolies claimed, "Andy Warhol's . . . commercial for Schrafft's restaurants opens up a whole new area for artists to explore."[29] Perpetuating Warhol's status as an experimental artist (rather than just a commercial hack), Warhol's associate told the *National Observer*, "We wanted to use the electronic effects of the medium for decorative design. We made eighteen tries . . . to work to a certain effect, like the changes in color you get when you dial color TV incorrectly."[30] In this sense, much of the publicity surrounding the Shrafft's ad made it seem simpatico with video artists' interest in using television as an artist's medium, and in particular their fascination with distorting and manipulating the TV signal for abstract and/or psychedelic effects.

Warhol, however, did not seek entry into the world of video art. Warhol TV was not counter-TV in the video-art sense, nor was it guerilla TV in the radical video activist sense.[31] Whereas Nam June Paik professed to be using the cathode ray tube as a canvas, Warhol—the most famous visual artist of his time—thought of TV primarily as a talk medium. So, too, whereas hating TV was a passion for most youth-culture intellectuals and video artists, Warhol often spoke enthusiastically of television. In the *Art in America* article, Warhol reversed the youth culture's underground (cinema) logic when he told Margolies, "My movies have been working towards TV. It's the new everything. No more books or movies. Just TV."[32] Later, in 1981, when asked to give a definition of video art, he responded, "Video art? There's no video art, we're trying to be commercial. . . . Have you watched video art on TV and seen how awful it is? Commercial TV is the best."[33] Then, in his characteristic way, he entirely reversed his position in a subsequent interview saying, "Video art is better [than TV]. It's just better. You can do whatever you want to do, whenever you want to do it."[34] In this regard, rather than taking sides

in the then heated battles between commercial TV and video art, Warhol confounded the "great divide" between them, making it difficult for anyone to firmly categorize him on either side of the fence.

Not surprisingly, in this respect, Warhol was noticeably absent from the video-art scene. Although his Exploding Plastic Inevitable multimedia performances with the Velvet Underground have something in common with performance art and happenings, and while his "Andy's Up-Tight" multimedia performances resonate with some early guerilla video "put-ons,"[35] Warhol maintained that his greatest goal in life was to become a TV talk show host. "The few times in my life when I've gone on television," said Warhol in 1975, "I've been so jealous of the host on the show that I haven't been able to talk. As soon as the TV cameras turn on, all I can think is, 'I want my own show ... I want my own show.'"[36] Rather than searching for medium specificity or thinking of his productions as counter-TV, Warhol gravitated to everyday genres—talks shows, soaps, makeovers, and fashion. Warhol embraced commercial TV's everydayness—not exactly to emulate it, but rather to explore it.

MEDIA SCANDALS AND TALK SHOWS

In the most obvious sense, Warhol engaged television through his own celebrity appearances on interview formats and daily talk shows. Although his TV appearances were certainly a bid for fame, for Warhol publicity was never just about selling himself. Instead, as Jonathan Flatley argues, Warhol's public appearances provided him with a means of giving visibility to a queer counterpublic. Following Michael Warner and Nancy Fraser's work on queer visibility and "subaltern counterpublics" respectively, Flatley argues that Warhol's Factory served as a counterpublic that enabled the "appearance and visibility of alternative sexual practices." In this interpretation, a counterpublic is not necessarily political in an activist sense, but rather a space where alternative and even oppositional practices can be invented and circulated among marginalized groups. In other words, rather than claiming that Warhol had a direct political intent or strategy for social intervention in line with classic theories of the public sphere (which is always impossible to do with Warhol), Flatley envisions the Factory and Warhol's art (especially his portraits) as a means of "giving face" to a variety of sexual and social subjectivities that existed outside of heteronormative ideals. Flatley concludes that Warhol's films, paintings, drawings, and photos all exhibit a "utopian impulse ... to turn galleries, museums, movie theaters, art studios, and other places into queer counterspaces."[37]

Although Flatley doesn't notice it, for Warhol, television was also an important medium for developing a queer counterspace.[38] Warhol's description of the pop attitude as one that made him and his entourage feel like "insiders" is especially apt in this regard.[39] Television literally allowed Warhol to bring the social outcasts of postwar America inside the homes of millions of Americans. Even his earliest broadcast advertisements used publicity counterintuitively to insert an image of queer life into the network lineup. For example, his drawings of boys for CBS's "The Nation's Nightmare" and *Studio One* were tamer versions of his erotic boy sketches that eventually appeared in his more sexually explicit "Drawings for a Boy Book" exhibited at the Bodley Gallery in New York City in 1956. So too, Warhol's "Underground Sundae" commercial was not just a psychedelic feast of colorful forms; although they wound up on the cutting room floor, the initial taping sessions for the commercial included factory superstars Viva and Joe Dallesandro, both of whom had just appeared in his X-rated queer western, *Lonesome Cowboys* (for which Warhol was put on an FBI list). In effect, whether intentionally or not, Warhol used television publicity and commercials as a stage for queer visibility in a society where publicity had become tantamount to publicness.

Moreover, it seems entirely plausible that the production cultures of network television—especially the fields of graphic art and set design—offered opportunities for gay men like Warhol and Lisanby to convene and socialize. As Warhol recalled in *POPism*, "Naturally the factory had more gays than, say Congress, but it probably wasn't even as gay as your favorite TV police show." Then he added, "I think the reason we were attacked so much and so vehemently was because we refused to play along and be hypocritical and covert. That really incensed a lot of people who wanted the old stereotypes to stay around. I often wondered, 'Don't the people who play these image games care about all the miserable people in the world who can't fit into these stock roles?'"[40]

In the 1960s, Warhol's television interviews became a means of derailing TV's stock roles and for making the "other's" everyday visible to national audiences. At the time, the standard artist's interview format either followed the convention of the visit to the artist's home (depicting male artists as family men) or else presented artists alone in their studios (as isolated and decidedly masculine romantic heroes expressing their inner souls). In distinction, Warhol never let TV cameras into his private residence, and rather than depicting himself as a family man or in the role of the isolated male artist, he tended to manipulate the interview genre (both in press and on TV) so as to trouble these stock portrayals. For example, in a 1966 interview on the NET

Viva and Joe Dallesandro pose with commercial producer Frank Hefferen during the taping of Warhol's commercial for "Underground Sundae."

series *USA: Artists*, Warhol displays his queer everyday life with his Factory entourage, with scenes of Edie Sedgwick dancing, the Velvet Underground performing, Warhol's assistant Gerard Malanga doing his famous whip dance with another man dancing in the frame, Warhol silkscreening (a picture of Marlon Brando) with Malanga, and then pushing his silver *Clouds* out the window after announcing that he's given up painting to become a filmmaker. The Velvet Underground's "trippy" music plays on the soundtrack, and the episode ends with glimpses of the Exploding Plastic Inevitable.

Although *USA: Artists* does spectacularize the Factory, Warhol's own performances on talk shows typically undercut interviewers' attempts to transform him into a subject of media scandal. In the *USA: Artists* program Warhol famously stumped his host, Alan Soloman, who kept insinuating that Warhol had a dubious reputation. Swiveling on his Saarinen pedestal chair, Soloman says:

> There's something that I think needs to be explained for the public, which has, at this point, a certain impression of you . . . and I'm not sure that it's the one that you would want them to have, although I don't think it matters to you very much. Is that true?"

Warhol seems bewildered or even hurt, and he answers simply by mumbling, "What?" in his classic posture of reticence, with his two fingers over

Alan Soloman tries to get
Andy Warhol to talk (*USA:
Artists*, NET, 1966).

his mouth and dark sunglasses hiding his eyes. The camera rapidly zooms in
for a tight shot, as if trying to dramatize his nonresponse. Soloman nervously
continues, asking him if he cares about his reputation, but Warhol further
derails the insinuations, saying, "Uh, oh, I don't really understand . . . I'm so
empty today. I can't think of anything. Why don't you just tell me the words
and they'll just come out of my mouth." As Caroline Jones argues, in this
interview Warhol's "very passivity [constitutes] his refusal."[41]

Although he was famously shy, Warhol's nonresponse was likely not spon-
taneous. Since the early 1960s Warhol had perfected the art of the difficult in-
terview by using all sorts of tactics to stump the press (including responding
with only a yes or no, having friends answer for him, and giving inconsistent
answers to different interviewers).[42] In this case Soloman becomes increas-
ingly exasperated by Warhol's refusal to engage and in a final act of despera-
tion begs him to answer a question. Warhol replies, "No, no. But you repeat
the answers too." Now stating the obvious, Soloman replies, "Well, I don't
know the answers." All of this takes place on a sparse set with one of Warhol's
huge Elvises behind them and soup cans on the side. Compared to the art-
work, the two men look tiny, so that Warhol's refusal to comply actually has
the effect of forcing the spectator to look at his paintings without the pedan-
tic explanations of the standard TV art show. As if to reclaim its authorizing
and pedagogic function, the program intersperses the dead-end interview
footage with scenes featuring Soloman's voiceover narration in which he tells
audiences what Warhol is all about, stressing (like other critics of his time)
Warhol's outsider status and his cool distance and detachment. Moreover,
the contrast between Warhol's performative persona and the more typical
TV image of the artist was highlighted in this program by the fact that the
first half of the episode portrayed Roy Lichtenstein, alone in his studio and
extremely verbal. In fact, whereas Warhol says almost nothing on the show,
Lichtenstein garrulously narrates the entire segment, and unlike Warhol,
Lichtenstein accepts Soloman's premise (that pop scandalized authentic art)

Chapter 7

by presenting an intellectual and aesthetic defense of pop art's commercial logic.[43]

Warhol's ability to derail media scandals also comes into sharp focus in a 1966 interview on the *Louis Lomax Show*, a local program aired on the Los Angeles station KTTV. Lomax was a civil rights leader, and at the time he was running for mayor in Los Angeles. His audience was filled with mostly white college students and his guest lineup usually included people with shock value that Lomax characteristically held up to moral interrogation. On this episode, Warhol appears with International Velvet and Ultra Violet, promoting his new film, *Chelsea Girls*. When Lomax moralizes about what he perceives to be the film's outrageous depiction of drug addicts, lesbians, and homosexuals, Warhol says, "It's a comedy." The outraged Lomax replies, "A comedy?" Warhol says, "Well, we passed that stage . . . these people are what they are. And you don't have to think about them anymore. So it's a comedy now. . . . The idea is these people are what they are. And it's a comedy." As he did with Soloman, Warhol gets the upper hand, this time making Lomax's studio audience laugh every time he asserts the film is a comedy.

Although he never discussed this, Warhol seemed intuitively to grasp television's vaudevillian modes of presentation. Just as MoMA and other art shows had utilized the straight man/buffoon vaudeville couple to popularize art, Warhol was brilliant at turning his interviewers into the buffoon while (ironically) taking on the role of straight man with his unreadable deadpan style. This clever inversion seems in many ways part of what Kelly Cresap calls his "trickster" persona, which, she argues, provided a means by which Warhol ambiguously expressed and deflected associations with his own homosexuality.[44] For example, when Lomax asks, "But do you think that these subjects [lesbians, homosexuals, drug addicts] are fit things for the cinema?" Warhol says, "We're not pushing any of the subjects that you're talking about." Then, when Lomax more bluntly inquires if there are any lesbians in the movie, Warhol, with a look of bewilderment, says no (and the audience laughs). "Homosexuals?" Lomax adds, and Warhol says, "One or two, I think."

The entire exchange on the Lomax program also suggests the ambiguous and tenuous links between different rights movements of the era, as the African American Lomax seems blind to gay and lesbian rights, while Warhol seems equally blind to Lomax's own marginal position as a black man on an almost entirely white medium, speaking to an almost entirely white studio audience, and running for mayor in a notoriously racist town (the Watts Riots took place a year before the show aired). Nevertheless, Warhol's insistence on the utter banality of the content of his underground movies

undercuts the shock-jock tactics of local TV and suggests that perhaps the most radical act on television is to just be boring. After all, if straight couples like Ozzie and Harriet Nelson could be on TV for sixteen years in plots about what chairs to buy or which pancake mix to eat, why couldn't drag queens be similarly entitled to bore the American public? Although Warhol himself never posed it in this way, his use of the broadcast medium raised the question of why only certain kinds of people get to be ordinary on television. Symptomatically in this regard, his preferred title for his much dreamed of talk show was *Nothing Special*.[45]

More generally, Warhol TV disrupted the dialects of boredom and scandal in media. Whereas midcentury U.S. media represented homosexuality, drug addicts, and poverty as horrific social problems, as celebrity "dirt," or via "flamboyant" entertainers like Liberace, Warhol TV presented homosexuals, drug addicts, and social dropouts as mundane—that is, as people who also had an everyday life and who were not simply sideshows for middle-class excitement, outrage, or guilt. Even in the late 1960s, when TV supposedly discovered the sexual revolution, television programs consistently relied on burlesque depictions of queers as thrilling subjects of scandal.

NBC's *Rowan and Martin's Laugh-In* (which was broadcast between 1968 and 1973) is the perfect case in point. Lauded in the press for having "raised America's hip quotient by 300%," *Laugh-In* presented itself as the psychedelic ambassador of the sexual revolution.[46] Blending all the latest styles—pop, op, psychedelic art, and happenings—*Laugh-In* had fast-paced editing, a graffiti-wall stage set, and mod girls like Goldie Hawn who wore tiny bikinis and (in the tradition of body art) had slogans painted all over their skin. Yet, like the 1950s variety shows, *Laugh-In* was a standard (if self-reflexive) version of vaudeo-modernism, with a classic vaudeville couple, straight man (Dan) and baffoonish clown (Dick), and many of its jokes were taken straight from vaudeville. For example, a script for a 1969 episode begins with stage instructions for a "vaudeville crossover" in which Dan remarks, "If Raquel Welch married Cassias Clay, that would be like bringing the Mountains to Mohammed." In true vaudeville fashion, the stage directions call for "Music: 4 Bars and into Vamp."[47] *Laugh-In* also featured stock variety-show send-ups about "fairies," with guests like Liberace (who also played super-villain Lilac Louie on *Batman*), Tiny Tim (the ukulele playing soprano and implied castrato), and the "fey" sportscaster Alan Sues (who chimed "tinkle, tinkle, tinkle," while he rang a bell with a limp wrist).[48]

In its regularly featured "cocktail party" and news sketches, *Laugh-In* told sexually titillating jokes about Warhol and pop art. In a 1969 cocktail party

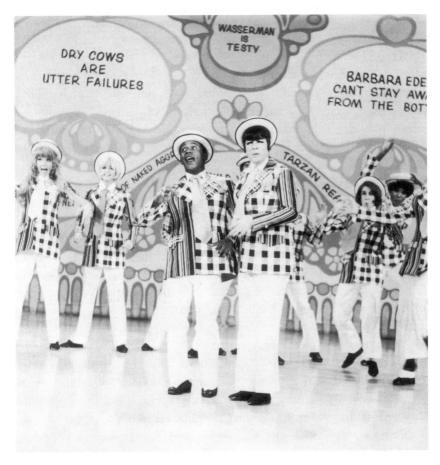

Vaudeo modernism goes pop in *Rowan and Martin's Laugh-In* (NBC, ca. 1969).

segment, Tiny Tim talks about "fop art" on the famous gay beach resort, Fire Island. In a 1968 cocktail party segment when guest star Barbara Feldon talks about "dirty movies," she quips, "Andy Warhol is working on one. This time I hear no one of either sex will be allowed to see it." And in a 1969 episode when Dan and Dick read the "news of the future," they report, "Hollywood—1989. Avant-garde filmmaker Andy Warhol Jr. today shocked the entire film world with his new movie, *Orgy Girl*, which features a love scene between two fully clothed people. In its defense, Warhol said the clothed scene was done in excellent taste and besides, it will only be shown in foreign markets." In scenes like this, Warhol is depicted as a sexual outlaw who, like Liberace or Tiny Tim, was popular to the extent that he played the eccentric

weirdo in the straight culture's newfound (hetero) sexual liberation. Perhaps his discomfort with this role is why he and his entourage staged an "Andy's Up-Tight" performance for the David Susskind talk show in 1971 (another program which typically moralized on drugs, transsexuals, yippies, etc.). Along with members of the Velvet Underground, filmmaker Barbara Rubin, and the East Village band The Fugs, Warhol famously "flipped out" Susskind when, for example, John Cale caressed Malanga with a whip and Rubin and others began filming the show with their own cameras (all this to the smell of pot). In what is now a famous example in Warhol lore, the outraged Susskind stopped taping the show halfway through the hour.[49]

WARHOL'S EVERYDAY TELEVISION

In his own television and video productions Warhol deflated the scandal of homosexuality by rendering it ordinary. Just as French theorist Henri Lefebvre and the Situationists (led by Guy Debord) saw everyday life as a kind of eruptive force that provided an unpredictable, lived form of potential alterity in postwar France, Warhol TV used quotidian television genres—soap operas, makeover formats, and fashion shows—to provide a mediaspace for a different vision of the everyday in postwar America.[50] Warhol's TV productions and commentary about TV suggest that he was interested in making an alternative mode of everyday television about people who didn't live in nuclear families, who didn't work normal shifts, and who did not live by the standard "rhythms of reception" that television schedules offered.

In 1981, when Warhol and his crew produced three segments for *Saturday Night Live*, he enigmatically suggested how the temporal flow of "live TV" was something aimed at only certain kinds of lifestyles. In rehearsal footage (that eventually made its way to the airwaves in an edited version) an off-screen crewmember asks Warhol if he likes *Saturday Night Live*. Warhol says, "I hate the show. And I never watched it. . . . And if you're home on a Saturday night, why are you home on a Saturday night?" Then he adds that he does like *reruns* of the show. "Maybe it is the time it's on. It's not usually on live and it's on earlier or later or something like that. . . . Well it's actually on when you're at home. Before it was on when you were out. Now it's on when you're home."[51] Like other people who did not abide by the eight-hour work schedule or typical leisure time clock for family fun, Warhol's own use of television was rooted in a queer relation to the entire apparatus of TV time. Rather than watching in network primetime, Warhol was part of the "fringe time" public ("fringe time" being a term broadcasters used to describe late night, late afternoon, and early morning hours when stations usually aired

reruns, syndicated game shows, or old movies). In fact, on a number of occasions Warhol said that reruns were among his favorite things on TV.[52] Although this does seem an apt choice for an artist who proclaimed his love for "leftovers" (old toys, stray cats, fading movie stars, etc.), his taste for reruns also speaks to his own use of television as a queer viewer living outside the everyday patterns of family life and 9–5 work hours around which primetime schedules were planned. For Warhol, and no doubt many other viewers of the period, watching TV was an act that had to be done in relation to (and in negotiation with) "straight time."

Warhol's first videotaped productions, the *Factory Diaries*, present glimpses of his alternative mode of everyday life at the Factory by organizing TV time in ways that were entirely different from television's commercial rhythms and time flows. Adapting a form associated with women's autobiographical writing, Warhol recorded life in the Factory on an everyday basis, uninterrupted, unedited, and in no particular standard intervals or duration. The *Factory Diaries* began in earnest in late 1971, but his diary-style video footage dates back to 1965 when Norelco loaned Warhol video equipment to review for *Tape Recording*, a technical magazine. To publicize its equipment, Norelco held a "world premiere underground party" for Warhol on October 29, 1965, which was located in an unused subway tunnel beneath the Waldorf Astoria Hotel.[53]

The extant footage of Warhol's first video endeavors includes party and dance scenes as well as Billy Name giving Edie Sedgwick a haircut out on the fire escape, and Edie talking to the camera. Warhol referred to these first tapes as "home movies," and like other hobbyists at the time who shot photographs off TV, Warhol also used the video camera to take images directly off the screen (and sometimes Warhol taped people in front of the TV set, changing the channels).[54] Later, in 1971, after Warhol acquired a Sony Portapak reel-to-reel 1/2-inch system, the footage (some in color) began to look more professional. While some of this is interview footage, for most part the materials compiled in the *Factory Diaries* are unedited scenes of everyday life at the Factory, with people talking to the camera.[55] Yet, the footage suggests that Warhol was also considering TV in a more painterly and formalist sense. For example, some diary "entries" show the camera looking out the window at street scenes while the soundtrack records ambient noise and conversations inside the Factory. In these cases, it appears that Warhol (or whoever is shooting the action) is exploring point of view, framing, image composition, and other aspects of form. In fact, despite his refusal to call himself one, Warhol sounds very much like a video artist when he tells the publisher of *Tape*

Recording, "We like to take advantage of static. We sometimes stop the tape to get a second image coming through. . . . It's so weird. So fascinating."[56] Taken as a whole, the *Factory Diaries* represent a hybrid between home movies, Hollywood glamour shots, the filmed *Screen Tests* (also shot in the Factory), interviews, art tapes, scientific/ethnographic observation, and surveillance tapes (the first tapes were filmed with a stationary uninterrupted camera as in a "bank vault" set-up).[57]

On a more philosophical level, the *Factory Diaries* express the complexities involved in Warhol's attitude toward reality as something both banal and hyperbolically performed. David Joselit argues that Warhol thought TV and life "mutually derealize one another."[58] In *The Philosophy of Andy Warhol*, Warhol writes, "A whole day of life is like a whole day of television. . . . At the end of the day the whole day will be a movie. A movie made for TV."[59] For Joselit these passages suggest the "deadening of affect" and emotional dissociation involved in the media-life conflation. Whatever Warhol's personal psychology (which is, of course, an entirely other issue), the *Factory Diaries* deal with the relation of media and real life by depicting human expression and interaction as being entirely dependent on media technologies. This is most clear in Warhol's own diary entry (1976) in which he discusses his meeting with Man Ray. Rather than talking about Ray or his feelings towards him, Warhol instead recounts how he and Ray mediated each other through a series of photographic encounters. Warhol says, "Then I took a picture of Man Ray, then Man Ray took a picture of me; then I took a picture of Man Ray, then Man Ray took a picture of me," and on and on with slight variations in an endless—if funny—tyranny of the same. More generally, the *Factory Diaries* present real life through an aesthetics of boredom in which the various filmed subjects are given "nothing special" to say. While Warhol notoriously claimed to enjoy boredom, the various people in these videos often seem ill at ease with that. David Bowie (1971) tells the camera "I prefer to do something" and begins doing mime and finally walks out of frame. Dennis Hopper (1971) fills up time with a completely unmotivated lecture on modern art from Cézanne to Pollock to Warhol. Edie Sedgwick (1965) seems to run out of things to say and so screams at the top of her lungs, then laughs and sneezes. Warhol's first double-projection film, *Inner and Outer Space* (1965), incorporated the Sedgwick tape, showing Edie as she became increasingly uncomfortable with the sight of her televised image.[60]

In this sense, while on one level the *Factory Diaries* seem simpatico with some of the documentary impulses behind Warhol's agent/friend Emile D. Antonio, on another level they bear the traces of Warhol's portraiture and his

obsession with the intersections between fame, glamour, decay, and death. The *Factory Diaries* might be best understood as a form of video genre painting that gives viewers a sense not of life as it was lived, but of the atmosphere of what it was like to be in the Factory at the time. Symptomatically in this regard, after he appeared on *The Love Boat*, Warhol said the best part of the program was all the extras on the set, which the producers referred to as "atmosphere."[61] Although the *Factory Diaries* might be said to objectify people because of the way they collect and portray individuals as atmospheric extras on the set, they also record a vision of everyday life that looks altogether different from the one that network television routinely offered. With their assortment of drag queens, artists, rock stars, and dropouts hanging out on dirty couches in noisy factory spaces, the *Factory Diaries* form a counternarrative to commercial television's relentless depiction of happy families, clean suburbs, and bucolic ranch-style homes as the "normal" everyday.

However, this is not to say that the *Factory Diaries* are in some way a utopian revolutionary gesture or intended as guerilla television in the video-activist sense. Unlike much of the video art and activism at the time, the *Factory Diaries* are in no way an explicit condemnation of television nor do they set out to provide a utopian vision either for media or for life. Instead the tapes often record depression and desperation, and their picture of everyday life also suggests the exclusivity of Warhol's circle (mostly white, rich, and famous). Although the tapes do provide visibility for gay and other marginalized publics, at the time gay rights leaders and feminists didn't hold Warhol in esteem. (In fact, in 1971, *Art in America* reported, "Andy is despised by Gay Liberation and the Women's Revolt," because he "doesn't take a position.")[62] Warhol's inspiration lies more in recording everyday life at the Factory than in providing an ideal. In this sense, Warhol's depiction of the everyday was riddled with its own exclusions, even if he did provide visibility for people that television routinely confined to the eccentric boundaries of its "vital center."

In the early 1970s, Warhol continued to pursue his interests in video by appropriating commercial broadcast genres. Between 1973 and 1975, he returned to the soap-opera format when he and his coproducer Vincent Fremont (who actually did most of the production) made experimental tapes for television. By this time, Warhol had set up a studio at 33 Union Square West where he and Fremont developed test ideas for a television series, with Warhol contributing to the script concepts. There are hours upon hours of unedited footage of these experiments.[63] However, there is one edited tape that gives some sense of the finished product that Fremont (who edited it)

Terry Guerin and Pat Cleveland in *Vivian's Girls* (1973). Produced and directed by Andy Warhol and Vincent Fremont. © 2008 The Andy Warhol Museum, Pittsburgh, PA, a museum of Carnegie Institute. All rights reserved.

had in mind. The tapes are composed of three titled segments: *Vivian's Girls* (1973, ten videotapes) is the most conventionally "soapish" and focuses on an actress who runs a rooming house for models and drag queens.[64] Shot in black and white, the story follows Vivian, the girls, and their suitors, fluctuating between interior scenes of Vivian's parlor, scenes inside cars, and location shoots of, for example, a poorly lit exterior shot in a park where the girls flee an attempted assault. The tapes appear to experiment technically with staging, location shooting, and ambient sound.

The other segments titled *Phoney* (1973, twenty-three videotapes) and *Fight* (1975, seven videotapes) are much more improvisational in nature, featuring Factory regulars who fight, strip, eat, and talk on the phone. Brigid Berlin (who had been in *Chelsea Girls* and other Warhol films) appears in *Phoney*, improvising a scene in which she fights on the phone with her mother about her weight and gorges herself with cream pies in bed (apparently, a highly autobiographical scenario since the near-300-pound Berlin was a pie addict and had herself staged performance art in which she battled on the phone

with her society-matron mother, Honey, so that everyone in the theater could hear Honey's outrage at Brigid's lifestyle and weight). In another segment, drag queen Candy Darling is all made up, talking on the phone. In a *Fight* tableau, Berlin and actor Charles Rydell appear in an extended brawl set in a living room. While packed with histrionics and modeled on the soap-opera form, these are portraits of down-on-their-luck, mostly unglamorous people that would not be on U.S. daytime soaps. Moreover, as opposed to the soap opera's scripted and stagy dialogue, these scenes play out like Warhol's early films, with free association between actors who improvise on a theme.

Similar soap-opera-like scenes appear on videotapes that Warhol and Fremont produced in the mid-1970s, and which exist as catalogued tapes (in raw footage form) in the Andy Warhol Video Collection. One tape marked "Heavy-set Frizzy Haired Woman and Husband in Kitchen Fight about their Marriage" shows the back of a woman's frizzy head in the foreground of the frame as she and her husband fight about the fact that she has a career and he cleans the toilets. The footage follows the generic sitcom plots of gender reversals (for example, when sitcom housewives like Lucy Ricardo go to work while husbands like Ricky stay at home), but strips the standard plot down to bare essentials, replacing scripted comic banter with babbling improvisations and swapping the high production values of multi-camera sitcom shoots with static camera set-ups. (Although he was not operating the camera, Warhol can be heard talking to the actors.) Other footage from this period labeled "Water Front Zombies" (alternatively "Some Sort of Girl Gang Fantasy") is composed of location shots of the Lower East Side docks of New York. Again, the tape appears to be an experiment with location shooting and sound. It shows a street scene of down-and-out people living amidst garbage. A narrative develops as a girl gang drives a car and then smashes it to pieces in what appears to be an abandoned factory. With their improvisational tableaus and unglamorous cast and settings, these tapes all reveal Warhol's broader fascination with television's histrionic efforts to transform the lackluster everyday into the excitement of the "real."

Warhol's sense of a life performed for media is encapsulated by his most famous quip, "In the future everybody will be world-famous for fifteen minutes," a phrase that takes on new meaning in the age of reality TV. Perhaps not coincidentally in this respect, Warhol was on the scene in 1971 when Craig Gilbert began filming *An American Family*, a twelve-hour serialized PBS documentary that featured the Louds, the first family to let their lives be filmed as they lived it in front of television cameras. Widely regarded as an influential reality TV prototype, the program followed Bill and Pat Loud's

Brigid Berlin and Charles Rydell in *Fight* (1975). Produced and directed by Andy Warhol and Vincent Fremont. © 2008 The Andy Warhol Museum, Pittsburgh, PA, a museum of Carnegie Institute. All rights reserved.

Candy Darling in *Phoney* (1973). Produced and directed by Andy Warhol and Vincent Fremont. © 2008 The Andy Warhol Museum, Pittsburgh, PA, a museum of Carnegie Institute. All rights reserved.

divorce and the adventures of their son Lance, who became the first person to come out on national television. In the second episode Pat goes to visit the Chelsea Hotel, where her son Lance resides. They also go to the Whitney, where the TV cameras capture them looking at a Warhol retrospective. Later, in 1986, Lance confessed that when filming *An American Family* he was "totally influenced" by Warhol. "I was in *Chelsea Girls II*, the sequel."[65] When *An American Family* aired in 1973, Lance became the subject of a huge media scandal. A critic for the *New York Times* referred to him as the "evil flower" of the family and the "devil" of the show. The critic sympathized with his mother Pat, a "45-year-old woman from Santa Barbara" who had to endure the "perverse world of transvestites, drug addicts, pushers, and the sight of Lance in gold lamé gloves lounging in a dark village pad, apparently high . . . in a world full of men who swing on painkillers." Analyzing his fall into moral chaos, the critic observed that Lance's homosexual tendencies first surfaced when, at fourteen years of age, "he dyed his hair silver in admiration of Andy Warhol." (Warhol and Lance actually spoke on the phone and wrote letters to each other since Lance was fifteen).[66]

The critical commentary surrounding *An American Family* suggests the limits of mainstream media representation for gay publics in the period, even on so-called public television and in the *New York Times*, which each wound up fanning the flames of homophobia. Nevertheless, Warhol continued to explore television, even more aggressively as changes in the media industries made TV more available to him. The 1970s were a moment of transition in which new distribution systems of cable, satellites, and the Public Broadcasting System promised to reach and also formulate new kinds of media publics. In the late 1960s, public television (including NET, the Public Broadcasting Laboratory [PBL], WGBH in Boston, WNET in New York, KQED in San Francisco, and, by 1969, the newly launched PBS), offered filmmakers, poets, painters, musicians, and video and performance artists a display window for experimental work.[67] Still, many of the shows on local educational stations and PBS were packaged according to rather standard broadcast formats of art education. In fact, much of public TV proceeded on the conventional wisdom that most people were either hostile to art or bored by education.

For example, *Who's Afraid of the Avant-Garde?* (a 1968 episode of the PBL series on WNET) began with the premise that almost everyone was. Douglas Macagy, now at the Albright Knox Museum in Buffalo, New York, welcomed viewers to a glimpse of the Buffalo Arts Festival and the museum's exhibition on avant-garde art. In the standard procedure of the MoMA days, various

program segments filmed at the Albright Knox featured an assortment of Buffalo "yokels" (mostly women, elderly couples, and African American children) completely baffled by the avant-garde art on display, and various experts then explained what it all meant. The program then segued to "acts" by poet Allen Ginsberg, architect Buckminster Fuller, jazz musician Cecil Taylor, filmmaker Jonas Mekas (who screened two of his shorts), and a collaborative performance titled *Rainforest* choreographed by Merce Cunningham and scored by John Cage. Warhol provided his silver *Clouds* as set design for *Rainforest*, which also included costume design from Rauschenberg and Johns.[68]

Although programs like this one tried to create a space for alternative perspectives (for example, this show mixed political news segments with performances), their pedantic narration was not at all the kind of TV Warhol wanted to make. Apart from his contribution to *Rainforest*, Warhol did not produce TV for educational channels. Instead, in his characteristic fashion, Warhol sought to establish a commercially viable TV career, only now by creating programs for the newly mushrooming cable channels. In 1979 Warhol took hold of cable as a new opportunity, and along with Fremont he began to produce shows for New York cable.

When Warhol's programs first aired, cable was still a rather chaotic affair with an eclectic mix of community voices, would-be actors, video evangelists, and video artists and collectives like NYU's Alternative Media Center and the New York–based Open Channel, which saw cable access as a potentially democratic distribution system. Moreover, cable was unstructured by any scheduling patterns so that audiences saw it mostly on a catch-as-catch-can basis. Although Warhol's cable shows look rather primitive by today's standards, at the time critics praised them for being a cut above the rest. In a 1985 article in *NY Talk*, critic Alan Jones wrote, "I first discovered Andy Warhol's television show in the cable wilderness one evening in 1979. Somewhere between Rev. Leola Brown Gospel Hour and something called Frantic Fran, I came upon the highest quality cable broadcast I'd seen to date."[69] It is, of course, entirely possible that critics perceived Warhol's shows to be a cut above the rest because a famous artist made them, but it is nevertheless the case that Warhol poured a great deal of revenue into the effort. Although the cable stations charged Warhol only about $25 per half hour in the early years, Warhol used broadcast-quality equipment. He shot the early cable shows with an Ikegami HL-79-A camera and a Sony BVU 110 recording deck, a high-end investment for Manhattan Cable at the time. Any time a new piece of equipment came out, Warhol tried it.[70] Able to offset costs with his finan-

cial success in other realms, Warhol used the new cable stations to realize his life-long dream to be a talk show host.

WARHOL'S TV MAKEOVER

Beginning in 1979 and until his death in 1987, Warhol created three different series for cable. Unlike his earlier experiments, the cable shows increasingly utilized fast-paced editing and computer effects (Warhol said he liked to play around with color on the Commodore computer).[71] Essentially a TV version of Warhol's already thriving magazine, *Interview*, his cable shows were filled with glamorous celebrities. When asked if the programs were art, Fremont said, "We don't call it artists' television. . . . It's a crossover from the magazine. We discover people."[72] The cable shows coincide with the period in which Warhol proclaimed himself a "business artist" and the time when he most aggressively marketed his own image empire. In addition to the cable series, Andy Warhol Productions made industrial, music, and fashion videos for such clients as Nicole Miller and Bottega Veneta as well as bands like The Cars and Curiosity Kills the Cat. Yet in contrast to the Habermassian conclusion that publicity necessarily shuts down publicness, Warhol used publicity as a central means for participation in the mediated social spheres of everyday life. And, once again, in the cable shows he used women's broadcast genres counterintuitively.

The first cable show, *Fashion*, began in 1979 on the New York City public access station Manhattan Cable. Produced by Fremont (who was also vice president of Andy Warhol T.V. Productions) and directed by Don Munroe (a graduate of the Rhode Island School of Design and head of the video studio at Bloomingdale's department store), the program began as a simple demonstrational and fashion-show format with introductions by Warhol, who typically appeared in a headshot, clicked a Polaroid camera, and said, "Fashion." The first episode featured a makeup artist doing two makeovers interspersed with girls holding up before and after photos. As *Fashion* evolved, the crew left the studio to shoot in drag clubs and other places around town. The show placed the drag performances alongside interviews with fashion designers like Betsy Johnson and Halston. In this way, the programs implicitly questioned the normative (heterosexualizing) boundaries between fine art, haute couture, and drag.

Warhol used similar tactics in *Andy Warhol's T.V.* (1980–83) and MTV's *Andy Warhol's Fifteen Minutes* (1986–87), which presented segments with rock/new-wave stars (like Hall & Oates and Debby Harry), artists (like Cindy Sherman and David Hockney), fashion designers (like Giorgio Armani and

Perry Ellis), filmmakers (like Steven Spielberg), and an assortment of models, dancers, actors, and authors.[73] The programs often used the makeover format self-reflexively to stage gender performances. For example, in a 1981 episode of *Andy Warhol's T.V.*, Warhol introduces the show while a makeup artist puts powder and red lipstick on his face; other episodes present interviews with guests having their hair blown dry or makeup applied. A 1981 episode features filmmaker John Waters sitting with an unmade-up Divine, who remains silent until she has her drag makeup applied.[74] As Freemont noted, Warhol expressed his painterly sensibility by insisting the camera remain still for many of the interview segments, thereby framing talk show guests as one might present them in portraits.[75]

Other episodes directly reference Warhol's paintings, but again within the context of fashion and drag. In the 1985 pilot episode for *Fifteen Minutes*, Debbie Harry wears a Halston dress and stockings made to look like Warhol's camouflage paintings. Blurring the boundaries between drag, haute couture, and fine art, Warhol signs Harry's leg and then Harry introduces a sequence featuring what she calls "neo-drag." Warhol took similar liberties with the borders between drag, fashion, and fine art in a 1983 episode of *Andy Warhol's T.V.* that presents cast members of *One Life to Live* in a lineup with high-fashion designer Bob Mackie, modern dancer June Anderson, and heavyweight boxer Ken Norton, who models Fernando Sanchez's lingerie along with sexy models. Then Warhol interviews rodeo performers, who also model fashions. Insofar as men on horses were icons in gay culture (not least of all in Warhol's film *Lonesome Cowboys*), the interview (coupled with Norton's fashion segment) provides an opportunity for the camera to depict buff male bodies as subjects of male desire.

Indeed, despite his burning desire to go commercial, in the cable shows Warhol often derailed the "straight" interview format by introducing topics that TV talk shows would have addressed only as social problems.[76] In a 1981 episode of *Andy Warhol's T.V.* that features artist Larry Rivers, Warhol turns the artist's interview format inside out. Rather than letting Rivers discuss his paintings (which Rivers at least initially seems to want to do), Warhol derails him by asking him why he doesn't get a nose job. In fact, the two spend the bulk of the interview talking about plastic surgery. Finally, Rivers winds up confessing that he has recently had an "eye bag job." When considered alongside the other topics they discuss—Rivers's recent revelation that he likes gay sex, his enjoyment of sadomasochistic sex, and his discussion about his prostrate trouble and related fears of diminishing virility—the fact that Rivers got an eye job would seem (at least by the standards of 1980s TV) less

Title sequence to *Andy Warhol's Fifteen Minutes*, episode 1 (MTV, 1986). Produced by Vincent Fremont. Directed by Don Munroe. Executive director, Andy Warhol. © 2008 The Andy Warhol Museum, Pittsburgh, PA, a museum of Carnegie Institute. All rights reserved.

shocking than the fact that he was discussing intimate details of his queer sex life on TV. Yet in his characteristic deadpan way, Warhol remains blasé about everything but the eye job, which he responds to with an incredulous gasp (followed by effusive compliments). In this way, as a TV interviewer Warhol reverses the mechanisms of popular scandal and Hollywood gossip that in his time outed gay men. Rivers's coming-out narrative and frank discussion of his sexual preferences are presented as just one more banal bit of TV talk while Warhol features the makeover eye-job story as the shocking "reveal."[77]

In a 1981 segment that he produced for *Saturday Night Live*, Warhol once again used the makeover genre counterintuitively, not to hide something ghastly, but rather to reveal it. Just as he followed his pop portraits of nose jobs, soup cans, and stars with his equally beautiful "Disaster" series of suicides, electric chairs, and tuna-fish poisonings, Warhol used the makeover genre to reveal the chilling horrors of performative glamour.[78] The segment opens with Warhol looking in a mirror as a makeup artist applies chalky

powder to his already superwhite face. The credits roll: "Andy Warhol on Makeup." Then Warhol says: "I don't want to talk about men wearing makeup or perfume. I don't want to talk about New York fairies and hairdressers. I have something more important and meaningful to say." A second set of credits roll, announcing: "Andy Warhol on Death." Still framed in the mirror shot, Warhol recites his views on death, concluding:

> Death can really make you look like a star. But then it could be all wrong because if your makeup isn't right when you're dead you won't look really right. . . . Everybody always . . . when they go to see an open casket they always say, Did ya see that makeup? I mean isn't it wonderful? God! I mean didn't they do the right thing? . . . I waited in line for, I think, the Judy Garland. . . . Oh let's not talk about that.[79]

Here, Warhol rejects the logic of *Saturday Night Live* altogether, turning a live comedy show into a rumination on death—not only death as a concept, but with his memory of Garland, a specific death that also evokes the gay subculture that mourned her. This haunting tension between TV liveness and death was expressed on the image track by a "DVE" special effect that Munroe had first developed for *Andy Warhol's T.V.* Described by one reviewer as "a sort of Chuck Close fade-out," the DVE was a transitional effect composed of tiny mosaic patterns that came up on screen to abstract and then obliterate the image.[80] In this case Warhol's face devolved into tiny squares, eventually readable only as a blur. The DVE effect created a similar dialect of "life and death" and "presence and absence" that Thomas Crow attributes to Warhol's early Marylins so that in its visual look Warhol's performance had an uncanny feel.[81] This *Saturday Night Live* segment was also Warhol's most explicit refusal to be cast in the stock role of the "swish" artist, always there for a cameo appearance on TV's normalizing lineups. "I don't want to talk about New York fairies and hairdressers," he says, "I have something more important and meaningful to say."

In the end, Warhol TV reveals both the possibilities and limits that commercial television could offer. Warhol's embrace of commercialism allowed him luxuries that most video artists at the time could not afford. He had his own studio, he used his so-called business art to fund his own media projects, and he basically approached television as the research-and-development wing of his empire. By the 1970s, Warhol was a kind of one-man media conglomerate.[82] Yet, despite his desire to be an insider, Warhol never really did perform according to the conventions of commercial TV. Warhol TV was symptomatic of all the tensions between (and within) the fields of art and

Andy Warhol's T.V. on Saturday Night Live (NBC, 1981). Andy Warhol T.V. Productions. Produced by Vincent Fremont. Directed by Don Munroe. © 2008 The Andy Warhol Museum, Pittsburgh, PA, a museum of Carnegie Institute. All rights reserved.

commercial media production during his time, and many of the shows were more an expression of these tensions than they were a fully achieved intervention. Nevertheless, his lifelong engagements with TV were not just a strategy for making money or achieving even more fame. From his CBS and NBC illustrations of beautiful boys to his film *Soap Opera* to his "Underground Sundae" with Viva and Joe to his television interviews, *Factory Diaries*, experimental soaps, and cable drag/makeovers, Warhol used popular broadcast genres as a means of publicizing the everyday lives of people that network TV presented only as subjects of prurient display. At the risk of overvaluing Warhol's efforts, or turning Warhol TV into its own golden age, I think it is worth considering Warhol's work in television as an important attempt to return the realm of the everyday to a wider group of citizens.

Meanwhile, Warhol's own everyday encounters with television are best represented not by what he produced, but rather by the enormous amount of TV he taped. What did Warhol tape on TV? Reruns of sitcoms like *The Mary Tyler Moore Show* and *Father Knows Best*, daily newscasts, and game shows like *Celebrity Sweepstakes*. That is, he taped precisely those everyday genres that refused to represent men like him or else made them play denigrating stock roles of New York fairies and hairdressers. Perhaps taping these shows and saving them for future generations made Warhol feel like a real insider. After his death, the Warhol Foundation donated Warhol's tape collection to the Paley Center for Media. It seems fitting that Warhol should have given back to television culture exactly what it gave him.

••• EPILOGUE: FRAMING TV, UNFRAMING ART

When will television become an art form? It is still environmental. A simple answer is, of course, that television is not an art form because there is nothing around it yet. There will be a moment when television will become an art form. . . . With satellites, television ceases to be environmental and becomes content. Becomes an art form. . . . When television becomes an old technology, we will really appreciate its glorious properties. —MARSHALL MCLUHAN, 1967

Sophistication of consciousness in the arts today (1969) is so great that it is hard not to assert as matters of fact that the LM moon craft is patently superior to all contemporary sculptural efforts; that the broadcast verbal exchange between Houston's Manned Spacecraft Center and the Apollo 11 astronauts was better than contemporary poetry/that with their sound distortions, beeps, static, and communication breaks, such exchanges also surpassed the electronic music of the concert halls; that certain remote control videotapes of the lives of ghetto families recorded (with their permission) by anthropologists are more fascinating than the celebrated underground films; that not a few of those brightly lit plastic and stainless steel gas stations, of, say, Las Vegas, are the most extraordinary architecture to date; that the random trancelike movements of shoppers in a supermarket are richer than anything done in modern dance; that lint under beds and the debris of industrial dumps are more engaging than the recent rash of exhibitions of scattered waste matter; that the vapor trails left by rocket tests—motionless, rainbow colored, sky filling scribbles—are unequalled by artists exploring gaseous media; that the Southeast Asia theater of war in Vietnam, or the trial of the "Chicago Eight," while indefensible, is better than any play; that . . . etc., etc., . . . nonart is more art than Art art. —ALLAN KAPROW, 1969

At the end of the 1960s, media philosophy and art criticism were beginning to run on parallel tracks. The above observations—one by media theorist Marshall McLuhan, the other by Happenings innovator Allan Kaprow—each express visions of the future of TV and art in a media-made culture. McLuhan predicts that the new satellite technology will turn the TV "environment" into a historical artifact and thereby *frame* it as art. Kaprow celebrates the

unframing of art and its dissolution into media environments made possible by TV, video, satellites, neon, computers, and so forth. Yet even while their conclusions (and politics) differ, McLuhan and Kaprow are each engaged in a common concern of the period regarding the converging futures of art and media.[1]

Television's trajectory as a cultural form did not exactly follow either McLuhan's or Kaprow's visions. McLuhan was wrong in his technological determinist assumption that media technologies become art only when new media eclipse (or enclose) them. Television's status as art was not determined by its technological trajectories alone, but also—and much more significantly—by the social, cultural, and political struggles through which TV was formed. Since the late 1930s, museum curators, network executives, graphic artists, critics, advertisers, architects, FCC regulators, television producers, and audiences all tried to define TV's status as art and culture. In other words, people were framing TV as art even before it was a commercial medium. By the same token, Kaprow's reversal of aesthetic canons (his embrace of the broadcast signal, industrial waste, noise, and—before Venturi—Las Vegas architecture) was a symptomatic response to his historical moment. He wrote his "un-art" thesis in the context of a raging battle against the elitism and political biases of museums and other venues of high culture, a battle that was often waged in relation to the various rights movements, social activism, democracy, and global crises. This anti-museum logic helped to fuel new movements in performance, conceptual, installation, and media art that artists initially embraced for their radically democratic dimensions. Yet, these movements were rapidly institutionalized.

As Michael Rush points out in his discussion of video-installation art of the period, "While much of late twentieth-century installation art is rooted in an anti-museum attitude characteristic of the 1960s and early 1970s, it is museums and galleries that are the primary locus for such art; this 'context' art . . . itself needs an institutional context to be seen."[2] Video's reliance on the museum went hand in hand with its evacuation from the public airwaves so that video and television came to occupy two separate cultural spaces, replicating the great divide between the avant-garde and mass culture that had underpinned the history of modernism. Despite treatises on the advent of a new postmodern culture that began to be heard in the 1970s, video and television replicated the contradictions and ambivalence regarding museum art and commercial culture we have seen throughout this book.

I want to conclude by considering how and why television and video—which shared the same technological components—came to stand in the

artistic and popular imagination for essentially distinct and opposing cultural forms—one resolutely commercial, representational, entertaining, and viewed in the privacy of the home; the other a mostly museum-world phenomenon that engaged abstraction and the aesthetic problematic of media specificity, and appealed to art publics located mostly in urban centers. In fact, quite contrary to McLuhan's predictions, TV did not become art—instead it became video art.

IT'S NOT TV: IT'S VIDEO ART

A number of critics and historians have analyzed the paradoxes involved in the early video movement. In the 1960s, a new—if loosely organized—group of international artists revived previous Marxist attacks on the museum (and Dada attempts to integrate art with life) by either leaving the museum altogether (for street performance, happenings, multimedia shows, and other nonmarketable forms of art) or else reorganizing tactics of display within the museum (including the introduction of video installations). Early gallery installations in the late 1950s and early 1960s set off new experimentation with television as art, and these experiments especially flourished as video technology became more available and more mobile. When Sony introduced its first portable 1/2-inch black-and-white videotape recorder, artists and activists began to incorporate the new equipment into their work. In 1965, about the same time that Warhol began to experiment with his Norelo video camera, Nam June Paik acquired his first Sony portapack and, as the legend goes, right after the purchase he recorded the pope's procession on Fifth Avenue in New York City. Later that night, Paik exhibited the footage at the artist hangout Café A-Go-Go, an event that is generally considered to have inaugurated U.S. artists' more widespread embrace of video.[3] Following this, conceptual and performance artists like Carolee Shneeman, Bruce Nauman, Joan Jonas, Dan Graham, and Vito Acconci integrated video into performance and installations.

By the end of the 1960s and in the early 1970s video collectives such as the Raindance Corporation, Videofreex, Ant Farm, Global TV, and Top Value Television (aka TVTV) staged performance-art pieces and also created alternative, "guerilla" news. For example, TVTV's *Four More Years* presented alternative coverage of the 1972 Democratic and Republican Conventions, while Ant Farm's *Media Burn* (1975) staged a media event at San Francisco's Cow Palace (recorded by the collective) in which a reconstructed 1959 El Dorado Cadillac convertible drove through a wall of burning TV sets.

Video's rise also coincided with the antiwar, feminist, and various civil rights movements, which made use of video technology to stage protests and create alternative art and documentaries.[4] Throughout the period, artists and activists typically conceived of broadcast television as a "wasteland," but rather than suggesting liberal reform (as Minow did), they typically spoke in more revolutionary terms. Paik took up arms, stating, "TV has attacked us all of our life. Now we're hitting back."[5] In 1971 video activist Michael Shamberg of the Raindance Corporation published *Guerilla Television*, a how-to manual/manifesto instructing readers on how to use new portable video technology to challenge the ideologies and practices of commercial TV and American society at large.[6] Moreover, unlike the nationalism of U.S. broadcasting, early video artists and activists could imagine themselves as part of a more international movement that was taking place in locations around the globe.

Video activism (in the form of guerilla performances and/or alternative documentary) coexisted and sometimes intersected with various art-video practices aimed at aesthetic interventions that broke conventional patterns of television as these were formed through commercial broadcasting. Educational stations such as New York's WNET, Boston's WGBH, and San Francisco's KQED, as well as the newly formed PBS network, fostered these endeavors with programs like WGBH's "The Medium Is the Medium" (1969), the first U.S. program devoted to artists' use of television, and "Video—The New Wave" (1974), the first national PBS broadcast of video art. Museum and gallery exhibitions such as "TV as a Creative Medium" at the Howard Wise Gallery in 1969 and alternative art spaces like the Kitchen (founded in 1971 in New York City) provided venues for video and the electronic arts. Art critics helped to clarify an overall aesthetic problematic and practice.

David Antin's oft-cited essay, "Video: The Distinctive Features of the Medium" (a version of which was first published in *Art Forum* under the title "Television: Video's Frightful Parent"), took up the modernist cause of media specificity and quickly became a manifesto of sorts among video artists and critics for its bold proclamations and incisive descriptions of video art's attempts to distinguish itself, even empty itself, of television. According to Antin, video artists critiqued TV's commercially informed scheduling patterns, private-viewing protocols, photographic realism, generic formulae, subject matter, commercials, and overall tyranny of boredom (which artists often self-reflexively commented upon through strategies of repetition, time loops, parody, and overall refusals of pleasure also found in experimental and underground cinema). In the context of his own critique of commercialism,

Antin especially sparked interest in the "theater of poverty," low-budget aesthetics employed by video artists like Elanor Antin, Andy Mann, Ira Schneider, and Beryl Korot.[7]

More generally, in the spirit of McLuhan's formalist pronouncement "the medium is the message," video artists (who often explicitly embraced McLuhan) critiqued commercial television by turning away from content and toward abstract forms of feedback and distortion. Paik's *Electronic TV* (exhibited at the Galerie Parnass in Wuppertal in 1963) included thirteen monitors with abstract noise and patterns generated by magnets applied to TV sets randomly scattered on the gallery floor. Similarly, Wolf Vostell's *TV-de-coll/age-Ereingrisse für Millions* (first created in 1959) distorted the TV image by manipulating knobs, dials, antennae, and vertical controls. Painterly abstraction and/or graphic distortion via electronic manipulation continued with tapes such as Joan Jonas's *Vertical Roll* (1972), which used the properties of bad transmission and signal interference to abstract portions of the female body; Dan Sandon's *Colorwipe* (1973), which experimented with light and color in a painterly fashion; and Steina and Woody Valsulka 's *Golden Voyage* (1973), a multilayered homage to Magritte using electronic manipulation.

Video artists also created tapes and installations that critiqued what they perceived to be TV's "passive" viewing protocols by forcing viewers into active participation and involvement. Paik's *Participation TV* (1965), Les Levine's *Slipcover* (1966), Bruce Nauman's *Video Corridor* (1968), Vito Acconci's *Command Performance* (1974), Ira Schneider and Frank Gillette's *Wipe Cycle* (1969), Dan Graham's *Performer/Audience/Mirror* (1977), and Peter Campus's *Negative Crossings* (1974) explored the act of viewing and its relation to such social, aesthetic, and psychic phenomenon as surveillance, feedback, voyeurism, narcissism, seduction, and the uncanny experience of seeing oneself "live" on TV. Meanwhile, installations by such artists as Paik, Vostell, Doug Hall, Yoko Ono, and Dan Graham sought to defamiliarize video from its object status in the privatized home environment, often by questioning the line between furniture and sculpture or else by placing television in public sites such as stores or office complexes.[8]

Referring to this period of artistic and activist intervention as video's "mythic past," Marita Sturken argues, "For many, video represented a tool with which to 'revolt' against the establishment of commercial television. For others, it was an art medium with which to wage 'war' on the establishment of the commercial art world." As Sturken demonstrates, this initial excitement was fueled by government and private granting institutions (such as the New

York State Council for the Arts and the Ford and Rockefeller Foundations) that supported video work and facilitated the growth of experimental production sites. Yet, as Sturken also notes, this period was short lived. "Ironically," she writes, "While the majority of early video activity took place outside of established social organizations and museums, the institutionalization of the medium (however ambivalent) took hold quickly."[9] By 1976 most major national museums already had exhibitions of video art. By the mid-1970s, most video collectives began to disband. So, too, as Sturken and other historians have observed, the museumification of video art was precipitated by changing funding structures, as granting institutions began to steer away from financing activist or information-based work toward funding "video art." As the funding sources for public television dwindled, distribution outlets for video work on public stations also grew scarce. Commenting on the end of video's "utopian moment," Martha Rosler argues, "The 'museumification' of video has meant the consistent neglect by art-world writers and supporters of the relation between 'video art' and broadcasting, in favor of a concentration on a distinctly modernist concern with the 'essentials of the medium.'"[10]

In the late 1960s and early 1970s, some video and performance artists did try to cross over into network TV. For example, CBS enlisted video artists and activists to participate in *NOW*, an experimental news series, but in the end the network decided (ironically) that *NOW* was "ahead of its times," and cancelled production. More generally, as *Art in America* reported in 1971, when video collectives (most of which had radical youth-culture politics) attempted to distribute their tapes to networks, the networks demurred on the grounds of technical inferiority, saying the Sony 1/2-inch tapes were not up to broadcast quality.[11] In the end, rather than engaging video activists or artists, the networks more typically concentrated in this period on what Todd Gitlin termed the "turn to relevance" with so-called quality realist dramas and sitcoms like *The Mod Squad* and *All in the Family* (CBS) that dealt with social issues in the context of familiar and popular TV formats and were aimed at lucrative demographics, especially the 18–49-year-old urban middle class.[12] And despite the early endeavors of stations like WGBH, WNET, and KQED, video art and activism had a relatively short shelf life on most public channels. In fact, video art on public TV typically provoked the same kind of taste wars with which MoMA officials struggled during the years of the Television Project.

In 1985, when PBS aired the first national video series, *Alive from Off Center* (which included not just art tapes but also music videos by art bands like

the Talking Heads), the show was panned on both sides of the mass vs. avant-garde taste divides. While it was carried in urban centers, stations elsewhere thought the program did not appeal to Middle American tastes, and because PBS's audience skewed old (fifty years or more), even the music videos were not a draw. Meanwhile, art critics found it to be "The silliest mix of art and commerce . . . with the patented PBS schoolmarmish didacticism."[13] Like Warhol, some video artists placed hopes in the new cable channels, but by the mid-1980s cable was itself a highly concentrated industry and the promise of cable access was fading fast.[14] In this context, video art quickly became a stranger to the airwaves, and video artists grew even more dependent on the museum to exhibit their work. As John Hanhardt wrote in 1986, "Despite the PBS projects and a few alternative cable series, the realization of artists' television has proved to be nearly impossible."[15]

The divide between video and TV had become so deep so quickly that by the 1980s a number of galleries, museums, and festivals reflected on the issue. In 1983 the American Film Institute (AFI) devoted space in its third annual National Video Festival (which was funded by the Sony Corporation) to a consideration of commercial television. The conference honored Ernie Kovacs as a video pioneer and also featured *All in the Family* producer Norman Lear on a panel titled "Breakout Programs" devoted to TV that "totally breaks with conventions."[16] But while the AFI anointed a few TV producers as "auteurs" through a discourse of exceptionalism, overall the AFI contextualized video art not as TV but rather as a wing of its more established film festivals, and the major focus was on video's relation to art cinema (for example, the festival screened Godard's video *Scenario du Film Passion*). In keeping with the 1960s film-festival practice of showing art films alongside award-winning TV commercials, the AFI festival also screened cutting-edge commercials and the new form of video art/publicity—music videos. (The program included such videos as Donna Summer's "She Works Hard for the Money," Elvis Costello's "Accidents Will Happen," and Michael Jackson's "Billy Jean" and "Beat It").

Other museum exhibitions of the 1980s considered television as source material for artists, in this case placing video art within an art-historical context. In 1986, the Queens Museum of Art in New York presented "Television's Impact on Contemporary Art," offering a detailed look at how artists and photographers from Warhol to Lee Friedlander to Keith Haring used television as a subject in their work.[17] In a somewhat similar vein, the 1986 "TV Generations" show at the Los Angeles Contemporary Exhibitions (LACE) gallery explored "The influence of television as a source of iconography in

contemporary art" and "showcase[d] generations of artists who grew up with television translating that 'vision' to their work." The show, however, was less an exploration of television than it was an exhibition of video art's endeavors to distinguish itself from network TV. In the exhibition catalog, Peter D'Agostino asked, "How does one consider commercial television and art in the same context?" While he suggested that the critical term "postmodernism" and the blurring of high and low provided some useful answers, he nevertheless argued that critics and artists needed to "articulate the differences in form, content, and context that exist, for example, between the productions of the media industry and artists' work." Even more emphatically, Hanhardt's essay in the same catalogue expressed disdain for TV. Unlike the AFI, which sought to enlist music video in the canon, Hanhardt called MTV the ultimate "capitalist cooptation" of video art.[18] Indeed, even at exhibitions supposedly devoted to considering the links between TV and art, the distinction between the two was paramount, and video art (so far as it endured) existed inside the gallery and apart from the airwaves. Whatever democratic mission originally inspired it, video art had become rarified and almost entirely inaccessible to a broader public.

One of the most curious aspects of the critical discourse on video is the critics' almost complete amnesia for the partnerships between commercial television and the art world *before* the advent of video art. Apart from some mentions of a few notable educational and instructional programs, museum retrospectives and video critics have almost entirely ignored the mergers between art and industry through which commercial television flourished since the 1940s.[19] One might even say that in order to establish its own future, video art depended upon a collective amnesia in which artists and museum curators simply had to erase the memory of their links with TV's commercial past. In histories of video art, we never hear of the graphic artists, set designers, architects, art directors, experimental filmmakers, museum officials, and modern artists who worked with the networks throughout the period of TV's meteoric rise. This selective memory and erasure of the past helped to establish the mythic tale of avant-garde exceptionalism in which video artists appear to stand outside of history as a unique set of luminaries somehow able to infiltrate what Hanhardt referred to as the "seamless hegemonic tool" of the TV industry.[20] In fact, however, the industry's hegemony was never really seamless; instead, from the beginning television's power as a cultural form was secured through mutually beneficial collaborations with artists who were, so to speak, in bed with industry from the beginning— some for commercial gain, some for purposes of artistic experimentation,

some for democratic ideals of pedagogy and edification—and some for all at once.

FROM ART TO NOSTALGIA:
CBS REVISITED

While art galleries, museums, and festivals displayed video according to the rules of art exhibition and avant-garde questions of "the future," the broadcasting industry was itself formulating another exhibition context for commercial television based on a ritual relation to the past. Building on earlier attempts by MoMA and the Academy of Television Arts and Sciences to create a public library for television, at the end of the 1960s William Paley began to envision a private museum dedicated to television programs.[21] The Museum of Broadcasting was founded in 1975; by 1991, in response to cable, the museum changed its named to the Museum of Television and Radio (MTR); in 2007 it renamed itself once more as the Paley Center for Media. As the board chairman, Paley guaranteed funding, while Robert Saudek, the executive producer of the 1950s program *Omnibus*, served as the museum's first president and gave it the proper golden-age aura.[22]

Not surprisingly, given CBS's long history of using art for corporate promotion, Paley's museum was a finely crafted balancing act between public service and public relations. Of all three networks, CBS had always been the most invested in the apparatus of television criticism and preservation. CBS's efforts in this regard were aimed at undermining the negative criticism about TV that circulated in the popular press (especially in the wake of the quiz show scandals and Minow's speech). Attempting to discredit detractors, executives at all three networks often referred to newspaper critics as hacks, and noted that they had no industry, art-world, or academic credentials. In an even more clever strategy, CBS also tried to discredit newspaper writers by establishing their own in-house army of "quality" critics who often had distinguished university credentials. In fact, in the early 1960s CBS devised a plan to publish a scholarly television journal. Although the journal never came to fruition, it did materialize in 1961 in book form as *The Eighth Art*. As the first network-sponsored foray into humanities-oriented television criticism, the book was edited by Robert Louis Shayon, a widely respected golden-age critic, and contained essays by professors at Cambridge, Harvard, and the like.[23] Moreover, and even more paradoxically, at the dawn of the 1970s CBS (via its publishing company Holt, Reinhart and Winston) financed the publication of Michael Shamberg's *Guerilla Television*. Acknowledging the irony in his introduction, Shamberg applauded CBS for its willingness to publish

his book despite its strong criticisms of the network.[24] Clearly, CBS had much to gain through its philanthropic efforts. By funding critics and video activists, CBS appeared to be open to all forms of democratic debate while at the same time controlling the climate of criticism. The TV museum was part of that larger corporate strategy.

The museum's self-proclaimed democratic mission was to provide an interpretation of the broadcast past, and "Paley himself saw museum interpretation as one of the greatest benefits for the general public."[25] From the start, the museum was a popular success. In 1979, the *New York Times* reported that the museum was so crowded that in the two years since it opened it had to turn away "three-quarters of its visitors."[26] The *Times* also spoke of the eclectic cultural sensibilities of the museum's patrons, commenting on the mix of people watching such "high" golden-age performances as Toscanini's NBC Orchestra and those watching the commercial likes of *The Making of Star Wars*. As the Paley Center's former president, the late Robert M. Batscha, stated, "We're effectively the first public library of the world that's been created for television and radio. You don't have to be an academic. You don't have to be in the television business. Anybody can have access to the collection."[27] Despite the "something for everyone" ethos, the museum (located in the posh Fifth Avenue shopping district, right near MoMA and Black Rock[28]) charges a ticket price that ensures its largely middle-class patronage, and it also arranges and displays television according to legitimizing discourses of art collecting. Museum events cater to connoisseur values of "rarity," "authorship," and "private screenings." For example, the Paley Center has variously mounted exhibits on the lost live *Honeymooners* sketches and TV "auteurs" like Dennis Potter, and it began to feature private screenings when the museum expanded in 1979 to include a sixty-three-seat auditorium. More regularly, Paley's museum appeals to the general public through contemporary strategies of museum exhibition, including blockbuster festivals, celebrity signings and star-studded panels, interactive exhibits, and, most of all, nostalgia. In this respect (to borrow Walter Benjamin's famous formulation) Paley transformed the medium's "exhibition value" into "cult value."[29]

By the 1990s the TV museum's cult status came to a postmodern dramatic pitch when the Paley Center established its Beverly Hills sister location. Designed by architect Richard Meier (who also designed the Getty Center in Brentwood, California, and the Museum of Contemporary Art in Barcelona), the Beverly Hills museum is an avant-garde monument to TV's commercial past. Finished in enameled white metal panels with expansive walls of glass and a circular-shaped glass-plated rotunda entranceway, the

museum is the postmodern postscript to CBS's Television City—only this time rather than have form follow the functions of television production, the museum seeks to establish its function through its form. Harking back to the modernist sentiments of Le Corbusier, Meier claimed, "The main purpose of the building, like of the media it celebrates, is communication. We made it as open and transparent as possible, and devoid of mystery, so that people passing by can plainly see what happens inside."[30] Meier's use of the media as a metaphor for the building suggests the extent to which the museum itself is the main attraction on display. In fact, by the time the Beverly Hills location opened, the UCLA Film and Television Archive (just down the road) already had a more voluminous collection (free to the public). Moreover, vintage television programs were already being widely circulated on nostalgia cable networks like Nickelodeon's "Nick at Nite," and the video market supplied the public with a wide array of vintage shows. This means that the "unique" experience offered by the museum is found not in its artifacts (which are relatively accessible elsewhere) but in its ability to frame TV programs within an extraordinary display context. Indeed, like the postmodern museum more generally, the Paley Center's cultural worth is not really demonstrated by its documents, but rather by the monument—the building—that contains them.

In fact, Hollywood insiders praised the Beverly Hills museum not only— or even primarily—for its collection, but rather for the building. Admitting that a museum of television would probably have to contain some "garbage," producer Larry Gelbert (of CBS's *MASH*) claimed that the building was nevertheless, "The best piece of architecture to come up in Beverly Hills in years." Similarly, the architecture critic for the *Los Angeles Times* wrote at the time of its opening, "The building's severe Modernist style, and the choice of Meier—rather than a more funky designer like, say, Frank Gehry—comes from the cultural aspirations of the people who create television and radio. It reflects their desire to be taken seriously as artists rather than as mere entertainers." In this sense, it is not surprising that even while the Paley Center publicity boasts about the museum's popular appeal, the museum directors and industry people still promote the museum through discourses of art, education, and public service. At the Beverly Hills opening, Diane English, the creator/producer of CBS's *Murphy Brown*, told a reporter, "Being able to look at television is as important for our culture and our history as looking at a great painting."[31]

Although they still circulate today, such grand statements of television's value as an art medium typically enlist little or no sympathy in a culture

where people are no longer concerned about whether or not TV is an art. In fact, such statements seem more like a residual discourse (circa 1961) deployed by people who can't readily think of anything new to say. Rather than worrying about whether TV is an art, the industry has, since the 1980s, discovered the tremendous value of nostalgia in cable networks like Nick at Nite, "season in a box" DVDs, and online TV fan sites. Moreover, because the Paley Center often partners with Nickelodeon and Nick at Nite, many of its exhibition strategies follow the same logic of TV nostalgia. Apart from a few examples of art shows on PBS, the Paley Center does not display or collect video art—once again naturalizing the idea that video art and TV are for distinctly different publics.

Given this history of museum exhibition, we should not be surprised that the TV vs. art divide is more intact than ever. University research also follows this path. While TV is studied mostly as a communications medium and/or sociological object (albeit with some attention to textual form), video art is pursued mainly through art historical questions of context, media specificity (or dissolution), and philosophy. Journals that publish essays on TV (e.g., *Television and New Media, Critical Studies in Media Communication,* and *The International Journal of Cultural Studies*) rarely if ever publish an essay on video (or digital) art while the opposite is true for art journals like *October* or *Grey Room.* Similarly, TV text books and readers are typically silent on issues of video or digital art, while the new academic interest in "visual culture studies" almost entirely elides some sixty years of television by jumping from the visual technologies of nineteenth and early twentieth-century culture (stereoscopes, panoramas, cinema) to digital art. Yet, these splits and antagonisms say more about the way disciplines in the academy divide their objects of study than they do about the actual history of the media. If, as so many critics assert, these lines were blurred with postmodernism, this is not the case with television. Instead, in both academic and popular circles television is widely viewed as the opposite of art. Meanwhile, for those with more utopian aspirations, the digital media have become the new "environment" for change. Indeed, the utopian sentiments ascribed to television in its early decades, and then to video, are now displaced onto digital media. Even while much of the industrial, social, political, technological, and cultural context for media has changed, the statements circulated about digital culture raise similar hopes and fears to those that were uttered about television and video. In concluding this book, therefore, I find it impossible to provide historical closure. Instead, it seems to me that we are still very much part of the "discursive formation" through which television evolved.

REFRAMING THE HISTORY OF
TELEVISION AND ART

Rather than giving closure to the past, I want to end this book by introducing the perspectives of cultural critic Stuart Hall, a major voice in media and cultural studies. Although his 1980 essay "Encoding-Decoding" is now required reading for most media scholars, in 1971 Hall wrote a lesser known—in fact, as far as I can tell, entirely forgotten—four-part report for UNESCO that offered a particularly prescient insight into the TV vs. art vs. anti-art debates. Titled "Innovation and Decline in the Treatment of Culture on British Television," the report's final section ruminates on the relations among television, art, and everyday life. Unlike McLuhan or Kaprow, whose visions revolved around the convergence between technology and art, Hall introduced a third term: entertainment. Rather than the typical binary logic that pitted art against commercial entertainment, Hall saw that the significance of television lay not in the antagonisms between the two, but mainly in the way art and entertainment were being integrated into and merged with lived experience. Citing from Walter Benjamin and adapting his insights to postwar media, Hall claimed that with television, "The ritual relationship between 'art' and audience has been destroyed." Accordingly, he argued, television "require[s] new ways of defining the categories of everyday life, 'art,' and entertainment."[32]

Like his British predecessors Raymond Williams and Richard Hogart, Hall thought seriously about popular media as a both a social and artistic resource for postwar publics, and he reframed the TV vs. art vs. anti-art debates by considering television's integration into the cultures of everyday life.[33] Criticizing the "serious" art shows such as Sir Kenneth Clark's *Civilization* for their attempt to re-ritualize art, Hall said, "Television is least comfortable, and seems least to exploit its intrinsic qualities when it inhabits—with traditional attitudes—the domain of high art itself." Although he remained critical of television's formulaic genres, commercial constraints, institutional hierarchies, and general failure to provide a democratic culture, Hall saw the potential for a newly emerging "television art" in popular programs like the British soap opera *Coronation Street* and NBC's *Laugh-In*. Such programs, he claimed, exploited television's "potential outside the traditional 'aura' of art, which increasingly comes across as a domain of exclusive privilege and taste." In the spirit of Dada and the revolutionary politics of the 1960s, Hall concluded, "Television invites us, not to serve up the traditional dishes of culture 'more effectively,' but to make real the utopian slogan which appeared in May 1968, adorning the walls of the Sorbonne. 'Art is dead, Let us create everyday life.'"[34]

Ending my own book in 2008, it seems impossible to conclude with this same joyous "May '68" vision. For one thing, as I have argued, the industry has tried to confer ritual/cult value onto TV through appeals to a golden-age past, the construction of architectural monuments like the Paley Center, the "vintage" packaging of DVDs, and the creation of TV nostalgia cable networks. Yet, despite these industrial schemes, Hall's observation is still striking today for its insistence on the need to see the mergers of art and media through the lens of popular entertainment. By taking entertainment seriously, Hall acknowledged one of the most centrally important uses of television— one that most critics simply ignored (and still ignore) as a trivial pursuit. What Hall observed is something we have seen throughout this book: the convergences and realignments between ordinary everyday entertainment forms and the more rarified experiences of looking at art.

In the postwar decades, television was a central venue through which the public engaged with the visual art of the times. Rather than just remediating older forms of popular entertainment, television presented the new visual experiences of postwar modern art and design within the context of an increasingly national (and international) consumer economy. Television networks understood the power of the image for establishing national corporate identities and branding techniques that became the hallmark of postwar modern design. Although duly criticized for their crass commercialism and destruction of culture, television commercials often turned out to be one of the greatest purveyors of visual experimentation on the TV medium. And even while some television programs did attempt to bestow aura onto art, television also provided new ways of looking at art in the context of popular forms (like vaudeville) while it also served as a vehicle for debates about art's greater purpose. Indeed, television was the mid-twentieth-century centerpiece of deeply social and political struggles over art, commerce, taste, and the everyday visual forms through which publics are both amused and informed.

As the Sony commercial with which I began this book suggests, the television and digital-media industries still invest in art, and the public continues to encounter the visual arts through everyday modes of entertainment. But the changing modes of production, distribution, and regulation—as well as cultural, social, and aesthetic changes more broadly—have significantly altered TV in the "postnetwork" era. Niche marketing, deregulation, cable, satellites, globalization, and convergence with computers do make TV a different animal today from what it was in the three-network period. At the present moment, there is almost no utopian aspiration for television. Public TV has largely become a ghost medium, and critics continue to lash out

at what many perceive to be TV's mindless babble.[35] Yet, this longstanding bias against TV has blinded critics to the deep-rooted connections through which people experience art and entertainment in their daily lives. Indeed, it is likely that television's greatest historical import lay neither in its destruction of culture (as so many critics still like to say) nor (as the industry likes to boast) in its exposure of audiences to the "serious" arts, but rather—as Hall first noted—in its mergers of entertainment, art, and the everyday. It is my hope that this book will rekindle those concerns.

••• NOTES

INTRODUCTION

1. See http://Bravia-advert.com. Retrieved November 17, 2006.

2. Barbara Klinger discusses this high-tech marketing strategy more generally in *Beyond the Multiplex: Cinema, New Technologies, and the Home* (Berkeley: University of California Press, 2006).

3. I use the term "everyday modernism" as opposed to the critical term "vernacular modernism," which is associated with nineteenth- and early twentieth-century modernity (the rise of department stores, cinema, new forms of mobility in the city) and which Miriam Bratu Hansen has deftly described as part of a diverse set of modernisms made available through classical Hollywood cinema to a mass consumer public from the 1920s through the 1950s. See Miriam Bratu Hansen, "The Mass Production of the Senses: Classical Cinema as Vernacular Modernism," *Modernism/Modernity* 6:2 (1999): 59–77. By "everyday modernism" I refer to a broad postwar era lifestyle phenomenon experienced through midcentury forms of quotidian modern cultural experiences and artifacts (often consumer items)—from television viewing to modern package design to aerodynamic tailfin cars to midcentury modern architecture and furniture (both commercial and residential) to textile designs with boomerang shapes to the proliferation of suburban shopping malls to the abstract designs of jazz album cover art to the increased popular interest in museum excursions culminating in the popularity of pop art. More abstractly, the term signals the general enthusiasm in the postwar period for designs that signified progress, science, and forward-looking lifestyles. I also use the term "everyday" insofar as the embrace of modern art and design had become more ordinary in the postwar period and

more available in mass-produced versions to middle-class consumers. And I am using the term "everyday modernism" to signify the fact that modern art and design had by midcentury became quotidian forms of the nation insofar as New York had outdistanced Paris as a world market and center for modern art. This nationalism, as we shall see, nevertheless depended on international appeal in the cold war era and the continued incorporation (and exoticism) of diverse cultural modernities (such as African art and Native American art) through such items as mass-produced knickknacks for the home or jazz programs on TV.

4. I am using Lizabeth Cohen's phrase in *A Consumer's Republic: The Politics of Mass Consumption in Postwar America* (New York: Vintage, 2003).

5. Taylor cited in R. W. Stewart, "Television Goes into the Entertainment Field as a New Merchandising Medium," *New York Times*, July 6, 1941: X10; Gilbert Seldes, "Two Suggestions for Art on TV," *Art in America* 4, no. 47 (1959): 45.

6. The episodes are: "Lucy Becomes a Sculptress" (1953); "Gracie Becomes a Portrait Artist after a Museum Visit" (1955); "Draw Me a Pear" (1965); "Art and the Addams Family" (1964); "Corn Pone Picassos" (1967); "Ed the Artist" (1965).

7. Weaver cited in Robert J. Wade, *Designing for TV: The Arts and Crafts in Television Production* (New York: Pellegrini and Cudahy, 1952), foreword.

8. See, for example, Brian G. Rose, *Television and the Performing Arts: A Handbook and Reference Guide to American Cultural Programming* (New York: Greenwood Press, 1986); William Hawes, *Live Television Drama, 1946–1951* (New York: McFarland and Company, 2001).

9. Although there are excellent histories of the relationship between the film and television industries, there is very little work on the aesthetic relations between cinema and TV. For notable examples, see John Ellis, *Visible Fictions: Cinema, Television, Video* (London: Routledge, 1982); John T. Caldwell, *Televisuality: Style, Crisis, and Authority in American Television* (New Brunswick: Rutgers University Press, 1995); Siegfried Zielinski, *Audiovisions: Cinema and Television as Entr'actes in History* (Amsterdam: Amsterdam University Press, 1999).

10. For studies of British art documentaries and instructional programs, see John A. Walker, *Arts TV: A History of Arts Television in Britain* (Bloomington: Indiana University Press, 2003); and Philip Hayward, ed., *Picture This: Media Representations of Visual Art and Artists*, 2nd ed. (Bedford: University of Luton Press, 2003). For a reference to art documentaries, see Nadine Covert, ed., *Art On Screen: A Directory of Films and Videos about the Visual Arts* (New York: Program for Art and Film, 1991). For pop on TV, see chapter 7.

11. Newton N. Minow, "The Vast Wasteland," address to the thirty-ninth annual convention of the National Association of Broadcasters, Washington, D.C., May 9, 1961. Printed in Newton N. Minow, *Equal Time: The Private Broadcaster and the Public Interest* (New York: Atheneum, 1964), 45–69.

12. T. W. Adorno, "Television and the Patterns of Mass Culture," *Mass Culture: The Popular Arts in America*, ed. Bernard Rosenberg and David White (New York: Free Press, 1965), 482. This is a reprint of the 1961 essay.

13. Cecilia Tichi, *Electronic Hearth: Creating an American Television Culture* (New York: Oxford University Press, 1991), especially chapters 8 and 10.

14. Allen Ginsberg, "Television Was A Baby Crawling toward That Deathchamber," *Planet News, 1961–1967* (San Francisco: City Light Books, 1968), 15–31.

15. McLuhan spoke of TV's hypnotic effects in a 1969 episode of the CBS panel show *Sunday Showcase* (available at the UCLA Film and Television Archive). His comments on the presidency are in Marshall McLuhan, *Understanding Media: The Extensions of Man* (1964; repr., Cambridge, MA: MIT Press, 2001), 336.

16. Discussions of TV and postmodernism especially circulated in the late 1980s and 1990s. For examples see E. Ann Kaplan, *Music Television, Postmodernism and Consumer Culture* (New York: Routledge, 1987); Jim Collins, "Postmodernism and TV," in *Channels of Discourse, Reassembled: Television and Contemporary Criticism,* ed. Robert C. Allen (Chapel Hill: University of North Carolina Press, 1992), 327–53; Lynne Joyrich, "All That Television Allows: Melodrama, Postmodernism, and Consumer Culture," in *Private Screenings: Television and the Female Consumer,* ed. Lynn Spigel and Denise Mann (Minneapolis: University of Minnesota Press, 1992), 227–51; Andrew Goodwin, *Dancing in the Distraction Factory: Music Television and Popular Culture* (Minneapolis: University of Minnesota Press, 1992); Toby Miller, *The Avengers* (London: BFI, 1998), 117–45.

17. David Antin, "Video: The Distinctive Features of the Medium," in *Video Culture: A Critical Investigation,* ed. John G. Hanhardt (1975; repr., Rochester, NY: Peregrine Smith Books, 1986), 148; David Ross, "Truth or Consequences: American Television and Video Art" (1984; repr., Hanhardt, ed., *Video Culture*), 172.

18. Two notable museum exhibits are the "Television's Impact on Contemporary Art" show at the Queens Museum in New York in 1986 and "The New Frontier" exhibit at the Austin Museum of Art in Texas in 2000. For more, see the epilogue.

19. David Joselit, *Feedback: Television against Democracy* (Cambridge, MA: MIT Press, 2007).

20. For modernism's introduction into the U.S., see, for example, Francis M. Nauman, ed., *How, When, and Why Modern Art Came to New York* (Cambridge, MA: MIT Press, 1996), 41–43. For the rise of various American modernisms, see, for example, Daniel Joseph Singal, ed., *Modernist Culture in America* (New York: Wadsworth, 1991); Erika Doss, *Benton, Pollock, and the Politics of Modernism: From Regionalism to Abstract Expressionism* (Chicago: University of Chicago Press, 1991). For a detailed account of the Guggenheim exhibit, see Susan Davidson and Philip Rylands, eds., *Peggy Guggenheim & Fredrick Keisler: The Story of Art of This Century* (New York: Guggenheim Museum, 2004).

21. Clement Greenberg, "Avant-Garde and Kitsch." The essay was first published in the *Partisan Review* (Fall 1939). Reprinted in vol. 1, *Clement Greenberg: The Collected Essays and Criticism: Perceptions and Judgments 1939–1944,* ed. John O'Brian (Chicago: University of Chicago Press), 5–22.

22. Doss, *Benton, Pollock, and the Politics of Modernism.*

23. For more on the rise of American painting during this period see Irving Sandler, *The Triumph of American Painting: A History of Abstract Expressionism* (New York: Praeger, 1970). In chapters 1 and 4, I discuss these cold war era campaigns in more detail.

24. Walter Benjamin, "The Work of Art in the Age of Mechanical Reproduction," *Illuminations,* ed. Hannah Arendt, trans. Harry Zohn (1936; repr., New York: Schocken Books, 1969), 217–52.

25. György Kepes, *The Language of Vision* (Chicago: Paul Theobald, 1944); Laszlo

Moholy-Nagy, *Vision in Motion* (Chicago: Paul Theobald, 1947); Rudolph Arnheim, *Art and Visual Perception* (Berkeley: University of California Press, 1954).

26. William Sener Rusk, "Our New Ways of Seeing," *College Art Journal*, vol. 15, no. 1 (Autumn 1955): 38.

27. John Berger, *Ways of Seeing* (London: BBC and Penguin Books, 1972). The essays in the book refer to Benjamin's earlier theorizations in "The Work of Art."

28. Neil Harris, *Cultural Excursions: Marketing Appetites and Cultural Tastes in Modern America* (Chicago: University of Chicago Press, 1990); Roland Marchand, *Creating the Corporate Soul: The Rise of Public Relations and Corporate Imagery in American Big Business* (Berkeley: University of California Press, 1998); T. J. Jackson Lears, *Fables of Abundance: A Cultural History of Advertising in America* (New York: Basic Books, 1994); Andreas Huyssen, *After the Great Divide: Modernism, Mass Culture, and Postmodernism* (Bloomington: Indiana University Press, 1986); Thomas Crow, *Modern Art in the Common Culture* (New Haven: Yale University Press, 1996); Robert Jenson, *Marketing Modernism in Fin-de-Siècle Europe* (1975; repr., Princeton: Princeton University Press, 1986); Cecile Whiting, *A Taste for Pop: Pop Art, Gender and Consumer Culture* (Cambridge: Cambridge University Press, 1997); Doss, *Benton, Pollock, and the Politics of Modernism*; Michelle Bogart, *Artists, Advertising, and the Borders of Art* (Chicago: University of Chicago Press, 1995).

29. Dr. Frank Stanton, "Commerce, Industry, and the Arts," address delivered to Arts Council of Columbus, Ohio, February 23, 1967, pp. 3, 7. Special Collections, Watson Library, Metropolitan Museum of Art, New York.

30. Christopher Reed, ed., *Not at Home: The Suppression of Domesticity in Modern Art and Architecture* (London: Thames and Hudson, 1996); Crow, *Modern Art in the Common Culture*; Timothy J. Clark, "Jackson Pollock's Abstraction," in *Reconstructing Modernism: Art in New York, Paris, and Montreal, 1945–1964*, ed. Serge Guilbaut (Cambridge, MA: MIT Press, 1995), 172–243; Whiting, *A Taste for Pop*; Dickran Tashjian, *A Boatload of Madmen: Surrealism and the American Avant-Garde, 1920–1950* (London: Thames and Hudson, 2001).

31. For more on educational broadcasting and the politics of taste, see Laurie Ouellette, *Viewers Like You: How Public Television Failed the People* (New York: Columbia University Press, 2002).

32. Janice A. Radway, *A Feeling for Books: The Book-of-the-Month Club, Literary Taste, and Middle-Class Desire* (Chapel Hill: University of North Carolina Press, 1997); Joan Shelley Rubin, *The Making of Middlebrow Culture* (Chapel Hill: University of North Carolina Press, 1992), 266–329. On the formations of taste cultures, also see Michael Kammen, *American Culture, American Tastes: Social Change and the 20th Century* (New York: Alfred Knopf, 1999); Herbert Gans, *Popular Culture and High Culture: An Analysis of the Evaluation of Taste* (New York: Basic Books, 1999).

33. Dwight MacDonald, "Masscult and Midcult," *Against the American Grain: Essays on the Effects of Mass Culture* (1960; repr., New York: Random House, 1962), chapter 1.

34. Russell Lynes, "Highbrow, Lowbrow, Middlebrow," *Harper's Magazine*, February 1949; reprinted in *Life*, April 11, 1949, 100–101; Ashley Montagu, *The Cultured Man* (New York: Perma Books, 1959).

35. See, for example, Cecil Smith, "Every TV Set Owner Is a Critic and Rightly So,

But—," *Los Angeles Times*, July 6, 1954: 28; Walter Ames, "Producer Says TV Snobs Look 'Out Window' When Good Shows Arrive," *Los Angles Times*, March 23, 1954: 22.

36. Caldwell, *Televisuality*.

CHAPTER 1

1. Russell Lynes sums up popular responses to the Armory Show in "Whirlwind on Twenty-Sixth Street," in *The Tastemakers* (New York: Harper and Brothers, 1955), 208–22. For more, see Martin Green, *New York 1913: The Armory Show and the Patterson Strike Pageant* (New York: Collier Books, 1988), especially chap. 6; Nauman, *How, When, and Why Modern Art Came to New York*.

2. For discussions of painting in fiction films see Diane Waldman, "The Childish, the Insane, and the Ugly: The Representation of Modern Art in Popular Films and Fiction of the '40s." *Wide Angle* 5, no. 2 (1982): 52–65; Angela Dalle Vacche, *Cinema and Painting: How Art Is Used in Film* (Austin: University of Texas Press, 1996), 13–42; Robert Rosen, "Notes on Film and Painting," *Hall of Mirrors: Art and Film since 1945*, in ed. Russell Ferguson (New York: Monacelli Press, 1996), 245–61; Philip Hayward, ed., *Picture This*; Susan Felleman, *Art in the Cinematic Imagination* (Austin: University of Texas Press, 2006).

3. Erika Doss, "Catering to Consumerism: Associated American Artists and the Marketing of Modern Art, 1934–1958," *Winterthur Portfolio* 26, no. 2/3 (Summer–Autumn 1991): 143–67.

4. Serge Guilbaut, *How New York Stole the Idea of Modern Art: Abstract Expressionism, Freedom, and the Cold War*, trans. Arthur Goldhammer (Chicago: University of Chicago Press, 1983), 91.

5. Stanford Research Institute, "Long Range Planning Service," 1962, 2, papers of August Heckscher, White House Staff Files, 1962–63, John Fitzgerald Kennedy Library, Boston, Massachusetts (hereafter referred to as the JFK Library).

6. Ibid., 4. Diane Crane states that the "number of [New York] art galleries handling twentieth-century American art was more than three times as great in 1977 as in 1949, almost two-thirds of these originating in the 1960s." Diana Crane, *The Transformation of the Avant-Garde: The New York Art World, 1940–1985* (Chicago: University of Chicago Press, 1989), 5.

7. Dore Asiton, "From Chromos to Masterpieces," *New York Times*, March 30, 1958: sec. II, 3.

8. Karal Ann Marling, *As Seen on TV: The Visual Culture of Everyday Life in the 1950s* (Cambridge, MA: Harvard University Press, 1994), 59. As Marling observes, television's favorite family, Ozzie, Harriet, David, and Ricky Nelson, served as product spokespeople for Picture Craft paint-by-number kits. Also see William L. Bird, *Paint By Number* (Princeton: Princeton Architectural Press, 2001). Note that most of the paint-by-number sets were realistic paintings of landscapes, animals, and the like.

9. James Thrall Soby, "Art on TV," *Saturday Review*, April 13, 1957, 29.

10. *TV Guide*, February 4–10, 1957.

11. By using the term "poach" here I am invoking Michel de Certeau's theory of everyday life in relation to "tactical" appropriations of consumer society (*The Practice of Everyday Life*, trans. Steven Rendall (Berkeley: University of California Press, 1984). In

that book, de Certeau sees "poaching" as a tactic through which people experience their lives in modern consumer societies. Even while confronted with highly mass processed and mediated forms, people can still make their own experience. Using the metaphor of the supermarket, de Certeau argues that while the market presents shoppers with mass-produced goods, people can still make their own meal. In this sense, I use the phrase "everyday modernism" to capture this sense of tactical poaching in which people could steal from a variety of artistic and decorative orthodoxies to create their own more eclectic sense of style.

12. The WPA was established in 1935 and later renamed Work Projects Administration.

13. Crane, *The Transformation of the Avant-Garde*, 9; Guilbaut, *How New York Stole the Idea of Modern Art*, 55–58.

14. These remarks are from the *New York Herald Tribune* and cited in Russell Lynes, *Good Old Modern: An Intimate Portrait of the Museum of Modern Art* (New York: Antheum, 1973), 236–37. Also see Guilbaut, *How New York Stole the Idea of Modern Art*, 88–89; and Peter DeCherney, *Hollywood and the Culture Elite: How the Movies Became American* (New York: Columbia University Press, 2005), especially chapter 5 on MoMA.

15. Marling, *As Seen on TV*, 64–68.

16. Erika Doss, "The Visual Arts in Post-1945 America," in *A Companion to Post-1945 America*, ed. John-Christophe Agnew and Roy Rosensweig (London: Blackwell, 2002), 113.

17. Guilbaut, *How New York Stole the Idea of Modern Art*, 55.

18. William J. Lederer coined the term "the ugly American" in his book of that title (New York: W. W. Norton & Company, 1958). I am using it to cover the concept that prevailed at the time, but the term itself was not in popular circulation during much of the period.

19. Guilbaut, *How New York Stole the Idea of Modern Art*. Also see Frances Stoner Saunders, *The Cultural Cold War: The CIA and the World of Arts and Letters* (New York: New Press, 1999), 252–78.

20. Eva Cockcroft, "Abstract Expressionism, Weapon of the Cold War," in *Pollock and After: The Critical Debate*, ed. Francis Frascina (New York: Harper and Row, 1985), 125–33; Saunders, *The Cultural Cold War*, 252–78.

21. Dondero cited in Cockcroft, "Abstract Expressionism, Weapon of the Cold War," 130. For more see Gilbaut, *How New York Stole the Idea of Modern Art*; Marling, *As Seen on TV*, chapter 2; Saunders, *The Cultural Cold War*, 252–53.

22. Harry S. Truman cited in Saunders, *The Cultural Cold War*, 252.

23. Saunders, *The Cultural Cold War*, 253.

24. Greenberg, "Avant-Garde and Kitsch."

25. Meyer Schapiro, "The Liberating Quality of the American Avant-Garde," *Artnews* 56 (Summer 1957): 38.

26. Jennifer Way, "In Due Course Themselves Advertisements? Painterly Abstract Painting and Discourses of Consumer Culture in the 1950s," *Journal for Cultural Research* 7 (2003): 6. See also Marcia Brennen, *Modernism's Masculine Subjects: Matisse, the New York School, and Post-Painterly Abstract Expressionism* (Cambridge, MA: MIT, 2004), 42–45; Doss, *Benton, Pollock, and the Politics of Modernism*.

27. Doss, *Benton, Pollock, and the Politics of Modernism*, 392–403. For the Pollock story see *Life*, August 8, 1949.

28. For European attitudes toward American art and popular culture during this period see Reinhold Wagnleitner and Elaine Tyler May, eds., *Here, There, and Everywhere: The Foreign Politics of American Popular Culture* (University Press of New England, 2000); Reinhold Wagnleitner, *Coca-Colonization and the Cold War: The Cultural Mission of the United States in Austria after the Second World War* (Chapel Hill: University of North Carolina Press, 1994); Richard H. Pells, *Not Like Us: How Europeans Have Loved, Hated and Transformed American Culture since World War II* (New York: Basic Books, 1998); Richard F. Kuisel, *Seducing the French: The Dilemma of Americanization* (Berkeley: University of California Press, 1997).

29. Katherine Kuh, "The Unhappy Marriage of Art and TV," *Saturday Review*, January 21, 1961, 61.

30. Vance Kepley, "From 'Frontal Lobes' to the 'Bob-and-Bob' Show: NBC Management and Programming Strategies, 1949–1965," in *Hollywood in the Age of Television*, ed. Tino Balio (Boston: Unwin Hyman, 1990), 41–61. See also Pamela Wilson, "NBC Television's Operation Frontal Lobes: Cultural History and Fifties Program Planning," *Historical Journal of Film, Radio, and Television* 15, no.1 (1995): 83–104; William Boddy, "'Operation Frontal Lobes' versus the Living Room Toy," *Media, Culture and Society* 9, no.3 (1987): 347–68.

31. For examples of these ads, see the following issues of *Sponsor*: May 4, 1953, 54; February 21, 1955, inside cover; February 6, 1956, 16–17; October 30, 1961, 15; April 16, 1962, 15; August 26, 1963, 3; December 12, 1966, back cover.

32. American Broadcasting Company, "Report on 1948," 12–13. Special Collections, Performance Arts Library, New York Public Library. These annual reports were directed at business clients.

33. In the 1950s, public-affairs shows that discussed modern art were typically produced or co-produced by museums, and even these usually focused on European artists rather than the abstract expressionists.

34. Note that while Castro would have been conceived as "foreign" and a revolutionary rebel, and while his relationship to the U.S. was troubled, he was not yet at this point widely seen as an enemy to America.

35. Marling, *As Seen on TV*, 76–77. For her detailed study of Moses, see Karal Ann Marling, *Designs on the Heart: The Homemade Art of Grandma Moses* (Cambridge, MA: Harvard University Press, 2006).

36. For a discussion of African American jazz in Paris since the twenties, see Tyler Stovall, *Paris Noir: African Americans in the City of Light* (Boston: Houghton Mifflin, 1996).

37. See Frank Kofsky, *Black Nationalism and the Revolution in Music* (New York: Pathfinder, 1970), 109–11; Andrew Ross, "Hip and the Long Front of Color," *No Respect: Intellectuals and Popular Culture* (New York: Routledge, 1989), 79.

38. Penny M. Von Eschen, *Satchmo Blows Up the World: Jazz Ambassadors Play the Cold War* (Cambridge, MA: Harvard University Press, 2004), 20, 28. See also Kofsky, *Black Nationalism and the Revolution in Music*, 109–11; Ross, "Hip and the Long Front of

Color"; Ingrid Monson, *Freedom Sounds: Civil Rights Call Out to Jazz and Africa* (New York: Oxford University Press, 2007). For Paul Gilroy on black modernism and music, see his *The Black Atlantic: Modernity and Double Consciousness* (Cambridge, MA: Harvard, 1993).

39. Ibid., 15; and "CBS Stations to Produce One-Hour TV Jazz Show," *Down Beat*, April 25, 1963, 16.

40. For example, in 1964 *Jazz Scene USA* was popular in France, Spain, Italy, Portugal, Finland, Sweden, Germany, Holland, Denmark, Singapore, Kenya, the Sudan, and New Zealand. "Jazz On Television," *International Musician*, June 1964, 14.

41. Spigel, *Make Room for TV: Television and Family Ideal in Postwar America* (Chicago: University of Chicago Press, 1992), 112.

42. Lisa Parks, "As the Earth Spins: *Wide Wide World* and Early Global Television," *Screen* 42, no. 4 (2001): 343.

43. Ernest Dichter, "Taste," *Art Direction* 9, vol. 10 (January 1958): 62.

44. The set for *Omnibus* was constructed to look like a gallery with Cooke as a museum curator of sorts. Cooke introduced each show by pointing to still images from the night's segments that literally "hung" in frames on the studio wall, and the camera zoomed in to offer a preview of each.

45. Alistair Cooke paraphrased in Thomas M. Jones, "Omnibus—a Unique Experiment in TV Programming," *Printers' Ink*, July 3, 1953, 32.

46. Doss, *Benton, Pollock, and the Politics of Modernism*, 205–19.

47. A tape of this is available at the JFK Library. This cultural alliance between France and the U.S. was also prevalent in popular culture. In her study of what she calls "cosmopolitan film culture," Vanessa R. Schwartz examines the zeal for "Frenchness" and French art films like *Gigi* (1958) and the various collaborations and cultural exchanges between the U.S. and France in the 1950s and 1960s. See *It's So French: Hollywood, Paris, and the Making of Cosmopolitan Film Culture* (Chicago: University of Chicago Press, 2007).

48. James A. Abbot and Elaine M. Rice, *Designing Camelot: The Kennedy White House Restoration* (New York: International Thompson Publishing Company, 1998).

49. With one out of every three homes tuned to the program, the *Tour* (which aired simultaneously on CBS and NBC) was a huge popular success. ABC did not run the *Tour,* opting instead to feature its police show, *Naked City*. See Jack Gould, "Mrs. Kennedy TV Hostess to the Nation," *New York Times*, February 15, 1962, 18.

50. Although it now appears to be an entirely contrived performance, critics enthusiastically praised Jackie as a "natural" for TV. See ibid.; and "That TV Tour," *Newsweek*, February 26, 1962, 23–24. When Lady Bird Johnson took over as first lady, she also starred in a TV special titled *Paintings in the Whitehouse: A Close-Up.*

51. Soby, "Art on TV," 29.

52. Ibid.

53. Philip Wylie, *A Generation of Vipers* (New York: Holt, Rinehart and Winston, 1955).

54. Ibid., 215.

55. Ibid.

56. Huyssen, *After the Great Divide*, chapter 3.

57. It is interesting to note in this regard that television art plots portrayed women in much the same vein that Ann Gibson argues was central to abstract expressionist paint-

ings of the era. According to Gibson, "Two of the principle roles that these Abstract Expressionists gave women in art works were those of the 'devouring mother' and the femme fatale." She points, for example, to de Kooning's "Woman" series of the early 1950s and David Smith's *Spectre of Mother* (1946). Ann Eden Gibson, *Abstract Expressionism: Other Politics* (New Haven: Yale University Press, 1997), 51.

58. For discussions of the macho image of abstract expressionists and/or their defense against homosexuality, see Marcia Brennan, *Modernism's Masculine Subjects: Matisse, the New York School, and Post-Painterly Abstract Expressionism* (Cambridge, MA: MIT, 2004); Michael Lega, "Reframing Abstract Expressionism: Gender and Subjectivity," in *Pollock and After: The Critical Debate*, 2nd ed., ed. Francis Frascina (New York: Harper and Row, 2000), 348–60; Kelly M. Cresap, *Pop Trickster Fool: Andy Warhol Performs Naiveté* (Champaign and Urbana: University of Illinois Press, 2004), see especially chapter 1, "New York School's Out."; Kenneth E. Silver, "Master Bedrooms, Master Narratives: Home, Homosexuality and Post-War Art," in *Not at Home: The Suppression of Domesticity in Modern Art and Architecture*, ed. Christopher Reed (London: Thames and Hudson, 1996): 206–22; Saunders, *The Cultural Cold War*, 254–55; Gibson, *Abstract Expressionism*. As Gibson argues, the image of the abstract expressionist artist as a white, heterosexual, super-masculine type helped to marginalize the abstract work being done at the time by women and artists of color while naturalizing a narrowly defined cannon composed of an "essential eight" men of white European descent (Adolph Gottlieb, de Kooning, Motherwell, Barnett Newman, Pollock, Ad Reinhardt, Rothko, and Clyfford Still). Even if these canonical artists (in their personal lives) did not exactly fit the macho image they were assigned, the reigning stereotype upheld an image of the American abstract expressionist artist as a quintessentially white, heterosexual, and virile man of action.

59. Michael Rogin discusses the links between communism and momism in American film of this period. See his *Ronald Reagan, The Movie: And Other Episodes in Political Demonology* (Berkeley: University of California Press, 1987), 236–71.

60. See *The Twilight Zone*, "The Midnight Sun, " (1961); *One Step Beyond*, "The Open Window" (1959); and the *Thriller* episode discussed in the text. Between 1970–73, NBC's *Night Gallery* featured host Rod Serling introducing the program while standing in a gallery with fright-provoking paintings that foreshadowed the evening's themes.

61. Such programs were family friendly versions of lurid pulp fiction paperbacks that told stories about wayward women who worked as artist's models. See, for example, Clement Wood, *Studio Affair* (New York: Beacon Books, 1951); Warwick Scott, *Naked Canvas* (New York: Popular Library, 1955); Louis Richard, *Artist's Woman* (New York: Beacon-Signal Books, 1963).

62. Stephen Heath, "Narrative Space," *Questions of Cinema* (Bloomington: Indiana University Press, 1985), 19–75.

63. The title art for *Thriller* is composed of animated abstract shapes.

64. See Spigel, *Make Room for TV*.

65. Although Warhol claims that he got his idea for his cow wallpaper from art dealer Ivan Karp, given the persistence of this vaudeville joke, it does seem possible that Warhol was (either intentionally or not) reenacting the traditional rube stereotype in his deadpan pop style.

66. William Boddy, *Fifties Television: The Industry and Its Critics* (Urbana: University

of Illinois Press, 1990); Robert Vianello, "The Rise of the Telefilm and the Networks' Hegemony over the Motion Picture Industry," *Quarterly Review of Film Studies* 9 (Summer 1984): 204–18; Spigel, *Make Room for TV*.

67. Clement Greenberg, "Contribution to a Symposium," *Art Digest* (1953). Reprinted in his *Art and Culture* (Boston: Beacon Press, 1961), 124–26.

68. Brennan, *Modernism's Masculine Subjects*, 40.

69. Ibid., 52–53. In this passage, Brennan is speaking about responses to de Kooning. For Motherwell as well as other artists and critics on this same issue, see David Craven, "Abstract Expressionism, Automatism, and the Age of Automation," in Frascina, *Pollock and After*, 324–60.

70. "Dinah Shore's TV Art," *Look*, December 15, 1953, 44–46. Later in the decade Dinah Shore presented artworks by famous entertainers. In fact, in the same episode featuring Clem "the painter," Skelton thanked Shore for featuring his own paintings on her show. Note that the musical variety modern painting theme continued in the 1960s with shows like *Jimmy Durante Meets the Lively Arts* (ABC, 1965); *The Bell Telephone Hour* ("Masterpieces and Music," NBC, 1966); and *ABC's Stage '67* ("C'est La Vie," ABC, 1967).

71. There is very little discussion of set design in histories of U.S. TV of this period, and that which exists has focused on realist drama rather than variety shows. In his analysis of live anthology dramas, Kenneth Hay claims that the shows targeted centrist tastes and typically had the realistic, naturalistic set designs of the right-wing theater. Kenneth Hey, "*Marty*: Aesthetics vs. Medium," in *American History/American Television*, ed. John E. O'Conner (New York: Fredrick Unger, 1983), 95–133. However, the abstract sets used on variety shows of the period suggest that audiences were seeing a much more eclectic mix of styles than just realism and naturalism. For British dramas, see John Caughie, *Television Drama* (Oxford: Oxford University Press, 2000); Jason Jacobs, *The Intimate Screen* (London: Oxford University Press, 2000).

72. Wade, *Designing for TV*, 112. Wade's exact title at NBC during this period was executive coordinator of production development.

73. Wade (*Designing for TV*, 68) also noted the influence of German expressionist set design. Wade further discussed staging and set design in Robert J. Wade, *Staging TV Programs and Commercials: How to Plan and Execute Sets, Props, and Production Facilities* (New York: Hastings House, 1954).

74. Harriet Van Horne, "The Living Theatre on Television," *Theatre Arts*, September 1951, 53.

75. Wade, *Designing for TV*, 74.

76. Jack Gould, "TV: Fred Astaire Debut," *New York Times*, October 18, 1958, 43; Richard F. Shepard, "Astaire Wins 9 Emmy Awards For TV Show," *New York Times*, May 7, 1959, 67; "Fred Astaire 'Dazed' by Winning 9 Emmys," *Los Angeles Times*, May 8, 1959, B1; http://www.emmys.org/awards/archive/index.php.

77. J. Fred MacDonald, *Blacks and White TV: African Americans in Television Since 1948* (Chicago: Nelson Hall, 1983) and Donald Bogle, *Primetime Blues: African Americans on Network Television* (New York: Farrar, Straus and Giroux, 2002). See also Melvin Patrick Ely, *The Adventures of Amos 'n' Andy: A Social History of an American Phenomenon* (New York: Free Press, 1991).

78. Mr. Harper, "Lively (For Once) Art," *Harper's Magazine*, February 1958, 81–82.

79. Ibid.

80. See, for example, "Jazz On Television," *International Musician*, June 1964, 14. In the 1960s, jazz shows even had camera people improvise special visual effects in sync with the beat. In 1962 the Los Angeles ABC affiliate station ran *The Lively Ones*, which used offbeat audio-visual devices as transitions between jazz acts. Similarly, between 1964 and 1966 the Boston station WGBH ran *Jazz Images*, in which the production crew flipped video control switches to the beat of the live jazz performances in the studio.

81. The shooting script for "The Art of Ellington!" was prepared by Fred Price Productions and is dated May 3, 1963, and in the Duke Ellington Collection, Collection #301, Subseries 4C: Broadcasts, box 12, folder 35. Archives Center, Smithsonian National Museum of American History, Washington, D.C. (hereafter referred to as the Ellington Collection).

82. In airing Ellington's program, CBS and United States Steel were likely cognizant of a previous NBC program "Manhattan Towers," a ninety-minute colorcast musical revue that was based on composer Gordon Jenkins's musical composition and hit record of the same name. The October 27, 1956, episode of the NBC series *Saturday Spectacular*, "Manhattan Towers," featured a mostly white cast including Phil Silvers and Helen O'Connell, and it was modeled on the Broadway revue format, but the *Chicago Defender* praised it for featuring blues/jazz singer Ethel Waters. See "Ethel Waters on TV Socko," *Chicago Defender* (daily edition), November 27, 1956, 14. See also, "Three Join Cast of Spectacular Special," *New York Times*, October 5, 1956, 36; Jack Gould, "TV: 'Born Yesterday,'" *New York Times*, October 29, 1956, 55.

83. Columbia Records even issued a special promotional 45 rpm recording and, with U.S. Steel, underwrote a radio-station contest for the best letter explaining why a drum is like a woman (the prize was a set of bongo drums). "Special Promotion Featuring Interview with Duke Ellington Given to Radio Disc Jockeys, Special Tie-ins," Company Report, Ellington Collection, Subseries 4B: Scripts, box 4, folder 13. A few months before the program aired, Edward R. Murrow's *Person to Person* featured Ellington in his elegantly appointed Upper East Side brownstone, talking about the upcoming broadcast. Chatting with Murrow while retiring in his den, complete with a new hi-fi console and midcentury modern décor, Ellington promoted "Drum" while also drawing the viewer's attention to his paintings (including his own painting *Satin Doll*, a portrait of an African woman, rendered in a modern "primitive" style).

84. Although Ellington wrote and composed music, he worked with scriptwriter Will Lorin, who adapted the original music for television.

85. In 1943 Ellington became the first African American jazz artist to headline a concert in Carnegie Hall.

86. Ellington cited in J. P. Shanley, "Restless Music Man," *New York Times*, May 5, 1957, 141. For more, see Jack Gould, "Jazz Fantasy, 'A Drum Is a Woman,' Staged," *New York Times*, May 9, 1957, 48.

87. Beatty also appeared in films, including experimental filmmaker's Maya Deren's *Study in Choreography for the Camera* (1945).

88. "Drum" was adapted for television by Will Lorin, but Ellington was involved with the script adaptation as well. Norman Felton (who also directed prestige dramas) was director. Paul Godkin (who had recently choreographed *Around the World in Eighty Days)* was choreographer.

89. Duke Ellington's "A Drum Is a Woman," revised script, April 12, 1957, Act I, p. 4,

Ellington Collection, Subseries 4B: Scripts, box 4, folder 8. A black-and-white kinescope of the actual broadcast is housed in the Paley Center for Media.

90. "A Drum Is a Woman," revised script, April 12, 1957, Act II, p. 12.

91. This review was in *Time*, May 20, 1957, and cited "U.S. Steel Hour Advertising and Promotion, A Drum Is a Woman, The Critics Said," Ellington Collection, Subseries 4B: Scripts, box 4, folder 3.

92. The finale (set in outer space) is especially erotic, as an exotically outfitted Madame Zajj seductively implores Joe: "Come with me to my Emerald Rock Garden just off the moon where darkness is only a translucency. Come climb with me to the top of my tree where the fruit is ripe and the taste is like the sky. Star rubies are budding in my diamond-encrusted hothouse."

93. Von Eschen, *Satchmo Blows Up the World*, 121–47.

94. Gilroy, *The Black Atlantic*; Graham Locke, *Blutopia* (Durham, NC: Duke University Press, 1999).

95. "A Drum Is a Woman," undated script draft, p. 6, Ellington Collection, Subseries 4B: Scripts, box 4, folder 9. See also "A Drum Is a Woman," revised script, April 12, 1957, Act III, p. 3, Ellington Collection, Subseries 4B: Scripts, box 4, folder 8.

96. These comments came from critics for the *Knickerbocker News*, Albany, NY; *Columbus Citizen*, OH; *Detroit Times*; *Time*; *San Francisco Examiner*; *New York Herald Tribune*; *Concord Transcript*, CA; and *Lowell Sun*, MA. All cited in "U.S. Steel Hour Advertising and Promotion, A Drum Is a Woman, The Critics Said."

97. "Leaders Praise Ellington's TV," *Chicago Defender* (daily edition), May 28, 1957, 17; Rob Roy, "Duke's 'A Drum Is A Woman' Has TV Merit—But," *Chicago Defender* (national edition), May 18, 1957, 8.

98. As one critic put it, "The thought kept plaguing me that maybe television now is spreading the unsophisticated philosophy that a woman should be beaten regularly—like a drum." See Anthony LaCamera, "Ellington Explains Show Title," *Boston American*, May 3, 1957. In Ellington Collection, Scrapbook vol. 15, microfilm roll 3, May 4, 1955–November 27, 1958. Confronted with complaints about the wife-beating connotations, Ellington said "Drum" was an allegory for the musician's love of his craft—a love deeper than romantic love itself. As he put it, "You often hear . . . of musicians who hand out dough to the girl and say, 'Get lost honey. I want to spend time with the instrument.'" Ellington cited in Bill Ladd, "Is Duke a Musician—A Playwright—or Both?" *Louisville Courier Journal*, May 2, 1957. In Ellington Collection, Scrapbook vol. 15, microfilm roll 3, May 4, 1955–November 27, 1958.

99. In July 1957, CBS radio presented the broadcast premiere of Ellington's orchestral suite "Such Sweet Thunder." See "New Ellington Suite Hailed By Coast-To-Coast Audience," *Chicago Defender* (daily edition), July 2, 1957, 18.

100. For an analysis of *Playboy's Penthouse*, see Ethan Thompson, "What, Me Subversive? Television and Parody in Postwar America" (Ph.D. diss., University of Southern California, 2004).

101. As Andrew Ross argues, by connecting "cool" with black cultural styles, and especially the concept of black authenticity and sexual potency, Mailer's essay described a new kind of hip persona for white men (like the Beats) who identified with black cultural styles—especially bebop—in their search for nonconformist, "authentic" lifestyles.

Andrew Ross, "Hip and the Long Front of Color," 83–89. See also Lewis MacAdams, *Birth of Cool: Beat, Be-bop, and the American Avant-Garde* (New York: Free Press, 2001).

102. One jazz critic dubbed Allen "The best friend jazz has on TV." "Steve Allen . . . Friend of Jazz," *International Musician*, January 1963, 18. Allen produced *Jazz Scene: USA*, which catered to specialized tastes and was exported abroad. See ibid. and "TV Comes Alive with Summer Jazz," *Down Beat* 29, no. 20, July 19, 1962, 15.

103. David Sterritt, *Mad to Be Saved: The Beats, the '50s, and Film* (Carbondale: Southern Illinois University Press, 1998); David Sterritt, *Screening the Beats: Media Culture and the Beat Sensibility* (Carbondale: Southern Illinois University Press, 2004).

104. Larry Wolters, "TV Goes All Out on Beatniks," *Chicago Tribune*, November 19, 1959, G12. *The Many Loves of Dobie Gillis* (CBS) was famous for its beatnik character Maynard G. Krebs, and *Route 66* (CBS) also popularized the Beat road story (so much so that Kerouac tried to sue the producers). For more discussion of Beats and TV, see Katie Mills, *The Road Story and the Rebel: Moving Through Film, Television, and Fiction* (Carbondale: Southern Illinois University Press: 2006), 64–83.

105. Daniel Belgrad, *The Culture of Spontaneity: Improvisation and the Arts in Postwar America* (Chicago: University of Chicago Press, 1998), 197.

106. On this show Allen promotes the new jazz album that he and Kerouac just produced.

107. After the commercial, a final "road story" ensues in the form of a gospel number titled "To Make a Solid Road," performed by Frankie Lane and an all-black chorus.

108. Coiner cited in Carl Spiel Vogel, "Advertising: Use of Fine Arts Increasing," *New York Times*, April 13, 1958, F10. For historical studies of the use of art in advertising, see Bogart, *Artists, Advertising, and the Borders of Art*; Marchand, *Advertising the American Dream: Making Way for Modernity, 1920–1940* (Berkeley: University of California Press, 1985); Marchand, *Creating the Corporate Soul*; Lears, *Fables of Abundance*; Susan G. Josephson, *From Idolatry to Advertising: Visual Art and Contemporary Culture* (Armonk, NY: M. E. Sharpe, 1996); Doss, *Benton, Pollock, and the Politics of Modernism*.

109. See, for example, Howard H. Fogal, "Design vs. Research," *Art Direction* 9, no. 6 (September 1957): 68–70. For more, see chapter 2.

110. Paul Rand, *Thoughts on Design* (1947; repr. and rev. ed., London: Van Nostrand Reinhold, 1970). For a discussion of Rand's use of modern techniques, see Richard Hollis, *Graphic Design: A Concise History* (London: Tames and Hudson, 1994), 112–13; Jessica Helfand, *Paul Rand: American Modernist* (New York: William Drenttel Editions, 1998); Franc Nunoo-Quarcoo, *Paul Rand: Modernist Designer* (Baltimore: University of Maryland Press, 2003).

111. Hal Zamboni, "Influence of Modern Art on Design and Typography," *Advertising and Selling*, February 1948: 39–91. Also see Egbert Jacobson, "Modern Art: Its Influences on Today's Graphic Designers," *Print* 12:3 (November/December 1958): 50–53. Although advertising artists copied elements of abstract art, abstract expressionist paintings were not often used as source material in ads. *Art Direction* noted in 1956 that the "extreme emotional intensity of Abstract Expressionism precludes its being used to any extent for advertising, editorial, and reporting purposes." "Abstract Expressionism and Communication Design," *Art Direction* 9, no.10 (January 1958): 71.

112. "1937–1957: A Contrast in Consumer Ads," *Art Direction* 9, no. 10 (January 1958):

76. For historical analysis of the big picture ad, see Maud Lavin, *Clean New World: Culture, Politics, and Graphic Design* (Cambridge, MA: MIT Press, 2002); Hollis, *Graphic Design*, 112–29; Richard Horn, *Fifties Style: Then and Now* (New York: Michael Friedman Publishing, 1985), 38–59.

113. Pierre Martineau, "Words Becoming Less Important, Symbolism More Important in Advertising," *Advertising Age*, March 26, 1956, 99–103.

114. Ibid.

115. Andrew Armstrong, "There is an Accounting for Taste," *Art Direction* 8, no. 8 (November 1956): 66.

116. Janet L. Wolff, *What Makes Women Buy: A Guide to Understanding and Influencing the New Woman of Today* (New York: McGraw Hill, 1958), 254.

117. Stephen Baker, *Visual Persuasion: The Effect of Pictures on the Subconscious* (New York: McGraw-Hill, 1961), chapter 7.

118. Penny Sparke, *As Long as It's Pink: The Sexual Politics of Taste* (New York: Pandora, 1995).

119. Barbara Kaye, "Aimed Design," *Art Direction* 9, no. 7 (October 1957): 45. "Mondrian Layouts are Easy!" *Printers' Ink*, April 16, 1954, 44–46; "Mondrian Layouts Multiply," *Printers' Ink*, May 28, 1954, 34–35. At the 1956 Visual Communications Conference, Dr. M. F. Agha (a pioneer of modern design) said the "Mondrian influence" had become a "graphic arts gimmick," and he implored fellow artists to avoid it along with the equally gimmicky imitations of Hans Arp's "floating kidney," Max Ernst's antique collages, and the "buckeyed monster . . . à la Picasso." Dr. M. F. Agha cited in "Visual Communications Conference," *Art Direction* 8, no. 4 (July 1956): 49–50.

120. A. W. Lewin cited in "Lewin Tilts with 'Be-Bop' School of Advertising," *Advertising Age*, May 21, 1956, 42. For more debates about modern art in ads see Richard S. Chenault, "Believable Illustration Attracts More Readers," *Advertising & Selling*, June 1948, 38, 119; Frank Baker, "Art and the Advertising Business," *Advertising & Selling*, March 1951, 79; "A Taste for Taste," *Art Direction* 9, no. 4 (July 1957): 58–63; Everard W. Meade, "Will the Mona Lisa Sell Soap?" *Art Direction* 9, no. 6 (September 1957): 58–60; Alvin A. Beckerman, "Psycho-Sell," *Art Direction* 10, no. 7 (October 1958): 49–51. For a historical discussion of graphic designers using modern art techniques in the 1940s and 1950s see Ellen Lupton and Abbot Miller, *Design, Writing Research* (New York: Phaedon, 1996), 82–84.

121. Lester Rossin, "How Agencies Use Art," *Advertising and Selling*, May 1950, 60.

122. Lester Rondell, editorial, *Annual of Advertising and Editorial Art*, 28th annual committee, New York: Pitman Publishing, 1949, n.p.

123. "Abstract Expressionism and Communication Design," 71.

124. Wolff, *What Makes Women Buy*, 55, 57; "How an Art Director Can Get a Woman Interested," *Printers' Ink*, November 30, 1956, 26.

125. For more on women, design, and commercials, see chapter 6.

126. Jones, "Omnibus," 39.

127. "Chicago's Jim Brown—Commercial Experimenter, 1937–1957," *Art Direction* 9, no. 10 (January 1958): 80.

128. For an overview of 1950s animation companies that specialized in modern design and produced commercials featuring it, see Amid Amidi, *Cartoon Modern: Style and Design in Fifties Animation* (San Francisco: Chronicle Books, 2006).

129. "Selling with a Smile," *Art Direction* 7, no. 12 (March 1956): 49.

130. Bosley Crowther, "McBoing Boing, Magoo and Bosustow," *New York Times*, December 21, 1952, SM14; Aline B. Louchheim, "Cartoons as Art," *New York Times*, August 23, 1953, X8.

131. "Selling with a Smile," 48–51.

132. "Industrial Technique," *Printers' Ink*, April 5, 1957, 27.

133. Ibid. The Esso ad was most likely produced by Elektra Films.

134. For one of his independent films, Storyboard's founder John Hubley (who designed the "Bop Corn" commercial) even hired Dizzy Gillespie to make a humorous short mocking the advertising industry's exploitation of jazz. Titled "A Date with Dizzy," the 1956 film shows Gillespie and his band scoring an animated "pencil test" for a commercial, but the sponsor doesn't like Dizzy's music and makes him watch commercials like the E-Z Bop spot to get the hang of scoring ads. "A Date with Dizzy" is available on YouTube.

135. Not all advertisers were convinced that abstract animation appealed to average consumers. For example, Bob Foreman, the vice president in charge of television and radio at BBDO, said: "I have noticed in recent months a tendency among storyboard artists . . . to create animation of a decidedly 'moderne' school. I refer to what may be best described as the McBoing Boing technique. It's an ultra-bizarre type of drawing which leans more heavily on the *New Yorker* than it does on Disney. . . . It is my belief that this style of animation, in contrast to the more traditional, is way over the heads of the TV audience." Bob Foreman, *An Adman Ad-Libs on TV* (New York: Hastings House, 1957), 66.

136. Museum curator James Johnson Sweeney produced and coauthored the film. Hubley's wife, Faith, who often worked with him, also worked on the film. The film was completed in 1957. See Amidi, *Cartoon Modern*, 99.

137. Aline B. Louchheim, " Cubism and Futurism," *New York Times*, August 17, 1952, X8.

138. Martineau cited in "A Taste for Taste," 60.

139. Cohen, *A Consumer's Republic.*

140. Rossin, Dichter, Exner, Margulies, and Lippincott cited in "Taste," 53–54, 55, 56, 62. For more on *Home*, see Marsha F. Cassidy, *What Women Watched: Daytime Television in the 1950s* (Austin: University of Texas Press, 2005), chapter 6; Spigel, *Make Room for TV*, 81–85.

CHAPTER 2

1. The original designs are housed in the William Golden Collection, Rochester Institute of Technology, Rochester, NY (hereafter referred to as the Golden Collection). Unless otherwise indicated, examples of the CBS advertisements and publicity materials discussed in this chapter are also reprinted in Pineles Golden, Kurt Weihs, and Robert Strunsky, eds., *The Visual Craft of William Golden* (New York: George Braziller, Inc., 1962). For newspaper layouts and ad design for all three networks, I looked at over 1,000 ads in the *New York Times*, the *Chicago Tribune*, and the *Los Angeles Times* from 1948–70.

2. Strand achieved his status in the New York City art world through films like *Manhatta* (1921) and major exposure as a documentary filmmaker in the 1930s (making *The Plow That Broke the Plains* in 1936).

3. Marchand, *Creating the Corporate Soul.*

4. These are the words of Charles T. Coiner, vice president and art director at N. W. Ayer and Son, Inc., the agency that handled the Container Corporation of America account. Cited in Carl Spiel Vogel, "Advertising: Use of Fine Arts Increasing," *New York Times*, April 13, 1958, F10.

5. Dennis P. Doordan, "Design at CBS," *Design Issues* 6, no. 2 (Spring 1990): 6.

6. Wally Olins, *The Corporate Personality: An Inquiry Into the Nature of Corporate Identity* (London: Design Council, 1978).

7. "CBS's Urbane Dr. Frank Stanton," *Printers' Ink*, November 28, 1958, 67; "CBS Steals the Show," *Fortune*, July 1953, 79–83. In 1949, CBS Television had a total billing of $3,400,00; by 1952, the billings had grown more than twenty times to $69,000,000. Lawrence Audrain and Victor Strauss, "Columbia Broadcasting System," *Print* 9, no. 2 (October 1952): 10.

8. Steven Heller and Elinor Pettit, *Graphic Design Timeline: A Century of Design Milestones* (New York: Allworth Press, 2000), 134.

9. Sally Bedell Smith, *In All His Glory: The Life and Times of William S. Paley and the Birth of Modern Broadcasting* (New York: Simon and Schuster, 1990), 101.

10. "CBS's Urbane Dr. Frank Stanton," 67–70. Mrs. Paley (as the newspapers called her) was a frequent subject of the society pages, which described her appearances at costume balls, fashion shows, and museum exhibitions.

11. "CBS's Urbane Dr. Frank Stanton"; "At the End of the Rainbow," *Time*, December 1950, 55.

12. "At the End of the Rainbow," 55.

13. Stanton cited in "Print Panel," *Print* 12, no. 3 (November/December 1958), 55.

14. Frank Stanton, introduction in Pineles Golden et al., *Visual Craft of William Golden*, 9.

15. "What Agency and Client Readers Want in Radio-TV Ads," *Sponsor*, December 27, 1954, 40–41, 83–84.

16. "CBS Steals the Show," 79, 81.

17. Golden outlined these tasks in ibid., 10–11.

18. Frank Stanton, "Let's Consider the Role of the Art Director in Broadcasting," *Thirty-Second Annual of Advertisers and Editorial Art* (New York: Visual Arts Books, 1953), 67.

19. Married to Cipe Pineles (art director at the girls' magazine *Charm* from 1950–59), Golden traveled across the fields of art, fashion, and advertising with ease.

20. Stanton, introduction in Pineles Golden et. al, *Visual Craft of William Golden*, 9.

21. Coiner cited in Vogel, "Advertising: Use of Fine Arts Increasing," F10.

22. The novel features a man who leaves his job at an arts foundation to become a richer but entirely miserable martini-swigging PR man for the United Broadcasting Company. Sloan Wilson, *The Man in the Gray Flannel Suit* (New York: Simon and Schuster, 1955).

23. "Museum Displays Advertising Art," *New York Times*, April 16, 1942, 24.

24. For discussions of MoMA's graphic design, see Monroe Wheeler, "The Publishing Programme of New York's Museum of Modern Art," *Penrose Annual* 44 (1950): 32–33; Peter Selz and Robert Kosta, "American Graphic Design," *Penrose Annual* 50 (1956): 45–50.

25. Charles Coiner, "Clipping Board: The N.A.D. Club's 28th Annual," *Advertising and Selling*, April 1949, 38–39.

26. Aline B. Louchheim, "Advertising Art Takes on New Look," *New York Times*, March 20, 1949, X8. *Advertising and Selling* also singled out this ad. See Coiner, "Clipping Board," 39.

27. The Yale program was heavily supported by industry.

28. "Schools of Design: Progressive New Concepts Set the Pace," *Print* 12, no. 3 (November/December 1958): 46.

29. Ivan Vartanian, introduction in *Andy Warhol: Drawings and Illustrations of the 1950s* (New York: Distributed Art Publishers and Goliga Books, 2000), 98. (The book has no credited author or editor.)

30. The American Institute of Graphic Design, press release, March 1, 1954, box 2, Golden Collection.

31. "How the International Design Conference in Aspen Can Help Your Company," brochure, 1960, box 5, Golden Collection.

32. William Golden, "Type Is to Read," in Pineles Golden et al., *Visual Craft of William Golden*, 14–15. This is a reprint of a speech Golden delivered on April 18, 1959, at the Type Directors Club of New York forum titled "Typography U.S.A."

33. Ibid., 14–15.

34. Ibid., 27.

35. William Golden, "Visual Environment of Advertising," in Pineles Golden et al., *Visual Craft of William Golden*, 63. This essay is a transcript from a talk Golden originally presented at the ninth IDCA, June 21–17, 1959.

36. In the draft version of the speech, Golden was even more frank about his dislike for the "avant garde designer of the New Renaissance Man." William Golden, "Visual Environment of Advertising," draft, 2–3, box 5, Golden Collection.

37. Golden, "Visual Environment of Advertising," 63.

38. Ibid., 61.

39. Golden, "Type Is to Read," 27.

40. William Golden cited in "Excerpts from the Panel Discussion related to William Golden's paper at the Aspen Design Conference," in Pineles Golden et al., *Visual Craft of William Golden*, 81.

41. Golden, "Visual Environment of Advertising," 63.

42. This photograph is used as the frontispiece for Pineles Golden et al., *Visual Craft of William Golden*.

43. Pollock cited in Craven, "Abstract Expressionism, Automatism, and the Age of Automation," 242. For more on the artisan aspects of abstract expressionism, see Russell Ferguson, ed., *Hand Painted Pop: American Art in Transition, 1955–62*, museum catalog, Museum of Contemporary Art Los Angeles (New York: Rizzoli International Publications, 1992). The exhibition of the same name was curated by Paul Schimmel and Donna De Salvo.

44. For a discussion of Pollock in *Vogue*, see, for example, Timothy J. Clark, "Jackson Pollock's Abstraction," in *Reconstructing Modernism: Art in New York, Paris, and Montreal*, ed. Serge Guilbaut (Cambridge, MA: MIT Press, 1995), 171–243. For the *Life* story see "Jackson Pollock: Is He the Greatest Living Painter in the United States?" 44. For analysis of the life layout, see Francis Francina, "The Politics of Representation," in *Modernism in Dispute: Art since the Forties*, ed. Paul Wood, Francis Francina, Jonathan Harris, Charles Harrison (London: Open University, 1993), 126.

45. I am borrowing the phrase "organization man" from the classic study by William H. Whyte Jr. of 1950s business culture in *The Organization Man* (Garden City, NY: Double Day, 1958). For more on the bureaucratic business culture of advertising firms in the 1950s,

see Thomas Frank, *The Conquest of Cool: Business Culture, Counterculture, and the Rise of Hip Consumerism* (Chicago: University of Chicago Press, 1997).

46. Golden's staff included three well-respected designers, Mort Rubenstein, Kurt Weihs and Rudi Bass; operations director John Cowden; and copy chief Robert Elliot, who supervised a staff of three. For expressions of company pride, see Howard S. Meighan to Mr. Golden, memorandum, office communication, Columbia Broadcasting System, May 25, 1952, box 2, Golden Collection.

47. William Golden, "The Background of Consumer Advertising," unpublished report (ca. 1957), 23, box 5, Golden Collection. Also see Henry Fox cited in 29th annual committee, *Annual Advertising and Editorial Yearbook* (New York: Pitman Publishing Corp., 1950), n.p.

48. John Cowden, "A Tribute to William Golden," in Pineles Golden et al., *Visual Craft of William Golden*, 138.

49. Lawrence Audrain and Victor Strauss, "Columbia Broadcasting System," *Print* 8, no. 3 (October 1953): 15. For more on Golden's art department see Rene Elvin, "Programme Promotion in Sponsored T.V.," *Art & Industry* 56, no. 336 (June 1954): 182–91; Will Burtin, "The Golden Touch," *The Journal of Communication Art* 2, no. 6 (June 1960): 10–13; Audrain and Stauss, "CBS Program in Print," 9–27.

50. Golden, "The Background of Consumer Advertising," 23.

51. Sparke, *As Long as It's Pink;* Lavin, *Clean New World,* especially chapters 5 and 6.

52. In the 1940s, even before TV was a commercial reality, CBS considered ways to create a distinctive TV trademark. At this time Gilbert Seldes was director of programming for CBS television, and in that capacity he argued that CBS would need a clear identifying logo for its on-air station identification. He suggested a modern abstract design, specifically, "a geometric figure . . . spinning about surrounding our initials." See Mr. Seldes to Kerton, Murphy, Goldmark, memorandum, February 24, 1939, Columbia Broadcasting System, Inc., office memoranda, August 18, 1937–May 9, 1941, Theatre Collection, Performing Arts Library, New York Public Library, New York (hereafter referred to as Seldes/CBS Papers).

53. William Golden, "My Eye," in Pineles Golden et al., *Visual Craft of William Golden*, 152. This essay is reprinted from *Print* 13, no. 3 (June 1959): 32–35. Prototypes for the eye ran in newspaper ads in early 1951 and were more whimsical, feminine-looking eyes. Note that there are various trade tales about how the eye was created, including rumors that CBS graphic designer Georg Olden invented or helped Golden design the trademark.

54. Maureen Turim notes a 1992 Magritte exhibition catalog that cites a 1952 version of the eye-cloud image and she speculates that the CBS logo was influenced by *Le Faux Miroir.* Turim argues that because the Magritte painting was in MoMA's collection it "was undoubtedly well known to CBS." Nevertheless, Golden never mentions it as a source nor does anyone else at CBS, to my knowledge. See Maureen Turim, "The Image of Art in Video," in *Resolutions: Contemporary Video Practices,* ed. Michael Renov and Erika Suderburg (Minneapolis: University of Minnesota Press, 1966), 31. For the Magritte catalog, see Sarah Whitfield, *Magritte* (London: South Bank Centre, 1992).

55. Burton, "The Golden Touch," 33.

56. Golden, "My Eye," 153. New uses for the eye continue into the present. On the occasion of its seventy-fifth anniversary, CBS commissioned Peter Max to make an original painting of the eye.

57. This photograph is in box 2, Golden Collection.

58. In contrast, NBC and ABC had inconsistent branding in the early 1950s, and their affiliates did not always use the same logos. In the early 1950s, NBC affiliate ads alternated between a xylophone image and a logo that was simply three dots with the letters "N," "B," and "C" in each. The use of the xylophone sound symbol (rather than the CBS eye) had do with NBC's attempt to promote TV and radio as complimentary rather than competing media. On air, the xylophone was accompanied by the famous NBC radio chimes. In 1956, under the direction of its new art director John J. Graham, the network developed the NBC peacock, but that was used only for color programs. In the late 1950s, NBC alternated between the peacock, the dots, and an animated snake that Graham designed in 1959. ABC and the short-lived DuMont network were much less design conscious. ABC's art department generally used photos or took art from its partner, Walt Disney, to advertise Disney shows. Dean D. Linger (director of advertising and promotion at ABC) said, "We don't have any particular identifying theme in our advertisements through artwork." Linger cited in Carl Spiel Vogel, "Advertising: Television Turns to the Press," *New York Times*, December 1, 1957, 220.

59. Golden, "My Eye," 153.

60. Golden, "The Background of Consumer Advertising," 5.

61. Ibid., 22.

62. William Golden, "The Art Director in Television Network Promotion," in *Art Directing for Visual Communication and Selling*, Art Directors Club of New York (New York: Hastings House, 1957), 125–26.

63. Spigel, *Make Room for TV*, chapter 4.

64. Golden, "The Background of Consumer Advertising," 23.

65. A Czech émigré, Bouché first worked as an illustrator for the French and British versions of *Vogue* in the 1930s. In 1941, after fleeing the Nazi occupation, he became an illustrator for U.S. *Vogue*. By the 1950s, Bouché was a popular celebrity portraitist, and in 1961 he made a portrait of Mrs. Jacqueline Kennedy.

66. Bogart, *Artists, Advertising, and the Borders of Art*, 143–47.

67. Ibid.

68. The Bouché ads often appeared next to the more theatrical-looking "vaudeo" style ads of other networks in the early 1950s, giving CBS a particularly distinct modern look. For comparisons of this sort see (on page 90 of this text) *Chicago Tribune*, February 28, 1954, NW10; *New York Times*, January 10, 1954, X17; *New York Times*, December 27, 1953, X13; *New York Times*, March 9, 1952, X12; *New York Times*, February 7, 1954, X13.

69. Like many of the CBS artists, Martin worked for the Office of War Information. His friend Ben Shahn influenced his style.

70. Fritz Eichenberg, "The American Artist-Printmakers," *Penrose Annual* 53 (1959): 19.

71. As Shahn argued, it was most important to have "a play back and forth, between the big and little, the light and the dark, the smiling and the sad, the serious and the comic." Shahn cited in Howard Devree, "Compassion in a Line," *New York Times*, October 17, 1957, BR12. For the image, see Pineles Golden et al., *Visual Craft of William Golden*, 80–81.

72. Vianello, "The Rise of the Telefilm,"; Boddy, *Fifties Television*.

73. CBS used the coronation drawing both in a newspaper ad and for its forty-eight page "souvenir" brochure that included a color fold-out insert of the Queen's procession drawn by Topolski.

74. Val Adams, "The Coronation Ceremonies on TV and Radio," *New York Times*, May 31, 1953, X9.

75. Between 1958 and 1960, Topolski created *Coronation of Elizabeth II* (100 foot by 4 foot) for Buckingham Palace.

76. NBC also hired a sketch artist to depict the Queen's coronation event in the modern graphic style. This one used Weaver's complimentary media strategy, advertising the coronation as both a TV and radio event. For the ad, see *New York Times*, June 2, 1953, 41.

77. In the late 1950s, when the networks were beginning to use videotape, Golden faced a similar challenge with the coronation of Pope John XXII, which was taped in Europe and once again flown immediately to CBS for broadcast. For this program, Golden chose painter/illustrator John Groth, who often sketched sports or war scenes, and who used his "speed line" technique to capture the action-packed coronation firsthand.

78. Golden, "The Background of Consumer Advertising," 22.

79. Golden, "The Background of Consumer Advertising," 5.

80. Nick Browne, "The Political Economy of the Television (Super) Text," *Quarterly Review of Film and Television* 9:3 (Summer 1984): 174–82.

81. Olden was trained in art at Virginia State College and worked as a boy doing illustration for the magazine *Flash*. When Colonel Lawrence W. Lowman, head of communications at the OSS, returned to his civilian job as vice president of CBS television, he appointed Olden as art director. The scant information on Olden suggests that he while he was successful among the relatively liberal-minded executives at CBS, he nevertheless felt the racism of the pre–civil rights corporation and design community more generally. By the end of the 1960s, he filed a civil rights action against with his employer, McCann Erickson. See Julie Lasky, "The Search for Georg Olden," *Graphic Design History*, ed. Steven Heller and Georgette Ballance (New York: Allworth Press, 2001), 115–28.

82. "Video Veteran," *Opportunity* 25 (Summer 1947): 158–60.

83. Notably, the CBS press release announcing his employment in 1945 made no mention of Olden's racial identity, even while that would have been remarkable at the time. "Georg Olden Joins WCBW Art Department," CBS Television press release, October 8, 1945. This press release is in the personal collection of Mark Quigley, manager, Archive and Research Study Center, UCLA Film and Television Archive. For more on Olden's struggles with racism, see Lasky, "The Search for Georg Olden."

84. Georg Olden, "Graphic Design in Television," in *Art Directing for Visual Communication and Selling* (New York: Hastings House, 1957), 117–19.

85. Georg Olden, "Can Television Use Better Art?" *Printers' Ink*, December 11, 1953, 72.

86. Olden, "Graphic Design in Television," 117–19.

87. "New York's Thirty-Sixth," *Art Direction* 9, no. 2 (May 1957): 95–108; "Art Directors Pick Best Ads in Print and TV," *Printers' Ink*, June 3, 1955, 34–36.

88. William Bunce cited in "Originality Is the Formula," *Art Direction* 10, no. 1 (April 1958): 108–9.

89. Ibid.

90. George Lipsitz discusses the significance that nostalgic ethnic sitcoms like *Mama* had for the new consumer society in "The Meaning of Memory: Family, Class, and Ethnicity in Early Network Television Programs," in *Private Screenings: Television and the*

Female Consumer, ed. Lynn Spigel and Denise Mann (Minneapolis: University of Minnesota Press, 1992), 71–109.

91. Bennett's thoughts are paraphrased in this article. See "What Happens to Packages on Color TV?" *Art Direction* 8, no. 6 (September 1956): 64. The trade journal lists Bennett as art director of graphic arts, although the organizational charts for 1954 and 1955 at NBC list his precise title as "supervisor of titles unit." See "Organization Charts Developed for Management Conference Meetings—Television Network Program Division Production," January 10, 1955, box 1, folder 3, NBC Records, Wisconsin Center Historical Archives, State Historical Society, Madison, WI (hereafter referred to as the NBC Records).

92. John B. Lanigan cited in "What Does TV Do to Package Design?" *Art Direction* 16, no. 10 (January 1964): 123. Lanigan was the vice president in charge of the commercial film company Video Tape Productions, Ltd.

93. Duffy cited in ibid., 117–21.

94. Mary Beth Haralovich, "Sit-coms and Suburbs: Positioning the 1950s Homemaker," Spigel and Mann, *Private Screenings*, 111–41. According to Haralovich, television domestic sitcoms such as *Leave It to Beaver* and *Father Knows Best* provided a perfect environment for the display of products because they situated them in idealized homey settings and sentimental family plots.

95. Lanigan cited in "What Does TV Do to Package Design?" 124.

96. Anne Friedberg, *Window Shopping: Cinema and the Postmodern* (Berkeley: University of California Press, 1994). For more on the female flaneur, see Susan Buck-Morss, "The Flaneur, the Sandwichman, and the Whore: The Politics of Loitering," *New German Critique* 39 (Autumn, 1986): 99–140; Giuliana Bruno, *Streetwalking on a Ruined Map: Cultural Theory and the City Films of Elvira Notari* (Princeton: Princeton University Press, 1993).

97. Although Margaret Morse does not talk about package design, the comparisons that designers made between television, driving, and shopping seem especially interesting in light of Morse's essay on the intersecting ontological experiences of freeways, malls, and television in the 1950s. See her "An Ontology of Everyday Distraction: The Freeway, the Mall, and Television," in *Logics of Television: Essays in Cultural Criticism*, ed. Patricia Mellencamp (Bloomington: Indiana University Press, 1990), 193–221.

98. Francis Harvey, "Type and the TV Screen," *Print* 13, no. 6 (April/May 1954): 9.

99. For a short biography of Graham, see Jennifer Jue-Steuck, "John J. Graham: Behind the Peacock's Plumage," *Design Issues* 19, no. 4 (Autumn 2003): 1–6. Graham was employed at NBC from 1945–77. The organizational charts in the NBC Records list Graham as art director in the National Advertising and Promotion Division in Television as early as 1954, although Jue-Steuk dates his role as art director as beginning in 1956. The discrepancy may have to do with the fact the title of art director was applied to different NBC divisions (such as the graphics division, scenic design, and promotion) at different times. In 1954 Graham worked under Jacob Evans, who was director of national advertising and promotion. For the organization chart, see Vice President in Charge of Integrated Services, Interdepartment Correspondence to All Vice Presidents and Department Heads, April 26, 1954, 3, box 1, folder 3, NBC Records.

100. John Graham and Al Sherman, "Television Posters," *Art Direction* 8, no.1 (April 1956): 42–44.

101. Bass also produced title cards for network programs.

102. For examples of award-winning art, see editions of the *Annual Advertising and Editorial Yearbook* (New York: Pitman Publishing), which began publishing television art in 1948.

103. Dorfsman cited in Stewart Kampel, "Giving Credit Where It's Due—In Graphic Arts," *New York Times*, January 12, 1964, X19. For more on Dorfsman, see Dick Hess, *Dorfsman & CBS* (New York: American Showcase, 1987). His personal papers are housed in the Lou Dorfsman Collection, Herb Lubalin Study Center of Design and Typography, School of Art, Cooper Union, New York, NY.

104. Even in the 1960s, ABC's art department was not centralized. The various divisions of the network were free to buy artwork from outside sources, which meant that there was "a wide variance in the overall quality of the work ABC produced." Irwin Rothman, "TV Promotion/Advertising," *Print* 14, no. 4 (July/August 1965): 36–41.

105. Rothman, "TV Promotion/Advertising," 36.

106. Golden, "The Background of Consumer Advertising," 24–26.

107. Ibid., 28.

108. More amenable to mass production, in 1958 NBC adapted an engraving technique called "mezzotint" (first developed in the seventeenth century) to mass produce an arty look. Developed for newspaper reproduction by the Grey Advertising Agency for NBC, mezzotint gave an "etched artwork, pointillist effect to stock photographs." Via mezzotint, NBC hoped to create a "definite trademarked effect," but at the same time satisfy billing contracts because the images were based on publicity stills. Vogel, "Advertising: Television Turns the Press." For an example, see *New York Times*, September 21, 1958, X16.

109. Golden did commission Hirschfeld for one program, *The Lively Arts*. But in this case his use of Hirschfeld meshed with his plan to hire artists who fit the program content, which was Broadway/Hollywood news.

110. In 1964 Dorfsman rose from his role (since 1960) as creative director for the CBS Television Network to become director of design at CBS, overseeing design in all parts of the corporation.

111. "The Man at the Window," *Ebony*, November 1960, 79–85.

112. "Art—For the Sponsor's Sake," *Sponsor*, November 2, 1964, 47–48. Famous Artists School also offered a mail-order course in how to become a TV graphic artist. See ASIFA-Hollywood Animation Archive Project Blog.

113. Thomas Barry, "TV On-Screen Graphics," *Print* 19, no. 4 (July/August 1965): 31–35.

CHAPTER 3

1. See the AIA Library at http://www.aia.org/library_honorawards_49_59.

2. Terry Smith, *Making the Modern: Industry, Art, and Design in America* (Chicago: University of Chicago Press, 1993). For more on this history of modern design for corporate headquarters, see Gwendolyn Wright, *USA: Modern Architects in History* (London: Reaktion Books, 2008).

3. Note that both the NBC and CBS radio facilities buildings I describe below cost roughly $2,000,000, which represented the greatest investments in any broadcast facilities to date.

4. The publicity statement comes from a 1938 advertisement titled "New Radio City of the West," source unknown; "New Hollywood Radio City to Go into Service Tomorrow," *Los Angeles Times*, October 16, 1938, E1. Adorned with corporate art, the front lobby featured a "brilliant mural 25 feet high and 40 feet wide" that depicted the "far-flung activities of radio." "NBC Studio Open Monday," *Los Angeles Times*, October 13, 1938, A2.

5. Doordan, "Design at CBS," 8–12.

6. A few years earlier, in 1934, Paley hired Lescaze to refurbish a Broadway theater into a modern radio production facility.

7. The primetime show was part of a nineteen-hour-long program schedule aired that day. See "Columbia Dedicates Coast Radio Center," *New York Times*, May 1, 1938, 7; and an advertisement in *Los Angeles Times*, April 30, 1938, 9.

8. Florence Crowther, "The Video Temples of Hollywood," *New York Times*, July 27, 1952, X9.

9. Jack Gould, "Working in a Closet: Cramped Settings Destroy Video's Perspective," *New York Times*, August 16, 1953, X9.

10. These are minutes to the meeting that summarize Wade and McNaughton's comments. *A.T.S. News* (January–February 1946), 2, Special Collections, Performing Arts Library, New York Public Library. (All *A.T.S. News* volumes cited hereafter are in this collection.)

11. For example, in 1950, CBS-produced shows accounted for more than half of the CBS nighttime schedule). Oscar Katz, "Building in Two Directions," *Variety*, November 12, 1952, 37.

12. Broadway properties for ABC included the Vanderbuilt Theater, Shubert and Ritz Theaters, Ben Marden's Playhouse, and Times Hall; DuMont (which was then a part-time network) used the Adelphi Theater on Sunday nights. NBC used studios in its Rockefeller Center location but also leased and owned theaters such as the Broadway's Colonial Theater, the Ziegfeld Theater, and the International Theater on Columbus Circle. NBC also had Brooklyn studios and 67th Street studios. See Louis Calta, "Marden Theatre Is Leased to ABC," *New York Times*, September 28, 1948, 31; Ross Parmenter, "Small Auditoriums Profit by Conversion of Times Hall to Television Studio," *New York Times*, June 24, 1951, 83; CBS theaters are cited in the text. Note, too, that while production was concentrated in New York, the networks had converted studios in other parts of the country, especially Los Angeles and Chicago.

13. Jack Gould, "News of Radio," *New York Times*, February 18, 1948, 54; "CBS Gets Auditorium Theatre for Television," *Wall Street Journal*, July 3, 1950, 6. See also Wade, *Designing for TV*, 26.

14. Katz, "Building in Two Directions."

15. Wade, *Designing for TV*, 26.

16. Ibid., 24.

17. David Ffolkes, "The Triumph of Mediocrity," *Theatre Arts*, May 1951, 43.

18. Otis Riggs, "Designing for TV," *Theatre Arts*, February 1951, 52.

19. David Ffolkes cited in ibid., 96.

20. Ted Sherbourne, "Perspective in TV Studio Production," *Televiser* (January 1950): 22–23.

21. Otis Riggs, "Designing for TV," *Theatre Arts*, February 1951, 52.

22. William Molyneux, "Less Than Meets the Eye," *Theatre Arts*, August 1953, 70.

23. Lydia Bond Powel, "Television and the Metropolitan Museum of Art," unpublished museum report for the Metropolitan Museum of Art, New York, 16, Watson Library, Special Collections, Metropolitan Museum of Art, New York.

24. Gould cited in Rose, *Television and the Performing Arts*, 194.

25. Molyneux, "Less Than Meets the Eye," 71. Television critic Harriet Van Horne credited the "Chicago School" of television with making cameras a vital part of the show, and not just recording instruments. Harriet Van Horne, "Television in the Round," *Theatre Arts*, November 1951, 85. For additional examples of articles that praise mobility and fluidity of action, see Mordi Gassner, "Advancing Television Technique," part I, *Televiser*, May 1950, 9–11; Mordi Gassner, "Advancing Television Technique," part II, *Televiser*, June 1950, 18–19; Irwin A. Shane, "20 Points for Checking TV Production Ideas," part I, *Televiser*, October 1950, 14; Arthur Todd, "Dolly in on Television Dance," *Theatre Arts*, September 1951, 87–88; Walter Hart, "Directing for TV," *Theatre Arts*, February 1951, 51–52.

26. Note that while Jan Scott designed sets throughout the 1950s, she said this in 1963. Jan Scott, Charles Lisanby, Burr Smidt, "Design in Television," Television Quarterly 2, no. 3 (Summer 1963): 41. Note too that Scott was the set designer for NBC's acclaimed spectacular *Peter Pan* (1955). With its flying star, *Peter Pan* was, of course, the height of mobility in set design for its time.

27. See Charles Adams, "The Stage Director in Television," *Theatre Arts*, October 1951, 78.

28. Myron M. Freedman, "Television Cameraman," *Televisor*, September 1950, 9–10; "Stage and Artist in the Television Era," *Art News*, February 1952, 59.

29. Sidney Lohman, "'Romeo and Juliet to Be Offered with Arena Theatre Technique," *New York Times*, May 15, 1949, X9.

30. Norman McCleery cited in Van Horne, "Television in the Round," 49, 84. For historical analysis, see William Lafferty, "No Attempt at Artiness, Profundity or Significance: *Fireside Theater* and the Rise of Filmed Television Programming," *Cinema Journal* 27, no. 1 (Fall 1987): 23–46; Rose, *Television and the Performing Arts*; William Hawes, *Filmed Television Drama: 1952–1958* (Jefferson, NC: McFarland, 2003), 48–49.

31. For set designs, see boxes 598 and 599 in part 7, office files, NBC Records. For "Technical Facilities Reports," see boxes 211, 212, 213 in part 7, office files, NBC Records; Studio One Production Files, 1948–55, Performing Arts Library, Theatre-Special Collections, New York, NY.

32. Harriet Van Horne, "The Living Theater on Television," *Theatre Arts*, September 1951, 53, 77.

33. Bert Gold, "Quo Vadis TV?" *Televiser*, December 1951, 9.

34. The first color spectacular was broadcast on September 19, 1954, from NBC's newly opened color theater in Brooklyn. A ninety-minute musical titled *Satin and Spurs*, it was produced by the renowned stage director Max Liebman. See Hawes, *Filmed Television Drama*, 41. Subsequently, NBC's Brooklyn color studio provided the stage for many spectaculars. For more on the transition to color and its demands for studio space see Robert B. Monroe, "CBS Television Color Studio 72," *Journal of the SMPTE* 64 (October 1955): 542–49.

35. Wade, *Designing for TV*, 26.

36. Dorothy O'Leary, "Hollywood Outdistanced by East," *New York Times*, June 13, 1948, XX20.

37. Stanton cited in *A.T.S. News* 7, no. 6 (March 1968): 7; Trammel cited in "NBC to Build Video Station in Chicago Soon," *New York Times*, May 16, 1949, 38.

38. American Broadcasting Company, "Report on 1948," 10. The same ABC report announced that the network had opened up a studio in Chicago's Civic Opera building.

39. In 1951, ABC owned and operated five stations in the six largest television markets, but had only fourteen affiliates in other parts of the country. NBC had sixty-three and CBS had thirty. See Christopher Anderson, *Hollywood TV: The Studio System in the Fifties* (Austin: University of Texas Press, 1994), 138. The FCC 1948–52 freeze on station allocation made it hard for ABC to plan future affiliate acquisitions.

40. In the early 1950s, ABC became the first network to fill the majority of its primetime schedule with filmed programs. Ibid., 138.

41. ABC's 1949 company report announced the opening of its Hollywood studios. See American Broadcasting Company, "Report on 1949," January 1950, 38, Special Collections, Performing Arts Library, New York Public Library; for images of the Center, see "We're Rapidly Becoming Capital of Television," *Los Angeles Times*, January 2, 1953, E101.

42. "CBS Plans Television City on 15-Acre Hollywood Site," *Wall Street Journal*, May 25, 1950, 3.

43. See http://www.oscars.org/awardsdatabase/index.html.

44. James Steele, ed., *William Pereira* (Los Angeles: USC Architectural Guild Press, 2002), 83.

45. "Lever Brothers' Luckman," *Time*, June 10, 1946, cover and 80–81.

46. Charles Luckman, *Twice in a Lifetime: From Soap to Skyscrapers* (New York: W. W. Norton, 1988), 283. During Luckman's tenure, Lever Brothers was also one of the first companies to experiment with television production (Lever produced "Wednesday at Nine" for the WABD station in New York). In 1945, Lever won an ATS award for the program and its commercial. *A.T.S. News* 4, no. 1 (August 1945): 3.

47. Luckman, *Twice in a Lifetime*, 242.

48. For a complete chronology of Pereira's buildings, with Luckman and alone, see Steele, *William Pereira*, 196–253. For Luckman's buildings, see Luckman, *Twice in a Lifetime*, 289–399.

49. In his memoir, Luckman recalls that Paley and Stanton proposed the idea of Television City to him at a lunch meeting in 1950. See Luckman, *Twice in a Lifetime*, 283.

50. CBS press release cited in "Gilmore Stadium Sold to CBS for TV City," *Los Angeles Times*, May 25, 1950, A1.

51. J. L. Van Volkenburg, "TV's Newest Milestone: Pattern for the Future," *Variety*, November 12, 1952, 27.

52. Eugene Paul, *The Hungry Eye* (New York: Ballantine, 1962), 80.

53. Carroll Caroll, "The Ultimate in Push-Button Entertainment Needs Writers Too," *Variety*, November 12, 1952, 23. CBS's promotional ads referred to the structure as an "assembly line" and "factory." See *Variety*, November 19, 1952, 33.

54. Crowther, "Video Temples of Hollywood."

55. David J. Jacobson, "I Remember a Monster," *Variety*, November 12, 1952, 29. Jacobson was Public Relations Director at CBS.

56. William L. Pereira and Charles Luckman, "CBS Television City," *Arts and Architecture*, January 1953, 21. See also William L. Pereira and Charles Luckman, "Take a Sandwich-Loaf Idea, Add Some Imagination, and Presto—CBS-TV City," *Variety*, November 12, 1952, 29, 54.

57. Steele, *William Pereira*, 14.

58. According to Steele, Pereira was "trusting in the creative ability of others" and placed "client needs . . . above ego." Ibid., 16.

59. According to Steele, Pereira abhorred Luckman's factory orientation, and this was a primary cause for their parting in 1958. Recalling his work with Luckman, Pereira said, "The businessman who hires us doesn't need another businessman to do the work; he needs an architect. It was like working in a factory . . . I just know I wasn't doing my best." Pereira cited in Steele, *William Pereira*, 18.

60. "Pile Driving Job Started at TV City," *Los Angeles Times*, December 30, 1950, A5.

61. Walter Ames, "Architects Tell Problems of Making TV City Flexible," *Los Angeles Times*, February 6, 1952, 24; Hank Warner, "The First 21 years of CBS-TV: From Henry Burbig to 'Lucy,'" *Variety*, November 12, 1952, 52.

62. Steele, *William Pereira*, 88.

63. "TV City: A Picture Report," *Architectural Forum*, March 1953, 146.

64. Crowther, "Video Temples of Hollywood"; "Hollywood Ready with First TV City," *New York Times*, November 14, 1952, 29.

65. "TV City: A Picture Report," 146–49.

66. Pereira and Luckman, "CBS Television City," 21.

67. "TV City: A Picture Report," 148; Walter Ames, "Architects Tell Problems of Making TV City Flexible," *Los Angeles Times*, February 6, 1952, 24.

68. George Rosen, "California, Here We Come: TV City Sparks Coast Tele Boom," *Variety*, November 19, 1952, 22.

69. Pereira and Luckman, "CBS Television City," 23. See also Pereira and Luckman, "Sandwich-Loaf Idea."

70. Pereira and Luckman, "CBS Television City," 22.

71. "TV City: A Picture Report," 146.

72. Paul Virilio, *Speed and Politics*, trans. Mark Polizzotti (New York: Semio(texte), 1986); Paul Virilio, *Open Sky*, trans. Julia Rose (New York: Verso, 1997).

73. *Variety*, November 19, 1952, 32–33.

74. Val Adams, "The Izenour Board: TV's Lighting Wonder," *New York Times*, January 31, 1954, X13.

75. "TV City: A Picture Report," 148.

76. Beatriz Colomina, "Media as Modern Architecture," in *Architecture: Between Space and Use*, ed. Anthony Vidler (New Haven: Yale University Press, 2008), 66, 60. See also her discussions of midcentury residential, commercial, and exhibition buildings (as well as film and media productions) by Charles and Ray Eames, Philip Johnson, and Eero Saarinen in *Domesticity at War* (Cambridge, MA: MIT Press, 2007). Colomina also discusses architects' appearances on television programs in "Johnson on TV," (lecture, Televisuality symposium, School of Architecture, Syracuse University, NY, April 11, 2008). Note that the relationship between media and architecture was already embedded in earlier modernist designs. As Beatriz Colomina argues, Le Corbusier's modern office buildings used windows as a communication device that allowed occupants to peer out and seek

information from the city. Beatriz Colomina, *Privacy and Publicity: Modern Architecture as Mass Media* (Cambridge, MA: MIT Press, 1996).

77. Steele, *William Pereira*, 89.

78. Reinhold Martin, "Atrocities; Or, Curtain Wall as Mass Medium," *Perspecta* 32 (2001): 70–72. Note that Martin observes that the iconic buildings such as Mies's Seagram building are typically considered as avant-garde monuments, but that the curtain wall—as a general phenomenon and in its replication as a mode of mass construction by postwar commercial building firms—is often considered by critics to be a hallmark of the administered corporate culture of the postwar period. By considering the curtain wall in general as a media form, Martin questions this distinction between avant-garde architectural monuments and the logic of mass construction by commercial firms.

79. Ibid., 71. Note that Martin argues the "event" is not just something external to the office building, but rather "its own modular reduplication, its own dispersion at all scales"— i.e., the media logic upon which the curtain wall is based.

80. Stoller also shot the publicity still of William Golden standing before the wall of eyes in CBS Television City.

81. Steele, *William Pereira*, 88–89.

82. Despite the lack of nature at Television City, it is interesting to note that like other architects of his time, Pereira wrote about the relationship among nature, technology, and architecture. See William Pereira, "Architecture, Nature and the City," in Steele, *William Pereira*, 20–63.

83. "Some Vital Statistics on CBS Television City," *Variety*, November 12, 1952, 36.

84. Morse, "An Ontology of Everyday Distraction."

85. See the ad for the Macy's exhibit in *New York Times*, June 30, 1952, 7.

86. Jacobson, "I Remember a Monster," 29.

87. Ibid.

88. Ibid.; *New York Times*, June 30, 1952, 7; "Video City Model on Display," *New York Times*, June 29, 1952, F5.

89. Jacobson, "I Remember a Monster," 29. The *Los Angeles Times* promoted the spectacular model and referred to Television City itself as an "ultramodern plant." See "Two Ton Working Model of TV City to Be Placed on Display Tomorrow," *Los Angeles Times*, September 21, 1952, B2.

90. "NBC Making Plans for Expansion Here," *Los Angeles Times*, November 10, 1950, 23; "NBC Exercises Its Option on Burbank Site," *Los Angeles Times*, November 7, 1951, A1; "Work to Start on Burbank TV Studios Soon," *Los Angeles Times*, December 20, 1951, 19; "Burbank Land Deal Escrow for NBC TV—Radio Center Will Close," *Los Angeles Times*, August 16, 1951, A3; "NBC Asks More Time to Buy Burbank Site," *Los Angeles Times*, September 18, 1951, A6.

91. West cited in "NBC's New $3,500,000 TV Studios Previewed," *Los Angeles Times*, October 1, 1952, 20. The NBC Burbank studios were 9,000 square feet compared to the 12,500 square feet studios at CBS.

92. Ibid.

93. "CBS Goes on Air First Time from New TV City," *Los Angeles Times*, October 4, 1952, A1.

94. "Bowran Sets Saturday as Television City Day," *Los Angeles Times*, November 11, 1952, 21.

95. "Another Historic Milestone," *Variety*, November 12, 1952, 1.

96. Rosen, "California, Here We Come," 1. CBS spent approximately $100,000 to promote the events, including the dedication program *Stars in the Eye*.

97. Note that Van Volkenberg was president of CBS Television while Stanton was president of the entire CBS Corporation. All citations from "CBS Dedicates Television City; Parade Dropped," *Los Angeles Times*, November 16, 1952, B1. See also Thomas M. Pryor, "Rain Puts Damper on TV City Opening," *New York Times*, November 16, 1952, 50; "Hollywood Ready with First TV City"; Walter Ames, "CBS Television City to Be Dedicated Today with Parade, All-Star Variety Program," *Los Angeles Times*, November 15, 1952, A5.

98. Ely, *The Adventures of Amos 'n' Andy*.

99. Rosen, "California, Here We Come," 1, 22.

100. George Rosen, "Paley Comet Designed for TV," *Variety*, November 26, 1952, 29, 41.

101. Jack Hellman, "TV's Westward Ho!," *Variety*, November 12, 1952, 36.

102. Jack Gould, "C.B.S. Unveils Its Television City on Coast with Star-Studded Dedicatory Program," *New York Times*, November 17, 1952, 34.

103. "TV Networks Deny Role," *New York Times*, January 15, 1957, 44.

104. In his memoir Luckman recalls that about a year after Television City was completed, he received a call from a movie entrepreneur who had a scheme to produce a centralized television, motion-picture, and radio-production center in New York. Luckman recalls pitching the "city within a city" idea to Paley, Sarnoff, and Leonard Goldenson (president of ABC), but after eleven months of infighting the networks rejected the scheme. Luckman, *Twice in a Lifetime*, 286–88.

105. "CBS TV Unit Weighs Consolidating Studios in a Production Center," *Wall Street Journal*, January 4, 1961, 3.

106. In 1954, United Paramount Theaters (UPT) officially acquired ABC, and in that same year ABC/UPT invested in Disney's new theme park in exchange for acquiring the rights to air *Disneyland*, the studio's program-length advertisement for its new theme park. By the late 1950s, Warner Brothers began producing cop shows and westerns for ABC; Columbia's subsidiary Screen Gems was a telefilm sitcom factory; and the talent agency Music Corporation of America (MCA) became a major player in television production. Anderson, *Hollywood TV*; Boddy, *Fifties Television*; Mark Alvey, "The Independents: Rethinking the Television Studio System," in *The Revolution Wasn't Televised: Sixties Television and Social Conflict*, ed. Lynn Spigel and Michael Curtin (New York: Routledge, 1997), 139–59.

107. Paul, *The Hungry Eye*, 80.

108. Ibid., 90.

109. "WCAU TV-Radio Center," *Architectural Forum*, September 1952, 148–51.

110. "Sheffield Plan Resold to CBS," *New York Times*, May 17, 1952, 32; "CBS Buys Site for TV-Plant in Mid Manhattan from Sheffield Farms," *Wall Street Journal*, May 17, 1952, 8.

111. Luckman, *Twice in a Lifetime*, 285; Steele, *William Pereira*, 197, 228; http://luckman-partnership.com. The architects separately designed headquarters for media corporations such as Warners, ABC, and Columbia Pictures.

112. Steele, *William Pereira*, 197; "History of Idaho Commercial Television," Idaho State Historical Society Reference Series, number 673, 1989, 23–24. Available at http://www.idahohistory.net (accessed June 29, 2004).

113. Architects' statement in "First Honor Eero Saarinen and Associates," *AIA Journal* 46, no. 1 (July 1966): 26. Also see Aline B. Saarinen, ed., *Eero Saarinen on His Work* (New Haven: Yale University Press, 1961).

114. Bedell Smith, *In All His Glory*, 444.

115. Aline Saarinen to Dr. Stanton, July 23, 1962, Aline and Eero Saarinen Papers, General Correspondence, microfilm roll #2075, Archives of American Art, Smithsonian Institute, New York (hereafter referred to as the Saarinen Papers).

116. "CBS to Construct 38-Story Building in Mid-Manhattan," *Wall Street Journal*, February 19, 1962, 9.

117. Irwin Rothman, "CBS Builds an Image: The Graphic Look of a Corporate Headquarters," *Print* 20, no.1 (January/February 1966): 11–17; Hess, *Dorfsman & CBS*, 34.

118. Virginia Lee Warren, "Woman Who Led an Office Revolution Rules an Empire of Modern Design," *New York Times*, September 1, 1964, 40.

119. Dorfsman cited in Rothman, "CBS Builds an Image," 15; Hess, *Dorfsman & CBS*, 35, 44.

120. Bedell Smith, *In All His Glory*, 444.

121. "First Honor Eero Sarrinen & Associates," 26–28.

122. Peter Blake, "Slaughter on 6th Avenue," *Architectural Forum* 122 (June 1965): 18. For discussion, see Martin, "Atrocities," 68.

123. Ada Louise Huxtable, "Eero Saarinen's Somber Skyscraper," *New York Times*, March 13, 1966, 135.

124. Hess, *Dorfsman & CBS*, 36–37; Huxtable, "Eero Saarinen's Somber Skyscraper," 135.

CHAPTER 4

1. This program was a special episode of the public-affairs series *Excursion* and was funded by the TV-Radio Workshop of the Ford Foundation. See "Excursion #19 (Modern Art on Horseback)," script version II, January 29, 1954. Reprinted as an insert in *Print* (October/November 1954), n.p. The episode aired on January 31, 1954.

2. Alan Wallach, "The Museum of Modern Art: The Past's Future," *Art in Modern Culture: An Anthology of Critical Texts*, ed. Francis Frascina and Jonathan Harris (New York: Harper Collins, 1992), 282–91. Note this was the same year RCA debuted its commercial television system at the New York World's Fair.

3. Betty Chamberlain, draft of letter to Federal Communications Commission, ca. 1951, series III. box 19, folder 12d, Early Museum History Administrative Records: Television Project, 1939–55, Museum Archives, Museum of Modern Art, New York, NY (hereafter referred to as the Television Project); Betty Chamberlain, "TV: Hope Tempered," *Art Digest* 26 (November 1, 1951): 34.

4. Christopher Reed further argues the "Domestic . . . remains throughout the course of modernism a crucial site of anxiety and subversion." Reed, *Not at Home*, 7, 15–16. For more on modern art/design, women, and domesticity, see Whiting, *A Taste for Pop*; Sparke, *As Long as It's Pink*; Lucy R. Lippard, *The Pink Glass Swan: Selected Feminist Essays on Art* (New York: New Press, 1995); Colin Painter, ed., *Contemporary Art and the Home* (New York: Oxford, 2002).

5. Gibson, *Abstract Expressionism: Other Politics*.

6. Minutes from the meetings are transcribed in *A.T.S. News*. MoMA's film library

curator Iris Barry lectured members on production techniques in motion pictures, and the museum also screened examples of television shows and commercials. See *A.T.S. News* 3, no. 4 (April 1, 1945): 2.

7. Powel, "Television and the Metropolitan Museum of Art"; Betty Chamberlain, "TV: Hope Tempered." As early as 1932, the Metropolitan Museum of Art in New York granted formal permission for the use of its picture materials on experimental television broadcasts.

8. Tom Braden to Nelson A. Rockefeller, June 29, 1948, series III, box 18, folder 3, Television Project. As discussed in the text, Braden went on to be an agent in the CIA.

9. Allon Schoener, "Television, an Important New Instrument of Mass Education for Museums," speech presented at The Role of Museums in Education Seminar at the United Nations Educational Scientific and Cultural Organization, September 27, 1952, Brooklyn, New York, 1. The transcribed talk is in the papers of Davidson Taylor, box 278, folder 10, NBC Records.

10. The bulk of programming consisted "of a few photos, particularly views of the Museum, of the garden with people eating in it, of the movie hall. These are used in programs about what to do on the weekend if it rains and if it doesn't and you have to stay in the city." Betty Chamberlain, letter to Miss Ethel Hoffman, July 30, 1948, series III, box 19, folder 12d, Television Project.

11. Untitled report, n.d., series III, box 19, folder 12d, Television Project.

12. Betty Chamberlain to Miss Ethel Hoffman, July 30, 1948.

13. William Paley cited in Douglas Macagy, *The Museum Looks in on TV* (1955), 196, series III, box 14, Television Project.

14. "The Museum and Television," May 1949, 2, series III, box 19, folder 12d, Television Project.

15. See Lynes, *Good Old Modern*, 233; Amy Marver, "Home-made Modern: MoMA, Women, and the Transformation of European Modernism into American Style," (Ph.D. diss., University of California, Irvine, 2001).

16. "The Museum of Modern Art in New York," museum booklet, 1936, writings for the Museum of Modern Art, file D6, microfilm reel 3260, frame 962, Alfred Hamilton Barr Papers, Archives of American Art, Smithsonian Institute, Washington, D.C., and New York, NY (hereafter referred to as the Barr Papers).

17. Powel, "Television and the Metropolitan Museum of Art," 45. In addition, during the Depression, New York's Associated American Artists (AAA) tried to democratize fine art by making inexpensive reproductions available to ordinary citizens.

18. Stanford Research Institute, "Long Range Planning Service," 2.

19. Reed, *Not at Home*; Huyssen, *After the Great Divide*; Griselda Pollack, "Modernity and the Spaces of Femininity," in Frascina and Harris, *Art in Modern Culture*, 121–35. Pollock's essay begins by considering the antagonism to femininity in the context of MoMA's "great man" historical canon.

20. Both citations are in McCandlish Phillips, "Attendance Sours at Museums Here," *New York Times*, November 27, 1961, sec. I, 3.

21. This is mentioned by William Paley in his address at Museum of Fine Arts, Boston, inauguration of the centennial celebration, January 6, 1967, Boston, MA. In Special Collections, Watson Library, Metropolitan Museum of Art.

22. This phrase was used by Douglas Macagy, who was nominally in charge of MoMA's Television Project. See his *The Museum Looks in on TV*, 6.

23. For example, a 1952 study of museum attendance at MoMA showed that "only 40.3 percent of the total people attending from March 31 through April 22 entered the galleries without also patronizing its movies and/or restaurant." Macagy, *The Museum Looks in on TV*, 6.

24. Lynes, *Good Old Modern*, 233.

25. In the interest of his international and particularly Latin American investments, Rockefeller expanded MoMA's international program and reconstituted it as the International Council of MoMA in 1956. Cockcroft, "Abstract Expressionism, Weapon of the Cold War," 125–33. Peter DeCherney shows how Rockefeller, as head of the State Department's Office of the Coordinator of the Inter-American Affairs (CIAA) also made ties with Hollywood to make film a central means of U.S. propaganda in the 1940s (especially in Latin America) and how Rockefeller and MoMA continued to use American film as a weapon in the cold war in the 1950s. See DeCherney, *Hollywood and the Culture Elite*, chapter 5.

26. For more on the International Organizations Division, see Saunders, *The Cultural Cold War*.

27. Guilbaut, *How New York Stole the Idea of Modern Art*.

28. Betty Pepis, "Art in the Home," *New York Times*, September 20, 1953, sec. 6, 52–53.

29. Edward J. Wormley, "The Year in Design," *New York Times*, September 25, 1949, sec. XX, 3.

30. Judy Klemesrud, "Instant Redecorating (If a Fuse Doesn't Blow)," *New York Times*, November 5, 1966, 24.

31. Macagy was an art historian and critic. Between 1945–50 he directed the California School of Fine Arts (which was renamed the San Francisco Art Institute in 1961). During this period, Macagy championed non-objective painters such as Clyfford Still and Mark Rothko. In 1951 he was appointed executive secretary of the New York Museums Committee for UNESCO and worked out of an office at MoMA under museum director Rene d'Harnoncourt. See David Beasley, *Douglas Macagy and the Foundations of Modern Art Curatorship* (Simcoe, ONT: Davus Publishing, 1998), 47, 60. Although d'Harnoncourt gave Macagy the title "director of television," Macagy was involved in many other facets of museum work in the early 1950s, and his involvement with the Television Project was mostly in a supervisory role. He took credit for the report *The Museum Looks in on TV*, based on Peterson's preliminary report described herein. In 1947 Macagy hired Peterson to teach the first filmmaking courses at the California School of Fine Arts, during which time Peterson established his own film company, Orbit Films. When Orbit failed, Macagy (then at MoMA) hired Peterson, who admits in his autobiography, "I knew nothing about TV." Sidney Peterson, *The Dark Side of the Screen* (New York: Anthology Film Archives and New York University Press, 1980), 124.

32. Betty Chamberlain claimed, "Dick Griffith [the curator of the Film Library] says the film people, much as they hate TV, could not possibly raise any serious objection to our operating such a TV department as long as it is not the same department as the film library." See her memorandum to René d'Harnoncourt, April 11, 1952, series III, box 18, folder 3, Television Project. By 1954 the Film Library did cooperate with a producer at NBC, and the network put film librarian Iris Barry on the "NBC payroll as official agent

and coordinator in Europe." See Richard Griffith to the Coordinating Committee, memorandum, October 22, 1954, series III, box 18, folder 7, Television Project.

33. In the Barnouw model, industry workers like playwright Paddy Chayefsky, director/producer Worthington Minor, or CBS journalist Edward R. Murrow are presented as exceptions to the rule. While these people often did act with great courage against commercial trends, such "exceptionalist" histories fail to explore the larger cultural conditions under which their actions were possible. As opposed to this, by looking more broadly at the relationships between the networks and traditional institutions of the arts, we can see that such people operated in a cultural field where the arts and television were not diametrically opposed. In addition, we can see that their actions were generated because of—not despite of—the relationships among different cultural institutions. See Erik Barnouw, *Tube of Plenty: The Evolution of American Television,* (New York: Oxford University Press, 1975). This book was a condensed version of Barnouw's three volume *History of Broadcasting in the United States* (New York: Oxford), which he wrote over the course of the 1960s.

34. Numerous scholars have detailed links between commerce and museums. See, for example, Harris, *Cultural Excursions*; Andreas Huyssen, "Escape from Amnesia: The Museum as Mass Medium," in *Twilight Memories: Marking Time in a Culture of Amnesia* (New York: Routledge, 1995), 13–35; Daniel J. Sherman and Irit Rogoff, eds., *Museum Culture: Histories, Discourses, Spectacles* (Minneapolis: University of Minnesota Press, 1994); Whiting, *A Taste for Pop*; Marver, "Home-made Modern."

35. For example, in 1936 when MoMA held its Van Gogh exhibit, the Saks Fifth Avenue department store promoted it with a Van Gogh–inspired display in its window it called "Van Gogh Colors." Marver, "Home-made Modern," 12. Marver also discusses more downtown/downscale stores' relations with MoMA.

36. The Detroit Art Institute was so keen on the link between art appreciation and consumerism that its education department hosted a show called "Let's Go Shopping" on a local commercial station.

37. Untitled notes on "Good Design" Show, ca. 1953, Series III, Box 18, Folder 3, Television Project.

38. "Projects," ca. Fall 1953, series III, box 18, folder 4b, Television Project.

39. Betty Chamberlain to René d'Harnoncourt, memorandum, July 25, 1951, series III, box 19, folder 2d, Television Project.

40. The New York State Federation of Women's Clubs also resisted state-run TV and in 1953 adopted a resolution at their annual convention opposing state-owned and state-operated television stations for educational purposes. They opposed the use of taxpayer money for television and did not want the government dictating education and cultural affairs. According to the *New York Times*, "Whispers of socialism were heard among delegates opposing state-owned television." Lillian Bellison, "State-Owned Video Stations for Education Opposed by Federation of Women's Clubs," *New York Times*, November 11, 1953, 41.

41. See, for example, her memorandum to René d'Harnoncourt, July 25, 1951.

42. Untitled notes, ca. 1954, series III, box 18, folder 4b, Television Project. My guess is that either Peterson or Macagy wrote these notes with respect to the *They Became Artists* series that I discuss further on.

43. Douglas Macagy to René d'Harnoncourt, memorandum, September 23, 1953, series III, box 18, folder 8c, Television Project. It should be noted that even while they embraced commercial television, Macagy and his colleagues at MoMA knew that, despite some common interests, commercial broadcasters often held museum people in contempt, and vice versa.

44. Macagy, *The Museum Looks in on TV*, 1–17.

45. Ibid., 40.

46. Peterson, *The Medium*, 1955, 2, series III, box 14, folder 14, Television Project.

47. Ibid., 5–6.

48. Ibid., 6.

49. Ibid., 15–16.

50. Russell Lynes, "Highbrow, Lowbrow, Middlebrow," 19 (citations are to *Harper's* version). Although Macagy spoke the language of "brows" he specifically resisted placing the television audience into any brow level. He wrote, "Reasonably accurate calipers for gauging brow heights in the American television audience still have to be formed." See *The Museum Looks in on TV*, 43.

51. Tom Funk drew the taste-level chart for *Life*, April 11, 1949, 100–101.

52. Lynes, "Highbrow, Lowbrow, Middlebrow," 20.

53. Wallace cited in ibid.

54. Untitled report, ca. 1950, series III, box 19, folder 12d, Television Project.

55. Macagy, "The Practical Outlook," in *The Museum Looks in on TV*, 53–70. Macagy thought that television was more utilitarian than aesthetic. He claimed the viewers' "dollhouse window on the world is a functional piece of furniture," and TV was a "labor saving device" that substituted for actual activities in the outside world (40).

56. Pierre Bourdieu, *Distinction: A Social Critique of the Judgment of Taste*, trans. Richard Nice (Cambridge, MA: Harvard University Press, 1987).

57. Macagy, *The Museum Looks in on TV*, 11.

58. Ibid., 56–58.

59. I am referring here to Benjamin's "The Work of Art."

60. Macagy, *The Museum Looks in on TV*, 18.

61. Macagy, however, pointed out that "asking too much" of the TV audience was also a mistake. *The Museum Looks in On TV*, 24.

62. Ibid., 63.

63. Peterson, *The Medium*, 101.

64. Ibid.

65. Paddy Scannell, *Radio, Television, and Modern Life: A Phenomenological Approach* (Oxford: Blackwell, 1996), 24. Emphasis in original.

66. "What's Art to Me?" internal museum report, ca. December 1939, microfilm reel 3260, frame 922–26, Barr Papers. The same report recommended that it was crucial to distribute (for 10 cents a copy) an illustrated pamphlet so that radio listeners could visualize the artworks being discussed (frame 928).

67. Clayton Frank, "The 'Art in America' Radio Programs, 1934–1935," *Studies in Art Education* 40, no. 1 (Autumn 1998): 31–45.

68. Stewart, "Television Goes into the Entertainment Field."

69. Powel, "Television and the Metropolitan Museum of Art." For example, a broadcast

about American houses was shot on one set with a lecturer using a pointer to demonstrate housing models. For more discussion of these shows, see Gilbert Seldes's memoranda relating to his work as director of programs for CBS Television in Seldes/CBS Papers.

70. Powel, "Television and the Metropolitan Museum of Art," 62–64.

71. Ibid, 3.

72. Ibid., 69. By 1948, when the museum consigned CBS to wire its galleries for television, technicians tried to redesign museum lighting "to bring out the lifelike qualities of the many famous paintings." In this regard, the demands for televisual liveness and reproducibility also changed the exhibition space of the museum itself. "The Metropolitan Seeks Video Advice," *New York Times*, February 24, 1949, 28. The museum was wired for television by 1954.

73. Allon T. Schoener, "San Francisco TV Program reaches 40,000," *Art Digest* 26 (October 1, 1951): 10. Also see Schoenor, "Television, an Important New Instrument of Mass Education for Museums."

74. Allon T. Schoener, letter to Davidson Taylor, October 5, 1952, Papers of Davidson Taylor, box 278, folder 10, NBC Records. Two years later, NBC considered producing a show with Salvador Dali in which "Mr. Dali of the waxed mustaches and frantic manner would paint a picture for NBC audiences while they watched." Robert D. Graff, to Davidson Taylor, memorandum, June 9, 1954, Papers of Davidson Taylor, box 279, folder 69, NBC Records. Note as well that in 1953, d'Harnoncourt met with NBC executive Davidson Taylor to discuss numerous plans for collaboration. Davidson Taylor to Sylvester L. Weaver Jr., memorandum, November 12, 1953, Papers of Davidson Taylor, box 279, folder 14, NBC Records.

75. Division of Education, *Seventy-Eighth Annual Report for the Year 1953* (Boston: Museum of Fine Arts, Boston, 1953), 39–40. In 1954, the Museum of Fine Arts, Boston, began to wire its building to televise programs (on station WGBH) from all exhibition floors. See Walter Muir Whitehill, *Museum of Fine Arts, Boston: A Centennial History* (Cambridge, MA: Harvard University Press, 1970), 614–15.

76. Division of Education, *Eighty-Fifth Annual Report* (Boston: Museum of Fine Arts, Boston, 1960), 83; Museum of Fine Arts, Boston, *Eighty-Fourth Annual Report* (Boston: Museum of Fine Arts, 1959), 76. Note as well that in its cold war efforts to spread American culture abroad, in 1961 the USIA distributed *Invitation to Art* to the Thai Exhibition in Bangkok. See Division of Education, *Eighty-Sixth Annual Report* (Boston: Museum of Fine Arts, Boston, 1961), 95.

77. Val Adams, "Art Instruction for the Masses," *New York Times*, January 20, 1952, sec. II, 3. For an essay on Gnagy, see Susan Morgan, "Each and Every One of You," *Real Life Magazine* 18 (Summer 1985), n.p.

78. Howard Conant, "Committee on Art Education: TV and Children's Creativity," *Art Digest* 27 (June 1953): 23–24. Although WNBT continued to air the program by "popular demand," it offered the committee members an "opportunity to televise a series of constructive educational programs" (23). The other program museum officials deplored was the popular children's art show, *Winky Dink and You*, which sold play-along art kits. See Macagy, *The Museum Looks in on Television*, 30.

79. Adams, "Art Instruction for the Masses," 3.

80. This film is housed at the UCLA Film and Television Archives, Los Angeles, CA.

81. This program was the radio version of the celebration for the opening of the West 53rd Street building. It included popular personalities from Walt Disney to President Roosevelt. See "Program to Celebrate the Opening of the Museum of Modern Art," script, May 9, 1939, file D5: "Writings for MoMA: 1939 Broadcast," microfilm reel 3260, frame 871, Barr Papers. The actual program was broadcast on May 10, 1939, over NBC's WJZ. Note that this program resulted in attacks of vulgarization by museum critics as well as anger expressed by the architects for the new building, who were not mentioned on the show. Barr wrote a long letter to an NBC executive going through the script (which an NBC scriptwriter wrote) page by page. He was especially worried that Danish radio wanted to rebroadcast the show because Barr felt it made the museum look undignified to the well-educated Danes. He particularly disapproved of Walt Disney's statements that films represented a true picture of America, and he said that the president of the University of Chicago was the "boner" of the broadcast for having gotten an art historical fact wrong. He concluded, "There is a certain point at which popularizing becomes vulgarizing. I think we went past that point several times in the opening broadcast." Alfred Barr to Mr. Street, June 12, 1939, file D5, "Writings for MoMA: 1939 Broadcast," microfilm reel 3260, frames 865–66, Barr Papers.

82. Peterson, *The Medium*, 103. Chamberlain also noted the importance of including this layman character. She wrote, "In general there is an attempt to have discussion, probably with laymen present such as taxi drivers, etc. to keep the program lively. No one wants to see a program resembling a college lecture with slides." Betty Chamberlain, letter to Miss Ethel Hoffman, July 30, 1948. In programs and films of this type, the "skeptic" was usually a woman or a working-class man, while the expert was a white man.

83. The actual program is slightly different from the script. I transcribed this dialogue from the kinescope that is housed at the Paley Center for Media, New York, NY.

84. *Dimension*, script, airdate: October 16, 1954, series III, box 18, folder 3, Television Project.

85. Untitled notes, ca. 1954, 2, series III, box 18, folder 3, Television Project.

86. Peterson, *The Medium*, 103.

87. See "Budget for Proposed Series of TV Films on the Subject of Good Design," ca. 1953, series III, box 18, folder 3, Television Project.

88. "Proposal for TV: Good Design," spring 1953, 2, series III, box 18, folder 3, Television Project.

89. "Report on TV Activities," ca. 1953, Box 18: Folder 3, Television Project.

90. "TV Proposal—Good Design at the Table," ca. 1953, series III, box 18, folder 3, Television Project. The proposal included plans for a viewer contest.

91. "Broadcast Text: Margaret Arlen at 8:55 over WCBS-TV (NY)," airdate: March 17, 1954, 2., series III, box 18, folder 3, Television Project.

92. See, for example, T. H. Robsjohn-Gibbings, "American Idiom," *New York Times*, September 24, 1950, 4; Betty Pepis, "Decorating the Walls," *New York Times*, May 31, 1953, 39; Pepis, "Art in the Home"; J. C. Furnas, "You, Too, Can Have Art Treasures," *Saturday Evening Post*, November 3, 1957, 28, 63–64; "Art for Interiors," *Time*, October 5, 1953, 86.

93. In 1968, NBC made Saarinen host of her own morning show, *For Women Only*, which, unlike most morning TV at the time, featured controversial subjects like pro-abortion and anti-Vietnam stands.

94. Aline Saarinen, *The Proud Possessors* (New York: Random House, 1958). Saarinen also edited *Eero Saarinen, on His Work*.

95. Aline Saarinen cited in Beverly Solochek, "Don't Be Fooled by the Title," *New York Post* (ca. 1970). This article is a press clipping in "Writings, Printed Material, Notes and Miscellany," microfilm reel 2076, Saarinen Papers.

96. "Frank Views on Art (Including 'Sacred Cows' are Offered by Critic Aline Saarinen On NBC-TV's 'Today,'" NBC press release February 13, 1963; "Aline in Wonderland," NBC press release, February 27, 1963; and Joe Sheridan, "Art Critic Says Title Stuffy," newspaper clipping (from unknown source) in "Writings, Printed Material, Notes and Miscellany," microfilm reel 2076, Saarinen Papers.

97. "Aline in Wonderland."

98. "Tall, Trim and Talkative," *Variety*, September 5, 1962, 2; Alan Gill, press release for "TV-Radio Today," January 10, 1963, in "Writings, Printed Material, Notes and Miscellany," microfilm reel 2076, Saarinen Papers; "Tall, Trim and Talkative," *Variety*, September 5, 1962, 21. Some fan mail for the *Today* segments contained voyeuristic comments on Saarinen's sex appeal. See Sawelson-Gorse, "Sound Bites and Spin Doctors," in John Alan Farmer, *The New Frontier: Art and Television, 1960–65*, museum catalog (Austin: Austin Museum of Art, 2000), 73.

99. Saarinen cited in Efron, "Why is Aline Saarinen a Cultural Institution?" *TV Guide*, April 25, 1970, 29. She also said this in "Intelluptously Speaking," *Time*, November 3, 1967, 86.

100. Although NBC sought out attractive fem-cees for *Today*, the network thought the housewife audience would reject sexpots, and for this reason the presentation of femininity was carefully controlled. See Spigel, *Make Room for TV*, chapter 3. For an interesting study of the "glamour-puss" problem on early TV, see Christine Becker, "Glamour Girl Classed as TV Show Brain: The Body and Mind of Faye Emerson," *Journal of Popular Culture* 4, no. 2 (summer 2004): 242–60.

101. Harriet Van Horne, "TV Brings Past into the Present," *New York World Telegram and Sun*, May 10, 1965; "Intelluptuously Speaking." Both clippings in "Writings, Printed Material, Notes and Miscellany," microfilm reel 2076, Saarinen Papers; Marya Mannes, "Art on TV," *Art in America* 53, no. 6 (December–January 1965–66): 59. Note that one of Saarinen's first network television appearances was on the August 27, 1962, episode of CBS's *Calendar*, which presented a preview of fall fashions for Yves Saint Laurent and Christian Dior. See "Paris Fall Fashions Previewed on *Calendar*," CBS press release, August 22, 1962, in "Writings, Printed Material, Notes and Miscellany," microfilm reel 2076, Saarinen Papers.

102. Aline Saarinen cited in "Intelluptuously Speaking."

103. The MoMA show aired on May 24, 1964, shortly after Saarinen's critically acclaimed NBC special "The Art of Collecting" (January 19, 1964). Based on her book, *The Proud Possessors*, this documentary visited the homes of prominent art collectors, thereby bridging art with interior décor.

104. "Sunday," shooting script for May 24, 1964 broadcast, 3, in "Writings, Printed Material, Notes and Miscellany," microfilm reel 2076, Saarinen Papers.

105. Mannes, "Art on TV," 59.

106. "Intelluptuously Speaking."

107. In a network memo titled "Selling Color TV," an NBC scriptwriter noted that a

program set in a museum with colorful paintings was a good way to stimulate sales of color sets. Robert D. Graff to Davidson Taylor, memorandum, May 14, 1954, Papers of Davidson Taylor, box 279, folder 69, NBC Records. Also see "TV at the Met," *Art Digest* 28, no. 16 (May 15, 1954): 7.

108. Addressing himself to a tourist class of viewers, Metropolitan Museum of Art director Francis Henry Taylor hosted the program, telling viewers to "enjoy lunch in our magnificent new museum restaurant" and promising prospective visitors they could even "sit down and smoke." "A visit to the Metropolitan is fun as well as exciting," he enthused. In the usual balance between popular pleasure and public service, Taylor concluded, "However, the real value of any museum is not its showmanship but the quality of its collection." See "'A Visit to the Metropolitan Museum of Art,' NBC Television (Compatible Color Broadcast)," script, airdate: May 8, 1954, 4–5, 8, Papers of Davidson Taylor, box 279, folder 69, NBC Records. After the program aired, Davidson Taylor wrote to NBC president Robert Sarnoff, saying, "I thoroughly share your view that we have here the basis for a series of programs in color." See Davidson Taylor to Robert Sarnoff, memorandum, May 11, 1954, Papers of Davidson Taylor, box 279, folder 69, NBC Records.

109. Pages 43–45 of the script for this segment of *Home* are in file 221, "NBC Television," microfilm reel 2178, frame 1197–98, ca. September 1955, Barr Papers. The show aired on September 29, 1995. In this case, the script called for Arlene Francis to voice the skepticism of the "laygal" by telling the audience, "Perhaps you've heard or used such words [as] puzzling or crazy, when referring to modern art?" This is another draft of the *Home* script for the September 29, 1955, broadcast. See "Color Spot," script file 221, "NBC Television," microfilm reel 2178, frame 1199, Barr Papers.

110. Robert W. Sarnoff cited in Mannes, "Art on TV," 57.

111. Saarinen also wrote and hosted NBC's 1965 special on the newly opened Israel Museum, which was transmitted over the "early bird" Comsat satellite, and she wrote and co-hosted the first satellite TV art auction, "Bravo, Picasso!" (NBC, 1967), which covered an international auction of Picasso paintings held at museums in Paris, New York, Texas, and Los Angeles.

112. Edith Efron, "Why is Aline Saarinen a Cultural Institution?" *TV Guide* (April 25, 1970), 29; Beverly Solochek, "Don't Be Fooled by the Title," *New York Post*, ca. 1970, n.p,. in "Writings, Printed Material, Notes and Miscellany," microfilm reel 2076, Saarinen Papers.

113. See *The Museum and Television*, May 1949.

114. Fred Rickey to René d'Harnoncourt, June 19, 1951, series III, box 19, folder 12d, Television Project.

115. Alfred H. Barr Jr., to Mr. Rickey, June 20, 1951, series III, box 19, folder 12d, Television Project.

116. *Through the Enchanted Gate* was funded by NBC and produced by Victor D'Amico, the director of the Department of Education at MoMA. The brainchild of D'Amico and NBC vice president Ted Cott, it was critically acclaimed. The program was participatory in nature, encouraging children at home to send in their art projects and also encouraging parents to write to NBC to receive a free printed guide to the program. Over 3,200 parents submitted requests. See Michelle Harvey, "Through the Enchanted Gate: The Modern on TV," *MoMA Magazine*, September 2001, 27–29.

117. Peterson, *The Medium*, 45–47.

118. "Projects," 2–3. Another report stated, "Although precautions had been taken to avoid a stylistic resemblance to Dufy's drawings in the animated sequences, it was felt that a slight sense of parody had crept in." See Macagy, *The Museum Looks in on TV*, 202.

119. See Elizabeth Tillet, "Case Studies," appendix in Macagy, *The Museum Looks in on TV*, 225.

120. Tillet, "Case Studies," 266. Prints of the films are in the Celeste Bartos Film Study Center at MoMA, New York, NY.

121. Committee on Art Education—TV Seminar, "Text for Introductory Speech," ca. 1954, series III, box 18, folder 3, Television Project.

122. Tillet, "Case Studies," 267.

123. "Description of Series," n.d., 1, series III, box 20, folder 16b, Television Project.

124. As one report said, Peterson "was hoping to open the eyes of the audience to things they looked at every day without seeing." "Description of Series," 2.

125. The film is now in MoMA's Celeste Bartos Film Study Center. It was conceived by Peterson and directed by Ruth Cade.

126. "Description of Series," 1.

127. Committee on Art Education—TV Seminar, "Text for Introductory Speech."

128. *Point of View*, report, n.d., series III, box 20, folder 16b, Television Project.

129. *Point of View*, report.

130. Assistant secretary at MoMA (no name) to Mavro Television Company, March 18, 1955, series III, box 20, folder 16b, Television Project. The museum also stipulated that the narration would be pulled from the film. Macagy said, "The narration was brash; the effect could be too closely associated with the aesthetically inhibitive outlook encouraged by commercial broadcasting." *The Museum Looks in on TV*, 205.

131. As Macagy suggested, "Some [curators] fear the stigma of the popularizer. . . ." See *The Museum Looks in on Television*, 21.

132. See especially his *The Field of Cultural Production* (New York: Columbia University Press, 1993).

133. Douglas Macagy, "The Museum on TV—Art at Second Hand," *Art in America*, March 1957, 50–51. In his autobiography, Peterson recalled his work for MoMA with more sanguine (if often sarcastic) resignation. In 1955, when the TV Project ended, he returned to Los Angeles where he worked for UPA and later Disney. See Peterson, *The Dark Side of the Screen*.

134. Vincent Price cited in transcribed speech before the American Federation of the Arts, "Banquet, Guest Speaker, Vincent Price," Shamrock-Hilton, Houston, TX, April 5, 1957, 12, Fondren Library, Rice University, Houston, TX. The transcription indicates numerous moments of audience laughter at jokes about highbrow intellectualizations of art by psychologists and critics who also spoke at the banquet.

135. Macagy, *The Museum Looks in on Television*, 19.

136. For more on artists who used TV as a source for their paintings, see chapter 7.

137. Macagy speculated on changes in museum display caused by television in *The Museum Looks in on Television*, 9.

138. MoMA's library efforts were part of a wider archive movement of the era. As early as 1959 the American Academy of Television of Arts and Sciences began planning a TV Library, and by 1967 it put its collections on permanent loan at the University of Califor-

nia, Los Angeles. In addition, in the early 1960s, Hollywood stars and industry workers teamed up with city officials in an effort to create the Hollywood Museum, devoted to film, television, radio, and the recording arts. Although the plans did not materialize, an architectural model of the museum was made by none other than William Pereira. For more, see Lynn Spigel, "Our TV Heritage: Television, the Archive, and the Reasons for Preservation," in *A Companion to Television*, ed. Janet Wasko (London: Blackwell, 2005), 67–102.

139. See Betty Chamberlain to René d'Harnoncourt, memorandum, April 11, 1952, series III, box 18, folder 3, Television Project.

140. Richard Griffith to Douglas Macagy, memorandum, July 24, 1952, series III, box 18, file 2a, Television Project.

141. In 1957 the Film Library made its first TV acquisition, a kinescope of a live television production, Horton Foote's *The Trip to Bountiful*, with Lillian Gish. Richard Griffith, "A Report on the Film Library, 1941–1956," bulletin XXIV, no. 1 (Fall 1956): 14. Griffith discussed the vexing issue of copyright law at length. Richard Griffith, "Appendix 3: Prospect for a Television Archive," in Macagy, *The Museum Looks in on Television*.

142. Haidee Wasson, *Museum Movies: The Museum of Modern Art and the Birth of Art Cinema* (Berkeley: University of California Press, 2005). See also, DeCherney, *Hollywood and the Culture Elite*, chapter 4; Alison Trope, "Mysteries of the Celluloid Museum: Showcasing the Art and Artifacts of Cinema" (Ph.D. diss., University of Southern California, Los Angeles, 1997).

143. Jac Venza, ed., *Television USA: 13 Seasons* (New York: The Museum of Modern Art Film Library and Doubleday, 1962), 15.

144. Abe Liss in Venza, *Television USA: 13 Seasons*, 38.

145. See Lucy R. Lippard's discussion of New York pop in *Pop Art* (New York: Praeger, 1966), especially 69–90.

146. Gregory Battcock, "The Sociology of the Set," in *The New Television: A Public/Private Art*, ed. Douglas Davis and Allison Simmons (Cambridge, MA: MIT Press, 1978), 21. This was the publication that came out of the "Open Circuits" conference.

147. This blurb is an excerpt from a review by *American Cinematographer*. Emphasis mine.

CHAPTER 5

1. Script, "Saturday Night Color Carnival," script, airdate: January 19, 1957, Ernie Kovacs Papers, 1940–62, The Charles E. Young Research Library, Department of Special Collections, University of California, Los Angeles (hereafter referred to as the Kovacs Papers). Kovacs improvised on the script in the on-air version, but the content was basically the same. The on-air version is in the Paley Center for Media, New York, NY.

2. See, for example, Robert Rosen, "Ernie Kovacs: Video Artist," in *Transmission*, ed. Peter D'Agostino (New York: Tanam Press, 1985), 143–49.

3. Bruce Ferguson, "The Importance of Being Ernie: Taking a Close Look (and Listen)," in *Illuminating Video: An Essential Guide to Video Art*, ed. Doug Hall and Sally Jo Fifer (San Francisco: Aperture, 1990), 350.

4. Minow, "The Vast Wasteland," 52.

5. Michel Chion, *Audio-Vision: Sound on Screen*, ed. and trans. Claudia Gorbman (New York: Columbia UP, 1994).

6. For theories of the aesthetics of talk and/or sound on television, see Margaret Morse, "Talk, Talk, Talk: The Space of Discourse on Television," *Screen* 26, no. 2 (March–April 1985): 2–15; Rick Altman, "Television/Sound," in *Studies in Entertainment: Critical Approaches to Mass Culture*, ed. Tania Modleski (Bloomington: Indiana University Press, 1986), 39–54; Sean Cubitt, *Videography: Video Media as Art and Culture* (New York: St. Martin's Press, 1993), 110–29; Chion, *Audio-Vision*.

7. Chion, *Audio-Vision*, 165. It should be noted that silent film was itself not silent—at least when we consider the reception conditions in which these films were exhibited. Piano music, orchestra pits, sing-alongs, lectures, and the noise of projectors were part of the silent-film experience. See Rick Altman, *Silent Film Sound* (New York: Columbia University Press, 2005).

8. Rudolf Arnheim, "In Praise of Blindness," in *Radiotext(e)*, ed. Neil Strauss (New York: Semiotext(e), 1993), 20–25. The 1936 original is in Arnheim's *Radio: An Art of Sound*, trans. Margaret Ludwig and Herbert Read (London: Faber & Faber, 1936); Rudolf Arnheim, "A Forecast of Television," *Film as Art* (1957; repr., Berkeley: University of California Press, 1967), 194. The essay was originally published in *Intercine*, a periodical of the International Institute for Educational Film, in 1935.

9. This is one of the very first ads for television sets. See the John W. Hartman Center for Sales, Advertising, and Marketing History, Emergence of Advertising in America 1850–1920, online collection at http://scriptorium.lib.duke.edu. I discuss these types of advertisements at length in *Make Room for TV*.

10. Thomas H. Hutchinson, *Here Is Television: Your Window on the World* (New York: Hastings House, 1946). Hutchinson was a producer of television programs.

11. CBS advertisement, ca. 1953, personal collection, source unknown.

12. Jonathan Sterne, *The Audible Past: Cultural Origins of Sound Reproduction* (Durham, NC: Duke University Press, 2003), 219, 222–23.

13. Jane Feuer, "The Concept of Live Television: Ontology as Ideology," in *Regarding Television: Critical Approaches—An Anthology*, ed. E. Ann Kaplan (Los Angeles: American Film Institute, 1984), 12–21; Stephen Heath and Gillian Skirrow, "Television: A World in Action," *Screen* 18, no. 2 (Summer 1977): 7–59; William Boddy, *Fifties Television*; Altman, "Television/Sound,"; Spigel, *Make Room for TV*, chapter 5; Jerome Bourdon, "Live Television Is Still Alive: On Television as an Unfulfilled Promise," in *The Television Studies Reader*, ed. Robert C. Allen and Annette Hill (London: Routledge, 2004), 110–23.

14. Altman, "Television/Sound," 49–50.

15. Mark Slouka, "Listening for Silence: Notes on the Aural Life," in *Audio Culture: Readings in Modern Music*, ed. Christoph Cox and Daniel Warner (New York: Continuum, 2005), 42.

16. For more on the quiz show scandals see William Boddy, "The Seven Dwarfs and the Money Grubbers: The Public Relations Crisis of US Television in the Late 1950s," Mellencamp, *Logics of Television*, 98–116.

17. See, for example, "Public Sparks War on TV Commercials," *Los Angeles Times*, November 2, 1959, 12; "FTC Charges Mennen Used Deception in TV Commercial," *Wall Street Journal*, November 11, 1960, 18; "GM. Libbey-Owens' TV Commercials Called Misleading by FTC," *Wall Street Journal*, November 5, 1959, 13; "Pursuit of the Beard," *Wall Street Journal*, May 28, 1964, 14.

18. Jacob Smith, "The Frenzy of the Audible: Pleasure, Frenzy, and Recorded Laughter," *Television and New Media* 6, no.1 (February 2005): 23–47.

19. Ralph Morse, "RX for Comedy: Kovacs," *Life*, April 15, 1957, 167–77; Philip K. Scheuer, "A Town Called Hollywood: It Doesn't Seem There's Much to Laugh About," *Los Angeles Times*, November 17, 1957, F2; Larry Wolters, "A Crying TV Need: Laughs!" *Chicago Tribune*, April 10, 1958, C6; Cynthia Lowry, "Comedians Branch Out in Search of Survival," *Chicago Tribune*, January 29, 1961, NWC. For discussion, see Spigel, *Make Room for TV*, 147.

20. See Jack Gould, "Live TV vs. Canned," *New York Times Magazine*, February 5, 1956, 27; and "CBS Revises TV Policy to End Program 'Deceits,'" *New York Times*, October 20, 1959, 1, 42.

21. Frederic Wakeman, *The Hucksters* (New York: Rinehart & Company, 1946); Vance Packard, *The Hidden Persuaders* (New York: David MacKay, 1957). MGM released a film version of *The Hucksters* in 1947. Other films that took a derisive look at radio/TV advertisers include *The Seven Year Itch* (1955), *A Face in the Crowd* (1957), *Lover Come Back* (1961), and *Good Neighbor Sam* (1964).

22. "Poll Shows Listeners Skeptical of TV Ads," *Los Angeles Times* December 6, 1959, 11. This and other studies also suggested that viewers thought some commercials were in poor taste. See "Television—Viewers Critical of Commercials," *Printers' Ink*, September 18, 1964, 59. A study conducted by the American Association of Advertising Agencies (AAAA) found that 21 percent of its sample population felt unfavorable toward advertising because it was false or misleading, and that 3 percent objected because "commercials were too loud or too long." American Association of Advertising Agencies, *A.A.A.A. Study on Consumer Judgment of Advertising: An Analysis of Principle Findings*, condensed and edited version of the presentation made to government officials at the invitation of Mrs. Esther Peterson, special assistant to the president for consumer affairs, Washington, D.C. (New York: American Association of Advertising Agencies, 1965), 13 (hereafter referred to as *A.A.A.A. Study*).

23. Social Science Research Inc., "Television's Challenge to Creativity," *Art Direction* 9, no. 12 (March 1958): 33.

24. Jean Wade Rindlaub cited in Wolff, *What Makes Women Buy*, 260.

25. "FCC Finds Little Use of Louder Volume in Radio, TV Commercials," *Wall Street Journal*, December 24, 1956, 8. Upon hearing of the FCC findings, Jack Gould of the *New York Times* disagreed and invited the networks and FCC to "listen for themselves." See Gould, "Plugs in Review," *New York Times*. April 5, 1959, X15.

26. In the same year, Congressional hearings on the FCC proposed rules to limit the length and frequency of commercials. United States Congress, House Committee on Interstate and Foreign Commerce, Broadcast Advertisements: Hearings before a Subcommittee of the Committee on Interstate and Foreign Commerce, House of Representatives, 88th Cong., 1st. sess., on HR 8316 [and other] bills to amend the Communications act of 1934 to prohibit the Federal Communications Commission from making certain rules relating to the length or frequency of broadcast advertisements. November 6, 7, and 8, 1963, Washington, D.C.: U.S. Government Printing Office, 1963.

27. "FCC to Ask Stations to Tune Down Loud Radio-TV Commercials," *Wall Street Journal*, July 12, 1965, 6.

28. CBS advertisement, *New York Times*, January 26, 1959, 53.

29. "Sound Meter May Curb Loud TV Commercials," *Wall Street Journal*, April 3, 1967, 18.

30. Jacques Attali, "Noise and Politics," in Cox and Warner, *Audio Culture*, 7–9.

31. Jacques Attali, *Noise: The Political Economy of Music* (Minneapolis: University of Minnesota Press, 1985), 8. In this book Attali argues that what counts as music is always socially produced, and in this regard music ideals have been dependent on the simultaneous social construction of its opposite, "noise"—the boundary line that defines all music is not. Music is always threatened by a tasteless invasion of someone else's noise (and usually that someone else is already an outsider to the social order in which music is produced). Similarly, I would argue, in the case of broadcast sound, pleasurable listening was always defined against invasive noises—static, interference, and, in this case, the din of commercial babble.

32. For a summary of these kinds of studies, see Karl D. Kryter, "The Effects of Noise on Man," *Journal of Speech and Hearing Disorders*, Monograph Supplement 1 (1950). In *The Soundscape of Modernity: Architectural Acoustics and the Culture of Listening in America, 1900–1933* (Cambridge, MA: MIT, 2004), Emily Thompson discusses the related phenomenon of noise abatement campaigns during the Progressive Era and the creation of zoning laws intended to restore peace to noisy industrial cities (120–30).

33. Rita Reif, "Suggestions to Cut Down Home Noise," *New York Times*, October 21, 1957, 30. Addressed to a male reader, the article suggests that in addition to loud appliances, the other major causes of noise in the home are "the wife and children."

34. Real cited in "Report: Ninth International Design Conference in Aspen," June 23, 1959, box 5, Golden Collection, 26–28.

35. Fellows cited in "Ad Critics Aim Fire at 4 Targets," *Printers' Ink*, April 2, 1954, 48.

36. "Quiets Television Clatter,'" *Wall Street Journal*, December 13, 1954, 9. For other such devices, see "Quiets Noisy TV Sets," *Wall Street Journal*, June 19, 1953, 16; "TV Headset Lets Dad Snooze as Junior Listens," *Wall Street Journal*, February 1, 1954, 4; and an ad for "TV Phones" in *New York Times*, February 7, 1954, X13.

37. Val Adams, "Even the Dogs Howl at Those Ads," *New York Times*, December 26, 1965, X15. More resourceful viewers devised counterattacks. In 1961 one woman wrote to the *Los Angeles Times* boasting of her consumer boycott of "sponsors who blare commercials so loud on TV that it wakes the baby." She added, "When a product advertises in a normal voice on TV, we change to that product immediately." J. I. Tracey to editor, "We Get Letters," *Los Angeles Times*, January 22, 1961, E47.

38. *A.T.S. Newsletter* 6, no. 2 (February 1947): 2.

39. During the late 1940s, Marcel Marceau revived pantomime on the Paris stage and by the mid-1950s he was known to American audiences and appeared on TV variety shows.

40. Larry Wolters, "Pantomime Art Is Revived by TV Funny Men," *Chicago Tribune*, April 1, 1951, A17.

41. For overviews of his television work and biographies of Kovacs, see Diana Rico, *Kovacsland: A Biography of Ernie Kovacs* (New York: Harvest Books, 1990); David G. Walley, *The Ernie Kovacs Phile* (New York: Simon and Schuster, 1975).

42. See, for example, "Utility Expert," *Time*, January 28, 1957, 66.

43. Murray Schumach, "Kovacs Explains Wordless Shows," *New York Times*, December 21, 1961, 31.

44. At the opening and closing of the show, a conductor falls into a drum filled with bread dough.

45. Although very few people had color receivers at this time, the network and sponsor were keen to test color transmission.

46. This reprise of Eugene was included in ABC Special #6 aired on November 24, 1961.

47. More generally, Kovacs used framing tricks to create audio-visual surprises that reveal the artificial nature of television's pictorialism, its framing of the world. Kovacs had a deep interest in comic strips (which are also centrally concerned with the visual frame in relation to the unfolding of humor in narrative time). See Schumac, "Kovacs Explains Wordless Shows," 31; Helen Dudar, "Nothing but Best for Ernie Kovacs," *New York Post*, April 6, 1968, 33.

48. "The Saturday Night Color Carnival," script, Kovacs Papers. The harp was likely there both for Robert Maxwell's "Solfeggio" as well as for Harpo Marx, whom Kovacs initially suggested as the guest star for the episode in this script.

49. Kovacs originally wanted to have silent commercials in this show, but the "small-minded advertiser wouldn't go along with him." See Cecil Smith, "No Words Minced—Kovacs Is Fun," *Los Angeles Times*, November 24, 1961, A16.

50. Dwight Newton, untitled article, *San Francisco Examiner*, January 22, 1957, box 19, folder titled "The Saturday Night Color Carnival," Kovacs Papers. The Lewis show was actually the first hour of *The Saturday Night Carnival* special.

51. *Time*, January 28, 1957, 66, box 109, folder 103, Kovacs Papers.

52. Frederic Morton, "Ernie Kovacs: The Last Spontaneous Man," *Holiday*, October 1958, 87–156.

53. The Kovacs ABC specials aired from April 20, 1961, through January 23, 1962. They were irregularly scheduled. Kovacs was producer, writer, host, codirector, and principle performer. The last special aired after his death.

54. The show was broadcast April 20, 1961.

55. The "Kitchen Symphony" appeared in Special #4 (ABC, September, 2, 1961). It is a montage with kitchen utensils, a dancing chicken, paper rolling off a paper roll, a jumping coffee pot, sardines rolling out of a can, a peeling banana, toast popping up, an exploding salad, and it ends on the dancing chicken.

56. Kovacs to "All Concerned," memorandum, ca. June 1, 1961, box 22, folder titled "Ernie Kovacs Special #3," Kovacs Papers. Although this is in a folder marked Special #3, it is actually about Special #4.

57. Sergei Eisenstein, Vsevolod Pudovkin, and Grigori Alexandrov's, "A Statement on the Sound-Film" (1928) is published in Sergei Eisenstein, *Film Form: Essays in Film Theory*, trans. Jay Leyda (1949; repr., New York: Harvest, 1969), 257–60.

58. See, for example, Daniel Albright, ed., *Modernism and Music: An Anthology of Sources* (Chicago: University of Chicago Press, 2004); Douglas Kahn, *Noise, Water, Meat: A History of Sound in the Arts* (Cambridge, MA: MIT, 2001); Thompson, *The Soundscape of Modernity*, 134–38; Umbro Apollonio, *Futurist Manifestos* (Boston: MFA Publications,

1970); Rosalee Goldberg, *Performance Art: From Futurism to the Present* (New York: Thames and Hudson, 2001); Timothy Taylor, *Strange Sounds: Music, Technology and Culture* (New York: Routledge, 2001).

59. Given his interest in all styles of music, it seems likely that Kovacs would have known of Cage.

60. Rosen, "Ernie Kovacs: Video Artist"; Ferguson, "The Importance of Being Ernest"; Walley, *The Ernie Kovacs Phile*.

61. Edgar Penton, "Give 'Em the Unexpected Is Versatile Ernie Kovacs Creed," *Plain Dealer*, June 10–11, 1961, box 109, scrapbook 2, Kovacs Papers.

62. Harriet Van Horne, "Fun-House Revisited," *World Telegram Sun*, May 19, 1961, box 109, scrapbook 2, Kovacs Papers.

63. "Kovacs Clouds Past in Puffs of Smoke," *Los Angeles Examiner*, April 20, 1961; Marie Torre, n.t., *New York Herald Tribune*, May 19, 1961; Dwight Nelson, "The Riddle of the Ernie Kovacs TV Show," *San Francisco Examiner*, October 22, 1961; all in box 109, scrapbook 2, Kovacs Papers; "King Leer," *Newsweek*, September 18, 1961, 64. See also Hank Grant, "The Ernie Kovacs Special ABC-TV, April 20, 10:30–11 pm," *Hollywood Reporter*, April 21, 1961, box 23, folder titled "Correspondence," Kovacs Papers. In line with the praise Kovacs received for toning down TV noise, Grant commented, "Another blessed twist: no audience or laugh track—and we never laughed harder!"

64. Warner Twyford, "TV's Creative Talent," *Virginia Pilot*, April 24, 1961; Sherwood Kahn, "Zany Kovacs in Orbit . . . Out of Control," *Louisville Times*, Kentucky May, 19, 1961; both in box 109, scrapbook 2, Kovacs Papers.

65. "Speaking of Pictures," *Life*, February 19, 1951, 12–13.

66. Jack Gould, "TV: Fun with Kovacs," *New York Times,* July 3, 1956, 51. Gould added, "For some viewers he may be an acquired taste."

67. Ernie Kovacs, *Zoomar* (Garden City, NY: Doubleday, 1957).

68. Norman Shavin, "$5,000 for Two Hours Work," *Atlanta Journal and Constitution*, ca. August 1959, 13A, box 107, scrapbook 2, Kovacs Papers.

69. "The Eddie Fisher Show," script, airdate: September 30, 1958, box 33, folder titled "Eddie Fisher Show"; " Dinah Shore Chevy Show," script, airdate: November, 24, 1957, box 33, folder titled "Guest on Dinah Shore Chevy Show"; "Perry Como Show," script, airdate: February 23, 1957, box 19, folder titled "Perry Como Show." All in Kovacs Papers.

70. "Kovacs on Music" aired on May 22, 1959.

71. Bourdieu, *Distinction*.

72. "Ernie Kovacs, Edie Adams offer ideas for Intellectuals," *TV Guide*, May 14–20, 1960, 28–30.

73. Morton, "Ernie Kovacs," 89. The *Person to Person* episode turned out to be the perfect showcase for Kovacs's counter-distinctive tastes. Ironically, the first guest on the episode was etiquette expert Amy Vanderbilt, who showed viewers around her tastefully appointed Connecticut country home.

74. Harry Henderson, "Rugged American Collectivism: The Mass Produced Suburbs: Part II," *Harpers*, December 1953; William H. Whyte Jr., *The Organization Man* (1956; repr., Garden City, NY: Double, 1957).

75. "King Leer," 64.

76. Mrs. Olga Beck to Ernie Kovacs, January 2, 1960, box 58, folder 3; Mrs. Jacob Fox to Ernie Kovacs, April 9, 1954, box 55, folder 2. Both in Kovacs Papers.

77. Of the two, Allen's more typical variety/talk show was certainly easier to format and he enjoyed more success on the networks. But, as the commentary cited herein suggests, critics typically saw Kovacs as the "genius."

78. Kovacs cited in Sid Bakal, "Ernie Talks about Comedy," *New York Herald Tribune,* June 11–17, 1961, sec. 9, 50, box 109, scrapbook 2, Kovacs Papers. A photospread in *Life* did show Ernie and Edie lying in bed, watching "twin TV sets" with their little dog Lolita between them. But given that the photo was clearly staged and the twin TVs suggested an "offbeat" viewing style, this photograph functioned more as a Kovascian sight gag than as a document of their everyday lives as TV viewers. See Morse, "RX for Comedy: Kovacs," 167.

79. Although some speculate that Fred Allen said this first, Kovacs is often cited for having said, "Television—a medium. So called because it is neither rare nor well-done."

80. Hedda Hopper, "Kovacs Makes Pitch for California Living," *Chicago Tribune,* December 29, 1959, 17.

81. "King Leer," 64.

82. Mrs. Haladen H. Hungate to Ernie Kovacs, September 30, 1956, box 61, folder 5; Mrs. Edward Joseph Schmidt to Ernie Kovacs, May 25, 1959, box 58, folder 3; Mrs. Ann Davidson to Ernie Kovacs, October 2, 1954, box 55, folder 6. All in Kovacs Papers.

83. Robert Marks to Ernie Kovacs, May 25, 1959, box 62, folder 4, Kovacs Papers.

84. Mrs. Ed Blackwell to Ernie Kovacs, October 23, 1956, box 61, folder 5, Kovacs Papers.

85. Mr. Thomas Kullman to Ernie Kovacs, letter and artwork, ca. 1959, box 58, folder 3; Mr. C. H. Trutner to Ernie Kovacs, letter and artwork, ca. 1954, box 55, folder 2; Mrs. Betty Gluckman to Ernie Kovacs, letter and artwork, ca. 1955, box 58, folder 4; Marjorie L. Sheldon to Ernie Kovacs, letter and artwork, June 5, 1959, box 58, folder 3. All in Kovacs Papers.

86. Henry Jenkins, *Convergence Culture* (New York: NYU Press, 2006).

87. Tellingly in this regard, in his novel *Zoomar* Kovacs portrays not the advertisers, but the network suits as the villains. At the end of the novel his hero says, "And the networks can't blame the sponsors. The cost-accounting system you have all fallen into is making decent programming impossible" (346).

88. Even before Kovacs's silent ads, in 1951 Y&R used silent interludes in its ads for *Schlitz Playhouse.* The trade journal *Televiser* spoke of one such commercial, characterized by "restraint and good taste" that "entirely eliminates all audio elements, except for the musical accompaniment." See "Art for Beer's Sake," *Televiser,* January 1951, 11. It is difficult to know if Kovacs was aware of this commercial, but none of the critical commentary on his ads remarked on it, and instead attributed the discovery of the silent commercial entirely to Kovacs.

89. For critical praise of the ads, see "What's New: Kovacs, Freberg, Shaggy Dogs," *Advertising Age,* March 21, 1960, box 102, folder 2; Alan Patureau, "Even Commercials Are Silent on Kovacs' *Silents Please!" Atlanta Journal,* April 20, 1961, box 109, scrapbook 2. Both in Kovacs Papers.

90. The commercial is described in "Kovacs: He Made TV Selling Fun," *Printers' Ink,* April 13, 1962, 58; and "TV Preview," *Broadcasting,* October 5, 1959, box 107, scrapbook 2, Kovacs Papers. A version of this commercial also appears after the opening credits in the ABC special that reprised the Eugene skit.

91. This was the middle commercial in the ABC special that reprised the Eugene skit.

92. Kovacs cited in Penton, "Give 'Em the Unexpected," n.p.

93. Seymour Soloman to Ernie Kovacs, ca. 1959; Mona Gibbs to Ernie Kovacs, November 5, 1959; Mrs. Art Treadwell to Ernie Kovacs, December 11, 1959. All in box 58, folder 3, Kovacs Papers.

94. "How to Persuade a Lady," *Printer's Ink,* August 31, 1956, 22; "The Arty Sell—And to Men at That!" *Sponsor,* January 18, 1958, 36–37.

95. The ad ran in the *Saturday Evening Post.* See "Ad to Help Smoke Get in Your Eyes," *New York Times,* July 11, 1957, 34.

96. As an article in *Printers' Ink* noted, Kovacs's shows were aimed at the "gourmet of smokers." See "Kovacs: He Made TV Selling Fun," 58.

97. Jack Mogulescu cited in ibid., 60.

98. Bob Davis cited in ibid. Davis worked at the advertising agency Papert, Koenig, Lois, which had the account for the ABC specials.

99. See "What's New: Kovacs, Freberg, Shaggy Dogs."

100. Ibid.; Walley, *The Ernie Kovacs Phile,* 193.

101. Patureau, "Even Commercials Are Silent."

102. Ralph Porter, "Pictorial Contrasts Reincarnated," *Art Direction* 10, no. 7 (October 1958): 16.

103. See, for example, *The Patty Duke Show* ("Fiancé for a Day," 1966); *Gilligan's Island* ("Castaways Pictures Presents," 1965).

104. Throughout the 1950s, Keaton experienced a TV comeback, not only in a short-lived sitcom (*The Buster Keaton Show,* 1952) but also on numerous variety shows and anthology dramas invoking his silent-film persona.

105. "Old Silent Films Are Booked for WJZ Video on Sunday Nights Starting Next Week," *New York Times,* October 1, 1948, 50.

106. *Laughter USA* was part of NBC's series *Dumont Show of the Week.* In 1961, NBC featured a special devoted to Cecil B DeMille titled *The World's Greatest Showman.*

107. Following Kovacs, Jay Ward's 1963 series, *Fractured Flickers,* re-edited and parodied silent films.

108. Filling in for the deceased Kovacs after his death, on a 1963 ABC special Sid Caesar did a silent show (and silent commercials for Dutch Masters) that featured Caesar in a pantomime routine about the rise and fall of a silent-film star. Rather than Kovacs's audiovisual experimentation, the show was a stock parody of silent movies. Caesar was given a special award at the Clio Award ceremonies in 1963 for his Dutch Masters commercials. Peter Bart, "Advertising: 'Clio' Awards Are Presented," *New York Times,* May 27, 1963, 54.

109. Peter Bart, "Advertising: The Art of Selling with Silence," *New York Times,* September 17, 1963, 69.

110. Ralph Porter, "Pictorial Contrasts Reincarnated: A Commercial without Words—A New Television Series," *Art Direction* 10, no. 7 (October 1958): 16.

111. Schnitzer cited in ibid.

112. Schnizter cited in *Print* (1959) Special Issue: Report on the 9th Annual IDCA, 36, box 5, Golden Collection.

113. "The Adult Commercial," *Printers' Ink*, March 23, 1962, 21–40.

114. Jack Gould, "Plugs in Review: Ingenuity, Inanity Mark Some TV Commercials," *New York Times*, April 5, 1959, X15; Patureau, "Even Commercials are Silent." Also see Morrie Rysking, "'Soft-Sell' Pays Off in Prestige," *Los Angeles Times*, December 13, 1961, B5.

115. For descriptions of these commercials, see "Outstanding Television Ads," *Printers' Ink*, January 13, 1967, 26; "What's Best in TV," *Art Direction* 17, no. 4 (July 1965): 62.

116. Stephen Frankfurt cited in Bart, "Advertising: The Art of Selling with Silence," 69.

117. Ibid.

118. "The Adult Commercial," 21–40.

119. Ralph Porter, "Film Art: The Charm of Non-Shouting," *Art Direction* 13, no. 12 (March 1962): 57.

120. Ralph Porter, "The Still Photographer as Movie Maker," *Art Direction* 15, no. 3 (June 1963): 75.

121. Porter, "Pictorial Contrasts Reincarnated," 16.

122. Schnitzer cited in Report on the 9th Annual IDCA, 35.

123. Lee Savage, "TV's One Minute World Is the New Entertainment," *Art Direction* 17, no. 9 (December 1965): 72.

124. Ibid.

125. Irving A. Taylor, "Aimed TV: Cultivating the Language of Silence: A Call for Samurai Ads," *Art Direction* 15, no. 12 (March 1964): 74.

126. Slouka, "Listening for Silence," 45.

127. Art Seidenbaum, "Visual 'Pitch' Replacing TV's Amateur Salesmen," *Los Angeles Times*, December 13, 1963, D21.

128. Harold C. Schonberg, "The New Age Is Coming," *New York Times*, January 14, 1968, D15.

CHAPTER 6

1. Irving A. Taylor, "Ads a Go-Go: Dynamic Oases in a Desert of TV Wasteland," *Art Direction* 16, no. 7 (October 1965): 52.

2. Frank, *The Conquest of Cool*.

3. Barbara Wilinsky, *Sure Seaters: The Emergence of Art House Cinema* (Minneapolis: University of Minnesota Press, 2001).

4. Jerry Schnitzer cited in Report on the 9th Annual IDCA, 38; Arthur Bellaire, *Advertising: A Handbook of Modern Practice* (New York: Harper and Brothers, 1959), 84. Bellaire was vice president in charge of television and radio copy at BBDO.

5. Bellaire, *Advertising*, 103–4. Fully animated ads cost roughly twice as much as a live commercial, and even limited animation was expensive and labor intensive.

6. Ibid., 100.

7. The price of color receivers started to go down in 1964, but the color boom did not take place until after the 1966–67 season. In 1968 only 24.2 percent of U.S. households had color sets; in 1972 more than half (52.6 percent) of households had color sets, and for the first time the sale of color receivers surpassed the sale of black-and-white sets; in 1975

more than two-thirds (70.8 percent) of households had color sets; and by 1978 78 percent of households had a color receiver. See Cobbett Steinberg, *TV Facts* (New York: Facts on File, 1980), 144. NBC, which held the RCA color standard patents, was the most aggressive network in the move to color. By the 1965–66 season, all but one and a half hours of NBC's prime time programs were in color. See Lynn A. Yeazel, "The History of Color Television," in *American Broadcasting: A Sourcebook on the History of Radio and Television*, ed. Lawrence W. Lichty and Malachi C. Topping (New York: Hastings House, 1975), 79.

8. Harry Wayne McMahan, *The Television Commercial: How to Create and Produce Effective TV Advertising* (New York: Hastings House, 1957), 23.

9. American Association of Advertising Agencies, *A.A.A.A. Study,* 18, 24.

10. Unnamed advertising executive cited in Jack Roberts, "Way Out West," *Art Direction* 16, no. 12 (March 1965): 114.

11. "Ad Men Want Better TV—But Not by Fiat," *Printers' Ink* (October 6, 1961): 13. Richard A. Pinkham, senior vice president in charge of broadcast operations at Ted Bates & Co. (one of the major television sponsors) expressed similar disappointment with television. See Peter Bart, "Advertising: TV 'Illness' Called Temporary," *New York Times*, July 27, 1961, 42. For more advertiser debates about the wasteland, see "Programming: The Great TV Debate," *Advertising Week*, February 16, 1962, 21–26; "Is TV Really Too Commercial?" *Printers' Ink*, February 9, 1962, 25–33.

12. Schnitzer cited in Report on the 9th Annual IDCA, 38.

13. Philip H. Dougherty, "Key Man in TV," *New York Times*, December 15, 1968, F18.

14. Some of these companies (such as Warner/Filmways or EUO/Screen Gems) were mergers between studio industrial film units and independent commercial production houses.

15. There was also competition and infighting among agency art directors and film directors at the commercial production houses because each sought to control the commercial's aesthetic features but had different kinds of expertise. See Stephen Baker, "Have TV Art Directors Come of Age?" *Art Direction* 9, no. 6 (September 1957), 102; Ralph Porter, "The New-Wave Agency Film Maker," *Art Direction* 15, no.1 (April 1963), 21; "TV Ads Are Becoming AD/Producers," *Art Direction* 16, no. 12 (March 1965), 84–85; Linda Pivar, "Art Directing the TV Commercial," *Art Direction* 17, no. 1 (April 1965), 111.

16. Porter, "The Still Photographer as Movie Maker," 75.

17. Vichniac admitted, "I did not make money from my film journalism but I did make money from soap companies." See Report on the 9th Annual IDCA, 40.

18. Schnitzer, cited in ibid., 35, 38.

19. Ibid., 34–35.

20. Ralph Porter, "The Trial: Composition in Motion," *Art Direction* 15, no. 2 (May 1963): 80. *La Parisienne* was originally released in Europe in 1957.

21. Ralph Porter, "Graphics of the Subconscious," *Art Direction* 15, no. 7 (October 1963): 142; Ralph Porter, "Go Go Go with Stock Shots & Sound," *Art Direction* 14, no. 12 (March 1963): 55.

22. Ralph Porter, "Film Art: The Influence of Bergman and Fellini on Commercials," *Art Direction* 14, no. 8 (November 1962): 94. The Zee tissue TVC was titled "Softness" and produced by DDB. It seems likely Porter was referring to the Clio-award-winning Zee's napkin commercial titled "King," also produced by DDB.

23. Ralph Porter, "Exuberance or Lethargy: The Validity of Theatricalism," *Art Direction* 15, no.11 (February 1964): 58; Ralph Porter, "Film Art," *Art Direction* 15, no. 11 (February 1964): 58.

24. Murray Duitz, "'65 New York Film Festival," *Art Direction* 17, no. 9 (December 1965): 82.

25. Don Baron, "Go See *Blow-Up!*" *Art Direction* 19, no. 1 (April 1967): 16.

26. For a classic discussion of generic characteristics of art cinema see David Bordwell, *Narration in the Fiction Film* (Madison: University of Wisconsin Press, 1985).

27. Mike Elliot, Alvin Chereskin, and Jack Roberts cited in "What Happened in Ad Art in 1966?" *Art Direction* 18, no.10 (January 1967): 88.

28. Ralph Porter, "TV Commercials Often Draw on Avant-Garde Films," *Art Direction* 13, no. 9 (December 1961): 63.

29. "Few American Commercials Cop First Prizes at Cannes," *Art Direction* 13, no. 9 (December 1961): 82–85; "TV Commercials' World Series," *Sponsor*, August 9, 1965, 44–48.

30. Dan Sullivan, "Ivy Leaguers Ask What's Happening," *New York Times*, April 25, 1966, 34. According to this article, the Princeton conference was attended not only by staid professor types but also "young girls" from area colleges.

31. Paul Gardner, "TV Commercials Gain Art Status," *New York Times*, February 15, 1965: 55.

32. Vincent Canby, "Movie: Animated Films, All in a Row," *New York Times*, November 28, 1968, 68.

33. Vincent Canby, "'Independent Cinema' Series Adds Dimension to Festival," *New York Times*, September 27, 1966, 51.

34. Vogel cited in Vincent Canby, "TV Marvels Join in Film Festival," *New York Times*, September 7, 1966, 51.

35. Canby, "TV Marvels."

36. Ralph Porter, "The Mogubgub Approach," *Art Direction* 14, no. 11 (February 1963): 80.

37. Milt Felson cited in Philip H. Dougherty, "Key Man in TV—Director of Commercial," *New York Times*, December 15, 1968, F18.

38. Lee Savage, "TV's One Minute World Is the New Entertainment," *Art Direction* 15, no. 9 (December 1965): 72.

39. Joan Walker, "And Now a Word From . . . (Hooray!)," *New York Times*, June 16, 1968, D15.

40. Gerald Weales, "Be Quiet, The Commercial's On," *Television Quarterly* 6, no.3 (1967): 24.

41. Kubrick cited in Hollis Alpert, "Is It Strangelove? Is It Buck Rogers? Is It the Future?" *New York Times*, January 16, 1966, 43.

42. For more on this campaign, see "The Adult Commercial," *Printers' Ink*, March 23, 1962, 23–26.

43. McMahan, *The Television Commercial*, 22. For similar commentary about intelligent audiences/consumers, see Peter Bart, "Advertising: Cognizance of Culture," *New York Times*, January 19, 1963, 13; Baker, *Visual Persuasion*; "Programming: The Great TV Debate," *Printers' Ink*, February 16, 1963, 26–27; "TV and the Cultural Explosion," *Sponsor*,

January 28, 1963, 30–32; Daniel Burnheim cited in "The Adult Commercial," *Printers' Ink*, March 23, 1962, 30.

44. Charles Goldsmith, "What's behind the Creative Revolution?" *Art Direction* 8, no. 10 (January 1967): 92.

45. Whit Hobbs, "You Have to Grade Up," *Printers' Ink*, March 20, 1964, 70–71.

46. Susan Sontag, "Notes on Camp," *Against Interpretation and Other Essays* (New York: Farrar, Straus and Giroux, 1966). The essay was originally published in *Partisan Review* in 1964. Niles Chignon, *The Camp Followers Guide!* (New York: Avon, 1965). For an analysis of *Mad*'s TV spoofs, see Thompson, "What, Me Subversive?"

47. "The Adult Commercial," 26, 33.

48. Savage, "TV's One Minute World," 72.

49. Wilinsky, *Sure Seaters*.

50. "Culture Market: Class for the Mass," *Printers' Ink*, May 3, 1963, 21.

51. Montagu, *The Cultured Man*, 245.

52. Paul Gardner, "Late Late Show Addiction," *New York Times*, November 3, 1963, X15.

53. The watershed of films began when General Tire and Rubber Company, owners of the Mutual Broadcasting System, bought RKO pictures from Howard Hughes and thereby acquired a valuable library of recent films. William Lafferty, "Feature Films on Prime-Time Television," in *Hollywood in the Age of Television*, ed. Tino Balio (Boston: Unwin Hyman, 1990), 235–56; Leo Bogart, *The Age of Television* (New York: Fredrick Unger, 1956), 169.

54. Lafferty, "Feature Films on Prime-Time Television," 242.

55. Gardner, "Late Late Show Addiction," X15.

56. Ibid.

57. In his 1963 audience survey, Gary A. Steiner estimated that nearly twice as many women as men watched movies on TV. See Steiner, *The People Look at Television: A Study of Audience Attitudes* (New York: Alfred A. Knopf, 1963), 172. In the previous decade, the NBC-Hofstra study of 1951 found that women tended to watch more movies on television than men. See Bogart, *The Age of Television*, 88–89.

58. *Saturday Night at the Movies* was also NBC's attempt to replace its expensive "spectaculars" with more economical fare. See Lafferty, "Feature Films on Prime-Time Television," 245.

59. For the full sponsor list see "TV—Some New Faces, New Sponsor Line-ups," *Printers' Ink*, September 9, 1966, 25.

60. Lafferty, "Feature Films on Prime-Time Television," 246.

61. Bosley Crowther, "Boom in Revivals," *New York Times*, January 21, 1962, 93; Kenneth Tynan, "Legendary Film Figures Unify Modern Culture," *Los Angeles Times*, April 21, 1968, 1.

62. Lawrence Alloway, "Popular Culture and Pop Art," in *Pop Art: A Critical History*, ed. Steven Henry Madoff (Berkeley: University of California Press, 1997), 168.

63. As early as 1953, *Omnibus* screened European experimental films.

64. "Ingmar Bergman Interview Set," *Los Angeles Times*, August 19, 1964, D17; "Horse Operas in Italy Get Needle from Television," *Los Angeles Times*, July 26, 1965, C21. The Brakhage and Connor interviews are available at MoMA.

65. Other episodes in the series featured playwrights such as Tom Stoppard and Har-

old Pinter, poet Lawrence Ferlinghetti, the Watts Actor's Studio, and experimental film-makers.

66. Fellini cited in "Stimuli of Experiment," *Time*, April 18, 1969.

67. Ibid.

68. Ibid.

69. Edith Zorrow cited in Howard Thompson, "Preparing 'The Art of Film' for Video Gourmets," *New York Times*, April 26, 1964, X17.

70. Jack Gould, "Television: 'Rashomon'", *New York Times*, December 14, 1960, 79; Val Adams, "V Plans Drama by Satyajiy Ray," *New York Times*, August 25, 1964, 67.

71. Don Page, "A TV 'Nut' Bolts the Ratings Rut," *Los Angeles Times*, August 3, 1967, C14.

72. Francis Coughlin, "Films with a Wallop Slated on WGN-TV," *Chicago Tribune*, September 11, 1962, 24.

73. Alvey, "The Independents."

74. The *Printers' Ink* article also noted that while Hitchcock took "pot shots at the institution of commercialism itself," he never "maligns Bristol-Myer's products." See "Bristol Myers Alfred Hitchcock: His 'Personality' Sells What He Derides," *Printers' Ink*, July 18, 1958, 63–68. Also see "Integrating Programs and Sell," *Printers' Ink*, April 1, 1960, 54. For analysis of the series, see Thomas M. Leitch, "The Outer Circle: Hitchcock on Television," in *Alfred Hitchcock: Centenary Essays*, ed. Richard Allen and S. Issii Gonzales (London: BFI, 1999), 59–71.

75. For discussions of Cassevetes's television series, see Raymond Carney, *Cassavetes on Cassavetes* (New York: Faber and Faber, 2001), 48–101; Liza Trevino, "A Highly Distinctive Movie-Watching Experience: Independent Film and Television from the Network Era to the Digital Age," (Ph.D. diss., University of Southern California, 2005).

76. Rex Reed, "Are You Ready for Cops-and-Robbers a la Alain Renais?" *New York Times*, July 23, 1967, 79.

77. Melnick cited in ibid.

78. Robert Alden, "Advertising: How Agencies Pick TV Shows," *New York Times*, April 19, 1960, 60. Ted Bates & Co. and J. Walter Thompson made the largest number of TV commercials during the period. However, the "creative shops" like DDB tended to win more art-direction awards.

79. The slogan also appears on the image track in mod typeface.

80. Wallace A. Ross, ed., *Best TV Commercials of the Year* (New York: The American TV Commercials Festival, Inc., 1967), 55.

81. In 1956 Chevrolet became the first car manufacturer to launch a national print advertising campaign aimed solely at female consumers, and perhaps even more astonishingly (given the lack of women in leadership roles at agencies), the company appointed a woman to direct it. The campaign was aimed both at housewives and career women. "How to Persuade a Lady."

82. There were several versions of this commercial, all with slightly different tag lines.

83. "What Hollywood Doesn't Tell Madison Avenue," *Sponsor*, July 15, 1963, 33.

84. For example, Baker recommended this strategy in *Visual Communications*.

85. Ross, *Best TV Commercials of the Year*, 103.

86. Chevrolet received favorable letters from people who saw the ad on *Bonanza*. Ibid.

87. Wolff, *What Makes Women Buy*, 14–17, 29; Baker, *Visual Persuasion*.

88. These include, for example, United Airlines ("Take Me Along," Leo Burnett, 1968) and Braniff International Airlines (no title, Wells, Rich, Greene, Inc., 1966).

89. Ross, *Best TV Commercials of the Year*, 122–23.

90. Ibid., 123.

91. Advertisers had previously connected women's fashion to travel in print ads. See "How to Persuade a Lady," 22.

92. For mod fashion and liberated sexuality in *The Avengers*, see Moya Luckett, "Sensuous Women and Single Girls: Reclaiming the Female Body on 1960s Television," in *Swinging Single: Representing Female Sexuality in the 1960s*, ed. Moya Luckett and Hilary Radner (Minneapolis: University of Minnesota Press, 1999), 277–98; Toby Miller, *The Avengers* (London: BFI, 1998). Michael Kackman discusses mod fashion in *Citizen Spy: Television, Espionage, and Cold War Culture* (Minneapolis: University of Minnesota Press, 2005). For Bond-style print ads, see Tony Bennett and Janet Woolacott, *Bond and Beyond: The Political Career of a Superhero* (London: Routledge, 1987).

93. This was part of a series of award-winning TVCs (known as the Go-Go-Go campaign) for Goodyear tires that Porter compared to the films of Truffaut. Porter, "Go Go Go." The previously discussed "Foggy Road" Goodyear ad was part of this series.

94. Nancy Sinatra sued Goodyear for using her song without permission. See "Goodyear 'Stole' Her Boots, Nancy Sinatra Says in Suit," *Wall Street Journal*, March 14, 1968, 14.

95. "Of Carnaby and Kings: The 'Mod' Fashion Scene," *Print* 23, no. 2 (March/April 1969): 43.

96. VPI producer cited in Ross, *Best TV Commercials of the Year*, 24–25. For the use of op art in fashion magazines, see Whiting, *A Taste for Pop*, 213–20.

97. The division was run by China Machado, a former French artist and top model for Richard Avedon. See Faith Garrett, "High Style for Film and TVC," *Art Direction* 20, no. 9 (December 1968): 54–55.

98. "TV for 1967–68: Specials, Specials, Specials, Specials," *Printers' Ink*, September 8, 1967, 6–9; "Specials Display a Feminine Look," *Los Angeles Times*, March 31, 1968, C3.

99. These "Beat Goes On" commercials with Clark were part of a larger ad campaign and played as one-minute spots prior to the time the special aired.

100. Note that *Finian's Rainbow* was about racism, so that the special's antiracist themes served as a tie-in to the movie.

101. In the fashion-shoot segment, Nancy refers to Sammy Davis Jr. as "Bruce," a name then typically coded as gay, and Sammy speaks in an affected voice mimicking the kind of speech inflections Hollywood usually attributed to gay-coded characters. These gay connotations may have (either consciously or unconsciously) been used by the producers to defuse white anxieties about black male sexuality with white women. However, by the end of the number, Davis returns to his hipster persona, dancing with the sexualized connotations of James Browne, Ray Charles, and other blues/soul artists of the time.

102. Harry Belafonte, "'Look,' They Tell Me, 'Don't Rock the Boat,'" April 21, 1968, D21. For a discussion of how Belafonte and other black performers of the late 1960s and 1970s used commercial TV to promote civil rights, see Christine Acham, *Revolution Televised:*

Prime Time and the Struggle for Black Power (Minneapolis: University of Minnesota Press, 2005).

103. Aniko Bodroghkozy, *The Groove Tube: Sixties Television and the Youth Rebellion* (Durham, NC: Duke University Press, 2001). Bordroghkozy draws upon Gitlin's excellent account of the way the networks tried to target younger, urban demographics in the late 1960s. Todd Gitlin, *Inside Primetime* (New York: Pantheon, 1983).

104. For discussion of CBS censorship of the Smothers Brothers, see Bodroghkozy, *The Groove Tube*, chapter 4; John O'Connor, *American History/American Television: Interpreting the Video Past* (New York: Fredrick Ungar,1983); *The Censorship Struggles of the Smothers Brothers Comedy Hour* dvd, directed by Maureen Muldaur (Los Angeles: Bravo Cable and New Video Group, 2002).

105. For more on the early video collectives, see the epilogue.

106. Bodroghkozy, *The Groove Tube,* chapter 3. For the original, see Abbie Hoffman, *Revolution for the Hell of It* (New York: Dial Press, 1968), 134.

107. David Joselit, "Yippie Pop: Abbie Hoffman, Andy Warhol, and Sixties Media Politics," *Grey Room* 8 (Summer 2002): 67. Joselit is referring to Todd Gitlin, *The Whole World Is Watching: Mass Media in the Making and Unmaking of the New Left* (Berkeley: University of California Press, 2003).

108. "Madison Avenue Gets Involved," *Print* 22, no. 4 (July/August 1968): 40.

109. Murray Duitz, "Is There a New Cinema?" *Art Direction* 19, no.1 (April 1967): 26, 28.

110. Murray Duitz, "Shorts at the Festival," *Art Direction* 20, no. 8 (November 1968): 18, 109.

111. Prior cited in Dougherty, "Key Man in TV," F18.

112. Everett Aison, "Saul Bass: The Designer as Filmmaker," *Print* 13, no.1 (January/February 1969): 90.

113. Martin Goldman, "AD makes House Short," *Art Direction* 20, no. 7 (October 1968): 63–64.

114. Before making *Putney Swope*, Downey had made a number of low-budget films.

115. Vincent Canby, "'Putney Swope,' a Soul Story," *New York Times*, July 11, 1969, 19.

116. Ralph Leezenbaum, "Inside This Year's Biggest Spoof," *M/C* 297, no. 10 (October 1969): 53–62.

117. Downy cited in ibid., 60.

118. In fact, 1968 was a watershed year for public outcries against network racism. The year marked the release of the Johnson administration's "Kerner Report," which studied the causes of racial unrest in American cities (and was most famous for its conclusion, "Our nation is moving toward two societies, one black, one white—separate and unequal.") The Kerner Commission met with network executives to suggest ways to use television to better ends, and in 1968 the networks all ran documentaries about racism. In this context, CBS News joined forces with the Black Film Association to present an eight-part series on racism. The first of these starred Bill Cosby discussing the cultural causes of racism, analyzing demeaning black stereotypes in Hollywood films, and considering how Picasso and Gaughin had "stolen" techniques from African art. For analysis, see MacDonald, *Blacks on White TV*. The "Kerner Report" was the informal name usually used to

designate the report released on February 29, 1968, by the National Advisory Commission on Civil Disorders, chaired by Illinois governor Otto Kerner Jr.

119. For advertising's increased focus on the African American market, see Robert E. Weems Jr., "The Revolution Will Be Marketed: American Corporations and Black Consumers during the 1960s," *Radical History Review* 59, no. 94 (Spring 1994).

120. Lapin Reynard, "An Absurd Black (and White) Comedy of American Family Life in Three Acts, a Prologue, and an Epilogue (Musical Accompaniment Optional), Written after Viewing 45,512 Commercials," *Print* 20, no. 3 (May/June 1966): 11.

121. Leezenbaum, "Inside This Year's Biggest Spoof," 54.

122. Thomas Crow, *Art of the Sixties* (New York: Orion Publishing, 1996), 12.

123. See also Marshall McLuhan, "Television in a New Light," in *The Meaning of Commercial Television*, ed. Stanley T. Donner (Austin: University of Texas Press, 1967), 90.

124. Max Horkheimer and Theodor W. Adorno, "The Culture Industry: Enlightenment as Mass Deception," *Dialectic of Enlightenment*, trans. John Cumming (New York: Continuum, 1988), 167.

CHAPTER 7

1. Andy Warhol, *The Philosophy of Andy Warhol (From A to B and Back Again)* (New York: Harcourt Brace Javonovich, 1975), 26.

2. Warhol's codirector on the film was Jerry Benjamin.

3. David James makes this point in "'The Unsecret Life: An Advertisement," *October* 56 (Spring 1991): 21–41. James argues that varieties of this "good Warhol"/"bad Warhol" rise-and-fall story arc can be found in a range of commentaries, but James especially singles out what he feels is the best of these analyses: Thomas Crow's "Saturday Disasters: Trace and Reference in Early Warhol," *Modern Art in the Common Culture* (New Haven: Yale University Press), 49–68. The same basic story arc appears in commentary from people close to Warhol. For example, his assistant Gerard Malanga says, "The kind of paintings he made from the '70s onward—excepting, of course, the shadows series—bear no connection to the early work—that is, the radical work from the '60s. . . . He became a cash cow." In Gerard Malanga, *Archiving Warhol: An Illustrated History* (New York; Creation Books, 2002), 161. Similarly, this story arc forms the premise for Chuck Workman's 1991 documentary, *Superstar: The Life and Times of Andy Warhol*.

4. Whiting, *A Taste for Pop*, 192. Whiting refers to critics like Lucy Lippard, John Rublowsky, Barbara Rose, and Irving Sandler.

5. John G. Hanhardt, "Andy Warhol's Video & Television," *The Andy Warhol Film Project*, exhibition catalogue, Whitney Museum of American Art, February 22–March 22, 1991. In response to the exhibition David James wrote a short review, "TV Regained . . . Sort Of," *Motion Picture* (1991), 43–45. John Alan Farmer discusses some of the 1960s footage in "Pop People," in Farmer, *The New Frontier*, 64–65. Other critics have considered Warhol's relation to TV within the context of his multimedia performances with the Exploding Plastic Inevitable. See Joselit, "Yippie Pop"; Branden W. Joseph, "'My Mind Split Open': Andy Warhol's Exploding Plastic Inevitable," *Grey Room* 8 (Summer 2002): 80–107.

6. James, "The Unsecret Life," 30. Despite James's claims regarding the need to see these four Warhols together, he himself makes dismissive comments about the 1980s cable

shows and *Love Boat* appearance, so that these moments of Warhol become part of the "fallen artist" story arc that James later critiques. See James, "TV Regained," 43–44.

7. For Warhol's exploits in commercial design, see ibid.; Patrick S. Smith, *Andy Warhol's Art and Films* (Ann Arbor: UMI Research Press, 1986); Ivan Vartanian, *Andy Warhol: Drawings and Illustrations of the 1950s*; Victor Bockris, *Warhol: The Biography* (Cambridge, MA: De Capo Press, 2003); Kenneth Goldsmith, "Success Is a Job in New York," in *Andy Warhol: Giant Size*, ed. Phaidon Editors (New York: Phaidon Press, 2006), 14.

8. "Upcoming Artist, Andy," *Art Director and Studio News*, April 1951, 20; Joseph Masheck, "Warhol as Illustrator: Early Manipulations of the Mundane," *Art in America*, May–June 1971, 48–53; Vartanian, *Andy Warhol*, 104, 109; David James, "The Unsecret Life," 21–41; Whiting, A *Taste For Pop*, 18–22; Smith, *Andy Warhol's Art and Films*, 29–38; Goldsmith, "Success Is a Job."

9. Charles Lisanby cited in Smith, *Andy Warhol's Art and Films*, 367.

10. Pat Hackett, ed., *The Andy Warhol Diaries* (New York: Time Warner, 1989), 805.

11. "Upcoming Artist, Andy."

12. Vartanian, *Andy Warhol: Drawings and Illustrations of the 1950s*, 10.

13. Olden, "Can Television Use Better Art?" 72; "Illustrating for Television," *American Artist* 18, no. 7 (September 1954): 42. Both of these reproduce illustrations of Warhol's title art.

14. Unlike abstract expressionist artists, who were virtually absent from 1950s TV interview formats, television showcased pop artists almost immediately upon their rise to prominence in the art world. One of the first major television interviews appeared on New York's channel 13 in 1964. Titled "Oh Dada, Poor Dada, Moma's Hung You in the Closet and I'm Feeling So Sada," it featured Lichtenstein, Rosenquist, and Warhol. See Paul Gardner, "Channel 13 Plans Study of Pop Art," *New York Times*, March 16, 1964, 63.

15. For critical reactions to pop and/or its relation to the market and collecting, see Whiting, A *Taste for Pop*; Crane, *The Transformation of the Avant Garde*, 37–42; Alan R. Pratt, ed., *The Critical Response to Andy Warhol* (Westport, CT: Greenwood Press, 1997); Madoff, *Pop Art*.

16. For artists' renderings of television, see *Television's Impact on Contemporary Art*, exhibition catalogue, The Queens Museum (New York: The Queens County Art and Cultural Center, 1986); and Farmer, *The New Frontier*.

17. Whiting, A *Taste for Pop*, 138.

18. There are a few notable examples. See *Art Direction* 17, no. 4 (July 1965): 66. Note too that in 1969 Warhol himself began appearing in television commercials. The first was an ad for Branniff International Airlines in which he costarred with boxer Sonny Liston and talked about pop art.

19. Joel Cahn, "It's a Technical World for the Color TV/AD," *Art Direction* 17, no. 7 (October 1965): 91–92.

20. For the increase in color TVCs, see Joel Cahn, "Color Raises the Creative Ante for the TV/AD," *Art Direction* 17, no. 6 (September 1965): 78–79; "Television: Color TV Ads," *Printers' Ink*, October 22, 1965, 33–34; "The Fall TV Schedule: More Color, More Sponsors," *Printers' Ink*, September 10, 1965, 13–16. In 1965 NBC strategically adjusted costs of renting its studios and other equipment for producing color commercials, effectively

raising the cost of black-and-white and lowering the cost of color to put them on the same level. "Color: Will TV Ads Follow Programs to Tint?" *Printers' Ink*, April 9, 1965, 32.

21. ABC dual-marketed *Batman* to children and adults (encouraging adults to read the show with a campy wink). For more on this as well as critical responses to *Batman* in relation to pop and camp, see Lynn Spigel and Henry Jenkins, "Same Bat Channel/Different Bat Times: Mass Culture and Popular Memory," in *The Many Lives of Batman: Critical Approaches to a Superhero and His Media*, ed. Roberta Pearson and William Uricchio (London: BFI, 1991), 117–48. For a discussion of the relationship of pop and camp and queer politics in *Batman*, see Sasha Torres, "The Caped Crusader of Camp: Pop, Camp, and the Batman Television Series," in *Pop Out: Queer Warhol*, ed. Jennifer Doyle, Jonathan Flately, and José Esteban Muñoz (Durham, NC: Duke University Press, 1996), 238–55.

22. "Discotheque Frug Party Heralds Batman's Film and TV Premiere" *New York Times*, January 13, 1966, 79.

23. Ibid.

24. Ralph Porter, "Warhol's *Chelsea Girls*," *Art Direction* 19, no. 2 (May 1967): 50; "Split Screen Comes to TVC with a Twist," *Art Direction* 19, no. 3 (June 1967): 67. Also see Ken Saco, "A Psychedelic TV Commercial," *Art Direction* 18, no. 10 (January 1967): 36. Although advertisers claimed Warhol as their inspiration, most of these split-screen ads actually used an exquisite-corpse layout or else the standard Mondrian grids of the 1950s rather than Warhol's multiple-projection technique in *Chelsea Girls*.

25. According to the *National Observer*, the soundtrack included studio noises while "the sundae vibrates to coughs." Then, an off screen announcer asks, "Andy Warhol for a Schrafft's?" and the announcer concludes, "A little change is good for everybody." See Harold H. Brayman, "New Flavor at Old Favorite: Warhol and Underground Sundaes: Schrafft's Will Never Be the Same," *National Observer*, October 28, 1968, 8. *Time* magazine also describes the ad; see "Shrafft's Gets With It," *Time*, October 15, 1968, 98. A color still from the commercial is in John S. Margolies, "TV—The Next Medium," *Art in America*, September 1969, 48–55.

26. "Shrafft's Gets With It," *Time*, October 15, 1968, 98. The signed frame appears in "It's a Bird, It's a Plane, It's Andy Warhol and the Superstars," *M/C* (November 1968): 33.

27. Shattuck cited in "Shrafft's Gets With It."

28. "It's a Bird, It's a Plane," 33.

29. Margolies, "TV—The Next Medium," 48–49. More recently, David Joselit has also discussed Warhol's commercial in relation to Paik. See Joselit, *Feedback*, 13–14.

30. Brayman, "New Flavor at Old Favorite," 8.

31. For more on video activism, see the epilogue.

32. Warhol cited in Margolis, "TV—The Next Medium," 49.

33. Diana Loevy and Veronica Visser, "From Campbell's Soup to Cable," *Home Video*, November 4, 1981, 54.

34. Alan Jones, "Andyvision: From Silkscreen to TV Screen," *NY Talk*, September 1985, 47.

35. The most famous of these took place on January 13, 1966, at a dinner held for the New York Society for Clinical Psychiatry at Delmonico's Hotel. At this event, Warhol, the Velvets, Edie Segwick, Gerard Malanga, and filmmakers Jonas Mekas and Barbara Rubin (who did most of the filming) assaulted the dinner guests during their multimedia

performance by rushing up to them with cameras and asking them embarrassing sexual questions like "Is his penis big enough?"

36. Warhol, *Philosophy*, 50.

37. Jonathan Flatley, "Warhol Gives Good Face: Publicity and the Politics of Prosopopoeia," in Doyle et al., *Pop Out,* 104–5. For Warner and Fraser's work on counterpublics, see Michael Warner, *Publics and Counterpublics* (New York: Zone, 2005); Nancy Fraser, "Rethinking the Public Sphere: A Contribution to the Critique of Actually Existing Democracy," in *The Phantom Public Sphere,* ed. Bruce Robbins (Minneapolis: University of Minnesota Press, 1993), 1–32.

38. Although I am using Flatley's notion of a "queer counterspace," I believe it would be more accurate to see Warhol's counterspace in relation to Michel Foucault's concept of "heterotopia" rather than Flatley's use of the term "utopia." As opposed to utopias, which are ideals, heterotopias are actual material spaces that exist alongside of, yet also reorder, the dominant spaces of everyday life. (Foucault mentions cemeteries, museums, and cinemas as examples.) In this regard, we might view Warhol's Factory as a heterotopia that reordered Ford's factory by inverting principles of industrial reproduction into art production and by, for example, replacing the regimented time clock and efficient assembly-line workers with an assortment of drug addicts, artists, models, rock stars, and runaways who "waste" time there, hanging out, shooting up, and having sex as Warhol worked. (Foucault argues that heterotopias are connected to "heterochronias," or breaches of traditional experiences and uses of time.) In this sense, Warhol's queer counterspace should be seen as a material reordering of dominant uses of public space, but neither the Factory nor his mediated spaces were ever utopian ideals. The Warhol Factory famously included power dynamics of race, gender, and class that could hardly be called utopian for all participants). For his theory of heterotopias, see Michel Foucault, "Of Other Spaces: Utopias and Heterotopias," in *Rethinking Architecture: A Reader in Cultural Theory,* ed. Neil Leach (London: Routledge, 1997), 350–56.

39. Warhol is describing a cross-country trip he took with some of his entourage in the early 1960s. "Suddenly we all felt like insiders because even though pop was everywhere—that was the thing about it, most people still took it for granted—whereas we were dazzled by it—to us, it was the new Art. Once you 'got' Pop, you never see a sign the same way again. And once you got Pop, you could never see America the same way again." Andy Warhol and Pat Hackett, *POPism: The Warhol Sixties* (1980; repr., San Diego: Harvest, 1990), 39. Flatley uses this as the epigraph to his essay "Warhol Gives Good Face."

40. Warhol and Hackett, *POPism,* 17.

41. Caroline A. Jones, *Machine in the Studio: Constructing the Postwar American Artist* (Chicago: University of Chicago Press, 1996), 92–93. The *Artists USA* series was directed by Lane Slate.

42. For a discussion of Warhol's interviews and strategic self-presentation in them, see Reva Wolf, "Through the Looking Glass," in *I'll Be Your Mirror: The Selected Andy Warhol Interviews,* ed. Kenneth Goldsmith (New York: Caroll & Graf, 2004), xi–xxxi.

43. Analyzing the critical commentary on him, Whiting shows that Lichtenstein was most often depicted during this period as a family man. *A Taste for Pop,* 127–28.

44. Cresap presents an illuminating analysis of Warhol's tactical use of naiveté and tricksterism, particularly in the context of New York School abstract expressionism and

the "macho" and homophobic leanings of that movement. See Kelly M. Cresap, *Pop, Trickster, Fool: Warhol Performs Naiveté* (Urbana: University of Illinois Press, 2004).

45. Warhol, *Philosophy*, 6. Warhol had wanted to name his MTV cable show *Nothing Special*, but according to Warhol the people at MTV thought that title was "too negative." Warhol cited in Jones, "Andyvision," 47.

46. "An Era of Rowan and Martin?" *McCall's*, October 1969, 80.

47. *Rowan and Martin's Laugh-In*, script #0283–21, airdate: February 24, 1969, 4A, Doheny Cinema Library, University of Southern California, Los Angeles.

48. More difficult to categorize as a stock homosexual character is Flip Wilson's female alter ego, Geraldine, who first appeared on *Laugh-In*. On one level, cross-dressing was entirely in keeping with variety shows. Numerous variety-show hosts had previously dressed up as women while keeping their "straight" personae in tact. Although Wilson also kept his comic persona as straight, he was the first black man to cross-dress on network television, and his performance usually provoked issues about race performativity and racism.

49. For a discussion, see Joseph, "My Mind Split Open," 89.

50. Henri Lefebvre, *Critique of Everyday Life*, vol. 1, trans. John Moore (1947; repr., London: Verso, 1991); Henri Lefebvre, *Everyday Life in the Modern World*, trans. Sacha Ravinovitch (New Brunswick: Transaction Publishers, 1990); Ken Knabb, ed., *Situationist International Anthology* (Berkeley: Bureau of Public Secrets, 1989). For discussion, see Michael Sheringham, *Everyday Life: Theories and Practices from Surrealism to the Present* (London: Oxford, 2006).

51. Warhol and his crew produced three separate segments for *Saturday Night Live* in 1981. They were directed by Don Munroe. They were shot in Warhol's studio and left hours of rehearsal footage behind. The rehearsal footage for this segment is available under the titles, "Andy Warhol's TV on 'Saturday Night Live'" with Andy Warhol," 1981, and "Andy Warhol on SNL Part 2 #1–3," 1981, Film and Video Archive of the Warhol Foundation, The Andy Warhol Museum, Pittsburgh, PA (hereafter referred to as the Warhol Film and Video Archive).

52. On the rehearsal footage Warhol talks about his love for reruns; ibid. Although he professed equal fondness for the news, even here he claimed to have liked CNN because "They do a lot of repeating," with fifteen-minute loops cycling all day. Warhol cited in Jones, "Andyvision," 47.

53. Richard Ekstract, "Pop Goes the Videotape: An Underground Interview with Andy Warhol," in Goldsmith, *I'll Be Your Mirror*, 71. Ekstract notes that the exact content of the tapes shown at the party remains unknown.

54. Ibid., 75–76.

55. Some of the interview footage is shot in color and appears to be film.

56. Andy Warhol interviewed by Ekstract, "Pop Goes the Videotape," 76.

57. Hanhardt, "Andy Warhol's Video & Television," 4.

58. Joselit, "Yippie Pop," 70–71.

59. Warhol, *Philosophy*, 5. In the same passage Warhol captured the sense of derealization and disassociation involved in his confrontation with death by likening his life to a TV show: "People sometimes say that the way things happen in the movies is unreal, but actually it's the way things happen to you in life that's unreal. The movies make emotions look so strong and real, whereas when things really do happen to you, it's like watching

television—you don't feel anything." He continues, "Right when I was being shot and ever since, I knew that I was watching television. The channels switch, but its all television" (91).

60. As John Alan Farmer argues, Edie's discomfort and disorientation is highlighted in the film by the fact that the tape is in a constant state of deformation as her face dissolves into zigzagged lines and ghost images, and finally voids into blackness. Farmer, *The New Frontier*, 64–65.

61. Jones, "Andyvision," 47.

62. David Bourdon, "Warhol as Filmmaker," *Art in America*, May–June 1971, 53.

63. The soap-opera video footage is stored at the Warhol Film and Video Archive.

64. According to Fremont, *Vivian's Girls* was inspired by *Chelsea Girls* and Gregory La Cava's *Stage Door* (1937). See Hanhardt, "Andy Warhol's Video & Television," 4. The tape also includes performances by Nancy North and Paul Palmero.

65. Lance and Pat's discussions are in *Lance Loud!: A Death in An American Family* (New York: PBS Home Video, 2001).

66. Annie Roiphe, "Things Are Keen but Could Be Keener," *New York Times*, February 18, 1973, 292. Pat Loud recalls the phone conversations in *Lance Loud!*

67. See, for example, Neil Hickey, "Notes from the Video Underground," *TV Guide*, December 9, 1972, 8.

68. This program was shot by documentary filmmakers Richard Leacock and D. A. Pennebaker and produced by David Oppenheim. In 1972 PBS presented a repeat performance of *Rainforest* on *American Playhouse*. Much slicker than the 1968 version, this show had a standard hour-long variety format, featuring different dance pieces strung together with explanatory narration. Warhol's contribution (the silver *Clouds*) remained essentially the same, but other pop artists (including Johns, Stella, and Rauschenberg) presented much more elaborate colorful set designs that were made specifically for this version.

69. Jones, "Andyvision," 45. *Home Video* similarly called *Andy Warhol's TV* "One of the only aesthetically noteworthy shows on public access." Robert DiMatteo, "Cable Vision Reviews: Warhol's MSG Show fast-paced, laid-back, erratic, amusing, ultra-hip," *Cable Vision*, August 22, 1983, 27.

70. Jones, "Andyvision," 45.

71. Warhol cited in Jones, "Andyvision," 47.

72. Fremont cited in Katherine M. Willman, "Vincent Fremont, Producer of Andy Warhol's T.V.," *Artcom* 18 (1982): 11.

73. *Andy Warhol's T.V.* was alternatively aired on Manhattan Cable (1980–82) and the Madison Square Garden Network (1983).

74. This interview is unlike most of the *Andy Warhol's TV* series. It appears to be taken from an earlier version of the interview in the *Factory Diaries* dated February 11, 1975.

75. Fremont cited in Jones, *Andyvision*, 45.

76. Although TV still by and large presented homosexuality as a titillating joke or social problem, in the post-Stonewall decades, the depiction of homosexuality on TV had changed somewhat from the earlier decades. By the 1980s, shows like *Dynasty* contained gay characters and catered to camp (or "mass camp") tastes.

77. Admittedly, in 1981 it would already be somewhat shocking to see two men talk about their desire for nose and eye jobs. At that point cosmetic surgery had not yet been

as mainstreamed as it is now and certainly would have seemed a "queer" conversation between men.

78. This fascination with performative glamour was registered in a series of "camouflage" portraits taken by Christopher Makos that showed Warhol in various states of ghoulish androgyny with, for example, chalky white makeup, blood-red lips, and women's wigs. See Christopher Makos, *Andy Warhol* (New York: Charta, 2002).

79. The rehearsal footage for this segment is available under the title "Andy Warhol's TV by Don Munroe and Vincent Fremont, Sue Etkin," 1981, Warhol Film and Video Archive.

80. Jones, "Andyvision," 45.

81. Crow is speaking of the 1962 Marilyn Monroe diptychs. See his "Saturday Disasters," 53.

82. Although Warhol's TV productions were still operating in the red at the time of his death, he did amass a fan base. Fremont, said, "Being on cable TV opened up a whole new audience of twelve- to fifteen-year-old fans. We got tons of letters from high-school teachers saying one of the first names to come up in art class was always Andy Warhol." Program notes for "Test Transmissions," exhibition at the Centre for Contemporary Arts, Glasgow, June 17–July 22, 2006, http://www.cca-glasgow.com/events/test_trans.html.

EPILOGUE

1. McLuhan, "Television in a New Light," 91, 106–7; Allan Kaprow, "The Education of the Un-Artist, Part I," *Essays on the Blurring of Art and Life*, ed. Jeff Kelley (1969; repr., Berkeley: University of California Press, 1993), 97.

2. Michael Rush, *New Media in Late 20th-Century Art* (London: Thames and Hudson, 1999), 116.

3. Note, however, that Warhol's subway happening occurred prior to the Paik event.

4. Deirdre Boyle, "A Brief History of American Documentary Video," in *Illuminating Video: An Essential Guide to Video Art*, ed. Doug Hall and Sally Jo Fifer (New York: Aperture, 1990), 62. For a history of activist video, see Deirdre Boyle, *Subject to Change: Guerilla Television Revisited* (New York: Oxford University Press, 1997). For a history of feminist video art, see Martha Gever, "The Feminism Factor: Video and Its Relation to Feminism," in Hall and Fifer, *Illuminating Video*, 226–41; Alexandra Juhasz, ed. *Women of Vision: Histories in Feminist Film and Video* (Minneapolis: University of Minnesota Press, 2001).

5. Rush, *New Media in Late 20th-Century Art*, 117.

6. Michael Shamberg, *Guerilla Television* (New York: Holt, Reinhart and Winston, 1971).

7. Antin, "Video." Antin's "Television: Video's Frightful Parent, Part 1" is in *Art Forum*, December 1975, 36–45.

8. For detailed descriptions of these and other early video artworks discussed herein, see Rush, *New Media in Late 20th-Century Art*; Hall and Fifer, *Illuminating Video*; Farmer, *The New Frontier*; Michael Rush, *Video Art* (London: Thames and Hudson, 2003); Hanhardt, *Video Culture*; Davis and Simmons, *The New Television*; Cubit, *Videography*; Frank Popper, *art.of.the.electronic.age* (London: Thames and Hudson, 1993); Douglas Davis, *Art and the Future: A History/Prophesy of the Collaboration between Science, Technology, and Art* (New York: Praeger, 1973); Edith Decker-Phillips, *Paik Video* (Barrytown, NY: Bar-

rytown, Ltd., 1998); Ira Schneider and Beryl Korot, eds., *Video Art: An Anthology* (New York: Harcourt Brace Jovanovich, 1976); Peggy Gale, ed., *Video by Artists* (Toronto: Art Metropole, 1976).

9. Marita Sturken, "Paradox in the Evolution of an Art Form: Great Expectations and the Making of a History," in Hall and Fifer, *Illuminating Video*, 106, 111.

10. Martha Rosler, "Video: Shedding the Utopian Moment," in Hall and Fifer, *Illuminating Video*, 33.

11. Chloe Aaron, "The Video Underground," *Art in America*, May–June 1971, 75.

12. Todd Gitlin, *Inside Prime Time* (New York: Pantheon, 1983).

13. Kathy Rae Huffman, "Video Art: What's TV Got to Do with It?" in Hall and Fifer, *Illuminating Video*, 88. Huffman is citing Arlene Zeicher, "Rapping about Wrapping," *LA Weekly*, November 28–December 4, 1986, 20.

14. Video artists of the 1970s also considered the home video market as a means of distribution, but that did not pan out.

15. John G. Hanhardt, "Notes toward a Post-Television Video," in *TV Generations*, exhibition catalogue, Los Angeles Contemporary Exhibitions gallery, February 21–April 12, 1986, 25.

16. American Film Institute, National Video Festival catalogue, AFI, Los Angeles, September 22–25, 1983, and John F. Kennedy Center for the Performing Arts, Washington, D.C., October 22–23, 1983, 39.

17. The Queens Museum, *Television's Impact on Contemporary Art*, museum catalog, 1986.

18. Hanhardt, "Notes toward a Post-Television Video," 25.

19. Symptomatically in this regard, Antin declared, "The history of television in the United States is well known," and he went on to describe the standard story of the networks' monopoly over technology and transmission, yet made absolutely no mention of the deep connections between the industry and the art world during the formative period. See Antin, "Video," 40.

20. John Hanhardt, "De-Collage/Collage," in Hall and Fifer, *Illuminating Video*, 71.

21. See William T. Murphy, "Television and Video Preservation: A Report on the Current State of American Television and Video Preservation," vol. 1, prepared for the Library of Congress (Washington, D.C.: Government Printing Office, October 1997), 16. For more on the Paley Center and the history of television's preservation, see Spigel, "Our Television Heritage."

22. Richard F. Shepard, "Tune in Soon for Best of Yesteryear," *New York Times*, July 22, 1979, 33.

23. Robert Louis Shayon, ed., *The Eighth Art* (New York: Holt, Reinhart and Winston, 1962). For more on CBS's interests in television scholarship, see Spigel, "The Making of a TV Literate Elite," 67–70.

24. Shamberg, "Process Notes," in *Guerilla Television*.

25. Murphy, "Television and Video Preservation," 60.

26. Shepard, "Tune in Soon."

27. Batscha cited in Bernard Weintraub, "Museum of TV and Radio Goes Bicoastal," *New York Times*, March 18, 1996, C11.

28. In 1991, the Paley Center moved from its original location on 53rd Street to the architecturally grand Philip Johnson building next to Black Rock on 52nd Street.

29. Benjamin, "The Work of Art."

30. Richard Meier cited in Leon Whiteson, "TV Museum Both Formal and Inviting," *Los Angeles Times*, June 2, 1996, K5.

31. Larry Gelbert cited in Bernard Weintraub, "Museum of TV and Radio Goes Bicoastal," C12; Whiteson, "TV Museum Both Formal and Inviting," K1, 5; Diane English cited in Weintraub, "Museum of TV and Radio Goes Bicoastal," C12.

32. Stuart Hall, "Television as a Medium and Its Relation to Culture: Some Provisional Notes," part IV of report to UNESCO, "Innovation and Decline in the Treatment of Culture on British Television," November 1971, 111. Birmingham: Stenciled Occasional Papers, Centre for Contemporary Cultural Studies, University of Birmingham Special Collections.

33. Raymond Williams, *Communications* (Harmondsworth and Baltimore: Windus, 1962); Richard Hogart, *The Uses of Literacy: Aspects of Working-Class Life with Special Reference to Publications and Entertainments* (Harmondsworth: Penguin, 1958).

34. Hall, "Television as a Medium," 112–13.

35. In the last decade, this attack has been especially directed at the glut of reality programs. However, it should be noted that the industry and several critics have at the same time embraced a few scripted series (mostly on pay cable) as evidence of a new "golden age."

● ● ● INDEX

Adams, Charles, 116
Adams, Edie, 191, 198, 199, 200
Addams Family, The (ABC), 4
Adderley, Julian Cannonball, 51
Admiral Broadway Revue (NBC and DuMont), 19, 44, 48, 136
Adorno, Theodor, 7, 249
"Adult Commercial," 225
Adventures of, The* (Hubley), 64
advertisements, in print media: big picture ad as way to reach female consumers, 58–59; CBS consumer/newspaper ad art, 75, 86–92, 94–98, 107–8; CBS trade ad art, 68–69, 74–77, 78, 93–94; data-heavy, 74; emphasis on modern graphic design, 5, 58, 59, 62, 71–72, 77–79; and fine art used in ad copy, 58, 59, 69, 204; and growing relationship between fine and commercial arts, 11, 78–79; and history of corporate advertising, 69–70; increasing use of photography over sketch art, 108; television station, 74–75; theater-bill, 88–89, *90*; use of artist's signature in, 89
Advertising Age, 58, 59, 205
advertising artists: and belief systems and values of 1960s counterculture, 213–15, 243–44; as cinephiles, 214–15, 220; elevated status in trade journals, 77; high salaries for, 222; image as television's creative avant-garde, 213, 223; and independent and underground filmmaking, 221–22, 243, 244–48; who became filmmakers, 223, 245–48; who thought of themselves as civic leaders in a national campaign to democratize taste, 66; use of silence as sales technique, 207–12
advertising industry and agencies: appeal to "class" consumers with sophisticated tastes, 15, 27–28, 77, 78, 91, 94, 204, 205, 209, 211; appeal to female consumers, 28, 58–59, 60, 204, 232–40; appeal to modern lifestyles and ideals of progress, 60–62, 66; CBS as largest advertising medium in the world by 1954, 73; color reproduction, 259; "creative revolution" and artistic innovation, 109, 205, 210, 213–14; embrace of Warhol, 260, 261–62; focus on American market, 352n119; involvement in counterculture and social causes, 244; and Marshall McLuhan, 248–49; metareflexive commentary on, 248–49; public skepticism about, 184; racism in, 242, 247; recognition that second generation TV

viewers were media literate and more weary of commercials, 224–25; recognition that women no longer identified with housewife role, 236–37; response to "vast wasteland" criticism, 213; separate TV departments, 6, 217; tension between youth-culture themes and need to attract mass audience, 242–43. *See also* advertisements, in print media; television commercials; television commercial film business
Advertising and Selling, 58, 59–60
advertising trade journals: debate of design vs. market research issue, 58, 76; reviews and discussions of films and film festivals, 209–10, 218–22
Aer Vue Corporation, 187
AFI, 291
affiliate stations: and modern architecture, 130, 140; network contracts and industry relations, 27, 28, 67, 71, 96, 118, 228, 242; use of network promotional art and trademarks, 70, 75, 86, 99, 102
Agha, M. F., 76, 84, 312n119
Ailey, Alvin, 54
Albers, Josef, 78
Alberto hair products, sponsor for *77 Sunset Strip*, 232
Albright Knox Museum, Buffalo, New York, 277–78
Alexandrov, Grigori, 195
Alfred Hitchcock Presents (CBS), 231, 232
Alive from Off Center (PBS), 289–90
Allen, Fred, 188
Allen, Gracie, 4, 89, 137
Allen, Steve, 56, 57, 197, 200, 311n106
Allen, Woody, 240
Allied Chemical Corporation Fibers Division, 151
All in the Family (CBS), 289, 290
Alloway, Lawrence, 228
Aloha Stadium, Hawaii, 120
Alphaville (Godard), 219, 233
American Academy of Television Arts and Sciences TV library, 336n138
American Artist, 255
American Association of Advertising Agencies (AAAA), 184, 215, 216
American avant-garde, 3, 21, 24, 25, 26, 146, 150
American Family, An (Gilbert, PBS), 275, 279
American Federation of the Arts (AFA), 159, 173

Art Direction, 77, 217, 223, 245, 246, 260; on abstract expressionism and advertising, 311n111; on the "big picture" in advertising, 58; on color commercials, 259; on creativity in commercials, 213; embrace of European art cinema, 218; forum on taste, 67; on Fred Mogubgub, 222; on McLuhan, 248; on modern art in advertising, 60; on product packaging as abstract art, 59; on product packaging for television, 104; rejection of Hollywood-style realism, 220; on silent ads, 209, 210; on UPA, 63

Art Directors Club (ADC), 77, 106, 217, 233; award shows, 147, 176

Art Directors Club of New York Exhibit, 60

Art Forum, 287

art-house commercials. See art-cinema commercials

art-house theaters. See art cinema

Art in America, magazine, 166, 173, 262, 273, 289

Art in America, radio series, MoMA and the first nationally broadcast art series, 159

Art in Your Life (San Francisco Museum of Art), 160

Arts in the Americas, The, CBS and Metropolitan Museum of Art experimental television program, 159

artist's model, as a suspect figure, 42

art museums: attendance, 1950s and 1960s, 3; bridges between world of art, everyday life, and consumerism, 150–51, 162; interest in using television as a second gallery, 147; Marxist attacks on, 286; modern, 13; partnerships with TV networks and broadcast stations, 147, 159–60, 162, 163, 165, 166–173; turn to television to court new publics, 145

Art News, 116

" Art of Ellington!, The," 52

Art of Film, The (WNDT), 229–30

"Art of This Century" show, 10

"arts explosion" (aka "cultural explosion"), 2, 3, 11, 67, 347n43

arts programming. See public-affairs programs

Artzybasheff, Boris, 78

Ashcan School, 10

assemblage art, 174, 176, 257

Associated American Artists (AAA), 20

Astaire, Fred, 50

At Land (Deren), 217

Atlanta Journal, 205, 207

Attali, Jacques, 186, 340n31

audio-visual experimentation, 52–55, 212, 213

"auteur" directors, 223

"authenticity," 51

avant-garde: American, 3, 21, 24, 25, 26, 146, 150; commercials as, 176, 221; French, 46–57; Golden's skepticism about, 79–80; vs. kitsch, 10, 26, 79–88, 142–43; and mass culture, 285

Avedon, Richard, 6

Avengers, The (ABC), 237

"bad girl" models, 39, 42

Baker, Stephen, Visual Persuasion, 59, 236, 237

Balaban and Katz, 119

Ball, Lucille, 71, 89, 107

ballet, abstract or stylized stage sets, 47

Ballet, Jan, 92

Ballet Mécanique (Léger), 62

Band-Aid, commercials: "Field," 208; "Strip, Patch, Spot," 62–63

Bardot, Brigitte, 218, 226

Barnouw, Eric, 152; and historical model, 330n33

Baron, Don, 219–20

Barr, Alfred H., 145, 162, 166, 169, 333n81

Barry, Iris, 327n6, 329n32

Bart, Peter, 207

Bartock, Bela, 189, 196

Basie, Count, 32

Bass, Rudi, 316n46, 320n101

Bass, Saul, 6, 52, 78, 106, 217, 320n101

Batman (ABC), 6; "Pop Goes the Joker," 259; premier party that Warhol attended, 259–60

Batscha, Robert M., 293

Battcock, Gregory, 177

Batten, Barton, Durstine, and Osborn (BBDO), 52, 108

Bauhaus School, 80, 85

Bayer, Herbert, 79

Bazaar, 238, 239

BBC radio, 158

BBC television series, Ways of Seeing, 12

"Beach" advertising campaign, commercials for Cole of California swimsuits, 233, 234

Beatles: films, 223; "We Can Work It Out," 242

"beatnik," 56, 198

Beats, 56, 231, 310n101; aesthetic, 57; and TV, 7, 311n104

Beatty, Talley, 54

original plant, 122–23; Paley's conception of, 121–22, 123, 124; parking lot, *129*, *131*; photographed by Ezra Stoller, 126; promotion and competition, 130; in relation to 1950s Los Angeles theme architecture, 127–28; Stanton's conception of, 121–22, 123, 124; studios and "sandwich-loaf" principle, 123; size and basic layout, 122–23; "studio style," 135; "Television City Day," 132–33; ten years after conception, 139; *Variety's* front-page review of, 137–38; "vital statistics," 129. *See also* Luckman, Charles; Pereira and Luckman Associates; Pereira, William C.

Cecil, William, 48

Celebrity Sweepstakes (syndicated), 283

Central Intelligence Agency (CIA): International Organizations Division, 150; promotion of American art in name of freedom, 25

Cézanne, Paul, 52

Chadbourn, Alfred C., 108, 109

Chagall, Marc: *Birthday*, 166; *They Became Artists* TV series at MoMA, 170

Chamberlain, Betty, 148, 153, 329n32, 333n82

Chaplin, Charlie, 172, 188, 189, 190, 206

Charles, Ray, "What'd I Say?", 241

Chase, Barry, 50

Chayefsky, Paddy, 330n33

"cheesecake" advertisements for TV stations, 74–75, 76, 86

Chelsea Girls (Warhol), 260, 274; Warhol's promotion of on television, 267

Chereskin, Alvin, 220

Chevrolet advertising: appeal to women, 235–36, 349n81; "Lazy Afternoon" commercial for Chevrolet Caprice Custom Coupe, 235–36; "Pinnacle" commercial for Chevrolet convertible, 235, *236*; silent (pantomime) commercial, 207

Chicago Art Institute, 62

Chicago Defender, 55

"Chicago School" of television, 322n25

Chicago Tribune, 56, 88

Chicago World's Fair, Armour and Company exhibit building, 119

Childress, Alvin, 133

Chion, Michel, 180

"Chromo Key" special effects, 108

Chrysler: "boomerang" design, 60; commercial for "Forward Look" tailfin cars in *An*

Evening with Fred Astaire, 60; commercial for Plymouth cars in *The Steve Allen Plymouth Show*, 57; "Forward Look" cars, 67

Churchill, Winston, 24

Cigar Institute of America, 204

Cinderella (CBS), 92

Cinema 9, 230

Cinema 16, 220, 245

cinéma vérité, 228, 237, 240

Citizen Kane (Welles), 228

Civilization (Clark, BBC-2), 296

civil rights movement, 287

Clairol hair color, commercial for, 209

Clark, Kenneth, 296

Clark, Petula, *The Beat Goes On*, 240, 241–42; "Beat Goes On" advertising campaign, 350n99

Clarke, Shirley, 245

"class" vs. "mass" audience, 15, 27–28, 78, 94, 204, 205, 209, 211, 256

Clave, Antoni, 109

Cleveland, Pat, 274

Climax! (CBS), 139; "A Man of Taste," 39–40

Clio Awards, 217, 233

Clooney, Rosemary, 196

coaxial cable, 96

Coca, Imogene, 19, 188

Cockcroft, Eva, 25, 150

Coe, Fred, 117

Cohen, Lizabeth, 66

Cohen-Séat, Gilbert, 218

Coiner, Charles T., 58, 314n4

Colbert, Claudette, 38

cold war: and Abstract Expressionist painting, 3; ideological role of arts in, 17

Cole of California, "Beach" campaign commercials, 233–34

Colgate Comedy Hour, The (NBC), 44, 88

Colgate-Palmolive-Peet Company, 119, 205

collage, 10, 40, 58, 194, 220, 224, 222, 238

Collector's Item (unsold pilot), 41

Colomina, Beatriz, 126, 324n76

color film, 108

Color Me Barbra (CBS), 167–68, *169*

color television: all-color lineups for prime-time shows in 1966–67 season, 259; CBS/RCA patent war, 75; commercials, 57, 60, 63, 215, 217, 219, 233, 235, 246, 259, 261, 264; NBC peacock, 105; NBC spectaculars, 117; and package design, 104, 259, 261; and

educational television (*continued*)
330n40; and video art, 289–90. *See also* NET
and PBS
8½ (Fellini), 218, 249
Eighth Art, The (ed. Shayon), 292
Eisenhower, Dwight D., 30; emphasis on the
arts, 17; "weekend painter," 24
Eisenstein, Sergei, 194, 195, 209, 210, 222
Electrographics, 216
electronic noise, 212
Elizabeth, Queen, coronation, 97
Ellington, Duke: first African American jazz
artist to headline a concert in Carnegie
Hall, 309n85; interest in use of visual
and theatrical interpretation to compli-
ment musical compositions, 52; *Person
to Person* appearance, 309n83; primetime
network program devoted to audio-visual
experimentation of jazz, 52–55; "Satin
Doll," 52, 309n83; "Sophisticated Lady," 52;
State Department tours, 31; "Such Sweet
Thunder," 52; "Take the A Train," 52; *Timex
All Star Jazz Show*, 51; use of TV to convey
black modernism, 15, 50. *See also* "A Drum
Is a Woman"
Elliot, Mike, 220
Elliot, Robert, 316n46
Ellis, Perry, 280
Emerson, Faye, 168, 169
Empire (Warhol), 260
Encyclopedia Britannica's "True Life" children's
books, "Library" commercial, 208–9
English, Diane, 294
Entertainment Tonight (syndicated), 17
Ernie Kovacs Papers, 16
Ernst, Max, 312n119
Errol Flynn Theater, "The Model," 42
Erwin, Wasey & Co., 204
Esquivel, Juan Garcia, 189; "Jalousie," 194
Esso Gasoline, commercial for, 63, 65
Esso World Theater series (WOR), 230
EUE/Screen Gems, 220, 223
European art cinema, 3; as model for TV com-
mercials, 218–20, 223–24; in U.S. popular
culture, 226, 233–37. *See also* movies on TV;
art-cinema TV
European design theory, 79, 85
European modernism, 146
European new-wave cinema, 214. *See also* art
cinema

European public, view of American art as a
cheap imitation of the real thing, 26
Evans, Jacob, 319n99
Evening with Fred Astaire, An (CBS), 50, 60
"everyday modernism," 22–23, 303n11; vs.
vernacular modernism, 299n3
Excursion (NBC), 327n1
Exploding Plastic Inevitable (EPI). *See* Warhol,
Andy
E-Z Pop popcorn, "Bop Corn" commercial, 64,
65, 313n134

F. William Free & Co., 260
Face in the Crowd, A (Kazan), 339n21
Factory Diaries (Warhol), 271–73
Fairfax district, Los Angeles, 128
Famous Artists School, 108–9, 320n112
Farmers Market, Los Angeles, 118
fashion, 33, 61, 81, 155n10; and costume design,
48, 50, 54, 55, 189; magazine illustration, 82,
89, 90, 255; "mod" in commercials, 237–39;
"mod" in TV programs, 240–41, 350n92;
photography, 219, 233, 235, 238, 239; seg-
ments and shows on TV, 159, 165, 167–68,
252, 253, 270, 279–80; shows at museums,
150, 159
Fashion (Manhattan Cable), 279
Father Knows Best (ABC), 283, 319n94; "Brief
Holiday," 42
Federal Communications Commission (FCC),
4, 69, 152, 183, 213, 228, 285; "freeze" on
station allocation, 153, 323n39; monitoring
of sound levels of commercials, 185; "public
interest," 27, 34; UHF, 153. *See also* Minow,
Newton, "Vast Wasteland" speech
Federal Trade Commission (FTC), crackdown
on fraud in television commercials, 183
Feedback (Joselit), 9
Feinger, Lyonel, 21
Feldon, Barbara, 269
Fellini, Federico, 218, 219, 226, 229, 230, 249
Fellows, Harold E., 187
Felson, Milt, 222
Felton, Norman, 309n88
fem-cees, 164, 165, 334n100
femininity: alignment of television with, 177;
"othering of," 147; threat of associated with
the arts, especially American and European
modernism, 39–43
feminist movement, 287

"More than Meets the Eye" (CBS), 64

Morgan, Henry, 172

Morse, Margaret, 129, 319n97

Motherwell, Robert, 21, 33, 47, 307n58

Moulin Rouge (Huston), 33

Movin' with Nancy (NBC), 240–41; commercials for RC cola, 242; mix of cinematic style and mod fashion, 240–41; mixed race dancing, 242

Mozart, Wolfgang Amadeus, 208

MPO Videotronics, 216, 223

Mr. Ed (CBS), 4

Mr. Magoo, 63

Mr. Magoo, 170

Mr. and Mrs. North (NBC), "Hand Painted Murder," 42

MTV, 17, 291

multimedia performances, 8, 263, 286

Mumford, Lewis, 7

Munroe, Don, 279, 282

Murnau, F. W., 226

Murphy Brown (CBS), 294

Murrow, Edward R., 330n33; advertising portrait of, 89, *91*; advocate for the internationalization of jazz, 32; with Grandma Moses, *31*; *Person to Person*, 21, 29–30, 199, 309n83; *See It Now*, 29–31, 107

Museum Council Television Committee, 147

Museum Looks in on TV, The, 329n31

Museum of Contemporary Art, Barcelona, 293

Museum of Fine Arts, Boston (BFA), popular arts formats, 160

Museum of Modern Art (MoMA), 13, 25, 73; 1949 ADC exhibit, 78; 1952 "Cubism and Futurism" show, 66; ambivalence toward public and women visitors, 149; attempt to create a public library for television, 292; Celeste Bartos Film Study Center, 16; contributions to prominence of graphic design and commercial art, 78; efforts to spread American modern art abroad and cultural cold war, 150; embrace of video art and disengagement from television, 176–77; exhibitions of abstract expressionism generally ignored women and African American artists, 146–47; historical commitment to industrial design and the display of everyday objects, 152; history in New York City's commercial culture, 152; idea that modern art and design represented freedom and individual expression, 150; interest in collecting television as an art object in and of itself, 175; male-centered cannon, 146; "Open Circuits: An International Conference on the Future of Television," 176–77; postwar surge in attendance, 149; promotion of modern furniture design, 150; radio programs about art, 149, 159; relations with department stores, 152, 330n35; retrospective on Strand's work, 69; "The Revolution of the Eye," 173; "Road to Victory" show, 24, 149; saw television as central to maintenance of its own cultural power, 148; simultaneous embrace and "othering" of femininity, domesticity, and commercial women's culture, 147; symposium on pop, 176; Television Archive, 151, 176; UPA exhibition, 64; use of American film as a weapon in cold war, 329n25; view of commercials as avant-garde art, 176, 221; *What Is Modern Art?*, 161

Museum of Modern Art (MoMA) Film Library, 176; circulation of reels of award-winning commercials to universities in 1960s, 221; image as a "tastemaker," 175; initially hostile to television, 151, 175; retrospective of "golden age" programs called "Television U.S.A.: 13 Seasons," 175–76

Museum of Modern Art (MoMA) Television Project: assumptions about TV audiences and their tastes, 154–68; assumptions about the female nature of the television audience, 154–55, 156, 163; attitude toward educational state run channels,152–53; first museum in the United States to present itself in a television program, 145; four related aims in pursuit of television, 151; host-humiliation technique, 161–63; internal museum report on the *Point of View* series, 172; linking of fine art with homemaking practices, 164; preference for commercial broadcasting over educational channels, 152–53; problems around production of in-house experimental TV programs, 169–72; quest to find a popular television format for art education, 158–59, 160–61; simultaneous embrace and "othering" of femininity, domesticity, and commercial women's culture, 147; stress on need to reach typical TV viewer at home through liaisons with commercial networks, 145–46; television programs devoted to the

New York City Center Opera Company, 54
New Yorker Theater, 228
New York Film Festival: 1966, 221–22; 1968, 245, 246
New York Public Library, television-related collections, 16
New York School abstract expressionism, 3, 26, 47, 146, 355n44
New York State Council for the Arts, 289
New York State Federation of Women's Clubs, 330n40
New York Times, 198, 207, 212
New York World's Fair, 120
niche marketing, 297
Nickelodeon, "Nick at Nite," 294, 295
Night at the Opera, A (Marx Brothers), 228
Night Gallery (NBC), 307n60
"Night Ride," commercial for Breck shampoo, 233
noise, 340n31; abatement campaigns, 340n32; commercials, 185, 187, 192, 202, 205, 207, 210–12; domestic, debates about and discourse on, 186–87; television, 179–80, 186–87, 188
"noise" bands, 212
non-objective art, 21, 22
non-sync sound, 245
Norelco, 271
Norton, Ken, 280
NOW (CBS), 289
Noyes, Eliot, 68
Number 9 (Pollock), 82
N.Y.P.D. (ABC), 231–32
NY Talk, 278
NYU Alternative Media Center, 278

O'Connell, Helen, 309n82
October, 295
O'Doherty, Brian, 160
Odyssey (CBS), 173
Office of War Information (OWI), 24, 29
O'Keefe, Georgia, 47
Olden, Georg, 6, 108, 208, 316n53; in charge of CBS on-air art, 100–102; interest in the relationship between image and type, 102; leader in the "titling" field, 102; poses in his Bronx, New York, home with his TV set and one of his own paintings, *101*; struggle with racism, 318n81, 318n83; title art for the CBS mystery series *The Web*, *103*; on Warhol

as title artist, 255; whimsically abstract and minimalist style, 100–101
Oldenberg, Claes, 64
"Old Movie Kitchen," commercial for 7-Up, 207
Old Spice body talcum and electric shave lotion, commercial aired on *See It Now*, 62
Olins, Wally, *The Corporate Personality*, 70
Omnibus (CBS), 4, 27, 34–35, 37, 45, 164, 198, 199, 292, 306n44
One Life to Live (ABC), 280
"One Minute Movie, The," 221, 248
One Step Beyond (syndicated), 41
online TV fan sites, 295
Ono, Yoko, 288
"On the Riviera," commercial for Cover Girl makeup, 237
on-screen art (aka on-air art), 6, 98–106; graphic techniques also used on product packages, 103–5; professional recognition of, 106; relation to the visual experience of shopping, 105. *See also* title art for television
op art, 13, 268; in commercials, 238, 239
Open Channel, 278
"Operation Frontal Lobes," 27
Oppenheim, David, 357n68
Opportunity, 100
Orange County Airport, 120
"Ordinary Paper," commercial for Xerox, 223–24
"Oriental Blues, The," 199
Osborne, William Church, 78
Our Town, 197
Outside the Curing Barn (Benton), 34
overhead tracking shots, 236

package design, 12; creation of package art specifically for readability on the TV screen, 104; and modern graphic design, 104; problems with distortion and legibility on color television, 259; relation to pop art, 64
Package Designer's Council, 104
Packard, Vance, *The Hidden Persuaders*, 184, 246, 249
Paepke, Walter, 79
Paik, Nam June, 212, 262, 286, 287; *Electronic TV*, 288; *Participation TV*, 288
paint-by-number kits, 21
painting, in cold war culture, 23–37
Paintings in the Whitehouse: A Close-Up, 306n50

as a "signature" artist, 255; *Soap Opera*, 252, 253, 254, 283; soap opera experiments between 1973 and 1975, 273–75; split-screen style, 260; standard historical explanation of rise and fall as an artist, 253–54; taping of "Underground Sundae" commercial, 264, 265; title art for *Studio One* "Letter of Love," 255–56, 257, 264; top twelve title artists in the 1953 "Who's Who in Art" for television, 255; "trickster" persona, 267; and TV time, 252, 270–71; as underground filmmaker, 260; "Underground Sundae" commercial for Shrafft's restaurants, 260, *261, 262,* 283; *USA: Artists* program, 265, *266,* 267; videotaping and collecting of TV programs, 283; view of TV primarily as a talk medium, 262; views on video art, 262–63; *Vivian's Girls, 274;* "Water Front Zombies" (alternatively "Some Sort of Girl Gang Fantasy"), 275

Warhol Factory, 263, 264, 265; as "heterotopia" and "heterochronia," 355n38

Warhol Foundation, 283

Warner, Michael, 263

Warner Bros., 216, 326n106

Warren, Earl, 110, 137

Washington Crossing the Delaware (Rivers), 30

Wasson, Haidee, 175

Waters, Ethel, 309n82

Waters, John, 280

Watts Riots, 267

Way, Jennifer, 26

Ways of Seeing (Berger, BBC), 12

W. B. Doner and Company, 64

WCBS "Late Show," 227

WCBW, New York, 3, 159

Weaver, Sylvester "Pat," 4–5, 27, 28, 32, 117; "Operational Frontal Lobes," 72

Web, The (CBS), Olden title art for, 102, *103*

Weill, Kurt, 195

Weir, Forest, 133

Welles, Orson, 52, 197, 228

Wesselmann, Tom, 257

West, John K., 131

WGBH, Boston, 160, 277, 287, 289, 309n80

WGN, international art films, 230

What's Art to Me?, MoMA radio series, 159

What's Up, Tiger Lily? (Allen), 240

Whiting, Cecile, 12, 253, 257

Whitman, Robert, 221

Whitney Museum of American Art, 25, 277

Who's Afraid of the Avant-Garde? (PBL, WNET), 277

"Why Not?" commercial for Brazil Coffee, 208

Whyte, William H., Jr., 200; *The Organization Man,* 315n45

"Wide Boots," commercial for Goodyear tires, 238, 249

Wide Wide World (NBC), 33

Wiene, Robert, 226

Wilder, Billy, 198

Wilinsky, Barbara, 226

Williams, Raymond, 296

Williams, Spencer, 133

Will Success Spoil Rock Hunter? (Tashlin), 184

Wilson, Flip, 356n48

Wilson, Sloan, *The Man in the Gray Flannel Suit,* 77, 314n22

Wind Across the Everglades (Ray), 218

Winky Dink and You (CBS), 332n78

Wipe Cycle (Schneider and Gillette), 288

Wisconsin Center for Film and Television Research, 16

Wisdom (CBS), 27

WJZ, 206

WKIZ-TV, 230

WNBT, New York, 160

WNDT, New York, 229

WNET, New York, 277, 287, 289

WNTA, New York, 230

Wolfe, Tom, 221

Wolff, Janet, *What Makes Women Buy,* 59, 236

Wolters, Lee, 188

women: as abstract expressionist artists, 146, 306n57; associated with art depicted as subversives in TV dramas, 39–43; and Cigar Institute of America, 204; considered by advertisers to be more interested in art than were men, 58–59; drivers and car/tire commercials, 60, 223–34, 235–36, 238; as fans of Ernie Kovacs, 200, 204; and fantasies of travel in commercials, 237; as "fem-cees" in programs about art, 164; major audience for both televised movies and cinematic television shows, 13, 232, 348n57; "modern," suspect in popular culture, 38–43; and modernism, 146; and MoMA's outreach to, 145, 146, 150–51, 154–56, 163–64, 166, 173; and museum-directors' fears about, 149; as target audience for art–cinema commercials, 232–37. *See also* housewives; momism